SIGNAC
1863–1935

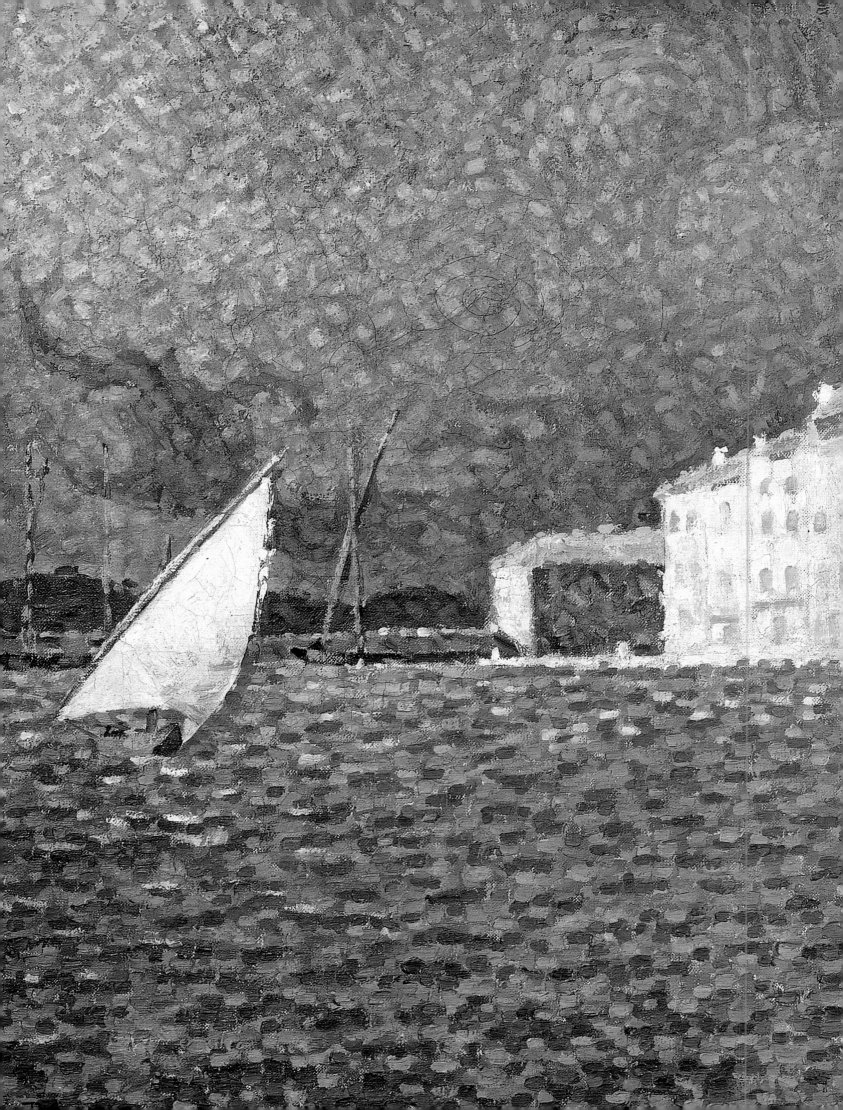

SIGNAC
1863–1935

Marina Ferretti-Bocquillon,
Anne Distel, John Leighton, and Susan Alyson Stein

WITH CONTRIBUTIONS BY

Kathryn Calley Galitz and Sjraar van Heugten

THE METROPOLITAN MUSEUM OF ART
YALE UNIVERSITY PRESS

This catalogue is issued in conjunction with the exhibition
"Signac, 1863–1935," held at the Galeries nationales du Grand
Palais, Paris, February 27–May 28, 2001; the Van Gogh Museum,
Amsterdam, June 15–September 9, 2001; and The Metropolitan
Museum of Art, New York, October 9–December 30, 2001.

The exhibition is made possible in New York by
The Florence Gould Foundation.

The exhibition was organized by the Réunion des Musées
Nationaux/Musée d'Orsay, Paris; the Van Gogh Museum,
Amsterdam; and The Metropolitan Museum of Art, New York.

This publication is made possible in part by the Janice H.
Levin Fund.

Published by The Metropolitan Museum of Art, New York

John P. O'Neill, Editor in Chief
Kathleen Howard, Editor
Antony Drobinski, Designer
Peter Antony and Megan Arney, Production
Minjee Cho, Desktop Publishing

The essay "Signac: Drawings and Watercolors" by Marina
Ferretti-Bocquillon first appeared, in slightly different form,
in the exhibition catalogue by Marina Ferretti-Bocquillon
and Charles Cachin, *Paul Signac: A Collection of Watercolors and
Drawings* (Little Rock, Arkansas, and New York, 2000).
Permission to reprint was granted by Brian Young, Curator
of Art, Arkansas Arts Center, Little Rock.

The Chronology has been adapted from Cachin 2000.

Map on p. 296 designed by Adam Hart.

*

Jacket/Cover illustration: Paul Signac, *The Port at Sunset,
Saint-Tropez, Opus 236* (cat. no. 61), detail
Frontispiece: Paul Signac, *The Storm, Saint-Tropez*
(cat. no. 91), detail

Library of Congress Cataloging-in-Publication Data

Signac, Paul, 1863–1935.
　　Paul Signac, 1863–1935 / Marina Ferretti-Bocquillon . . .
[et al.]
　　　　p. cm.
　　Catalog of an exhibition at the Grand Palais, Paris,
Feb. 27–May 28, 2001, Van Gogh Museum, Amsterdam, June
15–Sept. 9, 2001, and the Metropolitan Museum of Art, New
York, Oct. 9–Dec. 30, 2001.
　　Includes bibliographical references and index.
　　ISBN 0-87099-998-2 (hc.)—ISBN 0-87099-999-0 (pbk.)—
　　ISBN 0-300-08860-4 (Yale University Press)
　　I. Signac, Paul, 1863–1935—Exhibitions. 2. Neo-impres-
sionism (Art)—France—Exhibitions. I. Ferretti-Bocquillon,
Marina. II. Grand Palais (Paris, France) III. Van Gogh
Museum, Amsterdam. IV. Metropolitan Museum of Art
(New York, N.Y.) V. Title.

N6853.S49 A4 2001
759.4—dc21

　　　　　　　　　　　　　　　　　　　2001030720

CONTENTS

DIRECTORS' FOREWORD

When Paul Signac first showed his wonderful painting *The Dining Room* (cat. no. 24) in Paris in 1887, a critic quipped, "After the *Grande Jatte* of M. Seurat, we now have the *petit tasse* of M. Signac." It has been Signac's fate to be presented as the second man of Neo-Impressionism. Whereas his better-known contemporary, Georges Seurat, is honored as an innovator and a key figure in the history of modern art, Signac is usually presented as a follower and an imitator. Signac's role as the promoter and scribe of Neo-Impressionism has tended to attract more attention than his individual achievement as a painter. He was, so the story runs, a talented man who benefited from the proximity of genius.

The present exhibition is the first major retrospective of the artist's work in almost forty years. Our simple aim has been to offer the public a chance to reassess Signac's work in its own right. We have attempted to bring the individual character of his art to the fore, following his development from his first tentative exercises in outdoor painting, closely modeled on the Impressionists, to the amazing coloristic fireworks of his last paintings, which seem to verge on abstraction. While the shadow of Seurat still extends over much of his output, in our view Signac's work has an intensity and expressive power that is entirely his own. This enthusiastic and restless man was in love with the light and life of the natural world. From the impersonal, aloof style of Neo-Impressionism he evolved his own, more fluid language in both oils and watercolors, creating an art that is at once still and controlled yet also alive with a thousand nuances of vibrating color.

The planning of this exhibition was greatly facilitated by the recently published catalogue raisonné of Signac's work by Françoise Cachin. Our project is indebted to Mme Cachin, who has combined her unique insight as granddaughter of the artist with her eminence and skills as an art historian to create the publication that will be the basis for all future study of Signac's work. In the preparation of this show Mme Cachin was unfailingly generous with her advice and knowledge. We benefited also from the expertise of Mme Cachin's assistant on the catalogue raisonné, Marina Ferretti-Bocquillon, who worked with the curators on the selection of the exhibition and contributed to the catalogue.

A special word of thanks is due to the many lenders who have generously contributed their works to this show. More than fifty private and public collections from ten countries have participated, and we are grateful to them all for their willingness to support our project. Naturally, with an exhibition of this scope, it has not been possible to obtain all the works we wanted for all the venues. Certain key works such as *Portrait of Félix Fénéon* (cat. no. 51) and *In the Time of Harmony* (cat. no. 75) could only be shown at one venue. Sadly, the fragility of Signac's early masterpiece, *The Milliners* (fig. 4) from the Foundation E. G. Bührle Collection, precluded it from traveling at all. From the start we were determined that Signac's production of works on paper, in particular his watercolors, would be well represented, but restrictions for showing these light-sensitive works meant that we had to make two more or less separate selections: one for Paris, relying on the resources of French museum collections,

and the other for Amsterdam and New York, drawn from the holdings of The Metropolitan Museum of Art and, thanks to their gracious cooperation, from the superb collection formed by James T. Dyke that was recently donated to the Arkansas Arts Center in Little Rock. We are very grateful to Mr. Dyke and to Townsend Wolfe for their support of this project.

Finally we would like to thank all those in our own institutions who worked hard to ensure the success of this exhibition and, especially, the curatorial team, Anne Distel and Marina Ferretti-Bocquillon in Paris, John Leighton in Amsterdam, and Susan Alyson Stein in New York. The respective strengths of our differing collections in Paris, Amsterdam, and New York will provide intriguing contexts for Signac's work, and at each venue the public will have the chance to measure Signac against some of the greatest talents of the nineteenth century. In our view he will not be found wanting.

PHILIPPE DE MONTEBELLO
Director, The Metropolitan Museum of Art, New York

JOHN LEIGHTON
Director, Van Gogh Museum, Amsterdam

FRANCINE MARIANI-DUCRAY
Director, Musées de France
President, Réunion des Musées Nationaux

ACKNOWLEDGMENTS

Signac, 1863–1935 represents the dedication and generosity of a number of individuals. In the first instance, we gratefully acknowledge the lenders to this undertaking (see pp. X–XI), several of whom made special allowances so that key works might be shown in one or more venues of the exhibition. Other friends and colleagues warmly supported this project. We are indebted to those who helped locate works of interest, who negotiated loans on our behalf, and who have shared the benefit of their knowledge, resources, and expertise. We extend our warmest thanks to Delphine Allanie-Costa, Matthew Armstrong, Françoise Cachin, Madeleine Charpentier-Darcy, Robert Clémentz, Pina Comar, Regina da Costa Pinto Dias Moriera, Desmond Corcoran, Françoise Dacby, Guy-Patrice Dauberville, Michel Dauberville, Pascal Desroches, Lucy Dew, Alan Dodge, Douglas Druick, Marina Ducrey, James T. Dyke, Rachel Esner, Jack Flam, Caroline Durand-Ruel Godfroy, Gloria Groom, Beth Ann Guynn, Vivien Hamilton, Colin Harrison, Cornelia Homburg, Mark Henderson, Robert Herbert, Waring Hopkins, Aurore Hardouin, Christian van Holst, Petra van Houten, Jeanne-Marie Imbert, Jean Indrigo, Sona Johnston, Paul Josefowitz, Gillian Keay, Akira Kofuku, Dominique Lacoste, Georges Liébert, Luuk van der Loeff, Neil MacGregor, Françoise Malartre, Evan M. Maurer, Charles S. Moffett, David Nash, Steven Nash, Patrick Noon, Michael Pakenham, Robert McDonald Parker, Elizabeth Pergam, Marshall Price, Rémi Rabu, Anne Roquebert, Sabine Schulze, George T. M. Shackelford, Evelyn Silber, Evert van Straaten, Martin Summers, Isabelle Vazelle, Townsend Wolfe, and Brian Young.

We would like to thank members of the staffs of our respective institutions who have collaborated on *Signac, 1863–1935*.

In Paris, as the first venue of this exhibition, our colleagues at the Réunion des Musées Nationaux, under the direction of Philippe Durey, assumed a pivotal role in coordinating the project. We are especially grateful to Vincent David and Francine Robinson of the Département des Expositions; their efficiency and diplomacy in administering loans was of enormous assistance to us all. The French-language edition of the catalogue was edited by Marie-Dominique de Teneuille and designed by Bruno Pfäffli. At the Musée d'Orsay we would like to acknowledge Luce Abelès, Sophie Boegly, Alexis Brandt, Isabelle Cahn, Laurence des Cars, Christian Garoscio, Gabriel Harlay, Caroline Mathieu, Monique Nonne, Virginie Noupissié, Marie-Pierre Salé, Patrice Schmidt, and Laurent Stanich.

At the Van Gogh Museum in Amsterdam we express our appreciation to Andreas Blühm, Sjraar van Heugten, Leo Jansen, Martine Kilburn, Hans Luijten, Rianne Norbart, Fieke Pabst, Benno Tempel, Heidi Vandamme, Marije Vellekoop, Sara Verboven, Aukje Vergeest, Melanie Verhoeven, and Fien Willems.

At The Metropolitan Museum of Art, New York, we are especially grateful to Kathryn Calley Galitz, Research Associate, who contributed to the catalogue and provided invaluable research and administrative assistance. Her enthusiasm and commitment were a great asset to the project. The English edition of the catalogue was produced under the direction of John P. O'Neill, Editor in Chief. Kathleen

Howard, Senior Editor, guided the book through its various phases of production with her characteristic mix of keen intelligence and unflappable grace. The final editing of the book benefited greatly from the editorial skills of Jane Bobko and Cynthia Clark. A talented production team, headed by Peter Antony and Megan Arney, ensured the reproductive quality of the catalogue; Antony Drobinski was responsible for its attractive and intelligent design. Mary Laing, as an editor and translator, contributed significantly to the veracity of the text. Jean Marie Clarke ably translated from the French. We also acknowledge Jean Wagner, for her bibliographic expertise, as well as the crucial assistance provided by Minjee Cho, Margaret Donovan, Carol Fuerstein, Joan Holt, and Robert Weisberg.

Other colleagues at the Metropolitan Museum made valuable contributions to the realization of the exhibition: Philippe de Montebello and Mahrukh Tarapor, Director's Office; Everett Fahy, Gary Tinterow, and Rebecca A. Rabinow, European Paintings; Laurence B. Kanter and Manus Gallagher, Robert Lehman Collection; Colta Ives, Drawings and Prints; Hubert von Sonnenburg and Lucy Belloli, Paintings Conservation; Marjorie Shelley and Margaret Lawson, Paper Conservation; Linda M. Sylling, Operations; Nina S. Maruca, Registrar's Office; Valerie Troyansky, Special Publications; Claire Dienes, Photograph and Slide Library; Kenneth Soehner and Heather Topcik, Thomas J. Watson Library. The handsome design of the installation and its graphics are the work of Michael Langley and Sophia Geronimus of the Design Department.

The Metropolitan Museum is grateful for The Florence Gould Foundation's generous funding of the exhibition in New York. Our sincere gratitude also goes to the Janice H. Levin Fund for supporting the English edition of the catalogue.

SUSAN ALYSON STEIN

JOHN LEIGHTON

ANNE DISTEL

MARINA FERRETTI-BOCQUILLON

LIST OF LENDERS

PUBLIC COLLECTIONS

AUSTRALIA	Melbourne	National Gallery of Victoria 16
ENGLAND	Leeds	Leeds Museums and Galleries (City Art Gallery) 15
FRANCE	Besançon	Musée des Beaux-Arts et d'Archéologie 122, 160
	Lyons	Musée des Beaux-Arts, Lyons 98
	Montreuil	Mairie de Montreuil 75
	Nancy	Musée des Beaux-Arts, Nancy 88B
	Paris	Bibliothèque nationale 41
		Musée Carnavelet 5
		Musée du Louvre, Fonds du Musée d'Orsay 11, 12, 19, 64, 65, 76, 92, 112, 115, 116, 123–30, 161, 165, 176, 182
		Musée d'Orsay 4, 21, 23, 39, 63, 69, 89, 111, 131
		Musée de la Marine 90
		Musée du Petit-Palais 132
	Saint-Malo	Musée d'histoire 173
	Saint-Tropez	L'Annonciade, Musée de Saint-Tropez 78, 91, 148, 149
GERMANY	Berlin	Staatliche Museen zu Berlin, Nationalgalerie 8
	Stuttgart	Staatsgalerie Stuttgart 31
	Wuppertal	Von der Heydt-Museum 66
IRELAND	Dublin	The National Gallery of Ireland 96
JAPAN	Miyazaki	Miyazaki Prefectural Art Museum 58
	Shimane	Shimane Art Museum 119
	Tokyo	The National Museum of Western Art 97
THE NETHERLANDS	Amsterdam	Van Gogh Museum 14, 33, 41, 88A
	The Hague	Gemeentemuseum Den Haag 34
	Otterlo	Kröller-Müller Museum 7, 24, 67
SCOTLAND	Glasgow	Glasgow Museums: Art Gallery and Museum, Kelvingrove 38

PRIVATE COLLECTIONS

ANONYMOUS LENDERS

AUTHORS

Marina Ferretti-Bocquillon [MFB]
Art Historian, Paris

Anne Distel [AD]
Chief Curator
Musée d'Orsay, Paris

Kathryn Calley Galitz [KCG]
Research Associate, Department of European Paintings
The Metropolitan Museum of Art, New York

Sjraar van Heugten
Chief Curator
Van Gogh Museum, Amsterdam

John Leighton [JL]
Director
Van Gogh Museum, Amsterdam

Susan Alyson Stein [SAS]
Associate Curator, Department of European Paintings
The Metropolitan Museum of Art, New York

A NOTE TO THE READER

In the headings of the catalogue entries works are given English titles based on the titles used in the recent Signac catalogue raisonné (Cachin 2000); these titles, in French, appear following the catalogue raisonné number (FC). Information pertaining to media, dimensions, and credit lines has been provided by the owners. For the dimensions, height precedes width.

Citations are abbreviated throughout the catalogue; full references are provided in the Bibliography, which also includes material not cited in the text. Catalogues raisonnés of artists' works are designated, in most cases, by a single-letter abbreviation of the author's last name; a complete listing precedes the Bibliography.

All known exhibitions during the artist's lifetime are recorded under Exhibitions; the short-form citations are keyed to the Bibliography.

Full names and life dates of individuals cited in the text, when known, may be found in the Index.

The numeration of works in the catalogue corresponds to the French edition with the following exceptions: 59, 60, 61, 85a, 85b, 86, 88a, 88b, 97, 105. These works appear in the French catalogue as cat. nos. 60, 61, 59, 85, 86, 86bis, 88, fig. 3 (p. 244), and nos. 105 and 97 respectively.

Seurat's drawing of Paul Signac, fig. 30, is exhibited in Amsterdam and New York.

SIGNAC
1863–1935

OUT OF SEURAT'S SHADOW: SIGNAC, 1863–1935, AN INTRODUCTION

JOHN LEIGHTON

I N THE FIRST MONOGRAPH DEVOTED TO Signac, published in 1922, Lucie Cousturier observed contradictory elements in the artist's character, describing him as a man at once generous and defiant, tender and violent.[1] Signac was known to his contemporaries as an ebullient, forceful personality, the apparent opposite of the taciturn, solitary Georges Seurat. Even Van Gogh spoke of Signac's fiery temper, and when Signac visited him in the hospital at Arles, Vincent was pleasantly surprised to find his visitor "quiet, though he is said to be so violent."[2] The substantial documentation that Signac left behind, including letters, journals, and publications, does indeed reveal various and sometimes opposing sides to his personality: the restless man of action who has a predilection for reflection and serenity; a seemingly boundless energy coupled with a feeling for precision; an open-minded, searching intellect combined with an unyielding certainty.

Signac's artistic personality is also difficult to summarize. He took to painting as part of a youthful assertion of independence and quickly evolved a bold, self-confident approach. But although he would always retain a strong sense of individuality, his talent thrived on support and sustenance from others. His career is punctuated by a series of close friendships with painters such as Georges Seurat and Henri Edmond Cross and writers like Félix Fénéon who could provide this encouragement. Signac's writings, in both public and private form, demonstrate a constant need for dialogue in order to test his direction and to define and redefine his artistic principles. At certain moments it seems that the calm, confident character of his art is more apparent than real, masking anxious soul-searching and experimentation. His description of his friend Cross—"a cold and methodical thinker and a dreamer, strange and troubled"—could with some justification be applied to Signac himself.[3]

Destiny has assigned to Signac the role of the second man of Neo-Impressionism, an artist of talent in the shadow of Seurat. He now has the position of an artist who is more admired for his historical importance than for his individual achievement, a painter who figures widely in the indexes of textbooks without becoming the subject of one. This publication and the accompanying exhibition place the emphasis firmly on Signac's own accomplishment. The selection

has been made from a production that includes more than six hundred paintings as well as a substantial body of works on paper (mainly watercolors), with the aim of providing an overview of his development and a sense of his total oeuvre. While the imprint of Seurat is in some ways ever present, the individual character of Signac's work comes to the fore, with its often surprising inventiveness, chromatic brilliance, and expressive power.

Signac moved from an art based on observation and the direct study of nature, through the rigor and optical precision of Neo-Impressionism, to a personal and subjective art based on his own concepts of pictorial and social harmony. The gradual shift from a form of realism in which his painting was closely modeled on the exterior world to an abstracted art with its own interior logic is indeed central to his development. But this was not an easy or straightforward path. Robert Herbert has noted the "pairs of opposites [that are] so often intertwined" in Neo-Impressionism:[4] rational method combined with poetry and enigma; political commitment set against aesthetic purity; reality as opposed to style and artificiality. Signac's art evolved along the interfaces of such opposites and tensions. In some respects, his art, like his own character, was an amalgam of contradictions.

IMPRESSIONISM

Signac's artistic career began with rebellion, albeit in a rather mild and middle-class form. In 1880, aged sixteen, he cut short his schooling and immersed himself in a world of avant-garde art and literature. The death of his father earlier that year and the subsequent sale of the family's successful saddler's shops in Paris provided a secure financial future and allowed him to follow his youthful instincts. As he later recalled: "My family wanted me to be an architect, but I preferred to draw on the banks of the Seine rather than in a studio at the École des Beaux-Arts."[5]

The rich fabric of artistic and literary life in Montmartre formed the backdrop for this assertion of independence. While still a teenager he was drawn into the fringes of the heady, anarchic circles of writers, performers, and artists in this increasingly colorful environment. He participated in youthful cliques and associations, attended literary soirées, and tried his hand at writing; in 1882

Fig. 1. Paul Signac, *The Scaffolding of the Sacré-Coeur*, 1882–83, oil on wood, 19½ x 12⅝ in. (49.5 x 32 cm). Private collection, FC 27

he contributed two pieces to the newly created *Chat Noir* journal, including an accomplished pastiche in the Naturalist style of Émile Zola.[6]

Signac's earliest surviving picture dates from 1881 (FC 1). After a sporadic start, his enthusiasm for painting gradually intensified and overtook his literary aspirations. He painted along the riverbanks at Asnières (where his mother now lived) and on summer trips to Port-en-Bessin on the Normandy coast. Several paintings are on small panels that would have fitted inside the lid of a handheld painting box for working outdoors. Other works are of a more ambitious size but also seem to have been painted on the spot. These experiments are impulsive and informal in character, yet they display a familiarity with the vocabulary of advanced landscape painting. Some focus on a single motif such as a haystack, a washhouse, or a pumping station with a directness that is reminiscent of Camille Pissarro or Alfred Sisley. From an early age Signac had an eye for unusual features or viewpoints that would bring a banal subject to life: a pair of legs intruding into an interior composition (cat. no. 1); a "portrait" of a friend seen from the back (cat. no. 2); a fence zigzagging like a scar through a suburban landscape (fig. 1).

Unlike most of his later associates Signac had no systematic training as an artist. His only "formal" education was a few months in the "open"

studio of Émile Bin, a minor academic artist, at the beginning of 1883. Instead he visited exhibitions and dealers and used the works of Édouard Manet, Claude Monet, and the Impressionists as his guide. He later described how he had scrutinized their paintings, trying to understand their method and in particular seeking out the rationale behind their employment of color and color contrasts. He even wrote to Monet asking for his advice and requesting a meeting.[7]

Looking back on this phase, Signac recalled his own crude form of Impressionism: "This consisted of piling up reds, greens, blues and yellows, in a rather careless way but with great enthusiasm."[8] But "Impressionist" is only a partly satisfactory label for these impetuous works. He reacted strongly to what he saw and felt, and his painting displays a pleasure in the materiality of paint and an energy of brushwork that often go beyond the descriptive touch of Impressionism. Works like *Rue Caulaincourt* (cat. no. 5) are animated by slashes and stabs of liquid paint laid on with impatient, untidy haste. At the same time this vigor is tempered by a preference for tightly ordered compositions. In a slightly earlier work, *The Road to Gennevilliers* (cat. no. 4), a view of a deserted suburb is punctuated by the rhythmic verticals of trees, signposts, and factory chimneys that are set against a

pattern of horizontals and diagonals formed by roads, paths, walls, and open spaces. The bottom of the composition is abruptly closed off by the glimpse of a tree trunk and by blue streaks of shadow from some unseen foliage. The bright, slightly acrid coloring of this work seems to derive from Manet and Armand Guillaumin, but the sensitivity to effects of light, the feeling for mood and atmosphere, and the insistent geometry of the design reveal Signac's own emerging artistic personality.

SIGNAC AND SEURAT

Signac encountered the work of Georges Seurat at the first exhibition of the newly formed Société des Artistes Indépendants in 1884. Seurat was represented by a single work, the monumental *Bathers at Asnières* (fig. 2). It depicts a suburban site that was familiar territory for Signac, and its luminous coloring and patterned brushwork would have suggested researches similar to his own. Yet the huge scale, the passive, hieratic figures, and the carefully constructed architectonic composition evoke a calm authority that is alien to Signac's impulsive early work. The originality of *Bathers at Asnières* and of Seurat's subsequent large canvas *A Sunday Afternoon on the Island of La*

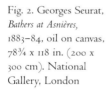

Fig. 2. Georges Seurat, *Bathers at Asnières*, 1883–84, oil on canvas, 78¾ x 118 in. (200 x 300 cm). National Gallery, London

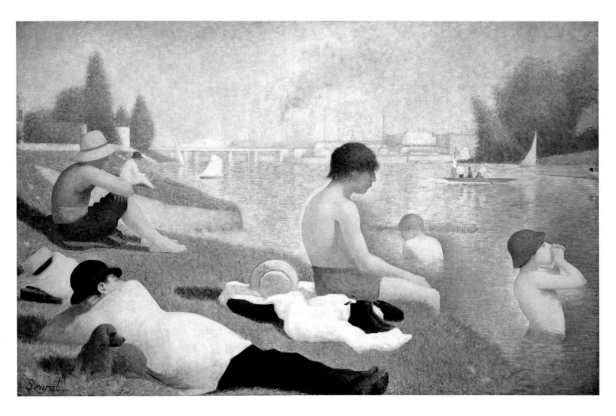

Fig. 3. Georges Seurat, *A Sunday Afternoon on the Island of La Grande Jatte,* 1884, oil on canvas, 81½ x 121¼ in. (207.6 x 308 cm). The Art Institute of Chicago, Helen Birch Bartlett Memorial Collection, 1926.224

Grande Jatte (fig. 3) would set the tone for Signac's work over the following years.

It has often been observed that the friendship that developed between Seurat and Signac was in many respects a union of opposites. The companionable, extroverted Signac with his devastating humor and mariner's manner was an unlikely comrade for the urbane Seurat, who was by nature terse and aloof. Their artistic backgrounds were also quite different. By the time of their first meeting in 1884, Seurat had already undergone an academic training, supplemented by several years of experiments in drawing and painting in Paris and its suburbs. Signac's work at that date was raw and untutored, and it is not surprising that their collaboration took on something of the character of a master-pupil relationship. Seurat provided Signac with a model for a more ambitious art. His academic background, his grounding in draftsmanship, and his determination to identify and assemble the component parts of a revitalized modern style opened up new possibilities for a slightly younger artist who was casting about for a more directed approach. Exposure to what Signac later listed as the qualities of "determination, coordination, gravity, discrimination, reflection" in Seurat's art was in some ways a compensation for his own lack of formal training.[9]

The gregarious Signac gave Seurat entrée into his wide circle of acquaintances in the Parisian avant-garde. In the mid-1880s Signac was establishing an impressive and multilayered network of friends and contacts. He was already in touch with some of the older generation of Impressionist artists; he had met Armand Guillaumin in 1884 and through him Camille Pissarro in 1885. He knew Gustave Caillebotte through a shared interest in boating. From his activities around the exhibitions of the Indépendants group, Signac was also developing friendships with younger artists several of whom, including Charles Angrand, Albert Dubois-Pillet, and Henri Edmond Cross, would later form part of the community of Neo-Impressionists. Through his literary interests Signac knew a great many writers, novelists, critics, and poets, some of them aspiring beginners, others with well-established careers. Between 1884 and 1886 he was a regular at the haunts of young intellectuals, places like the Brasserie Gambrinus, which attracted a wide circle of Naturalist and Symbolist writers, including such future friends and champions of his art as Fénéon, Gustave Kahn, and Jean Ajalbert, and the informal soirées held by the influential Robert Caze, whom he knew from his Chat Noir days. This competitive, stimulating mix of shifting allegiances, suffused with radical left-wing politics, was very different

from the world of Seurat, whose few friends dated from his days at the École des Beaux-Arts.

Signac's new friendship with Seurat did not at first lead to a dramatic shift in the younger artist's painting but rather seems to have reinforced his growing interest in color and structure. During a summer sojourn at Saint-Briac on the Brittany coast in 1885, for example, Signac painted a series of breezy coastal pictures whose fresh, bright color schemes and simple compositions are still indebted to Monet and especially the latter's cliff-top views of the early 1880s (cat. nos. 9, 10). But if the example of Monet and Impressionism still predominates, there is a rigor in the handling of paint, a more calculated treatment of color, and an increasing simplicity in design in several of

these works. This can be partly explained by his exposure to fresh stimuli, such as the latest work of Pissarro and Paul Cézanne (one of whose works he had recently acquired), but his contact with Seurat might also account for this new sense of discipline and direction.[10]

Later in 1885 Signac began work on his first substantial figure composition, *The Milliners* (fig. 4). Signac's largest painting to date, it was clearly designed to make a statement, positioning its author in the vanguard of modern art. It was begun in the autumn, apparently in a conventional manner that was then worked over with a rash of small dots and dashes of color. Seurat would later claim that Signac had reworked his canvas after he had seen the latest pointillist

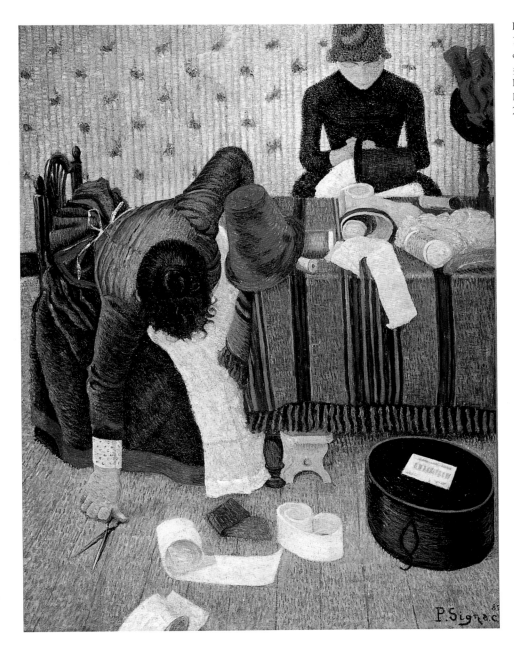

Fig. 4. Paul Signac, *The Milliners*, 1885–86, oil on canvas, 45⅝ x 35 in. (116 x 89 cm). Foundation E. G. Bührle Collection, Zurich, FC III

treatment of his *Grande Jatte* and was "definitively won over" to the new approach.[11] When it was shown at the Indépendants exhibition in 1886 as *Apprêteuse et garnisseuse (modes), rue du Caire*, several critics recognized that it was "in the line that M. Seurat is pursuing" and picked up on its most distinctive technical feature, the densely worked surface composed of small touches of paint.[12] According to Fénéon, it was "a systematic and convincing paradigm of the new process."[13]

Since then, most commentators have been content to see this work as a curious by-product of Seurat's *Grande Jatte*. From the precision of its title to individual details of technique, Signac's picture does indeed echo its more famous counterpart. As in Seurat's composition every element in the painting seems calculated to subvert the spontaneous, momentary glimpse of Impressionism. The fastidious technique is accompanied by a sharp-edged flatness to the forms. The simplified figures, drained of any psychological interaction, seem almost to have been stitched into an elaborate, decorative configuration. It is difficult not to be charmed by the inelegant, witty rendering of the subject in a work that, for all its debt to Seurat, is stamped with its own character. If Seurat's reductive, dissolving style of painting suggests an invisible order that lies beyond everyday appearances, Signac's picture seems to remain tied to the visible, tangible world. He uses the pictorial language of a fractured, busy surface to re-create texture and substance. The claustrophobic compression of space into two dimensions is combined with an almost manic sewing together of pattern, shapes, stripes, and lines in a painterly pattern that seems appropriate to the subject.

Of all Signac's many contacts with other artists, his relationship with Seurat was the most decisive. It also remains the most difficult to define. History has tended to depict Seurat as the genius with vision and to cast Signac in the role of a mere follower or imitator. Seurat himself, ever jealous of his position as a pioneer, would stress his role as the inventor of the Neo-Impressionist style, thrusting Signac firmly into the background. Signac's balanced account is probably more accurate. In his treatise *D'Eugène Delacroix au néo-impressionnisme* he managed to protect the primacy and originality of Seurat's contribution while still suggesting that his own, unruly art may have had a liberating effect on his older friend.[14] In the sec-

ond half of the 1880s, however, Seurat's art was the crucial catalyst for the development of Signac's painting, providing a model for his technique, his manner of working, and on occasion the design of his compositions. Against this background the apparent differences in their art, such as the obvious materiality of Signac's touch and his instinct for stronger color contrasts, can seem like nuances. It would take Signac almost a decade to evolve a style that he could properly call his own, and even then the difficult legacy of being a supporting player and an accessory to a greater talent would always linger.

"WE ARE IN A STUDIO, NOT A LABORATORY"

The exhibition of Seurat's *Grande Jatte* in 1886, first at the eighth and final Impressionist group show and then later in the year at the Indépendants, was in effect the launch of a new artistic movement. The artists who took up and developed Seurat's innovations in the coming months were diverse in character and background, ranging from a senior Impressionist, Camille Pissarro, and his son Lucien to relative unknowns, such as Angrand and Dubois-Pillet. What we now, for convenience, call Neo-Impressionism was never a uniform or fully coherent movement. Yet it was Signac who did the most to generate a sense of shared identity and interest among this medley of talents. He was a tireless and talented promoter, a powerhouse of enthusiasm. Where there was friction, he was often either the cause or the mediator. Where there was success, Signac was often behind it, lobbying critics and journalists for reviews, organizing exhibitions, or establishing contacts at home or abroad. In a remarkably short time Paul Signac had moved from being an enthusiastic amateur on the fringes of Impressionism to a prominent role at the center of the Parisian avant-garde.

The change in Signac's art seems equally noteworthy. In a sequence of landscapes and city views painted in 1886 (cat. nos. 13–16) he explored the potential of Seurat's technical innovations. In place of the robust, fluid style of his earlier work he evolved an art of control and refinement. Where before, color was applied as a somewhat haphazard response to the subject, it was now planned and contrived, with juxtapositions of

Fig. 5. Paul Signac, *The Dining Room* (cat. no. 24), detail

complementary and contrasting colors. Movement and spontaneity were overtaken by a method that stressed qualities of permanence and carefully tuned harmony.

Signac's work of this period proudly invites attention to its craftsmanship and to the meticulousness of its production. Fénéon's famously detailed analysis of a square centimeter of the *Grande Jatte* would have rendered equally rewarding results if applied to a painting such as *The Dining Room*, painted in 1886–87 (cat. no. 24; fig. 5).[15] The surface is built up with several layers of diaphanous color, beginning with broad, sweeping brushstrokes, which were then worked over with successive veils of colored touches of gradually diminishing size. The smallest strokes, virtually dots, often appear to have been added at a late stage, reinforcing the drawing or providing extra nuances to the color. As the picture progressed, the intermediate layers seem to have been scraped down as part of an effort to retain a smooth, even surface that is so distinct from the rasping textures and happy accidents of Impressionism.

The result is an extraordinarily rich and complex web of color. Much has been written about the "optical mixture" of the Neo-Impressionist technique and the way that surfaces were divided into small touches of color so that, when viewed from certain distances, "the blending is more or less accomplished by the eye of the beholder."[16] Together with the interaction of contrasting

colors, the partial fusion of the colored touches in the eye does indeed create a lively shimmer, which Signac later described: "the separated elements will be reconstituted into brilliantly colored lights."[17] However, the fussy, particulate structure of paintings like *The Dining Room* remains prominent as a decorative feature. Something of the appeal of the technique must surely lie in the way in which we, as spectators, can resolve the tiny touches of color into shapes and forms, while taking pleasure in the intricacy of its myriad, constituent parts.

When *The Dining Room* was first exhibited in 1887, there were critics who were keen to highlight the "science" of Signac's technique and in particular his systematic approach to color. Paul Adam, for example, described how the reflections were "scientifically established" and noted "the very expert gradation of the hues."[18] A few years later, in 1890, when Fénéon wrote the first extended appraisal of Signac and his art, he devoted most of his text to color theory, employing jargon and reveling in the complexity of his subject.[19] Since then it has often been assumed that Signac was using color and color contrast with a method and precision that were modeled closely on contemporary science and the study of optics. But, as Robert Herbert, John Gage, and others have pointed out, the Neo-Impressionist's relationship with science was not a simple one.[20] The notion of a "scientific" grounding was an important part of the Neo-Impressionist program, helping to distinguish Signac and his colleagues from the intuition of the older generation of Impressionists. In the 1880s, however, Signac was reaching out into areas of science that were themselves developing and shifting. The physics of light, the interaction of colored pigments, and the physiological reactions to color were all of interest to Signac, but his understanding of these was pieced together from widely differing sources of varying reliability. When combined with his study of the work of other artists, such as Eugène Delacroix and the Impressionists, the resulting "science" and theory were very much a personal construct.[21]

Signac's motives for turning to theory developed over the years. Initially his interest in the action of color contrasts and in optical mixing was driven by a broadly naturalist concern to achieve greater luminosity in his paintings. In the later 1880s and early 1890s, this was gradually

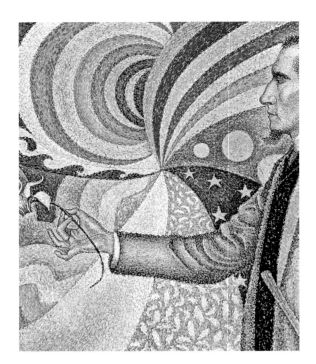

Fig. 6. Paul Signac,
Portrait of Félix Fénéon
(cat. no. 51), detail

overtaken by an interest in more abstract notions of harmony and in the expressive power of color. In the later 1890s when he came to write his well-known treatise *D'Eugène Delacroix au néo-impressionnisme*, Signac was at pains to strip down and simplify his color theory: "All that is involved consists of four or five precepts enunciated by Chevreul which elementary school pupils should know."[22] He emphasized that the painter was a poet and a creator not a scientist, following Fénéon's observation that "we are in a studio, not a laboratory."[23]

More intriguing, perhaps, than his second-hand studies of optics is Signac's friendship with Charles Henry, a visionary and eccentric polymath whose interests ranged over a bewildering array of subjects from mathematics to aesthetics. His wildly speculative ventures into psychophysics and in particular his theories about how colors and the various directions of lines can provoke differing emotions were of interest to both Signac and Seurat. Thus, for example, Henry held that upward-moving lines produce feelings of joy whereas the effect of downward-moving lines is sadness. In 1888 and 1889 Signac was a willing collaborator in Henry's experiments, and he provided illustrations for some of his publications.[24] Henry's efforts to use his theories to improve the education of artisans and workers in industrial art appealed to Signac, who thought that it would teach them "to see the correctness and beauty of things."[25] In October 1889 he wrote to Fénéon: "I have just completed forty plates for

an aesthetic of lines, in the manner of Charles Henry.... In short, it's a primer of aesthetic education.... [The plates] have cost me more than 600 hours of work."[26] Whether Henry's theories had any profound impact on Signac's painting is harder to establish. Signac said that in his paintings of Portrieux and Cassis he had used "Charles Henry's latest discoveries on the rhythms and measures of lines and colors."[27] We should, however, resist the temptation to make diagrams of these compositions and to look for joyous or melancholy lines. The idiosyncratic notions of his friend Henry were probably no more important for Signac than, for example, the work of Symbolist poets and writers in encouraging him to explore the expressive potential of the basic components of his art.

Signac was by nature curious, and his sharp intellect was eager to probe, dissect, and understand any aspect of science or its related disciplines that might have a bearing on his art. Yet, in a way not dissimilar to his friend Fénéon, he gave priority to his artistic intuition, and he was also not averse to the parody of his own scientific aspirations. The one painting that encapsulates this ambiguous attitude is appropriately enough a portrait of Fénéon (cat. no. 51; fig. 6), arguably the masterpiece of Signac's early career and certainly his finest figure painting. The critic's distinctive profile is set against a background of abstract patterns, derived, as Françoise Cachin discovered, from a modest Japanese print.[28] The hallucinatory background with its spiraling lines, kaleidoscopic shapes, and color contrasts, including ascending reds and cascading greens, is an exaggerated application of Henry's theories. It would be difficult to imagine a work that better conjures up the ambivalence of Signac and his circle of friends, for whom serious artistic and intellectual endeavor could easily be coupled with a mocking, self-knowing pretentiousness.

"AN ART OF GREAT DECORATIVE DEVELOPMENT"

In the second half of the 1880s Signac established his working pattern: the winter months were spent largely in his Paris studio, while the summer was devoted to extended painting campaigns at a coastal resort. Between 1885 and 1890 he

produced a sequence of ambitious figure paintings that were painstakingly pieced together in the studio with the help of smaller studies and sketches. These larger works, designed to attract attention at public exhibitions, were supplemented by groups of modest landscapes and marines that depended on a more direct confrontation with his subject.

The development of Signac's style in the later 1880s can be followed through his successive summer seasons of painting. His *Town Beach, Collioure* (cat. no. 27; fig. 7) typifies the gentle luminosity of the marines that he painted during his stay at this Mediterranean resort during the summer of 1887. The individual elements of the stretch of shoreline are closely observed, from the light sparkling on the water to the playing-card forms of the interlocking buildings. As the painting progressed, however, it seems that the qualities of direct sensation and observation were gradually subjected to a more unifying vision. The first layers of freely worked paint were systematically overlaid with smaller touches, while the stronger color contrasts, such as Signac's trademark combination of orange and blue, were worked through with flurries of white and pale-colored dots. One year later, when he was at Portrieux on the northern coast, Signac distilled the physicality of his painting even further. In *Tertre Denis, Portrieux* (cat. no. 30; fig. 8) the flecks and stipples of color still evoke a vibrant, scintillating light, but they also remain curiously insistent as decorative elements, ordered into patterns across the surface. The ragged boundaries between shore, sea, and

sky have been transformed into a series of undulating, melodic lines running through the picture.

By 1891, when he produced a series of masterful marines at Concarneau in Brittany, Signac's tremulous balance between nature and art had tilted further toward the artificial. In *Evening Calm, Concarneau* (cat. no. 55) the foreground folds and creases have taken on the simplified character of stage scenery. The complex layering of his earlier Neo-Impressionist canvases has given way to a unified, dotted touch together with simpler and more obviously arbitrary combinations of color. In the most majestic of these pictures, *Sardine Fishing, Concarneau* (cat. no. 56; fig. 9), Signac created a composition of utter simplicity. The slowly moving fishing fleet is spread across

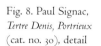

Fig. 7. Paul Signac, *The Town Beach, Collioure* (cat. no. 27), detail

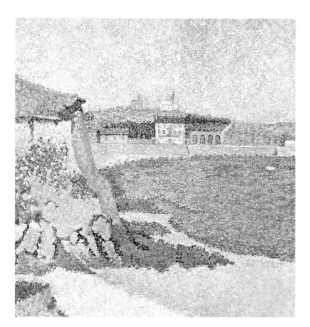

Fig. 8. Paul Signac, *Tertre Denis, Portrieux* (cat. no. 30), detail

Fig. 9. Paul Signac, *Sardine Fishing, Concarneau* (cat. no. 56), detail

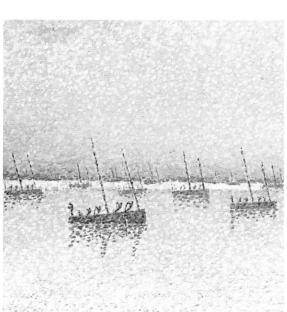

the painting like "notes of music on a score."[29] The analogy is appropriate, for Signac himself used musical titles for this series of pictures— scherzo (FC 213), larghetto (cat. no. 54), allegro maestoso (cat. no. 55), adagio (cat. no. 56), and presto finale (FC 219)—dropping the descriptive titles when the pictures were shown at the exhibition of Les XX in Brussels in 1892. In these boldly stylized works the notion of painting as a succession of momentary sensations transfixed in oil paint has been replaced by the effect of a slowly unfolding performance, played out in resonant and deliberate color harmonies.

Writing about Signac in 1891, Fénéon referred to his latest Concarneau paintings, commenting that these works "cause a harmonious and nostalgic dream to blossom in the light."[30] Typically he devoted most of his article to a discussion of the painter's technical concerns, playing down the role of subject matter: "Man, animal, even plant life and cloud are rare in his paintings. He likes the geometry of jetties and signal stations; he is the painter of the physiognomy and movement of boats."[31] In successive reviews the critic had followed the progress of Signac's art, noting with approval his evolution of "an art of great decorative development."[32] This view of Signac's work as a gently evolving art of harmony and synthesis can, however, mask some of the shifts and uncertainties that lay behind his development in the later 1880s, the most remarkable aspects of which were not stylistic or technical but were to be found in the realm of subject matter. It is of great interest that in 1891 Fénéon characterized Signac as an artist apparently uninterested in human narrative and as a painter in search of the timeless and the enduring.

In his earliest, Impressionist-inspired works Signac had established a repertoire of river scenery and suburban views, interspersed with coastal landscapes from his summer vacations. These are pictures by an artist who was clearly interested in modern themes and who observed the distinctive and sometimes discordant character of his surroundings. At first glance he seems simply to carry this forward into the second half of the decade, with his larger figure pictures adding a more ambitious note. A number of his pictures are remarkable for their frank portrayal of the industrial suburbs. In *The Gas Tanks at Clichy* (cat. no. 16; fig. 10) he depicts a gritty, working-class area on the fringes of the city, where a curiously picturesque huddle of workers' houses is hemmed in by the giant cylinders of a row of gas tanks. In other works the factories and bridges of this newly formed urban landscape provide the backdrop for scenes of leisure and boating along the Seine (cat. no. 28). Yet in contrast to the sentimental depictions of suburban wastelands by artists such as Jean-François Raffaëlli or even the dramatic vistas of similar subjects by Van Gogh, Signac's painting does not prompt meditation on the dehumanizing effect of encroaching industry. In *The Gas Tanks at Clichy* the effect seems more coolly decorative than politically engaged, an ordinary corner that is transformed into an eccentric yet lively patchwork of texture and color. To borrow James Fenton's words, this picture demands nothing, "especially not our sympathy."[33]

Signac's paintings of well-appointed middle-class interiors offer a counterpoint to his views of the margins of Paris. Here too narrative content is submerged in the intricacy of the formal constructions. Like *The Dining Room* (cat. no. 24; fig. 11), *Sunday* (cat. no. 40; fig. 12) evokes a stifling interior, this time with a couple seemingly lost in their own thoughts, their backs turned to each other. The passive figures are surrounded and indeed almost overwhelmed by their lavish furnishings. Signac documents the details of carpets, tassels, costume pleats and folds, and floorboard chevrons in a convoluted tour de force of pattern and visual rhyme. Some recent commentators have suggested that Signac intended to satirize the stiff conventionality of bourgeois life and

Fig. 10. Paul Signac, *The Gas Tanks at Clichy* (cat. no. 16)

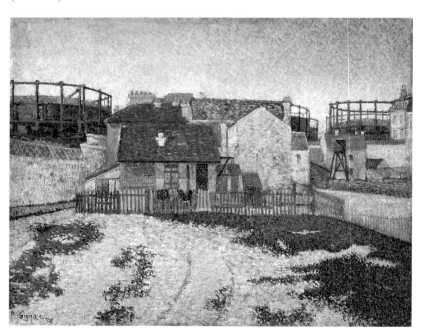

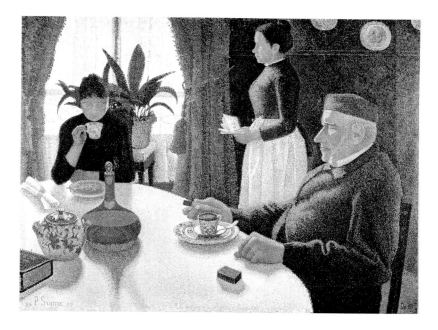

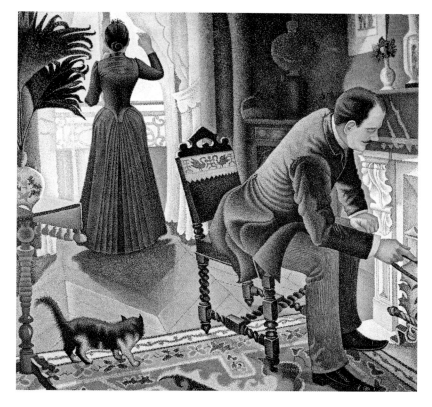

Fig. 11. Paul Signac,
The Dining Room (cat.
no. 24)

Fig. 12. Paul Signac,
Sunday (cat. no. 40)

capitalist bourgeois were suitable themes for the modern painter.[36] This concern was doubtless fueled by his interest in contemporary literature and, more important, by his increasing commitment to radical politics. By the end of the 1880s, most of his friends and admirers were associated with the anarchist-communist movement. A full study of Signac's politics, his motivations and allegiances, has yet to be made, but it is clear that his fidelity to radical left-wing politics was deep and lifelong. His anarchism, pacifism, and later antifascism remained consistent, surviving even the terrible disillusionment of the early twentieth century. A few years before his death he published a statement paying tribute to young socialist artists and recalling his youthful loyalty to the same values and principles, "when I stood with Reclus, in the time of Émile Henry and Vaillant."[37]

In the 1880s, however, Signac's instinct for an art that was politically engaged was not easy to reconcile with the evolving Neo-Impressionist manner. His preoccupation with the formal elements of his craft—the workings of color, the expressive potential of line, and the interaction of pattern—encouraged a tendency toward the decorative and the harmonious in his work. The new style favored an art that was prim, aloof, and reserved. One senses this tension between an art that depicts the reality of modern life yet at the same time remains abstracted and distant in works such as *The Gas Tanks at Clichy* with its odd combination of the bleak and the beautiful.

Signac's solution to this dilemma was one adopted by several other painters associated with Neo-Impressionism. In an essay published in Jean Grave's anarchist journal *La Révolte* in 1891 Signac set out his view that innovation in art could be associated with revolution in politics. He asserted that it would be a mistake to assume that only art that is overtly propagandist in character can be politically motivated. By retaining their independence, the "natural aesthetes, revolutionaries by temperament," would also deal "a forceful blow of a pickax to the antiquated social structure." It was a simple equation: "Justice in sociology, harmony in art: the same thing."[38]

The emergence of this standpoint was crucial for Signac. The links that he made between the painter's freedom and radical politics and between artistic and social harmony freed him from the burden of explicit narrative content and allowed him to linger in the realm of aesthetics. It explains,

manners.[34] When the picture was first shown, however, several writers thought the figures' awkwardness and vacancy reflected the artist's ineptitude rather than expressed a social comment.[35]

Several factors seem to be at play in these depictions of urban and suburban Paris. Signac's choice of subjects suggests a sympathy for an art that was locked into realities of contemporary life. He wrote later that the "working-class housing of Saint-Ouen or Montrouge, squalid and dazzling," and the "decadent pleasures" of the

for example, why he could call for revolution and at the same time paint sunsets along the river Seine. By about 1889, the contemporary edge to Signac's art was already beginning to fade away. Where before he had painted the gas tanks and factories of Clichy and Asnières, his favored sites were now farther downstream—at Herblay, for example, where in 1889 he produced a series of schematic river views (cat. nos. 37–39), some of which are devoid of human presence. He painted empty coastal scenes in Brittany suffused with a gentle melancholy (cat. nos. 29–31), and, in the south of France, the apparently ageless character of the sun-soaked Mediterranean coast was becoming his central motif (cat. nos. 34–36). It was thus that Fénéon in 1890 could with justification praise Signac for having created "exemplary specimens of an art of great decorative development, which sacrifices anecdote to arabesque, analysis to synthesis, fugitive to permanent, and . . . confers on nature, which finally grew tired of its precarious reality, an authentic reality."[39]

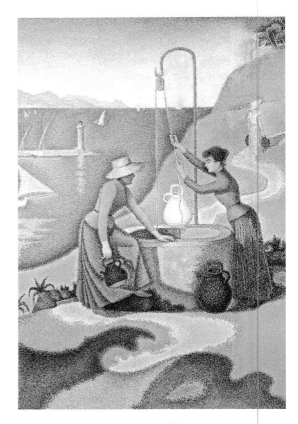

Fig. 13. Paul Signac, *Women at the Well* (cat. no. 63)

SAINT-TROPEZ

In some accounts of nineteenth-century art Neo-Impressionism is all but written off after the death of Seurat in 1891. The demise of its leading talent was just one of a number of setbacks for the movement. Other adherents had been lost either by attrition (Dubois-Pillet died during a smallpox epidemic in 1890) or defection (Pissarro was moving away from what he came to regard as the constrictions of the pointillist technique). But if Neo-Impressionism was losing its original momentum as an avant-garde grouping, it still remained a potent force. New recruits, such as Cross and Théo van Rysselberghe, were won over, and the style was attracting increasing interest from painters and critics abroad, notably in Belgium but also in Germany and the Netherlands. The first exhibition exclusively devoted to Neo-Impressionist artists opened in Paris at the Hôtel Brébant in 1892, and a year later the "Neo-Impressionist boutique" was inaugurated in the rue Laffitte. The venture, supported by the maverick Count Antoine de La Rochefoucauld, was short-lived (it closed within a year), but its very existence as a shopwindow for this diverse group was something of a triumph.

For Signac himself the first half of the 1890s was a period of change and realignment. He was deeply affected by the death of Seurat and seems to have been aware of the need to fill the artistic vacuum that now threatened. But loyalty to a dead colleague, coupled with the need to establish his own artistic identity, was not an easy legacy to handle. And while Signac had won praise for his latest works, he had also received some of the severest criticism of his career to date, notably from Octave Mirbeau and Gustave Geffroy.[40] The artist's removal in 1892 to the Midi was therefore a strategic withdrawal. In March 1892 he set sail from Finistère in his eleven-meter yacht, *Olympia,* and traveling via the Canal du Midi and Marseilles, he arrived in Saint-Tropez in early May. In Signac's description the journey has the quality of a mock-heroic retreat.[41] He rented "a pretty little furnished cottage" not far from the old town. Later, in 1897, he purchased the property of La Hune, to which he added an extensive studio. From 1892 on Signac usually divided his time between his residence in the south and his apartment in Paris, with intervals of extensive travel in France and abroad. At Saint-Tropez he found space and tranquillity to develop his art, far from what he called, with characteristic bluntness, "this Paris and its so-called intellectual crap."[42] But he kept a firm foothold in the

capital, which remained the outlet for his work and the center of his efforts to promote the group activities of the Neo-Impressionists.

The pictures from Signac's first years at Saint-Tropez are surprisingly diverse and often experimental in character. In some of his pictures he evokes the spirit of Seurat's later marines, using a severe, linear geometry as the armature on which to build glowing yet subtle color combinations (*The Port at Sunset, Saint-Tropez*, cat. no. 61). Other works, such as *The Town at Sunset, Saint-Tropez* (cat. no. 58), are less obviously controlled and more lyrical. The most remarkable are those paintings in which the subject is pared down to a few simple natural elements: a pine tree resplendent on a hill, for example, or a pair of majestic cypresses behind a gateway (cat. no. 67). Signac always tended to dwell on a particular feature or characteristic in a landscape: here, the striking detail becomes the painting's whole subject. The vibrancy of his color and the movement that swirls through his patterned brushwork became a highly effective evocation of the lushness and fecundity of his new surroundings.

Describing his cypresses to Cross, his latest confidant, Signac wrote: "Simplification of the elements leads you to more color."[43] On one level paintings such as this carry forward the manner of his work at Concarneau in which the simplicity of the composition forces attention to a dramatic play of color across the canvas.

Although these were finished and exhibitable works, they were also rehearsals for more ambitious pictures. In the same letter to Cross he added, "I will emerge better equipped to tackle the large canvas."[44] Since his arrival in Saint-Tropez, Signac had nurtured plans for a major new figure composition. This resulted first in *Women at the Well* (cat. no. 63; fig. 13) and then in *In the Time of Harmony* (cat. no. 75; fig. 14), his largest picture. Marina Ferretti-Bocquillon has revealed the careful process of preparation and the various resonances that surround these complex, highly contrived pictures.[45] The strident color of *Women at the Well* was intended to generate its own light on a dark wall (it originally had a subtitle: "decoration for a panel in half-light"). Ferretti-Bocquillon describes the painting as a respectful homage to Seurat. The odd vertical format, the dimensions, and the blue frame echo Seurat's last picture, *The Circus* (fig. 42), which had recently been shown in two posthumous retrospectives organized by Signac. Even the eccentric shadow in the foreground seems like an afterimage of the clown in the foreground of Seurat's painting. But if it is an homage, it also seems like a deliberate counterpoint to the dead artist's last masterpiece. In place of the artificial world of the circus, Signac offers a southern Eden, a healthy, outdoor world whose inhabitants literally draw their sustenance from the bowels of the earth. The suffuse coloring of *The Circus* is replaced by robust combinations

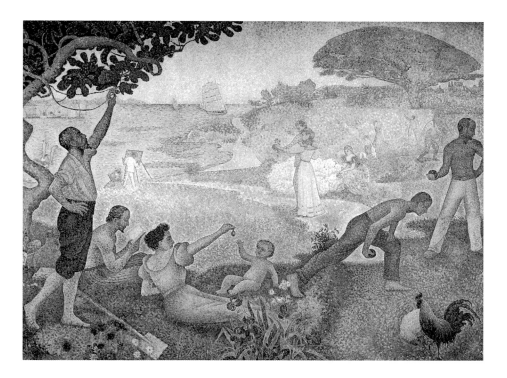

Fig. 14. Paul Signac, *In the Time of Harmony* (cat. no. 75)

of pure, bright colors, and Seurat's witty, caricatural drawing by an ungainly simplification of the figures.

In the Time of Harmony has an equally ambiguous relationship with the work of Seurat. Its composition obviously alludes to *La Grande Jatte,* and its large scale demonstrates that Signac was eager to make a manifesto picture, aspiring to a grand, public art and perhaps hoping to regenerate something of the controversy that surrounded the painting that launched the Neo-Impressionist movement a decade earlier. But Signac was now adapting the monumental figure piece to his own political vision (he at first thought of calling it *In the Time of Anarchy*). He combined the mural scale of Puvis de Chavannes with the ideas of Pyotor Kropotkin to offer a sentimental, utopian vision of a future in which humankind, released from the tyranny of labor through technology, has reestablished its harmonious relationship with the natural world.

Once again Signac pits the apparent decadence of the bourgeois world depicted by Seurat against his own Mediterranean paradise. But, perhaps not surprisingly, the reception of the picture was muted when it was first shown at the Indépendants in 1895. The bite in Seurat's *Grande Jatte* lay in part in its very impenetrability, its apparently coded yet ambivalent rendering of contemporary society. Signac transformed the ambiguity of *La Grande Jatte* into a programmatic picture that can almost be read like a political tract, thereby coming perilously close to the kind of propagandist approach he himself had warned against earlier. He took comfort in the fact that the picture had been admired by several painters.[46] His efforts to harness Seurat's legacy and to take Neo-Impressionism in a new direction certainly did not go unnoticed by his colleagues. In Pissarro's view, Signac had been "unfaithful to Seurat."[47]

TOWARD AN ART OF HARMONY

In 1894, inspired by his reading of Delacroix's recently published journal, Signac began to keep his own journal. About the same time he stopped using the opus numbers that he had added to the titles of his works since 1887 and wrote to Fénéon that he no longer painted directly from nature. In one of his first journal entries that year

he wrote: "A canvas of 25 [81 x 60 cm] painted from nature, seems to me more and more a loss of time. Work must consist in: 1) documents quickly taken from nature as needs arise, 2) creations of the work based on these documents."[48] This important change was more than just a modification in his working methods. In effect Signac was proclaiming a new basis for his art. The notion of painting as slave to nature had given way to a much more subjective and personal approach—as Signac noted in his journal, "the hard and useful period of analysis" had been replaced by "that of personal and varied creation."[49] Direct observation and the rigorous scrutiny of a motif were "a kind of slavishness." Instead the key words became *liberty* and *harmony*. In a refrain that Signac would repeat often he told Théo van Rysselberghe: "Let's liberate ourselves! Our goal must be to create beautiful harmonies."[50]

This change in artistic vision was no sudden revelation but rather the result of his researches over several years. Looking back to the seascapes made at Cassis in the 1880s, Signac noted that he had never made works that were as "objectively exact."[51] These were paintings that were begun and, we must assume, worked on extensively in front of the subject, with a technique that was adjusted to the recording of natural appearances. But already in the later 1880s and even more so after his move to Saint-Tropez, he had begun to treat his subjects with freedom, bringing out the decorative aspects of his art and especially the rich, sonorous qualities of his color. By 1894 he could claim: "Several years ago I, too, tried very hard to prove to others, through scientific experiments, that these blues, these yellows, these greens were to be found in nature. Now I content myself with saying: I paint like that because it is the technique which seems to me the most apt to give the most harmonious, the most luminous and the most colorful result . . . and because I like it that way."[52]

Several of the artists with whom Signac was in close contact were acutely aware of the problems in balancing an abstract, decorative art with the observation of nature. Signac was appalled, for example, by the Naturalist tendencies that he felt were slipping back into Van Rysselberghe's art, and from about 1899 the two artists locked horns on this issue in a correspondence extending over several years. While Van Rysselberghe accused Signac of producing pictures that were mechanical,

monotonous, facile, and lacking in sensibility, the latter would respond by patiently explaining the logic of his systematic approach to color and the emotion that was contained in its purity and harmony.[53]

Signac's ambition to forge a role for Neo-Impressionism as a style suited for large-scale, politically motivated decorations was not abandoned immediately, but he found little encouragement in this direction. In 1897 he offered *In the Time of Harmony* for an installation in the new Maison du Peuple (House of the People) that Victor Horta was setting up in Brussels, but indignant at the architect's indifference and procrastination, he withdrew his offer some three years later. Also in 1897 Signac began *The Wrecker* (cat. no. 88b; fig. 15), the first of a projected cycle of three such decorations on the theme of labor. A literal echo of his own earlier call for an art that would deal "a forceful blow of a pickax to the antiquated social structure," it is a curiously aggressive image. It is based on a lithograph (cat. no. 88a) that he made for Jean Grave's journal *Les Temps nouveaux* in which the call to dismantle the old order is even stronger, with the massive, heroic figure of the worker set against a rising sun. The execution of the painted work was hesitant if not tortuous, and it did not emerge from his studio until 1901 when it was shown at the Indépendants with the hopeful subtitle "panel for a Maison du Peuple." The projected related works, *The Boat Haulers* and *The Builders*, were never realized.

The obvious symbolism of *The Wrecker* was a dead end, and with the exception of an unsuccessful entry in a competition for a town hall at Asnières, it was the last of his efforts to create monumental public decorations. Over the years he occasionally restated his belief in an art suffused with political spirit, but more often he stressed the autonomy of the work of art, playing down the importance of subject matter. In *D'Eugène Delacroix au néo-impressionnisme* the relation of art

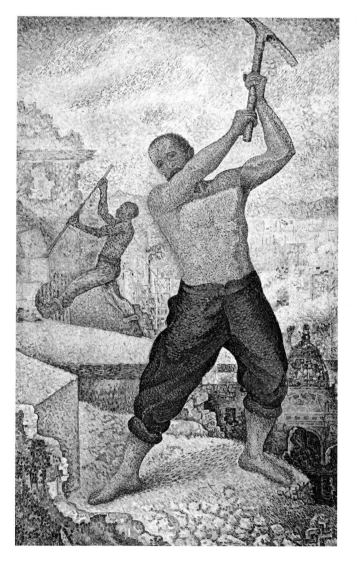

Fig. 15. Paul Signac, *The Wrecker* (cat. no. 88b)

Fig. 16. Paul Signac, *The Lighthouse, Saint-Tropez* (cat. no. 94), detail

and politics is not considered. Instead he presents an admirably clear discussion of the techniques of Neo-Impressionism in which aesthetic harmony is posited as the ultimate goal of art. For Signac the content of a picture had become absorbed into the elements of its construction; as he told Van Rysselberghe, the "elements of beauty" were not simply means "but an end" and the methods of Neo-Impressionism should in themselves be considered "a religion, a philosophy."[54]

In the mid-1890s Signac's technique became looser, with color laid on in separate, tessera-like blocks across the canvas. Signac rejected the notion of Pointillism, developing a horror of the "dot," which he now found mechanical and inimical to brightness in a painting. He simplified the design and structure of his pictures, relying increasingly on the play of color across the canvas as both the architecture and the drama of his compositions. Each touch of color was brought into careful conspiracy with its neighbor in elaborate sequences of contrasts and relationships: "Starting from the contrast of two hues, and disregarding the surface to be covered, he will oppose, graduate, and pro-portion his diverse elements on each side of the dividing line until he encounters another contrast, a new gradation. And so, from contrast to contrast, the canvas will be covered."[55] The purity of color

in each stroke, the angle and patterning of the touches, the play of warm against cool colors, these became his painterly preoccupations.

The evolution of Divisionism (as Signac pre-ferred to describe his method) was encouraged by aspects of his own practice. In oil studies for his larger compositions he had often used a schematic, simplified touch to experiment with color combinations. His increasing interest in watercolor also helped to focus his attention on the purity and clarity of color. His first hesitant experiments with watercolor took place in the early 1890s, and it quickly became one of his principal modes of expression. Watercolor was not just a convenient method for making quick notations after nature but was also a form of practice, a way of rehearsing the processes of composition in color.

Signac found support for his divisionist style in his studies of theory and of art. He quoted, for example, John Ruskin's description of nature as a "mosaic of different colors."[56] He became an avid student of the art of the past and found common cause with an array of masters from Pinturicchio to Poussin. However, it was Turner, whose work he studied on a number of visits to London, who became "the master whom I think of most often." The English artist gave him "the

finest lessons in that *liberty* which I strive for with all my might."[57] Signac also continued to measure his work against that of the more recent past, and Seurat was never far from his thoughts. On several occasions during the 1890s when Signac encountered the works of his dead friend, he described them in terms that mingle admiration with a dissatisfaction with their overall gray tonality or their mechanical quality. Signac endlessly extolled the virtues of his freer technique, perhaps because it allowed him to remain loyal to the basic principles of Neo-Impressionism while striking out on his own.

Signac's later work, in both oil and watercolor, is dominated by a simple repertoire of a few favored subjects, mainly harbor scenes and riverbanks. The artist traveled widely to often far-flung sites, but his basic treatment of his subjects varied little, whether he was presenting nostalgic views, which in mood and composition evoke the grandeur of Claude Lorrain's seaports, or depictions of the grimmer industrial harbors of the north. Be it Marseilles, Venice, or Constantinople, his motif was merely the starting point, a pretext for fantasies of radiant color. If his earlier Neo-Impressionism was an art of

renunciation and restraint, his mature style is rich, luxuriant, and sensual.

The finest of these later canvases are impressive performances, with a few simple elements orchestrated into extraordinary optical effects. Freed from the burden of description, color takes on its own exuberant life. In *Saint-Tropez* (cat. no. 97; fig. 17) it is difficult not to be drawn in by the closely articulated harmonies of blues, pinks, and greens in the foreground and the shimmering yellows, oranges, and reds in the distance. The most delicate nuances form part of a simple confrontation between the cool colors in the shaded foreground and the light that radiates from the composition's center. Maurice Denis described Signac's later work, with its combination of graded color and sentiment, as a form of "reasoned romanticism," opposed to what he called the scientific naturalism of his earlier Neo-Impressionism.[58] The description seems apt for works such as *Saint-Tropez* with its bizarre combination of a modern technique and a timeless vision reminiscent of Claude or Turner.

Signac's success in the twentieth century was in some ways a limited one. His first monographic exhibition at Siegfried Bing's gallery L'Art

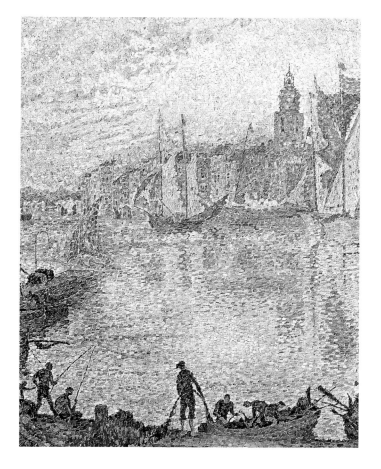

Fig. 17. Paul Signac, *Saint-Tropez* (cat. no. 97), detail

Nouveau in 1902 was followed by numerous other shows in France and abroad. The circle of his admirers and collectors extended to Germany and Belgium, and when Fénéon took a job with the Paris dealers Bernheim-Jeune in 1906, he quickly secured an advantageous contract for his friend, which was renewed over several years. Signac's presidency of the Indépendants from 1908 confirmed his position as an artist of influence. Yet critical reaction to his work continued to be mixed. He witnessed the growing idolization of contemporaries such as Van Gogh and Gauguin, while appreciation of his own work remained modest. Even when he was presented as a founder of modern art—at the 1912 Sonderbund exhibition in Cologne, for example—his work was ignored or its validity questioned.[59]

The attention of younger artists such as Matisse and the Fauves brought new encouragement to Signac, but for them, as for a wide range of others from Mondrian to Kandinsky, Neo-Impressionism was a speed lesson in nineteenth-century art and a way station on the trip to other destinations. As he grew older, Signac, ever social and alert, maintained an impressive network of contacts at home and abroad. His interests in politics, literature, and art remained diverse, but there was something strangely isolated about this nineteenth-century artist adrift in a modern age. After 1909 his output in oils slowed down dramatically. He was never prolific as an oil painter, but on average he had turned out a substantial group of more than ten works each year. After 1910 and, especially during the war years, his production in oils was erratic, and his annual total was rarely more than three or four medium-size or large canvases. The complexities of his personal life may have played a role here, but he was devoting a good deal more energy to watercolor painting, which was better suited to his restless, peripatetic lifestyle. It may also have been difficult for Signac to maintain his gentle art of harmony and purity amid the harsh realities of twentieth-century life.

The late works of Signac are the culmination of many years of reflection, theorizing, and practice. In some ways it could be said that his art had come full circle, regaining through the medium of color something of the simplicity, the directness, and the vitality that had initially attracted him to painting. The modern viewer will perhaps prefer the severity and restraint of the Neo-Impressionist works of the 1880s and early 1890s to the later pictures. Certainly the contradictions and tensions that gave an edge to his earlier pictures are largely dissipated in his production of the first decades of the twentieth century. The urge toward a politically committed art is absorbed into an ideal of artistic harmony. The conflicting demands of art and nature, decoration and realism, are resolved into a sometimes self-indulgent style in which the rudiments of color theory provide the support for amazing pyrotechnics of color. Nevertheless, in the best of his later works Signac combined the sensual legacy of his first pictures with the cool rationality of Neo-Impressionism to create an art of extraordinary chromatic richness and feeling. The intensity that he brought to all aspects of his craft remained consistent. And however much his talent for the manipulation of color was nurtured by the theories and by the art of others, it was a talent that retained its own distinctive character. As Cross wrote to Van Rysselberghe: "I always experience a very painterly emotion in front of Signac's canvases; I like to look at them close up as much as from far away. There's a play of hues in them as ravishing as happy combinations of gems, and it is his alone."[60]

NOTES

1 Cousturier 1922, p. 49.
2 Van Gogh 1958, vol. 3, p. 143, letter 581 (French ed., 1960, vol. 3, p. 312).
3 Signac journal entry, December 14, 1894, in Rewald 1949, vol. 36, pp. 111, 170.
4 Herbert in New York 1968, p. 14.
5 Kunstler 1935, p. 4.
6 Signac 1882a; Signac 1882b.
7 Signac 1899 in Cachin 1978, p. 109, translated in Ratliff 1992, pp. 252–53; letter from Signac to Félix Fénéon, September 9, 1933, Signac Archives; for Signac's letter to Claude Monet, see Geffroy 1922, pp. 248–49.
8 Signac journal entry, April 12, 1899, in Rewald 1953, pp. 52, 79.
9 Signac 1947, p. 78.
10 See Chronology, under 1894.
11 Letter from Seurat to Félix Fénéon, June 20, 1890, reprinted in Paris–New York 1991–92, p. 383. Seurat was reacting to an article by Fénéon on Signac in Les Hommes d'aujourd'hui, 1890, in which Seurat is not mentioned.
12 Ajalbert 1886a, p. 392.
13 Fénéon 1886b in Cachin 1966, p. 78.
14 Signac 1899 in Cachin 1978, pp. 107–12; translated in Ratliff 1992, pp. 252–54.
15 Fénéon 1886a, reprinted in Cachin 1966, p. 65.
16 Rood 1879, p. 117; on optical mixing and the various confusions associated with it, see Ratliff 1992, pp. 35f., and especially the lucid accounts in Gage 1999, pp. 77–78, 214–15.
17 Signac 1899 in Cachin 1978, p. 124; translated in Ratliff 1992, p. 264.
18 Adam 1887, cited in Paris 1963–64, pp. 18–19.
19 Fénéon 1890.
20 See Herbert in Paris–New York 1991–92, pp. 4ff., and Gage 1999, pp. 209ff. See also Amsterdam–Pittsburgh 2000–2001.
21 Signac's unfolding interest in science, aesthetics, and color theory was doubtless stimulated by his contact with Seurat. Their sources were probably similar, ranging from the standard but outdated texts of Michel-Eugène Chevreul and the more accessible and accurate work of Ogden Rood to the writings of aestheticians such as David Sutter and Charles Blanc and perhaps extending to the more advanced research of scientists such as James Clerk Maxwell and Hermann von Helmholtz.
22 Signac 1899 in Cachin 1978, p. 53; translated in Ratliff 1992, pp. 217–18.
23 From a note Fénéon sent to Signac in connection with some suggestions Charles Henry had offered about a draft of Fénéon's 1890 article in Les Hommes d'aujourd'hui; Signac Archives, cited in Halperin 1988, p. 134.
24 Henry 1890a; Henry 1890b.
25 Letter from Signac to Vincent van Gogh, in Van Gogh 1958, p. 153, letter 584a.
26 Letter from Signac to Félix Fénéon, see Dijon 1989, no. 198.
27 Signac 1890, cited in Paris 1963–64, p. 29.
28 Cachin 1969, pp. 90–91.
29 Paris 1963–64, p. 47.
30 Fénéon 1891 in Halperin 1970, vol. 1, p. 199.
31 Ibid., p. 198.
32 Fénéon 1890 in Halperin 1970, p. 177.
33 Fenton 1998, p. 159.
34 Hutton 1994, pp. 204–8.
35 Paris 1963–64, pp. 34–35, and Ward 1996, p. 158.
36 Signac 1891.
37 Signac in Association des Écrivains et Artistes Révolutionnaires 1933, cited in Hutton 1994, p. 247.
38 Signac 1891. See Herbert and Herbert 1960, pp. 472–82, 519–21.
39 Fénéon 1890 in Halperin 1970, p. 177.
40 Mirbeau 1891, p. 1; Geffroy 1892.
41 Signac 1892, pp. 343–44.
42 Cachin 1971, p. 51.
43 Saint-Tropez 1992, p. 44.
44 Ibid.
45 Ibid., pp. 32ff., 50ff.
46 Signac journal entry, August 23, 1894, in Rewald 1949, vol. 36, p. 118.
47 Bailly-Herzberg 1980–91, vol. 4, p. 61, letter 1127.
48 Signac journal entry, August 23, 1894, in Rewald 1949, pp. 101, 167.
49 Signac journal entry, September 1, 1895, in Rewald 1949, pp. 126, 174.
50 Undated letter from Signac to Théo van Rysselberghe (1902?), The Getty Research Institute, Research Library, and Special Collections, Los Angeles. The author is grateful to Elizabeth Pergam for researching the Signac letters held amongst the Van Rysselberghe correspondence in this archive.
51 Signac journal entry, in Rewald 1949, pp. 106, 168.
52 Signac journal entry, August 23, 1894, in Rewald 1949, pp. 101, 167.
53 Van Rysselberghe Correspondence, The Getty Research Institute, Research Library, and Special Collections.
54 Undated letter from Signac to Théo van Rysselberghe, see n. 50 above.

55 Signac 1899 in Cachin 1978, p. 122; translated in Ratliff 1992, p. 262.
56 Ibid., p. 137; translated in Ratliff 1992, p. 272.
57 Signac 1905.
58 Denis in Paris 1907, cited in Ward 1996, p. 324, n. 87.
59 See for example the reaction of Schmidt (1912, p. 232). The author is grateful to Benno Tempel for reviews of Signac's contribution.
60 Letter from Henri Edmond Cross to Théo van Rysselberghe, 1905, Paris, Bibliothèque Centrale des Musées Nationaux, Paris, MS 416.

SIGNAC: DRAWINGS AND WATERCOLORS

MARINA FERRETTI-BOCQUILLON

I N SIGNAC'S WORKS ON PAPER—FROM HIS FIRST attempts using pen and ink or a Conté crayon to his large, resolutely classical preparatory wash drawings—we see the artist developing a means of expression that for him rapidly became a happy alternative to the laboriousness of the Neo-Impressionist method. Watercolors occupy a dominant place in his oeuvre. Of considerable range, Signac's efforts as a watercolorist include his

Fig. 18. Paul Signac,
The Bench (cat. no. 20)

initial experiments at Saint-Tropez, with their colorful, moving frankness, and his later, skillfully executed works; there are intimate touches from his pages of notebooks and illustrated letters to friends, as well as finished works intended to be hung alongside his oil paintings. The late watercolors, in particular the series devoted to the Ports of France, provide a virtual graphic report on the coastal landscape of France before World War II. As the works progress, a kind of visual diary of Signac's artistic explorations takes shape. We witness his rapid mastery of these means of expression, which, as a self-taught artist, he initially found hard to tackle. The works also vividly trace the route of the artist on his constant travels: in his own words he had become a "watercolorist on the go."[1]

Signac is remembered as an artist in love with color and as an ardent defender of Neo-Impressionist theories. His works in black and white have, however, remained relatively unknown, although they are plentiful and varied, and their quality is undeniable. They richly deserve to be rediscovered.

Initially, Signac drew in order to work out ideas for his paintings: his sketches served to help him set

up a composition, study a detail, or try out an idea for a picture. It was under the influence of Seurat, whom he met in 1884, that Signac initially tried using a Conté crayon, illustrated here (cat. no. 20; fig. 18) by the study of a townscape with naturalist overtones. It was an illustration for the book *Sur les talus* (On the Banks) (1887) by his friend the writer Jean Ajalbert. The illustration unflinchingly conveys the melancholic climate of the poem: "Il flotte des tristesses de rêve, dans l'air / Saturé des senteurs mourantes de l'automne / Éparses en les souffles du vent qui chantonne / Aujourd'hui d'une voix déjà pleine d'hiver." (Dreamlike sorrows float in the air / Saturated with the dying smells of autumn / Scattered by the gusts of the wind that sings / Today in a voice already full of winter.)

Young Signac seems not to have been dissatisfied with this work, since he noted it in his cahier d'opus (workbook), where he was inclined to record his paintings. About the same time a few drawings intended to illustrate articles for the magazine *La Vie moderne* also appeared in his notebooks. These are drawings executed using a pointillist technique, rarely practiced by the artist except for reproducing paintings such as the *Passage du Puits-Bertin, Clichy* (cat. nos. 18, 19) and *The Dining Room* (cat. no. 25).

Drawing, which was at first subordinated to working out a picture, quickly became an exercise that Signac enjoyed for itself, a relaxation to which he could devote himself without its necessarily being a step in the preparation of a painting: "Every hour I take a little rest which I spend either writing a few lines of the Delacroix [*D'Eugène Delacroix au néo-impressionnisme*], or copying some master's drawing, or trying to draw from memory."[2] The artist would also leave his studio in order to give himself "the delight of a few rough sketches in watercolor,"[3] accumulating views of the village of Saint-Tropez, the harbor, and his garden, all arranged in portfolios carefully organized according to theme. He would later, in his studio, refer to these to collect information on the outline of a ship's prow, the detail of a tree trunk, etc. Signac's old friend Camille Pissarro, during his experimentation with Neo-Impressionism, used the same procedure with the watercolors he painted while he was living in the village of Éragny-sur-Epte in Normandy.[4]

In the years before and after the turn of the century, Signac produced a large number of pen-and-india-ink or sepia drawings, often compared with the "bamboo" drawings done by Vincent van Gogh in Arles in 1888 using a sharpened reed. But, oddly enough, it is the Dutch painter's drawings that exhibit a fondness for broken lines—hatching, dots, the repetition of small loops—thus taking on a pointillist appearance (figs. 19, 20), whereas Signac's pen-and-ink drawings are more traditional in character. It is the ardent advocate of Neo-Impressionism who conveys the sinuous forms of a sail or a reflection by means of an unbroken line. Despite the moniker, there is nothing to indicate that Signac used a sharpened reed like his friend Van Gogh rather than a pen, and we have not found any account by the artist or those close to him mentioning the use of bamboo.

In drawing, Signac quickly found an independent means of expression that occupied an increasingly important place in his work. In 1910 he did very little painting, and his graphic work proliferated. In a series of works on paper, which would be exhibited the following year at the Galerie Bernheim-Jeune, he depicts Paris with its floods and the Seine with its bridges, using pen and ink, charcoal, or watercolor. For, by now, Signac had discovered watercolor, an art he devoted himself to with obvious pleasure and which would gradually take precedence over his oil painting.

Apart from a few gouache studies made about 1885 for *The Milliners* (fig. 4), his first large figural picture, and an 1890 ink and watercolor portrait of Maximilien Luce reading Jean Grave's anarchist publication *La Révolte*, Signac for a long time drew in black and white, reserving color for his oil paintings. However, in a letter of August 30, 1888, Pissarro urged him to try watercolor: "It is valuable and very practical. In just a few minutes you can take notes that would be impossible by other means—the fluidity of a sky, some transparent effects, a mass of small pieces of information that cannot be conveyed working slowly: effects are so fleeting."[5] But Signac, an admirer of Eugène Delacroix, enthralled by color and making a methodical study of its laws, ignored the advice for the time being. Although he produced a lithograph to illustrate the *Application of Charles Henry's Chromatic Circle* (cat. no. 33) that same year, it was in the context of a study of the abstract laws of color and not yet a matter of noting the fleeting nature of life's effects.

It was only after Seurat's death that Signac made his first attempts as a watercolorist, while en route to Saint-Tropez in his sailing boat, *Olympia*. On

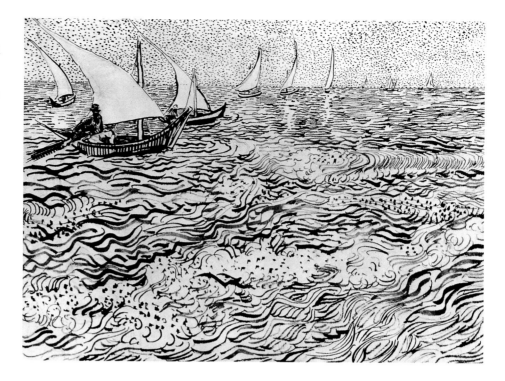

Fig. 19. Vincent van Gogh, *Fishing Boats at Sea*, 1888, reed pen and ink over graphite, 9⅝ x 12⅝ in. (24.5 x 32 cm). The Solomon R. Guggenheim Museum, New York, The Justin K. Thannhauser Collection

Fig. 20. Vincent van Gogh, *Street in Les Saintes-Maries*, 1888, brush, reed pen and ink over graphite, 9½ x 12¼ in. (24 x 31 cm). The Metropolitan Museum of Art, New York, Bequest of Abby Aldrich Rockefeller, 1948 48.190.1

May 3, 1892, he was in Toulon and communicated his difficulties to Pissarro: "I am trying watercolor. It isn't working, absolutely not. I can see that it is a very valuable means of collecting information, but it will take me a lot longer to be able to use it."[6] A few days later he reached Saint-Tropez, which seduced him, and he decided that from then on he would spend part of the year there. While waiting for his painting supplies to arrive, he continued to practice, making a few watercolor drawings for the large composition *Women at the Well* (see cat. nos. 64, 65). It was during this time that he made his last studies in Conté crayon (see cat. no. 59), a technique he abandoned in order to convey the Saint-Tropez landscape in color.

Signac's earliest watercolors indicate that he quickly showed an amazing aptitude for the medium and was immediately capable of exploiting its possibilities. Signac was not dissatisfied with his attempts as a watercolorist. Indeed, at

the end of 1892 he exhibited three "notations" at the first Neo-Impressionist exhibition, held at the Hôtel Brébant in Paris. Signac had found a new means of expression, which he was to take to a high level of perfection and which was to occupy a major place in his work. He began systematically to exhibit his watercolors alongside his oil paintings and his drawings; indeed, he often insisted that his works on paper be shown alongside his paintings on canvas. He had no compunction about protesting to the organizer of the Vienna Secession in 1900 because he had not been informed that the event was reserved for oil painting. "Moreover, I think nothing is more pleasing to the eye at an exhibition of paintings than to be able to rest on the black and white of drawings, or the pale tints of watercolors. On what grounds does an avant-garde exhibition like the Secession differentiate between water-based and oil-based art?"[7] He won his point.

The watercolors were immediately successful. While Signac had been the butt of criticisms and had suffered defections for his defense of Neo-Impressionism, he attracted favorable comment for his work as a watercolorist. The critic Arsène Alexandre supported him, buying one of the first watercolors of 1892. These spontaneous, unpretentious records appealed to a select group of buyers: the composer Vincent d'Indy bought three 1892 pictures, and Denys Cochin, a member of the Chambre des Députés for Paris and a noted collector of Impressionist works, also bought some.

With his constant concern for balancing linear and color expression, Signac soon felt the need to structure his notes. About 1895, according to his notebooks, his superb watercolors "heightened with ink" appeared. Once again Signac developed very quickly and we see him moving from a pleasant, correctly composed drawing to the powerfully structured picture depicting the bay of Saint-Tropez seen from the chapel of Sainte-Anne (cat. no. 74). Here color and graphic effects vie for authority, and the clear-cut lines of the buildings contrast boldly with the sinewy curves of the Mediterranean vegetation.

During the same period, about 1895, Signac openly gave up the idea of using oils to paint from life. Watercolor, which would henceforth play an intermediary role between nature and the finished work, allowed him to reconcile his love of the outdoors, his continually awakened curiosity, with his distinct penchant for intellectual speculation,

which prompted him to paint works that were composed, measured, decorative, and almost abstract. Nobody failed to notice this dual nature, neither his friends nor art historians, who were confused by the seeming contradiction in a personality prone to extroversion submitting to the demands of a profession requiring long periods of reflection. As early as 1894, Pissarro urged him to free himself from the constraints of the divisionist method of painting: "I am far from convinced that you are on the right track for your essentially painterly temperament, and the fact that I have said nothing about this to you up until now is because I felt that you would not like it. Think carefully, and see if the time has not come for you to evolve toward a freer art more based on feeling, and more in tune with your nature."[8] But this advice showed a poor understanding of Signac's steadfast will—it is not for nothing that he was nicknamed the Saint Paul of Neo-Impressionism—and of his loyalty to the memory of Seurat.

Much later the historian André Chastel reiterated this view, writing that one should see Signac "as having the stature and character of a sailor and restore to him that sort of natural truculence, which yields in some strange way when faced with the demands of his profession."[9] Signac's temperament did not in fact yield when faced with the constraints of Neo-Impressionism. In his painting we do not find Seurat's delicate light, distant poetry, or aristocratic hauteur, but a brilliance of color, a boldness, and an authority that speak of a completely different nature. His paintings express disciplined energy, channeled rather than stifled by the taxing process of painting small dots or by the arduousness of executing preparatory studies, drawings, and sketches. This impatient nature, which would, we imagine, be sorely tried by the slow work involved in working up the painted canvas, also had a predilection for precision and intensity.

Signac, who was a fencer, found in watercolor, where mistakes and second attempts are impossible, a sphere of expression that suited his temperament: quick, effective, and lucid. A watercolor either works or it does not, it is thrown away or it is kept; it is not possible to have another go. A watercolorist records "the elements of beauty, the images of life that pass before him" before choosing the effect in the studio.[10] What captivated him was the freedom of a technique where the hand is "a mere organ of transmission subordinated to the brain and the eye."[11] Signac, who chose to convey

Fig. 21. Théo van Rysselberghe, *Paul Signac: "In Sight of Zierikzee,"* 1896, colored pencil, 6 x 5⅛ in. (15.2 x 13 cm). Private collection

a universe that is the epitome of change—the universe of water, light, reflections, and wind—had found the solution to the challenge he had set himself. Signac the sailor, as well as Signac the asthma sufferer, who avoided confined atmospheres and stove fumes, enjoyed the intoxication of the open air and the direct contact with nature before returning to the calm of his studio to devote himself to work requiring deeper thought.

At the turn of the century Signac, anxious to find a Neo-Impressionist style of drawing closely linked to color, used a Tachist-like technique in which he juxtaposed brushstrokes to create a vibration on the surface of the paper comparable to that obtained on his divisionist canvases. This technique can be seen very clearly in the landscapes

of Saint-Tropez and Samois done in 1899–1900 (cat. nos. 106, 107). However, while he used pure color and avoided mixing the tones, which remained isolated from one another by the white of the paper, Signac never used Pointillism in watercolor, as Pissarro would do on occasion and as Hippolyte Petitjean later did. Rather than the small dot, which at this period became larger on his canvases, he preferred the play of contrast and division. Signac exploited a more mobile, Impressionist brush and continued to structure his works with a pen or pencil. He evolved toward ever greater freedom, which he asserted with an increasingly flowing touch, less broken up.

Before 1895 Signac brought back a series of pictures painted on location during his travels to Port-en-Bessin, Collioure, Portrieux, and Cassis (see cat. nos. 6–7, 27, 29–31, 34–36). Once freed of the demands created by plein air oil painting, he could indulge in his wanderlust without being burdened with equipment. Canvases, paints, easels, and brushes now remained in the studio; henceforth he traveled with only his pencil and a box of watercolors in his pocket. In a notebook, or on a few sheets of paper, he would note down the effects as they passed before his eyes, leaving the conception and execution of the painted canvases until his return. Through his sketches we follow him to Marseilles, Venice, and Constantinople. The Belgian painter Théo van Rysselberghe, who accompanied him to Holland, has left us an amusing portrait of his friend viewed from behind looking at a watercolor in progress, careful to miss nothing of the spectacle displayed before his

Fig. 22. J. M. W. Turner, *The Grand Canal, Venice,* 1835, oil on canvas, 36 x 48⅛ in. (91.4 x 122.2 cm). The Metropolitan Museum of Art, New York, Bequest of Cornelius Vanderbilt, 1899 99.31

eyes (fig. 21). Often Signac used his "travel notes" immediately upon returning to his studio, but sometimes they lay dormant in his notebooks for a few years before being used to work out a picture.

Like the English landscape artist J. M. W. Turner, Signac has left us a sort of visual diary, the memoirs of a tireless tourist—only World War I could keep him, very briefly, in one place. On one sheet after another, he eagerly recorded the sights he saw.

Signac's stay in Venice in 1904 signaled an acceleration in his graphic output. He spent nearly a month there, drawing frantically, telling his friend Henri Edmond Cross in a letter that he would bring back more than "two hundred informal watercolor sketches."[12] In fact, on this trip he numbered his sheets (see cat. no. 112), including color notes on some of them. We have no difficulty in sensing the enthusiasm, the urgency, with which Signac worked from life. It was of prime importance that nothing be forgotten, nothing missed from the spectacle. Thanks to these colored sheets, upon his return to France he was able to paint a series of canvases inspired by Venice (see cat. nos. 111, 113, 114). This city, which had come under the artistic spotlight when the French translation of John Ruskin's *Stones of Venice* appeared, attracted Théo van Rysselberghe, Alfred William Finch, and Claude Monet in 1908. Signac found the first two there during his second watercoloring visit.

Signac often spent time copying works of favorite masters with a pencil or a brush to exercise his visual memory. As his friend and biographer George Besson recalls, Signac "wrote and often recounted how he had spent a long time acquiring the memory of the forms essential for freedom of expression. He exercised that lazy memory by drawing from memory, or after reproductions of the masters, making ten, twenty sketches of the same subject until he had found and retained the movement of the original."[13] He also, and mainly, exercised that memory in front of the pictures themselves on his many visits to museums. In 1910 the Galerie Bernheim-Jeune organized the exhibition *D'après les maîtres* (After the Masters), where Signac showed a group of watercolors painted after the Turners he had seen in London the previous year. "It is necessary to learn in order to become free," he had declared as early as 1898.[14]

It was probably through copying the pictures of the masters that Signac had the idea of reproducing his own pictures to establish his *liber veritatis*

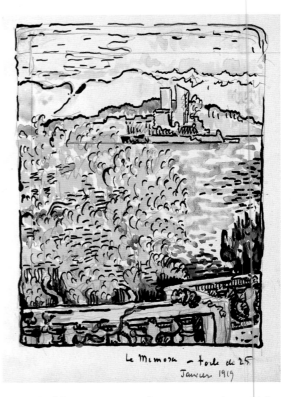

Fig. 23. Paul Signac, *Mimosa, Antibes*, 1919, watercolor and ink drawing after his painting (FC 532, location unknown), page from Signac's watercolor book (vol. 2, pl. 23). Private collection

(book of truth). The project, which took shape about 1908, included drawings that he made after his canvases as well as the titles of the originals, their dimensions, and their exact dates. Certain paintings are familiar to us only through old black-and-white photographs—we therefore get an idea of their colors only through these valuable drawings. But above and beyond the obvious usefulness of this first catalogue, it is quite evident that Signac devoted himself to this reproduction work with real enjoyment; indeed, the interest of these stunning "portraits of pictures" goes well beyond their documentary qualities (see fig. 23).

Signac's discovery of watercolor did not prevent him from continuing to practice black-and-white drawing with equally obvious pleasure, and that means of expression retained a crucial place in his process of working up paintings. The Conté-crayon drawings of the early days, full of contrasts between shade and light, were succeeded by large, adaptable wash drawings made in india or chinese ink, preparatory cartoons in the purest tradition of classical art. As early as 1894, Signac's journal entries expressed his need to look to the sketch for no more than the idea and to decide the final arrangement of the picture on a cartoon of the same format. "For research into lines and angles, I feel it is

impossible to square off a small sketch. An angle that looks fine in small dimensions may look awful enlarged."[15] During this period he was preoccupied with large decorative painting and reverted to more traditional techniques, noting in his journal, "What good it would do me to see Michelangelo's decorative figures again before completing my picture." He also alludes to the works of Raphael, writing that they have "dependable rules, now lost," hidden in them.[16]

Signac began to create very fine preparatory cartoons, typically squared off so they could be transposed to the canvas. *La Rochelle*, made for the picture of the same title painted in 1912, is emblematic of this qualified return to classicism (cat. no. 133). We can clearly perceive the concern of the artist, who admired Nicolas Poussin and Claude Lorrain, with achieving balanced, measured compositions where the viewer's eye would be led across the surface of the canvas by full, guiding curves. For both his drawings and his watercolors, Signac used a Japanese brush, "i.e., an implement that has a fine point at the same time as a wide base, and can consequently produce the most varied lines, making it possible to indicate openly the starting-point of a stroke, or, on the contrary, to drown deliberately its contour."[17] He first exhibited these preparatory cartoons in 1911. The poet Guillaume Apollinaire, who was also an exacting art critic, enjoyed his discovery of them, writing that "these last have not been seen before. They are very beautiful drawings, broadly executed and well composed."[18]

Signac continued to prepare his paintings in oils in this way up until the time of his death in 1935.

Sometimes these large wash drawings indicate that a change was made in the final work, as in *The Lighthouse, Groix*, where the artist changed the position of a boat to give the composition more dynamism (cat. nos. 152, 153). Often the preparatory cartoons show a lyricism that is less present in the finished work. The emphatic boldness of the Lézardrieux bridge crossing the river Trieux (cat. no. 156) expresses a latent Romanticism—he was, after all, a passionate admirer of Claude, Turner, and Delacroix—that is often less perceptible in his pictures.

After Paul Cézanne's death in Aix-en-Provence in 1906, the dealer Ambroise Vollard and the Galerie Bernheim-Jeune jointly purchased 187 watercolors by the artist. Félix Fénéon, an art critic and a friend of Signac's from his early days, organized the first major exhibition of these relatively unknown works at the Galerie Bernheim-Jeune in 1907. The catalogue includes nearly eighty watercolors and is illustrated by two reproductions of still lifes, one of which is shown here (fig. 24). While Cézanne's pictures from this first exhibition are not directly reflected in Signac's work, a second, similar event organized at the Galerie Bernheim-Jeune in early 1914 quite obviously did not leave him untouched. During the months that followed, Signac painted several watercolors that, in their terrestrial subject matter, show the influence of Cézanne. These were often views of mountains in muted tones—blue green is the dominant color—and a heavily applied brushstroke that distinguish them from previous works. Toward the end of the war, Signac wrote to Fénéon telling him he had

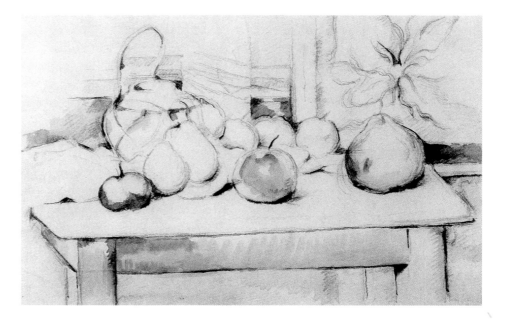

Fig. 24. Paul Cézanne, *Ginger Jars and Fruit on a Table*, 1888–90, watercolor and graphite, 9½ x 14⅛ in. (24 x 36 cm). Private collection

Fig. 25. Johan Barthold Jongkind, *Honfleur*, 1863, watercolor, 5⅞ x 9 in. (15 x 23 cm), frontispiece from *Jongkind* (1927), by Paul Signac (location unknown, formerly owned by George Besson)

done a series of watercolors, still lifes of flowers and fruit, and shortly afterward asked Fénéon to send him photographs of a Cézanne watercolor, as well as a painting by him of "rich fruit," to hang on the walls of his studio in Antibes.[19]

The first still-life watercolors date from this period, late 1918 or early 1919. In one (cat. no. 146), the square, brown brushstrokes in the background, the lines that accompany the volume of the yellow and red fruit, and the emphatic structure of the checked tablecloth are reminiscent of Cézanne. This work is very close to a still life dated 1919 (cat. no. 144) and to a watercolor published in the 1922 monograph devoted to Signac by Lucie Cousturier.[20]

All of these still lifes should, undoubtedly, be seen as an homage to the Aix master, but an homage in which Signac's temperament as a colorist, rather than being held in check by his admiration, is expressed with a liveliness seldom achieved in his landscapes. In June 1926 the Galerie Bernheim-Jeune held another important retrospective of Cézanne's work. Signac, who was in Paris to attend a meeting of the Société des Artistes Indépendants, went to see it. Back at Bourg-Saint-Andéol he returned to the theme of the still life: one of his sheets is dated July 14, 1926 (cat. no. 147). He then returned to the book he was writing about the Dutch painter Jongkind.

Signac had long admired the work of Johan Barthold Jongkind, whose watercolors he collected; he felt particularly close to the artist who, like him, had been a "friend of boats and the wind"[21] (fig. 25). In May 1899 he had devoted several pages of his journal to an account of his

visit to the Jongkind exhibition at the Galerie Durand-Ruel: "There are about fifty water colors there, the value of which is most gratifying." His account concludes with the following thought, which seems to be premonitory with regard to Signac himself: "Truly, the fate of a Jongkind, gaily and superbly painting until his very end—due to the hostility or indifference of the public—gives one his courage back, and it is with a heart full of joy from this lesson of art and life that I will leave Paris."[22]

In 1927 Signac published a monograph devoted to the Dutch painter, in particular to his drawings and watercolors, which were, according to Signac, "the most characteristic part of his work. The part that teaches us to know him better and love him more. It was also the part he liked best. . . . It was the joy of his life."[23] Françoise Cachin has rightly pointed out that what Signac says about Jongkind could often apply to himself, and when he writes about Jongkind as a watercolorist he is, in fact, writing a virtual treatise on the art of watercolor.[24] Signac expresses his admiration for "Turner the idealist," "Jongkind the realist," and "Cézanne the analyst," at the same time advocating their methods, which were also his own.[25]

His book on Jongkind gave Signac an opportunity to summarize a technique he had been using for more than thirty years. In it, he goes against the recommendations usually made to watercolorists, in particular stigmatizing the use of "pimply torchon paper"; he preferred to use a sheet of smooth paper that would allow the tip of the brush to run smoothly over it and the water of the wash to "stand still for a few seconds in little pools where

the drying processes will separate the paint color into infinitely varied minute quantities."[26] He does accept "the intelligent use of gouache,"[27] with which he could obtain a larger number of colors. Above all, he advocates letting the white of the paper show through, both by transparency and by leaving it blank, to enable the colors, thus isolated from one another, to harmonize while at the same time retaining their intensity.[28] To him it seems superfluous to cover the whole sheet of paper: "Are there in existence more splendid skies, more solid stretches of countryside than those glorified by Cézanne on a wretched sheet of paper with barely twenty brushstrokes of watercolor on it?"[29] He rejects the use of successive layers, which make the paint color lose its purity, giving the sheet the overall tonality of a "heap of rotten vegetables," and maintains that "any color that is covered is more or less sullied. . . . The values, from the lightest to the deepest, will be established at the first attempt, and will pass directly from the palette to the paper. The whole thing will consist of a scatter of juxtaposed strokes, not superimposed ones. Like strewn flowers."[30] He sees nothing wrong in letting the pencil or pen drawing show through, in the manner of Turner, Jongkind, Cézanne, or the Japanese. He even advocates deftly drafting the picture in pencil, then heightening it with a few brushstrokes in watercolor, a tried-and-trusted technique of which he soon gave a masterly demonstration with his Ports of France series.

This ambitious watercolor project would be warmly embraced by Gaston Lévy. Cofounder of Monoprix department stores and an avid collector of works by nineteenth- and early-twentieth-century artists, Lévy met Signac about 1926. The two men soon became friends, enjoying holidays together at Belle Île and the seaside resort of La Baule in Brittany (fig. 26), where Lévy owned a villa, Orphée, at which Signac was a frequent visitor. Gaston Lévy became one of Signac's most enthusiastic patrons. He bought works by the artist in all media but shared with his cousin André—who was Signac's neighbor in Saint-Tropez—a particular passion for the watercolors (André later bought many works owned by Gaston when the Depression forced the latter to sell a large part of his collection). Gaston Lévy also undertook to produce a catalogue of Signac's paintings for which he collected many photographs and a great deal of information with the help of the artist himself.

In December 1928 Signac told Gaston about a dream he had long nurtured: the Ports of France project, which would be the crowning achievement of his career as a watercolorist. With this major series of watercolors of the harbors of France, he would follow in the footsteps of Joseph Vernet, Nicolas Ozanne, and Louis Garneray. Signac had in mind a journey that would take him to one hundred harbors in France with the objective of painting two watercolors of each site. He would let Lévy, who commissioned the project, choose the one he liked best and would keep the other for himself. He thought work on the project would take five to six months to complete. It took shape in April 1929, when Signac told his friend, collector, and patron, "Sète done. 99 to go!"[31]

Signac traveled up and down the coast of France from 1929 to 1931. In February 1931 he looked forward to "the final round of harbors

Fig. 26. Signac and the Lévy family at La Baule, ca. 1930, photograph; back row, from left to right: Gaston Lévy, Signac, Liliane Lévy, Gaston's wife, and André Lévy, Gaston's cousin. Signac Archives

from Marseilles to Mussolini."[32] The Ports of France series enables us to follow the artist, then in his mid-sixties, day by day from harbor to harbor. The watercolors provide an amazing account of landscapes that would suffer great destruction and undergo major changes in the years to come and attest to the artist's vital energy and his delight at being able to devote himself unreservedly to his favorite subjects: harbors, the sea, and boats. In spite of his failing health, the tireless traveler conveyed the variety of the skies, the riggings, and the harbor equipment with obvious relish. There is not a trace of nostalgia in these brilliantly fresh and energetic sheets where metal bridges, cranes, and oil tankers have just as much right to a place as do tuna boats or Newfoundland fishing boats.

After completing the series on the harbors of France in 1931, Signac gave up the practice of spending his summers at Lézardrieux, the Breton village overlooking the river Trieux where he had worked since 1924. Instead, he bought a house at Barfleur in Normandy, a small, more austere fishing harbor, for his summer vacations. Signac enjoyed the unsophisticated company of fishermen, just as he loved the rocky coast of this wind-battered Norman headland. From his windows overlooking the harbor on one side and the lighthouse on the other, he observed the life of the harbor, the comings and goings of the boats. Always wearing his sailor's cap and an old roll-neck sweater, he paced up and down the quays and drew.

In 1935, perhaps sensing that he did not have much longer to live, he set out on his last journey, marveling at his discovery of Corsica. Traveling from one harbor to the next with the energy of a young man, he made his last Mediterranean notes. Only two months before his death on August 15 he had been working without respite on a dazzling series of watercolors.

This essay first appeared, in slightly different form, in Little Rock 2000.

NOTES

1 Letter from Signac to Louis Vauxcelles, October 18, 1910, Fondation Custodia, Paris, and letter from Signac to Berthe Signac, October 23, 1910, Signac Archives.
2 Signac journal entry, June 2, 1897, in Rewald 1952, pp. 269, 300.
3 Signac journal entry of September 29, 1898, in Rewald 1952, pp. 278, 304.
4 Pissarro 1993, p. 225.
5 Letter from Camille Pissarro to Signac, August 30, 1888, Signac Archives.
6 Letter from Signac to Camille Pissarro, May 3, 1892, Paris, Librairie de l'Échiquier, cat. no. 2, no. 85.
7 Letter from Signac, February 19, 1900, Archiv der Wiener Sezession, Österreichische Galerie, Vienna.
8 Letter from Camille Pissarro to Signac, January 23, 1894, Signac Archives.
9 Chastel 1963, p. 12.
10 Signac, preface to Paris 1913, unpaged.
11 Signac 1927, p. 71.
12 Letter from Signac to Henri Edmond Cross, n.d. (1904), Signac Archives.
13 Besson 1965, p. 12.
14 Signac journal entry, April 27, 1898, Signac Archives (in connection with the purchase of reproductions after the *Travaux d'Hercule* [Labors of Hercules] by Poussin).

15 Signac journal entry, September 8, 1894, quoted in Paris 1963–64, p. 107.
16 Letter from Signac to Henri Edmond Cross, summer 1893, and Signac journal entry, September 6, 1894, quoted in Saint-Tropez–Reims 1992, p. 57, n. 15.
17 Klingsor 1921.
18 Apollinaire 1911a, as cited in Apollinaire 1972, p. 133.
19 Two letters from Signac to Félix Fénéon, September 20 and 30, 1918, Signac Archives.
20 Cousturier 1922, fig. 30.
21 Signac 1927, p. 129.
22 Signac journal entry, May 16, 1899, in Rewald 1953, pp. 57, 80.
23 Signac 1927, p. 61.
24 Cachin 1971, p. 120.
25 Signac 1927, p. 116.
26 Ibid., pp. 101–3.
27 Ibid., p. 105.
28 Ibid., pp. 106–7.
29 Ibid., p. 109.
30 Ibid., pp. 109–10.
31 Letter from Signac to Gaston Lévy, early April 1929, private collection.
32 Letter from Signac to Gaston Lévy, February 1931, private collection.

SIGNAC:
THE GRAPHIC WORK

SJRAAR VAN HEUGTEN

COMPARED WITH PAUL SIGNAC'S MORE than six hundred paintings and hundreds of drawings, his graphic oeuvre, consisting of only twenty lithographs and seven etchings, is rather modest. The majority of these prints were produced during the heyday of color lithography, in the last decade of the nineteenth century.

Some of Signac's prints are based on drawings or paintings;[1] others have no known model. His first etching—a café-concert scene, little more than a finger exercise—has been dated about 1885 (KW 1). Approximately two years later followed the small, charming black-and-white lithograph of a woman at a window (cat. no. 41). It was published in *La Revue indépendante* in 1888, and Signac, in preparation for his large-scale figure painting *Sunday* (cat. no. 40), made variants of the motif in Conté crayon and oil (cat. nos. 43, 44). In 1890 he produced yet another black-and-white lithograph, this time for the cover of a collection of poems by Charles Cros (KW 3).

In 1889 Signac, more or less fortuitously, became the first of a younger generation of artists who came to understand color lithography as an independent means of artistic expression. In January of that year his famous illustration documenting the use of his friend Charles Henry's chromatic circle had appeared on a program for the Théâtre-Libre (KW 4; cat. no. 33). A truly pioneering role in the development of lithography cannot, however, be assigned to this artist: the nature of the print simply demanded color, and lithography was one of the easiest methods of reproducing it.[2]

Signac did not make his next lithograph until 1894, offering further evidence that his interest in applying the *Cercle chromatique* was not an exploration of the artistic qualities of the medium itself. In 1891 Pierre Bonnard and Henri Toulouse-Lautrec propelled the art of color lithography to new heights, and many artists followed their example. This increased interest in the graphic arts led to the establishment of André Marty's *L'Estampe originale* in 1893, a series of nine albums that brought together the prints of mainly young artists. The seventh edition (1894) included Signac's *Saint-Tropez, II* (KW 6; fig. 27), a new rendition of his first, failed attempt at the subject (KW 5).

As the title *L'Estampe originale* implies, Marty's aim was to publish original prints, designed and produced by the artists themselves. In this sense Signac's contribution is somewhat controversial. We know for certain that he himself did not draw

the scene directly on the stone but rather sent the material to the printer from the south of France. On the basis of surviving letters Pat Gilmour concluded in 1990 that *Saint-Tropez* is nothing more than a reproduction made by the printer, Edward Ancourt, of a watercolor he had received from the artist.[3] There is, however, another possibility, as was pointed out a few years later.[4] Like many artists unversed in graphic techniques, Signac worked with *papier à reporter,* or transfer paper. An original drawing on this type of paper could be directly transferred onto the lithographic stone. This was probably the method utilized for both the failed first version and its improved successor. Along with the prepared drawing Signac also sent the watercolor, which was to serve the printer as a guide for coloration. It is known that Marty sometimes encouraged artists to use transfer paper and that Signac employed it on other occasions. One such drawing for an unexecuted lithograph has survived,[5] and another, from 1923 depicting the Seine in flood, was actually transferred and printed.[6] That the artist continued to use this method, even in one of his last lithographs, indicates that he never truly mastered the graphic artist's métier—probably not even that of black-and-white lithography, which does not require great proficiency.[7] There was much discussion about *papier à reporter* in the nineteenth century, as not everyone was convinced of the originality of lithographs initiated in this manner.

In 1897 Signac made an etching of the harbor at Flushing (KW 7), which served as the model for a color lithograph later that same year (KW 8; fig. 28). The latter formed part of a series of six produced for the publisher Gustave Pellet. The exact date of some of these sheets remains uncertain, but on the basis of the surviving correspondence (and judging by the biographical facts as they are known today, which tell us that he visited the Netherlands for the first time in 1896), it seems safe to assume that they were all executed between 1896 and 1898.[8] In terms of their coloration, these lithographs are quite remarkable: although Signac always employed a more or less pointillist-like technique, there is hardly any intermingling of the colored dots. They are set down instead in large patches next to one another. The dots have thus become a purely stylistic device. That the artist employed these dots not merely as a technique but also for reasons of style is demonstrated by his "dotted" pen drawings (see cat. nos. 18, 19, 25). Seurat and his circle introduced the pointillist method in order to test new theories of color, but this cannot have been an issue in these black-and-white drawings.

Signac turned out the majority of his graphic works in the years 1896–98. In addition to the six lithographs for Pellet, he also made a lithograph on zinc after *In the Time of Harmony* (KW 14; cat. no. 87) and one in black and white depicting wreckers at work (KW 15; cat. no. 88a), which

Fig. 27. Paul Signac, *Saint-Tropez, II,* 1894, color lithograph, 16½ x 23⅛ in. (41.9 x 58.7 cm). The Metropolitan Museum of Art, New York, Rogers Fund, 1922 22.82.1–69

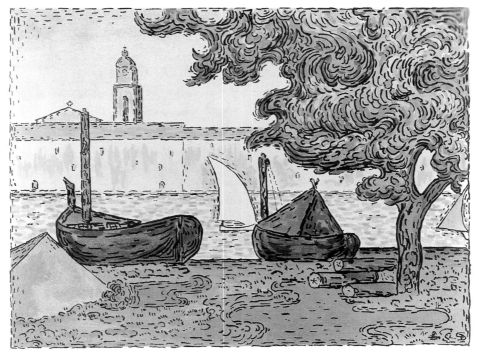

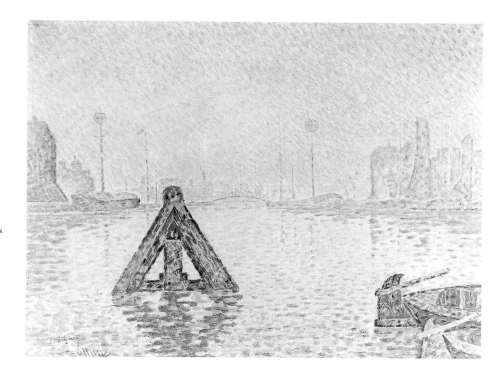

Fig. 28. Paul Signac, *Flushing Harbor*, 1897, color lithograph, 12⅛ x 16¼ in. (30.8 x 41.3 cm). The Metropolitan Museum of Art, New York, Rogers Fund, 1921 21.97.8

was the basis for a later painting (cat. no. 88b). Signac's anarchist leanings and left-wing political vision are clearly expressed in these prints. *In the Time of Harmony* is a socially minded utopian pastoral, and the symbolism of the toiling workers is clear: as old structures are pulled down, a new dawn breaks on the horizon.[9] Like many artists, Signac viewed prints—affordable works of art that could be produced in large numbers—as a means of reaching a wider audience. These two lithographs, each with its incontestable message, were specifically addressed to the working classes; they were even published in the anarchist magazine *Les Temps nouveaux.*

Signac created three further etchings and two more color lithographs in these years. The latter demonstrate that he was already thought of as a serious graphic artist. *The Port, Saint-Tropez* (KW 19; fig. 29), was commissioned by the art dealer and publisher Ambroise Vollard, whose instinct for talent was infallible; while *Evening* (KW 20) was reproduced in the ambitious avant-garde periodical *Pan.*

After 1898 such works became less important to Signac. Probably about 1900 he produced another small etching (KW 21), and he made a lithographed copy after a Cézanne in 1914 (KW 22; fig. 56). The lithograph of the flooding Seine was done in 1923, as mentioned above. The view of the Pont des Arts in Paris (KW 24) appears to come from 1927. About that time he finally created a series: three versions on the same motif, a

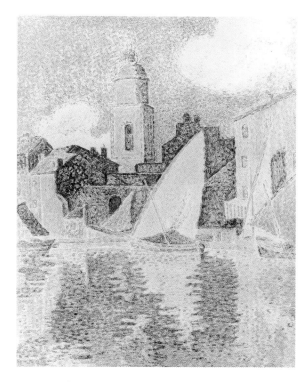

Fig. 29. Paul Signac, *The Port, Saint-Tropez*, 1898, color lithograph, 17⅛ x 13 in. (43.5 x 33 cm). The Metropolitan Museum of Art, New York, The Elisha Whittelsey Collection, The Elisha Whittelsey Fund, 1987 1987.1087

diagonally placed boat with the island of Saint-Malo in the background (KW 25–27). These late works are executed with both speed and confidence but are otherwise unambitious. Drawing and painting had clearly gained the upper hand.

NOTES

1 See Kornfeld and Wick 1974, in which a number of examples are given. See also Wick 1962, pp. 83–96.
2 On the color lithographs, see Kornfeld 1997, pp. 102–18.
3 Gilmour 1990, pp. 271–75.
4 See Boyer 1991, pp. 26–45, esp. p. 32.
5 Kornfeld and Wick 1924, unpaged preface. Also reproduced in Kornfeld 1997, p. 118, fig. 42.
6 See Van Heugten in Kornfeld and Wick 1974, no. 23.
7 For a description of the method of working on transfer paper, see Kornfeld 1997, p. 104.
8 See Gilmour's corrections to Kornfeld and Wick 1974; Gilmour 1990, pp. 272–74.
9 See Hutton 1994, pp. 59–63, 135–41 (*In the Time of Harmony*), 248 (*Les Démolisseurs*).

PORTRAIT OF PAUL SIGNAC: YACHTSMAN, WRITER, INDÉPENDANT, AND REVOLUTIONARY

ANNE DISTEL

PAUL SIGNAC WAS DEPICTED BY SEVERAL of his artist colleagues: Georges Seurat executed a Conté crayon drawing of him (fig. 30), Théo van Rysselberghe portrayed him at the helm of his boat (fig. 31), and Bonnard showed him on the deck of one of his boats in the company of friends (fig. 32). In the first work he is a proper bourgeois in a top hat, and in the other two he is a sailor: unexpected avatars of a Neo-Impressionist painter who nevertheless would have recognized himself in these various guises. Seurat's drawing illustrated and introduced a seminal article on the theory of Neo-Impressionism written in 1890 by Félix Fénéon, who dedicated this major text to Signac (see fig. 91). The artist was a sailor throughout his life; he bought his first boat when he was a teenager and over the years would own some thirty craft. Even several months before his death he was still exploring small ports along the Corsican coast. These portraits do not show him as a painter (a photograph of the serious twenty-year-old Signac posing with a palette fills this necessary iconographic function; fig. 64) but suggest that he be considered under aspects that

are only apparently distinct from his vocation as an artist.

THE ARTIST AS SAILOR

Signac felt the first stirrings of his double vocation in the studies he painted along the banks of the Seine in the early 1880s.[1] He was a resolute autodidact, determined to bypass the École des Beaux-Arts, and he sought his examples among the Impressionists, especially Claude Monet, who exerted a decisive influence on his choice of subject matter. He kept a canoe at Asnières, which led him to favor waterscapes, first along the Seine in the Parisian suburbs and then on the Brittany coast. As early as 1885 his nautical eye spotted such details as buoys off Saint-Briac and wavelets stirred by the wind, features that a layperson might not notice. Even the titles of his works indicate the specialist: *Stiff Breeze from N ¼ NW, Saint-Briac* (cat. no. 9). His entire career as a painter was shaped by this second vocation: sailing and painting were a good combination. Always eager to make his opinions known, he

dubbed his first boat *Manet-Zola-Wagner* and later christened his first large sailboat *Olympia* (see fig. 33), an homage to Édouard Manet's painting (which a group of subscribers led by Monet forced upon the recalcitrant curators of the French national collections in 1890). It was to the *Olympia*— a sleek eleven-meter cutter large enough to carry a crew—that he withdrew in search of peace after Seurat's death in 1891. Aboard the *Olympia* he sailed south from Brittany, reaching the Mediterranean via the Canal du Midi, and docked in Saint-Tropez for the first time in early May 1892. In that same year Gustave Caillebotte, a painter whom Signac had closely studied and who also collected boats (though with much deeper pockets than those of Signac), sponsored the membership application of his young "colleague" to a yacht club.[2]

Signac's correspondence became a chronicle of his cruises: aesthetic explorations interrupted by competitive regattas. In a letter to the art critic Louis Vauxcelles from the spring of 1917—in the midst of war—he mentioned an exhibition held by the Ligue Navale Française and exclaimed: "Why did they not invite me to [participate in] *Peintres de la Mer* (*Marine Painters*): am I not a 'Painter to the Navy Department'?; I have had twenty-nine boats, won more medals in races than a Prix de Rome at the Salon; my villa is called 'La Hune,' and, well, I have painted a few seascapes and a bit of water! I regret this all the more as this is a very fine exhibition. But it does not prevent me from sleeping."[3]

Later, in 1929, when Gaston Lévy commissioned him to paint a series of watercolors devoted to the ports of France, he gave recognition to a project that Signac had carried on informally throughout his years of sailing and travels. Signac did not restrict his research to the ports—many of which were destroyed during World War II and so preserved for posterity by his works—he was also interested in the vanishing world of the old clippers, and he noted details of their intricate rigging in his sketchbook while talking with old seafarers on the docks of Brittany. Here the sailor (and collector of rare terminology) took the lead over the painter who did not need many notations from life. Observation of detail was only a preface to the work of a painter, for, as Signac maintained: "Personally, except for a quick indication which memory or a camera would often supply just as well, any artist's work must

be creative. And isn't the painter just as well able to create at his table or at his easel as under a bridge or on a road?"[4] In an 1892 lithograph his friend Maximilien Luce showed him intensely absorbed in working at the easel in his studio, brush in hand (B 764).

SIGNAC THE WRITER

No less emblematic is Seurat's image of his friend Signac. The well-to-do artist is presented as an austere, proper bourgeois—the opposite of the clichéd disheveled creator—shouldering his cane with an assured yet nonchalant determination, probably a familiar gesture. Seurat seems to have wanted to immortalize the dedicated painter who spent his time discussing, writing, struggling, arguing, and searching for exhibition spaces to convince the art public and court the critics. This was the painter to whom Camille Pissarro wrote: "The entire 'Neo' burden rests on your shoulders. Seurat will not be attacked because he keeps quiet. I am disdained as an old codger. But they sink their teeth into you, man, knowing how feisty you are."[5]

The young Signac seems to have hesitated between a career as a writer and as a painter. The Naturalist "documents" that he published in *Le Chat Noir*[6] were Parisian sketches that recalled the subjects of his paintings: the downtrodden and those who lived in Parisian suburbs. These subjects also provided material for the poetry and novels of the young generation of poets and writers who published in *Le Chat Noir, La Revue indépendante,* and *La Vogue* and whom Signac knew and admired. These writers, who claimed to have gone beyond Naturalism in their novels and who praised the poetry of Arthur Rimbaud, Paul Verlaine, Jules Laforgue, and Stéphane Mallarmé, included Félix Fénéon, Jean Ajalbert, Paul Alexis, and Gustave Kahn, all of whom would write favorable reviews of the work of Signac and his friends. Yet in deciding to become a painter, Signac did not completely abandon the world of literature: he was an avid reader and bibliophile. Fénéon, sensitive to the luxury and refinement that placed his friend outside the struggling bohemian world, described his collection with evident pleasure: "In his library, the leather, paper, and fabric of the bindings commingle: silvery blue for Leonardo da Vinci; parchment white

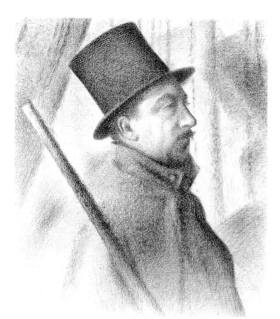

Fig. 30. Georges Seurat, *Paul Signac*, 1890, Conté crayon, 14⅜ x 12½ in. (36.5 x 31.6 cm). Private collection (see also fig. 91)

Fig. 31. Théo van Rysselberghe, *Signac on His Boat*, 1896, oil on canvas, 36¼ x 44¾ in. (92.2 x 113.5 cm). Private collection

and gold for Rimbaud and Mallarmé; violet for Baudelaire; blue and orange for Kahn; purple and black for Leon Tolstoy; glossy pink for Paul Adam."[7] Among Signac's favorite writers in later life was Stendhal. He wrote a pocket bio-bibliographical guide to the author, printing it in an edition of fifty-nine (the writer's age at his death) on the eve of World War I. It was to have been the introduction to his book on Stendhal, which was never published.[8]

Throughout his life Signac maintained a steady correspondence with friends (often including watercolors), and he put his pen at the service of political causes. An early example of his courteous but uncompromising militancy is his letter to Émile Zola on February 8, 1886—when Zola's novel *L'Oeuvre* was appearing in serial form—to point out an error in his formulation of the theory of complementary colors. This clarification was in the same vein as Signac's short, polemical articles published pseudonymously by Paul Alexis (Trublot) in *Le Cri du peuple*[9] or those mentioned by Fénéon in his 1890 profile of the artist.[10] Like one of his favorite masters, Eugène Delacroix,

and like his contemporaries Maurice Denis and Édouard Vuillard, Signac kept a journal.[11] The published extracts from 1894–1909 are a valuable record of the artist's thoughts and of the artistic life of his times.

His major work, *D'Eugène Delacroix au néo-impressionnisme*, was published in 1899. Widely distributed when it came out, it has been regularly reprinted since then as the manifesto of Neo-Impressionism and an example of a theoretical text written by a painter (a rarity in France).[12] He began writing it at a slow pace in 1896, ten years after the first exhibitions of the Neo-Impressionist movement, represented at the beginning by Seurat and Signac, and by Camille Pissarro, who rallied to the cause of his younger colleagues. Signac was not entirely satisfied with the texts written by his friends (including Fénéon) and believed that the art public needed further elucidation. Paralleling Seurat's laconic and polemical communiqués, Signac repeatedly explained the theoretical writings that nourished the Neo-Impressionist movement and contributed to the illustrations for Charles Henry's texts. His own book shows

Fig. 32. Pierre Bonnard, *Signac and Friends on His Boat*, 1924–25, oil on canvas, 49 x 54¾ in. (124.5 x 139 cm). Kunsthaus, Zurich

Fig. 33. Signac at the tiller of his yacht *Olympia*, ca. 1895, photograph. Signac Archives

that Signac wanted to survey the state of the group after Seurat's death in 1891, as well as to reflect on his own life (he was now thirty-five). He probably also wanted his voice to be heard among those of Paul Gauguin, Émile Bernard, and, especially Denis, the recognized head of the "Neo-Traditionists," whom he considered intelligent but misguided.[13] Until the end of his life Signac always allowed extracts, adaptations, or summaries to be printed for exhibitions of the group.[14] From being a participant and a witness, he became more and more a precise historian, yet without ever losing his biting wit. His tendency to proselytize led him to undertake, in the 1920s, the translation of Ruskin's *Elements of Drawing*, a book that was important to the "Neo" group and that Henri Edmond Cross had begun translating while Signac was working on *D'Eugène Delacroix au néo-impressionnisme.*[15] Signac's monograph on Johan Barthold Jongkind (1927) is one

of the few books on this artist written in French. Still relevant, it combines the reflections of a historian, the observations of a collector, and the views of a watercolorist who admired the Dutch painter's craft.

Signac did not content himself with the limited power of avant-garde reviews and specialized publications. Forgoing the sheltering walls of the literary world, he worked in the field, taking on such thankless tasks as administrating exhibitions and selling his works and those of his friends.

SIGNAC AND THE INDÉPENDANTS

In spring 1884 the artists rejected by the Salon jury decided to form a group to remedy their exclusion from the public arena. Famous precedents had been the Salon des Refusés of 1863 (at which

Manet showed his *Déjeuner sur l'herbe*) and 1873 (which featured Pierre-Auguste Renoir's *Allée cavalière au Bois de Boulogne*). These pell-mell exhibitions, in which the best—as designated by posterity—often hung side by side with the worst, were inexpensive for the participants: nominal fees and the admissions usually covered the expenses, while the government gave its approval and contributed space. The Exposition des Artistes Indépendants, housed in barracks in the Cour des Tuileries, opened its doors on May 15, 1884, and did not differ from previous events of the sort. Besides a slew of unknowns the catalogue listed Seurat, Paul Signac, Charles Angrand, Albert Dubois-Pillet, Henri Edmond Cross, Odilon Redon, and Émile Schuffenecker. All of these very different painters had not known one another and became acquainted at the meetings and assemblies that led to the founding of the Société des Artistes Indépendants proper in June. The society's first exhibition, which opened in December 1884, was at the Pavillon de la Ville de Paris, near the Palais de l'Industrie on the Champs-Élysées.[16]

The Société des Artistes Indépendants and its exhibitions catalyzed the Neo-Impressionist movement, a historical fact that Signac, an active contributor, often pointed out.[17] This new society was "based on the elimination of admission juries and [had] as its goal to permit artists to present their works freely to the judgment of the public." It owed a great deal to the efforts of the man who became its first vice president: Albert Dubois-Pillet, a career officer, commander of the Garde Républicaine, Freemason, and painter. He wrote the society's statutes and tracts, found space for the first exhibition, obtained support from the city of Paris (the society adopted the colors red and blue—the heraldic colors of Paris—for its catalogues and held regular banquets for its members under the name "Dîners du Rouge et du Bleu"), and worked untiringly to organize the exhibitions from 1886 to 1888. All this was achieved in the face of opposition from the military hierarchy, which suspended him in 1887 and which could station him outside the capital. When Dubois-Pillet was promoted to squadron chief of the Le Puy gendarmerie in 1889 (he died there soon after), the painter Edmond Eugène Valton became the society's first official president and held this office until 1908. He was succeeded by Paul Signac, who had often served as vice

president and member of the board throughout this period.[18]

Unsurprisingly, Signac, self-taught disciple of the Impressionists, joined forces with the Indépendants in spring 1884. He could expect no indulgence from the jury of the official Salon, and there were then no venues except the Salon in which a young painter could exhibit. After the first exhibition of the Société des Artistes Indépendants in late 1884, and at the urging of Pissarro, Paul Durand-Ruel, the only Parisian gallery owner who supported innovative movements, chose works by Seurat and Signac for exhibition in New York in April–May 1886—an experiment that he never repeated.

Another result of the initiative of 1884 was an invitation from several members of the group that had been organizing exhibitions of the Impressionists since 1874—Pissarro, Armand Guillaumin, and Berthe Morisot (who helped obtain Edgar Degas's approval)—to a few young new-style Indépendants—Seurat, Signac, Redon, Schuffenecker—to exhibit with them in an apartment in the rue Laffitte. This exhibition, held in spring 1886, was the eighth and last of the by-then irremediably dispersed Impressionist group. On this occasion works by Pissarro (and his son Lucien), Seurat, Signac, and others were shown together in the same room, dominated by Seurat's *A Sunday Afternoon on the Island of La Grande Jatte* (fig. 3).

The excellent publicity for the newcomers carried over to the second exhibition of the Indépendants, which opened in August 1886, again in the Tuileries. In the mind of the public this new "Salon" became a consequential place where "five hundred productions of the most heterogeneous, heteroclite, heterodox, and higgledy-piggledy kinds could be seen, [among them] Parisian landscapes by Georges Seurat and Paul Signac on view for the first time."[19] Seurat's large-format *toiles de lutte* (painted manifestos) would be exhibited at the annual exhibition of the Indépendants until his death in 1891. Conscious of the advantages of the group, Signac was able to curb his temper for the sake of "camaraderie and in the interest of our future exhibitions," ignoring Seurat's pettiness and fits of jealousy and maintaining his "admiration for the artist."[20] This accommodation did not come easily—he was not patient by nature. In the middle of preparations for an exhibition, Dubois-Pillet wrote him: "You are

young, you are in a hurry, you are extremely fierce in the discussions."[21]

Although governed by a Neo-Impressionist majority, the society remained faithful to the principle of free expression and welcomed newcomers without restriction. Among them were not only the "two hundred nobodies" roundly decried by Gauguin, who refused to participate in the exhibitions,[22] but also Henri Rousseau (starting in 1886), Vincent van Gogh (from 1888 to 1891), Henri de Toulouse-Lautrec (beginning in 1889), and Pierre Bonnard, Maurice Denis, and Félix Vallotton (the last three starting in 1891). This independent salon reached only a limited public: the thirty-six hundred paid admissions during one month for the first exhibition in 1884, or the sixty-five hundred of 1887, were nothing compared to the forty-five thousand visitors who stormed the official Salon on a free-admission Sunday.[23]

"WE COULD MAKE A LITTLE, ARISTOCRATICALLY (??) DISCREET EXHIBITION THERE."

As early as 1886 the Indépendant exhibitions—in which the works were for sale—attracted the attention of such middlemen as Alphonse Portier and Hippolyte Heymann, who were already dealers of Impressionist works.[24] But it would take a few years for the Neo-Impressionists to find their collectors. Although Signac, like Seurat, was subsidized by his family, he expended great energy in making his work and that of his friends known. Like other contemporary painters (Van Gogh, Gauguin, Émile Bernard),[25] he found novel venues for exhibitions—cafés, restaurants, offices of literary reviews—thus saving expenses and attracting a new public. The few suitable Parisian galleries, such as Durand-Ruel, Petit, or Boussod-Valadon (despite the presence there of Théo van Gogh, Vincent's brother), were as yet out of reach. Père Tanguy's small shop, until his death in 1894, surely contained works of the Neo-Impressionists, alongside those of Van Gogh and Cézanne, but more for the benefit of the painters and a few critics than for serious buyers.[26]

The best source of information about exhibitions and sales remains the correspondence of Camille Pissarro, who, although supported by Durand-Ruel, was always on the lookout for clients for himself and his son Lucien, a Neo-Impressionist of Seurat and Signac's generation. In February 1887 Signac in conjunction with Les XX of Brussels was planning an exhibition in Paris. He wrote to Pissarro, telling him that Georges Lèbre, the new owner of the review *La Vie moderne*, had "just rented a spacious town house and offers us the parlors free of charge (he keeps the admission fees) to organize an exhibition of the most advanced of the Brussels XX: Seurat, Dubois-Pillet, and I would agree to accept. We could make a little, *aristocratically*(??) discreet exhibition there. Our names would make another appearance, facilitating our major exhibitions in the years to come. . . . Lèbre has a special clientele of *gens du monde*, a public we have not yet reached; it is perhaps worth a try."[27] Despite Pissarro's agreement this project was never realized. Signac persevered and exhibited works in the rehearsal room of the Théâtre-Libre in the rue Blanche in 1887–88, in the offices of *La Revue indépendante*—which championed the Neo-Impressionist group—at 11 rue de la Chaussée-d'Antin in January 1888,[28] and in rooms in the Hôtel Brébant at 32 boulevard Poissonnière. The Brébant exhibition, held in December 1892, was the first to present the Neo-Impressionists as a coherent group.[29] The Impressionist exhibitions and those of Les XX in Belgium had demonstrated the advantages of groupings, even when based on vague affinities. Signac was convinced of the power of the group, and his constant concern was to maintain the divisionist "aristocracy."

La Vie moderne had successfully exhibited Manet and the Impressionists in its offices in the early 1880s, and the Neo-Impressionists' *Revue indépendante* display followed this precedent. According to Gauguin—an informed, if partial observer—the place was a "dump," and he refused to participate.[30] The Théâtre-Libre also has an explanation. André Antoine had just embarked on this theater project, when Trublot (Paul Alexis) printed an announcement in his column "À Minuit" in *Le Cri du peuple* on September 7, 1887, pretending that it had been written by Antoine himself: "I have some sixty or eighty square meters of wall space to decorate in my rehearsal room. I thought of the other young people, those who sometimes paint or carve wonders. . . . They could come and hang their finished canvases here, and since there will be a coming and going of chic people, it will be a very modest, but perhaps

useful exhibition."[31] For his rehearsals Antoine had just rented "a large atelier with separate staircase in the back of the courtyard and a nice smoking parlor"[32] and probably also had hopes of finding subtenants to help cover his costs. Both Signac and Van Gogh exhibited at the Théâtre-Libre in 1887–88.[33] Antoine must have appreciated the Neo-Impressionist style, because he printed his program for the 1888–89 season on the back of Signac's famous lithograph *Application of Charles Henry's Chromatic Circle* (cat. no. 33).

A similar deal must have been made with the owner of the Hôtel Brébant. We read in a letter written by Seurat's mother to Signac on December 29, 1892: "I consent with reluctance to leaving my canvases, as I would not like you to be sued by the owner."[34] This suggests that the owner had certain rights in the venture. The letter goes on to indicate the chaotic conditions of these exhibitions: "I would prefer seeing them in a dark corner than in front of the stove, completely warped and dried out." Vincent van Gogh tried to group the painters of the "Petit Boulevard" in a restaurant in the avenue de Clichy in 1887 but had to dismantle the exhibition posthaste after a quarrel with the owner. Gauguin and Bernard did not fare better at the Café Volpini during the 1889 Exposition Universelle. As Dubois-Pillet wrote to Signac: "The paintings are hung in three or four rows. The lowest ones are at two meters, hung indiscriminately and crooked, and it is impossible to get close to them because of the tables of the guests, the sideboard full of foodstuffs, the counter, and finally the orchestra."[35]

DEALERS AND COOPERATIVES

Signac clearly hoped to find the ideal art dealer to represent the Neo-Impressionists continuously, outside the annual Salon des Indépendants, as Durand-Ruel had done for the Impressionists. Théo van Gogh's efforts were too short-lived to be significant. The dealers who exhibited the Indépendants before 1900 were Louis Léon Le Barc de Boutteville, L. Moline, and Siegfried Bing.

Louis Léon Le Barc, who married into the De Boutteville family,[36] had a store at 47 rue Le Peletier (next door to Durand-Ruel's) and eked out a living selling old masters. Over fifty and not sure of their significance, yet "disinterested and daring," as Denis described him,[37] he let himself be persuaded by the painter Paul Vogler to represent the young artists. Le Barc assembled an impressive group under the vague rubric "Symbolist and Impressionist Painting," which included the Neo-Impressionists, as well as Gauguin, Alfred Sisley, and Toulouse-Lautrec, and opened an exhibition on December 15, 1891, where two pictures by Signac drew some notice.[38] The following exhibitions, which included Van Gogh (1892), the Nabis (a series of exhibitions in 1893), and Toulouse-Lautrec, turned his shop into a sanctuary for the Parisian avant-garde,[39] although neither Signac nor his friends (except for Angrand)[40] were among its regular exhibitors. Le Barc himself had mixed feelings toward them: "Buy them, he would tell [his clients]: they will improve with time, they will age well. . . . Besides their school will not last: setting down their little dots is too time-consuming!"[41] Le Barc's eclectic gallery did not survive his death in 1897;[42] it was taken over by the framer Dosbourg and lost the luster it had gained.

Signac probably did not go out of his way to court Le Barc, who favored the cause of the "Neo-Traditionists," perhaps because he enjoyed access to a gallery at 20 rue Laffitte. This shop[43] had been rented in December 1893 by Count Antoine de La Rochefoucauld—aristocrat, Indépendant painter, and would-be patron of the arts who had met the Neo-Impressionists through Paul Adam—in order to hold exhibitions of the Neo-Impressionist group. On December 5, 1893, Pissarro forwarded to his son Lucien a sort of bulletin that Signac had sent him; it summarized the situation: "Anarchist grouping—regular storefront—new exhibitions every month. A monthly bulletin/catalogue will be sent to the press and collectors. Twenty percent of the proceeds will be withheld from the paintings sold by Moline, who is in charge of sales. From this twenty percent he will have to pay for the room, lighting, etc. There will be a symbolic fee (one franc per year?) so as to equalize the rights for everyone. Opening, December 15."[44]

Pissarro approved of the cooperative spirit of this venture and recommended it to Lucien but abstained from joining himself. Signac managed to convince Angrand but had no luck with another former exhibitor from the Hôtel Brébant, Léo Gausson, who refused to join because he was afraid of being tied to a coterie.[45] Signac wrote to Van Rysselberghe and described the storefront:

"Greenish blue, round metal letters, vermilion red, it already sings the dynamogenic song of light, energy, health, and triumph."[46] An invitation card dated 1893–94, bearing the names of Angrand, Cross, Luce, Petitjean, Lucien, Georges and Félix Pissarro, La Rochefoucauld, Signac, and Van Rysselberghe, states that the paintings will be changed every month and that solo exhibitions will be held.[47] This was a new version of the venture that had been tried at the Hôtel Brébant, only this time the business was established in the midst of the art galleries of the rue Laffitte. Moline directed the establishment but wrote to Signac on June 9, 1894: "They say I am not the man for the job of running the store. Vollard is supposed to be the suitable one, a man of the profession."[48] This mention is a valuable record of the early fame of Ambroise Vollard, an art dealer who had a gallery first at 37, then at 39, rue Laffitte. But Vollard had little interest in the Neo-Impressionists, and Moline renewed the lease at 20 rue Laffitte in his own name.[49]

The little we know about Lucien (or Léonce) Moline indicates that he was an active, not altogether reliable man, with no personal wealth, and that he was not much liked by Pissarro, who was usually generous in his judgments.[50] One of Moline's first exhibitions at the Galerie Laffitte was an homage to Seurat in February–March 1895 that included twenty-four paintings and thirteen drawings, along with works by other artists.[51] Soon after, Moline seems to have turned to selling various contemporary objets d'art.[52] Pissarro mentioned him for the last time in a letter to his son Lucien dated December 9, 1897, and little is known of him afterward.[53] Le Barc and Moline being out of the running, Vollard lost no time in opening his doors to Gauguin, Van Gogh, and the Nabis—still neglecting the pointillists—and gained ground in the rue Laffitte. The only competitor left to champion the cause of the Neo-Impressionists seems to have been Siegfried Bing.

After several months of alterations by the architect Louis Bonnier, Bing's new gallery at 22, rue de Provence (also opening onto 19 rue Chauchat)[54] was opened on December 26, 1895. Having made his reputation and fortune by trading in Oriental objets d'art, he decided to create his own establishment—with the help of the Belgian Henry van de Velde, among others—and became one of the promoters of Art Nouveau in Paris. Given Signac's close links with the Belgian

avant-garde, it is not surprising that Bing would present works by Signac, as well as by Cross and Van Rysselberghe, in his "cabinet d'amateur." Although Signac was an unconditional admirer of Art Nouveau—he enthusiastically moved into Hector Guimard's Castel Béranger, a new Art Nouveau apartment building, in November 1897— his association with Bing came to nothing, as did Bing's project itself.[55] However, an intelligent collaboration with artists of a completely different orientation led to a major exhibition at the Galerie Durand-Ruel in 1899.

Starting in 1894, Signac's journal documents frequent visits to the Galerie Durand-Ruel, and while cursing the "*Symbolards*"—who included Gauguin and the Nabis—he described in detail a common project that led to an exhibition in March 1899. Represented were, to quote Signac, "nearly all those who for fifteen years have— outside the official Salons—made some new effort."[56] This meant the complete Nabi group, the Neo-Impressionists, Bernard and his friends, Redon, André, d'Espagnat, and Valtat but not Toulouse-Lautrec, who had lapsed into insanity. The groups were exhibited in their respective rooms, in conjunction with an exhibition of first-generation Impressionists. This association proved unproductive, and Durand-Ruel never repeated the experiment. Signac now concentrated his efforts on the annual reunion at the Salon des Indépendants.

SIGNAC, PRESIDENT OF THE SOCIÉTÉ DES INDÉPENDANTS

Signac effectively became president of the Société des Indépendants only in 1909, although he had been actively involved from the start, especially during the organization of the retrospectives devoted to Seurat and Van Gogh in 1891 and 1905. Until the end of his life, with a single brief interruption, he devoted a great deal of time and energy to his office, accepting both chores and honors. His abundant correspondence shows him to be very attentive to his fellow artists, as well as to the journalists and art critics who reviewed the exhibitions. His journal also records epic moments: "February 10, 1909: Visit to Dujardin-Baumetz [representing the administration of the Beaux-Arts] to obtain space for the Indépen-

Fig. 34. J. Roseman, Signac with members of the committee of the Société des Indépendants, 1926, photograph. Signac Archives

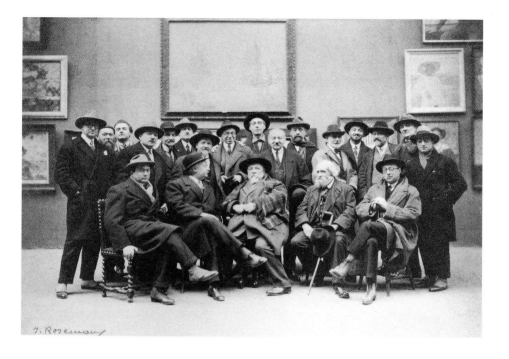

dants. We moved in for the kill . . . the beast collapsed on the desk, under attack from us and the *députés,* with Sembat, who accompanied us, leading the pack. In a moment of anger he spat out his scorn for the Indépendants, saying, in effect, that for 12.50 francs, anybody could exhibit with us. I showed him what the Indépendants had produced since 1884 for 12.50 francs and asked him for the results of the Prix de Rome laureates during that period. We finally carried the day."[57]

Signac knew that the Indépendants, who set no restrictions on admission, would be flooded by "young tapestry weavers and old flotsam from the Salon," but he was convinced that the most prominent artists would support the rest.[58] The catalogues listed hundreds of participants, in strict alphabetical order. Among them were Bonnard, Georges Braque, Cézanne, Marc Chagall, Giorgio De Chirico, Denis, Derain, André Dunoyer de Segonzac, Albert Gleizes, Édouard-Joseph Goerg, František Kupka, Fernand Léger, André Lhote, Albert Marquet, Matisse, and Vallotton, as well as amateur painters like Julie Manet (daughter of Berthe Morisot), Paul Van Ryssel (pseudonym of Dr. Paul Gachet), Max Jacob, and Paul Jamot, a curator at the Louvre who was also a collector and donor. Except for the conspicuous absence of Picasso, this roster certainly beats that of the Prix de Rome.

Signac was often dismayed by the results of his efforts but was comforted by the fact that the official Salon was no better.[59] New salons were created, the most famous of which was the Salon d'Automne, founded in 1903 by its first president, the architect Frantz Jourdain.[60] These drew the attention of the public and critics away from the Indépendants, and on the eve of World War I a critic remarked: "The Indépendants seem to be, if not going out of business, then on the wane. The historic role of the Société is finished; the juries of the Salons d'Été and d'Automne have become more hospitable today, and each season sees more and more small exhibitions and groups of all kinds. They give everyone the opportunity to present themselves and so take away the Indépendants' former recruits."[61]

During the war, expressing solidarity with the painters on the front, Signac refused to organize exhibitions and wrote: "Soldiers do not paint. . . . At the first spring of peace, we will all be there."[62] And after the war the Indépendants were reborn. Signac's fame and stature led him to expand his activity outside of France. He organized the French section for the XII Biennale in Venice in 1920 and helped establish the public image of French art between the world wars: "We will group twelve painters around the seventeen Cézannes of the Fabbri collection [Fabbri was a famous Florentine-American collector], and next year we will call on the youngest ones. This year it will be Cézanne, Cross, Gauguin, Redon, Seurat, Bonnard, Roussel, Vuillard, Guillaumin, Luce, Signac, Valtat, Matisse, Marquet, Puy, Maillol, Guérin."[63] Although highly respected, he did

have some tenacious opponents—Francis Picabia, for example, by 1922[64]—and these conflicts were to lead to his resignation and that of Luce, then vice president, in 1924. But Signac was recalled by the board soon after. In early 1926 he had the gratification of organizing the major retrospective "Trente Ans d'art indépendant (1884–1914)" (Thirty Years of Independent Art [1884–1914]) and offering the presidency of that exhibition to Claude Monet: "The other presidents will be Paul Léon (who gives us the Grand Palais) and Paul Signac. Paul Léon between Monet and Signac; the Institute between two Indépendants. He is trapped! We hope that you, the great independent, whose art and life are a magnificent example, will kindly give your approval to the cause which we have been defending for thirty-four years against hell and high water."[65]

Signac resigned his presidency definitively in late 1934, just a few months before his death, and wrote somewhat nostalgically to the critic Adolphe Tabarant: "I wanted to give our old society a new reason for being by giving it back its independence. The majority of the committee prefers to continue with its compromises and to continue to exhibit anywhere. . . . I did not want to end up as a soup vendor. I have disembarked but not deserted. . . . Good old Luce has remained to save the flag and prevent the Indépendants of Seurat and Van Gogh from becoming the firm of Léveillé and Co. [a member of the board of the Indépendants]."[66] Taking up this topic again in a letter to Louis Vauxcelles, he announced that he would continue

to send in his works, adding that in any case he would be represented at the 1935 Salon by "my portrait by my daughter Ginette Cachin Signac, my portrait by comrade Glutchenko commissioned by the literary museum of Kharkov USSR, and my bust by the Martel brothers."[67] This exotic tribute, linked to his invitation to visit the Soviet Union in 1935, brings us finally to the painter's political commitment.

IMPRESSIONIST AND REVOLUTIONARY

Paul Alexis, writing under the pseudonym Trublot in the newspaper *Le Cri du peuple* on February 10, 1886, quoted from the letter of a "painter nothing like Cabanel" who had responded to the newspaper's call for a "*naturalisse*" subscription to support the miners' strike in Decazeville: "My dear Trublot, here five francs for the *naturalisse* subscription. A buck is not much, but cobalt blue is so expensive. Regards. Paul Signac, Impressionist painter, 130 boulevard de Clichy." Signac thus demonstrated his solidarity with the struggling proletariat, while also asserting his identity as an Impressionist. Pissarro was practically the only other Impressionist to share these ideas at the time. In these critical days for the French Republic the two artists sympathized with independent socialists inspired by the ideas of Pierre-Joseph Proudhon, Mikhail Bakunin, and above all Pyotor Kropotkin, such as the editor Jean

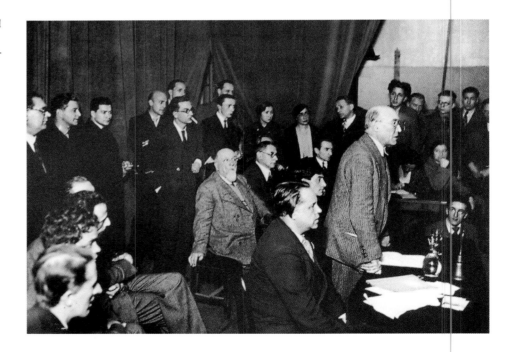

Fig. 35. Signac (seated center) at a meeting of antifascist intellectuals, with André Gide (standing at right), ca. 1934, photograph. Signac Archives

Grave, a revolutionary idealist linked with Élisée Reclus, the theoretician of the anarchist movement, and successively director of *La Révolte* and *Les Temps nouveaux*. Signac stated his convictions in the oft-quoted article "Impressionistes et révolutionnaires," printed in *La Révolte* on June 13, 1891, and signed simply "an Impressionist comrade." He considered the artists who slavishly followed the dictates of theory as sterile, and defended instead the "natural aesthetes, revolutionaries by temperament, who leave the beaten path to paint what they see, as they feel it, and who very often unconsciously deal a forceful blow of a pickax to the antiquated social structure that, worm-eaten, cracks and crumbles like an old, deconsecrated cathedral. . . . Sooner or later, true artists will be found on the side of the rebels, united with them in one and the same idea of justice."[68]

Being foremost a painter, Signac gave precedence to painting over political theory, despite his longstanding and sincere convictions. His great pictorial manifesto, *In the Time of Harmony* (cat. no. 75), depicts an anarchist utopia: in this future Eden the painter has a modest place in the sun, his easel facing the sea and his companion reading at his side.

Signac was working on this picture when his friends Fénéon and Luce—closely linked with the workers and a militant under police scrutiny[69]—were jailed and later acquitted during the crackdown following the wave of anarchist bombings of 1894 (Sadi Carnot, the president of the Republic, was assassinated in Lyons on June 24, 1894). Remaining far from Paris—like Pissarro, who extended his stay in Belgium—Signac was not implicated but immediately extended his help.[70] His offer to donate *In the Time of Harmony* to the Maison du Peuple in Brussels ended, however, in disappointment. Likewise, the lithograph done after it was not printed in Grave's *Temps nouveaux* (perhaps simply because of the high cost). On the other hand, the lithograph on which he based

the painting *The Wrecker* (cat. nos. 88a and 88b) was sold with an issue of *Les Temps nouveaux* in May 1896. Later, in 1910, a special issue of this same review titled *Biribi* featured Signac's antimilitarist drawing of the violent death of a young recruit in Algeria.[71]

Signac's purely artistic contribution was finally not as significant in its long-term effects as his personal commitment. He gave money to and signed petitions for antinationalistic, antimilitaristic, pacifist, and later antifascist causes, along with the other intellectuals of his day (see fig. 35). When the Dreyfus affair broke in January 1898, he was among the first to sign the letter of support for Émile Zola, who had just published his famous open letter "J'accuse." Signac's credo never changed: "The anarchist painter is not the one who represents anarchist pictures, but the one who struggles with his entire being against official and bourgeois conventions, without concern for wealth or reward, but with a personal contribution. The subject is nothing, or at least only part of the work of art, no more important than other elements: color, line, composition. . . . When the eye has been educated, the public will see things other than the subject in the picture. When the dreamed-of society exists, when the worker is free of stupefying exploiters, when the worker has the time to think and educate himself, he will appreciate all the different qualities of a work of art."[72]

Signac kept his distance vis-à-vis politicians and refused to join the Communist Party. Marcel Cachin, the father of Signac's son-in-law (Ginette Signac wed Dr. Charles Cachin in 1934), confessed that between "an old Marxist [himself] and an old Bakuninist [Signac], it is difficult to find a common ground for action. And so we took refuge on the grounds of personal affinity, and there it is perfect."[73] Hence the old painter was left to his "impressionist and revolutionary" dream, to his painting above all.

NOTES

1 See Chronology, October 1, 1880.
2 Letter from Gustave Caillebotte to Signac, March 29, 1892, Signac Archives in Paris–Chicago 1994–95, p. 318.
3 Letter from Signac to Louis Vauxcelles, undated,

Institut Néerlandais, Fondation Custodia, Paris, inv. 1979 A489. This letter can be approximately dated by the context; the exhibition "Peintres de la Mer" was held from April 16 to May 5, 1917. Signac had himself appointed as "peintre du Département

de la marine" in order to paint undisturbed in ports, which were restricted military areas in wartime. See also Chronology, April 17, 1915.

4 Signac journal entry, May 10, 1899, in Rewald 1953, pp. 56, 80.

5 Letter from Camille Pissarro to Signac, February 24, 1888, in Bailly-Herzberg 1980–91, vol. 2, letter 472.

6 Signac 1882a, an irreverent pastiche of Zola that demonstrated a good knowledge of the slang from the outskirts of Paris; Signac 1882b.

7 Fénéon 1890.

8 See Chronology, December 1913–January 1914 and April 8, 1921.

9 Letter from Signac to Denise Leblond-Zola cited in Leblond-Zola 1939, p. 298.

10 Fénéon 1890: "Brief notes in *Le Cri du Peuple* signed Néo, in 'Art et Critique,' 90, signed S.P., and in La Cravache, 88–89." In later years, Jean Grave called on Signac when he needed obituaries for his deceased colleagues: Pissarro in 1903, Cross in 1910 (see Chronology, November 13, 1903, and May 16, 1910).

11 Extracts from journals of 1894–95, 1897–99, were translated by Rewald and published in *Gazette des Beaux-Arts* in 1949, 1952, and 1953. Extracts from the 1901–9 journals were published in *Arts de France* in 1947.

12 It appeared in book form in June 1899 after parts had been printed in *La Revue blanche* starting in May 1898; it was immediately translated into German and published in *Pan*, July 1898, then abridged in a pamphlet. The original French text of this summary was printed in Münster–Grenoble–Weimar 1996–97, pp. 377–95.

13 Signac journal entry, May 20, 1895, in Rewald 1949, p. 122.

14 For example as prefaces to Paris 1932 and Paris 1933–34.

15 On the influence of Ruskin's book, see Herbert 2000, pp. 30–31; Ruskin's commentary in Cross's translation appears in chapter 7, "Témoignages," of Signac's book; on Signac and Ruskin, see also Coquiot 1914, p. 166. See also the letter titled "Saint-Paul" to an unknown correspondent (sale cat. of painters' autographs, Alain Nicolas, Paris, 1982, no. 130): "Cross' translation of Ruskin was never finished . . . Ruskin's book contains a lot of talk, but there are also precise and clear rules and laws."

16 See Bazalgette 1976, pp. 49ff.

17 See esp. Signac 1934.

18 Starting in 1889, the catalogues of the Société des Artistes Indépendants mentioned the names of the members of the bureau and their placement committee. For the fiftieth anniversary of the society, the catalogue published a list of past members.

19 Christophe 1890a.

20 Letter from Signac to Camille Pissarro, September 7, 1888, Paris 1975, no. 180.

21 Letters from Albert Dubois-Pillet to Signac, September 30, 1887, January 8, 1888, Signac Archives.

22 Letter from Paul Gauguin to Theo van Gogh, June 10, 1889, in Cooper 1983, p. 93, letter 13.

23 *La Chronique des arts et de la curiosité*, January 17, 1885, p. 18; Trublot 1887.

24 Alphonse Portier (1841–1902) and Hippolyte Heymann (1845–1910). Letter from Georges Seurat to Signac, July 28, 1886, Signac Archives.

25 Vincent van Gogh organized an exhibition in a restaurant in the avenue de Clichy in November 1887 and exhibited with Bernard, Louis Anquetin, and Toulouse-Lautrec: see Toronto–Amsterdam 1981, p. 92. It was there that Seurat met Van Gogh for the first time. Bernard organized an exhibition at a bar called the Café Volpini at the 1889 Exposition Universelle. According to Gauguin, the owner was supposed to receive a percentage of the sales; Cooper 1983, letter 21.

26 See Waern 1892, p. 541, in which Père Tanguy is called "a martyr to the cause of néo-impressionnisme [*sic*]," but the term seems to be used here in a broad (and imprecise) sense, for she mentions afterwards the names of Cézanne and Van Gogh. Angrand, Cross, Dubois-Pillet, Léo Gausson, Luce, Seurat, and Signac all contributed works to a benefit auction for Tanguy's widow, Hôtel Drouot, Paris, June 2, 1894. All had shown works there at one time or another.

27 Letter from Signac to Camille Pissarro, in Paris 1975, no. 170; Signac wrote to Octave Maus along the same lines, pointing out that this private house stood in the rue Duperré (no. 14); Chartrain-Hebbelinck 1969, p. 59.

28 See Fénéon 1888a, pp. 171–74.

29 An invitation card indicates the inauguration date as December 2; Fonds La Rochefoucauld, Fondation Custodia, Paris.

30 Cooper 1983, p. 79, letter 10; p. 93, letter 13B.

31 Cited by Leblond-Zola 1939, n. 9 above.

32 Antoine 1921, p. 58 (reference provided by Luce Abélès, who is preparing a study on the Théâtre-Libre); Antoine does not mention these exhibitions—which were supposed to be held between the rehearsal periods reserved for the actors and dramatists—and only briefly mentions the names of the painters he had known.

33 Signac's pre-catalogue (Signac Archives) mentions that *Snow, Boulevard de Clichy, Paris* (cat. no. 13) was bought by Montandon at an exhibition at the Théâtre-Libre in 1887 (probably the one in which Van Gogh also participated, November 1887–January 1888); a letter from Gauguin to Theo van Gogh around September 21, 1889 (Cooper 1983, letter 20) points out that Montandon, who had just bought one of his works, "had been with Leclanché one of my colleagues at a stockbroker's," informing us about this early collector of Signac's.

In a letter written to Signac during the Exposition Universelle, Dubois-Pillet, who criticized the conditions of the Gauguin and Bernard exhibition at the Café Volpini, expressed doubts about Signac's plans to exhibit at the Théâtre-Libre. Concerning Van Gogh, see his letter to Theo in Van Gogh 1958, vol. 2, p. 540, letter 473.

34 Signac Archives.

35 Letter from Albert Dubois-Pillet, Signac Archives.

36 Louis Léon Le Barc, the owner, born in Benerville-en-Caux, died at the age of sixty at his home in Pierrefitte (a suburb of Paris), 57, Boulevard de la Station, on October 11, 1897; witnesses were a nephew and a friend, which suggests that he had no children.

37 Maurice Denis, "Préface de la IXᵉ exposition des Peintres impressionnistes et symbolistes" (at Le Barc de Boutteville's in 1895), reprinted in Denis 1920, p. 25.

38 Camille Pissarro was solicited by Le Barc by letter on December 2 (Ashmolean Museum, Oxford) and rejected the offer but provided a full report to Lucien, see Bailly-Herzberg 1980–91, vol. 3, letters 708 (n. 3), 723, 726, 730.

39 Recognized as such by critics like Raoul Sertat (1895, p. 229).

40 See Lespinasse 1988, pp. 47, 50, 63, 64, 75, 83.

41 Cochin 1903, p. 14.

42 An amusing anecdote printed in *Bulletin de la vie artistique*, May 1, 1920, p. 316, relates that the cleaning of the facade of 47 rue Le Peletier uncovered the names of Manet, Monet, Sisley, Pissarro, Anquetin, Toulouse-Lautrec, Vogler, Lucie Cousturier, Lepère, Henry Moret, Louis Legrand, Duval-Gozlan, Dézaunay, Michel, Ibels, Van Gogh, Fauché, H. de Groux, Giran-Max, Maufra, Guilloux, Mantelet, and H. E. Cross.

43 The cadastral register (Archives de Paris, D1P4, 1876) describes a two-room boutique that had always been rented by picture dealers, the last of which was Alexandre Bernheim in 1891; La Rochefoucauld is mentioned as a tenant in 1894.

44 Pissarro, December 5, 1893, Bailly-Herzberg 1980–91, vol. 3, letter 965, and Thorold 1993, p. 339.

45 Letters exchanged by Gausson, Lucien Pissarro, and Paul Signac, published by Coret 1999, pp. 108–10.

46 Pogu 1963, p. 18.

47 Signac Archives.

48 Letter from Moline to Paul Signac, June 9, 1894, Signac Archives.

49 Signac already noted in his journal entry of September 30, 1894, in Rewald 1949, p. 168: "I learn through a letter from Moline that La Rochefoucauld, because of the little success of the shop on Rue Laffitte, has decided to give notice! I knew very well that the enthusiasm of this neophyte would be quenched by the urine of the first passerby who relieved himself in front of our shop!" According to the cadastral register, "Lucien" Moline had a lease starting in 1895, which he kept until 1898; the register mentions the "Moline et Cie." firm as a limited partnership trading in objets d'art, paintings, and engravings, incorporated on October 13, 1896, and liquidated on August 10, 1898. However, the name Moline appears as the buyer of a Cézanne listed in the minutes of the Chocquet sale on July 3, 1899, and in 1900 the name is still listed in the commercial directory at number 20. The cadastral register for the building is missing for 1900. Moline is always mentioned without his first name by the artists. Renart 1912 lists an "L. Moline, 18 rue Laffitte, Tableaux et dessins modernes." Since the publication of Hauke 1961, Moline has been referred to as Léonce. However, the only contemporary official reference found in the cadastral register, as mentioned above, calls him Lucien, as does Gachet 1956, p. 177.

50 Letters from Camille Pissarro to his son Lucien, May 3, 1895, May 26, 1895, Bailly-Herzberg 1980–91, vol. 3, letters 1133, 1138.

51 Moline used a distinctive red-wax seal that has also been found on works formerly belonging to Seurat's companion, Madeleine Knobloch.

52 See the letters of Camille Pissarro to his son Georges, December 14, 1895, December 19, 1895, Bailly-Herzberg 1980–91, letters 1188, 1191.

53 The Paris Hachette directory for 1912 lists a Moline, art dealer at 18 rue Laffitte. Coret, p. 129, cites a letter from Moline to Gausson of February 16, 1929, that mentions the purchase of a work by Petitjean for the State, which suggests that he was still active at this time.

54 Weisberg 1985, pp. 241–49.

55 A letter from Camille Pissarro to his son Lucien, January 21, 1896 (Bailly-Herzberg 1980–91, vol. 3, letter 1204), alludes to an incendiary article by Arsène Alexandre in *Le Figaro*, December 28, 1895.

56 Signac journal entry, March 15, 1899, in Rewald 1953, p. 76.

57 Signac 1947, p. 82.

58 Letter from Signac to a journalist (Vauxcelles? Alexandre?), February 9, 1909, Institut Néerlandais, Fondation Custodia, Paris, inv. 1979 A497.

59 Signac journal entry, April 22, 1897, in Rewald 1952, p. 299.

60 Solicited by Frantz Jourdain, Signac refused to participate in the new venture because it called for a selection jury; see Jourdain 1953, pp. 204–5 (reference kindly provided by Françoise Cachin).

61 Monod 1914, p. 3.

62 Letter from Signac to Louis Vauxcelles, Antibes, February 7, 1918, Institut Néerlandais, Fondation Custodia, Paris, inv. 1979 A 503, and another letter

along the same lines to an unknown person, January 23, 1917, Institut Néerlandais, inv. 1993 A 591.

63 Letter from Signac to Louis Vauxcelles, Institut Néerlandais, Paris, inv. 1979 A 488.

64 See Chronology, January 28–February 28, 1922, February 9–March 12, 1924.

65 Letter from Signac to Claude Monet, December 8, 1925, sale cat., Hôtel Drouot, Paris, May 31, 2000, no. A78.

66 Letter from Signac to Adolphe Tabarant, January 23, 1935, in *Catalogue d'autographes*, vol. 3 (Paris: Librairie Monogramme, "Salon des Vieux Papiers," October 1999), no. 15.

67 Letter from Signac to Louis Vauxcelles, January 14, 1935, Institut Néerlandais, Fondation Custodia, Paris, inv. 1979 A 513.

68 Signac 1891, pp. 3–4.

69 See Dr. Jean Sutter's informative publication *Maximilien Luce 1858–1941, peintre anarchiste* (1986). Luce is reading *La Révolte* in Signac's portrait of him for the cover of the 1890 edition of *Les Hommes d'aujourd'hui*.

70 Letter from Léo Gausson to Edmond Cousturier, July 14, 1894, cited in Coret 1999, p. 111.

71 See Paris 1987–88. The original drawing for "*Biribi*" is in the James T. Dyke collection; see Little Rock 2000, no. 133.

72 Undated manuscript, ca. 1902, in Herbert and Herbert 1960, p. 477.

73 Letter from Marcel Cachin to his son (Signac Archives), cited by Marina Ferretti-Bocquillon, cat. no. 75, p. 199, in this publication.

SIGNAC AS A COLLECTOR

MARINA FERRETTI-BOCQUILLON

JOHN REWALD, A PIONEERING SCHOLAR OF the history of Impressionism and Post-Impressionism, recalled his first meeting with Signac about 1933: "But he talked mostly about the others, those whom he admired: Jongkind, Seurat, Cross, as well as Stendhal and Fénéon. He showed me the beautiful Cézanne landscape he had bought . . . drawings by Degas, reproductions of Turner's pictures. He spoke of the hours he spent with Van Gogh in Arles, and he encouraged me to come back."[1] Doubtless the painter talked to him warmly of Neo-Impressionism, which he had long since made a part of history. And he also evoked his "*toiles amies*" (picture friends) and above all showed him his collection, which quite clearly conveyed his artistic convictions.

This collection numbered more than two hundred and fifty pieces—drawings and paintings that, for the most part, are widely dispersed today. Many were sold over the years by the artist's widow, Berthe, then by his daughter, Ginette. Some disappeared during World War II, others were given to friends and relatives, and still others were donated to institutions such as the Musée d'Orsay in Paris and L'Annonciade, Musée de Saint-Tropez. This impressive and important collection was not only a dazzling panorama of Impressionist and Post-Impressionist art but also an enlightened selection that sometimes throws an unexpected light on Signac's own work and his personality. It never achieved the great fame of Gustave Caillebotte's or the enormous size of Degas's, but it was notable for its quality and coherence. Well-to-do but not rich, Signac had supported two households and many costly pastimes, such as traveling and sailing.

Signac taught himself his craft by looking at the works of other painters: he had an extraordinarily sensitive and intelligent eye. As an assiduous museum visitor and gallerygoer, and as the organizer of the Salons des Indépendants and international exhibitions, Signac knew that a well-thought-out presentation could clarify the influences, links, and correspondences that comprise the warp and weft of art history. Like his 1899 treatise, *D'Eugène Delacroix au néo-impressionnisme,* his collection was an expression of his theories and opinions. Some of the choices of this impassioned and far from impartial collector might come as a surprise. Of course, the Neo-Impressionists held the place of honor on his walls: first of all Georges Seurat, closely followed by Henri Edmond Cross, then by Signac's revered masters—Paul Cézanne, Claude Monet, Edgar

Degas, and Johan Barthold Jongkind—as well as the most direct "descendants" of Neo-Impressionism, the Fauves and Bonnard, who were just as fascinated by color as he was. But his holdings also included a large Tassaert (probably a virtuoso piece, somewhat descriptive and grandiloquent), a charcoal drawing by Odilon Redon, a Félix Vallotton done in flat grays and blacks, and an unambiguously lascivious nude rendered in muddy colors by Sickert. Strangely enough the nude held a major place in the collection. Basically a landscapist, Signac seldom tried his hand at this genre. Yet the few drawings of a model, sketched on a rainy day at the house of a friend, show that he was not without talent in this area (cat. no. 117), and the small study very likely done when he met the second woman in his life, Jeanne Selmersheim-Desgrange (FC 489), displays a refreshing directness.

Actually Signac had two collections. The first was begun very early in his career with the purchase in the mid-1880s of an important Cézanne, *The Oise Valley* (fig. 36). Around this time he must have also bought his first Degas, his first Guillaumin, and his first Pissarro. The privileged young man had the opportunity not only to meet the Impressionists whom he so admired but to acquire their works as well. Soon came those of his Neo-Impressionist friends: Seurat, who undoubtedly gave him the portrait he did of him in Conté crayon (fig. 30); Luce, who sold him his first submission to the Indépendants; Cross, who became a convert to Neo-Impressionism in 1891; and his dear friend Charles Angrand, who painted too little—in Signac's opinion—but drew admirably. His purchases, gifts, and exchanges with his fellow painters continued until the end of his life. At the start of the twentieth century Signac met the up-and-coming Fauves at the Indépendants: Matisse, Van Dongen, Camoin, and Valtat, and he bought important works from the very beginning. In 1913, when he left his wife, Berthe, his by-then remarkable collection was divided between his apartment in the rue La Fontaine in Paris and his villa La Hune in Saint-Tropez. He left Berthe the bulk of these works—except for the Cézanne landscape, which later hung on the walls of his last apartment in Paris—and took up more modest lodgings in Antibes with Jeanne, then pregnant with their daughter, Ginette, and spent the war years there. The war deprived him of his independent income, and there was a sudden break in his activity as a collector. In 1918 he pored enviously over the catalogue of the Degas studio sale, but the drawings that he had so admired in his younger years were out of reach. He was able to buy some when his financial situation improved in the 1920s. His purchases rapidly increased, and his new collection was hung on the walls of his apartment in the rue de l'Abbaye in Paris, this time with fewer Seurats and more works by Jongkind and Cross. Paradoxically, the financial

Fig. 36. Paul Cézanne, *The Oise Valley*, ca. 1880, oil on canvas, 28⅜ x 35⅞ in. (72 x 91 cm). Private collection

Fig. 37. Vincent van Gogh, *Two Herrings*, 1888, oil on canvas, 13 x 16⅜ in. (33 x 41.5 cm). Private collection

crisis of the 1930s permitted him to acquire a superb Monet, *Apple Trees in Bloom beside the Water*; this painting had been shown in 1880 in the offices of *La Vie moderne* in an exhibition that played a decisive role in his choice of vocation.

Signac's sporadic journal entries provide much information on his purchases, as does his correspondence, especially with his friend Félix Fénéon, who was an art dealer and collector. Signac regularly exchanged works with his Neo-Impressionist friends, especially Cross, who traded his *The Farm at Evening* (C 39; private collection), for *The Town at Sunset, Saint-Tropez* (cat. no. 58)—both evocations of the south of France done in a common spirit and depicting the day's end, a favorite time for Mediterranean painters. His friendship brought him a still life by Van Gogh (fig. 37) that commemorated his visit to the painter in Arles on March 23–24, 1889. Later Van Gogh wrote to his brother Theo: "I gave [Signac] as a keepsake a still life which had annoyed the good gendarmes of the town of Arles because it represented two [smoked herrings] and, as you know, 'gendarmes' are called that."[2]

Through his position at the Salon des Indépendants, Signac came into contact with new artistic developments, but his taste for modern painting stopped with the Fauves, who are so well represented in his collection that one overlooks the absence of Cubists and abstract painters and the deliberate neglect of the Surrealists. He made purchases at the Hôtel Drouot and acquired works from his own dealer, the Galerie Bernheim-Jeune, in exchange for sums owed to him.[3] The archives of this gallery and of the Galerie Durand-Ruel, which he also patronized but to a lesser extent, allow us to identify and date certain purchases. Signac's correspondence with Gaston Lévy, a collector who shared his fondness for Jongkind and Cross, provides information on the provenance of other acquisitions, such as the Jongkind watercolors he found in the provinces.

Moreover, two inventories give an account of Signac's collection at the end of his life. The first, preserved in the Signac Archives together with the artist's journal and correspondence, was drawn up by Signac himself at the end of 1931 in Paris. Using a pocket agenda for the year 1931, the artist listed the works in his collection. Monet's *Apple Trees in Bloom beside the Water*, bought in early 1932, is absent, thus confirming the date of this document. The names listed include Jongkind, Cross, Luce, Cézanne, Monet, Renoir, and Seurat, which are followed by titles and capital letters: *P* for paintings (*peintures*), *A* for watercolors (*aquarelles*), *D* for drawings (*dessins*). The works kept in Saint-Tropez were not included in this handwritten inventory. For a description of the contents of the villa La Hune, we have to turn to another fundamental source: the

posthumous inventory of late October 1935, two and a half months after Signac's death. The entire collection is listed and essentially divided among his three residences: the rue La Fontaine apartment in Paris occupied by Berthe, the apartment in the rue de l'Abbaye—his last apartment in Paris—and La Hune in Saint-Tropez. He had little in Barfleur and even less at Viviers, where he rented a small house. Cross and Jongkind had a place of honor on the dining-room walls in the rue de l'Abbaye, which housed works that were purchased starting in the 1920s. In Saint-Tropez there was his notable installation of paintings by Cross, Matisse, and Valtat, as well as drawings and studies by Seurat and landscapes by Luce and Guillaumin. Van Rysselberghe was relegated to a bedroom in Saint-Tropez—a reminder of a bygone friendship and era. The largest number of works was in the rue La Fontaine apartment, where pieces by Seurat, Luce, Van Gogh, Cézanne, Vuillard, Bonnard, and others were hung in profusion and pell-mell. The posthumous inventory presents the last state of a collection that grew organically and changed according to the vicissitudes of trades, acquisitions, and—less frequently, but significantly—sales. For reasons explained below, Signac decided to sell a magnificent pastel drawing by Degas in 1898 and, short of funds at the end of World War I, Seurat's *The Circus* (fig. 42) to the American collector John Quinn in January 1923—but under the express condition that it be bequeathed to the Louvre.

As for the conspicuous shortcomings of this personal museum, Signac must surely have regretted possessing only one drawing by his beloved Manet, *The Singer* (private collection). The twenty-year-old Signac attended the great painter's posthumous auction in 1884 and carefully recorded the prices, but the paintings were already far beyond his means.[4] By Delacroix he had two pencil drawings, a watercolor "arab" and a sepia drawing "Mazeppa," which he would surely have liked to replace with a painting or compositional sketch. There was nothing by Turner (his works were almost impossible to find). It was too late to acquire much by the Romantics; Delacroix's major paintings had long been out of Signac's price range.

Signac was still quite young when he vainly tried to persuade his family to purchase Impressionist paintings, admired a Sisley in a gallery window, was shown the door at an exhibition by Gauguin for trying to copy a Degas, and attended the Manet auction, powerless to buy.[5] But at the age of twenty, when he received the money set aside by his grandmother to pay for a replacement recruit in case of mobilization, he was free to make his own choices, and he started buying paintings.[6]

From Père Tanguy he purchased a fine Cézanne landscape, *The Oise Valley* (fig. 36), which remained the pride of his collection throughout his career. This work had qualities that were to mark his own style: a strongly composed landscape, with regular brushstrokes creating a surface pattern that negates perspectival effects and reduces spatial depth. The young Signac had already painted several pictures that displayed similar concerns, and Cézanne's art was to remain a lasting reference for him. In 1908 Signac recalled, not without a hint of malice, that "[Maurice] Denis jumped back in horror when he saw one of the first Cézannes at no. 20 avenue de Clichy around 1889."[7] Evidently Signac had more than one Cézanne in his studio at the time. We know that he also owned a still life which he exchanged in 1898 for a fine selection of works by other artists. The painter noted in his journal: "Vollard comes to buy my Cézannes. I refuse to sell him the largest. But I agree to the exchange of a small still life and it is with great joy that I bring back a pretty little Renoir—a trifle, the head of a woman, in pink, blue, yellow, but completely Renoir and his charm—two water colors by Jongkind, and a Seurat from the beginning of [Divisionism]...."[8] The small still life he traded with Vollard might have been *Three Pears* in the Mellon collection (R 345).[9] At the time of his death Signac owned another painting by Cézanne, *Standing Bather* (R 262; T. Adachi collection, Japan), which he had purchased at the Galerie Bernheim-Jeune in March 1909. He copied it at Fénéon's request for a lithograph intended for the Cézanne album that was published by the gallery in 1914 (fig. 56). Signac was often asked if he would sell his Cézanne but could never quite bring himself to do it. After the war, when he was reunited with his beloved paintings, which Jeanne had brought

to Antibes from Paris, he got up at five in the morning to look at them and concluded: "It was an unforgettable hour for me: the victors are Cézanne and Seurat ... no doubt about it."[10]

Cézanne was one of the first artists included in Signac's collection, while Monet, whom he so admired and whose example was so decisive in his choice of vocation—specifically through the 1880 exhibition of his works in the offices of *La Vie moderne*—was one of the last. At the end of his life Signac owned two paintings by Monet: *The Village of Lavacourt* (W 501; private collection), which he bought at a fairly late date at the Galerie Barbazangues, and the astonishing *Apple Trees in Bloom beside the Water* (fig. 38), which he had seen at the 1880 *Vie moderne* exhibition and acquired only in 1932. Signac obtained this last work in lieu of money owed to him by his dealer Léon Marseille, who had been ruined by the 1929 crash. The artist was manifestly pleased with this arrangement, and the acquisition provided one of his last great joys as a collector. The blossoms and foliage of Monet's apple tree, rendered with rounded brushstrokes, create an allover pattern, anticipating the innovations of the Neo-Impressionists. In choosing this rather atypical Monet, Signac again selected a picture that echoed his work and may have had a direct influence on his manner. It dates from a period of Monet's career—the one in which Signac first discovered Impressionism—that remained a favorite: writing in 1899, Signac remarked that Monet's "good period" was "between 1878 and 1882."[11] By Renoir, with whom Signac had a more complex and less warm relationship, he had three studies: for *La Grenouillère*, the small female head mentioned above (stolen from Berthe in May 1940), and a spray of roses.

Guillaumin, who was among the first Impressionists Signac knew, helped and advised him in his early efforts. Very likely it was shortly after their encounter on the quays of Paris in 1884 that Signac acquired Guillaumin's *Quai de la Rapée* (fig. 59), whose compositional scheme he adapted in one of his own works from that year, *The Seine, Quai d'Austerlitz* (fig. 58). Later he bought a landscape by Guillaumin dedicated to Hippolyte Richard, as well as *The Thatched Huts* and three pastel portraits of children. Through Guillaumin, Signac soon met Camille Pissarro, who was also a collector and who assumed his usual role of benevolent master for the young artist. Signac remained grateful to him, even after Pissarro

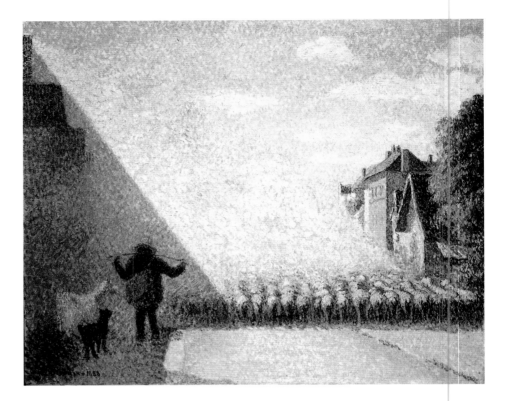

Fig. 39. Camille Pissarro, *The Flock of Sheep, Éragny-sur-Epte*, 1888, oil on canvas, 18⅛ x 21⅝ in. (46 x 55 cm). Private collection

abandoned the divisionist technique. Pissarro's Neo-Impressionist *The Flock of Sheep, Éragny-sur-Epte* (fig. 39) probably came into Signac's collection soon after its completion. In any case, it was in his studio in 1898 when the dealer Moline's employees tried to persuade him to sell his Cézanne.[12] In 1908 Signac bought another Pissarro from Jean Metthey, *Trawler in the Port, Dieppe* (v 1258; private collection), and a year later a picture from 1881, *Peasants in the Woods* (v 531; private collection). He also owned several drawings and watercolors by the old Impressionist (see v 1406, v 1552), including one that features the pointillist technique, which Signac himself never used in watercolors.

It was probably through Pissarro that Signac acquired his first Degas. On February 4, 1887, Pissarro left a drawing by Degas with the artist's mother, Héloïse Signac, probably in the hope of convincing her to help her son make this major acquisition.[13] Could this drawing have been the magnificent pastel by Degas that he offered Durand-Ruel in 1898 (fig. 40)? This is not impossible, although Lemoisne dates this work to 1892 (no. 1116). At any rate the history of this drawing, which is so revealing of Signac's personality, is interesting in and of itself. As a young man, Signac admired the work of Degas, as many of his earlier efforts show, and was impressed above all by his bold compositions, though sometimes through the

intermediary of Caillebotte's work. On December 16, 1898, Signac noted in his journal that he offered to sell a Degas pastel to Durand-Ruel: a very finished drawing of an actress in a green gown buttoning her gloves, with a dresser at her feet. This is undoubtedly the drawing now in Hartford. The archives of the Galerie Durand-Ruel confirm that it was placed on deposit there in January 1899 and then returned to Signac on April 1, 1899. Signac then sold it to the German dealer Gutbier, who subsequently sold it to the Paul Cassirer gallery. Cassirer put the drawing on deposit with Durand-Ruel on December 19, 1901. It was purchased by that gallery on February 5, 1903, and later sold to the American artist Romaine Brooks on January 27, 1905.[14]

Why did Signac sell this remarkable work, which, together with the Cézanne, was one of the most precious pieces in his collection? It was long thought that he was obliged to do so to finance the extensive renovation work he had undertaken at La Hune. But this explanation does not stand up to close scrutiny: Signac set up his new studio in August 1898 but decided to part with his pastel only in December. Furthermore, when he mentions this decision in his journal, there is no indication of financial obligations, but only of a deliberate resolution: "Wrote to Durand-Ruel to offer my Degas; I would much more prefer to use this money to buy works by Luce and Cross."[15] In fact, this was in the

middle of the Dreyfus affair and it was Degas's anti-Semitic opinions that led Signac to decide to part with one of his most cherished pieces.

The artist's journal shows how shocked he was by this affair and how the current demonstrations of anti-Semitism revolted him. His wife, Berthe Roblès, a distant relative of Pissarro's, was herself of Jewish origin. As early as January 15, 1898, Signac took a stance in the affair that was shaking France to its foundations by signing a collective oath of support for Émile Zola and congratulating him on his courageous position.[16] On January 17 he sent his name to *L'Aurore* to be included in the list of protesters. On February 11 he discussed the affair with his friend Pissarro and noted indignantly in his journal: "Since the anti-semitic incidents, Degas and Renoir avoid him and do not recognize him any more." In the next paragraph he criticized Degas's exhibition, although he liked the works to a degree: "It is very beautiful, very beautiful, but it is all scraps. No pictures." Several days later he wrote bitterly about Zola's court conviction. A journal entry of December 20 shows that he was outraged by the subscription organized by *La Libre Parole* for Colonel Henry's widow and the cries of "Death to the Jews." It was then that he made the decision to sell his

Fig. 40. Edgar Degas, *Before Curtain Call*, ca. 1880?, pastel, 20 x 13½ in. (50.8 x 34.3 cm). Wadsworth Atheneum, Hartford, The Ella Gallup Sumner and Mary Catlin Sumner Collection, 1956.477

Degas, placing it with the Galerie Durand-Ruel a month later. On December 28 he attended a pro-Dreyfus meeting,[17] having discussed the case at Christmastime with Maurice Denis, who mentioned their conversation in his notebook.[18] In his journal Signac compared Denis, who had signed the list in *La Libre Parole*, with the "good Vuillard," who had signed that of *L'Aurore*.[19] As John Rewald pointed out: "There was no just and generous cause which did not find [Signac] ready to step into the breach, and if there is one fear he never had, it was that of being too radical."[20]

Signac, however, remained faithful to those he had admired in his youth, and after Degas's death in 1917, he took an interest in the old artist's studio sales. On April 19, 1919, he wrote to Fénéon to thank him for having sent him the sale catalogue for the drawings and remarked: "I am always moved by these lines and forms which remind me of the beautiful pastels we once admired on the rue Laffitte when we were amiable young men. He is our old master. . . . I almost couldn't resist bidding on one, despite my dire straits."[21] But Signac did not have the means to purchase a Degas: the war had taken its toll financially and psychologically. Nevertheless, some of the drawings included in the Degas studio sales found their way into his collection years later: a fine charcoal drawing, *Two Dancers*, bought at the Galerie Durand-Ruel in 1930 (private collection),[22] a *Dancer Scratching Her Back* (private collection),[23] and *Female Nude Leaning Forward* (private collection), which Signac more prosaically dubbed "*Fesses*" (Buttocks) in his notebook.[24] In 1931 Signac's agenda listed no fewer than eight drawings by Degas: the ones just mentioned, a pastel of a *Dancer Bowing*, and drawings of a kneeling nude, laundresses, and jockeys. Some of these were probably acquired in 1925, when he wrote to Fénéon to ask him when he could see the Degas drawings.[25]

Another of the "old masters" who marked Signac's life and art was Jongkind. In 1931 his holdings of this artist's work included a painting, *Notre-Dame Seen from the Quays* (1864; private collection), fifteen drawings, two etchings, and at least twenty-six watercolors. Many of these were displayed in the dining room in the rue de l'Abbaye, which, like the dining room at La Hune, was the *salon d'honneur* for Signac—a bon vivant who liked to share a good meal with his friends. Signac, who admired Jongkind for many years and who may have even identified with him in certain respects, published a

book about the Dutch painter in 1927. Two water-
colors by Jongkind were among the lot of works he
received from Vollard in exchange for his Cézanne
still life on December 23, 1898. In May 1899 he
noted in his journal how pleased he was to have
seen Jongkind's exhibition at the Galerie Durand-
Ruel, calling it a "lesson of art and life."[26] The
painting *Notre-Dame Seen from the Quays* probably
entered his collection after World War I—it is
listed in the 1935 inventory among works in the
rue de l'Abbaye apartment.

Above all, it was Jongkind's watercolors that
caught Signac's attention and influenced his work
(see fig. 41). On March 2, 1929, he wrote to Gaston
Lévy with evident pride: "I have the pleasure of
announcing that, having benefited from your lessons
in daring and discernment, I have just bought three
watercolors by Jongkind for 55,000 francs, including
one for 25,000 francs! And I don't think I'm crazy.
They are as beautiful as the ones in the Camondo
collection."[27] On January 14, 1930, he sent 6,000
francs to Durand-Ruel for a Jongkind watercolor,
Honfleur 1 oct 1863.[28] At the end of the year he in-
formed Lévy of the purchase of another Jongkind
watercolor in Grenoble "for a high price. But what
a watercolor: *L'Escaut 26 sept. 1866*. . . . There isn't a
finer one at Camondo's or Gaston's [Lévy]."[29]

Boudin was also to be honored by inclusion in
Signac's collection: the agenda mentions six works,
two of which we have been able to identify:
a painting, *Jetties, Trouville* (s 3300; private collection),
and a very handsome pastel sky study (private col-
lection). On January 12, 1899, Signac commented
on his visit to the Boudin exhibition at the École

des Beaux-Arts in his journal: "It all is gray, fair,
pearly, vibrant, just like the Pissarros of the right
period. . . . Here is a man who was fond of boats
and knew how to draw. But this experience indeed
proves that one should avoid specialization: one
should vary the effects, the arrangements, make
paintings, not studies."[30]

SEURAT AND THE
NEO-IMPRESSIONISTS

Signac never got over Seurat's sudden death. On
every visit to his friend's mother he studied the
works he so admired. As he remarked in his journal
on December 29, 1894: "It is like soft and harmo-
nious light glowing on these walls." Later, in 1898,
he wrote similarly, declaring that Seurat's pictures
"illuminate with color and harmony the bourgeois
apartment. . . ."[31] He was as sensitive to the studies
and drawings as to the finished canvases, noting on
the occasion of an exhibition of panels and draw-
ings by Seurat at the Laffitte Galerie in 1895:
"What charm emanates from these smiles and
thoughts of a painter."[32]

According to the Seurat catalogue raisonné by
de Hauke, Signac at one time owned seventy-eight
works by Seurat, primarily oil sketches and draw-
ings. (The presence of so many marvels on one's
walls is an impossible dream for a private collector
today.) Thanks to Seurat's own list, we know that
in the winter of 1886–87, Signac already owned
two of his friend's works: a painting, *The Seine at
Courbevoie* (H 134; private collection), and an oil

study for *Fort Samson at Grandcamp* (H 156; private collection).[33] We believe that Seurat gave him his Conté crayon portrait, *Paul Signac* (fig. 30), as early as 1890, but not much is known about Signac's other acquisitions during Seurat's lifetime.

The drawing *Acrobat by the Ticket Booth* (H 671; private collection), which once belonged to Robert Caze, was probably purchased at the 1887 sale held after the latter's death. Upon Seurat's death in 1891 Signac inherited several works, including: oil on panel studies for *La Grande Jatte, Woman Sewing* (H 126; private collection), *Models* (H 180; private collection), and *The Channel at Gravelines, Evening* (H 209; L'Annonciade, Musée de Saint-Tropez). Subsequently, Signac bought works by his deceased friend from other heirs: from the painter Dario de Regoyos, another panel for *La Grande Jatte, Three Men Seated* (H 122; private collection); and from Émile Seurat, a drawing, *Fort de la Halle* (H 484; private collection), and a delicate oil study, *Aman Jean as Pierrot* (H 94; private collection). He acquired *The Circus* (fig. 42) and a Conté crayon drawing representing Seurat's father titled

Man Dining (H 600; private collection) from the artist's family at the 1900 Seurat exhibition held in the offices of the *Revue blanche*. The catalogue of this event, annotated in Signac's hand, indicates that the 1881 study *The Stonebreakers* (H 102) was already in his collection.[34] From Seurat's mother, he obtained by purchase or gift one of the last drawings, *Bareback Rider, Equestrienne* (H 707; private collection) as well as an oil sketch on canvas for *Chahut* (H 198; Albright Knox Art Gallery, Buffalo). It is not always known when or how he acquired the other works. Sometimes he traded: for example, the "Seurat from the beginning of [Divisionism]" which he acquired from Vollard in 1898, along with other works in exchange for a Cézanne still life (possibly *Village Road*, H 53; collection of Mrs. Alexander Lewyt). On the other hand, as we learn from a journal entry of December 1899, he traded a Seurat drawing and one of his own watercolors for two small panels by Maurice Denis.[35]

All in all, Signac assembled a remarkable Seurat collection, impressive especially for the quantity

Fig. 42. Georges Seurat, *The Circus*, 1890–91, oil on canvas, 73¼ x 59½ in. (186.2 x 151 cm). Musée d'Orsay, Paris

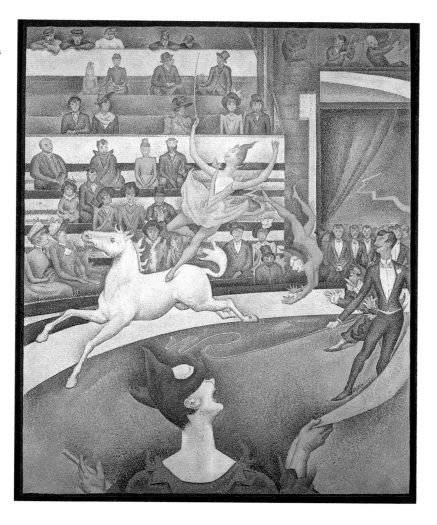

Fig. 43. Georges Seurat, *The Mine*, 1887–88, Conté crayon, 12¼ x 9½ in. (31 x 24 cm). Private collection

and quality of its drawings and panels. Among the notable examples were *Concierge* (H 603; Galerie Jan Krugier, Geneva); *Pierrot and Columbine* (H 674; Nichido Museum Foundation, Tokyo); *Man Hoeing with a Cultivator* (H 558; Musée du Louvre); *The Gleaner* (H 559; British Museum); and *Seated Man, Reclining Woman* (H 109; Musée d'Orsay), which Berthe Signac gave to Marguerite Rivière in 1892. *The Echo* (H 597; Yale University Art Gallery, New Haven), which by 1936 belonged to Jean Ajalbert, and *Woman with Parasol* (H 628; private collection), which was acquired sometime after Signac's death by André Dunoyer de Segonzac, were probably both sold by Berthe. The small compositional sketch for *La Grande Jatte* (H 141), stolen from Berthe in May 1940, has not been located.

Signac's posthumous inventory tells us nothing about the provenance of such works as *Scaffolding* (H 567; private collection) or *Woman with Parasol*, but it does throw light on the subject of a drawing that has been known under widely different titles. It was called *Saltimbanques* (Street Acrobats) in Lucie Cousturier's monograph of 1926 and in Gustave Kahn's 1928 study of Seurat's drawings. The de Hauke catalogue picked up this idea, titling it *Banquistes (appel au public—saltimbanques)* (Fairground entertainers [attracting the public—acrobats]), and finally it was identified by Robert Herbert as *Chef d'orchestre* (Bandleader).[36] In the Signac inventories the sheet appears under the title *La Mine* (*The Mine*; fig. 43),

indicating that it probably represents the descent or ascent of the elevator in a mine shaft overseen by the individual at the right who wears a helmet. In the foreground other figures in hard hats, presumably miners, await their turn.

Signac was not able to keep all of the works in his collection, and he sometimes sold them. He parted with *The Circus* after the war, selling it to the American collector John Quinn, stipulating that it be bequeathed to the Louvre, but worried about it until the end.[37] In 1934 he also sold the sketch for *Chahut* to the Wildenstein gallery. Yet at the time of his death, the Seurats still formed an impressive ensemble. Most of them were in the rue La Fontaine apartment. Together with the ones that decorated the dining room at La Hune, these were his first acquisitions. Others hung on the walls of the rue de l'Abbaye apartment, which suggests that Signac continued collecting them after World War I.

After Seurat, Cross was clearly Signac's favorite Neo-Impressionist painter. This fondness might be seen as an expression of loyalty to a friend who shared his enthusiasm for Neo-Impressionist technique to the very end, but in fact Signac had a sincere admiration for Cross's work: "One . . . feels in him the joy of painting, the love for delicate harmonies, something undefinably hesitant and mysterious and unexpected. He is both a cold and methodical thinker and a dreamer, strange and troubled."[38] As the inventories show, throughout his life Signac assembled a remarkable collection of Cross's works, both paintings and watercolors. During Cross's lifetime he acquired his friend's paintings through exchange but also bought them at Bernheim-Jeune, their common gallery, purchasing, for example, *The Shipwreck* (C 163; Musée d'Orsay, Paris) in 1907.

After Cross's death in 1910, Signac continued to collect his works, regarding each acquisition as a triumph. After the war, at the Cross studio sale in 1921, he bought the large picture *Bathers* (C 72; private collection). In 1924 he purchased *Provençal Coast (Le Four des Maures)* (C 156; Musée des Beaux-Arts, Douai) from Bernheim-Jeune. In January of the following year he bought three more paintings from the same gallery: *The Beach at Saint-Clair* (C 96; private collection), *Toulon, Winter Morning* (C 187; private collection), and *River at Saint-Clair* (C 210; location unknown). A month later, on February 26, 1925, he wrote to Fénéon: "I have just had my dining room painted chrome yellow no. 2 and hung

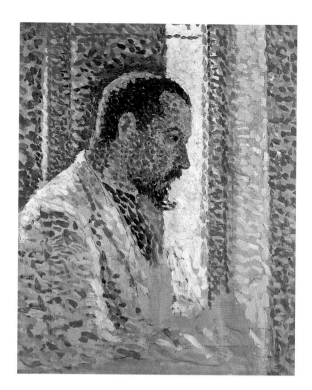

Fig. 44. Maximilien Luce, *Portrait of Paul Signac*, ca. 1889, oil on canvas, 13¾ x 10⅜ in. (35 x 26.5 cm). Private collection

five flamboyant Crosses there!"[39] And that May he announced: "At the Hôtel [Drouot] I acquired an attractive Cross of his nephew on the steps, of 1901." This was *Child in the Garden* (c 93; private collection).[40] He later purchased *The Beetle* (c 170; Walter F. Brown collection) and continued to collect works by his friend until the end of his own life: he informed Berthe in 1935 that he had bought "a superb watercolor by Cross representing Mme Cross gardening."[41] After World War I works by Cross filled the walls of the rue de l'Abbaye apartment, impressing John Rewald, the painter André Marchand, and Ginette Signac, who later mentioned them in their recollections.[42] Many were sold by Ginette Signac after World War II, for, as she wrote in her memoir, she preferred selling Cross's works to parting with her father's. The most important Cross, *The Evening Air*, as well as *The Shipwreck*, was, however, included in her 1976 donation to the Musée National d'Art Moderne (now in the Musée d'Orsay).

Thanks to this donation the French national collections also acquired the fan painted by Maximilien Luce, *The Louvre and the Pont Neuf* (b 248, Musée d'Orsay, Paris). Signac and the old revolutionary painter were friends, and Luce was handsomely represented in his collection. At Signac's death Luce recalled: "He bought my submission: the first painting I exhibited at the Indépendants. We became acquainted, and through him I met his friends from the Neo-Impressionist movement."[43] This first picture was the non-divisionist canvas called *The Toilette*. Signac also purchased another proletarian scene, *The Coffee* (1892; b 565, private collection), many landscapes, and several still lifes by Luce. Here, as usual, the modes of acquisition were diverse, including both gifts and purchases. By way of thanking Signac for flowers from the garden at La Hune, Luce sent him a still life with the following dedication: "To Paul Signac / my turn to cover you with flowers" (private collection).

In February 1907 Signac expressed dismay over Luce's exhibition at Bernheim-Jeune: "Up till now I have been his only buyer."[44] He purchased works by Luce from their common gallery: in February 1907 it was *Snow at Daybreak* (b 353), and in May 1909, two floral still lifes (b 1177 and uncatalogued). At a much later date, he discovered "a very beautiful sketch by Luce (canvas size 12), workers brandishing a red flag on top of some scaffolding. . . . It is as good as a Delacroix or Daumier."[45] Signac owned many views of Montmartre and portraits by Luce, starting with his own likeness from the early days of Neo-Impressionism: he appears in profile as an attentive young painter bent over his canvas, set off by a very delicate lighting effect (fig. 44). Arguably one of the most attractive portrayals of the young Signac, its sensitivity sets it apart from examples by Seurat and other painters. Signac also collected portraits of friends painted by Luce: the sketch (private collection) for the portrait of Cross now in the Musée d'Orsay and that for the portrait of Lucie Cousturier now in the Museum of Fine Arts, Boston (b 598; Gift of Ginette Signac, L'Annonciade, Musée de Saint-Tropez).

As for Van Rysselberghe, who painted the famous 1896 picture of Signac at the helm of his sailboat (fig. 31), he became in a way the official portraitist of the family. At La Hune he left portraits of Berthe and Héloïse Signac, the artist's mother (both in private collections), and a fine drawn portrait of Camille Pissarro (private collection). Signac also owned a handsome collection of drawings by Angrand, an artist for whom he always professed the highest admiration: "Angrand: his drawings are masterpieces. It is impossible to imagine a more beautiful arrangement of black and white; more lavish arabesques. They are the finest possible painter's drawings ever made, poems of light, well combined, well executed, most successfully carried out."[46]

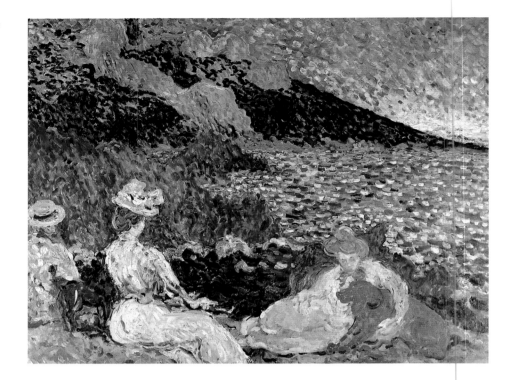

Fig. 45. André Valtat, *Women at the Seashore*, ca. 1904, oil on canvas, 50⅜ x 63¾ in. (128 x 162 cm). Private collection

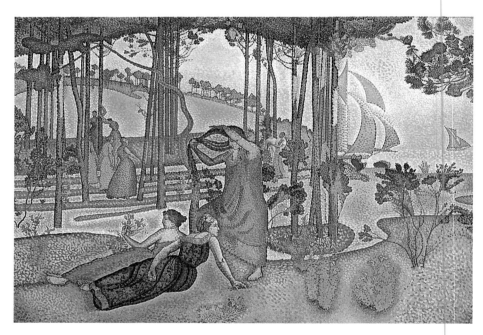

Fig. 46. Henri Edmond Cross, *The Evening Air*, 1893–94, oil on canvas, 45⅝ x 65 in. (116 x 165 cm). Musée d'Orsay, Paris

THE FAUVES

In 1904 Signac had the dining room in La Hune expanded, and in the following summer he created a carefully thought-out and programmatic decoration that has since become well known. To this end he chose three large-format and particularly demonstrative pictures: Valtat's *Women at the Seashore* (fig. 45), Cross's *The Evening Air* (fig. 46), and *Luxe, calme et volupté*, which Matisse undertook in Saint-Tropez in 1904 while he was summering there with Signac and Cross (fig. 47). Cross's painting clearly exerted an

influence on Matisse's, which adopts the gesture of the woman combing her hair and strictly adheres to the divisionist method. In hanging the paintings by Cross and Matisse face to face, Signac admirably and enduringly illustrated the decisive impact of Neo-Impressionism on the nascent Fauve movement. Valtat's picture was based on the laws of Simultaneous Contrast and done with freely divided brushstrokes. It was the first of the three to enter Signac's collection and represents "the tip of Cap Roux, on which are Suzanne Valtat and her dog, accompanied by the Bertnays, their neighbors, and their poodle."[47]

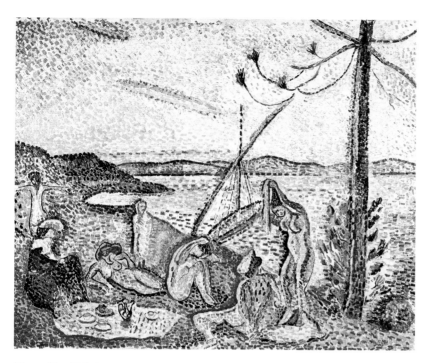

Fig. 47. Henri Matisse, *Luxe, calme et volupté*, 1904, oil on canvas, 38¾ x 46⅝ in. (98.5 x 118.5 cm). Musée d'Orsay, Paris

Signac acquired it from Valtat in exchange for his little three-wheeled car, a Bollée; the trade presumably took place in early 1904 since a letter from Georges d'Espagnat to Eugène Durenne indicates that Valtat owned the vehicle by March of that year.[48] The following year, in September 1905, Signac acquired the other two paintings. The acquisition of the Matisse involved a trade of "500 francs in gold and 500 francs in painting"; Matisse chose Signac's *The Green House, Venice* (FC 417; private collection, New York).[49] As for the Cross, Signac probably acquired it in exchange for one of his own works or another work by Cross.

Fig. 48. Kees van Dongen, *Modjesko, Soprano Singer*, ca. 1905–7, oil on canvas, 39⅜ x 32 in. (100 x 81.3 cm). The Museum of Modern Art, New York, Gift of Mr. and Mrs. Peter A. Rübel, 192.55

The very colorful Matisse was hung between two windows, against the light. As Signac stated from the start: "These three paintings are not pictures, but rather decorations."[50] He always paid close attention to the framing and saw to it that the frames respected the two-dimensional nature of the paintings; that is, he made sure they did not create an illusion of depth or space. The paintings were hung in the fall of 1905 after having been put into flat wood frames made of "veined plane-tree wood, very effective. What sumptuous meals now . . . even if the fare is meager."[51]

The Signac collection also featured a Matisse watercolor, *By the Sea (Gulf of Saint-Tropez)* (private collection)—a preliminary study for the picture in the Kunstsammlung Nordrhein-Westfalen, Düsseldorf—a painting of "bathers" mentioned in the rue La Fontaine inventory but as yet unidentified, and another painting, *Notre-Dame* (private collection), which was hung in the rue de l'Abbaye and so was acquired at a late date. With seven paintings listed in 1931, Valtat was the best-represented Fauve in Signac's holdings. In addition to the large picture in Saint-Tropez, Signac purchased his *Moonlight Effect*, which was exhibited at the 1905 Salon d'Automne, *Red Rocks at Esterel, The Schooner, The Port, The Freighters, Seascape,* and a colorful floral still life from 1905, which he acquired in 1926.[52] At Saint-Tropez he also had the sketch *Woman with the Fur*, a portrait of Mme Valtat (today in the Fridart collection), and a still life with fish.

Signac's fondness for the works of Camoin was more short-lived. He acquired an important painting, *Rue Bouterie*, which had been exhibited at the Indépendants in 1905, and wrote to Manguin in the fall concerning its placement in his villa in Saint-Tropez: "The Camoin is in the living room. . . . I like it less and less, while I appreciate the Matisse more and more. The one is a poem, while the other is a news report, albeit well told."[53] By Van Dongen, Signac had two exceptional works: *The Garter* (private collection), which he bought at Bernheim-Jeune in February 1907, and the extraordinary *Modjesko, Soprano Singer* (fig. 48), which he probably acquired at the Salon des Indépendants. This striking portrait of the transvestite Modjesko, a flamboyant diva, was perhaps one of the most surprising works in his collection.[54] It was sold by Ginette Signac during World War II to settle Berthe's estate after her death, in 1942. By his friend Marquet, Signac had a *Quay at Paris*; by Jean Puy, a *Port of Saint-Tropez, Concarneau*. Georges d'Espagnat was represented by *Bathers on a Beach, Saint-Tropez* (private collection).

Another painter for whom Signac had a great and lasting admiration was Bonnard. Already in 1909 Signac wrote: "The Bonnard exhibition . . . opened eight days ago. . . . I go every evening to spend some delightful moments. . . . I am buying one of his small pictures which, even if it does not have the importance of the larger ones, is at least very complete and very Bonnard."[55] The painting in question was *Hounds in Greenery* (D 256; Mr. and Mrs. Lester Avnet collection), purchased at Bernheim-Jeune, where Signac also bought *Boats in the Harbor, Cherbourg* (D 633; private collection) in 1912. The 1933 Bonnard exhibition at Bernheim-Jeune would be one of his last great artistic encounters: "It makes one feel like painting. Everything seems easy. Painting for painting's sake, nothing else. It's time one had something to like."[56]

THE COLLECTION'S SURPRISES

In 1922 the critic Lucie Cousturier wrote: "[Signac] is open to sensibilities other than those of the colorist, those that have nothing to do with the purity of tints and the divisionist technique that produces them. Not only does he hang paintings by Renoir, Cézanne, Pissarro, Van Gogh, Vuillard, Bonnard, Roussel, Matisse, Marquet, Valtat, Van Dongen, etc., on his walls, next to the works of divisionists like Seurat, Cross, Luce, and Van Rysselberghe, but he also hopes for the advent of new theories, new inventions."[57]

Indeed, Signac's collection reveals that he was not doctrinaire and unsympathetic to sensibilities different from or opposed to his own and that his personality was more complex than is often supposed. There is nothing surprising in the fact that his collection included engravings of French ports by Joseph Vernet, drawings by Paul Huet, or an etching by Forain for Huysmans's *Croquis parisiens.* And even the presence of a large painting by Octave Tassaert, *The Revolution of 1830,* is only half a surprise: as an admirer of Delacroix and Turner, he was evidently fond of Romantic painting and the revolutionary subject matter made it all the more appealing to him (especially since he had no picture by Delacroix). Unfortunately we have not been able to locate this painting, which the artist's daughter entrusted in the 1950s to the Yugoslavian embassy in Paris as a gift for the museum in Belgrade.

Signac's collection, as the reader may gather, betrays his great predilection for boats and scenes of the seaside. However, and more surprising, he also had a fondness for the nude, a genre he rarely essayed. Cross's *Bathers,* studies for Seurat's *Models,* and Matisse's *Luxe, calme et volupté* show that Signac had an appreciation for Neo-Impressionist interpretations of this subject so dear to academics. Other, more sensual nudes show his sensitivity to inspirations and styles radically different from his own. Two drawings by Degas, *Female Nude Leaning Forward* and *Woman Kneeling,* are clearly erotic and would probably have been difficult to exhibit in public at the time. This seems not to have concerned Signac. The refined sensuality of Van Dongen's *The Garter* surely did not escape his notice, even if it is possible to imagine that the blue and yellow harmony—his favorite color scheme—convinced him to buy this nude, one of the finest painted by the artist. The most surprising of the many nudes in the Signac collection is surely that by Walter Sickert, *The Camden Town Case,* a picture that has none of the hedonism of a Matisse or the elegance of a Van Dongen. It is a rather crude depiction of a murdered prostitute: the flaccid corpse painted in gray tones, and the genitalia exposed to view. We are light-years away from the art of Signac, who bought this painting in 1909 upon Fénéon's recommendation. He seems to have known and appreciated the English painter and known what to expect, for he wrote to his friend: "If you want to buy me a Sickert of your own choice, even if it is a bit lewd, I'll go along." To commemorate this acquisition, Sickert gave Signac a preliminary charcoal sketch for the painting and dedicated it "To Signac."[58]

Fig. 49. Odilon Redon, *The Centaur,* charcoal, 21½ x 18¼ in. (54.5 x 46.5 cm). Private collection

The nude he bought from Vuillard (private collection) was quite different from the Sickert: very delicate and nuanced, like all of the works by this artist, who was also antithetical to Signac. Yet Signac liked the man as much as the work and devoted some wonderful lines to him in his journal in 1898, saying that "he understands perfectly the inner voice of objects" and praising his "mute polychromy." He analyzed their many differences and concluded: "It does me much good to see a painter searching for art through means so different from ours, and suffering, as we do, from an opposite evil."[59] Signac also appreciated the company of Ker-Xavier Roussel, the painter of Mediterranean mythology. He bought *The Three Couples* by Roussel in 1909 at the Galerie Bernheim-Jeune and at the end of his life owned two landscapes by him, as well as a drawing and a pastel. Vallotton was another artist whose aesthetic sense was different from, if not the opposite of, Signac's. Again from Bernheim-Jeune, Signac acquired his *Boats, Honfleur*

(1901; private collection), a painting done in dark, flat colors, a harmony of black, grays, and olive green.

Although Signac often railed against the Symbolists in his journal and letters, one of the highlights of his collection—*The Centaur* (fig. 49), a charcoal drawing by Redon—was a fine example of the Symbolist approach. The two painters knew each other well; both played key roles in the founding of the Salon des Indépendants, and at the turn of the century they joined forces to organize a major exhibition of contemporary painting at the Galerie Durand-Ruel. Signac clearly liked Redon's work, even if it, too, was radically opposed to his own, and explained in his journal in 1895: "Saw at Lalande's a very good Redon: the studied lay-out, the unexpected character of the arabesques, the superb quality of the blacks and whites, their perfect arrangement—all make me admire this drawing completely . . . I do not know what it represents. But be it a peasant woman or a symbol . . . it is good art."[60]

NOTES

1 Rewald 1952a, p. 7.
2 Letter from Vincent van Gogh to Theo van Gogh, March 24, 1889, in Van Gogh 1958, vol. 3, p. 143, letter 581.
3 Letter from Signac to Félix Fénéon, undated [1909], Signac Archives: "Could you settle my balance for 1908–09. I received 10,000F + Bonnard Roussel Van Dongen 2800 + Delacroix and miscellaneous expenses 114.50: for a total of, I believe, 12,914. . . . It is agreed that the Cézanne and the Luce are for the financial year 1909–10."
4 Manet estate sale, Hôtel Drouot, Paris, February 4–5, 1884, annotated catalogue preserved in the Signac Archives.
5 See Chronology, under 1880 and 1884.
6 Unpublished memoirs of Ginette Signac, Signac Archives.
7 Letter from Signac to Félix Fénéon, July 11, 1908, Signac Archives.
8 Signac journal entry, December 23, 1898, in Rewald 1953, pp. 37, 74; the Renoir in question depicts the head of a young woman with a hat. This painting, together with a panel by Seurat—the final sketch for *La Grande Jatte*—was stolen in May 1940 from the home of Mrs. Jean Metthey, to whom Berthe Signac had entrusted it. A copy of the affidavit of theft at the Office des Biens Privés, filed on March 26, 1947 (File no. 16 892), is preserved in the Signac Archives.
9 As Rewald mentions in his catalogue (Rewald 1996, vol. 1, p. 230), Fénéon knew this small picture well

and had described it in an article in the March 19, 1892, issue of *Le Chat Noir*.
10 Letter from Signac to Félix Fénéon, July 14, 1918, Signac Archives.
11 Signac journal entry, April 22, 1899, in Rewald 1953, pp. 53, 79.
12 Signac journal entry, December 25, 1898, in ibid., p. 37.
13 Letter from Camille Pissarro to Signac, February 4, 1887, Signac Archives: "Surely you do not mind if Cluzel [sic] takes care of sending the Degas to your mother?" See also Camille Pissarro's letter to his son Lucien, January 25, 1887, in Bailly-Herzberg 1980–91, vol. 2, letter 388; translated in Rewald 1980, p. 98: "The more I think of it, the more mortified I feel about parting with my Degas, and the more convinced I am that our only course is to sell it . . . Signac says that it is worth at least a thousand francs . . . I am going to see Portier about it. I have not heard from Bracquemond."
14 Signac journal entries, December 16, 25, 1898, Signac Archives. Information pertaining to the provenance of this work was kindly provided by the Archives Durand-Ruel, Paris, and concerning the identity of the buyer "Mrs. Brooks," by Susan Alyson Stein.
15 Signac journal entry, December 16, 1898, Signac Archives.
16 Collective statement of support for Émile Zola, archive Musée Gatien-Bonnet, Lagny-sur-Marne.

17 Signac journal entries, January 17, February 11, 23, 1898, in Rewald 1952, pp. 275, 278, 301; December 20, 1898, in Rewald 1953, pp. 37, 74.

18 Denis 1957–59, vol. 1, p. 149.

19 Signac journal entry, February 7, 1899, in Rewald 1953, pp. 42–43, 76.

20 Rewald 1952, pp. 266, 299.

21 Letter from Signac to Félix Fénéon, April 19, 1919, Signac Archives.

22 Second Degas studio auction, Hôtel Drouot, Paris, December 11–13, 1918, no. 340, acquired by Durand-Ruel for 1,700 francs.

23 Third Degas studio auction, Hôtel Drouot, Paris, April 7–9, 1919, no. 132, part of a group of three drawings acquired by Bing for 5,500 francs.

24 Fourth Degas studio auction, Hôtel Drouot, Paris, July 2–4, 1919, no. 288, part of a group of three drawings acquired by Nunès and Fiquet for 400 francs.

25 Letter from Signac to Félix Fénéon, March 4, 1925, Signac Archives.

26 Signac journal entry, May 16, 1899, in Rewald 1953, pp. 57, 80.

27 Letter from Signac to Gaston Lévy, March 2, 1929, private collection.

28 Information provided by the Archives Durand-Ruel, Paris.

29 Letter from Signac to Gaston Lévy, December 7, 1930, private collection.

30 Signac journal entry, January 12, 1899, in Rewald 1953, pp. 40, 75.

31 Signac journal entries, December 2, 1894, in Rewald 1949, pp. 114, 170, and January 3, 1898, in Rewald 1952, pp. 273, 301.

32 Signac journal entry, February 22, 1895, in Rewald 1949, pp. 117, 172.

33 See Paris–New York 1991–92, p. 381, and nos. 163 and 153, respectively. This catalogue includes twenty-seven other works formerly owned by Signac (nos. 6, 14, 33, 38, 39, 44, 49, 90, 111, 117, 120, 126, 143, 174, 180, 183, 188, 198, 199, 201, 216, 218, 222, 223, 225, 229, 230). Thorough provenance entries by Susan Alyson Stein are provided in the English edition.

34 Catalogue preserved in the Signac Archives.

35 Only one of the two Denis panels owned by Signac have been identified: *Yellow Trestrignel*, also called *Young Women on the Beach*, 1897, oil on cardboard, 22.5 x 28.8 cm, private collection.

36 Paris–New York 1991–92, p. 303, no. 198.

37 Letter from Henri Verne, Director of the French National Museums, February 24, 1933, Archives des Musées Nationaux, P8/1927 Quinn Bequest: Signac asked him to take advantage of the renovation work in the Louvre and Musée du Luxembourg to return the "*Circus* by Georges Seurat, which was bequeathed to this museum by its owner, Mr. Quinn. It was at my request that this generous donor stipulated that this painting be returned to France and he destined it for the Louvre."

38 Signac journal entry, December 14, 1894, in Rewald 1949, pp. 111, 172.

39 Letter from Signac to Félix Fénéon, February 26, 1925, Signac Archives.

40 Ibid., May 25, 1925; the picture was acquired at auction, Hôtel Drouot, Paris, May 14, 1925, no. 62.

41 Letter from Signac to Berthe Signac, undated, Signac Archives.

42 Rewald 1952, p. 7; André Marchand, interviewed by F. Cachin and M. Ferretti-Bocquillon on October 20, 1988, recalled that the apartment was decorated with works by Signac and Cross; Ginette Signac, unpublished memoirs (Signac Archives), mentioned the "cadmium-yellow no. 2 dining room, with yellow velvet curtains. Amidst this flamboyant harmony, on the walls, all the paintings of H. E. Cross."

43 Luce 1938, p. 8.

44 Letter to Henri Edmond Cross, undated [February 1907], Signac Archives.

45 Letter from Signac to Berthe Signac, Signac Archives; this was probably the painting titled *The Red Flag*, private collection, reproduced in Mantes-la-Jolie 2000, unpaginated.

46 Signac journal entry, March 15, 1899, in Rewald 1953, pp. 45, 77.

47 Reminiscences of Suzanne Valtat, the artist's wife, as cited in Bordeaux 1995, p. 30.

48 This exchange is confirmed by a letter preserved in the Signac Archives in which Valtat discusses at length his experiences driving automobiles and asks Signac to send the "Delacroix brochure" that he had promised; and in a letter from Georges d'Espagnat to Eugène Durenne: "I saw Valtat, who does automobile landscapes; that is, drives with his canvases in his Bollée, which allows him to go quite far; in this manner he has done some superb studies."

49 Letter from Signac to Henri Matisse, cited in Paris 1993, p. 420; letter from Matisse to Simon Bussy, September 19, 1905, Bibliothèque Centrale des Musées Nationaux, Paris.

50 Undated letter to Théo van Rysselberghe, The Getty Research Institute, 870355, folder 6.

51 Letter from Signac to Manguin, Archives J.-P. Manguin.

52 Letter from Signac to Félix Fénéon, March 2, 1926, Signac Archives.

53 Letter from Signac to Manguin, Archives J.-P. Manguin.

54 Exhibited Paris 1908, no. 45, "Modjesko soprano singer," 1905–1907.

55 Signac journal entry, February 6, 1909, Signac Archives.

56 Ibid., June 29, 1933.

57 Cousturier 1922, unpaginated.

58 Letter from Signac to Félix Fénéon, June 12, 1909, Signac Archives.

59 Signac journal entry, February 16, 1898, in Rewald 1952, pp. 277, 302.

60 Signac journal entry, September 15, 1895, in Rewald 1949, pp. 128, 174.

AN ARTIST AMONG ARTISTS: SIGNAC BEYOND THE NEO-IMPRESSIONIST CIRCLE

SUSAN ALYSON STEIN

PAUL SIGNAC'S LOVE OF ART WAS RIVALED only by his joie de vivre. From the start of a career that would span fifty years, this spirited man and passionate, if disciplined, painter was a rebel—with a cause: to achieve an art of maximum color, light, and harmony. He found the means to this end in the divisionist technique invented by Georges Seurat. An instant convert to Neo-Impressionist style, Signac submitted his own—fundamentally different—artistic heritage to the rigors of a technique that he continued to practice with a devotion that invited both respect and ridicule. Many artists, like Pierre-Auguste Renoir, who had little taste for his paintings, nonetheless "always held the conscientious artist that [Signac was] in high esteem."[1] Others, like Francis Picabia, finding no redeeming qualities in the man or his art, were more dismissive of Signac: "the personality which springs from a system can no more interest us than that of a maniac who could write only with orange ink."[2]

Yet what makes Signac's personality of interest—intriguing, in fact—is that it does not conform to expectation. One might imagine, given his conscientious (or maniacal) dedication to a style that he had discovered in his youth and implemented, with endless variation, until his

death, that Signac had divorced himself from the art world or at least walked through it with blinders on. To the contrary. He was not a recluse like Georges Seurat or the older Gustave Moreau. Nor was he a silent witness to the onslaught of challenges to his métier that came in a rapid succession of "isms" as art was redefined in the late nineteenth and early twentieth century. Outgoing and outspoken, he was always very much at the center of things—as an active participant and organizer of exhibitions and soirées, as a critic and theorist, and as a peripatetic traveler, museum-goer, and collector. Self-taught and financially self-sufficient, Signac was able, to an enviable extent, to follow his own predilections, to determine from the onset to the end of his artistic career the course it would take, with little concern for the dictates of fashion or the marketplace.

Yet Signac, an avid yachtsman, who might forgive the analogy, has rarely been recognized as captain of his own ship, as it were, but instead as Seurat's first mate. True, Seurat provided Signac with a kind of navigational chart, one that Signac felt was the best direction for his art to take. But not only did they set sail from different ports—respectively, the École des Beaux-Arts and the "Impressionist school"—Signac had a longer

journey. He took Neo-Impressionism further—well into the twentieth century—and through friendships, experiences, and admirations, he enjoyed many detours along the way. Just as he always had.

Only the adage that "opposites attract" could have guaranteed the close and eventful association between Signac and Seurat. No two artists could have been more dissimilar than the reserved and laconic Seurat, who was tall and handsome, and the gregarious, somewhat stocky, Signac. Nor when they first met were they much alike in their artistic sensibilities. In Seurat's early work, which was responsive to the lessons of both J. A. D. Ingres and Eugène Delacroix and found its natural affinity in the landscapes of Camille Corot and the Barbizon school, the classical tradition held sway. Signac was a romantic in spirit: seduced from the start by the luminous seascapes of Claude Monet and by the "triumphant brushstrokes and wild colorations" of Armand Guillaumin.[3] First and foremost, Signac was a colorist, whose view of art was shaped by a painterly tradition of color and light. As a Neo-Impressionist, he saw himself as heir to the glorious contributions of Delacroix, Turner, and Monet.

It is with these masters that Signac aligns himself in his well-known treatise, *D'Eugène Delacroix au néo-impressionnisme* (1899). He accords pride of place to Delacroix, to whom he devotes the introductory chapters. Ingres is completely ignored. Within Signac's construct, he acknowledges the "incontestable influence" of Johan Barthold Jongkind and Turner, but at the expense of Corot, who is mentioned only in passing and not highlighted as an "admirable forerunner" of the Impressionists.[4] Other omissions are telling. From a nearly comprehensive list of the leading Impressionists and their contributions, with kudos to Monet, Renoir, Camille Pissarro, and Paul Cézanne, only two names are conspicuously absent: Gustave Caillebotte and Edgar Degas. If this can be taken as a gauge of Signac's admiration or as an estimation of their relative influence on his art, it is also true that within a positivist framework—where artists were linked by filial concerns—they simply did not fit.

That Signac's perspective on Neo-Impressionism was colored—quite literally—by his own sensibility did not go unnoticed. After all, upon reading Signac's manuscript, Félix Fénéon suggested

an alternative, more appropriate title: *Color in Neo-Impressionism.*[5] While Signac did not change his title or rectify the emphases of his text, he was not unwilling, it would seem, to reconsider his biases. Just before the treatise was published in book form, in 1899, he went to the Louvre specifically to see Ingres's *Grande Odalisque* (fig. 50). He admired it for "the splendor of the forms and . . . the willful and characteristic drawing with its deformations almost evoking Degas and Daumier." But while there, he saw again "with greater joy" Delacroix's *Women of Algiers* (fig. 51)—a "more complete, more integrated" work of art.[6]

Not only was Signac's estimation of the relative talents of Ingres and Delacroix very much in keeping with his own sentiments—his unerring regard for technical mastery was second only to his passion for color and compositional harmony; it also conformed to the sentiments of his age. While Ingres's merits were open to debate—most famously and with legendary consequences by Paul Gauguin and Vincent van Gogh—Delacroix's genius was virtually uncontested and was abundant enough, it seems, to inspire all artists working at century's end: the Symbolists, the Synthetists, the Neo-Impressionists, those who appreciated Ingres, like Gauguin and Degas, and those who did not, like Van Gogh and Cézanne.

Insofar as there was a "resurrection" of Delacroix's genius in the late nineteenth century, as Van Gogh observed, the "interpretations of it are so divergent and in a way so irreconcilable."[7] Artists who found confirmation for their view of art in Delacroix's example—as did Signac in the period following Seurat's death and Van Gogh at an equally critical juncture in his career—routinely defined Delacroix's greatness in their own terms. Van Gogh identified with Théophile Silvestre's description of the painter "who had a sun in his head and a thunderstorm in his heart" and found no small comfort in "that saying of Delacroix's," especially as time went on, "namely that he discovered painting when he no longer had any breath or teeth left."[8] Gauguin's boastful nature led him to "enjoy imagining Delacroix arriving in the world thirty years later and undertaking the struggle that I dared to undertake."[9] Signac was no different from Van Gogh or Gauguin among the colorists who saw themselves as heirs apparent to the great nineteenth-century master. The parallels that Signac drew between

Fig. 50. Jean-Auguste-Dominique Ingres, *The Grande Odalisque*, 1814, oil on canvas, 35⅞ x 63¾ in. (91 x 162 cm). Musée du Louvre, Paris

Fig. 51. Eugène Delacroix, *Women of Algiers in Their Apartment*, 1834, oil on canvas, 70⅞ x 90⅛ in. (180 x 229 cm). Musée du Louvre, Paris

himself and Delacroix, first in his 1899 treatise and later in a 1935 text, were certainly not lost on the attentive reader. For if Signac was a romantic at heart, he was one in the spirit of the great Romantic painter who "placed his incomparable science in the service of his fiery dash and daring and created for himself a technique founded entirely on method, calculation, logic, and set purpose, which did not chill his impassioned genius but raised it to new heights."[10]

More generally, Signac appreciated Delacroix's art because it embodied all the qualities that were fundamental to Neo-Impressionist painting, aptly summarized by Fénéon as an "art of great decorative development, which sacrifices anecdote to arabesque, analysis to synthesis, fugitive to permanent, and . . . confers on nature, which finally grew tired of its precarious reality, an authentic

reality."[11] Signac's notion of what constituted great painting was defined by these parameters, which were broad enough to embrace the works of a large constituency of painters. His artistic preferences tell us much about what mattered to him as an artist. For forty-odd years Signac's convictions never changed; they were simply renewed, and reaffirmed, in his discovery of the works of Turner and Jongkind, Monet and Cézanne, Pierre Bonnard and Henri Matisse.

Signac, whose art had been fostered by Impressionist painters, never lost an interest in their works. His long life provided ample opportunities for him to renew his acquaintance with the efforts of these "champions of color and light."[12] Some artists withstood the test of time or repeated viewing; others did not. Witness the two artists whom he admired most in his youth—Monet and Guillaumin—and how they fared in relationship to other key Impressionists who claimed Signac's affections.

When the seventy-one-year-old Signac was asked: "Who was it who prompted you to take up painting?" he replied, without hesitation: "It is Monet." Yet he added, "But the painter that I admired most when I was twenty was Guillaumin."[13] The distinction is telling: a half century later his admiration for Guillaumin quite clearly belonged to the past; in the case of Monet, it was ever present.

Impulsive by nature, Signac seems to have decided to become a painter under the impact of Monet's first one-man show at the offices of *La Vie moderne* in 1880. Such was Signac's enthusiasm that once he had completed his earliest attempts at plein air painting along the banks of the Seine, he eagerly sought out the older artist's guidance. He wrote to Monet:

Frankly, this is my position: I have been painting for two years, and my only models have been your own works; I have been following the wonderful path you broke for us. I have always worked regularly and conscientiously, but without advice or help, for I do not know any impressionist painter who would be able to guide me, living as I am in an environment more or less hostile to what I am doing. And so I fear I may lose my way and I beg you to let me see you, if only for a short visit. I should be happy to show you five or six

Fig. 52. Claude Monet, *Gray Day, Waterloo Bridge*, 1903, oil on canvas, 25⅜ x 39⅜ in. (64.5 x 100 cm). National Gallery of Art, Washington, D.C., Chester Dale Collection, 1963.10.183

Fig. 53. Paul Signac, *Rotterdam*, 1907, oil on canvas, 34¼ x 44⅞ in. (87 x 114 cm). Museum Boijmans Van Beuningen, Rotterdam, FC 448

studies; perhaps you would tell me what you think of them and give me the counsel I need so badly, for the fact is that I have the most horrible doubts, having always worked by myself, without teacher, encouragement, or criticism.[14]

In mid-May 1884, the date of Monet's (admittedly tardy) reply, the two artists met for the first time. "Our friendship dates from that day. It lasted until his death."[15] Signac's lifelong admiration for Monet—which led him to confide in a condolence note, "I loved and venerated him like a father"—was, however, briefly challenged in the late 1880s and 1890s.[16] With the advent of Neo-Impressionism, the once-progressive artist seemed hopelessly old guard, and a disappointed Signac felt Monet was only "drawing closer to

tradition" as he saw the brilliance and clarity of his Impressionist period (1878–82) give way to the "white, chalky and flat manner" of century's end.[17] Essentially Monet's works, at these junctures, seemed bereft of the very qualities that had initially attracted Signac: gone was "the revolutionary aspect of his work" along with his high-keyed palette and luminosity.[18]

Still in all, Monet's vision, as critics long recognized, had left an indelible imprint on Signac's art. This was for the better, in the eyes of Antoine de La Rochefoucauld, who noted in 1899 that "Signac has gained as a painter; he has come closer to Monet; but how far we are from the decorative if slightly stiff technique of Seurat."[19] Yet others, Octave Mirbeau most mercilessly, always contended that it was for the worse: whether in 1886 when he criticized Signac for being "too impressed" by Monet or when he wrote in 1894: "M. Signac began under the direct influence of Claude Monet. Afterward he tried to revive Seurat, but he has diminished him. It might perhaps be time for M. Signac, to our joy, to be willing to give us some Signac."[20] Nor was it just a question of influence but also the startling correspondence between paintings by the two artists that drew comment. Few critics avoided mention of Monet's celebrated paintings of the Thames (see fig. 52) when remarking on Signac's views of Rotterdam in 1907, whether they simply drew comparison, as did Paul Jamot, or found, like Louis Vauxcelles, the differences between "the techniques and temperaments of these two fine artists" instructive.[21] For André Pératé the relationship was inescapable, yet paramount, to his appreciation of Signac:

It is Rotterdam. . . . Oh! The first sensation of traveling in Holland! The smoke from the train that bears us into an infinity of light, so high above the smell of the waves, above the vibration of the steamers and the sails that glide in the distance! All that resonates in M. Signac's mosaic. It does not, however, make me forget M. Claude Monet's *Thames*; but it is something else, it is another light. I wonder if it pleases me so much because I collaborate with it, because I reconstitute it and create it in my own way, adapting the decomposition of the light prism to the sensibility of my own retina, and because finally my eye assimilates the elements that the painter supplies it

Fig. 54. Claude Monet, *The Grand Canal, Venice*, 1908, oil on canvas, 28¾ x 36¼ in. (73 x 92 cm). Fine Arts Museums of San Francisco, Gift of Osgood Hooker, 1960.29

Fig. 55. Paul Signac, *The Grand Canal, Venice*, 1908, watercolor, 7½ x 9⅞ in. (19 x 25 cm). Musée Marmottan, Paris, Bequest of Michel Monet, 5074

with; whereas before those marvelous pictures of the Thames I must succumb, for better or worse, to the vision of M. Claude Monet.[22]

Signac was not far behind. He too would succumb, once again and unreservedly, to Monet's vision in 1912. Apropos of a visit to the "Monet-Venice" exhibition held at Bernheim-Jeune, Signac, then forty-eight, addressed a letter to "My dear Master," which read in part:

I have had the pleasure of seeing a large number of your new works. And I experienced before your *Venices*, before the superb interpretation of those motifs that I know so well, an

emotion as perfect, as powerful as the one I felt around 1879 in the exhibition gallery of the *Vie moderne*, in front of your *Railroad Stations*, your *Paved Roads*, your *Flowering Trees*, an emotion that decided my career. A Monet has always moved me. I have always drawn a lesson from it, and in days of discouragement and doubt a Monet for me was always a friend and a guide. And these *Venices*, more powerful still, in which everything is in accordance with the expression of your will, in which no detail runs counter to the emotion, in which you have reached that inspired sacrifice that Delacroix always recommends to us—I admire them as the highest manifestation of your art.[23]

In time Signac, who enjoyed visits with Monet—and the gratification of reciprocal admiration, though late in coming and limited to his watercolors (Monet acquired four in 1921 [see fig. 55])[24]—was forced to revise his opinion, for his appreciation would go even higher. Perhaps few understood or valued Monet's last works more than Signac. "Finally, the apotheosis of his work is the Waterlilies series, in which everything is sacrificed to the play of color, shades, and tints. In these sumptuous symphonies he sums up and realizes all that he has pursued in the course of his life."[25]

No other Impressionist artist rivaled Monet for Signac's enduring veneration. Yet two artists came close: Édouard Manet and Cézanne. Signac had always reserved a special place in his affections—and equally on the bows of his boats, from the first, named *Manet–Zola–Wagner*, to his favorite, *Olympia*—for Manet. "What a painter!" Signac exclaimed in 1894. "He has everything: intelligent brain, impeccable eye, and what an easy hand!" Especially fond of the artist's early works, Signac felt that "from day to day the greatness of this painter becomes increasingly evident"; he reiterated in 1895, "I like Manet more and more."[26]

Signac's sense of Cézanne's greatness, whet at an early age when he succeeded in acquiring one of the artist's landscapes from the dealer Julien Tanguy (fig. 36), also grew stronger as time went on. The theorist who, in the 1890s, appreciated Cézanne's constructive stroke as the "connecting link between the Impressionist and Neo-Impressionist manner of execution" gave way to the watercolorist who, beginning in 1908, studied with rapt admiration

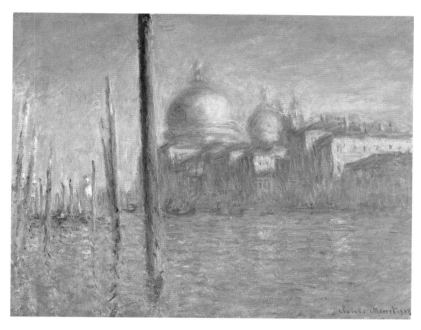

Fig. 56. Paul Signac, *Standing Bather*, after Paul Cézanne, ca. 1914, lithograph, 8 x 4¾ in. (20.4 x 12 cm), reproduced as plate VII in *Cézanne* (Paris, Bernheim-Jeune), 1914. Private collection, KW 22

Cézanne's "glorious" images.[27] In 1918 Signac confided to Félix Fénéon: "I look at them often and long—like so much that comes from this man, it's an excellent lesson and good training. . . . As in his oil painting every touch, every stroke is a victory."[28] As early as 1905 Signac placed Cézanne's artistic contribution on a par with Seurat's: "A still life by Cézanne, a cigar-box top by Seurat, these paintings are as beautiful as the *Mona Lisa* or two hundred square meters of Tintoretto's *Paradise*."[29] And this view was sustained until 1935, when Signac wrote: "But to give splendor to a plain wall, to a poor tuft of grass by means of observation, execution, shading, and contrast— these are the noble pictorial researches in which patient men like Cézanne and Seurat triumph."[30] Among the moderns, only Cézanne's name was evoked with Seurat's—no small measure of Signac's esteem.

If Signac's absorption in the works of Delacroix and Turner ineluctably led to his renewed and sustained appreciation for Cézanne and Monet, it was not without engaging his longtime affection for Renoir. The Impressionist "whose style was derived from Delacroix," as Signac often observed,[31] had never failed to charm Signac. Even the cryptic tone of Signac's critique of an

1890 exhibition was softened when it came to describing the "tenderness of a harmony pink (the background) and green (the dress)" of a Renoir portrait.[32] He delighted in Renoir's color, writing with joy about his acquisition in 1898 of "a pretty little Renoir—a trifle, the head of a woman, in pink, blue, yellow, but completely Renoir and his charm."[33] The following year, an Impressionist retrospective at Durand-Ruel allowed Signac to assess Renoir's achievement. Signac did so in glowing terms: "It is the final triumph for Renoir," he wrote. "The variety of his researches, the diversity of his compositions, in the unity of his genius. . . . The period I personally prefer is that of the years 1878 to 1882."[34] True to these sentiments, when Signac responded to a questionnaire in 1913 asking him to list his three favorite paintings in museums, he named: Tintoretto's *Paradise*, Delacroix's *Women of Algiers* (fig. 51), both in the Louvre, and Renoir's *Ball at the Moulin de la Galette, Montmartre*, then in the Luxembourg (now Musée d'Orsay) (fig. 57).[35]

To the same extent that Signac's passion for Delacroix's rich color drew him closer to Renoir, Signac's only moderate taste for the muted palette of Corot tempered his feeling for Pissarro's works, imbued as they are with a sensibility rarely betrayed in Signac's landscapes (see cat. no. 37). Signac always linked Pissarro to the painter of the Ville d'Avray. In his 1899 treatise Signac explained Pissarro's rejection of Neo-Impressionist technique: "As a direct descendant of Corot, he does not seek brilliance through opposition, as did Delacroix, but softness through the encounter of similar colors."[36] When Pissarro died four years later, Signac offered an epitaph: "Despite some quirks, this was an estimable and good man. The true type of old painter, such as we imagine the 'père Corot.'"[37] Though Signac respected Pissarro immensely, it was as much for his integrity and humanity as for his artistic efforts alone. Signac, who felt Pissarro's best period was 1882–83, was utterly disappointed by the Impressionist's late works, as he divulged in 1899: "There is no longer to be found any of the qualities of the fine colorist he used to be; neither is there the charm and splendor of the beautiful scene before his eyes."[38] At century's end Signac felt that next to Monet, Renoir, and Sisley, Pissarro "comes in only as a bad fourth."[39]

Signac always had a soft spot for Alfred Sisley. This may be traced back to Signac's teenage desire

to acquire in 1880 a lovely view of the Impressionist's Bas Meudon, and ahead to 1899, when he recorded his "pleasure to once more see at Bernheim's the pretty and crisp Sisleys of 1877. . . . There we have, jotted down with a quick stroke of the brush, reds, blues, greens, yellows, purples—all the singing gamut of the Impressionist palette."[40] In the short term Sisley would often "triumph" over Monet—as in 1899 when Signac wrote "judging by this retrospective exhibition, it is clearly revealed that he is first and foremost to have 'divided' the touch. And his paintings so treated have aged better than those of Monet."[41] However, in the long term this certainly was not the case. Favored with a long life that allowed him the luxury of historical perspective, Signac came to regard Sisley as a secondary talent, a good artist but not a great one. Such was the fate of other artists as well.

At the turn of the century Signac took stock of those who had made a lasting contribution to his own art in *D'Eugène Delacroix au néo-impressionnisme*. Guillaumin like Sisley earned an honorable mention, but Caillebotte and Degas did not even make the cut. These two artists no longer held the same appeal for Signac as they had at the start of his career. Caillebotte had befriended Signac in 1883, serving as a model for the future artist-boatsman and for the fledgling figure painter's first efforts in a genre that eventually occupied only a small place in his oeuvre (see cat. nos. 1, 2, 24, 40). Likewise, Degas's works so captivated the young Signac that he was prompted to make a copy in

1880 and to purchase a pastel perhaps as early as 1887 (see fig. 40). By the late 1890s, however, Signac's interest had cooled; he responded to Degas's recent works with guarded enthusiasm[42] and decided to sell the once-cherished pastel. Signac may have resisted, or even denied, Degas's talent for two decades (1898–1918). But late in life he assembled a collection of drawings by Degas that leaves no doubt of his sincere, and ultimately irrepressible, esteem. Degas's death in 1917 seems to have had a decisive effect on Signac's appreciation of his art. The nearly three thousand works that came to light when the contents of Degas's studio were sold in 1918–19 offered incontrovertible proof of his genius. Moreover, death conferred on the artist, whom Signac had found intolerable as a man, the status of "old master."

Unlike Degas, who was a late, great passion, or Monet, who remained his first and most abiding love, Signac seems to have written off his early devotion to Caillebotte and Guillaumin as youthful infatuation. Remarking on Guillaumin's *Landscapes of the Creuse*, exhibited at Durand-Ruel in 1898, Signac admitted: "As always very colored but without sacrifices and, then, an abuse of the 'brushstrokes.' Therefore, the pictures appear shallow and showy. I liked his painting very much fifteen years ago, at the age when one likes all exaggerations, but now I suffer from the lack of harmony. Besides, at that period, his pictures were not gaudy as they are now."[43] Guillaumin came to take a similar stance toward Pointillism

Fig. 57. Pierre-Auguste Renoir, *Ball at the Moulin de la Galette, Montmartre*, 1876, oil on canvas, 51⅝ x 68⅞ in. (131 x 175 cm). Musée d'Orsay, Paris, RF 2739

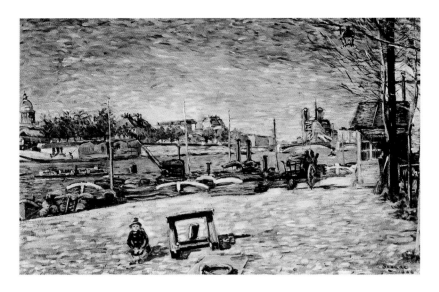

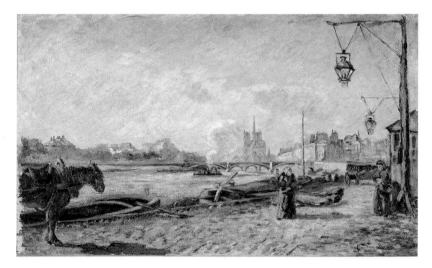

Fig. 58. Paul Signac, *The Seine, Quai d'Austerlitz*, 1884, oil on canvas, 23⅝ x 35⅞ in. (60 x 91 cm). Kakinuma Collection, Tokyo, FC 61

Fig. 59. Armand Guillaumin, *Quai de la Rapée*, ca. 1880–81, oil on canvas, 19¾ x 31⅛ in. (50 x 79 cm). Private collection

and the works of Seurat and Signac, confessing in 1914, that he had "been interested in their work at one time but that time no longer exists," and "frankly, it took too much time," he said, for him "to ever have tried it."[44]

Nonetheless from 1884, when the two artists met, until at least 1886, when factionalism resulted in petty behavior (out of loyalty to Gauguin "Guillaumin refused to shake Signac's hand"),[45] they enjoyed a close friendship. Even before this time, the impact of "M. Guillaumin's spirited and decorative hand" may be felt in Signac's art.[46] One needn't look any further than the compelling pair of works once preserved in Signac's own collection to understand the basis of their relationship. Surely Guillaumin, the only Impressionist who broke ranks with the group to exhibit at the

1884 Salon des Indépendants, could not have missed—except for the fact of its poor placement—Signac's homage to his work in *The Seine, Quai d'Austerlitz* (fig. 58), any more than the fledgling young painter could have ignored the guiding sensibility of an artist who "treats Paris as if it were Venice"—as critic Gustave Geffroy wrote of such works as Guillaumin's *Quai de la Rapée* when it was shown in 1881 (fig. 59).[47]

An autodidact, Signac naturally gravitated toward the works of other artists whose sympathies he recognized as akin to his own; this sometimes led to friendships, as in the case of Vincent van Gogh. Ten years Signac's senior, Van Gogh arrived in Paris in 1886 at age thirty-two and "did not even know what the Impressionists were"[48] and left, two years later, having weathered a crash course in modernism. Like Signac, Van Gogh benefited from Guillaumin's interest, Pissarro's support, and the lessons afforded by the always intriguing stash of artworks by fellow "dissidents" at the shop of Julien Tanguy, where the two artists met in 1887. Outings to Asnières and Saint-Ouen, where "we painted on the riverbanks" and "lunched together," were fondly recalled by Signac, along with the animated conversations he had with Van Gogh, who "shouted, gesticulated, brandishing his large, freshly painted size 30 canvas in such a way that he polychromed himself and the passersby."[49] It was largely through Signac that Van Gogh assimilated Neo-Impressionist technique, for as Seurat admitted, "I was less close to Van Gogh."[50]

The bonds that formed between the two artists, who had worked together side by side and favored similar motifs, such as the industrialized outskirts of Paris and still lifes of books, were cemented in the spring of 1889 when Signac, en route to Cassis, stopped to see Van Gogh in Arles. The "friendly and beneficial visit . . . contributed considerably to raising [the] spirits" of the disheartened Van Gogh, who, suffering the aftermath of his breakdown, had been confined to the local hospital and locked out of the Yellow House.[51] Signac succeeded in opening the door and inside "saw the marvelous paintings" that would long linger in his memory: "Imagine the splendor of those whitewashed walls from which these colors radiated in all their freshness!"[52]

A loyal friend, Signac defended Van Gogh's honor at a banquet held by Les XX in Brussels in 1890[53] and ensured, at the time of Van Gogh's

death later that year, that his legacy would be remembered. Signac arranged for a retrospective with the Indépendants in 1891 and offered to lend Octave Maus a hand in putting together a "Van Gogh exhibition" for Les XX, writing: "I am henceforth at your service. At Tanguy's there are close to one hundred canvases of the poor man, nearly all very beautiful. It would be easy, if his brother isn't able to handle it, to make a choice for Brussels."[54] While other friends had demurred from participating in such plans—among them Gauguin, who feared that it was "not at all good politics to exhibit the works of a madman"—

Fig. 60. Letter from Vincent van Gogh to Paul Signac, ca. April 5, 1889, ink, 8¼ x 10⅝ in. (21 x 27 cm). Private collection (letter 583b)

Émile Bernard also stepped forward by helping to mount memorial shows in 1890 and 1892 in Paris.[55]

Ironically Van Gogh, in life, had been unable to reconcile the differences between these two friends, despite his best efforts in the summer of 1887. "If you have already thought Signac and others who use Pointillism quite often do very fine things," Van Gogh wrote to Bernard, "instead of slandering them you must respect them and speak sympathetically of them, especially if there has been a quarrel. Otherwise one becomes a sectarian, narrow-minded oneself, and the equal of those who utterly despise all others and believe themselves to be the only just ones."[56] The advice fell on deaf ears. Bernard, at first "happy to know [Signac]," found "that while the method was good for the vibrant reproduction of light, it spoiled the color." He "instantly adopted an opposite theory,"[57] destroyed all of his pointillist studies, and like Gauguin—who referred to Signac as "a traveler in little dots"—made no secret of his contempt for Neo-Impressionism.[58]

It is telling that after having spent weeks in Gauguin's company, Van Gogh in the spring of 1889 was surprised to find "Signac very quiet, though he is said to be so violent; he gave me the impression of someone who has balance and poise, that is all. Rarely or never have I had a conversation with an impressionist so free from discord or conflict on both sides."[59]

Perhaps these excerpts answer the riddle of how Van Gogh and Signac succeeded in being friends at a time when mutual sympathies were certainly no guarantee that the efforts of one "original colorist," as Van Gogh described Signac, would be valued by the other.[60] Undoubtedly it was Signac's pure love of art as art that spared him the kind of sectarianism that one might expect from so staunch an advocate of Neo-Impressionism. The priority he always gave to the fundamental formal qualities of a work of art may well have had a democratizing effect on his judgments, if not the ability to appreciate, and precociously, the achievement of Van Gogh, the merits of Odilon Redon, and the late paintings of Monet.

Signac's passion for color was always held in check by an equal insistence on formalism (he virtually advocated nonobjective art by 1935). Long before he stated implicitly that "for the painter the only important thing is the pictorial subject,"

he submitted works to the 1888 exhibition of Les XX providing as titles only opus numbers (see fig. 61). "Wouldn't it be preferable," Signac asked, "if instead of being encumbered by a subject and a title, the painter, like the musician, were to title his work *Op. no.* . . . ? His repertoire would thus be infinitely varied and his freedom would not be restrained by the subject."[61] For Signac, nature—or the picturesque subject—was only a pretext for chromatic compositions, as it was in the works of Van Gogh and, ultimately, the Impressionist painters he held most dear: Monet and Cézanne, who fixated on a decreasing repertoire of motifs, or Renoir, who gave up plein air studies to compose paintings in the studio. In front of nature, Signac wrote, "genius simplifies, eliminates, sacrifices. It knows that there are always too many objects; that there are never any pictures that are too simple; that there are no beautiful paintings without beautiful *matière,* and that the *matière* is more important than the subject, the objects, and the literature."[62]

It stands to reason that Signac had little taste for paintings that sought to illustrate an idea or convey a religious message. He was wary of the pretension and insincerity of Gauguin's abstractions and was "stupefied at the platitude and imbecility" of fin-de-siècle academic painting, noting that on a visit to the Salon of 1897, he saw "subjects, illustrations, anecdotes—but not one beautiful line, not one beautiful color."[63] Such biases mitigated his enthusiasm for Henri de Toulouse-Lautrec's works, which he felt were governed by a more literary than painterly sensibility and were lacking in artistic virtues. Comparing Lautrec with Renoir, he concluded: "one [Renoir] has all the qualities of a fine painter, the other all the wit of a man of letters with the métier of a caricaturist."[64] Yet perhaps the most compelling demonstration of the premium Signac placed on the pictorial qualities of works of art is revealed in his remarks on Redon. Writing about a "very good Redon" that he admired for its "studied lay-out, the unexpected character of the arabesques, the superb quality of the blacks and whites, their perfect arrangement," Signac admitted: "I do not know what it represents. But be it a peasant woman or a symbol . . . it is good art."[65]

In general, Signac was dubious of the value of paintings by the so-called *Symbolards*—a catchall for "those who paint not what they see but what they think."[66] He found the works pompous,

Fig. 61. Paul Signac, Handwritten list of his paintings exhibited at the Salon des XX, Brussels, in 1888. Centre International pour l'Étude du XIXe Siècle, Brussels

superfluous, dreary, unpainterly—quite simply "junky."[67] He resented the relative ease of the Symbolists' success, unable to fathom the artistic merit or accept the novelty of their meager contribution: "it seems to me harder to make the public swallow their wretched and deceptive deformations than the blue locomotives and orange-tinted trees of Monet."[68] Their abstract visions paled, in every respect, to the triumphant (and, for the Impressionists, hard-won) victories over nature that characterize the works of all great artists.

Signac's journal records his despair in front of the "abominations" by Paul Sérusier and Georges Lacombe at the Indépendants in early 1895; the "wretched deformations of the Symbolists" at the Barc de Boutteville that May; and the "poor impression [that] all this is black and dirty and unattractive" he felt at Ambroise Vollard's show in 1898 where he found little pleasure in Édouard Vuillard's work and less still in the "little rags" by Bonnard, the "miserable imitations of the Florentines" by Maurice Denis, and "the most antiartistic pictures that can be" by Félix Vallotton.[69] Signac, however, did not dismiss these efforts out of hand. His writings reveal a more complex,

ambivalent, and telling reaction to the works of those painters known as the Nabis.

Between 1895 and 1899 Signac struggled not only to appreciate the art of Vuillard, Denis, and Bonnard but to accept the direction—a wrong turn?—that modern art had taken. "It seems that the influence of the Impressionists is finished and that the literary road—symbolic, black, gray, dull—is followed instead."[70] However, time and again, his criticism is tempered by a second look—at their efforts and back again at his own—and by a recognition of strengths and weaknesses on both sides.

Signac, writing with obvious affection for the man and his art, had this to say about Vuillard in 1898: "He is a subtle and intelligent chap, a nervously sensitive and searching artist. . . . He understands perfectly the inner voice of objects. They are by a beautiful painter, these pictures of a mute polychromy in which there always breaks out a colorful accent that regulates the harmony of the work." Yet Vuillard is

on the plateau which inclines too much toward fantasy and not in the other direction. We are tied down by the need for reality while he, because of too much fantasy, has to be satis-fied with little studies and is hardly able to go any further. His figures are shapeless—he can draw admirably, and if he makes neither mouths, nor hands, nor feet, it is because he doesn't want to. His pictures rather have the air of sketches. . . . We give too much preci-sion, he not enough, it seems to me. We suffer from opposite evils.[71]

Likewise Signac was struck in 1898 by the "charming inventiveness" of Denis's decorations. Though he felt that they "have more literary than artistic qualities" and suffered from an abuse of "dead and lusterless tints," in the end, he resolved, "one must fully admire the grace and intelligence of that art and especially the exquisite fantasy and freedom of the artist.—He is free, and quite free. He has what we lack. Unfortunately, he lacks what we have."[72] Signac's receptivity to the works of these young artists was reciprocated in kind. Denis was among the first and indeed one of the few to admire not only Signac's watercolors but also his paintings; moreover, he appreciated—with remarkable sensitivity—their respective places in Signac's oeuvre. Perhaps it took the like-

minded temperament of another artist-theorist to observe in 1905:

With Impressionism behind him Signac refined its theory, adapting it to his own sub-jectivity; and in those rapid, casual syntheses that are his watercolors—a kind of shorthand after nature—he deployed all his instinctive allurements, all the most attractive subtleties of pure color. He shows in this way his quite romantic taste for bold arabesques, movement, and brilliance. But when through the artifice of a strictly homogeneous composition, through a system of contrasts, he transforms his airy notations into paintings, far from causing the initial charm of the sketches to vanish, this process confirms its beauty, intensifies its joy.[73]

This notion of intense joy provides an apt segue to the third Nabi artist, Bonnard—for it describes just how Signac felt in front of the painter's works, albeit not at first but eventually. Initially Signac, as he confessed in 1899, simply could not see the charm of Bonnard's works, "in spite of all the good that is told me about him by Vuillard . . . to me the shape seems ugly, the color dirty, the arrangement banal."[74] Bonnard's charms would not escape him forever, and once he was seduced, the affection was lifelong. In the summer of 1933, Signac wrote: "Left Paris with the joy of Bonnard's exhibition in my heart. It makes one feel like painting. . . . Painting for painting's sake, nothing else. It's time one had something to like."[75]

Bonnard's works became one of the greatest pleasures of Signac's later years. He followed the younger painter's development with keen interest for the next quarter century, his enthusi-asm renewed on each occasion from 1909 until 1933 when one-man shows gave him the time to "spend some delightful moments" in the com-pany of paintings that he found so full of life.[76] One senses from Signac's profound admiration for Bonnard's works—which he described in 1909 as freely brushed yet masterfully orchestrated, playful yet intelligent, as beautiful in their overall effect as in individual details seen up close—that he had found a painter who approximated his ideal: one completely in control of his means but with such ease and seeming casualness of execu-tion that his results were disarming. Signac did

not keep these sentiments to himself; he conveyed them in print and in personal notes of congratulation, such as the one he sent, two years before he died, to Bonnard apropos of his show at Bernheim-Jeune in 1933: "Prodigious. The unexpected, the rarity, the new. I swear to you, my dear Bonnard, that since 1880 when I 'discovered' Claude Monet, I've never had such a great emotion from art. And the same impression: 'How easy that must be to do.' You understand a little what I want to say! And it was time to see that. What a lesson, what encouragement. You give me new strength."[77]

The close friendship that existed between the two men is documented in photographs (see fig. 62), in the younger painter's lively evocation of their joint outings at sea (see fig. 32), and in his expression of mutual esteem: "Signac represents the great realizer of colored structures and magnificent arrangements, in reaction against base realism and also the unconscious realism of the Impressionists."[78]

A number of younger artists would claim Signac's affections, and he theirs, but next to the "great emotion" that he felt for Bonnard—which he equated with his feeling for Monet—Signac seems to have reserved a special place for Matisse, analogous to the one he had reserved for Cézanne among the Impressionist painters whom he admired. In Signac's ultimate text on painting, published in 1935, the year of his death, he wrote that passion and logic were the essential qualities of creative genius. Having paired the sensibilities

of Turner and Monet, and conversely, Cézanne and Seurat, he arrived at Bonnard and Matisse. He distinguished Bonnard's approach "where love triumphs over reasoning," from that of Matisse, "where logic triumphs over sensibility."[79] Signac the watercolorist and the painter—not unlike Signac the art enthusiast—had, of course, embraced both tendencies.

Receptive to the work of his junior colleagues and invigorated by their company, Signac enjoyed the companionship and respect of a steady stream of artists who wished to take up the challenge he had presented at the end of *D'Eugène Delacroix au néo-impressionnisme*: "If there has not yet emerged among [the Neo-Impressionists] the artist who, by his genius, will impose this technique, at least these painters will have served to simplify his task. This triumphant colorist has only to appear; his palette has been prepared for him."[80]

Matisse, who had avidly read the treatise upon its publication in *La Revue blanche* in 1898 and was "fired with enthusiasm by the luminous exhibition" of Signac's watercolors, arranged on the heels of their meeting at the 1904 Salon des Indépendants, to spend that summer in Saint-Tropez.[81] At the age of thirty-four Matisse was ready, indeed eager, to pick up the "palette [that had] been prepared for him," and Signac, six years his senior, was happy—as was Henri Edmond Cross—to encourage the experiments of this talented younger artist in their style. Signac was especially impressed by the seriousness of Matisse's work habits; thirty years later, he described step-by-step the like-minded painter's reflective and methodical approach.[82] However, whatever promise that he saw of a would-be disciple in *Luxe, calme et volupté* (fig. 47)—a prized work in Signac's collection—was quashed with the debut of Matisse's *Joy of Life* (fig. 63) at the Salon des Indépendants in 1906, for this is when, as Matisse later put it, "Fauvism overthrew the tyranny of Divisionism."[83]

Matisse's change of direction was met with bitter disappointment on Signac's part[84] but seemed an inevitability to Cross[85] and to critic Louis Vauxcelles, who, between 1904 and 1906, had vigilantly tracked the development of "one of the most gifted artists of the rising generation."[86] Vauxcelles followed Matisse's work from sketches of 1904 "with their pure singing reds and blues [that] once recalled the watercolors of Signac" to his sudden "incursion into the realm of the theoreticians of the 'dot,'" exemplified at

Fig. 62. The Bonnards sailing with Signac, ca. 1914, photograph; from left to right: Marthe Bonnard, Jeanne Selmersheim-Desgrange, Signac, and Bonnard. Signac Archives

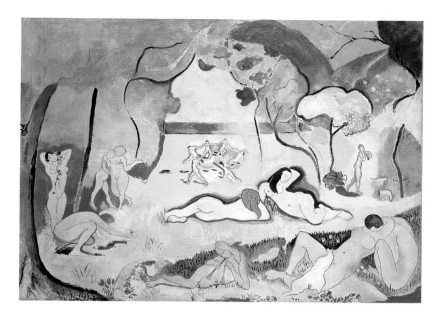

Fig. 63. Henri Matisse, *Joy of Life*, 1905–6, oil on canvas, 68⅞ x 94½ in. (175 x 240 cm). The Barnes Foundation, Merion, Pennsylvania

the 1905 Salon des Indépendants by *Luxe, calme et volupté*. Chastising Matisse by recalling the "touching experience of old Pissarro," Vauxcelles wrote that "your gifts are too magnificent, mixing and balancing intuitive sensations and will, for you to lose your way in experiments which, though admittedly sincere, run counter to your true nature."[87] By 1906 Matisse's submissions to the Salon d'Automne would mark another stage in his path. Vauxcelles observed: "Today [Matisse] seems to heed not the suggestion of M. Paul Signac, but the perilous constraint of M. Derain. He has abandoned the dot and ended up with coloration through flat planes. His canvas, which will not be understood, is called *Joy of Life*."[88]

Many of the emergent Fauves, for whom Neo-Impressionism was almost a rite of passage, would follow the same path toward an art of color that led Matisse to Signac's door in 1904. For those who came in Matisse's stead—like Albert Marquet, Charles Camoin, and Henri Manguin—and

for Louis Valtat, who lived nearby, or Kees van Dongen in the Netherlands, there was always a welcome mat. The lively interest that Signac showed in the works of these younger artists was reflected in his collection.[89]

Beyond those who enjoyed the fraternity of "painting and gossiping in the enchanted land," as one critic described the "valiant little colony" that took shape nearby Signac's studio in the south of France,[90] there were other artists who had ties to Signac—of a less intimate, but still consequent nature. This broader circle, including both colorists and formalists, was not limited to one "ism" in the international movements that sprung up in the early twentieth century. Among those recognized as having been inspired by the scintillating surfaces of his late mosaic-like style we count Robert Delaunay and Jean Metzinger as well as Piet Mondrian and Giacomo Balla. His influence was two fold, as a theorist and as a painter: Vasily Kandinsky, in *Concerning the Spiritual in Art*, acknowledged his debt to Signac's treatise with three footnotes, while Emil Nolde remarked: "The great French artists, Manet, Cézanne, Van Gogh, Gauguin and Signac, are those who have opened the way."[91]

However much Signac may have "opened the way" for the achievements of those that followed him, the route he took was very much his own. Amédée Ozenfant, who literally met Signac on a roadside, on his way south in 1914, fondly described "this determined rationalist who avoided chance so religiously in his art. . . . In painting he insisted on his method, fundamentally that of his friend Seurat, but . . . Signac allowed mixtures [of colors] and above all he used much larger and more authoritative mosaic touches, in keeping with his character. For in the end he was Signac, athlete, yachtsman, and a gentleman who knew what he wanted."[92]

NOTES

1 Letter from Pierre-Auguste Renoir to Signac, November 10, 1911, written when Renoir, who had just been promoted to *officier* to the Legion of Honor, agreed to represent Signac's becoming a *chevalier*; quoted in White 1984, p. 251. Renoir had expressed the same sentiments earlier, as a delighted Signac reported in his journal entry of January 16, 1895: "Renoir could not be kinder; he tells me that he is very happy to see me again, congratulates me on the conscientiousness of my research and asks me to call him . . . simply Renoir" (see Rewald 1949, p. 171). Renoir, however, never feigned appreciation for Signac's paintings; his aversion to Neo-Impressionism was well-known and long-standing.

2 Picabia 1922, written a few months after Signac had rejected his work from the Indépendants, quoted in Camfield 1979, p. 187.

3 Signac 1888a, p. 3.

4 Signac 1899 in Ratliff 1992, pp. 239–40.

5 See Cachin 1971, p. 81.

6 Signac journal entry, May 5, 1899, in Rewald 1953, p. 79.

7 Letter from Vincent to Theo van Gogh, ca. September 17, 1888, in Van Gogh 1958, vol. 3, pp. 44–45, letter 539.

8 Van Gogh, quoting from an article by Théophile Silvestre, in a letter to Anton van Rappard, September 1885, in Van Gogh 1958, vol. 3, p. 422, letter R58; see also a later letter from Van Gogh to Émile Bernard, end of July 1888, in ibid., p. 506, letter B13; and Van Gogh's paraphrasing of Delacroix's "saying" in letters to Theo, both September [1889], in ibid., pp. 203, 208, letters 604, 605.

9 Paul Gauguin's unpublished manuscript, "Diverses Choses," cited in New York 1997–98, p. 56.

10 Signac 1899 in Ratliff 1992, p. 230; see also Signac 1935, p. 156.

11 Félix Fénéon quoted in Signac 1899 in Ratliff 1992, p. 265.

12 Signac 1899 in Ratliff 1992, p. 239 and elsewhere.

13 Quoted in Kunstler 1935, p. 4.

14 Undated letter from Signac to Claude Monet, presumably written in the wake of Monet's 1883 show at Durand-Ruel, reprinted in Geffroy 1980, p. 175, and translated in Rewald 1961, p. 503.

15 Signac quoted in Kunstler 1935, p. 4.

16 Condolence letter from Signac to Blanche Hoschedé-Monet, December 8, 1926, reprinted in Hoschedé 1961, p. 56.

17 Signac journal entry, January 13, 1899, in Rewald 1953, p. 75.

18 Kunstler 1935, p. 4, quotes Signac as saying: "What attracted me about this artist was the revolutionary aspect of his work."

19 Letter from Antoine de La Rochefoucauld to Émile Bernard, March 28, 1899, reprinted in Rewald 1953, p. 78, and fig. 13 on p. 47.

20 Mirbeau 1886, reprinted in Mirbeau 1993a, p. 277; and Mirbeau 1894, p. 1, in Mirbeau 1993b, p. 52.

21 Jamot 1907, p. 28; Vauxcelles 1907b, pp. 1–2.

22 Pérat 1907, quoted in Paris 1963–64, pp. 78–79.

23 Letter from Signac to Claude Monet, May 31, 1912, reprinted in Geffroy 1980, p. 424; Monet replies on June 5: "The opinion of some, of whom you are one, is precious to me." See Wildenstein 1985, vol. 4, p. 385, no. 2014.

24 These watercolors were bequeathed by Michel Monet to the Musée Marmottan, Paris (nos. 5032, 5046, 5058, 5074 [fig. 55]); see Chronology, under 1921.

25 Signac 1935, p. 8, reprinted in Cachin 1964, p. 158.

26 Signac journal entries, December 14, 1894, January 4, 1895, in Rewald 1949, pp. 170–71.

27 Signac 1899 in Ratliff 1992, p. 260; see also Signac journal entry, December 21, 1908, in Signac 1947, p. 80.

28 Letter from Signac to Félix Fénéon, October 9, 1918, Signac Archives.

29 Signac's reply to Charles Morice's questionnaire was originally published in the Mercure de France in the summer of 1905, reprinted in Dagen 1986, p. 115; cited in Paris–London–Philadelphia 1995–96, p. 42.

30 Signac 1935, p. 9, reprinted in Cachin 1964, p. 161.

31 Signac 1899 in Ratliff 1992, p. 239.

32 Signac 1890, p. 77.

33 Signac journal entry, December 23, 1898, in Rewald 1953, p. 74.

34 Ibid., April 22, 1899, in Rewald 1953, p. 79.

35 The questionnaire was circulated by Louis Vauxcelles; on this subject, see the chronology by Marina Ferretti-Bocquillon in Cachin 2000, p. 383 (under December 1913–January 1914).

36 Signac 1899 in Ratliff 1992, p. 251.

37 Letter from Signac to Charles Angrand, November 17, 1903, quoted in Lespinasse 1988, p. 157, n. 2.

38 Signac journal entry, February 21, 1899, after visiting Pissarro's studio, in Rewald 1953, p. 76.

39 Ibid., April 22, 1899, in Rewald 1953, p. 79.

40 Ibid., February 21, 1899, in Rewald 1953, p. 76.

41 Ibid., April 22, 1899, in Rewald 1953, p. 79.

42 See n. 64 below.

43 Signac journal entry, April 27, 1898, in Rewald 1952, p. 303.

44 Borgmeyer 1914, p. 63.

45 Letter from Camille Pissarro to his son Lucien, December 3, 1886, in Bailly-Herzberg 1980–91, vol. 2, p. 86, letter 36.

46 Signac 1888a, p. 3.

47 Geffroy 1881, p. 3.

48 Letter from Vincent van Gogh to [H. M.] Levens, August–October 1887, in Van Gogh 1958, vol. 2, p. 513, letter 459a.

49 Letter from Signac to Gustave Coquiot 1923, reprinted in Stein 1986, p. 89.

50 Letter from Georges Seurat to Maurice Beaubourg, August 28, 1890, reprinted in Stein 1986, p. 90.

51 Letter from Vincent van Gogh to Signac, ca. April 5, 1889, in Van Gogh 1958, vol. 3, p. 149, letter 583b. The original, illustrated letter (fig. 60), remained with Signac until his death along with the still life of herrings that Van Gogh had given him as a keepsake (see fig. 37).

52 Letter from Signac to Gustave Coquiot, 1923, reprinted in Stein 1986, p. 136.

53 Following Lautrec's lead, Signac rallied to the defense of Van Gogh, whose works were maliciously attacked as those of an "ignoramus and charlatan" by academic painter Henry de Groux at the time of the vernissage of Les XX in 1890. A duel nearly ensued between the insult-hurling De Groux and Lautrec,

who retorted "that it was an outrage to criticize so great an artist." As Octave Maus recalled: "Seconds were appointed. Signac announced coldly that if Lautrec were killed he would assume the quarrel himself." See Rewald 1978, pp. 346–47.

54 Letter from Signac to Octave Maus, October 23, 1890, in Maus 1926, pp. 119–20, n. 2.

55 Bernard 1911, preface, reprinted in Stein 1986, p. 239, and see ibid., p. 240, for Gauguin's January 1891 letter to Bernard, calling such plans "idiotic."

56 Letter from Vincent van Gogh to Émile Bernard, summer 1887, in Van Gogh 1958, vol. 3, p. 476, letter B1.

57 Bernard's unpublished notes, cited in Rewald 1978, p. 52.

58 Paul Gauguin to Émile Bernard, ca. November 9–12, 1888, in Merlhès 1984, p. 274, no. 178.

59 Letter from Vincent to Theo van Gogh, March 24 [1889], in Van Gogh 1958, vol. 3, p. 143, letter 581.

60 Ibid., undated [1888], in Van Gogh 1958, vol. 3, p. 44, letter 539.

61 Signac 1935, p. 8, reprinted in Cachin 1964, p. 159.

62 Ibid., p. 156.

63 Signac journal entry, April 22, 1897, in Rewald 1952, p. 299.

64 Ibid., May 15, 1902, in Signac 1947, pp. 75–76, where, reflecting on Lautrec's one-man show in 1902, he agrees with the sentiments of a contemporary critic (Fagus in La Revue blanche). Signac did not deny the strength of Lautrec's vision, but felt that the sentiment "is more of a literary than painterly order. There are no grand, beautiful lines there, no beautiful harmonies, nothing of what constitutes good painting; but meager forms, meager colors, put to work by a droll spirit and a skilled hand." Subject to the same criteria, Lautrec's works fared somewhat better than those of the Salon painters in 1897 but at least a notch or two below Degas, whose late efforts drew Signac's praise as well as criticism. Signac found them "very beautiful" especially in color, but lacking in finish and resolve: "it is all scraps . . . these are studies for pictures, but not pictures . . . the stroke is confused and complicated." Signac journal entry, February 11, 1898, in Rewald 1952, p. 301.

65 Ibid., September 15, 1895 in Rewald 1949, p. 174. Later commenting on "Redon pastels, with ingenious chromatic arrangements," Signac confided "a lot of people see nothing but literature, whereas he seems to me to have pursued strangeness only to reach the unexpected and thus be free to handle tints as he pleases." Refuting the general view, Signac admired Redon in his terms—as an artist who exploited the subject (i.e., "strangeness") as merely a pretext for the play of color, line, and form; ibid., March 15, 1899, in Rewald 1953, p. 77.

66 Ibid., February 3, 1895, in Rewald 1949, p. 171.

67 Ibid., April 26, 1895, in Rewald 1949, p. 172; see also entries of May 6, 1895, in Rewald 1949, p. 173, and April 24, 1897, in Rewald 1952, p. 299.

68 Ibid., May 6, 1895, in Rewald 1949, p. 173.

69 See respectively, Signac journal entries, April 26, 1895, May 20, 1895, in Rewald 1949, pp. 172–73, and April 1898, in Rewald 1952, p. 302.

70 Ibid., April 24, 1897, in Rewald 1952, p. 299.

71 Ibid., February 16, 1898, in Rewald 1952, pp. 301–2.

72 Ibid., April 25, 1898, in Rewald 1952, p. 303.

73 Denis 1905, reprinted in Denis 1920, p. 194.

74 Signac journal entry, March 15, 1899, in Rewald 1953, p. 77.

75 Ibid., June 29, 1933, quoted in Cachin 1971, p. 119.

76 Ibid., February 6, 1909, in Signac 1947, p. 80.

77 Letter from Signac to Pierre Bonnard, summer 1933, in Terrasse 1988, pp. 180, 190, ill. p. 287.

78 Bonnard quoted in Luce 1938, p. 8.

79 Signac 1935, p. 10, reprinted in Cachin 1964, p. 163.

80 Signac 1899, as translated in Cachin 1971, p. 83.

81 According to the testimony of Jean Puy, as cited in Cachin 1971, p. 83, whose chapter on "Matisse and Fauvism" was invaluable to the brief summary provided here.

82 See Signac 1935, p. 9, reprinted in Cachin 1964, p. 163.

83 Matisse as quoted in Tériade 1929, cited in Flam 1978, p. 58.

84 Before he came to terms with Matisse's Fauvist style, Signac railed against Joy of Life, attacking the introduction of cloisonnist outlines "as thick as your thumb" around "flat, smooth colors which, however pure, seem disgusting." For his negative reaction to the painting, see the often-quoted letter from Signac to Charles Angrand, January 14, 1906, in Flam 1988, p. 51, and further testimonies cited in Barr 1974, p. 82, and Bock 1981, pp. 84, 93 (for Matisse's conciliatory letter to Signac of July 14, 1905).

85 Apparently Cross, who was less miffed than Signac, had sensed that Matisse's Neo-Impressionist phase would be short-lived. As Matisse later recalled: "Cross told me that I wouldn't stick to [divisionist] theory, but without telling me why. Later I understood. My dominant colors, which were supposed to be supported by contrasts, were eaten away by these contrasts, which I made as important as the dominants. This led me to painting with flat tones: it was Fauvism." (See Tériade 1951, cited in Flam 1978, p. 132, and Flam 1988, p. 46.)

86 Vauxcelles 1906 in Flam 1988, p. 51.

87 Respectively, Vauxcelles 1904 and Vauxcelles 1905 in Flam 1988, pp. 45–46.

88 Vauxcelles 1906 in Flam 1988, pp. 51–52.

89 See Marina Ferretti-Bocquillon's essay, "Signac as a Collector," in this volume, pp. 62–64.

90 Louis Vauxcelles's description of 1905, mentioning Signac, Cross, Camoin, and Manguin, cited in Cachin 1971, p. 87.

91 Nolde in a letter of 1908, quoted in Münster-Grenoble-Weimar 1996-97, p. 267.

92 Ozenfant 1968, p. 78.

PAUL SIGNAC,
IMPRESSIONIST PAINTER,
1882–1885

PAUL SIGNAC, IMPRESSIONIST PAINTER, 1882–1885

Paul Signac was born in Paris in 1863 into a well-to-do bourgeois family. Both his father and grandfather had prospered in the luxury saddlery business and could boast of having the emperor Napoléon III as a client. The family soon moved from the Bourse district to the rue Frochot in Montmartre, a private street known for the famous stage celebrities and artists who lived and worked there.

The neighborhood in which Paul Signac grew up lent itself well to nurturing a vocation in the arts, and as an only child he enjoyed the support of his liberal parents. As an adolescent, Signac was attracted by Impressionist paintings in gallery windows and went to the exhibitions held by the painters, then considered revolutionaries. In 1880, at the age of sixteen, he was thrown out of the fifth Impressionist exhibition by Gauguin for making a sketch after a picture by Degas and was told disdainfully that "one does not copy here, sir."[1]

During the same year Signac suffered the great loss of his otherwise happy childhood: his affectionate and attentive father, Jules Signac, died of tuberculosis in Menton. His mother, Héloïse Signac, and his grandfather sold the business and moved to Asnières, a new residential suburb of Paris. Although a good student, Paul Signac left school and rented a room in Montmartre, dividing his time henceforth between the city and Asnières.

The windows of the Signac house in Asnières looked out on a garden, the Seine, and the smokestacks of the factories in Clichy. This heterogeneous landscape appears clearly in an aerial photograph taken by Commander Fribourg in 1885 (fig. 75). The two bridges at Asnières—the railroad and the roadway—connected two completely different worlds: on one side was the residential section with its houses and gardens, and on the other were the factories, coal cranes, and gas tanks of Clichy. The aerial view also shows the new marinas upstream and the tip of the island of La Grande Jatte.

The banks of the Seine were to inspire many paintings, drawings, and watercolors by the young painter, but his earliest joy there was boating. His first boat was a canoe that he christened *Manet-Zola-Wagner*, a name expressing his youthful enthusiasm for modernity and artistic independence, as well as his indecisiveness over his own vocation. A career in music was, however, out of the question; Wagner's name was intended only as a provocation. With the exception of a few songs sung with his cabaret friends at the Chat

Noir, which he began frequenting regularly in 1881, Signac never manifested any musical ambitions and in his later years preferred the *Three-Penny Opera* to more sophisticated works.[2] His choice was between painting and literature.

Through his childhood friend Charles Torquet, Signac soon came into contact with literary circles, meeting the Naturalist writers at the Brasserie Gambrinus and evening gatherings at Robert Caze's home. In this way he met Paul Adam, Jean Ajalbert, Joris-Karl Huysmans, and Paul Alexis. He also became the friend of the critics Félix Fénéon and Gustave Kahn. These writers were later to become staunch supporters of Neo-Impressionism. In 1882 Signac wrote pastiches satirizing the ponderousness of Zola's style, though he had been an admirer of it shortly before.[3] Within a few years he assembled an impressive library of luxuriously bound books by Naturalist and Symbolist authors.[4] Signac never lost his fondness for literature, and his correspondence and writings show that he had a sharp, concise, and lively style of his own. The incident with Gauguin notwithstanding, the young Signac continued to visit avant-garde exhibitions, and this activity ultimately led to his choice of vocation.

Signac later said that the paintings of Claude Monet at the June 1880 exhibition in the offices of *La Vie moderne* led him to opt for the career of a painter.[5] He chose to be an Impressionist painter because of his liking for Monet, the outdoors, novelty, and independence. His first works date from the winter of 1881–82, when he was barely eighteen. Except for a brief stint at the "free studio" run by Émile Bin, he had no formal art instruction but devoted himself to the study of the works of Manet, Monet, Degas, and Caillebotte. As early as 1882 he produced his first series of brightly colored, rapidly painted studies. He tried his hand at the human figure and had his friends and young companion, Berthe Roblès, pose for him (cat. no. 3). His initial pictures display the mistakes and difficulties of the youthful autodidact, as we see in the curious lost profile and back devoid of volume in the portrait of Charles Torquet (cat. no. 2). Yet there were also some triumphs, like the still life in the same portrait. His first landscape efforts were more successful. He chose for his subjects the sites that were most familiar to him: the Seine, Montmartre, Clichy, Asnières. In the summer he left

Paris and traveled to Port-en-Bessin or Saint-Briac and painted on the seacoast, like so many other painters. His *Road to Gennevilliers* from 1883 (cat. no. 4) shows a precocious mastery of composition and lighting. It demonstrates that Signac was already familiar with the laws of color contrast established by Chevreul.

The Monet exhibition of March 1883 in the boulevard de la Madeleine had a direct influence on the studies painted by Signac at Port-en-Bessin the following summer. By this time Signac was painting quite acceptable Impressionist works. He had learned very quickly, even though his paintings still reflected his many sources: Monet, of course, in his seascapes and outdoor scenes, but also Caillebotte, whose compositions he sometimes quoted directly. His early production displays two characteristics that were to mark his work as a whole: a pronounced taste for frontal, geometric compositions with little perspectival depth and an unmistakable fondness for color.

In 1884 Signac participated in the first Salon des Artistes Indépendants. There he met Georges Seurat, who showed his *Bathers at Asnières* (fig. 2), which had been rejected by the official Salon, as well as his future Neo-Impressionist comrades: Charles Angrand, Henri Edmond Cross, and Albert Dubois-Pillet. Then came his first meetings with two painters he admired very much: he met Armand Guillaumin on the quays of the Seine shortly after the 1884 exhibition and Camille Pissarro in the following year. Both helped him with advice and influenced his current work more directly than had Seurat, whose impact was not yet apparent in his paintings. This was not the case with his drawings, however. By 1885, Signac had begun to try his hand at drawing with Conté crayon and produced works that clearly point to those of Seurat.

In 1884 Seurat had started work on a large-format painting, *A Sunday Afternoon on the Island of La Grande Jatte* (fig. 3), but without using the divisionist technique. As noted, Signac had an interest in Chevreul's color theories and his "masters" were still the Impressionists. He regularly met with Seurat; both painters admired Delacroix and read Charles Blanc's *Grammaire des arts et du dessin,* as well as the optical treatises of David Sutter and Ogden Rood. Both paid a visit to Chevreul.[6] In August 1885 Charles Henry published his "Introduction à une esthétique scientifique," which argued for an art based on scientific principles.

As a result of Henry's study of perception, Seurat started using his technique of "optical mixture." In October–November 1885 he applied tiny dots of pure color, which, it was thought, the spectator's eye would recompose at a distance. Signac's interest in color is generally recognized as having contributed to this discovery, and the young Impressionist painter probably stimulated his friend's own interest in this area. Nevertheless Seurat remains the inventor of the divisionist technique, a fact he stressed on a number of occasions, although Signac never called his precedence into question. Seurat began using Divisionism in fall 1885 in his Parisian studio when he reworked the paintings he had done in Grandcamp during the summer. *A Sunday Afternoon on the Island of La Grande Jatte*, which, according to Seurat, was ready for exhibition in March 1885,[7] was completely reworked in November to give it a pointillist appearance.

By December the future Neo-Impressionists were the talk of the ateliers. Guillaumin wrote to Pissarro: "Not knowing or practically not knowing what Seurat and Signac were doing, Degas must have been a bit worried by what he heard."[8] Preparations for the eighth and last exhibition of the Impressionists were under way. Ultimately both Seurat and Signac were represented despite the initial opposition of Degas and Eugène Manet, the painter's brother and the husband of Berthe Morisot.[9]

Also in December 1885 Signac undertook his first major interior scene, *The Milliners* (fig. 4). In it he depicted a world which he had come to know through Berthe Roblès, who was herself a milliner and who posed for the figure on the left, bending to pick up her scissors. The painting, exhibited in May 1886 with the title *Apprêteuse et garnisseuse. Modes (rue du Caire)* (Finisher and trimmer. Millinery [rue du Caire]), shows a milliner's workshop in the Sentier quartier, which is still the garment district of Paris. The precise descriptions "finisher" and "trimmer" show that Signac proceeded in the same way as his friends the Naturalist writers—Huysmans, for example, described a dressmaker's shop in *Les Soeurs Vatard*—informing himself about the trade and its terminology.

Signac knew these milliners and was able to observe their habitual gestures and activities, as Degas had done before him with ballet dancers and laundresses, as well as milliners (depicting the last

as early as 1882). Several years later Antoine de La Rochefoucauld, probably informed by Signac himself, pointed out that *The Milliners* was painted in the same color harmony as Delacroix's *Women of Algiers* (fig. 51), a fact that had gone unnoticed by the critics of 1886.[10] And yet Delacroix had been in the news in 1885, when Signac began painting this scene: a major exhibition of his paintings was held at the École des Beaux-Arts in March–April, and Alfred Robaut's first catalogue raisonné of his paintings, drawings, and graphic work also appeared in that year. Indeed, the blue and red of the dress of the black servant in *Women of Algiers* reappear in the figure on the left in Signac's painting. The rich tonality comes from the use of a wide range of pure colors and a fondness for red and yellow, as in the Delacroix. In both paintings the white in the center lightens the other colors. Nor is the subject matter as different from Delacroix's as one might think. The artist chose to evoke a closed, feminine world in this Naturalist harem, the Parisian version of *Women of Algiers* transposed to the workshops of the rue du Caire. Yet Signac's painting is as devoid of literary allusions as it is of the sensuality of his Romantic predecessor.

In painting his first major scene with figures, he adopted the objective detachment of a scientific observer. As noted previously, it is difficult for a self-taught painter to place figures into a setting effectively, and Signac was no exception. His depiction of space is extremely shallow and the simplified shapes are radically geometrized. He also emphasized the formal qualities of the accessories: conical hats, cylindrical bobbins, reels of satin or taffeta ribbon; on the floor lies a remnant of ribbon; rolls of protective paper form pale arabesques, and a hatbox is blazoned with the house label.

The picture was supposed to be radically modern yet was not done in the divisionist technique from the beginning. Signac reworked this 1885 painting very likely in February 1886, as Seurat hinted in a letter to Félix Fénéon: "Signac, definitively won over . . . , had just modified *The Milliners* following my technique at the same time as I was finishing the *Jatte*."[11] Signac added dabs of pure color over the originally broadly painted surface to produce the desired divided effect. Its genesis in two stages is probably responsible for the painting's present fragility, which prevents it from traveling.

In the meantime Camille Pissarro also adopted the novel technique in January–February 1886. Signac painted his first divisionist canvases at Asnières in the spring of that year: *The Junction at Bois-Colombes* (cat. no. 15), *The Gas Tanks at Clichy* (cat. no. 16), and *Passage du Puits-Bertin, Clichy*

(fig. 74). Neo-Impressionism was born. Signac recognized his friend's genius from the start and "benefited from [his] researches," as Seurat himself pointed out.[12] This "exact technique" permitted him to give color a predominant role, and he remained faithful to it to the end. MFB

NOTES

1 Besson 1935, p. 6; Rewald 1961, p. 440.
2 Unpublished memoirs of Ginette Signac, Signac Archives.
3 Signac 1882a, p. 4; and 1882b, p. 2.
4 Fénéon 1890.
5 Kunstler 1935, p. 4.
6 See in this connection Émile David's letter to Signac from January 2, 1885 (Signac Archives), cited by Herbert in Paris–New York 1991–92, p. 390, n. 2; Signac 1899 (Cachin 1964/1978, p. 114); and Roque, 1997, pp. 321–22.

7 See Paris–New York 1991–92, pp. 172, 384, n. 4.
8 Letter from Guillaumin to Pissarro, December 30, 1885, in Paris 1975, no. 78.
9 Letter from Camille Pissarro to his son Lucien, May 8, 1886, in Bailly-Herzberg 1980–91, vol. 2, nos. 334, 335.
10 La Rochefoucauld 1893b, p. 1.
11 Letter from Seurat to Félix Fénéon, June 20, 1890, Bibliothèque Nationale de France (Gift of M. de Hauke), translated in Paris–New York 1991–92, p. 383.
12 Ibid.

I. MONTMARTRE STUDY: STUDIO,
1883
Oil on canvas, 23⅝ x 15 in. (60 x 38 cm)
Signed and dated, lower right: P. Signac 82;
scratched in paint, below: Montmartre 83
Private collection
FC 23 (*Étude Montmartre [atelier]*)

Never before exhibited, this study, which apparently shows Signac's studio on the rue de Berthe, is the work of a young artist who had been painting for just a year. The view of his first studio is a declaration of his ambition. The modest room with its windows facing another building was nothing like the spacious skylit studios he occupied beginning in 1886, but the easel turned toward the daylight signals that it is his work space. Posing with palette and brush (fig. 64), he is a painter and more important an "Impressionist," that is, a modern and antiacademic artist. A candlestick set on the floor stands out in the light from the window. Light and color were to become Signac's prime concerns throughout his career.

This period, in which Signac decided to become a painter after having tasted bohemian life at the Chat Noir, a Montmartre cabaret, and having tried his hand at writing Naturalist stories, was later described by Tabarant: "At twenty, he could have made the common error / Of choosing some muse of dubious charms / But guided by a fate most vigilant / Paul Signac at twenty chose to marry Light."[1]

This study lacks the luminosity of Signac's future works, but it demonstrates qualities that would become characteristic of his art. His brushstrokes are long and sure, in the manner of Manet. He chose a strictly frontal view and gave his composition a solid architectonic base by emphasizing verticals and horizontals. Chastised at the fifth Impressionist exhibition for copying one of Degas's works, the young painter was in search of original compositions: here the legs of a figure on the right are boldly cut off.

The window and backlighting, the truncated figure, the Parisian character of the apartment and the facades opposite—all these elements point to Signac's intention of painting a work of Impressionist character. In his paintings, as in his writings and his activities as a collector and exhibition organizer, Signac consistently recognized his artistic affinities. Here he pays homage to Caillebotte, specifically to *Interior: Woman at the Window* of 1880, which was shown at the fifth Impressionist exhibition (fig. 65). Signac had seen this very modern work with a naturalistic touch that Huysmans celebrated in evocative terms.[2] Allusions to Caillebotte's *Interior* reappeared in Signac's work a few years later: first in a lithograph reusing the motif of a woman at a window, seen from the back (published in the *Revue indépendante* in 1888) (cat. no. 41), and then in *Sunday* (cat. no. 40), a larger interior scene with a bourgeois couple. MFB

NOTES
1 Tabarant 1929, p. 51.
2 Huysmans 1883, p. 93; Huysmans 1889, p. 121.

Fig. 64. Paul Signac with his palette, ca. 1883, photograph. Signac Archives

Fig. 65. Gustave Caillebotte, *Interior: Woman at the Window*, 1880, oil on canvas, 45⅝ x 35 in. (116 x 89 cm). Private collection

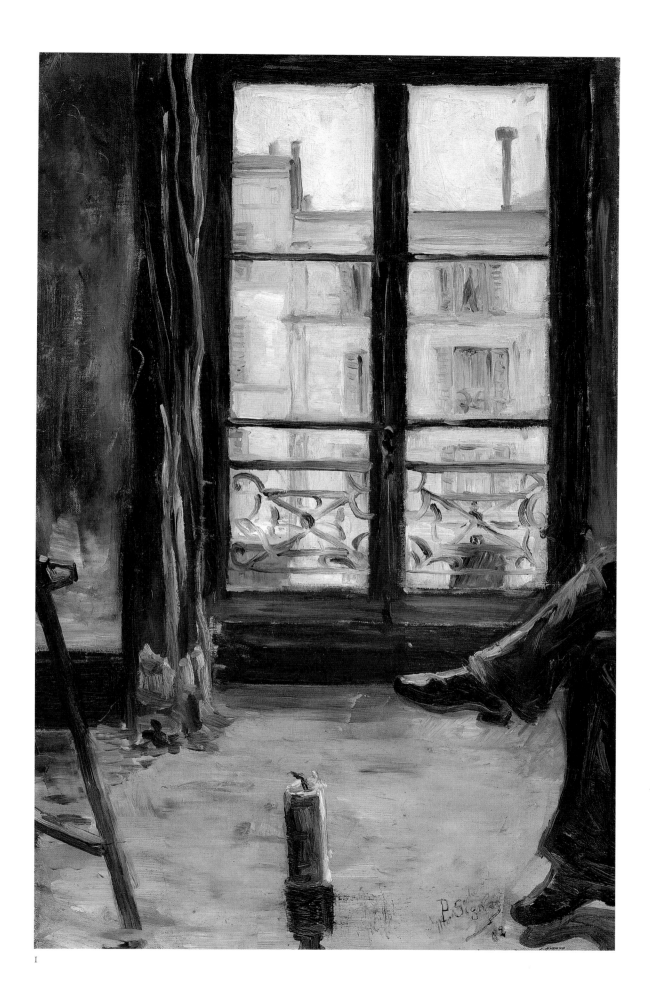

I

2. ASNIÈRES STUDY: CHARLES
TORQUET SEEN FROM BEHIND,
1883
Oil on canvas, 36⅜ x 25⅝ in. (92.5 x 65 cm)
Private collection
FC 31 (*Étude Asnières* [*Charles Torquet vu de dos*])

This picture, typical of the young artist's Impressionist period, was painted at the Signac family house at 42bis rue de Paris (now rue Maurice Bokanowski) in Asnières. Its broad strokes resemble those of Manet or Caillebotte. The pure colors include the bright blues and greens of the seascapes Signac painted at Port-en-Bessin that same year. There is little interest in depicting volumes, and some liberties have been taken with perspective. The handling of color shows precocious freedom, and a taste for unusual compositions is evident in the way the tabletop is tilted to present a still life. Caillebotte might have been the source for the male figure seen from the back. Here, as in *Montmartre Study: Studio*

(cat. no. 1), the window with its modern ironwork plays an essential role in the composition.

The artist's sketchbooks indicate that the model for this canvas, very likely painted in one sitting, was Signac's childhood friend Charles Torquet. With his brother Eugène Torquet, Charles frequented bohemian haunts in Montmartre and participated in the nightlife at the Chat Noir. Both brothers had literary ambitions. Charles poses here with an inkwell and sheets of paper that look more like music than text, possibly an allusion to songs he composed for the Chat Noir. He later translated Dostoyevsky and published several plays and novels, including the successful *Championne de tennis* in 1930. In January 1882 his brother published *Ballade de la joyeuse bohème*, dedicated "à mon ami Paul Signac," in the first issue of the *Chat Noir* review. This undistinguished piece gave no hint of his future achievements: in 1903 his *Force ennemie*, a novel published under the nom de plume John Antoine Nau, was awarded the first Prix Goncourt. MFB

2

3. THE RED STOCKING, 1883
Oil on canvas, 24 x 18⅛ in. (61 x 46 cm)
Private collection
FC 33 (*Le Bas rouge*)

This painting, like the previous studies (cat. nos. 1, 2), is the work of a beginner who probably gave no thought to exhibiting it. A friend was again the model: Berthe Roblès, a young milliner who had become Signac's companion. He had met this distant relative of Pissarro's a year earlier, and they appear together in a contemporary photograph of the Chat Noir group (fig. 109). Berthe sat regularly for him, but until their marriage in 1892 she was always shown with her face lowered or turned; her face appears for the first time in the 1893 *Woman with a Parasol* (cat. no. 69).

This intimate scene could have been taken out of a Naturalist novel: the bed and the erotic overtones of the red stockings—the latter often mentioned in Jean Ajalbert's "Impressionistic" verses—would have delighted Huysmans. But it is entirely Impressionist in spirit. Degas, Toulouse-Lautrec, Guillaumin, and Caillebotte all painted nudes or intimate scenes of this type. The young Signac, however, did not hazard the nude—an eminently academic subject.

Noteworthy is Signac's typical frontality, as well as the opposition between the verticals of the figure and the horizontals of the bed and rug. A recently discovered drawing (fig. 66) shows that Signac opted for a vertical emphasis from the start; having established it, he then concentrated on the colors. The red stocking that punctuates the center contrasts with the olive green skirt and bed.

The inaccuracies in the treatment of space and volume lend a *fa presto* quality to this unpretentious study. The woman's spontaneous movement and her disheveled hair have none of the dense sensuality present in Zola's or Maupassant's texts. Naturalism is marked by lightheartedness and youth. MFB

Fig. 66. Paul Signac, *Study for "The Red Stocking,"* 1883, graphite, india ink, and gouache, 9⅞ x 5⅛ in. (25 x 13 cm). Private collection

3

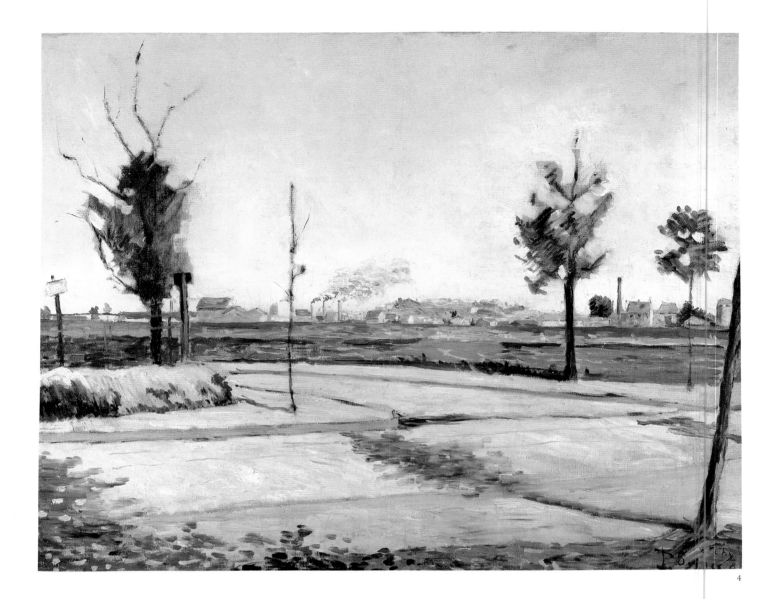

4

4. THE ROAD TO GENNEVILLIERS, 1883

Oil on canvas, 28¾ x 35⅞ in. (73 x 91 cm)
Signed and dated, lower right: P. Signac 83;
dedicatory inscription to Marichy partially erased
Musée d'Orsay, Paris, acquired in 1968 (RF 1968-3)
FC 48 (*Route de Gennevilliers*)

This spot marks the intersection of the newly built rue de Gennevilliers (today the rue Louis-Melotte) and the main road to Gennevilliers, at the outskirts of Asnières, some distance from the residential section where the Signac family lived. The old cemetery wall and buildings and factory smokestacks are seen in the distance. The agricultural plain of Gennevilliers, which the outlets of the Paris sewers made extraordinarily fertile, had become one of those indeterminate zones—half rural, half suburb—that inspired poets in search of modernism. It was the subject of a poem Jean Ajalbert dedicated to Raffaëlli: "The sun is weary of lighting the sky, gray / From the opaque smoke at the tops of the factories. . . . / The peasants there are more like sewer workers. . . . / The houses have roofs of 'vermilion' tile . . . / It is the country, yet without thatched roofs or cottages, / Without a single skylark or cricket. . . . / Each tree looks like a tall broom, erect in space."[1]

The Gennevilliers plain also attracted artists; Monet painted it as early as 1877, and Caillebotte, who owned large tracts of land there, painted it in 1884. For the Impressionists this area was different from the slums on the outskirts of Paris, which Raffaëlli had been depicting in his melancholic canvases.

Signac, for his part, used the plainest of terms to show a landscape in the throes of transformation: the newly built road, the spindly trees, the factories encroaching on the farmland, and the vermilion

roofs noted by Ajalbert. The geometry and lively colors of the place caught his attention. Again we see his fondness for dynamic compositional patterns of horizontals and verticals and his interest in color. The blue shadows, ocher sidewalks, and alternating areas of green and orange show that Signac was probably already familiar with Chevreul's theories. The depiction of space presented no problem for the artist, and a harmonious light fills this landscape which has

the rigor of a Seurat study, though the two artists had not yet met. This work, one of the young Impressionist's first successes, owes much to Monet, Caillebotte, Sisley, Guillaumin, Pissarro, and perhaps even Cézanne. Not yet twenty, Signac had mastered line and color. MFB

NOTE
1 Ajalbert 1886c, p. 6.

5. RUE CAULAINCOURT, 1884
Oil on canvas, 13¼ x 10 in. (33.5 x 25.5 cm)
Signed, dated, and dedicated, lower left: À l'ami
Cuvillier P. Signac Montmartre 84
Musée Carnavalet, Paris, Gift of Mr. and Mrs.
David Weill, 1955 (P 1938)
FC 58 (Rue Caulaincourt)

Exhibition: Paris 1884, Salon des Artistes
Indépendants, no. 71, Peinture: Rue Caulaincourt

Signac again depicts the transformation of a familiar landscape. He now had a studio in the

5

rue d'Orchampt, just a few steps from the rue Caulaincourt. The wood fence, vegetable patches, and windmills show the traditionally rural aspect of Montmartre, but sidewalks have been built and a streetlamp stands next to a spindly tree protected by a grille. The largest windmill is the Moulin du Blute-Fin or Moulin Debray, better known as the Moulin de la Galette.[1] In 1886 and 1887 Vincent van Gogh also painted the windmills of Montmartre.

As in Road to Gennevilliers (cat. no. 4) the rigorous construction is underscored by long brushstrokes in the manner of Manet. Lighter hues are applied according to the laws of color contrast: blue and yellow predominate, with green and red accents. In both there is a clear preference for strictly frontal views. The lines of the sidewalk and fence are parallel to the frame and are rendered in shallow spaces that press against the picture plane.

Signac's cahier d'opus records that this picture was shown at the first Salon des Indépendants in May 1884 as Peinture: Rue Caulaincourt.[2] It was painted early that year, shortly before Signac's first exhibition, which coincided with his decisive encounter with Seurat.

The work is dedicated to Ernest Eugène Cuvillier, a painter who had a studio in the rue d'Orsel in Montmartre and who had participated in the first Salon des Indépendants, later exhibiting at the Salon from 1887 to 1897. MFB

NOTES
1 The site was firmly identified by Bogomila Welsh-Ovcharov; see Paris 1988, p. 292.
2 In his cahier d'opus Signac listed his works, the names of their owners, and sometimes the exhibitions in which they appeared. In May 1884 he had not yet painted another picture of this subject. Snow, Rue Caulaincourt (FC 78) was done the following winter; it is unsigned and was probably not exhibited until the 1934 retrospective (Paris 1934, no. 2).

6. THE FISH MARKET, PORT-EN-
BESSIN, 1884

Oil on canvas, 23⅜ x 36 in. (59.5 x 91.5 cm)
Signed, lower left: P. Signac
Tai Cheung Holdings Ltd.
FC 64 (*Port-en-Bessin. La Halle aux poissons*)

In 1882 Signac spent his first summer at Port-en-
Bessin, where he undertook a painting campaign
à la Monet, executing quick sketches showing
various views of the harbor, docks, and beach.
He came back the following year and worked on
a new series of canvases that demonstrate his
rapid progress. Signac returned to the small Nor-
mandy port a third time in 1884, at which point
he was a full-fledged Impressionist who had mas-
tered the art of painting seascapes in *plein-air*.

The fish market, built in 1879, is a character-
istic edifice of the Second Empire, its modernity
somewhat incongruous in so modest a fishing

port. The artist created an original composi-
tion, using the walls of a house and a court-
yard to form an angle in the foreground. The
unusually animated scene appears as if ob-
served from a window. On the jetty stand sev-
eral small figures—mostly women—watching
the departure of the fishermen. The boats with
colorful sails leave the harbor; the pale light
from the sky is reflected in the water. The
brushstrokes, shorter and brisker than those of
earlier paintings, anticipate works to come,
though the influence of Seurat—whom Signac
had met shortly before—is not yet apparent.

Never exhibited, the painting remained
in the artist's studio for a long time. It was
acquired in the 1920s by Marcel Goldschmidt,
a German art dealer who was the first to take
an interest in Signac's pre–Neo-Impressionist
works. MFB

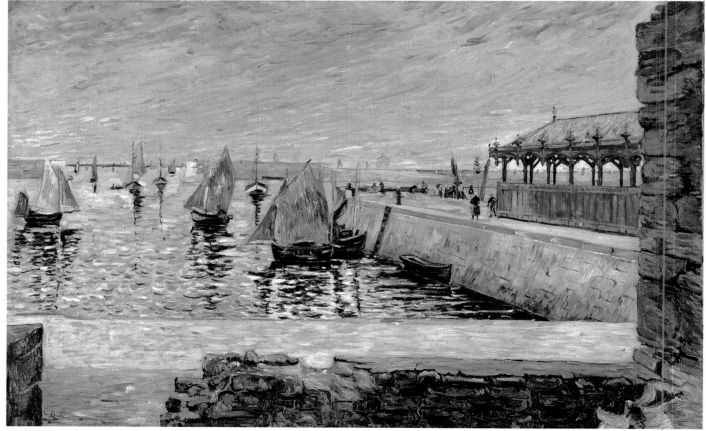

6

7

7. LA VALLEUSE, PORT-EN-BESSIN, 1884

Oil on canvas, 17⅞ x 25⅜ in. (45.5 x 64.5 cm)
Signed, lower right: P. Signac
Kröller-Müller Museum, Otterlo,
The Netherlands (1220–51)
FC 75 (*Port-en-Bessin. La Valleuse*)

During the Second Empire the development of railroads and leisure activities turned the Normandy coast into a magnet for vacationers, and villas and hotels were built everywhere. Views of the coast, first painted by Boudin and Monet, became Impressionist clichés. As early as 1870 Monet painted the impressive facade of the Hôtel des Roches-Noires and the superb villas facing the sea in Trouville. Signac saw these works at the 1883 retrospective at the Galerie Durand-Ruel in Paris. On this occasion he also saw Monet's views of Pourville and Varengeville from the previous year. This latter series directly influenced his work at Port-en-Bessin in the summer of 1884 (as it did Caillebotte's at Trouville and Villerville that same summer).

Signac chose to depict a modest fishing village, a subject quite unlike the seaside resorts at Deauville and Trouville. Yet Port-en-Bessin also had new construction, which would transform the site. As in Asnières and Montmartre, Signac wanted to paint the progress of modernism, represented here by the regular lines of the scaffolding: nothing very ambitious or original. Yet the pictorial qualities—light, color, composition—indicate that after three years of work and study, Signac had become a talented, in fact a very talented, young Impressionist painter. Without academic training but inspired by his love for color and his admiration for the Impressionists, he had reached a quite respectable level.

The air is palpable in this landscape and the depiction of space is masterly. Although Signac's flair for color and sensitivity for pictorial composition are evident in this light-filled scene, it recalls the works painted in the 1870s by his predecessors and thus presents nothing very new, much less revolutionary. His encounter with Seurat, a student at the École des Beaux-Arts, was to ripen into an enriching dialogue only in the next year. MFB

8

8. STILL LIFE WITH A BOOK AND ORANGES, 1885

Oil on canvas, 12¾ x 18¼ in. (32.5 x 46.5 cm)
Signed and dated (later, incorrectly): P. Signac 83
Staatliche Museen zu Berlin, Nationalgalerie
(NG 17/57)
FC 83 (*Nature morte. Livre, oranges*)

Exhibited in Paris and Amsterdam

The few still-life subjects in Signac's oeuvre date mostly from his early career. *Still Life with Pink Book and Pompom* (FC 53), a composition comparable to the present one, is dated 1883, and fish and shell-fish subjects were done at Port-en-Bessin in 1884. This genre played a subsidiary role in his production, but after World War I he briefly turned to it again and left a splendid series of watercolors of fruit and vegetables in homage to Cézanne (cat. nos. 144–47).

The present still life, although still quite modest, is more ambitious than those painted earlier at Port-en-Bessin. In the middle of a sharply creased white tablecloth lies a book, along with

three oranges, an apple, and a glass holding a bouquet of violets and nasturtiums. Books seldom appear in Impressionist still lifes, but Signac was an inveterate reader interested in contemporary literature, both Naturalist and Symbolist. He had many writers among his friends and had tried his hand at literary pastiches to enliven the evenings at the Chat Noir. Fénéon mentioned Signac's bibliophilism in his brief 1890 biography of the artist: "In his library, the leather, paper, and fabric of the bindings commingle: silvery blue for Leonardo da Vinci; parchment white and gold for Rimbaud and Mallarmé; violet for Baudelaire; blue and orange for Kahn; purple and black for Leo Tolstoy; glossy pink for Paul Adam."[1] Here we see the blue paper cover of *Au soleil*, a travel account by Maupassant published in 1882. Some years later, enchanted by Maupassant's account of the port of Saint-Tropez in *Sur l'eau*, Signac moved to the Mediterranean coast.

In early 1887 Signac met Vincent van Gogh, who soon after painted closely related still lifes, and worked with him around Asnières. Van

Gogh, also an avid reader of Naturalist novels, used the principles of color contrast and division as a means to a more colorful expression: he painted three highly colored and light-filled still lifes with books. Like Signac, he did not leave the book titles to chance: Maupassant's *Bel-Ami* appears conspicuously in a predominantly blue and yellow canvas (fig. 67). In the summer of 1887 Signac discovered the Midi at Collioure. Shortly after, Van Gogh also went "au soleil" (toward the sun) to create works with a new brilliance: he left Paris for Arles in February 1888, attracted by the light and "Japanese" landscapes of the south of France which Signac had probably described with great excitement.[2] MFB

NOTES
1 Fénéon 1890, p. 4.
2 Cachin 1988, p. 225.

Fig. 67. Vincent van Gogh, *Still Life with Plaster Statuette and Books*, 1887, oil on canvas, 21¾ x 18¼ in. (55 x 46.5 cm). Kröller-Müller Museum, Otterlo, The Netherlands

9. STIFF NORTHWEST BREEZE, SAINT-BRIAC, 1885
Oil on canvas, 18⅛ x 25⅝ in. (46 x 65 cm)
Signed and dated, right: P. Signac
Ray and Dagmar Dolby, San Francisco
FC 95 (*Saint-Briac. Bonne brise de nord-ouest*)

Exhibitions: Paris 1886, rue Laffitte, no. 192, *Bonne brise de N ¼ NO, Saint-Briac*, appartient à M. Heymann;[1] Nantes 1886, Palais du Cours Saint-André, no. 971, *Bonne brise de nord-nord-ouest (Saint-Briac)*

Signac's fondness for Saint-Briac had a long history: as early as 1881 he advised the Rivière brothers to vacation there, and he recommended this "dream spot" to his friend Jean Ajalbert in 1886.[2] In 1885, having spent three consecutive summers painting at Port-en-Bessin, he decided to go to Brittany for a change of inspiration. During this summer in Brittany he devoted an important series of paintings to views of the town of Saint-Briac and its surroundings.

This view of the coast in a strong wind displays the verve and freedom of Impressionism. The shadows of clouds advancing from the horizon darken the color of the water. Foam and spray indicate the strength of the wind; waves dash against the rocky coast; and the grass on the embankment in the foreground bends to the ground. The site recalls Saint-Lunaire, but as the title indicates, Signac, an experienced sailor, sought primarily to depict the effects of the rising wind. The broad outlines of the landscape were rapidly sketched in, and brisk, rhythmic brushstrokes render the changes caused by the oncoming squall. The painting's title was even more precise when it was shown at the eighth Impressionist exhibition—*Stiff Breeze from N ¼ NW, Saint-Briac*—where the last room had been set aside for the young "Neos" whom Camille Pissarro had taken under his wing. Signac was proud of this picture and found that its juxtaposition with more recent divisionist works was telling. He wanted to demonstrate his transition from "traditional" or "romantic" Impressionism, a style he had mastered effortlessly, to a method that was both modern and scientific and, in his eyes, the style of the future.

Writing about the eighth Impressionist exhibition, Félix Fénéon noted that "M. Signac is also a seascape painter of great distinction: the waters froth under fiery skies."[3] Jean Ajalbert also appreciated Signac's seascapes: "Green waves darken . . . foaming around the rocks . . . and

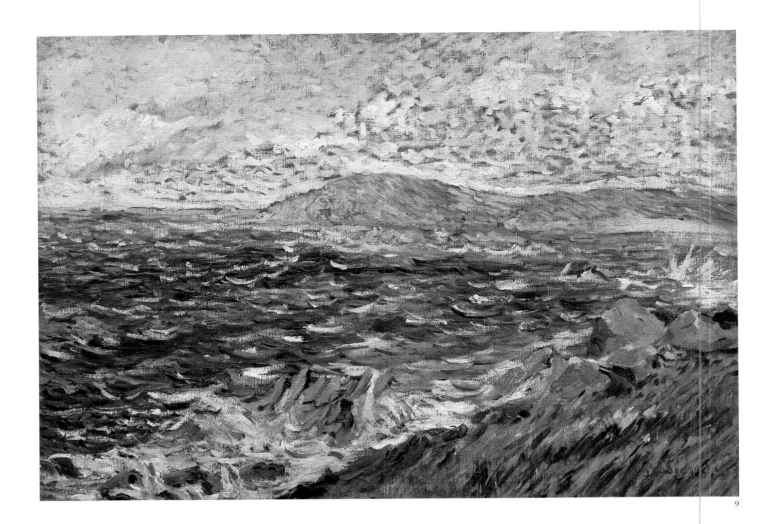

9

the light spreads fiercely."[4] Henry Fèvre was certainly alluding to this painting when he wrote: "Another sea, darkened by the heavy passage of angry storm clouds, dashes and thrusts in raging undulations gruff, choppy waves, with a fury, a diabolic tempestuous movement, hammering the shore."[5] MFB

NOTES

1 The ownership of this work by Heymann is not recorded in Signac's notebooks; regarding the dealer Hippolyte Heymann, see Anne Distel's essay, p. 41, n. 24, in this volume.
2 H. Rivière, "Les Détours du Chemin: Souvenirs inédits," private collection; Ajalbert 1886b, p. 3.
3 Fénéon 1886a in Halperin 1970, p. 37.
4 Ajalbert 1886a, pp. 391–92.
5 Fèvre 1886 (1992 ed., p. 22).

10. THE MARINERS' CROSS AT HIGH TIDE, SAINT-BRIAC, 1885

Oil on canvas, 13 x 18⅛ in. (33 x 46 cm)
Signed, lower right: P. Signac
Collection of The Dixon Gallery and Gardens, Memphis, Tennessee, Bequest of Mr. and Mrs. Hugo N. Dixon (1975.14)
FC 104 (Saint-Briac. La Croix des marins. Marée haute)

Painted at the mouth of the Frémur River, the present work shows that Signac observed the landscape with his usual attentiveness. Each rock formation has been recorded; this later enabled Jean-Pierre Bihr to recognize the site and to identify "above the cross, the Ebihens Tower, Platus in the middle, and to the right, the promontory with the chapel."[1]

Signac often painted two canvases of similar format from neighboring vantage points but under different lighting conditions to explore the intensity of color effects. Here he chose to depict the same site at high and low tides (fig. 68). Blue dominates the view at high tide, contrasting with the yellow of the grass in the foreground. Seen at

low tide, the sea is predominantly green, and the sandy beach is rendered in orange tones. These works evoke Monet, especially his paintings from Pourville and Varengeville. Signac's great fascination with transcribing the color of the water, with its blue, violet, emerald, and pink reflections, anticipates some of the *Waterlilies*. But Signac's brushwork is more fluid and regular, and he evidently took pleasure in representing the sea's surface. He adapted his brushwork to the subject: it is coarser for the rocks and lighter and more supple for the grass. The composition, rigorously geometric and frontal, still owes nothing to Seurat. The twenty-one-year-old Signac was achieving increasing mastery in his chosen medium. Any debt to Seurat may perhaps be seen in the simpler and more serene atmosphere of these seascapes. It should be remembered that after the 1884 exhibition of the Indépendants, where he met Seurat, he also became acquainted with Guillaumin, who in turn introduced him to Pissarro. Signac warmly admired these two

Fig. 68. Paul Signac, *The Mariners' Cross at Low Tide, Saint-Briac,* 1885, oil on canvas, 11¾ x 18⅛ in. (30 x 46 cm). Private collection, New York, FC 105

Impressionist painters, and at this time they had a greater influence on his work than Seurat, who was still working in a manner that could be broadly termed traditional. MFB

NOTE
1 Bihr 1992, p. 143.

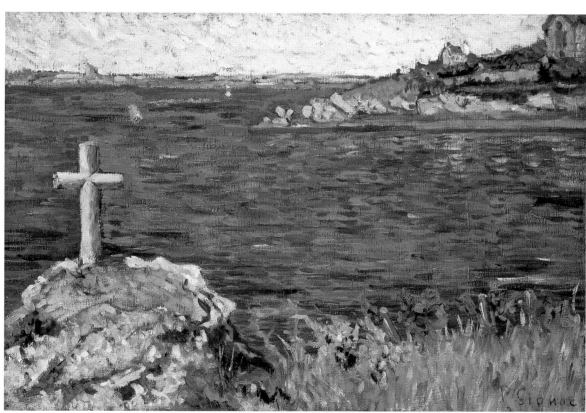

10

11. RUE VERCINGÉTORIX, 1885

(Illustration project for *Les Soeurs Vatard*
by J.-K. Huysmans)
Conté crayon, 8⅝ x 11¾ in. (22 x 30 cm)
Inscribed, bottom, in artist's hand: Dessin
pour les "Soeurs Vatard" de J. K. H. Rue
Vercingétorix. 1885
Musée du Louvre, Département des Arts
Graphiques, Fonds du Musée d'Orsay, Paris,
Gift of Françoise Cachin in memory of her
mother, Ginette Signac, 1997 (RF 50 850)

Exhibited in Paris only

In annotating the present work, Signac explicitly established a connection between this composition and *Les Soeurs Vatard*, a novel published in 1879 by J.-K. Huysmans. His indication, however, is almost superfluous for understanding the subject, which was entirely in keeping with other Naturalist representations of modern Paris. The rue Vercingétorix in the fourteenth arrondissement is not mentioned in the novel, but the Vatard sisters reside in the nearby rue Vandamme. The railroad embankment of the Chemin de Fer de l'Ouest, often mentioned in the book, is visible from both these streets.

Signac's friendship with the author is well documented. In 1886 Huysmans was listed as the owner of a drawing by Signac titled *Aux Tuileries* (today unidentified) shown at the eighth Impressionist exhibition (no. 200), indicating that the already influential novelist and critic wanted to support the young artist. In March of the same year Huysmans dedicated his *Croquis parisiens* to Signac. The two men may have met as early as 1883, when Huysmans's *Art moderne* was published (Signac had an autographed copy). The writer

also owned a painting by Signac dated 1883.[1] Huysmans at the time was a much more appealing figure for the young painter than Zola, whom the younger generation of Naturalists liked to ridicule. In fact, Signac published a satire of Zola in *Le Chat Noir* of February 11, 1882, and in January 1886 Camille Pissarro remarked to his son Lucien: "Yesterday I went to see Mr. Robert Caze [a poet and novelist close to Huysmans] with Signac . . . the youngsters are enthusiastic about our art! But as one they jump right on Zola's *L'Oeuvre*, which is very bad, it seems; they are severe."[2] Signac even sent Zola a minor correction apropos his novel.

There is another, almost identical drawing of the rue Vercingétorix,[3] but the project of illustrating *Les Soeurs Vatard* was never realized. Huysmans's publication of an article unfavorable to the Neo-Impressionists in the *Revue indépendante* in April 1887 precipitated a falling out between the two men.

The handling of Conté crayon, whose masterly use by Seurat was much admired by Signac since the early 1880s, is especially remarkable here. Signac's treatment, somewhat drier than Seurat's, seeks to describe a desolate setting as effectively as possible. Seurat produced hundreds of drawings, but there are very few finished drawings or studies from Signac's hand. AD

NOTES
1 Unidentified painting listed in Signac's precatalogue as a *Vue de Montmartre*.
2 Letter from Camille Pissarro to his son Lucien, January 23, 1886, in Bailly-Herzberg 1980–91, vol. 2, letter 309.
3 Cachin 1971, p. 34, fig. 21.

12. REGATTAS ON THE SEINE,

ca. 1885–86
Conté crayon, 8½ x 12¼ in. (21.7 x 31.2 cm)
Signed in graphite, upper right: P. Signac;
on verso: Signac atelier stamp
Musée du Louvre, Département des Arts
Graphiques, Fonds du Musée d'Orsay, Paris,
Gift of Françoise Cachin in memory of her
mother, Ginette Signac, 1997 (RF 50 851)

Exhibited in Paris only

This drawing, which is undated and unrelated to any other work, has generally been placed about 1885–86 through stylistic analogies with dated

sheets. It may also be compared with *Regattas at La Grenouillère* (Museum of Art, Rhode Island School of Design, Providence), another drawing in Conté crayon of similar subject and size which has been attributed to Seurat and dated 1890, mainly on stylistic grounds.[1] The relationship between these two works remains unclear, but Signac's drawing displays a descriptive verve distinct from Seurat's more austere sensibility. The semaphore and clubhouse of the yacht club are reminiscent of those of the Cercle de la Voile de Paris in Petit-Gennevilliers, opposite the wooded banks of Argenteuil,[2] which was popular for regattas because of the Seine's substantial width there.

Dessin pour les "Sœurs Vatard" de J.K.H.— Rue Vercingetorix. 1885

11

12

This topographical feature leads us to question Richard Thomson's otherwise appealing hypothesis that Signac's drawing was shown at the eighth Impressionist exhibition in 1886 under no. 201, with the title *L'Île des Ravageurs,* and belonged to Seurat at the time.[3] The Île des Ravageurs (also called Île de la Recette and Île Vaillant), however, is situated opposite Asnières—a paradise for boaters and rowboat races—and Clichy.

If the site depicted is indeed Petit-Gennevilliers, it is tempting to suppose that Signac had occasion to meet Caillebotte there. The Impressionist painter worked and sailed at this locale, regularly winning regattas during this period in his boat *Cul-Blanc.* AD

NOTES
1 Hauke 1961, no. 705; Conté crayon drawing, 9 x 11¾ in. (23 x 30 cm).
2 See the photograph of this site, ca. 1891–92, in Paris–Chicago 1994–95, p. 269, fig. 4. The bridge of Argenteuil is not visible, but the hillock on the far right could be the hill of Orgemont with its windmill.
3 Thomson 1985, p. 126.

FIRST YEARS OF
NEO-IMPRESSIONISM,
1886–1891

FIRST YEARS OF
NEO-IMPRESSIONISM,
1886–1891

THE EXHIBITION HELD IN THE RUE Laffitte in May–June 1886 has gone down in history as the last exhibition of the Impressionist group. More important, it marked the official birth of Neo-Impressionism. Mary Cassatt, Gauguin, Guillaumin, and Berthe Morisot were among the artists who participated, but Monet, Renoir, Sisley, and Caillebotte—who boycotted the event—were conspicuously absent. For his part Camille Pissarro exhibited his works in the final room, along with those of his more radical young comrades. The paintings of the future Neo-Impressionists were grouped around Seurat's *A Sunday Afternoon on the Island of La Grande Jatte* (fig. 3), which he had painstakingly reworked in line with the divisionist idiom. The exceptionally large format of this picture, the novelty of the divisionist method, and the bizarre stiffness of the figures made this suburban idyll an appropriate manifesto for the new movement. The serene, geometric seascapes that Seurat painted at Grandcamp added to the effect of newness.

Seurat's work was flanked by those of the Pissarros, father and son. Camille Pissarro's pictures featured his own divisionist efforts, attesting to his adherence to the new movement, as well as a number of drawings, gouaches, pastels, and etchings. His son Lucien showed his illustration work and engravings. As for Signac, he had nothing to show on so large a scale as Seurat's *Grande Jatte*, but his contribution was impossible to overlook, for it consisted of no less than eighteen pieces. His *Milliners* was exhibited with the title *Apprêteuse et garnisseuse (Modes), rue du Caire* (fig. 4). Although dated 1885, it had been largely reworked according to the divisionist technique in February 1886, as was *Snow, Boulevard de Clichy, Paris* (cat. no. 13) that May. The first divisionist works painted by Signac in the spring of 1886 were also presented: *The Junction at Bois-Colombes* (cat. no. 15), *The Gas Tanks at Clichy* (cat. no. 16), and *Passage du Puits-Bertin, Clichy* (fig. 74). Few in number, they were exhibited next to earlier works done in an Impressionist style. Three drawings rounded out his contribution to the show.

The critics and writers among his friends did their best to explain the new method of color division, and considering the novelty of the technique, Signac's works were rather well received. The picture that drew the most attention was also his most ambitious work, *The Milliners.* Firmin Javel conceded that it had movement and wit and concluded that it was "Parisian."[1] Jules Christophe

was charmed by the Naturalist character of the scene and called the painter "the lucky rival of the likes of Paul Alexis, Robert Caze, Ajalbert, and Paul Adam—with his milliners of the rue du Caire."[2] All of the critics commented on the preponderant role of color in Signac's works. Paul Adam remarked: "Among the other pictures, his proclaim an intensity of colors, with a richness that is specifically his own."[3] Jules Vidal quipped: "He has a lighthearted rawness."[4] But this last quality was not appreciated by everyone. To quote Maurice Hermel: "His raw colors irritate and exhaust the eyes; the violent hues exasperate them."[5]

That summer the second exhibition of the Société des Artistes Indépendants opened its doors. Seurat again showed his *Sunday Afternoon on the Island of La Grand Jatte* and the seascapes from Grandcamp, while Signac contributed his *Milliners,* the divisionist works from Asnières and Clichy, and his most recent landscapes from Les Andelys. Dubois-Pillet and Angrand also participated in this event, "and practiced the methods of the groundbreakers [Seurat and Signac]."[6] The representatives of Divisionism were together in the last room. They wanted to form a distinct and coherent group, to present themselves as a new school which, in their eyes, clearly stood for the future. The term "néo-impressionniste" appeared in print for the first time on September 19, 1886, in an article by Félix Fénéon: "The truth is that the Neo-Impressionist method calls for an exceptionally fine eye."[7]

From then on, exhibitions came one after the other, with Signac playing a predominant role in their organization: not just the Salon des Indépendants but also the Salon des XX in Brussels, where he began to exhibit in 1888. He made many converts in Belgium and worked untiringly with the Belgian painter Théo van Rysselberghe to organize exhibitions there. The Association pour l'Art in Antwerp could count on his regular participation.

The Neo-Impressionists also exhibited in places that would today be termed alternative: the rehearsal room of André Antoine's Théâtre-Libre and the offices of the *Revue indépendante* housed exhibitions of their works in winter 1887–88. But the first show devoted exclusively to the group was held at the Hôtel Brébant in late 1892, after the death of Seurat. In the words of Durand-Tahier: "The Neo-Impressionist painters want to distinguish themselves henceforth from the Symbolist painters, as well as from Manet's immediate successors."[8] The gallery run by Le Barc de Boutteville had shown their work several times but always along with representatives of other avant-garde tendencies. Signac had great hopes for the "Neo-Impressionist boutique" in the rue Laffitte, which was subsidized by Antoine de La Rochefoucauld and opened in December 1893, only to close its doors less than a year later. In late 1895 Signac exhibited divisionist paintings in a *cabinet d'amateur* designed by Henry van de Velde for the inauguration of Siegfried Bing's gallery L'Art Nouveau. Signac was of course actively involved in setting up the exhibition, which also featured his Neo-Impressionist colleagues.

The repeated presence of Neo-Impressionist works in most modern art showings did not go unnoticed. New adepts of the technique were gained in Brussels and Antwerp. For some, like Van Rysselberghe, this turned into a long-term commitment, while for others, like Finch, Van de Velde, and Lemmen, all of whom later turned to the decorative arts, Neo-Impressionism inspired a penchant for color and discipline.

From its debut in May 1886, the divisionist method attracted many converts. Among the crowd of visitors a young Dutch painter newly arrived in Paris was greatly struck by the Neo-Impressionist room and took it to be the essence of modernity itself. Although this had yet to become evident in his paintings, Vincent van Gogh also had a marked predilection for color. He quickly joined the most advanced artistic circles and met Signac and other innovative painters. Because of his tendency to explain and spread his convictions, Signac was rightly called the "Saint Paul of Neo-Impressionism" by Thadée Natanson.[9] Opposed in character, the two painters shared a friendship and an immoderate passion for color. They painted together at Asnières during the spring of 1887 and enjoyed a great camaraderie for several months. At this time Van Gogh liberally used pointillist brushstrokes in his paintings, but the requisite discipline and patience were foreign to his temperament. The "scientific" nature of the method left him rather cold; what interested him in this technique was the color effects it gave his pictures. As with many painters after him, the free application of the Neo-Impressionist method fostered the emancipation of his style. But although Van Gogh

continued to use pure colors and the principle of simultaneous contrast to heighten tonal intensity, he soon abandoned pointillist brushwork.

Neo-Impressionism was, however, a much more demanding technique for Signac, for he shared Seurat's dream of an "art-science" to a certain extent. Like so many others before him in search of certainty, Seurat strove to develop a method that would produce a formula of beauty, an unbeatable equation for harmony. For him, color division was only one of the many aspects of a more comprehensive method that was subordinated to a theory of expression in terms of line: "inhibitive," or sad, when the lines were directed downward and to the left of the composition, and "dynamogenic," or happy, when they pointed upward and to the right.

These ideas, elaborated by Humbert de Superville and Charles Blanc, were taken up by Charles Henry, a young scientist of wide-ranging interests who was working on the relation between line and color. He wrote "Introduction à une esthétique scientifique," published in August 1885 in *La Revue contemporaine*, where it caught the attention of Seurat and Signac. About 1888 the latter offered to collaborate with the scientist by drawing the diagrams and graphs to illustrate two further publications that came out in 1890: *Application de nouveaux instruments de précision (cercle chromatique, rapporteur et triple-décimètre esthétique) à l'archéologie* and *Éducation du sens des formes*. Like Seurat, Signac followed Henry's principles only in their broadest outlines and so kept a distance vis-à-vis the stimulating, if complex, theories. As Fénéon put it: "[Signac] is not a slave of this graceful mathematics; he knows well that a work of art is inextricable."[10]

If Signac momentarily succumbed to the spell of Henry's pseudoscientific objectivity, it may have been because he saw in it a modern and European expression of the detachment of the art of ukiyo-e. Like many of his contemporaries, he was a great admirer of Japanese prints and textiles, in which the artist's ego subordinated itself to the expression of beauty and of the grandeur of nature. In 1887, at a time when he was still seeing Signac, Van Gogh organized an exhibition of Japanese prints at the café Le Tambourin. Henri Rivière, one of Signac's childhood friends, took his inspiration from Japanese aesthetics and techniques and produced simple and very decorative prints. The art critic Arsène Alexandre later

recalled having contemplated Hiroshige's landscapes in Signac's company at the exhibition of Japanese prints held by the École des Beaux-Arts in the spring of 1890.[11] The studios of most modern painters were decorated with "accessible *japonismes*"[12] and references to the art of ukiyo-e soon became a fashionable cliché, an aspect which Signac abandoned about 1895.

Under the combined influences of *japonisme* and the theories of Charles Henry, Signac painted pictures that verged on abstraction, playing with the geometry of forms and color contrast, both of which he simplified to the extreme. These works executed in minute and varied brushstrokes and conceived in terms of tonalities, rhythms, and harmonies, have often been compared to music scores. They were merely colored variations on rather familiar themes, and they did not exclude precise topographical observation. Signac painted the suburbs of Asnières and Clichy, expressing without pathos the charms and modernity of a world in transformation.

By the mid-1880s Signac turned from the suburbs and their Naturalist associations and devoted himself to depicting places of leisure and sport: at Les Andelys, where he spent the summer of 1886, or at Herblay, where he sailed. He painted a number of series characterized by bright colors and simplified forms. Spending summers on the seacoast, he painted and sailed with a passion. His Norman and Breton seascapes from Portrieux and Saint-Briac display an extreme formal spareness, together with a fervent and subtle analysis of color shades and contrasts.

Signac discovered the south of France at Collioure and Cassis, which he depicted with an uncommon sensitivity and refinement. His interpretations of the Mediterranean were more luminous than colorful, a circumstance that astonished his contemporaries who were accustomed to the bright colors of Mediterranean painters. Paradoxically his landscapes from Collioure and Cassis were considered too pale. Signac defended himself: "I think that I have never done paintings as 'objectively exact' as those of Cassis. In that region there is nothing but white. The light, reflected everywhere, devours all the local colors and makes the shadows appear gray."[13]

Like his friend Seurat, Signac exhibited more ambitious works next to his Neo-Impressionist landscapes. He continued depicting modern genre

scenes, especially interiors. After *The Milliners* he painted two more large-scale compositions: *The Dining Room* (cat. no. 24), which takes up the theme of a middle-class family sitting at a table, and *Sunday* (cat. no. 40), in which he focused on the confining character of bourgeois marriage. In the latter he pushed the application of color and line theories to the extreme in order to give the picture a strong psychological impact; and this without resorting to more traditional means, such as facial expressions or eloquent poses. He wanted to express the inner life of the estranged couple merely in pictorial terms: form, line, rhythm, and color. *Sunday*, which depicts the theme of conjugal indifference with a rare detachment, was the artist's last concession to Naturalism. Not long afterward, Signac abandoned genre painting altogether. In late 1890 he painted the impressive likeness of Félix Fénéon (cat. no. 51), whose angular silhouette stands out against an abstract decor, a brilliant explosion of colors and forms. This painting, which masterfully combined *japonisme* and Charles Henry's theories of color and line, summed up and closed his first Neo-Impressionist period.

Although not devoid of humor, *Portrait of Félix Fénéon* was misunderstood when it appeared at the Salon des Artistes Indépendants in 1891. However, Signac could not pay much attention to the critical onslaught: he was profoundly shocked by Seurat's death, which had occurred several days after the opening of the exhibition. Overwhelmed by the loss of a friend whose genius he had recognized very early on, he sorrowfully informed Seurat's acquaintances and helped in the delicate task of settling the estate. He began to organize posthumous showings of Seurat's work: in February 1892 at Les XX in Brussels and one month later at the Indépendants in Paris.

During the dark year of 1891 Signac managed to paint his masterful and harmonious series of seascapes at Concarneau, among his most important works. In early 1892 he painted a work with decorative ambitions, *Woman Arranging Her Hair* (cat. no. 57). This warm, tender, and happy picture betrays no hint of the painter's preoccupations. The future of the Neo-Impressionist school lay in his hands, and while not shirking his duty, he reoriented Neo-Impressionism in a more personal direction. MFB

NOTES

1 Javel 1886, p. 1.
2 Christophe 1886, p. 194.
3 Adam 1886, p. 549.
4 Vidal 1886, p. 1.
5 Hermel 1886, p. 2.
6 Hennequin 1886, p. 581.
7 Fénéon 1886b, pp. 300–302.
8 Durand-Tahier 1892, p. 531.
9 Natanson 1948, p. 121.

10 Fénéon 1891, pp. 198–99.
11 Alexandre 1892, p. 2.
12 Unpublished journals of Henri de Régnier, March 1890, Bibliothèque Nationale de France: "At Gustave Kahn's, a table in a dining-room decorated with accessible *japonismes* beneath a high American lamp."
13 Signac journal entry, September 29, 1894, in Rewald 1949, pp. 106, 168.

13. SNOW, BOULEVARD DE CLICHY, PARIS, 1886

Oil on canvas, 18⅛ x 25⅝ in. (46 x 65 cm)
Signed, lower left: P. Signac
The Minneapolis Institute of Arts, Bequest of Putnam Dana McMillan (61.36.16)
FC 115 (*La Neige. Boulevard de Clichy*)

Exhibitions: Paris 1886, rue Laffitte, no. 191, *La Neige, boulevard Clichy*; Paris 1887, Salon des Indépendants, no. 456, *La Neige (Boulevard de Clichy) janvier 1886*; Paris 1887–88, Théâtre-Libre, no catalogue

Exhibited in New York only

The boulevard de Clichy was a familiar sight for Signac. He grew up not far from there, in the rue Frochot, a charming private street which at that time led to the place Pigalle. In 1886, the year he painted this picture, he moved to a new studio at 130 boulevard de Clichy. The setting here was just a short distance away. Although the area is much changed, this view might be taken from the rue Puget, just before the corner of the place Blanche.

The winter of 1885–86 was an especially snowy one in Paris. In December there were two snowfalls of more than four inches, and a blizzard hit the city on January 8. This event was reported in the *Illustration* of the following week.[1] The pointillist technique both unifies and animates the pictorial surface and thus was especially suited to rendering snow. Yet Signac paradoxically showed little predilection for the subject so favored by Monet. Angrand deplored this fact several years later: "I can say that you have too few snow scenes in your life, since I remember only a single one, that fine one of the watch-post, boulevard de Clichy."[2]

The present painting, which appears in the artist's cahier d'opus as his first divisionist work, dated January 1886, was in fact reworked in May, shortly before being sent to the last Impressionist exhibition. Signac had not yet begun to paint "au point" in January, and a careful examination of the painting shows that the small dabs of color stand out against a surface handled in a homogeneous, nondivided technique. This is particu-

larly apparent in the facade of the watch-post, where a flurry of blue dots covers red and ocher stripes painted in a more uniform manner.

Shown at the last Impressionist exhibition in 1886 and in 1887 at the Salon des Indépendants and André Antoine's Théâtre-Libre, this picture did not go unnoticed. Jean Ajalbert devoted some lines to it in his usual colorful style: "On the 'Boulevard Clichy' the swirling blizzard coats the trees, houses, and streetcars with snow. The lilac-mauve and violet landscape turns opalescent in the distance. Around the emergency post, whose

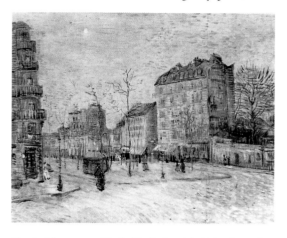

Fig. 69. Vincent van Gogh, *The Boulevard de Clichy*, 1887, oil on canvas, 18¼ x 21⅝ in. (46.5 x 55 cm). Van Gogh Museum, Amsterdam

red lantern shines on the facade striped with alternating bands of bricks, pale or blood-colored."[3] In terms of subject, purely thematic "affinities with Raffaëlli" were noted,[4] and according to Paul Adam, "the density of the frosty air unifies the white phantasmagoria."[5]

Arriving in Paris in March 1886, Van Gogh visited the Impressionist exhibition, where this painting was hung in the last room with an assemblage of Neo-Impressionist works grouped around *La Grande Jatte.* That is to say he would have seen it as one of the most advanced demonstrations of contemporary painting. Van Gogh probably had Signac's snowscape in mind the next winter, when he chose a very similar vantage point for his *Boulevard de Clichy* (fig. 69), painted with light and contrasting colors applied with fine brushwork.[6] MFB

NOTES

1 *L'Illustration*, January 16, 1886, pp. 1, 3.
2 Letter from Charles Angrand to Signac, February 1, 1901; in Lespinasse 1988, p. 133.
3 Ajalbert 1886a, p. 391.
4 Rouanet 1886.
5 Adam 1887.
6 For the early ownership of this work, see Anne Distel's essay, n. 33, in this volume.

14. THE JUNCTION AT BOIS-COLOMBES, 1886

Oil on canvas, 18⅛ x 25⅝ in. (46 x 65 cm)
Signed and dated (later, when it was sold), lower left: P. Signac 1885
Van Gogh Museum, Amsterdam (s 381M/1986)
FC 113 *(L'Embranchement de Bois-Colombes)*

The junction at Bois-Colombes still looks much the same as it did more than a century ago. It is located at Asnières, at the district line of Bois-Colombes, where the train station stands today; the trees of the present-day avenue Henri-Barbusse still separate the tracks from the houses. Signac's earlier urban and suburban scenes show a predilection for representing familiar sites: the windmills of Montmartre, the Gennevilliers road, the boulevard de Clichy, the pont d'Asnières, and the like. During the winter of 1885–86 he made many trips between his studio in Clichy and his family's house in Asnières, and it was probably during one of them that he decided to depict the railroad—

a favorite theme of the Impressionists, particularly Monet. Signac naturally chose the Saint-Lazare–Argenteuil line, which he regularly took to visit his mother in Asnières or to go boating on the Seine. At first he planned to represent the station in Paris: there are four handsome and quite finished sketches of 1885 showing different views of the Gare Saint-Lazare (see fig. 70) and an oil study on panel showing the station's exterior and the avenue des Batignolles tunnels (fig. 71). But he eventually decided against this subject, which Monet had often depicted masterfully, and later used the back of the panel for *Woman Reading* (cat. no. 23).

Ultimately Signac chose to represent the suburban station, a subject which Monet had already painted in *Train in the Snow* of 1875 (Musée Marmottan, Paris), which was exhibited at Durand-Ruel in 1883. In the foreground Signac shows the fence and posts bordering the tracks and then the stationmaster's shack and the railroad switches; in the background is a large Haussmannian building.

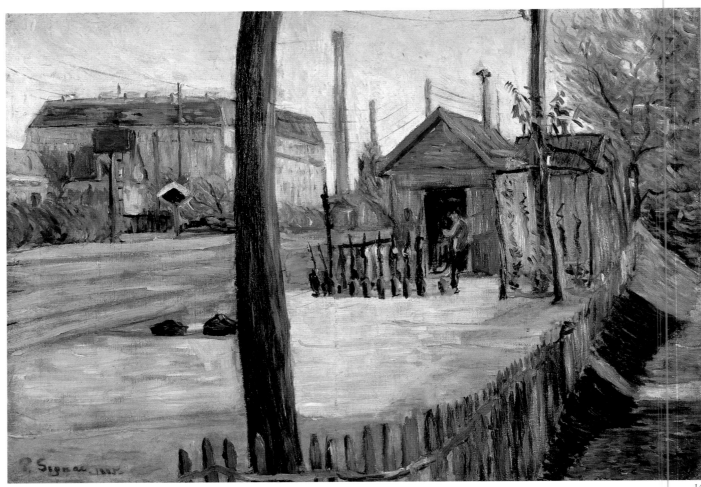

The new suburbs were expanding into the surrounding countryside, and Signac represented them without nostalgia. In fact, he never displayed fondness for the countryside unless it included the Seine; he preferred the modern landscapes that were being created before his eyes.

This crisp winter scene was painted under the same bright February sun that shines on Monet's views of the Gare Saint-Lazare, shading the snow with blue, yellow, and pink tints. Yet some leaves are visible on the trees and bushes, and the grass is already green. The present canvas was very likely painted at the end of the winter, in February–

March 1886, as was *Snow, Bois-Colombes,* which shows the same site similarly lit, but in even brighter colors (fig. 72). The date recorded for both versions of the subject in Signac's cahier d'opus—"Winter 1885–1886"—is not very precise. Both were probably done in February–March 1886, after *Snow, Boulevard de Clichy* (cat. no. 13), which was painted in January and reworked in a more pointillist style in May, just before the exhibition in the rue Laffitte. The artist may have wanted to give them a slightly earlier date in order to establish a smoother progression to *Snow, Boulevard de Clichy,* which has a clearly Neo-Impressionist style. MFB

Fig. 70. Paul Signac, *The Gare Saint-Lazare*, 1885, drawing, 4¾ x 3⅜ in. (12 x 8.5 cm). Private collection

Fig. 71. Paul Signac, *The Gare Saint-Lazare*, 1885, oil on wood, 9⅝ x 5⅞ in. (24.5 x 15 cm). Musée d'Orsay, Paris, (RF 1976–78) FC 133 (verso)

Fig. 72. Paul Signac, *Snow, Bois-Colombes*, 1886, oil on canvas, 13 x 18⅛ in. (33 x 46 cm). Private collection, FC 114

15. THE JUNCTION AT BOIS-COLOMBES, OPUS 130, 1886

Oil on canvas, 13 x 18⅛ in. (33 x 46 cm)
Signed and dated, lower right: P. Signac 86;
inscribed, lower left: Op. 130 à Darzens
Leeds Museums and Galleries (City Art
Gallery), United Kingdom (34/48)
FC 116 (*L'Embranchement. Bois-Colombes.
Opus 130*)

Exhibitions: Paris 1886, rue Laffitte, no. 195,
L'Embranchement de Bois Colombes; Paris 1886, Salon
des Indépendants, no. 370, *L'Embranchement de
Saint-Germain. Bois-Colombes.* Avril – mai, 1886

Exhibited in Amsterdam and New York

The series of three pictures of this junction,
painted in the first months of 1886 (see cat. no. 14
and fig. 72), records the coming of spring and,
more important, the evolution of Signac's style
from Monet's Impressionism to Seurat's Divi-
sionism. They document the appearance of the
divided-color technique that Signac was to use
from then on. The present painting, the third
version of the motif, is very likely the artist's first
"pointillist" work. It dates from April–May as
is indicated in the catalogue of the 1886 Salon
des Indépendants.

If this stylistic change owed much to Signac's
contacts with Seurat—who had resumed work
on *La Grande Jatte*—it nonetheless built on quali-
ties already inherent in his own work: the obser-
vation of landscape, the penchant for simple
geometric compositions, and above all the marked
fondness for color. Some details, like the fence and
the pattern of blue shadows on the ground, still
belonged to Signac's Impressionist mode. But the
broadly divided brushstrokes used throughout cre-
ate a highly vibrant atmosphere unlike that achieved
by Seurat's painstaking technique in *La Grande Jatte*.

Signac's first Neo-Impressionist works, painted
during the winter and spring, were shown in 1886
at the last Impressionist exhibition and at the
Salon des Indépendants. The following year their
impact on Van Gogh would be evident in his
use of divided-color technique at Asnières and
Clichy. One of the Dutch painter's works from
the summer of 1887, *Road on the Outskirts of Paris,
with a Peasant Carrying a Spade* (fig. 73), displays a
color scheme remarkably close to Signac's. The
topographical features are also familiar, and the
canvas may have been painted at Asnières near
the railroad and the junction at Bois-Colombes.

Signac gave the present work to the writer and
art critic Rodolphe Darzens, who thanked him

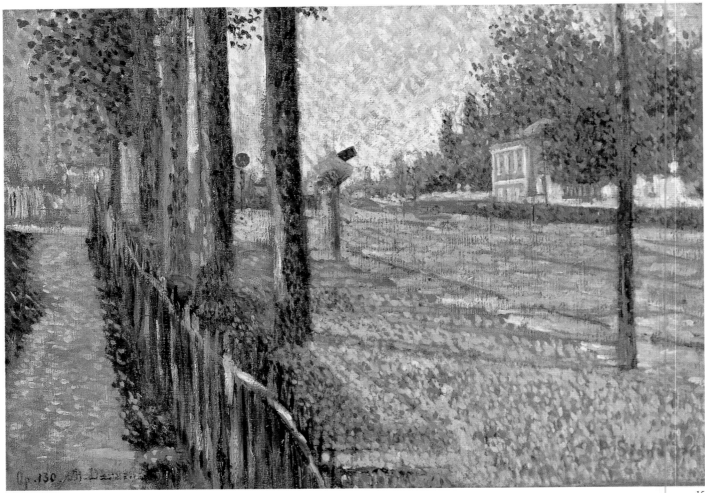

15

by writing in the artist's cahier d'opus: "Given to Rodolphe Darzens by Signac who is a good chap and a more serious painter than Raffaëlli and Degas, very gratefully R. D." Darzens, a friend of Fénéon's and André Antoine's, was active in literary circles and in the Théâtre-Libre. He was the first to publish Rimbaud's poems (*Le Reliquaire*, 1891), and Verlaine dedicated a sonnet to him. In 1885 he published *La Nuit*, with this dedication: "To the

painter Paul Signac, this book which he will not read but hide, for—compared to my goal—it is what academic painting is to the luminous compositions of the independent painters, *La Nuit*, with my friendship, Paris, December 30, 1887."[1] MFB

NOTE
1 Professor Michael Pakenham kindly brought this information to my attention.

Fig. 73. Vincent van Gogh, *Road on the Outskirts of Paris, with a Peasant Carrying a Spade*, 1887, oil on canvas, 18⅞ x 29½ in. (48 x 75 cm). Private collection

14

16. THE GAS TANKS AT CLICHY, 1886

Oil on canvas, 25⅝ x 31⅞ in. (65 x 81 cm)
Signed and dated, bottom left: P. Signac 86
National Gallery of Victoria, Melbourne,
Australia, Felton Bequest, 1948 (1817–4)
FC 117 (*Les Gazomètres. Clichy*)

Exhibitions: Paris 1886, rue Laffitte, no. 188,
Les Gazomètres, Clichy; Paris 1886, Salon des
Indépendants, no. 364, *Les Gazomètres—Clichy*.
Mars–avril 1886

The gas tanks no longer exist, but the area in which they stood, on the Seine between the pont d'Asnières and the passage du Puits-Bertin, has kept its industrial character. The narrow passage du Puits-Bertin, also painted by Signac (fig. 74), still exists, though in a slightly altered form. Squeezed between the railroad tracks and factory buildings, it still has an unappealing atmosphere. Signac painted a number of landscapes within this small area, but their different vantage points preclude their being regarded as a series. *The Gas Tanks at Clichy* and *Passage du Puits-Bertin* present two aspects of the same site, first from the quai de Clichy and then from the rear of the buildings, overlooking the Seine. An 1885 aerial photograph (fig. 75) gives an overall view of the site that Signac painted, including the residential section of Asnières, with its bungalows and gardens.[1]

Signac could probably see the gas plant from his family's house. The aerial photograph shows the extent of the industrial zone and the proximity of the subjects chosen by the artist: the factory, the coal cranes, the quai de Clichy, the pont d'Asnières (fig. 76) and the railroad bridge, the Bailet baths, and the rue de la Station were all situated within one square kilometer. Upstream is the Île de la Grande Jatte, where Seurat was working on his *Grande Jatte*, which celebrated the leisure activities of the Parisian petite bourgeoisie in the suburbs. Signac chose a more serious motif, in which nature had been edged out by industrial buildings and hovels. Still, this light-filled scene has none of the *misérabilisme* typical of Raffaëlli, who also lived and painted in Asnières. Signac saw this scene as a modern landscape: the gas tanks are said to have been designed by Gustave Eiffel, who constructed other buildings for the plant. The artist made no comment, either positive or negative. The gas tanks reappear the following spring in the background of the sun-filled painting *The Clipper* (FC 141) and, perhaps symptomatic of their excursions together, in Van Gogh's summer 1887 painting *Bridge at Asnières*. (F 240, The Menil Collection, Houston).

Fig. 74. Paul Signac, *Passage du Puits-Bertin, Clichy*, 1886, oil on canvas, 25⅝ x 31⅞ in. (65 x 81 cm). Location unknown, FC 118

Fig. 75. The bridges at Asnières, photographed from a balloon by Commander Fribourg, September 10, 1886. Archives Municipales, Asnières

Fig. 76. Asnières: The new bridge, ca. 1900, postcard. Archives Municipales, Asnières

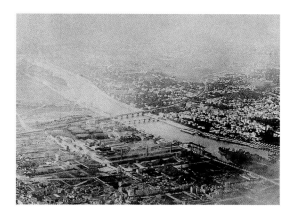

With *Snow, Boulevard de Clichy, Paris, The Junction at Bois-Colombes, Opus 130,* and *Passage du Puits-Bertin, Clichy* (cat. nos. 13, 15; fig. 74), this painting was among the artist's first Neo-Impressionist works. In May 1886 all four paintings were presented at the last Impressionist exhibition (nos. 187, 188, 191, 195); from August to September three were shown at the second exhibition of the Société des Artistes Indépendants, where this painting and *Puits-Bertin* were dated March–April in the catalogue. Signac's mode of Divisionism already diverged from Seurat's. The colors are brighter than those of *La Grande Jatte;* the brushwork is more varied, less regular, and expresses a very different temperament.

The critics were generally negative, but Félix Fénéon supported his friend: "M. Paul Signac is attracted to suburban landscapes. Those of his paintings dating from this year are done by color division; they achieve a frenzied intensity of light: *The Gas Tanks at Clichy* (March–April 1886) and the *Passage du Puits-Bertin, Clichy.*"[2] The Naturalist writer Jean Ajalbert left a more evocative description: "Here are the 'Gas Tanks at Clichy,' circular sausages, soot-colored, pipes looming above a hovel; laundry hanging to dry on a picket fence; the exalted light transfuses a new blood into the anemic tiles."[3] MFB

NOTES
1 This photograph was first published by Ronald Pickvance in Martigny 2000, p. 127.
2 Fénéon 1886a in Halperin 1970, p. 37.
3 Ajalbert 1886a, p. 391.

17. THE GAS TANKS AT CLICHY, 1885
Conté crayon, 9 x 11⅝ in. (23 x 29.5 cm)
Inscribed in graphite, lower left: Clichy 1885;
Signac atelier stamp, lower right
Private collection

This dynamic drawing, with strong tonal contrasts, was probably a study for the painting of the same subject (cat. no. 16); a plausible supposition given the sheet's date. Signac may later have considered it as a work in its own right, possibly for use as an illustration. Listed under no. 458 in the catalogue of the 1887 Salon des Indépendants was *Les Gazomètres de Clichy (Dessin pour la "Vie moderne")*. Could this have been the present drawing? Signac seems to have wanted to publish only pointillist drawings in this periodical (see cat. nos. 18, 19, 25): that is, drawings that were technically well suited to the mediocre printing processes available to the publisher. This version of *The Gas Tanks* might, however, have been intended for the review but not used (indeed, no drawing of the subject appeared in *La Vie moderne*) and perhaps was exhibited in 1887. AD

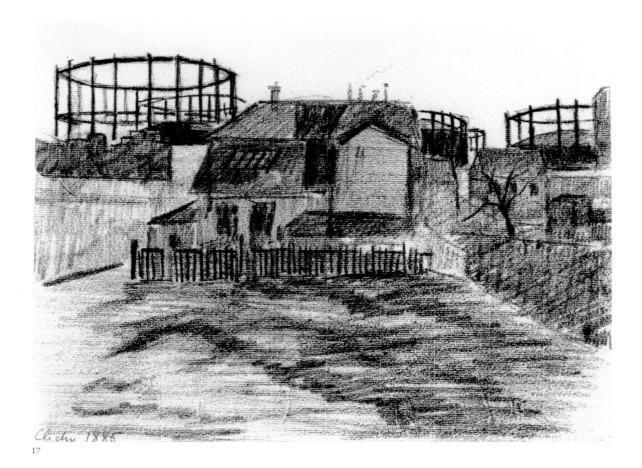

17

18. PASSAGE DU PUITS-BERTIN, CLICHY, 1886

Ink and graphite, 9⅝ x 14⅜ in. (24.5 x 36.6 cm)
Signed, lower left: P. Signac
The Metropolitan Museum of Art, New York,
Harris Brisbane Dick Fund, 1948 (48.10.4)

Exhibited in Amsterdam and New York

In fall 1886 Signac and Dubois-Pillet conceived of the idea of adapting pointillist technique to ink drawings. The present work, undoubtedly Signac's first experiment "au point," is typical of the handful of his drawings executed in this method between 1886 and 1888. All have painted counterparts, in this case, an oil of the same title (fig. 74) which was shown in the 1886 Impressionist exhibition (no. 187) and later that year with the Indépendants (no. 365). Scholars have tended to skirt the issue of the precise relationship between the works in each medium. In fact, the drawings were most certainly not studies for paintings but were modeled after them, with the impetus of publication in mind.[1] Robert Herbert persuasively argues that the present drawing, distinctive for its delicate finesse, represents Signac's initial, albeit unsuccessful, attempt at

producing an image for publication. A second drawing of the same motif with larger, fewer, and more emphatic dots in darker ink was the one reproduced in *La Vie moderne* on February 12, 1887, as an "Impressionist drawing by P. Signac" (cat. no. 19).[2]

Technical analysis reveals that the present drawing was executed with iron gall ink on Japan paper. There are two layers of stippled ink, with the darker on top. It is impossible to determine the degree to which the ink has faded, but when the present work is compared to a later drawing in the Metropolitan (cat. no. 25), it appears that the ink used here was more dilute and thus lighter in hue from the onset. The underdrawing on this sheet is only faintly visible to the naked eye. However, infrared reflectography (fig. 77) reveals a schematic graphite drawing of the primary architectural and figurative elements.[3] Signac's sketch reduces the composition to a kind of geometric blueprint—made up of lines, triangles, squares, rectangles, cylinders. Figures were added last and somewhat more deliberately, as we can see in the series of small corrections and adjustments he made to such details as the man's sack and the woman's hemline. SAS

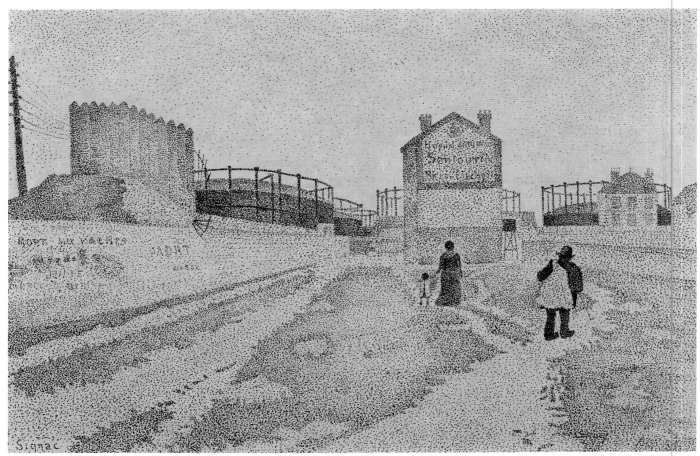

Fig. 77. Infrared reflectogram of *Passage du Puits-Bertin, Clichy*. Sherman Fairchild Center for Works on Paper and Photograph Conservation, The Metropolitan Museum of Art, New York

NOTES

1 It is worth noting in this context that when two pointillist drawings—Signac's *Collioure* and Dubois-Pillet's *Parisian Landscape*—were illustrated in the April 15, 1888, issue of *La Vie moderne* (p. 233), they were specifically described as "d'après son tableau" (after his painting).

2 See New York 1968, no. 91.

3 Marjorie Shelley, Conservator in Charge of the Metropolitan's Sherman Fairchild Center for Works on Paper and Photograph Conservation, generously provided technical information, based on recent microscopic and infrared study; Kristi Dahm made the composite infrared reflectogram image.

19

19. **PASSAGE DU PUITS-BERTIN, CLICHY,** 1886 or 1887
Brown ink and graphite, 6⅜ x 9¾ in. (16.3 x 24.8 cm); image framed in graphite, 4⅞ x 7¼ in. (12.4 x 18.3 cm)
Signed, lower left: P. Signac; annotated in the artist's hand, lower margin: Passage du Puits-Bertin–(Clichy) Ne pas réduire—publier sans marge.
Musée du Louvre, Département des Arts Graphiques, Fonds du Musée d'Orsay, Paris, Gift of Françoise Cachin in memory of her mother, Ginette Signac, 1996 (RF 50 853)

Exhibited in Paris only

As mentioned in the previous entry, Robert Herbert considered that the present drawing—the simpler and the smaller of the two versions—was the one used for reproduction in the February 12, 1887, issue of *La Vie moderne*. The painting of the same scene was exhibited at the eighth exhibition of the Impressionists in 1886 and then at the Salon des Indépendants in the same year. The instructions for the printer in the margin ("Do not reduce—publish without margin"), the size of the vignette in *La Vie moderne* (4⅝ x 7 in.), and the pinholes in the corners (for registration) corroborate this hypothesis.[1] Except for an old

photograph included in Signac's pre-catalogue, these two drawings and their reproduction are the only reminders of the now-lost painting. In addition to the old graffiti on the walls, we can see the traditional figure of the ragpicker with his poking stick and sack. These emblematic figures of the past, defended by writers and artists (for example, Raffaëlli), were condemned to oblivion by Prefect Poubelle's new regulations for household refuse collection.[2] AD

NOTES

1 To the contrary, Bogomila Welsh-Ovcharov considered this drawing as a first version dating from April–May 1886, done at the same time as the painting. See Paris 1988, no. 114.

2 The use of metal containers decreed on October 26, 1883, by Poubelle—whose name is perpetuated in "poubelle," the French word for garbage can—marked the end of the highly specialized activities of the ragpickers. Numerous articles (e.g., Louis Paulian, "Les Chiffonniers," *L'Illustration*, February 2, 1884) reported on the protests of the ragpickers and described the sophisticated social organization of this ancient trade in delightful and erudite detail.

20. THE BENCH, 1887
Conté crayon, diam. 9½ in. (24 cm)
Signed, bottom: P. Signac
Private collection

This melancholy drawing was used to illustrate *Sur les talus*, a collection of poems by Signac's friend Jean Ajalbert, which was published by Vanier in 1887. Signac was satisfied enough with this reproduction to suggest to Octave Maus that it be reused to illustrate the catalogue of the fifth exhibition of Les XX in Brussels in 1888.[1] There is another, sketchier, rectangular drawing in Conté crayon which must have been the initial conception for the composition.[2]

The roofs looming above the buildings that block the horizon recall those of the Louvre, leading some authors to title the work "Cour du

20

Carrousel." However, a review of Ajalbert's publication in *L'Art moderne* of October 27, 1887, called it "a place in the suburbs near the city walls," a no less hypothetical identification, but mysterious enough to suit the Symbolist spirit of the times.[3] AD

NOTES
1 Letter from Signac to Octave Maus, Wednesday, January 11, 1888, in Chartrain-Hebbelinck 1969, p. 62; see fig. 61.
2 See Little Rock 2000, p. 33, no. 2.
3 See Paris 1961, p. 98.

21. RIVERBANK, LES ANDELYS, 1886

Oil on canvas, 25⅝ x 31⅞ in. (65 x 81 cm)
Signed and dated, lower right: P. Signac 86
Musée d'Orsay, Paris, acquired by dation, 1996
(RF 1996-6)
FC 128 *(Les Andelys. La Berge)*

Exhibition: Paris 1887, Salon des Indépendants, no. 450, *La Berge (Petit-Andely)* août 1886

During his first summer as a Neo-Impressionist, Signac stayed in the Seine Valley in Normandy. At the beginning of June he took up residence in Les Andelys, not far from Giverny, and waited for Lucien Pissarro to join him. The site, which is on a bend of the Seine some sixty miles west of Paris, is especially beautiful, and Signac, charmed by the vividness of the colors and subject matter, wrote to Seurat at Honfleur. The latter's response was typical: "You see Les Andelys as colorful. I see the Seine [as] an almost indefinable gray sea, even under the strongest sun and blue sky."[1] If Signac did not spend the summer at the seashore—at Saint-Briac, for example, which he recommended to Jean Ajalbert[2]—it was because he was serving on the hanging committee of the second Salon of the Société des Artistes Indépendants and so did not want to be far from Paris. When the exhibition opened on August 21, it included four landscapes from Les Andelys, dated June–July and August 1886 (nos. 366–69). Commenting on these pictures, Fénéon wrote: "The most recent ones are also the most luminous and complete. The colors provoke each other to mad chromatic flights—they exult, shout! And the Seine flows on, and in its waters flow the sky and the vegetation along the riverside."[3]

Signac returned to Les Andelys after the opening and continued working on this series of landscapes, finishing ten in all. The present work was among those painted in August. The artist picked a spot downstream where the ruins of Château Gaillard towered over the village houses. The Seine dominates the composition, with a wooded island appearing on the right. When Signac exhibited this picture at the 1887 Salon des Indépendants together with three other paintings from Les Andelys, Gustave Kahn was enthusiastic about the liveliness and luminosity of the landscapes:

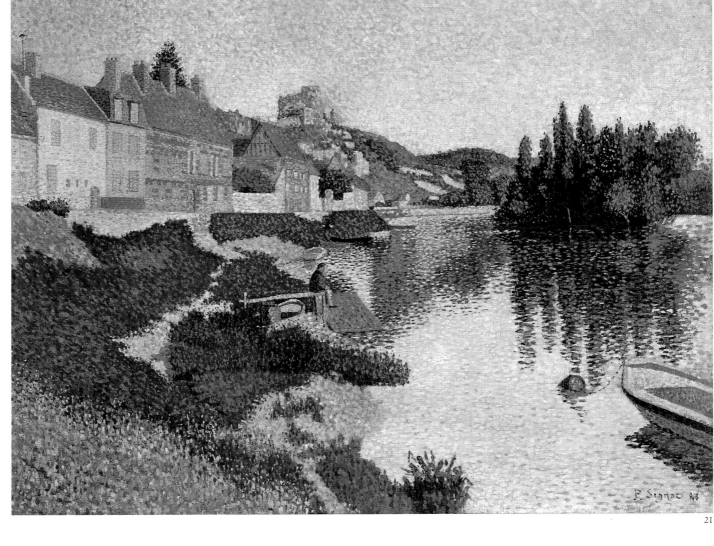

"Signac perpetually returns to bends in the river full of wooded isles, reflected trees, closely huddled houses, peasant women washing, sparkling patchworks of cultivated fields. It is the blaze of the Mediterranean sun that is fixed in these landscapes, imbued with the joy of things and illustrated with fantasies of light."[4] MFB

NOTES
1 Letter from Georges Seurat to Signac, June 25, 1886, Signac Archives.
2 Ajalbert 1886b, p. 3.
3 Fénéon 1886b, p. 301.
4 Kahn 1887, p. 230.

22. HILLSIDE FROM DOWNSTREAM, LES ANDELYS, 1886

Oil on canvas, 23⅝ x 36¼ in. (60 x 92 cm)
Signed and dated, lower right: P. Signac 86
The Art Institute of Chicago, Through prior gift of William Wood Prince, 1993.208
FC 125 (Les Andelys. Côte d'aval)

Exhibitions: Paris 1887–88, Théâtre-Libre, no catalogue; Paris 1887, Salon des Indépendants, no. 452, La Côte d'Aval (Petit-Andely) septembre 1886

This picture, one of the last painted during Signac's stay at Les Andelys, was also the most radically synthetic. The painter strongly accentuated the geometry of the landscape by reducing it to a sumptuous colored puzzle. In the foreground he used the bend in the Seine to create a composition based on two interpenetrating triangles with a dominant blue and yellow color scheme. The cultivated hill was rendered as a colorful mosaic pattern. It was

this painting that Gustave Kahn had in mind when he alluded to the "sparkling patchworks of cultivated fields." The village is a play of near-abstract shapes: cubic facades, trapezoidal roofs.

This painting was shown at André Antoine's Théâtre-Libre, which was frequented by the most noteworthy figures in contemporary Naturalist and Symbolist art and literature. Paul Signac belonged to this circle, along with many of his friends, including the Naturalist writer Paul Adam, whom he portrayed in an "Impressionist sketch [representing] M. Paul Alexis at Lucie Pellegrin's rehearsals."[1] Signac also illustrated the program of the 1888–89 season with an "application of Charles Henry's chromatic circle" (cat. no. 33). It was probably there that he met the sculptor Alexandre Charpentier, to whom he gave this painting. The two met regularly about 1891, when Charpentier was working on a series of portrait medallions of notable figures associated with the Théâtre-Libre, which included Signac. About this time he also did a portrait of Berthe Roblès (fig. 98), Signac's companion, and so the gift of this work may have been a way to thank the sculptor.

Most of the pictures painted at Les Andelys, Signac's first Neo-Impressionist series, were given to friends or family as gifts. His childhood friend the writer Charles Torquet (see cat. no. 2) received *Île à Lucas, Les Andelys* (FC 119); his dear friend Félix Fénéon received *Sunset, Les Andelys* (FC 121); Léon Lemonnier, a close friend of the Signac family's, received *Port Morin, Les Andelys* (FC 122); Camille Pissarro received *Bathing Place, Les Andelys* (FC 123; dedicated in French: "To my dear master C. Pissarro"); and *Riverbank, Les Andelys* (cat. no. 21) went to the artist's mother, Héloïse Signac. Signac was evidently aware that this series marked a turning point in his career and did not want to disperse them on the market. By giving them as symbolic gifts to his friends and loved ones, he also kept them within reach. The first pictures painted at Saint-Tropez in 1892 would also be given to close friends. MFB

NOTE
1 *La Vie moderne,* June 17, 1888, p. 373.

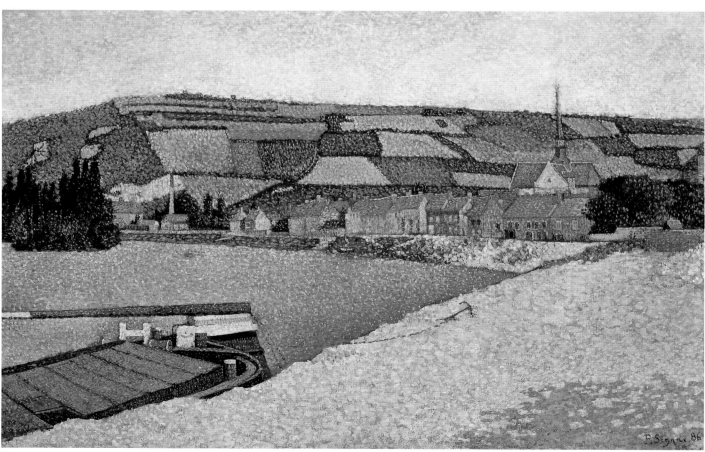

22

23. WOMAN READING, 1887
Oil on wood, 9⅝ x 5⅞ in. (24.5 x 15 cm)
Musée d'Orsay, Paris, Gift of Ginette Signac,
1979 (RF 1976–78)
FC 133 *(Femme lisant)*

The model for this figure was Berthe Roblès, who first appeared in Signac's *Red Stocking* (cat. no. 3) in 1883 (she married Signac in 1892). Her hairstyle and her characteristic profile are identifiable in both, but here she has become a Neo-Impressionist vision, rooted in geometric calculations. Her angular profile anticipates Signac's diagrams of 1888–89 for Charles Henry's *Application de nouveaux instruments de précision (cercle chromatique, rapporteur et triple-décimètre esthétique) à l'archéologie* and *Éducation du sens des formes.*

The precise contours and divided colors in this carefully thought-out study were atypical of Signac and must show the influence of Seurat. Signac usually handled his studies rather broadly, while Seurat treated each sketch as a finished work, even if it was a preliminary study for a more ambitious picture. Signac's only other painting on wood that compares to this one is *Snow, Montmartre,* which dates from January 1887 (FC 135; private collection).

The concentration, geometric quality, and immobility evident here are exceptional among Signac's oil sketches, as is the effect of artificial lighting that enhances the contrast between light and shadow. Although this picture directly anticipates the figures of *The Dining Room, Opus 152* (cat. no. 24), the studies that prepared this interior scene were handled more briskly without significantly divided colors. It may be that despite their small format both this panel and *Snow, Montmartre* were considered finished works in their own right. Neither is related to any important pictures, but the latter was shown at the 1887 Salon des Indépendants (no. 457).

The present work is painted on the recto of an earlier study (for verso, see fig. 71). MFB

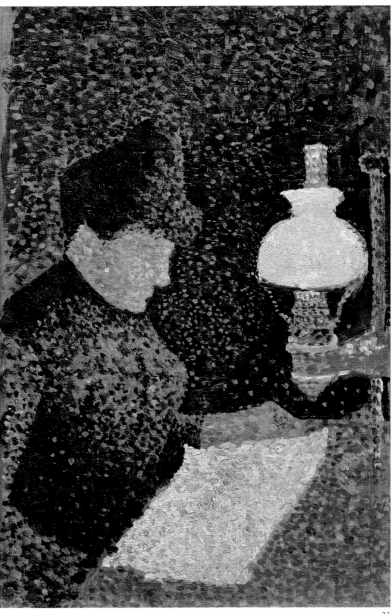

23

24. THE DINING ROOM, OPUS 152,

1886–87
Oil on canvas, 35 x 45¼ in. (89 x 115 cm)
Signed and dated, lower left: 86 P. Signac 87;
inscribed, lower right: Op 152
Kröller-Müller Museum, Otterlo,
The Netherlands (710-13)
FC 136 (*La Salle à manger. Opus 152*)

Exhibitions: Paris 1887, Salon des Indépendants,
no. 450, *La Salle à manger* (1886–1887); Brussels
1888, Exposition des XX, no. 1, *Op. 152* 1886–
1887; Paris 1892–93, Hôtel Brébant, no. 66,
La Salle à manger 1886; Düsseldorf 1928,
Kunsthalle, ill. p. 438

After *The Milliners* (fig. 4) Signac painted another interior scene of modern life of the same scale. Having depicted milliners at work on the rue du Caire, Signac turns to the subject of the bourgeoisie at home. A woman lifts a coffee cup to her lips, an old man in profile smokes a cigar, and a maid brings in a newspaper (the letters "LAS" are probably those of the daily *Gil Blas*). The anarchist Fénéon commented wryly on this domestic ritual, part of a well-to-do but highly structured lifestyle: "In a morning light, a young woman and an elderly man seated at a dining table; the maid brings a gazette, and the rum decanter bulges gloriously."[1]

Signac represented middle-class figures at a favorite activity—having lunch—a subject memorably represented by the Impressionists, especially Monet and Manet. However, the direct source for Signac's picture is found in Caillebotte, whose *Luncheon*, exhibited in 1876, clearly inspired the present work (fig. 78). Signac was twelve when Caillebotte's picture was first shown, and it is unlikely that he attended that Impressionist exhibition. He may have seen this picture on another occasion, at an exhibition that went undocumented or at the artist's studio, or he may have visited the Caillebotte family estate in Petit-Gennevilliers with Camille Pissarro or attended a regatta there on the Seine. In any case, the similarities between the two compositions are too striking to be coincidental.

In his picture Caillebotte showed his mother and brother being served by a butler in their apartment. The scene, dimly lit by diffuse backlighting, was brightened by sparkling crystal glasses and pitchers which stand out against the table's dark wood. Objects also play an important part in Signac's painting. His interior, simpler and

better lit, has a bourgeois character instead of the haut-bourgeois atmosphere of Caillebotte's. Plates on the wall have replaced the heavy Napoleon III sideboard laden with porcelain. The blue-and-white coffee service, the orange decanter, and the cigar speak of an unostentatious affluence.

There is a great deal of light in the apartment, and the artist took pleasure in rendering the blue shadows cast by the objects and the orange halo produced by the blue decoration of the sugar bowl and cups. The colors, which are much less diffuse than those of Seurat, are divided into large areas: the white of the tablecloth and the red and green of the walls. The figures and objects exist in a purple, blue, and orange ambience. The light picks out each detail of the scene, especially the man's profile.

The man's carefully defined facial features, as well as his rotund silhouette and solemn expression, suggest that this may be a portrait. Indeed, the model was Jules Signac, the artist's grandfather, who had already made an appearance in 1884 in the painting *My Grandfather in the Garden* (FC 81). The art critic Bernier, probably forewarned, identified the scene as the home of a "potbellied and sybaritic demolition contractor." In fact, before he made a fortune in his elegant saddlery establishment in the passage des Panoramas and then in a no less prosperous boutique run by his son in the rue Vivienne, Jules Signac was briefly active as a contractor. Here the former imperial supplier has become the "retiree of Asnières" (he moved to Asnières with his daughter-in-law and grandson after the death of his son). After Jules Signac's death Paul Alexis fondly described him as "this likable old man who was so hospitable to [Signac's] friends . . . and a reader of the defunct *Cri du peuple*."[2]

An open-minded man, Jules Signac does not seem to have opposed his grandson's choice of vocation or to have urged him to join the family's successful saddlery business. His benevolent authority dominates this composition. The young woman could be the artist's mother. But she, like the maid, is not so much a portrait as a type, a female form with geometric contours. These figures, shown either in profile or frontal view, complete Paul Signac's gallery of contemporary social types: after the milliners—finisher and trimmer—we see the bourgeois household, with the retiree, the mistress of the house, and the

servant. Like Seurat in *La Grande Jatte,* the artist rejected anecdotal details and individualized expression and gave his contemporaries the gravity and geometric stillness of Piero della Francesca's figures.

Camille Pissarro, who was close to the artist and then shared his aesthetic convictions, admired this work: "Signac's picture is very good; it will

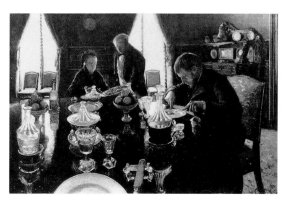

Fig. 78. Gustave Caillebotte, *Luncheon,* 1876, oil on canvas, 20½ x 29½ in. (52 x 75 cm). Private collection

be a surprise. Anquetin and Bernard were speechless in front of this painting, which shows real progress; these gentlemen are hard to please."[3] In general it was well received at the 1887 Salon des Indépendants and at Les XX in Brussels the next year. Wauters, however, commented in *La Gazette*: "After the *Grande Jatte* of M. Seurat, we now have the *petit tasse* of M. Signac."[4] But many critics expressed understanding and encouragement. Paul Adam admired the subtlety of the light and concluded: "This painting demonstrates the amazing transfiguration of reality."[5] Jules Christophe remarked that "*The Dining Room* evokes bourgeois life in a superbly well-distributed light and with the keen observation of a good novelist. This young and remarkably intelligent artist may have found his path in this genre."[6] Signac himself seems to have been pleased with the painting, later making a pointillist drawing of it for reproduction in *La Vie moderne* (cat. no. 25). MFB

NOTES

1 Fénéon 1887 in Halperin 1970, p. 67.
2 Letter from Paul Alexis to Signac, Signac Archives.
3 Letter from Camille to Lucien Pissarro, March 13 (?), 1887, in Bailly-Herzberg 1980–91, vol. 2, p. 140, letter 403.

4 Wauters 1888.
5 Adam 1887.
6 Christophe 1887, p. 123.

25. THE DINING ROOM, 1887

Ink and graphite, 8¾ x 10¼ in. (22.2 x 25.9 cm)
Signed in pen, lower left: P. Signac; inscribed and signed, lower right: La Salle à manger P. Signac
The Metropolitan Museum of Art, New York, Robert Lehman Collection, 1975 (1975.1.710)

Exhibited in New York only

This work was illustrated in *La Vie moderne* of April 9, 1887, where the critic Gustave Kahn described it as "a drawing 'au point' in an innovative technique."[1] The related painting (cat. no. 24) was then on view at the Salon des Indépendants. In translating his ambitious figure composition into an image suitable for reproduction, Signac relied on a graphite armature to plot the placement of key pictorial elements. His carefully laid-out underdrawing, masked by the successive layers of dots, is visible using infrared reflectography (see fig. 79). Signac left little to chance. He demarcated areas of solid form as well as of shadow

and devoted particular care to such details as the sitters' profiles, the folds of the man's jacket, and the curled fingers of his fist. Variances between the painting and drawing are most pronounced in the background. In the drawing a third plate is added to the decorative scheme on the wall, which shifts the arrangement slightly to the left. The plant's leaves—an aspect he wrestled with in the underdrawing—are now broader and longer and are complemented by a bulkier pot and wider table. Other differences include the disproportionately large tassel hanging from the curtains; the interruption of the tabletop's curve by the man's sleeve (to an extent not anticipated in his sketch); and the server's apron, which is less full, while her bustle is darker and more pronounced. No doubt technical difficulties—the challenge of transcribing nuances of texture, pattern, and shadow—account for certain lapses, especially in the depiction of small objects on the dining table, all of which differ in shape, scale, and relationships from their painted counterparts.

25

Two layers of stippling, remarkably uniform in size, are evident under the microscope: the lower layer is a lighter, somewhat transparent brown; the upper is a rich dark brown. Signac used iron gall ink, which was presumably somewhat darker in hue before exposure to light; the yellowing of the support—Japan paper (a long-fibered European-made paper)—especially at the center, indicates that the surface has been affected by light. The ink is still dark and non-corrosive, however, suggesting that Signac used a "well-balanced" mixture.[2]

This drawing was formerly owned by the art historian John Rewald, who published it in his pioneering *Post-Impressionism: From Van Gogh to Gauguin* (1956); Robert Lehman acquired it in 1960 at the sale of Rewald's collection.[3] SAS

NOTES

1 Kahn 1887, p. 230, ill. p. 231.
2 Marjorie Shelley, Conservator in Charge of the Metropolitan's Sherman Fairchild Center for Works on Paper and Photograph Conservation, generously

provided technical information, based on recent microscopic and infrared study; Kristi Dahm made the composite infrared reflectogram image.
3 Rewald 1956, p. 109; sale, *Important Nineteenth Century and Modern Drawings . . . The Property of John Rewald, Esq.*, Sotheby's, London, July 7, 1960, no. 117.

Fig. 79. Infrared reflectogram of *The Dining Room*. Sherman Fairchild Center for Works on Paper and Photograph Conservation, The Metropolitan Museum of Art, New York

26. SUNLIGHT, QUAI DE CLICHY, OPUS 157, 1887

Oil on canvas, 18⅛ x 25⅝ in. (46 x 65 cm)
Signed and dated, lower left: P. Signac 87; inscribed, lower right: Op. 157
The Baltimore Museum of Art, Gift of Frederick H. Gottlieb (BMA 1928.6.1)
FC 143 (*Quai de Clichy. Soleil. Opus 157*)

Exhibitions: Brussels 1888, Exposition des XX, no. 4, *Op. 157 Avril–mai 1887*; Paris 1888, Salon des Indépendants, no. 624, *Op. 157. Clichy. Avril–mai 1887*

Exhibited in New York only

In the spring of 1887 Signac continued his depiction of characteristic sites around the pont d'Asnières. From the left bank he painted a boat near the piers of the railroad bridge (*The Clipper*, FC 141, private collection). Then, as he had done the year before with *The Gas Tanks at Clichy* (cat. no. 16) and *Passage du Puits-Bertin, Clichy* (fig. 74), he set up his easel on the quai de Clichy and worked on two very similar paintings: *Gray Weather, Quai de Clichy, Opus 156* (fig. 80) and the

present work. For the first, Signac set up his easel downstream from the gas plant, facing the pont d'Asnières. The gas tanks are set back from the wharf and are therefore not visible, but we can make out the plant's coal cranes, which can also be seen in a number of other paintings by Signac and by Émile Bernard. The wharf, cranes, smokestack, and barge all underscore the industrial character of the site. Here, in the second version, Signac turned downstream toward the pont de Clichy. The sunshine gives the picture a completely different atmosphere, but the landscape details—the bridge's metal framework, the smokestack, and the warehouse—again document the area's industrialization. The insubstantial trees, some protected by metalwork, show that the quai de Clichy was still very new. Everything has been exactly observed, and each element conforms to the aerial photograph taken by Commander Fribourg (fig. 75).

This composition is one that Signac often used in his paintings. The wharf creates a large, light-colored triangle in the foreground with lines receding in depth. But the horizontal of

26

a footpath interrupts the perspectival effect, which is definitively blocked by the horizontals of the bridge. The vertical accents of the trees and smokestack lend a rhythm to the composition and emphasize its orthogonal character. The orangish hue of the quay is contrasted with the blue of the Seine and the green of the vegetation. The light is modulated by dabs of light-colored paint, larger in the foreground and then becoming little white dots scattered in the sky. The Neo-Impressionist technique, which suits the subject's modernity, creates a sense of objectivity and detachment while unifying the picture plane. Forms are disturbed only by the subtle vibration of the colors. This method was appropriate for an artist who wanted to paint scientifically and who welcomed innovation. At the time the more progressive among Signac's contemporaries were convinced that science would free the world from uncertainty.

This painting was purchased by another innovator, Siegfried Bing, one of the first Parisian dealers in Asian art. He published the magazine *Le Japon artistique* and contributed significantly to

the dissemination of the ukiyo-e aesthetic. His gallery L'Art Nouveau hosted Signac's first one-man show in 1902. For Bing, this picture, with its light colors, clearly defined forms, and deliberately simplified composition, was an unmistakable manifestation of *japonisme*. MFB

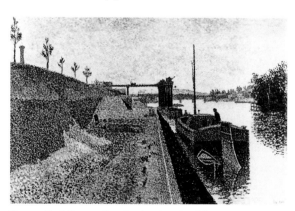

Fig. 80. Paul Signac, *Gray Weather, Quai de Clichy, Opus 156*, 1887, oil on canvas, 18⅛ x 25⅝ in. (46 x 65 cm). Location unknown, FC 142

27. THE TOWN BEACH, COLLIOURE, OPUS 165, 1887

Oil on canvas, 24¾ x 31½ in. (62.9 x 80 cm)
Signed and dated, lower left: P. Signac 87;
inscribed, lower right: Op. 165
The Metropolitan Museum of Art, New York,
Robert Lehman Collection, 1975 (1975.1.208)
FC 153 *(Collioure. La Plage de la ville. Opus 165)*

Exhibitions: Brussels 1888, Exposition des XX,
no. 10, *Op. 165*, Août–septembre 1887; Paris 1888,
Salon des Indépendants, no. 630, *Op. 165, Collioure
(Pyrénées-Orientales)* Août–septembre 1887

Signac spent his first Mediterranean sojourn in
Collioure, in the eastern Pyrenees, a few miles
from the Spanish border. This small port became
important in the history of art when Matisse
and Derain painted their first Fauve works there

in 1905. Between July and October 1887 Signac
painted four pictures in Collioure, which he
described when they were shown at the 1888
Salon des XX in Brussels: "Four seascapes from
Collioure, a Midi with blond shadows and
sparkling with soft colors. One is surprised not
to see the emphatic blues which are the pride of
the run-of-the-mill painters of Mediterranean
landscapes. These gentlemen do not see that
the orange tone—the light of the sun reflected
from all sides—discolors the shadows, attenuates
the local colors, and washes out the pure sky.
The Goncourt brothers, better painters than
M. Montenard, have Coriolis say: 'Look at the
white there in the corner of the studio; well,
I am going to surprise you: that is precisely the
value of the color of the shadow at Magnesia
in the month of July.'"[1]

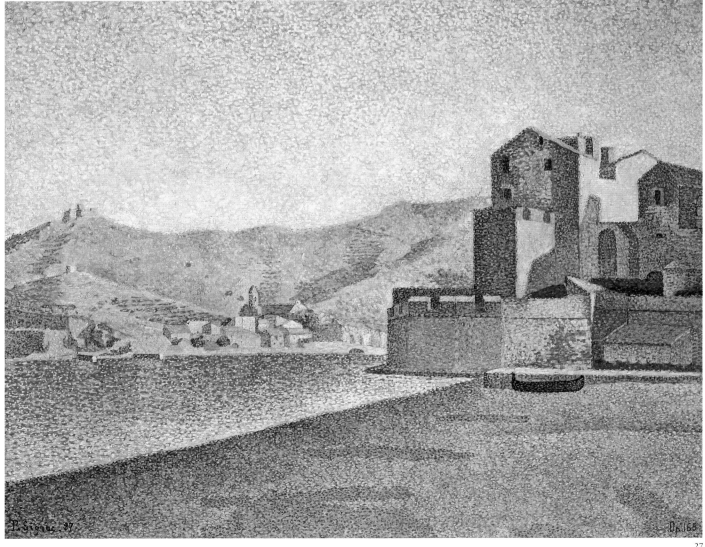

27

Signac, of whom Huysmans had said that he "'Marseilled' the suburbs,"[2] depicted a south of France with pale colors under an intense sun. There is none of the colorful gaiety of his views of Paris and its suburbs. The Mediterranean landscape with its "slumbering, quasi-Saracen constructions,"[3] rocky landscape, and glassy water is placed outside of time. Fénéon appreciated the austere beauty of the "four seascapes from Collioure (August–September–October 1887), perspectival effects driving a sharp angle of the sea into the beach, houses as daunting as citadels, no greenery, a final calm, a generally, infinitely gentle blondness. For the Midi of M. Signac's paintings is in no way apocryphal: it is a Midi in which the orange of the sun reflected everywhere pales the sky, renders the local qualities anemic, weakens the reactive force of the colors, clarifies the shadows. More superbly than ever before, M. Signac demonstrates his virtues of observation and harmony."[4]

In 1892 André Teissier, the first owner of this painting, was a notary's clerk in Paris and counted Georges Lecomte, Pissarro, and Signac among his friends. He later established himself as a notary in Mâcon, but he continued to see his painter friends and promoted their works by organizing exhibitions. MFB

NOTES
1 Signac 1888b, p. 3.
2 Huysmans 1887, p. 55.
3 Kahn 1888, p. 162.
4 Fénéon 1888a, p. 174.

28. STERN OF THE BOAT, OPUS 175, 1888

Oil on canvas, 18⅛ x 25⅝ in. (46 x 65 cm)
Signed and dated, lower left: P. Signac 88;
inscribed, lower right: Op. 175
Private collection, courtesy of Alex Reid and Lefevre Ltd.
FC 161 (*Arrière du Tub, Opus 175*)

Exhibited in Amsterdam and New York

In 1888 Signac worked at Asnières for the last time. In the following year he moved his studio to 20 avenue de Clichy, while his mother, Héloïse Signac, left the suburban Asnières for the seventeenth arrondissement in Paris. There were thus fewer occasions to travel between the avenue de Clichy and Asnières, although Signac did continue to sail. He took his friends out on the Seine in his catboat, which he called the *Tub*, and found new anchorages before the boat ultimately sank at Herblay in 1890.

After depicting different views of the quai de Clichy, in which he came ever closer to the river, Signac adopted the vantage point of the holiday sailor looking at the landscape from each end of his boat, *Stern of the Boat, Opus 175* and *Bow of the Boat, Opus 176* (fig. 81). These paintings anticipate an important change in his work. Little by little,

evocations of leisure activities and the pleasures of sailing would replace the industrial landscapes, with their bridges and metal cranes, which are still visible here. In these new landscapes Signac resisted the temptations of Naturalism and moved closer to Monet and the Impressionist tradition in his choice of subject. A new lyricism, associated with sailing, began to appear in his work. In any case, Signac found nothing sordid about the industrial suburbs. The river and the sea, which gradually became the main subject of his outdoor paintings, have a new poetry, which, however, did not exclude his close observation of the environment. He did not depict the *guinguettes* or the restaurants of Asnières, as Van Gogh did in 1887 (*Restaurant of the "Sirène," Asnières*, Musée d'Orsay, Paris [F 313]; *Restaurant Rispal, Asnières*, Bloch collection, Kansas [F 355]), but he adopted almost the same approach that the Dutch painter and his friend Émile Bernard had taken earlier (figs. 82, 83). Van Gogh had set up his easel only yards away —on the riverbank—and had painted Asnières as an industrial site and a suburban playground (*Moored Boats*, 1887, private collection [F 353]).

In the present work the industrial character of the landscape is still apparent. The foreground displays a rhythmic progression of moored boats leading up to the railroad bridge, which is crossed by a locomotive. In the middle ground we see the

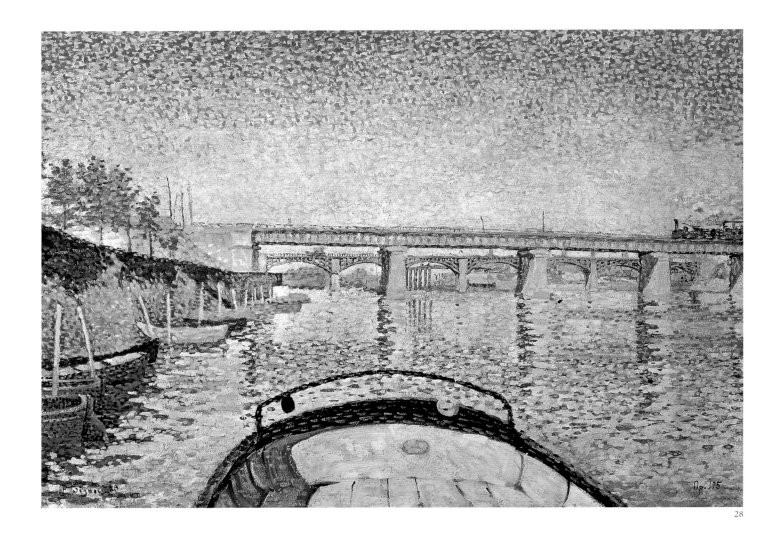

28

pont d'Asnières, and through its arches the cranes of the gas plant, emphasizing the ambiguity of the site, which was devoted both to water sports and rampant industrialization (see figs. 84, 85). As he had done the year before on the quai de Clichy, Signac turned downstream to paint the view under a clear sky and then faced upstream to paint a second version in cloudy weather. In *Bow of the Boat, Opus 176*, he showed the other side of Asnières, a pleasant suburb with wooded riverbanks offering leisure and water sports. Upstream lies the Île de la Grande Jatte. MFB

Fig. 81. Paul Signac, *Bow of the Boat, Opus 176*, 1888, oil on canvas, 17¾ x 25⅝ in. (45 x 65 cm). Private collection, FC 162

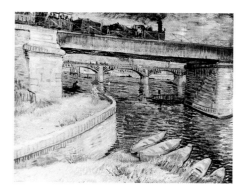

Fig. 82. Vincent van Gogh, *Bridge at Asnières*, 1887, oil on canvas, 20½ x 25⅝ in. (52 x 65 cm). Foundation E. G. Bührle Collection, Zurich

Fig. 83. Émile Bernard, *Bridge at Asnières*, 1887, oil on canvas, 18⅛ x 21⅜ in. (45.9 x 54.2 cm). The Museum of Modern Art, New York, Grace Rainey Rogers Fund, 1962, 113.62

Fig. 84. The Seine and the two bridges at Asnières, ca. 1885–95, postcard. Archives Municipales, Asnières

Fig. 85. The banks of the Seine at Asnières: A regatta day, ca. 1885–95, postcard. Archives Municipales, Asnières

29. THE MASTS, PORTRIEUX, OPUS 182, 1888

Oil on canvas, 18⅛ x 21⅝ in. (46 x 55 cm)
Signed and dated, lower left: P. Signac 88;
inscribed, lower right: Op. 182
Private collection
FC 166 (*Portrieux. Les Mâts. Opus 182*)

Exhibitions: Brussels 1890, Exposition des XX, no. 3, *Op. 182*, under the overall title *La Mer—Portrieux (Côtes-du-Nord)*, juin—sept. 1888; Paris 1890, Salon des Indépendants, no. 743, *Op. 182*, under the overall title *La Mer—Portrieux (Côtes-du-Nord)*, juin, juillet, août, septembre 1888

Seurat spent the summer of 1888 at Port-en-Bessin, which Signac had helped him discover. The latter had already explored the pictorial resources of the site (cat. nos. 6, 7) and decided to spend the summer in the north of Brittany, at Portrieux. This small port on the English Channel, which has since become part of the seaside resort Saint-Quay-Portrieux, inspired a remarkable series of nine paintings, for which six studies on panel survive (FC 164–78). Although working in a fairly small area, Signac wanted to depict the variety of maritime sights and create a synthesis of them in paint, as his description indicates: "7 op. from Portrieux (Côtes du Nord). Jetties, sloops, landmarks, yawls, semaphores, yachts, Icelandic schooner, shoals, lighthouses, and beacons: synthesis of a small Breton port."[1] He devoted one canvas to a general view of the port (FC 168) and no less than four to the jetty and lighthouse—in both sunny and cloudy weather. He also depicted the Plage de la Comtesse (FC 177) and the Tertre Denis (cat. no. 30).

The present view of the masts at Portrieux is among the most well known of this series. The regular pattern of boat masts tempers the strong

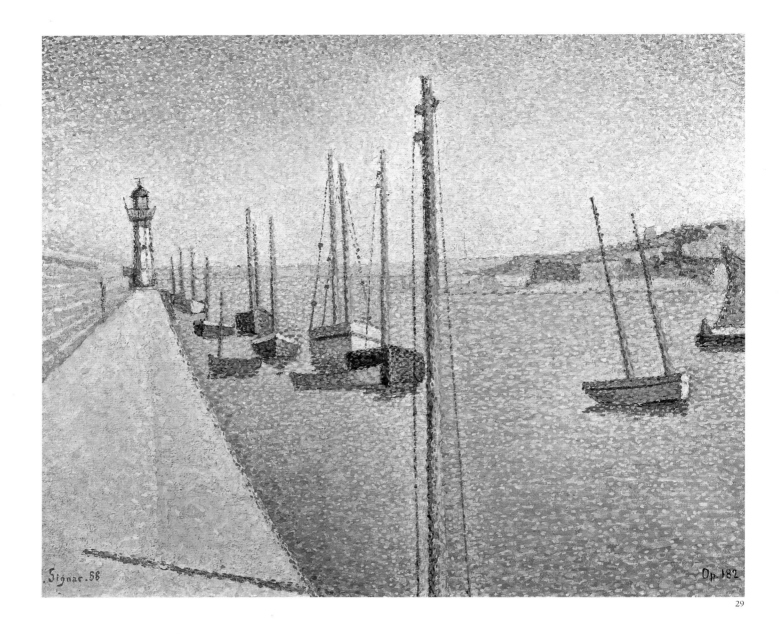

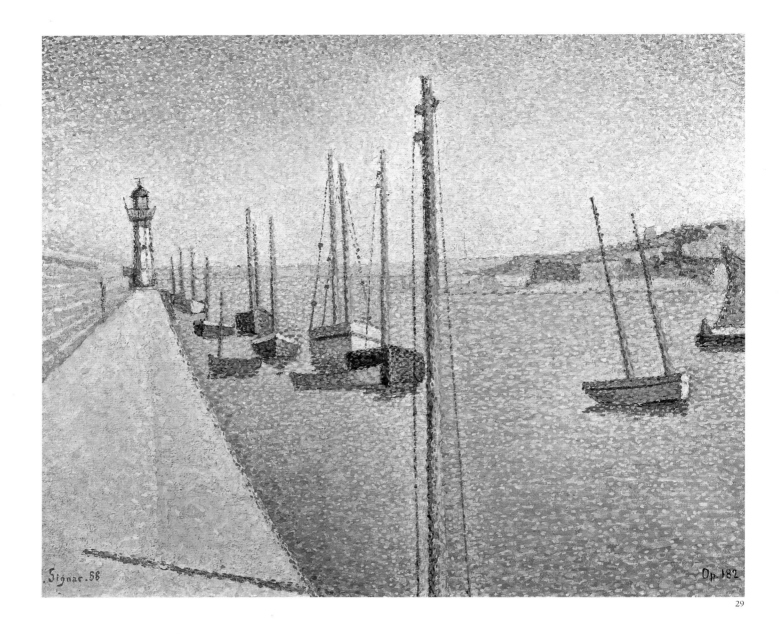

29

geometric thrust of the jetty, which forms a tri-
angle of surprising luminosity amid the other-
wise soft colors of the composition. Upon his
return to Paris Signac gave this picture to his
friend the writer Jean Ajalbert, who had shared
the joys of this vacation in Brittany and later
reminisced: "We decided to spend the summer
at the same spot, each taking up lodgings at a
fisherman's, eating our meals with him. . . . From
Portrieux, we sailed over to Jersey. An unforget-
table vacation."[2] MFB

NOTES
1 Signac 1890, p. 77.
2 Ajalbert 1934, p. 4.

30. TERTRE DENIS, PORTRIEUX, OPUS 189, 1888

Oil on canvas, 25⅝ x 31⅞ in. (65 x 81 cm)
Signed and dated, lower left: P. Signac 88;
inscribed, lower right: Op. 189
The Phillips Family Collection
FC 171 (*Portrieux. Tertre Denis. Opus 189*)

Exhibitions: Brussels 1890, Exposition des XX,
no. 6, *Op. 189*, under the overall title *La Mer—
Portrieux (Côtes-du-Nord)*, juin–sept. 1888

Françoise Cachin has noted that after Signac came
to know Seurat he painted "pure seascapes, with
a balance and a gentleness that he perhaps never
again equaled. One senses that at this period, under
Seurat's influence, he was seeking light more than
color."[1] This remarkably serene work is devoid of
human presence; the few scattered boats hardly
disturb the perfectly still sea. The landscape is
animated by the harmonious alternation of col-
ors after Chevreul's principles of color contrast.

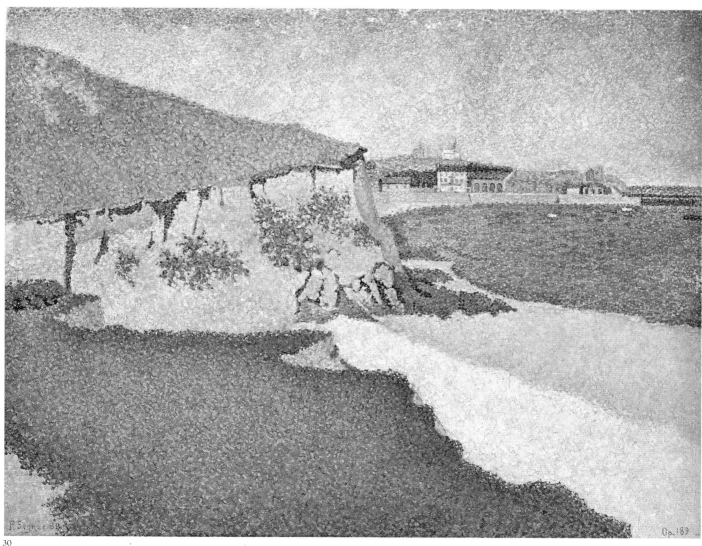

30

The subtle play of angles and broken lines creates a near-abstract composition with an especially harmonious rhythm. The lines are not unrelated to the "harmonic" diagrams that Signac drew to illustrate the complex ideas of Charles Henry,[2] whose influence on the artist was most evident in his landscape series from Portrieux. This is undoubtedly one of the reasons why these calm and aloof visions are so close to the work of Seurat, who was then busy painting his memorable series at Port-en-Bessin. Like Signac, Seurat was intensely interested in the young Henry's efforts to establish a mathematical basis for beauty. Both artists shared Henry's postulation of form and color as abstract or musical entities, free from any trace of Naturalism. The present work is considered "one of the most solid demonstrations of Signac's desire to apply his friend's theories to the rhythms and tempos of lines and colors."[3] It is fitting that Signac gave the painting to Henry—it remains a brilliant homage to the joint efforts of painter and scientist. MFB

NOTES
1 Cachin 2000, p. 30.
2 Henry 1890.
3 Cachin 2000, p. 30.

31. THE SWELL, PORTRIEUX, OPUS 190, 1888
Oil on canvas, 23⅝ x 36¼ in. (61 x 92 cm)
Signed and dated, lower left: P. Signac 88; inscribed, lower right: Op. 190
Staatsgalerie Stuttgart (2698)
FC 172 (Portrieux. La Houle. Opus 190)

Exhibitions: Paris 1889, Salon des Indépendants, no. 245, Op. 190, Portrieux, sept. 88; Brussels 1890, Exposition des XX, no. 7, Op. 190, under the overall title La Mer—Portrieux (Côtes-du-Nord), juin–sept. 1888

Robert Herbert compared this painting to a musical score: the waves are the lines and the sailboats the notes.[1] Indeed, the peaceful atmosphere and subtle simplicity of the decorative surface anticipated the deliberately "musical" series painted at Concarneau in 1891 (cat. nos. 54–56). The present composition was elaborated in a number of studies in which Signac gave the jetty greater or less prominence and experimented with various foreground elements—beach, quay, sailboat in dry dock. In the definitive version he opted for a pure and balanced arrangement. The jetty is in line with the horizon and the rocky shore opposite. The jutting angle of the quay counters the emphatic horizontality of the rhythmic pattern of rippling waves, as do the short verticals of the lighthouse and masts.

The works painted by Signac and Seurat during the previous summers were hung side by side at the 1889 Salon des Indépendants, and the closeness of their vision was noted by Jules Christophe. He first commented on the works painted by Seurat at Le Crotoy and Port-en-Bessin, then went on to say: "Similar calm effects have been achieved by M. Paul Signac in his two views of Portrieux (Côtes du Nord), which present about the same setting in a region of the same nature, at identical times of the day and seasons, seeming to have been painted on the same day, in a fraternal communion of ideas."[2]

From this point on, Signac avoided painting scenes that were too similar to those chosen by his sensitive and brilliant friend. New tendencies emerge in his landscapes. Their more intense colors and more strongly delineated forms, perhaps better suited to his temperament, had significant impact on his later work.

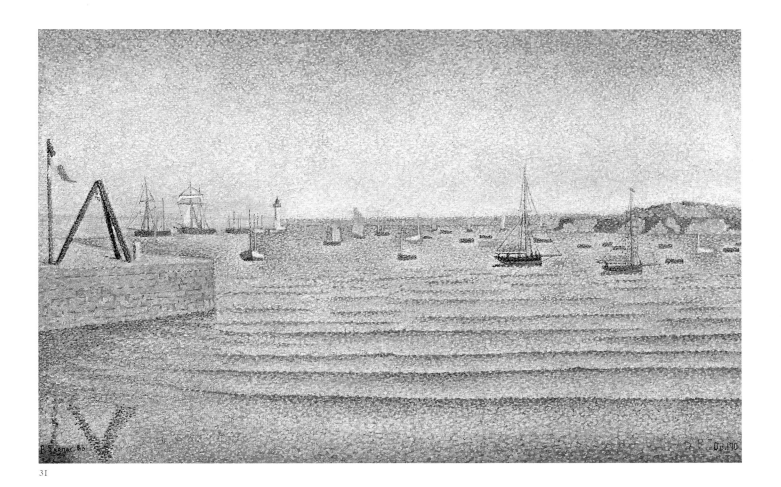

31

The artist kept this painting until 1896, when he traded it with the bookseller Mathias for a copy of Alfred Robaut's catalogue of the complete works of Delacroix.[3] This exchange seems symbolic. Seurat was dead, and Signac had left behind Henry's theories, which mark this delicate picture, subsequently finding sustenance for his Neo-Impressionist reflections in Delacroix. MFB

NOTES
1 Herbert in New York 1968, p. 136, no. 95.
2 Christophe 1889, p. 305.
3 Signac journal entry, April 26, 1896, Signac Archives.

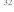

32. PLACE CLICHY, 1888
Oil on wood, 10¾ x 14 in. (27.3 x 35.6 cm)
Signed and dated, lower right: Signac 89
The Metropolitan Museum of Art, New York,
Robert Lehman Collection, 1975 (1975.1.210)
FC 179 *(Place Clichy)*

Exhibited in Amsterdam and New York

Signac's brisk preliminary sketches usually cap-
tured atmospheric effects or arrangements of
forms and colors that had caught his attention.
They displayed his joy in the visual world and
his great appetite for the delights of nature and
human activity.

This sketch from life, inscribed with a barely
readable date of 1889, did not serve as a prelimi-
nary study for a larger painting; no other version
of the subject is recorded in Signac's cahier d'opus,
which assigns the panel to 1888. At least a year
had elapsed since Signac had made two panels in
a style close to that of Seurat (cat. no. 23 and
FC 135). Here, we see a very different manner:
the brushwork is looser, more confident; the
colors explode and endow this modest view of
the place Clichy with a strong vibrancy.

At the time of Signac's death in 1935, Gustave
Kahn recalled his friend's early works: "The most
characteristic of these pictures [depicts] a corner
of a carnival seen at high noon on a hot day,
the ground baked by the sun, the booths and
merry-go-rounds covered with tarpaulins. A feel-
ing of deep solitude hangs over this fairground,
in which the organs and violins have been inter-
rupted by the unrelenting heat of the day."[1]
Although Kahn confused this panel in his mem-
ory with another picture of a fairground, the
description is otherwise quite precise and attests
to the strong impression the work had made
nearly half a century before.

Signac gave this masterly work to Jules Chris-
tophe, an art critic and writer who, like Fénéon,
worked as a clerk in the War Ministry. More-
over, he was one of the first defenders of Neo-
Impressionism and, with Signac and Aman-Jean,
belonged to Seurat's small circle of friends. He
wrote Seurat's biography for the April 1890 issue
of *Les Hommes d'aujourd'hui.* MFB

NOTE
1 Kahn 1935, p. 170.

33. APPLICATION OF CHARLES HENRY'S CHROMATIC CIRCLE,
1888
Color lithograph, 6⅛ x 7⅛ in. (15.5 x 18 cm)
Théâtre-Libre program of January 31, 1889

Exhibited in Amsterdam: Van Gogh Museum, Amsterdam (P770 M/1992)

Exhibited in New York: The Metropolitan Museum of Art, New York, Purchase, Reba and Dave Williams Gift, 1990 (1990.1056) [reproduced]

This print is a remarkable by-product of Signac's collaboration with Charles Henry. It originated as a watercolor design for a poster, made in 1888 to announce the publication of Henry's book *Cercle chromatique*. The poster was described by Félix Fénéon: "It is one of the minor applications of a general theory that will bring improvements to typography, costume, architecture, furnishings, . . . in short all the industrial arts, and will supply a tool for the analysis of beauty. M. Paul Signac's poster is a first trial: its polychromy is perfectly ordered."[1] This design was subsequently printed in a modified form on the front of programs for the Théâtre-Libre during the season of 1888–89.[2] The present example is the program for the performance of *Les Résignés* and *L'Échéance* on Thursday, January 31, 1889, by Henry Céard and Jean Julien respectively.

Signac, together with Seurat and Van Gogh, had shown some of his works in the rehearsal rooms of the Théâtre-Libre from November 1887 to January 1888. Founded by André Antoine in 1887, the Théâtre-Libre was an unusual venue with actors attempting to bring a new sense of naturalism to the stage. We can assume that the subscription audience, made up mainly of members of the artistic and literary avant-garde, would have appreciated Signac's witty program design with its crisp, modern style. Under the *T-L* (for Théâtre-Libre) Signac has placed a tondo into which he set the back view of the head and shoulders of a rotund spectator. The circular form evokes comparison with Charles Henry's chromatic circle. Robert Herbert has described the color combinations in detail: "Starting at the bottom of the right side of the 'T,' rising up to the top and down the other side, one has the colors in the order Henry placed them on his wheel. The 'L' repeats the first portion of this sequence, but upside-down. In the tondo, the hair of the spectator turns bluish-green to oppose the orange-red of the stage; the central portion of his hair is purple, and therefore flanked by the yellow of the footlights; the base of his hair again becomes bluish-green as it meets the ruddy flesh tones of his neck."[3]

The program is evidence of Signac's enthusiasm for Charles Henry's ideas about improving the quality of industrial art and design. It also evokes the artist's background and continued interest in the world of avant-garde writing and performance. JL

NOTES
1 Fénéon 1888b, p. 137.
2 Kornfeld and Wick 1974, no. 4.
3 Herbert in New York 1968, p. 137.

Application du Cercle Chromatique de Mʳ Ch. Henry.
Lith. EUGENE VERNEAU, 108, Rue de la Folie Méricourt, Paris.

33

34. CAP LOMBARD, CASSIS, OPUS 196, 1889

Oil on canvas, 26 x 31⅞ in. (66 x 81 cm)
Signed and dated, lower left: P. Signac 89;
inscribed, lower right: Op. 196
Gemeentemuseum Den Haag, The Hague
(SCH–1956–0054)
FC 182 *(Cassis. Cap Lombard. Opus 196)*

Exhibitions: Brussels 1890, Exposition des XX, no. 9, *Op. 196*, under the overall title *La Mer Cassis (Bouches-du-Rhône)*, avril–juin 1889; Paris 1890, Salon des Indépendants, no. 739, *Op. 196*, under the overall title *La Mer. Cassis (Bouches-du-Rhône)*, avril, mai, juin 1889 Prêté par M. Ch. Storm de S'Gravesande

Seurat spent the summer of 1889 at Le Crotoy, while Signac went to the south of France, stopping at Arles to visit his friend Vincent van Gogh, who had been hospitalized after his first breakdown. Signac continued southward to Cassis, a small port near Marseilles in the Bouches-du-Rhône, where he spent April, May, and June. Searching for a Mediterranean counterpoint to his views of Brittany from the previous year, Signac was looking for scenery and light that were completely different from those in Portrieux. He wrote enthusiastically to Van Gogh from Cassis: "White, blue and orange, harmoniously spread over the beautiful rise and fall of the land. All around, mountains with rhythmic curves."[1] He painted five canvases at Cassis and, as at Portrieux, all were devoted to the sea: *The Château, Cassis* (FC 181; now lost), *The Fallen Rocks, Cassis,* (FC 183; location unknown), and the three works in the present exhibition (see also cat. nos. 35, 36). Signac himself described the Portrieux and Cassis series when they were exhibited at the Salon des XX in Brussels under the general title *La Mer* (The Sea): "M. Paul Signac, 20 avenue de Clichy, Paris. Luminist technique of Neo-Impressionism

with application of the recent discoveries of Charles Henry on the rhythms and tempos of lines and colors. Collaborated with this scholar on *L'Éducation du sens des formes.* The sea: 7 op. from Portrieux. . . . And 5 op. from Cassis (Bouches-du-Rhône); tartans, Cap Canaille, dust, laotello [?], rocky coves, speronaros from the Balearic Islands, huts, blues, oranges, greenish pinks: the Mediterranean of Provence."[2]

In this synthetic seascape the curved lines create a play of triangles in alternating colors of yellow and blue washed out by the sun. In the middle a chaotic group of orange-toned rocks—a surprising explosion of forms and colors—animates the shadowless, motionless composition. The smooth sea reflects and decomposes the forms into subtle, powdery colors. The decorative qualities of this work enchanted Félix Fénéon, who later expressed a decided preference for the works of this period and remarked: "M. Paul Signac was able to create exemplary specimens of an art of great decorative development, which sacrifices anecdote to arabesque, analysis to synthesis, fugitive to permanent, and . . . confers on nature, which finally grew tired of its precarious reality, an authentic reality. To illustrate so many words, go see the most recent works, especially the op. 196 (Cassis. Cap Lombard), op. 200 (id. Cap Canaille [cat. no. 36]), op. 206 (The Seine in the Herblay Valley [cat. no. 38]). In them we see the vigor of form and the serene and delicate magnificence of color inextricably linked, and space pierced with light gathering in the skies."[3]

Unlike the works painted in Portrieux, most of which the artist gave to his friends, those from Cassis quickly found buyers, usually connoisseurs with close ties to the art world. The present work was purchased from its first exhibition in Brussels by Carel Nicolaes Storm van 's Gravesande, a Dutch painter of seascapes. MFB

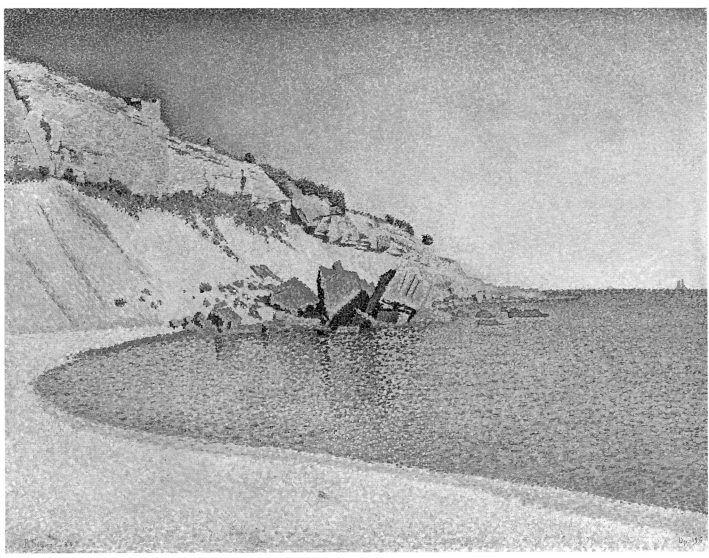

34

NOTES

1 Letter from Signac to Van Gogh, April 12, 1889, in
 Van Gogh 1958, vol. 3, p. 153, letter 584a.
2 Signac 1890, p. 77.
3 Fénéon 1890, p. 3.

35. THE JETTY, CASSIS, OPUS 198,
1889
Oil on canvas, 18¼ x 25⅝ in. (46.4 x 65.1 cm)
Signed and dated, lower left: P. Signac 89;
inscribed, lower right: Op 198
The Metropolitan Museum of Art, New York,
Bequest of Joan Whitney Payson, 1975
(1976.201.19)
FC 184 *(Cassis. La Jetée. Opus 198)*

Exhibitions: Paris 1889, Salon des Indépendants,
no. 246, *Op. 198. Cassis (Bouches-du-Rhône), mai 89;*
Brussels 1890, Exposition des XX, no. 11, *Op. 198,*
under the overall title *La Mer. Cassis (Bouches-du-
Rhône), avril—juin 1889*

Henri Dorra compared the works painted by
Signac at Cassis with Hiroshige's *Eight Views of Lake
Biwa.*[1] Indeed, the emphatic diagonal formed by
the beach in the foreground and the large empty
areas inevitably recall ukiyo-e compositions. It
should be kept in mind that during these first
years of Neo-Impressionism, Signac's work was
inspired as much by his admiration for Japanese
prints as by the theories of Charles Henry. In
1889, when this picture was shown at the Salon
des Indépendants, Fénéon already noticed the
analogies with Japanese lake landscapes and added:
"In front of this enchanting work, we are re-
minded for a moment—by a wavering affinity—of
those majolicas, the *péquariennes,* I believe, in
which blues and yellows of great purity lie in a
tin-bearing enamel that enlivens green, red, and
gold with the play of its iridescence."[2] On the
same occasion, Jules Christophe also admired
this painting, which he brilliantly described,
noting that it "expresses maritime Provence with
great charm and fidelity: the port of Cassis, the
Mediterranean an intense blue, ruddy earth, a
craggy hill, a tower ruin, low red houses with
blinding walls."[3]

Critics became less favorable as time went on.
In May 1891, when Signac again showed at the
Salon des Indépendants, Adolphe Retté wrote:

"We no longer find the luminous intensity and
rhythm of Cassis here (Opus 198, 1889 exhibi-
tion)." Three years later, during a trip through
the Midi in which he visited Cassis, the critic
claimed that among the painters who depicted
the Mediterranean, "only one name stands out:
that of Vincent van Gogh." He found Signac's
efforts pitiful: "The pointillist folly has distorted
his vision." He also deplored the absence of
an intense light in his works, saying that they
had "the value of a muddy mass," before he
went on to stigmatize the docility of the Neo-
Impressionists for immersing themselves in
the "fantasies of M. Charles Henry." This
unusually virulent article also attacked "those
horrible grimace makers, those apostles of the
ugly: the Bonnards, Vuillards, and assorted
Bernards."[4] In spite of the excessive nature of the
attack, Signac was shaken and wrote in his jour-
nal: "Read in 'La Plume' an article by Retté who,
finding himself in Cassis, felt the need of criti-
cizing unmercifully all the paintings which I did
there.... Yet I think that I have never done
paintings as 'objectively exact' as those of Cassis.
In that region there is nothing but white. The
light, reflected everywhere, devours all the local
colors and makes the shadows appear grey....
Van Gogh's paintings done at Arles are mar-
velous by their fury and intensity, but they do not
at all render the 'luminosity' of the South. Under
the pretext that they are in the South, people
expect to see reds, blues, greens and yellows...
While it is, on the contrary, the North—Holland,
for example—that is 'colored' (local colors), the
South being 'luminous.'"[5]

This painting was sold to Antoine de La
Rochefoucauld, through Vincent d'Indy, probably
after the 1890 exhibition of Les XX in Brussels.
Signac met La Rochefoucauld through the Natu-
ralist writer Paul Adam. One "Thursday in
November 1890," Adam asked Signac, "Would
you allow me to take you next Wednesday to

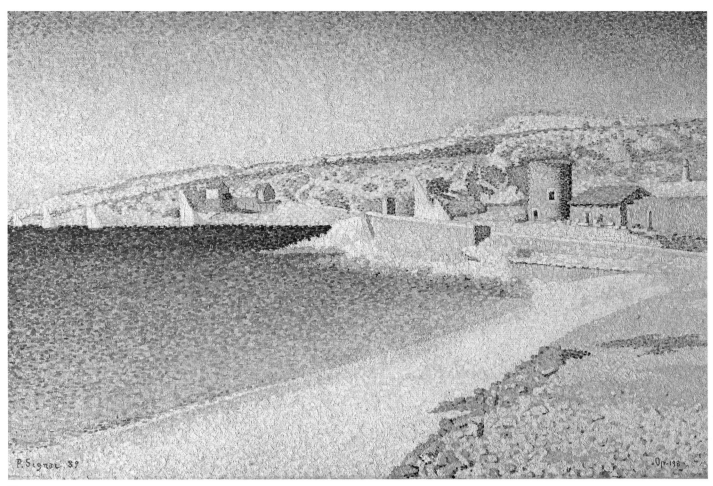

35

the young count de La Rochefoucauld [. . .] who
has taken up Impressionism, buys Monets and
Pissarros, and admires you, as well as Seurat and
Luce. He even paints himself. He would like to
have the color theory explained according to
your method."[6] La Rochefoucauld then adopted
the Neo-Impressionist technique, supported
Signac and his friends by opening a short-lived
gallery in the rue Laffitte, and devoted articles
to them in the no-less-ephemeral review *Le Coeur*.
Starting in 1895, however, he dropped Neo-
Impressionism in favor of Symbolism and the
Rose+Croix movement. MFB

NOTES

1 Dorra and Askin 1969, p. 89.
2 Fénéon 1889b, p. 252.
3 Christophe 1889, p. 305.
4 Retté 1891 (1968 ed., p. 295); Retté 1894, pp. 351–53.
5 Signac journal entry, September 29, 1894, in Rewald 1949, pp. 106, 168.
6 Letter from Paul Adam to Signac, November 1889, Signac Archives.

36. CAP CANAILLE, CASSIS, OPUS 200, 1889

Oil on canvas, 25½ x 32¼ in. (66 x 82 cm)
Signed and dated, lower left: P. Signac 89;
inscribed, lower right: Op 200
Private collection
FC 186 *(Cassis. Cap Canaille. Opus 200)*

Exhibitions: Brussels 1890, Exposition des XX,
no. 12, *Op. 200*, under the overall title *La Mer—
Cassis (Bouches-du-Rhône)*, avril – juin 1889; Paris
1890, Salon des Indépendants, no. 737, *Op. 200*
Prêté par Mme Monnom, under the overall title
La Mer—Cassis (Bouches-du-Rhône), avril, mai, juin
1889; Antwerp 1892, Association pour l'Art,
unnumbered

Commenting on the series Signac painted at
Cassis, Jules Christophe admired the "brilliant
ocher of the cliffs, the brilliance of the deeply
blue sky, the joyous sparkle of the Mediterra-
nean, giving the impression of a perky and tri-
umphant fanfare . . . very intelligently contrasted
with four views of a port in the Côtes du Nord
in the late summer, at peace and gray."[1] Of the
five paintings done at Cassis, this one is the
brightest and most Mediterranean in character
and color. The repetition of horizontal lines
expresses the serenity so characteristic of the
Mediterranean shore at the end of the day. The
roughness of the landscape is evident in the
abrupt profile of the cliffs. The warm colors,
like the rocks' orange-tinted ocher, and the pur-
ple of the foreground shadows suggest a sunset,
with its exaltation of the Mediterranean land-
scape. The host of small sails indicates that it is
time to return to port.

When this picture was shown in Brussels
at the 1890 Salon des XX, the painter Théo
van Rysselberghe told Signac that the serene

grandeur of the site had also inspired his friend the composer Vincent d'Indy: "Vincent d'Indy is here to conduct the concerts of French music. He was very pleasantly surprised to find *Cap Canaille*(?) in your contribution. It was in the house in the foreground that he composed his 'bell.'"[2] The French composer was given an oil sketch (now lost) for the painting as a souvenir and perhaps to thank him for his role in the sale of *The Jetty, Cassis* (cat. no. 35). D'Indy wrote to Signac on May 3, 1890: "I have received your (my) Cap Canaille, I hung it high above my worktable so as to have the exact impression of an open window giving out onto the red mountain."[3]

The painting itself was purchased at the XX exhibition in Brussels by Sylvie Descamps, the "Widow Monnom." The head of Monnom, a leading Belgian publisher, she was known for her daring and refinement and for her publication of young writers as well as the catalogues of Les XX and avant-garde reviews like *L'Art moderne*

and *La Jeune Belgique*. Several months before, Van Rysselberghe, a newcomer to the Neo-Impressionist cause, had married her daughter, Maria Monnom.[4]

In 1928 Signac advised his patron Gaston Lévy, then working on a catalogue raisonné of the artist's works, to ask Mme van Rysselberghe what had become of the two paintings that were in her mother's possession in Brussels: "a return of the fishing boats to Concarneau" (FC 219) and a Cap Canaille in Cassis, "one of the pictures that I painted with the utmost pleasure [in] 1889!"[5] MFB

NOTES
1 Christophe 1890, p. 102.
2 Letter from Théo van Rysselberghe to Signac, undated, Signac Archives.
3 Letter from Vincent d'Indy to Signac, May 3, 1890, Signac Archives.
4 Fontainas and Fontainas 1997, cahier 3.
5 Letter from Signac to Gaston Lévy, August 28, 1928, private collection.

37. **THE RIVERBANK, HERBLAY, OPUS 204,** 1889
Oil on canvas, 23⅝ x 36¼ in. (60 x 92 cm)
Signed and dated, lower right: P. Signac 89; inscribed, lower left: Op 204
Lord and Lady Ridley-Tree
FC 190 (*Herblay. La Rive. Opus 204*)

Exhibition: Lyon 1914, Exhibition universelle, unnumbered, *Le chemin de halage*

The death of Signac's paternal grandfather, buried in Asnières on June 28, 1889, probably precipitated the artist's departure from Cassis. He spent August and September at Herblay, not far from Paris, where he enjoyed the company of Maximilien Luce for several weeks. Now transformed by extensive urbanization, Herblay was then a rural market town on the Seine, where sailing enthusiasts braved the sometimes dangerous river traffic. Signac and Luce returned the following summer. A story recounted by Signac's friend the writer and critic Georges Lecomte recalls the carefree atmosphere of those days: "Last Sunday, between Val d'Herblay and Andrésy, the boats of M. Signac took Luce and a group of writers from the Symbolist faction [Fénéon, Edmond

Cousturier] for a sail. Messrs. P. Signac in his sealskin and G[eorges]. L[ecomte]. in rosy flannelette decorated the catboat the *Tub*, which tacked against the wind to sail up the Seine toward the beautiful islands. . . . The *Tub* was caught between a strong gust and a tugboat and sank. Thrown into the Seine, M. Lecomte was finally able to pull himself onto a barge: he even had the album that we had brought on board, *Figures et différents caractères gravés par Boucher d'après Watteau*."[1]

Signac also painted at Herblay, as shown by six paintings and three studies from 1889 (FC 188–96). The present view, painted slightly upstream from the town, depicts Herblay as it appeared then: fields, cultivated hillsides, rural houses, and a towpath where a peasant woman walks. On the left are wooded banks; in the distance a steamboat brings a touch of color into the morning light. The simplicity of the composition, which suits the site's rustic character, the purity of the Île-de-France light, the complete lack of pictorial sophistication—rare when the theories of Charles Henry and Japanese prints fostered a particularly refined conception of painting—are all reminiscent of the work of Camille Pissarro.

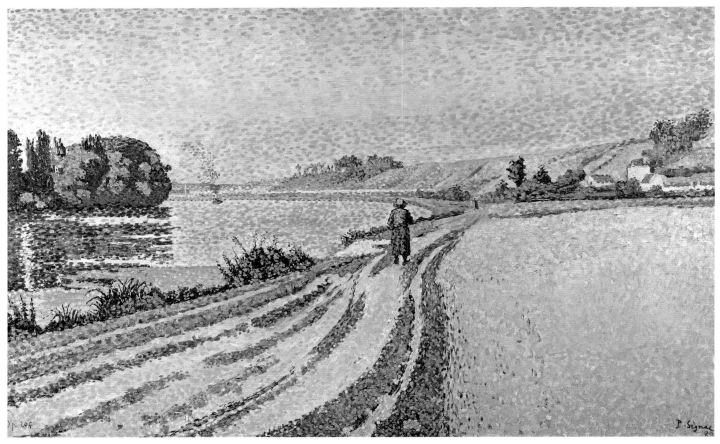

Signac gave this picture to Georges Lecomte as a souvenir of their pleasant times on the river and perhaps of the unintentional swim mentioned above. Several years later, at the auction to benefit Père Tanguy's widow, Lecomte purchased *The Dolphin, Herblay* (FC 195), another picture from this series. Lecomte, who was also a friend of Fénéon's and Guillaumin's, was a witness at Signac's wedding, as was Camille Pissarro, the subject of Lecomte's 1890 biography in *Les Hommes d'aujourd'hui.* Although Lecomte shared the anarchist convictions of his friends, he went on to pursue a career as an academician and president of the Société des Gens de Lettres. MFB

NOTE
1 Lecomte 1890b, pp. 239–40.

38. SUNSET, HERBLAY, OPUS 206,
1889

Oil on canvas, 22½ x 35⅜ in. (57.1 x 90 cm)
Signed and dated, lower right: P. Signac 89;
inscribed, lower left: Op 206
Glasgow Museums: Art Gallery and Museum,
Kelvingrove (3324)
FC 192 (*Herblay. Coucher de soleil. Opus 206*)

Exhibitions: Brussels 1891, Exposition des XX,
unnumbered, *Op. 206. Herblay (Seine-et-Oise)
Sept. 1889*, appartient à M. le Cte Antoine de la
Rochefoucauld, under the overall title *Le Fleuve*;
Paris 1891, Salon des Indépendants, no. 1109,
op. 206. Herblay, Seine-et-Oise. Septembre 1889,
A. M. le Comte Antoine de la Rochefoucauld,
under the overall title *Le Fleuve*

The reddish glow of sunset gives an uncommonly
lyrical atmosphere to this view downstream from
Herblay. The composition is extremely simple:
a wooded isle in the middle of the canvas—one
of the writer Georges Lecomte's "beautiful
islands" in the Seine—flanked by groups of trees
along the riverbanks. The horizon is near the
middle of the canvas: the trees and red sky are
reflected symmetrically in the water, which is
barely ruffled by the current. Antoine de La
Rochefoucauld, who owned this work, wrote: "In
this sunset at Herblay, the light blazes, the green
of the backlit trees gives way to the onslaught of
blue, the only color that prevails at this late
hour."[1]

While the green of the foliage is a strong
presence in the final painting, it is completely
lacking in the study for it painted on site
(FC 194). With just a few brushstrokes the artist
rapidly transcribed the effect of the pink and yel-
low sky and the backlit riverbank plunged in blue
shadow. This painting and *Fog, Herblay, Opus 208*
(cat. no. 39) were exhibited in 1891 at the Salon
des XX in Brussels and then at the Salon des
Indépendants under the overall title *Le Fleuve*
(The River). In 1892 Signac painted two fans
that repeat the subjects of these two works. He
gave the first to Maria van Rysselberghe, the
wife of the Belgian Neo-Impressionist, and the
second to his mother, Héloïse Signac. MFB

NOTE
1 La Rochefoucauld 1893b, p. 5.

38

39. FOG, HERBLAY, OPUS 208, 1889

Oil on canvas, 13 x 21⅝ in. (33 x 55 cm)
Signed and dated, lower left: P. Signac 89;
inscribed, lower right: Op. 208
Musée d'Orsay, Paris, acquired with the
participation of Ginette Signac and an
anonymous donor, 1958 (RF 1958-1)
FC 196 (Herblay. Brouillard. Opus 208)

Exhibitions: Brussels 1891, Exposition des XX,
unnumbered, op. 208. Herblay (Seine et Oise)
Sept 1889, under the overall title Le Fleuve; Paris
1891, Salon des Indépendants, no. 1111, op. 208.
Herblay, Seine-et-Oise. Septembre 1889, under the
overall title Le Fleuve

Here Signac again took up a position downstream
from Herblay, only this time looking toward
the town. We can see the same towpath and
white houses as in The Riverbank, Herblay, Opus 204
(cat. no. 37), but they are dominated by the bell
tower on top of the hill in the distance. A steam-
boat appears on the horizon, which is a little
lower than that of Opus 204. Nevertheless, the
composition of this small canvas displays a com-
parable simplicity: the trees on the island counter-
balance the curve of the hill; the landscape is
reflected in the Seine. There is a peaceful, almost
still atmosphere. The color effect, however, is
very different: here the fog attenuates the colors,
the blues and greens are pale and the orange dis-
appears. White dabs of paint only slightly mixed
with blue and yellow cover the picture plane,
dissolving the precise contours of the forms and
giving the whole a delicate and remote charm,
totally different from the colorful effusions of
the setting sun. As usual when he explored a site,
Signac changed his vantage point and composi-
tion very little. Instead the atmospheric effect,
rendered by color, results in a radical transfor-
mation, with the light determining the overall
tonality of the work. The painter took evident
pleasure in playing on this chromatic scale,
emphasizing higher notes or creating a subtle
Satie-like melody. MFB

39

40. SUNDAY, 1888–1890

Oil on canvas, 59 x 59 in. (150 x 150 cm)
Private collection
FC 197 *(Un dimanche)*

Exhibition: Paris 1890, Salon des Indépendants, no. 736, *Un dimanche.* Paris. 1889

Like many of Signac's figural works, this picture found little early favor. It was first shown at the 1890 Salon des Indépendants, next to his dazzling Cassis seascapes. It still proved to be unpopular at the 1963 Signac retrospective. After almost seventy-five years the criticism was the same—a stifling atmosphere, dark colors, stiff figures, and so on. This picture has none of the exuberant appeal of his contemporary seascapes, and its deliberately caustic nature has irked viewers. There is nothing diverting about the subject, so dear to the Naturalist writers.

In 1890 Jules Christophe summarized the scene with his usual terseness: "A Sunday in Paris, last year, a bourgeois interior, an insignificant young man tending the fire with a bored expression, and in the background, a young woman seen from behind, looking through a closed window, harmonized in calm blue."[1] Wryly alluding to Seurat's *A Sunday Afternoon on the Island of La Grande Jatte* (fig. 3), which showed a rather mixed petit-bourgeois and suburban society, Signac depicted the stuffy home-bound Sunday of a middle-class Parisian couple. He emphasized their conjugal indifference and, in the words of Georges Lecomte, "the bleak boredom of a couple sprawling its jaded nonchalance in the affluence of an over-heated drawing room."[2] As Françoise Cachin has remarked, this evocation of "bourgeois ennui, in a decor of houseplants and Henri-II–style chairs,"[3] would have been familiar to more than a few couples.

As often with Signac, the long elaboration which preceded this composition left no room for improvisation and charged each detail with meaning. According to Signac's cahier d'opus, he undertook this painting in October 1888. This probably means that the general composition was already established at that date. The initial idea for the composition was in fact even older. A lithograph printed in January 1888 in *La Revue indépendante,* and mentioned in the artist's cahier d'opus at the end of 1887, already represented the subject of a woman at a window next to a house-plant (cat. no. 41). A number of preliminary drawings and sketches (cat. nos. 42–48) allow us to explore the genesis of this complex work, which received its finishing touches on March 13, 1890, only a week before the opening of the Salon des Indépendants. Signac devoted some three winters in all to the elaboration of this ambitious composition.

Like *The Dining Room* (cat. no. 24), this painting was the deliberate transposition of a composition by Caillebotte, *Interior: Woman at the Window* (fig. 65), into the Neo-Impressionist idiom. Caillebotte's painting struck the lively imagination of Huysmans when it was exhibited in 1880: "A simple masterpiece. The truly magnificent thing about this scene is its life! The woman looking out at the street is bored, but also throbs, moves; one can see her loins stir beneath the marvelous dark blue velvet covering them."[4] This painting had also captivated Signac, who was sixteen years old at the time, discovering an Impressionism with Naturalistic strains and about to paint his first studies. A sketch done in his studio a few years later (cat. no. 1) already paid homage to Caillebotte's composition. Signac probably had occasion to see this painting again at the Galerie Durand-Ruel, either before or after it was sent to their New York branch for an exhibition of the Impressionist group in 1886. This connection is confirmed by a Conté crayon drawing and an oil sketch (cat. nos. 42, 45), which both show that Signac began by working on a composition similar to Caillebotte's picture.

Indeed, at the start Signac's young man faced left and read a newspaper, an arrangement very close to that of the painting of the older Impressionist, which also inspired a drawing by Lucien Pissarro that was printed in the July 22, 1888, issue of *La Vie moderne* (fig. 86). Pissarro presents Bastille Day, July 14: after pulling the curtains to shut out the noise of the popular festivities, a bourgeois couple find themselves in a boring tête-à-tête. The woman's silhouette, set off by the reflection of a mirror, is nearly identical to that in Caillebotte's picture. As for the dumbwaiter, its frail lines recall the Henri-II–style pedestal table in Signac's picture. It seems clear that both Signac and his friend Lucien Pissarro had recently seen Caillebotte's painting again, either at the artist's studio or at the Galerie Durand-Ruel and had talked about it together. Later, probably to avoid too many obvious similarities, Signac represented the couple facing in opposite

directions, turning the man to the right and omitting the newspaper.

A number of drawn and painted studies of the woman at the window have survived, evidence of the work that he devoted to this figure (see cat. nos. 43, 44). Signac used his companion, Berthe Roblès, as the model for the female figure, and one of the artist's friends must have posed for the figure of the man, who has turned his back and is halfheartedly tending a fire. A first oil sketch (FC 201) shows that the man posing was tall and bearded, resembling Georges Lecomte, who was to be a witness at the wedding of the artist and Roblès in 1892. Subsequently Signac modified the figure of the man but not his costume. A separate study for the head shows a more robust man without a beard (FC 202 recto). A cat, arching its back, appears only in the final sketch; it fills an empty spot in the foreground and so has a purely formal function (cat. no. 48). The center of the scene is occupied—ironically—by an embroidered chairback of two birds facing each other on either side of a fountain, a motif traditionally associated with love and marriage.

This stifling decor is full of significance. The many objects hint at middle-class affluence in a typical apartment of the Haussmannian era, with parquet floors, wrought-iron work, and a fireplace. The three figures—man, woman, and cat—are static, geometric in the extreme, and literally

trapped by their surroundings, which they echo. Using a play of formal correspondences, the artist associated the figures and the furniture by repeating the same forms in each. The folds of the man's right sleeve mimic the patterns of the marble fireplace, thus emphasizing the overall rigidity and ponderousness of this strangely frozen figure. The stiff folds of the woman's skirt seem carved out of wood and echo the floor's wood inlay, while the figure has been reduced to a silhouette devoid of substance. The only lively elements in this effigy are the extended hand and the stray strands of hair that repeat the dense tracery of the stylized leaves in a minor mode. The contour of the parti-color cat cleverly prolongs the carpet's arabesque.

Despite the many affinities with Caillebotte's composition, this Neo-Impressionist work is far more radical and abstract. Small dabs of paint homogenize the picture plane, allowing particular circumstances to be transformed into a type. As in Seurat's works, feelings, actions, and thought are all expressed by purely formal means. The choice of colors and contrasts, the direction of the lines, and the formal repetitions create an abstract effect that overrides individual expression. Even with Huysmans's imagination, it is difficult to imagine this woman's loins quivering or to praise the life that emanates from this scene. Besides, at the 1890 Salon des Indépendants, Huysmans noted "some hideous blues in horrible purples. It is dirty, dull."5

The young Signac—a confirmed anarchist—evidently had a bleak, sterile view of conventional bourgeois marriage. Familiar with the artist's methods, Antoine de La Rochefoucauld later wrote: "The basic direction of the lines is sad; they point downward. M. Signac is therefore also a poet; linear rhythm is to his mighty intellect what prosody is to a writer of verse."6 MFB

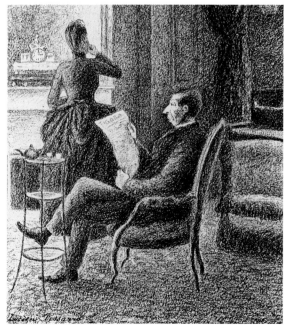

Fig. 86. Lucien Pissarro, "*During the July 14th Holiday: Those Who Pass It Up*," drawing published in *La Vie moderne*, July 22, 1888

NOTES
1 Christophe 1890, p. 102.
2 Lecomte 1890a, p. 204.
3 Cachin 2000, p. 30.
4 Huysmans 1883, p. 93.
5 See the catalogue of the Salon des Indépendants of 1890 annotated by Huysmans, quoted in the *Bulletin Pierre Bérès*, no. 90 (January 1966), unpaged.
6 La Rochefoucauld 1893b, pp. 4–5.

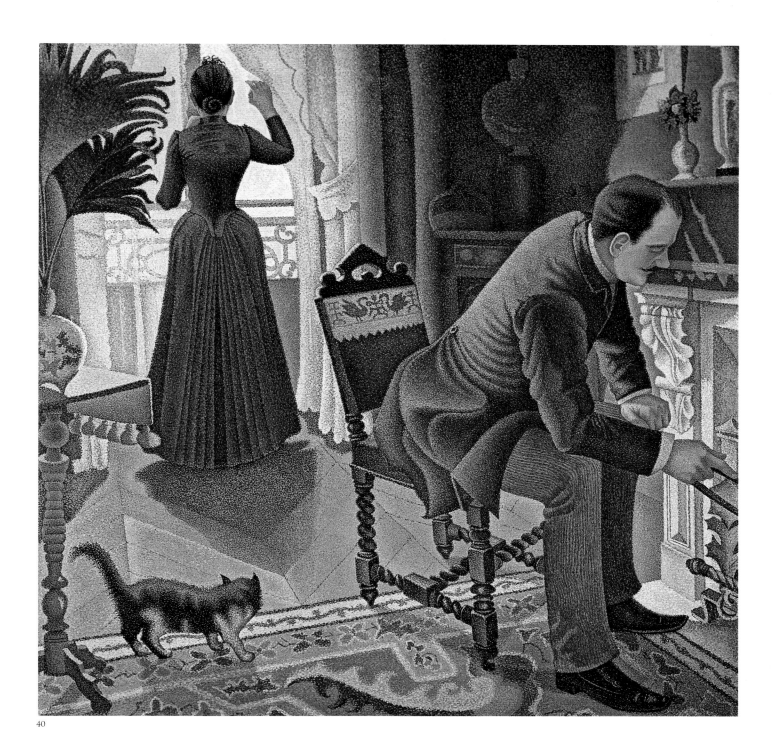

40

41. INITIAL CONCEPTION FOR "SUNDAY": WOMAN AT THE WINDOW, 1887 or 1888

Monochrome black lithograph, 6⅞ x 4⅝ in. (17.5 x 11.9 cm)

Exhibited in Paris: Bibliothèque Nationale de France, Département des Estampes et de la Photographie, Paris
Exhibited in Amsterdam: Van Gogh Museum, Amsterdam (P 768v/1992)
Exhibited in New York: The Metropolitan Museum of Art, New York, Harris Brisbane Dick Fund, 1928 (28.80.9) [reproduced]

Contrary to what one might think, this small lithograph came before rather than after the painting (cat. no. 40).[1] The January 1888 *La Revue indépendante* carried a notice: "From Paul Signac, a lithograph." This deluxe periodical offered its subscribers a print (or drawing in facsimile) with each issue; for example, two etchings by Camille Pissarro were announced in February 1888, and a lithograph by Jules Chéret in March. Given Signac's notes and the size of the print, which fits the review's format (7⅛ x 4⅞ in. [18 x 12.5 cm]),

this study may well be the lithograph offered by the *Revue indépendante.* Signac was disappointed in this venture. On Wednesday, January 11, 1888, he wrote to Octave Maus, who was in charge of Les XX in Brussels: "Wanting to avoid horrendous photographic manipulations, I have just executed a lithograph for the *Revue indépendante,* hoping for a direct reproduction according to my wishes. Nothing of the sort. Those litho pigs spoiled my stone and, to the great sadness of our friend Dujardin, I am going to oppose the insertion of this lousy reproduction in the *Revue.*"[2] We do not know if he had his way.

Signac later tried his hand at color lithography, notably in a program for the 1888–89 season of Antoine's Théâtre-Libre (cat. no. 33), and persevered in his efforts, in spite of his vexed dealings with printers. AD

NOTES
1 See Kornfeld and Wick 1974, no. 2.
2 Letter from Signac to Octave Maus, January 11, 1888, in Chartrain-Hebbelinck 1969, no. 1-2, p. 62.

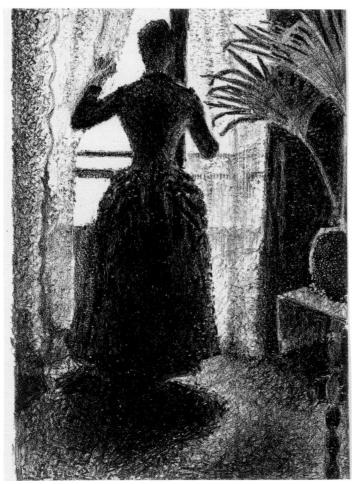

41

42

43

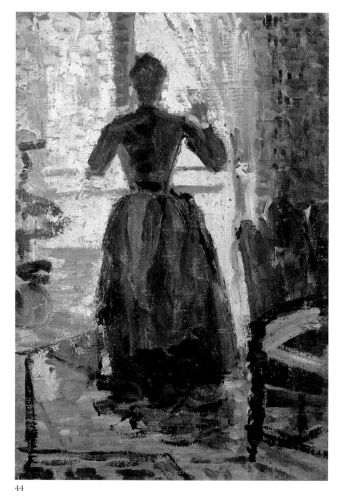

44

42. STUDY FOR "SUNDAY": WOMAN AT THE WINDOW; MAN READING A NEWSPAPER, 1888–89
Conté crayon, 8⅝ x 6¼ in. (22 x 16 cm)
Private collection

43. STUDY FOR "SUNDAY": WOMAN AT THE WINDOW, 1888–89
Conté crayon, 9½ x 6¼ in. (24 x 16 cm)
Private collection

44. STUDY FOR "SUNDAY": WOMAN AT THE WINDOW, 1888–89
Oil on wood, 9½ x 6¼ in. (24 x 16 cm)
Private collection
FC 199 *(Un dimanche [petite étude de la femme])*

First Years of Neo-Impressionism, 1886–1891 * 153

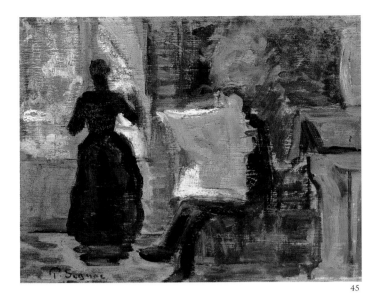

45. STUDY FOR "SUNDAY": WOMAN
AT THE WINDOW; MAN
READING A NEWSPAPER, 1888–89
Oil on wood, 6¾ x 5½ in. (17 x 14 cm)
Private collection
FC 198 (recto) (*Un dimanche [première pensée:
étude de l'homme et de la femme]*)

Exhibited in Paris only

45

46. OVERALL STUDY FOR
"SUNDAY," 1888–89
Ink wash, squared, 9¼ x 12 in. (23.5 x 30.5 cm)
Private collection

Exhibited in Paris only

46

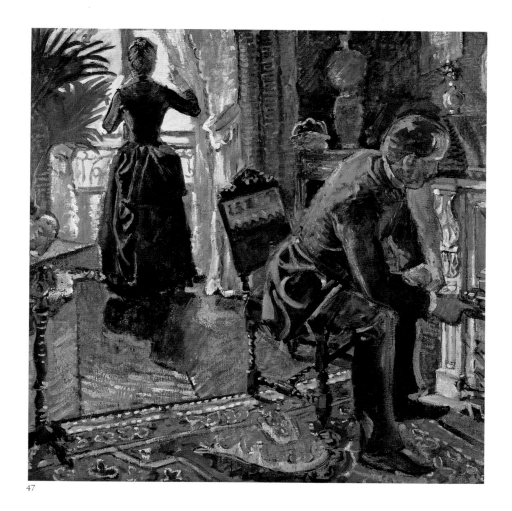

47

47. STUDY FOR "SUNDAY":
LARGE SKETCH WITHOUT CAT,
1889
Oil on canvas, 25⅝ x 25⅝ in. (65 x 65 cm)
Private collection
FC 203 (Un dimanche. Esquisse [grande esquisse sans
le chat])

48. STUDY FOR "SUNDAY":
SKETCH NO. 1 (FINAL SQUARED
SKETCH), 1889
Oil on canvas, 13 x 13 in. (33 x 33 cm)
Private collection
FC 204 (Un dimanche. Esquisse no. 1 [esquisse finale
avec mise au carreau])

48

49. SAINT-CAST, OPUS 209, 1890

Oil on canvas, 26 x 32½ in. (66 x 82.6 cm)
Signed and dated, lower left: P. Signac 90;
inscribed, lower right: Op. 209
Museum of Fine Arts, Boston, Gift of
William A. Coolidge (1991.584)
FC 205 *(Saint-Cast. Opus 209)*

Exhibitions: Brussels 1891, Exposition des XX,
unnumbered, *op. 209. Saint-Cast. (Côtes du Nord).*
Mai 1890, under the overall title *La Mer*; Paris
1891, Salon des Indépendants, no. 1112, *op. 209,
Saint-Cast, Côtes-du-Nord. Mai 1890 à M. Victor
Boch, de Bruxelles*, under the overall title *La Mer*;
Paris 1930, Galerie Bernheim-Jeune, no. 11, *Saint-
Cast*, 1890, ill.; Paris 1932, Galerie d'Art Braun,
no. 25, *Marine 1890,* ill. p. 9; Paris 1934, Petit-
Palais, no. 4106, *Baie de La Fresnaye 1890 appartient
à la galerie Léon Marseille*

In late April 1890 Signac was back in Saint-Briac,
where he stayed until August. His friend Eugène
Torquet was a few miles away at Saint-Cast, and
Signac paid him a visit. There he probably met
Henri Rivière, who also painted the baie de
La Fresnaye (fig. 87).

Signac's painting of the same site shows the
plage du Châtelet in the foreground; the Fort La
Latte is visible in the background at left, and the
pointe du Châtelet at right. An old postcard
allows us to compare Signac's view of the bay at
high tide with a view at low tide, the boats rest-
ing on their sides (fig. 88). As usual, Signac was
attentive not only to the main features and pro-
portions of the site but also to the details. Yet a
tendency toward simplification, which had begun
in the works of summer 1889 at Cassis, has
become more evident. The works of summer
1890 were as precise as they were synthetic and
anticipated the remarkable seascapes done at

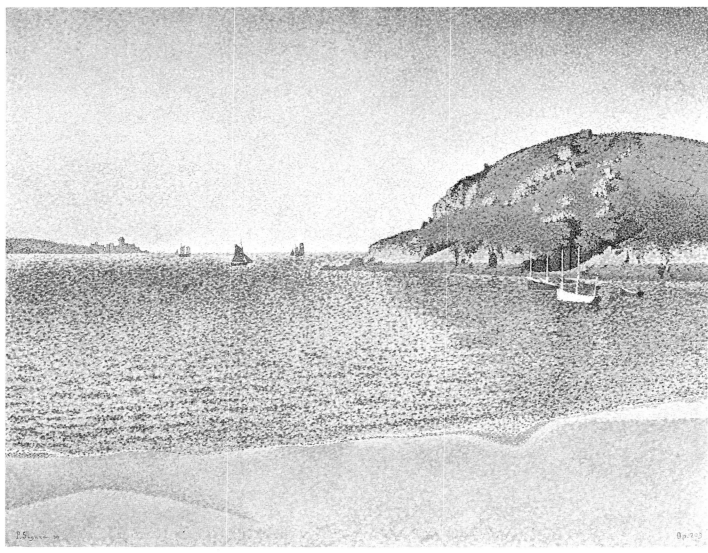

49

Fig. 87. Henri Rivière, *The Châtelet and the Fort of La Latte, Saint-Cast*, 1891, wood engraving, 13¾ x 9 in. (35 x 23 cm). Private collection

Fig. 88. Saint-Cast: The baie de La Fresnaye, ca. 1900, postcard. Private collection

Concarneau in the following year. The color scheme has been simplified to the extreme: the sand is blond; the sea, practically motionless, reflects the clear sky; the wet rocks have an orange tonality echoed by the fishing boats; and the purple shadows of the hill above contrast with the yellowed grass. The synthetic aspect of this work—the way the empty foreground organizes the overall composition—was inspired by Japanese prints, examples of which were still

fresh in his mind. Shortly before his departure for Brittany, Signac had gone to a major exhibition of Japanese art at the École des Beaux-Arts accompanied by the art critic Arsène Alexandre, who later reminisced: "We spent a long time looking at the landscapes by Hiroshige."[1] MFB

NOTE
1 Alexandre 1892, p. 2.

50. THE BEACONS AT SAINT-BRIAC, OPUS 210, 1890

Oil on canvas, 25⅝ x 31⅞ in. (65 x 81 cm)
Signed and dated, lower left: P. Signac; inscribed, lower right: Op. 210
Mr. and Mrs. Donald B. Marron, New York
FC 206 *(Saint-Briac. Les Balises. Opus 210)*

Exhibitions: Brussels 1891, Exposition des XX, unnumbered, op. 210. *Lancieux (Côtes du Nord)*. Juin 1890, under the overall title *La Mer*; Paris 1891, Salon des Indépendants, no. 1113, *op. 209, Lancieux, Côtes-du-Nord*. Juin 1890, under the overall title *La Mer*; Paris 1934, Petit-Palais, no. 10, *Les balises: Saint-Briac* 1890 (à la galerie M. Morot)

Françoise Cachin has observed that this is "one of Signac's barest landscapes, in which the essential element is the abstract beauty of the proportions, through which he sought to create, solely by the

interplay of contrasting colors and the opposition of horizontals and verticals, an impression of peace and balance. The subject is no more than an excuse for the vibration of color and the symbolism of lines."[1] Indeed, here the usually exuberant Signac expressed a remarkable serenity, a detachment and abstract lyricism comparable to those of Seurat. Several years earlier, during his Impressionist phase, he interpreted the site in a very different manner: the sky fading at the horizon, swiftly brushed in touches that also rendered the rippling waves and the craggy rocks (FC 94). In the present painting the color has become more unified and dissolves in a delicate luminosity. Here, more than in any of his other works, the linear rhythm expresses the teachings of Charles Henry as well as Signac's study of Japanese prints. The landscape is reduced to its

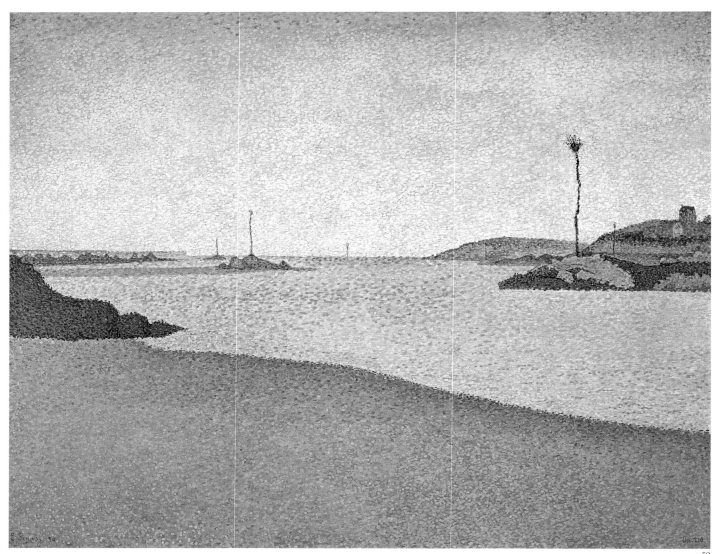

50

dominant lines and has no superfluous detail. Although no movement, no incident, no human presence disturbs the general harmony, Signac did not neglect the visual facts he observed. A century later Jean-Paul Bihr could identify each of the beacons: Gravelouse, Chéruette, Perronniaux, Cheval, Bouche, and Âne.[2] A wood engraving by Henri Rivière (fig. 89) suggests that Signac was not alone in his feeling for this well-known site. The two artists were excited by this natural spectacle and, preoccupied with Japanese art, both created spare depictions of it.

During his stay in Saint-Briac Signac painted four seascapes, all remarkably synthetic and serene. After depicting, in splendid detail, the baie de La Fresnaye at Saint-Cast (cat. no. 49), he picked out different aspects of Saint-Briac: the present work showing the beacons at the mouth of the Frémur; *Garde Guérin, Saint-Briac* (FC 207; Rau

Foundation, Zurich); and *Port Hue, Saint-Briac* (FC 208; Pushkin Museum, Moscow). These four seascapes were shown in the following year under the general title *La Mer* (The Sea) at Les XX in Brussels, and then at the Salon des Indépendants in Paris, where they were somewhat overshadowed by Signac's *Portrait of Félix Fénéon* (cat. no. 51), which drew great attention. In Brussels Octave Maus was sensitive to the artist's "masterly studies of sea and shore." But the extraordinary unity of these seascapes was often criticized. Alfred Ernst saw only the "most absurd uniformity. The water, the sand, the rocks, everything is handled in the same manner."[3]

Nevertheless, this remained one of Fénéon's favorite paintings, and on the occasion of the 1934 Signac retrospective at the Petit-Palais he wrote: "Among the oldest ones, no. 10, *Beacons at Saint-Briac*, especially fascinated me."[4] MFB

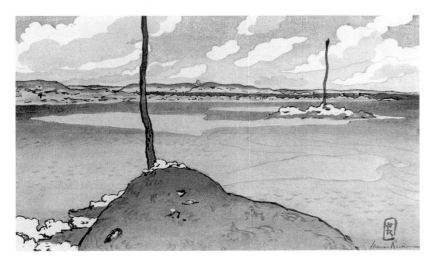

NOTES
1 Cachin 1971, p. 39.
2 Bihr 1992, p. 164.
3 Maus 1891, p. 216; Ernst 1891, p. 2.
4 Letter from Félix Fénéon to Signac, March 7, 1934, Signac Archives.

Fig. 89. Henri Rivière, *The Chéruette Beacon at Low Tide, Saint-Briac*, 1890, wood engraving, 13¾ x 9 in. (35 x 23 cm). Private collection

51. PORTRAIT OF FÉLIX FÉNÉON, OPUS 217, 1890–91

(AGAINST THE ENAMEL OF A BACKGROUND RHYTHMIC WITH BEATS AND ANGLES, TONES AND TINTS, PORTRAIT OF FÉLIX FÉNÉON IN 1890)

Oil on canvas, 29 x 36⅜ in. (73.5 x 92.5 cm)
Signed and dated, lower left: P. Signac 90; inscribed, lower right: Op. 217
The Museum of Modern Art, New York, Fractional gift of Mr. and Mrs. David Rockefeller, 1991
FC 211 *Portrait de Félix Fénéon. Opus 217 (Sur l'émail d'un fond rythmique de mesures et d'angles, de tons et de teintes, portrait de M. Félix Fénéon en 1890)*

Exhibitions: Paris 1891, Salon des Indépendants, no. 1107, op. 217, *Sur l'émail d'un fond rythmique de mesures et d'angles, de tons et de teintes, portrait de M. Félix Fénéon en 1890;* Brussels 1892, Exposition des XX, no. 1, under the same title, but as lent by Fénéon; Paris 1893, Galerie Georges Petit, no. 347, *Fénéon (Félix), Auteur dramatique et journaliste, Portrait peint par Signac* (Appartient à M. Fénéon); Paris 1934, Petit-Palais, no. 11, *Portrait de M. F. F. . . . , 1890* (à M. Félix Fénéon)

Exhibited in New York only

This extraordinary portrait marks the culmination of the decorative, of *japonisme*, and of abstraction in Signac's art. With the freely rendered color wheel creating the backdrop of a Japanese print, it is a brilliant finale to his first Neo-Impressionistic period. His demonstration of Charles Henry's color theories is both parodic and detached, as is his humorous allusion to scientific precision in the original title: "Against the Enamel of a Background Rhythmic with Beats and Angles, Tones and Tints, Portrait of Félix Fénéon in 1890."

Félix Fénéon (1861–1944) was one of the most curious and appealing figures of the late nineteenth century. An anarchist suspected of bombing the Foyot Restaurant in 1894, he earned his living as a clerk in the French War Ministry. He contributed to many literary and artistic reviews and wrote a regular column in *Le Matin* called "Nouvelles en trois lignes" (News in Three Lines), transforming trivial events into miniature masterpieces of irony and black humor. He was one of the most astute art critics of his day and a great discoverer of new talent (Seurat and Rimbaud received early encouragement from him). Well known for his discretion, he did little to publicize his gifts; later he became an art dealer at the Galerie Bernheim-Jeune, which he opened up to his Neo-Impressionist friends.

Fénéon's dandified appearance, complete with goatee, and his unconventional personality inspired a number of portraits, both written and pictorial. Among the most famous are that by Toulouse-Lautrec, which shows Fénéon in profile watching the performance of La Goulue (1895; Musée d'Orsay, Paris), and that by Félix Vallotton, who portrayed him working on proofs for *La Revue blanche* (1896; private collection), an image later taken up by Vuillard (1901; Solomon R. Guggenheim Museum, New York). Maximilien Luce depicted the art lover with one of Seurat's studies for *The Models* and a Japanese print (1903; Musée des Beaux-Arts, Nevers). Paul Valéry described him as "fair, gentle, and pitiless."[1] His friend the

Fig. 90. Japanese print (kimono pattern?), ca. 1866–80, color wood-block print. Private collection

Fig. 91. *Les Hommes d'aujourd'hui*, no. 373, May 1890, cover illustration after Seurat's portrait of Signac (fig. 30)

painter Émile Compard recalled that "he did not assert himself . . . he knew how to listen."[2] He also knew how to make people laugh, as the record of his cross-examination at the Trial of the Thirty demonstrates.[3] This remarkable critic championed Seurat's and Signac's cause from the start and was the first to use the term "Neo-Impressionist" in print (1886): "The truth is that the Neo-Impressionist method calls for an exceptionally fine eye."[4]

Above all he was Signac's closest friend. The two met about 1884 and frequented the same Symbolist literary circles, as well as the gatherings at the Brasserie Gambinus and the Friday salons of Robert Caze. Like Signac, Fénéon admired Seurat's work without reservation and also shared his great fondness for Degas's drawings and contemporary literature. All three were much impressed by Charles Henry, a young scientist of near-universal scope whose *Introduction à une esthétique scientifique* (1884) strongly influenced the future Neo-Impressionists. In 1890 Henry published his *Application de nouveaux instruments de précision (cercle chromatique, rapporteur et triple-décimètre esthétique) à l'archéologie* and *Éducation du sens des formes*, with illustrations by Signac. More than Seurat, Signac and Fénéon were aware of the limitations of these theories and avoided too strict an application of them.

In 1890 Fénéon wrote the first biography of Signac for the journal *Les Hommes d'aujourd'hui* (The Men of Today). He was twenty-nine, Signac twenty-six, and Henry thirty-one. Signac helped Fénéon with his research.[5] Fénéon sent his text to Signac, asking for corrections and commenting that "the terminological constraints of H[enry] seem excessive to me. We are in a studio, not a laboratory." Signac answered in a letter dated April 29: "Oh, how happy I am about your text. It is a perfect exposition of the technique, incomparable in its charm and accuracy. Do not worry too much about our Henry's criticism." In May Fénéon mailed a new set of proofs to Saint-Cast, where Signac was painting and sailing: "Don't pay compliments this time, just suggestions for important changes in my text. Should a set be sent to Ch. Henry?"[6]

Fénéon's biography of Signac begins: "This painter, the young glory of Neo-Impressionism." He then gives an explanation of color perception, which Signac took into account when he painted the background of the present portrait: "Two adjacent colors exert a mutual influence, each imposing its own complementary on the other; for green a purple, for red a blue green, for yellow an ultramarine, for violet a greenish yellow, for orange a cyan blue: contrast of hues. The lightest one becomes lighter; the darkest one

51

darker: contrast of values." He calls for "exemplary specimens of an art of great decorative development, which sacrifices anecdote to arabesque, analysis to synthesis, fugitive to permanent."

Fénéon mentions the painter's collaboration with Henry, citing the *Application de nouveaux instruments de précision* ("a very pure kind of scientific critique") and announcing the publication in 1890 of *Éducation du sens des formes,* for which Signac had prepared the plates. While warning against using Henry's method to execute a painting, Fénéon acknowledged its significant contribution toward the young painter's mastery of polychromatic and linear harmony.[7] The next year Fénéon repeated his underlying conviction that Signac "is not a slave of this graceful mathematics; he knows well that a work of art is inextricable."[8]

On the publication of *Les Hommes d'aujourd'hui,* Signac offered to paint his friend's portrait:

"I have it in mind this winter to do a painted, lifesize biography of Félix Fénéon. What do you think?"[9] Fénéon replied on June 25: "This idea of a portrait, ah, my dear Paul: I am only too willing to be your accomplice. If, one of these winters, my performance is good enough, I would not mind having it eternalized for the walls of the museums of the future, whose catalogue will read: Paul Signac (1863–1963) / Portrait of an Unknown Young Man H. 2 m 30 – L. 1 m 05 / Do you already have an idea for the pose, dress, and decor? And can I keep the monocle that you have not yet seen in my right eye? But I fear that this project will be impossible to realize, given the difficulty of reconciling Painting and War—both being divine. Well then, you will do a pen-and-ink portrait the size of a hand, and I shall be charmed."

Their correspondence continued, and on July 21 Signac wrote from Saint-Briac: "Oh! I often think

about this portrait, my dear friend Fénéon, and I shall be so pleased to do it! It will be anything but a banal portrayal, but a very composed picture, very organized as to line and color. An angular and rhythmic pose. A decorative Félix, entering with hat or flower in hand . . . on a tall, very narrow canvas. A contrived background with two complementary hues and a suit to harmonize. . . . Let us search together and we will find. Do you have wishes, ideas? In any event, you will not have to suffer much sitting: just enough time to make a panel and a drawing, from which: a picture."

Several days later Fénéon wrote back: "So I accept this portrait idea, and you would scarcely believe with how much fervor. If I were a painter, doing a portrait of anything masculine would horrify me. And do not think that I will submit ideas on this subject, as you asked. . . . I will give only this opinion: an absolutely frontal effigy. Do you agree?"[10] Finally, on November 21, 1890, in a letter written with pencils in every color of the spectrum, Signac invited Fénéon to sit for him: "I think that the time is nigh: as soon as you have a minute, be so gracious as to come to the studio in a light yellow overcoat. We will search together."[11]

As planned, a pencil drawing (formerly in the Rewald collection) and a brisk oil sketch (cat. no. 52) sufficed: Fénéon did not have to endure long sittings in the studio. The picture's background, hinted at in the sketch, required considerably more work. Françoise Cachin has pointed out an especially significant source: a Japanese wood-block print (fig. 90), which the artist kept in his studio, inspired not only the background design but also the picture's horizontal format.[12] Finally, a previously unpublished drawing (cat. no. 53) heightened with gouache shows that Signac made exhaustive trials for the ornamental patterns of the background: many different layers of corrections were pasted onto the original drawing. In adapting colors and motifs of Neo-Impressionist theory against the background of a Japanese print, Signac effected a deliberate synthesis of two elements emblematic of modernity in the eyes of the young group: science and Japan.

In his biography of Signac published a year earlier, "Utagawaféneon"[13] noted that Henry's method "might permit the mathematical study of Japanese color wood-block prints with dis-

crete colors in clearly defined outlines." There had indeed been discussions about undertaking "some studies of linear rhythms" and analyzing "three or four types of Japanese prints" with Henry the year before. Fénéon himself was preparing a book on Japanese prints, but it was never published.

The present portrait was exhibited at the Salon des Indépendants in spring 1891 with little success. Verhaeren found it "cold and dry."[14] And the title irritated more than one critic. Retté queried: "What is the meaning of this 'background rhythmic with beats and angles'?"[15] Many regretted that the sitter had been sacrificed to the background.[16]

In fact, Signac gave Fénéon the portrait and he kept it for the rest of his life. Like Fénéon's biography of Signac, the picture was a demonstration, a manifesto of sorts, as well as a private joke. It sealed a friendship that never faltered, a closeness rooted in a common struggle, and was part of the dialogue between the two friends. The composition alludes to Seurat's portrait of Signac, which had been reproduced on the cover of *Les Hommes d'aujourd'hui* (fig. 91). Signac, shown in profile facing right, looks rather stuffy with top hat, cape, and walking stick. Fénéon, who could be his pendant, is also shown in profile— his express wishes to the contrary. He is wearing his coat and has his top hat and walking stick in one hand and a cyclamen in the other, held out to an unseen companion. This hieratic figure contrasts strongly with the abstract background, which is a veritable kaleidoscope of colors, lines, and decorative motifs that refer loosely to Henry's theories.

Like Fénéon's biography of Signac, Signac's portrait of Fénéon is grounded in fact but infused with abstract and hermetic qualities. It suggests a playful collusion between the two: while it is a homage to the work of their common friend Charles Henry, it demonstrates an ironic distance from Henry's painstaking theorizing. Signac's initial enthusiasm for him would become less fervent. On December 14, 1894, he noted laconically in his journal: "A visit of Charles Henry, more and more poetic. From a correct and scientific premise, he draws conclusions of charming fantasy which he tries to prove mathematically."[17] MFB

NOTES

1 Interview with Solange Lemaître, December 17, 1962, quoted in Halperin 1991, p. 24.
2 Interview with Émile Compard, March 5, 1963, quoted in Halperin 1991, pp. 114–15.
3 Halperin 1991, pp. 322–25.
4 Fénéon 1886b, pp. 300–302.
5 Signac's response is recorded on a visiting card (carte de visite) to Fénéon, undated, Signac Archives.
6 Correspondence in the Signac Archives, partially published by Cachin 1969, pp. 90–91.
7 Fénéon 1890.
8 Fénéon 1891, pp. 198–99.
9 Letter from Signac to Félix Fénéon, June 18, 1890, Bibliothèque Centrale des Musées Nationaux, Paris, MS 408.
10 Correspondence in the Signac Archives.
11 Letter from Signac to Félix Fénéon, November 21, 1890, Bibliothèque Centrale des Musées Nationaux, Paris, MS 408, fol. 6.
12 Cachin 1969, pp. 90–91.
13 Utagawaférénon was the Japanese surname given to Fénéon by his friends. For the quote, see Fénéon 1890 in Halperin 1970, p. 178.
14 Verhaeren 1891, pp. 111–12.
15 Retté 1891, p. 295.
16 Olin 1892, p. 342, and Antoine 1890, p. 157.
17 Signac journal entry, December 14, 1894, in Rewald 1949, pp. 112–13, 170.

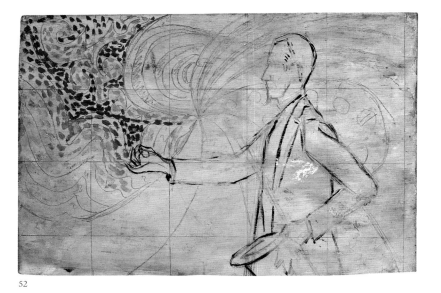

52

52. STUDY FOR "PORTRAIT OF FÉLIX FÉNÉON," 1890
Graphite and oil on wood, 9¼ x 13⅜ in.
(23.5 x 34 cm)
Private collection
FC 212 *(Portrait de Félix Fénéon [étude])*

Exhibited in New York only

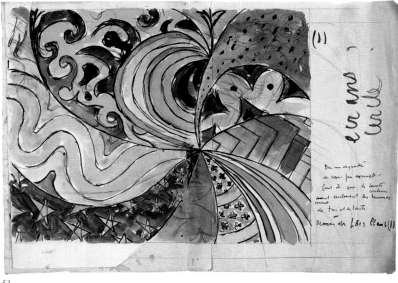

53

53. STUDY FOR "PORTRAIT OF FÉLIX FÉNÉON"
Drawing heightened with gouache, pasted paper, 12½ x 17⅜ in. (31.8 x 44.2 cm)
Annotations in right margin with brush, pen, and ink [from top to bottom]: (1) ; [sideways] ecrans / cercle ? ; [below] Dans un degradé de rose par exemple—faut il que les couleurs auront seulement des numeros de ton et de teinte ; — semis de pois blancs (1) ([1] ; screens / circle ? ; In a graduated range of pink, for example, should the colors have only the numbers of shade and tint ; —pattern of white dots [1])
Private collection

Exhibited in New York only

First Years of Neo-Impressionism, 1886–1891 ❋ 163

54. MORNING CALM, CONCARNEAU, OPUS 219 (LARGHETTO), 1891

Oil on canvas, 25⅞ x 32⅛ in. (65.8 x 81.7 cm)
Signed and dated, lower left: P. Signac 91;
inscribed, lower right: Op 219
Private collection
FC 215 (Concarneau. Calme du matin. Opus 219 [larghetto])

Exhibitions: Brussels 1892, Exposition des XX, no. 4.c, Larghetto (op. 219); Paris 1892, Salon des Indépendants, no. 1128, Matin, Concarneau; Antwerp 1892, Association pour l'Art, unnumbered

55. EVENING CALM, CONCARNEAU, OPUS 220 (ALLEGRO MAESTOSO), 1891

Oil on canvas, 25½ x 32 in. (64.8 x 81.3 cm)
Signed and dated, lower left: P. Signac 91;
inscribed, lower right: Op. 220
The Metropolitan Museum of Art, New York,
Robert Lehman Collection, 1975 (1975.1.209)
FC 217 (Concarneau. Calme du soir. Opus 220 [allegro maestoso])

Exhibitions: Brussels 1892, Exposition des XX, no. 3.b, Allegro maestoso (op. 220); Paris 1892, Salon des Indépendants, no. 1129, Soir, Concarneau; Paris 1892, Le Barc de Boutteville, no. 117, Le Soir à Concarneau; Paris 1892–93, Hôtel Brébant, no. 59, Soir. Concarneau; Paris 1926, Grand Palais, no. 2366

56. SARDINE FISHING, CONCARNEAU, OPUS 221 (ADAGIO), 1891

Oil on canvas, 25⅝ x 31⅞ in. (65 x 81 cm)
Signed and dated, lower left; inscribed, lower right: Op. 221
The Museum of Modern Art, New York,
Mrs. John Hay Whitney Bequest, 1998
FC 220 (Concarneau. Pêche à la sardine. Opus 221 [adagio])

Exhibitions: Brussels 1892, Exposition des XX, no. 2.a, Adagio (op. 221); Paris 1892, Salon des Indépendants, no. 1131, Calme. Concarneau; Paris 1892–93, Hôtel Brébant, no. 60, Calme (Concarneau); Antwerp 1892, Association pour l'Art, unnumbered, Calme (Concarneau, 1891); Brussels 1896, Salon de la Libre Esthétique, no. 391, Pêche à la sardine. Concarneau. Appartient à M. Alex Hallot; Brussels 1922, Palais des Beaux-Arts, no. 35; Brussels 1923, Galerie George Giroux, no. 199

During the summer of 1891 Signac sailed his new boat, Olympia, at Concarneau. The beginning of the season was rainy but successful: the yacht won several races. Signac and Berthe Roblès enjoyed the summer's late-arriving sunshine in the company of Georges Lecomte. They described themselves as "totally happy," and Signac painted a series of five pictures that reflected this serenity.[1]

The group of works painted at Concarneau explore the same subjects—fishing boats and the sea—seen at varying distances and different times of the day, not unlike the series paintings undertaken by Monet. In choosing his vantage point, Signac began close to the shore and then advanced farther out to sea. In the first painting, Morning Calm, Concarneau, Opus 219 (Larghetto) (cat. no. 54), the sardine boats leave port: the departure of the boats, with their sails of different colors and sizes, is rhythmically repeated to the horizon. The ocher of the ovoid rock in the foreground adds a warm touch to the overall pale blue color scheme. The crispness of the atmosphere and tonality renders the transparent quality of the morning light.

In Evening Calm, Concarneau, Opus 220 (Allegro Maestoso) (cat. no. 55), painted farther from the shore, the houses of the port are still visible, and the grassy slope and rocks in the foreground introduce more complex formal and chromatic elements. The sardine boats in the distance are again presented in rhythmic patterns, while in the middle the more sinuous lines of a tuna boat, with its fishing poles deployed, express a peaceful return to port.

Signac himself described Sardine Fishing, Concarneau, Opus 221 (Adagio) (cat. no. 56): "Have begun another setting sun, or rather already set. The water, the sky, and a hundred boats before the wind, on the horizon, sardine fishing."[2] In this painting he moved in closer to the boats. The absence of movement and of terrestrial elements—docks or rocks—creates a sense of absolute calm, embodied in water, sky, and space. The composition has been pared down to its essential elements: a horizon and the repeated, almost hieroglyphic motif of sardine boats with lowered sails and raised oars. The palette has a radical spareness: blue and yellow dominate, heightened by a few notes of orange. The simplicity, reinforced by the empty foreground, verges on abstraction.

These three paintings done at Concarneau in the summer of 1891 were preceded by the smaller

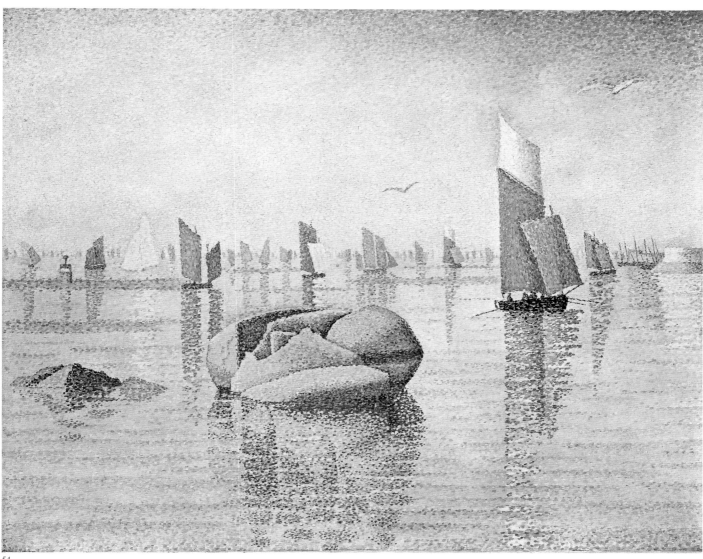

54

Sardine Boat, Concarneau, Opus 218 (Scherzo) (FC 213), which shows the harbor from a completely different angle, and were followed by *Return of the Boats, Concarneau, Opus 222 (Presto Finale)* (FC 219), in which the sardine boats hastily return to port after encountering a squall.

The artist created a strong unity among the four works he numbered opus 219 to 222. He painted the same subject, observed at different times of the day and from different distances. The horizon is, however, always at the same level, and the canvases are of identical format. The color schemes reinforce the overall harmony: these four pictures are composed of oppositions between two complementaries: yellow (ranging from ocher to orange) and blue (from sky blue to violet). In fact, when all five were first shown in

Brussels at Les XX in February 1892, Signac gave them a generic title, *The Sea: The Boats (Concarneau, 1891)*, and musical subtitles: *Scherzo* (op. 218), *Larghetto* (op. 219), *Allegro maestoso* (op. 220), *Adagio* (op. 221), and *Presto finale* (op. 222). The musical subtitles further underscore the unity of this series by presenting the paintings as different movements of the same piece. Once again the artist, who began assigning opus numbers to his works early on, approaches Charles Henry, who was interested in the analogies between music and painting. As Françoise Cachin has pointed out: "This was a preoccupation shared by all the Symbolist writers and painters. The system of harmonizing color schemes by combining divided colors reminded them of the role of notes and melodic lines in musical compositions."[3] More

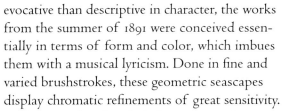

55

evocative than descriptive in character, the works from the summer of 1891 were conceived essentially in terms of form and color, which imbues them with a musical lyricism. Done in fine and varied brushstrokes, these geometric seascapes display chromatic refinements of great sensitivity.

Two months after their first presentation at the Salon des XX, Signac gave the pictures titles for the Salon des Indépendants that evoke the successive hours of the day: *Morning Calm, Sardine Fishing, Return of the Boats, Evening.* Fénéon described them in these terms: "The seasons and hours of the sea are symbolized by Paul Signac in a series of five works, *Boats.* Illustrating with their

progress sluggish skies with graded harmonies, the boats here fan out in the morning, there, in calm weather, align the parallels of bare masts and oars in a distant Egyptian procession."[4]

Most of the critics were charmed by these seascapes and reviewed them very favorably. Edmond Cousturier wrote: "With the recent pages of his symphonic *The Sea*, M. Signac continues to grace his canvases with the most lavish harmonies and to enchant the eye."[5] Jules Christophe noted: "seascapes from Concarneau, brilliant and precise . . . in which a squadron of fishing boats serenely manoeuvers,"[6] while Pierre Olin admitted that "the clarity of the water, the trans-

56

parency of the air, the play of light on the wavelets, and the vanishing point of the horizons, have been achieved with amazing precision and skill."[7]

These works quickly found buyers, unusual for Signac at the time. Henri-Nicolas Le Jeune bought *Morning Calm, Concarneau* in 1891. Two more, *Return of the Boats, Concarneau* and *The Sardine Boat, Concarneau*, were purchased by Belgian collectors at the 1892 Salon des XX in Brussels. In 1893 Antoine de La Rochefoucauld bought *Evening Calm, Concarneau. Sardine Fishing, Concarneau*, the boldest and most immaterial of these works, was the last to leave the artist's studio.[8] MFB

NOTES
1 Letters from Signac and Georges Lecomte to Félix Fénéon, autograph sale, Dijon 1989, nos. 202, 203.
2 Letter from Signac to Félix Fénéon, Signac Archives.
3 Cachin 2000, p. 42.
4 Félix Fénéon 1892 in Halperin 1970, pp. 212–13.
5 Cousturier 1892a, p. 3.
6 Christophe 1892, p. 157.
7 Olin 1892, p. 342.
8 By 1896 it was owned by Alex Hallot, who lent it to the Libre Ésthétique exhibition in Brussels (no. 391).

57. WOMAN ARRANGING HER HAIR, OPUS 227 (ARABESQUES FOR A DRESSING ROOM), 1892

Encaustic on canvas mounted on canvas,
23¼ x 27½ in. (59 x 70 cm)
Signed, dated, and inscribed, lower right:
P Signac 92 Op 227
Private collection
FC 222 (*Femme se coiffant. Opus 227 [arabesques pour une salle de toilette]*)

Exhibitions: Paris 1892, Salon des Indépendants, no. 1127, *Arabesques pour une salle de toilette (Peinture à l'encaustique)*; Paris 1892–93, Hôtel Brébant, no. 61, *Arabesques pour une salle de toilette (peinture à l'encaustique)*; Brussels 1893, Exposition des XX, unnumbered, erroneous opus number, *Op. 236, Arabesques pour une salle de toilette (Peinture à l'encaustique)*; Antwerp 1893, Association pour l'Art, unnumbered, erroneous opus number, *Op. 236, Arabesques pour une salle de toilette (Peinture à l'encaustique)*

Before fulfilling its original function—decorating a dressing room—this work was shown in Paris, Brussels, and Antwerp. The title remained the same throughout: *Arabesques for a Dressing Room (Encaustic Painting)*, underscoring the work's decorative function and unusual technique. The art critic Charles Saunier observed: "The color in some of Georges Seurat's pictures—*La Grande Jatte*—has altered. Some highlights have turned into shadows. This is serious in a work in which each color has a precise value. M. Paul Signac, ever wary of such treachery and guarding himself against it by using colors of the most careful manufacture, has resurrected the ancient—and permanent—process of encaustic painting to

preserve the freshness of a toilette scene with a woman dressing. The crisp and harmonious hues, and the special yellows add their brilliance to the radiant lines of the decor: supple arabesques formed by the curved lines of the furniture, Japanese screens, intimate objects with aesthetic contours."[1]

In choosing the encaustic technique, Signac was again influenced by the research of Charles Henry. In 1884 the young scientist coauthored a treatise about encaustic with the sculptor Henri Cros.[2] Impressed by the bright colors of the ancient funerary portraits from Al Fayyum that had been painted with wax, Cros and Henry traced the history of this technique, which allows the freshness of colors to survive for centuries, and pointed out its advantages: it permits a richer palette, it does not flake, it protects the support from humidity and worms, and it attracts little dust. The authors included a detailed practical treatise so that contemporary painters could utilize the technique.

The stability of pigments was one of Signac's constant concerns. After all, he had witnessed the alteration of the colors of *A Sunday Afternoon on the Island of La Grande Jatte* (fig. 3). Fénéon commented around this time: "Because of the pigments that Seurat used in late 1885 and in 1886, this historical work has lost its luminous charm: while the pinks and blues have held, the Veronese greens are now olive-colored, and the orange tones that represented the light, now represent only holes."[3] As early as 1887 Signac complained in a letter to Camille Pissarro about a Veronese green that had altered in just two days.[4] The

Fig. 92. Georges Seurat, *Young Woman Powdering Herself*, 1889–90, oil on canvas, 37⅛ x 31¼ in. (94.2 x 79.5 cm). Courtauld Institute Galleries, London

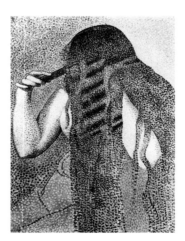

Fig. 93. Henri Edmond Cross, *The Head of Hair*, ca. 1892, oil on canvas, 24 x 18⅛ in. (61 x 46 cm). Musée d'Orsay, Paris

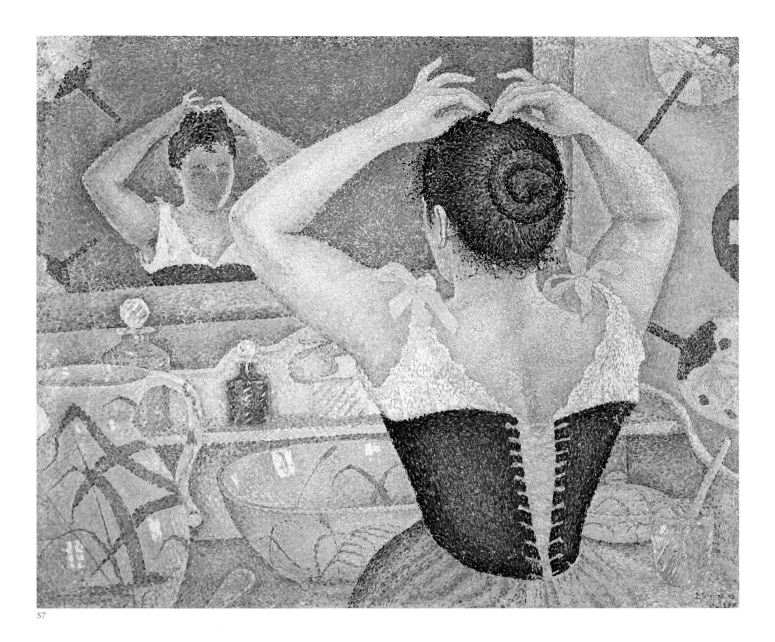

57

instability of Veronese green, as well as of silver white, which tarnishes upon contact with sea air, was the main subject of his correspondence with Blockx, a paint dealer in Antwerp, in the early 1890s.[5] Charles Henry's treatise must have held his attention, because in December 1890 he declared to his friend Henri Edmond Cross: "Disgusted by the all-too-changeable oil paints, I am going to try to paint with hot encaustic—Lefranc is going to prepare unalterable paints!"[6]

Before tackling the main canvas, Signac painted a study with this slow and painstaking process (FC 223). It was in fact the only work he painted in early 1892, just before leaving for the Midi and Saint-Tropez. To be sure, encaustic is a particularly exacting technique—the material for each brushstroke has to be heated—and its difficulty compounded the inherent slowness of the Neo-Impressionistic method.

It must also be remembered that in early 1892 Signac was very busy organizing posthumous exhibitions of Seurat's work. One of Seurat's last paintings, shown in Brussels in February and in Paris in March, was *Young Woman Powdering Herself* (fig. 92), which surely inspired the present picture. In it Madeleine Knoblock, Seurat's companion, is placed in a composition that opposes her full figure and the furniture's delicate lines.[7] Signac's picture of his own companion arranging her hair has a radically different conception. There is none of Seurat's rather cruel humor—the picture is decorative, tender, and cheerful.

Signac respects Berthe Roblès's privacy: her features are barely recognizable in the mirror, and only the curve of her shoulders and her coiffure betray her identity. Cross proceeded in the same way when he depicted his future wife in *The Head of Hair*, in which the sitter's hair dominates the picture and hides her face (fig. 93).

Here Signac's vision of harmony is created by an interplay of visual associations and correspondences. Berthe Roblès is shown from the back and front; her fingers echo the lacing of her chemise; the spiral of her chignon is implausibly visible in the reflection; and decorative elements—Japanese fans, flasks, porcelain—abound and underscore the decorative nature of the composition. Visual reality is subject to an insistent stylization, as in

the works of Seurat and Cross. The decorative concerns of the Neo-Impressionists were at their peak and achieved their most successful expression. Today, after more than a century, the colors' delicate freshness confirms Charles Henry's belief in encaustic painting. MFB

NOTES
1 Saunier 1892, p. 43.
2 Cros and Henry 1884.
3 Fénéon 1892 in Halperin 1970, p. 212.
4 Letter from Signac to Camille Pissarro; see Paris 1975, no. 175.
5 Correspondence preserved at the Signac Archives.
6 Letter from Signac to Henri Edmond Cross, December 14, 1891, Signac Archives.
7 Herbert in Paris–New York 1991–92, p. 333.

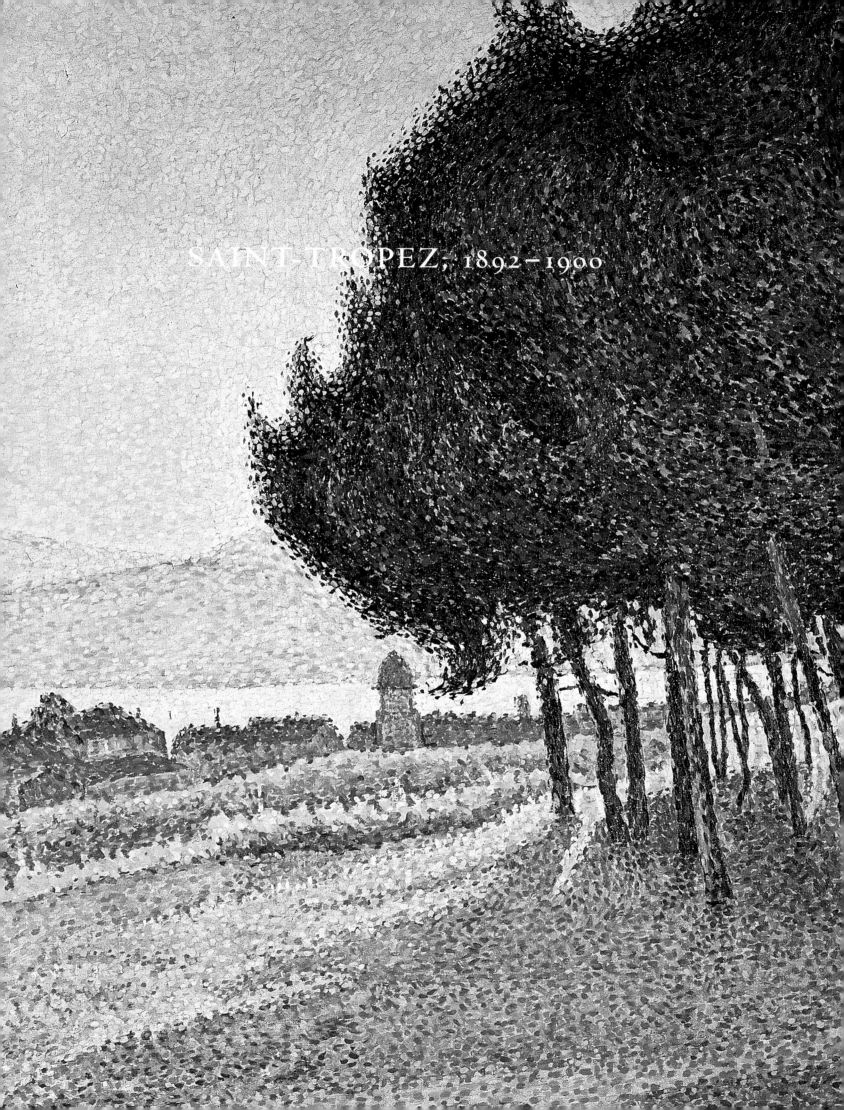

SAINT-TROPEZ, 1892–1900

SAINT-TROPEZ, 1892–1900

I AM SETTLED HERE SINCE YESTERDAY AND overjoyed. Five minutes out of town, in the midst of pine trees and roses, I discovered a pretty little furnished cottage. Kitchen, dining room, two bedrooms, toilet, veranda, a well, and a splendid garden. All for fifty-five francs a month—clean and very comfortable. In front the golden coast of the gulf, the blue sea breaking on a small beach, my beach . . . and a good anchorage for the *Olympia*. In the background the blue silhouettes of the Maures and the Esterel—there is enough material to work on for the rest of my days. Happiness—that is what I have just discovered."[1] These lines from Signac to his mother, written in 1892, tell the whole story of his discovery of Saint-Tropez, which he had reached on his sailboat *Olympia*.

From then on Signac lived part of the year in this small Mediterranean town, working and sailing constantly. He stopped painting scenes of Parisian life and devoted his brush entirely to Saint-Tropez until 1896, when he made a trip to the Netherlands with his friend Théo van Rysselberghe. The young Neo-Impressionists had expressed their sense of modernity in depictions of cities and their half-industrial, half-rural suburbs. They also painted vacation resorts, which

were still a relative novelty at the time. Starting in 1892, these subjects began to disappear from Signac's paintings. He chose instead to paint timeless landscapes with fishing boats (tartans) and the splendors of the Mediterranean flora. Signac left the frail trees of the suburbs behind, as well as the trends and narrow-mindedness of Paris. In his Provençal retreat he found his longed-for refuge. The year before, he had written to his friend Henri Edmond Cross, who had established himself at nearby Cabasson, at the foot of Fort Brégançon: "How I envy your life; dignified, simple, elevated, far from this Paris and its so-called intellectual crap."[2]

Revelatory in this respect is the composition of *Women at the Well* (cat. no. 63), which is a transposition of *The Circus* (fig. 42), the eminently Parisian picture which was Seurat's final work. A new world replaced the scenes of Parisian modernity in Signac's paintings. Now he sang the praises of the rustic life in Provence and his little fishing port.

During his first years in Saint-Tropez Signac was haunted by the memory of Seurat, and the compositions he admired frequently reappeared in his own work, much of which paid homage to his lost friend, intentionally or not: *The Port at Sunset, Saint-Tropez* (cat. no. 61) is an evocation of

Evening, Honfleur (fig. 96); *Woman with a Parasol* (cat. no. 69) contains the reminiscence of a figure from *A Sunday Afternoon on the Island of La Grande Jatte* (fig. 3); and *In the Time of Harmony* (cat. no. 75), which reverses the composition of *La Grande Jatte*, could be called "Sunday on the Shores of the Mediterranean."

Signac wanted to concentrate on decorative painting—large-scale mural compositions—a genre that, among the Neo-Impressionists, only Seurat had tackled. Decorative painting was in vogue at the turn of the century, and it often expressed leftist social or political concerns to which Signac, as an anarchist, was not entirely indifferent. Signac and other painters who idealized social harmony would have agreed with Manuel Devaldès's comments about Siegfried Bing's gallery L'Art Nouveau: "There are also paintings, and this is the only reproach that I would make to M. Bing: he should have restricted himself to wall decorations instead of endeavoring to collect futile canvases in Baroque frames on walls that would have produced a more impressive effect had they been decorated with murals . . . The role of easel painting will have no value in the world in which the new Art is to flourish . . . the talent of these painters would have been better used for decoration."[3]

Many critics attacked easel painting, stating that it was the instrument of bourgeois vanity. Out of loyalty and to honor Seurat's memory, Signac the autodidact undertook large-scale decorative compositions to advance the cause of Neo-Impressionism. However, when works such as *Women at the Well* and *In the Time of Harmony* were coolly received, his fervor decreased. In 1900 he made a last attempt in this genre by entering a contest for the decoration of the Asnières town hall. He refrained from depicting figures and limited himself to landscape, presenting Industry and Leisure in a decorative scheme adapted to the architecture. When the contest was won by a certain Henry Bouvet, Signac abandoned decorative painting for good.

Signac had been devoting himself exclusively to landscape painting for a number of years, and during this time his style had evolved. He took an interest in Art Nouveau at its beginnings, as can be seen in the sinuosities of *Women at the Well* and *Woman with a Parasol*. In 1897 he moved enthusiastically into Castel Béranger, the Art Nouveau building in Paris designed by Hector

Guimard (see fig. 118). He appreciated the building's rational and light-filled architecture—he called it the "joyous house" of the "City of the Future"[4]—but he realized that easel paintings had no place amid the floral patterns and arabesques of Art Nouveau. His failed attempt to donate *In the Time of Harmony* to the Maison du Peuple in Brussels had taught him a lesson. Signac came to see that painting, even decorative painting, was superfluous in buildings in which architects designed every detail of the decoration, and he distanced himself from this architect-centered aesthetic. In the formal realm he moved away from *japonisme*, which had become a cliché, and abandoned the pseudoscientific theories of Charles Henry, whom he did not cite in his 1899 treatise, *D'Eugène Delacroix au néo-impressionnisme*. In 1895 he stopped giving his paintings opus numbers. During this period he dropped the restrictive aspects of Neo-Impressionism, moved toward a greater freedom, and adapted the divisionist technique to his own purposes.

In 1892 Signac discovered watercolor, a technique that played an increasingly important part in his work. In 1894 he gave up the practice of painting outdoors, having noted: "Simplification of the elements leads you to more color."[5] But it was only after the long elaboration of *In the Time of Harmony*—his last homage to Seurat—that he left his early world behind. In 1895 he painted strong and pared-down works like *The Red Buoy, Saint-Tropez* (cat. no. 89), *The Storm, Saint-Tropez* (cat. no. 91), and *The Lighthouse, Saint-Tropez* (cat. no. 94). His style had evolved, his use of the dot was looser, his brushstrokes were more angular—giving his paintings a mosaic-like appearance—and his colors were more direct. The compositions tended toward a geometric simplicity in which colors were grouped into broad, contrasting areas. Signac expressed the full extent of his love of purity and clarity in form and color. As he noted in his journal in 1896: "[I have] simplified the lesser contrasts in favor of the overall effect."[6]

Signac also demonstrated his recently won freedom vis-à-vis nature. In his large decorative pictures he did not shrink from rearranging the landscape of Saint-Tropez according to his aesthetic concerns, relocating the jetty or the pine as he saw fit. He thus reconnected with the great tradition of composed landscapes. On the subject of *Sails and Pines* (cat. no. 95), he noted: "I composed the entire picture, taking a tree trunk

here, a pine branch there; the hill is the pointe Saint-Pierre, and it ends with the nice tower that I sketched at Port Man."[7] Using watercolor sketches and drawings done from life, Signac invented landscapes in the quiet of his studio. Nature for him, as for Delacroix, was "only a dictionary, where one looks for words. . . . where one finds words . . . the elements which make up a sentence or a story; but no one ever considered a dictionary to be a composition, in the poetic sense of the word."[8]

While Saint-Tropez was a haven where Signac was protected from the vicissitudes and fashions of Parisian life, it was not a hermitage. Signac was not tempted by isolation, and he lost no time in inviting his friends to join him there. The painters Luce and Van Rysselberghe and literary friends, like Fénéon, visited him in the Midi, to which he probably would never have moved had his good friend Cross not established himself there first.

Signac often worked on the shores of the Mediterranean with Cross, and more than once they painted similar subjects or elaborated similar compositions. Signac specialized in views of ports and sailboats, while Cross was interested in the hinterlands, life in Provence, and scenes of women bathing. They followed each other's works closely and occasionally took their inspiration from one another. In 1896 Signac painted *Sails and Pines* and Cross *Seascape with Cypresses* (c 56), which can be considered a nocturnal version of Signac's work. Cross evidently had Signac's *Woman in Pink* (1895; FC 289) in mind when he painted his *Woman in Violet* (c 57) in the following year, and the memory of his *Pink Cloud* (c 60) appeared many years later in Signac's *The Pink Cloud, Antibes* (cat. no. 135).

Inspired by Delacroix's journal, Signac began keeping one of his own in Saint-Tropez in 1894. There he set down his thoughts on the art of his contemporaries as well as on the art of the past. He began writing *D'Eugène Delacroix au néo-impressionnisme,* a belated manifesto of the Neo-Impressionist movement, which first gained prominence in 1886. In this sweeping and well-argued treatise, excerpts of which were published in *La Revue blanche* in 1898 (it came out in book form in 1899), he considered the Neo-Impressionist movement from a historical viewpoint. The scientific breakthrough of optical division was seen as the logical result of an evolution that inexorably led to Divisionism, after having passed through Delacroix and the "Romantic" Impressionists, of which Monet had been the leading representative.

Signac's mind was stimulated by frequent visits to museums and galleries. Not contenting himself with the Louvre and Parisian exhibitions, in 1896 Signac traveled to the Netherlands and again to Italy, which he had first visited in 1890. In 1897 he paid an attentive visit to the museum in Brussels. In 1898 he went to London to see the works of Turner, which he studied very closely, as we can see from his sketchbook. Signac no longer considered Neo-Impressionism a revolution but the culmination of a historical process. His interest in the works of the past led him to create well thought-out and balanced compositions in which he used divisionist technique to paint works of classical inspiration. His *Capo di Noli* (cat. no. 105) from 1898 marked his return to the sources of past art, and although the violent color schemes heralded the advent of Fauvism, his intelligent orchestration of the hues demonstrated a more complex analysis of color. For the first time in Signac's work, we see the principles of the classicizing landscape of Claude Lorrain, organizing the dazzling Neo-Impressionist surfaces.

At this time Neo-Impressionism itself was becoming a part of history. Recognition came in the form of a major exhibition held at Galerie Durand-Ruel in 1899. Representatives of the main innovative tendencies were shown on the walls of this prestigious gallery, but without explanatory labels. The exhibition, organized by Signac, Maurice Denis, and Odilon Redon, divided the featured artists into three rooms. The Neo-Impressionist room contained works by Signac and his friends Cross, Van Rysselberghe, Angrand, and Luce. Signac himself was generously represented by eleven paintings, while his portrait at the helm of the *Olympia* was the focus of Van Rysselberghe's contribution (fig. 31). Another room presented works by Redon, Bernard, Filiger, and d'Espagnat. The third room grouped the Nabis: Denis, Bonnard, Vuillard, Roussel, and Vallotton, to mention only the best known.[9]

This exhibition marked the beginning of recognition and success for the Neo-Impressionists. Although sales were slow at first, Signac finally caught the eye of an important collector, Denys Cochin. He received many good reviews. Some

were of course by writers who had long been faithful supporters, like Thadée Natanson, who noted: "M. Signac has succeeded in triumphantly justifying the divisionist technique. . . . He has made it clear that it was not a hindrance to anyone's talent," concluding, "Here is a demonstration that sparkles with clarity."[10] The group also won over some critics who had not been especially favorable to Neo-Impressionism. Gustave Coquiot gave it several lines of praise in *Gil Blas:* "Hung in a room of their own, brightened by their presence, here are M. Paul Signac and a few Neo-Impressionists." In *La Vogue* the same critic wrote: "Signac creates superbly clear and balanced forms under the haloed sun. He has a natural sense of grandeur."[11] MFB

NOTES

1 Letter from Signac to his mother, Héloïse Signac, undated [May 1892], Signac Archives.
2 Letter from Signac to Henri Edmond Cross, undated [late 1891], Signac Archives.
3 Devaldès 1896, pp. 21–22.
4 Signac 1899; see also Thiébaut 1991.
5 Letter from Signac to Henri Edmond Cross, undated [1893], Signac Archives.
6 Signac journal entry, June 25, 1896, Signac Archives.
7 Signac journal entry, October 16, 1896, Signac Archives.
8 Delacroix as cited by Signac in his *D'Eugène Delacroix au néo-impressionnisme* (Cachin 1987, p. 53); translated in Ratliff 1992, p. 217.
9 Concerning this exhibition, see Signac's journal entry of March 15, 1899, and Antoine de La Rochefoucauld's letter to Emile Bernard, March 28, 1899, published in Rewald 1953, pp. 44–51, 76–78.
10 Natanson 1899, pp. 504–12.
11 Coquiot 1899a, p. 2; Coquiot 1899b, pp. 57–58.

58. THE TOWN AT SUNSET, SAINT-TROPEZ, OPUS 233, 1892

Oil on canvas, 25⅜ x 31¾ in. (64.6 x 80.5 cm)
Signed and dated, lower left: P. Signac 92;
inscribed, lower right: Op 233
Miyazaki Prefectural Art Museum
FC 225 (*Soleil couchant sur la ville. Opus 233
[Saint-Tropez]*)

Exhibitions: Paris 1892–93, Hôtel Brébant, no. 57,
Soleil couchant (Saint-Tropez); Brussels 1893, Exposition
des XX, unnumbered, *op. 233, Soleil couchant/Soleil
couché* [confusion in opus numbers: *Soleil couché* is
op. 236]–*Saint-Tropez*; Antwerp 1893, Association
pour l'Art, unnumbered, under the same title;
Paris 1895, Salon des Indépendants, no. 1404, *Le
bois de pins. Saint-Tropez*, à M. H. C.; Amsterdam
1930, Stedelijk Museum, no. 281, *Pijnboom bosch
Op. 233* Knoedler & Co., New York, Paris

For his first painting of Saint-Tropez, Signac
chose a vantage point overlooking the town at the
edge of the pine groves. This site, located near
the plage des Graniers on the road leading to the
citadel, has changed a great deal since. Villas now
block the view of the harbor, and the vineyards
no longer exist; to admire a sunset, one has to go
beyond the pine trees. But in 1892 the view to the
sea was open, and one could see the town, then
of modest size, with its lighthouse, typical bell
towers, and large rural houses.

Sunsets were one of the few dramatic events
of the Mediterranean skies. Signac never tired of
watching the sun go down and often made water-
color notations of the astonishing variety of color
effects produced on the sea and the Maures hills.
He adopted this vantage point at different times
of his career: it became emblematic of Saint-

Tropez for him, and as if to document the course
of his progress, he seldom varied the composi-
tional scheme. The same view can be seen on a
painted fan of 1894 and in canvases from 1896
(fig. 94) and 1902 (fig. 95). A comparison of the
paintings affords a clear sense of Signac's artistic
development. In 1896 the paint dabs are looser,
the brushstrokes livelier; the forms are at once
simpler and less precisely outlined, and the freer
range of colors gravitates toward Fauvist hues. In
1902, when Signac took up the subject for the last
time, he created a more classical composition,
counterbalancing the mass of pine trees with a
cypress on the left.

Signac also devoted a number of oil studies,
watercolors, and drawings to this motif. Among
those related to the present painting is a Conté
crayon drawing (cat. no. 59) that served to estab-
lish the layout of the composition and its light
and dark tonal values; in addition there are two
energetic color studies on panel (FC 226, 300) that
may have served as preparatory studies. In 1896,
when Signac took up the composition again,
a vibrant watercolor heightened with ink (cat.
no. 60) served as the basis for that painting.

Signac again closely followed Charles Henry's
theories: the horizontals express the serenity of
the spot, while the ascending—"dynamogenic"—
diagonal of the footpath draws the spectator
on and suggests a mood of optimism and joy,
as do the arabesques of the pines and the play
of light and shadow in the foreground. Warm
colors dominate, with a major harmony of violet
and yellow and a minor key formed by the green
mass of pines offset by the orange roofs of the
houses. The inscription "Op 233" stands out

Fig. 94. Paul Signac, *Sunset, Pine Grove, Saint-Tropez*, 1896, oil on
canvas, 25⅝ x 31⅞ in. (65 x 81 cm). L'Annonciade, Musée de
Saint-Tropez, FC 299

Fig. 95. Paul Signac, *The Town and the Pines, Saint-Tropez*, 1902,
oil on canvas, 25⅝ x 31⅞ in. (65 x 81 cm). Private collection,
FC 383

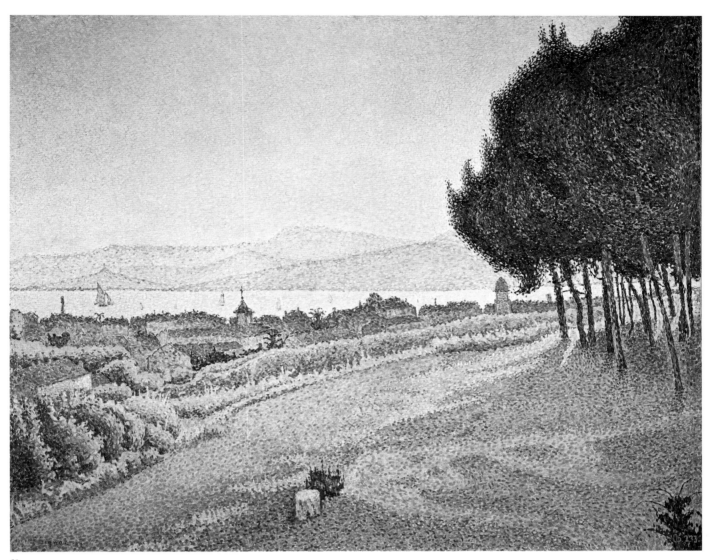

58

against the silhouette of a plant treated as a decorative motif in the right foreground.

By this date, the twenty-eight-year-old Signac had already produced about half of his finished paintings. Here he tempered the abstraction of his previous two years with Mediterranean light. Apparently satisfied with his work, Signac exhibited it on several occasions in 1892 and 1893. By 1895 Signac exchanged it for a fine painting, *The Farm at Evening* (C 39), by his friend Henri Edmond Cross, who wrote to him with graciousness and

wit: "What a pleasure it was for me to hold my 'Pine Woods' in my hands two days ago and to hang it in my small dining room. It is an absolutely delightful picture, as transparent, atmospheric, and willful as you."[1] MFB

NOTE
1 Letter from Henri Edmond Cross to Signac, undated [April–May 1895?], Signac Archives.

59. STUDY FOR "THE TOWN AT
SUNSET, SAINT-TROPEZ," 1892
Conté crayon and colored pencils, 8⅛ x 10¾ in.
(20.5 x 27.2 cm)
Private collection

Exhibited in Paris only

60. STUDY FOR "SUNSET, PINE
GROVE, SAINT-TROPEZ," 1896
Watercolor and ink, 6 x 7½ in. (15.3 x 19 cm)
Private collection

59

60

61. THE PORT AT SUNSET, SAINT-TROPEZ, OPUS 236, 1892

Oil on canvas, 25¾ x 32⅛ in. (65.5 x 81.5 cm)
Signed and dated, lower left: P. Signac 92;
inscribed, lower right: Op 236
Private collection, London
FC 229 (*Le Port au soleil couchant. Opus 236 [Saint-Tropez]*)

Exhibitions: Paris 1892–93, Hôtel Brébant, no. 58, *Soleil couchant (Saint-Tropez)*; Brussels 1893, Exposition des XX, unnumbered, erroneous opus number, *op. 233, Soleil couchant/Soleil couché—Saint-Tropez*; Antwerp 1893, Association pour l'Art, unnumbered, under the same title

Signac painted the harbor of Saint-Tropez often and from different angles. Here we see the last rays of the sun, while purple shadows settle over the scene, creating a play of contrasted reflections on the water. The composition recalls that of *Evening Calm, Concarneau, Opus 220* (cat. no. 55), painted the

previous year, and could well be its Mediterranean counterpart. The tuna boat has been replaced by a tartan: the sinuous linearity of its rigging is echoed by the contours of the hills. The harbor's rectilinear architecture in the foreground tightly

Fig. 96. Georges Seurat, *Evening, Honfleur*, 1886, oil on canvas, 25¾ x 32 in. (65.4 x 81.3 cm). The Museum of Modern Art, New York, Gift of Mrs. David M. Levy, 1957

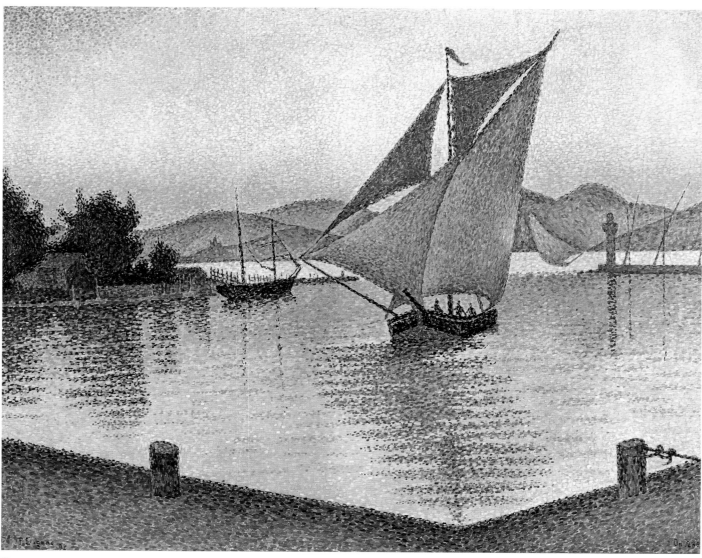

61

frames the composition and superimposes itself on the slope and rocks. This work features the same clarity of lines and forms and the same subtle color gradations as those painted in the years when he was close to Seurat. Indeed, the present composition recalls *Evening, Honfleur* (fig. 96). The latter, one of Seurat's most poetic seascapes, also depicts a sunset, but with more delicate, silvery hues, quite different from the sonorous tones of Signac, who achieved a lyricism absent in Seurat. Above all, the linearity of Signac's composition evokes the art of his late friend, with its strong horizontals animated by the insistent diagonals of the foreground and the verticals seen against the light. The composition and sunset effects were quickly established in two watercolors (James Dyke Collection, Arkansas Arts Center)[1] and a pair of oil sketches. These studies display a vigor and briskness quite removed from Seurat's thorough meditations.

The early history of the present work parallels Signac's first painting of Saint-Tropez (cat. no. 58): shown in the same exhibitions in 1892—93, it, too, was given to a friend—Georges Lecomte. MFB

NOTE
1 See Little Rock 2000, p. 34, nos. 4, 5.

62. HOUSES IN THE PORT, SAINT-TROPEZ, OPUS 237, 1892
Oil on canvas, 18¼ x 21¾ in. (46.5 x 55.3 cm)
Signed and dated, lower left: P. Signac 92;
inscribed, lower left: Op 237
Ambassador John L. Loeb, Jr.
FC 232 *(Maisons du port. Opus 237 [Saint-Tropez])*

Exhibition: Paris 1893, Salon des Indépendants, no. 1215, *Le Port. St-Tropez (Var)*

Here the artist depicts the harbor in full daylight. The sun shines brightly on the wharves, where a few fishing boats are tied up. Their diagonal masts bring rhythm and movement into an otherwise placid composition, dominated by vertical and horizontal lines. This picture, of smaller format than the earlier views of Saint-Tropez, displays a clear return to an emphatic simplification that Signac would further develop at the expense of

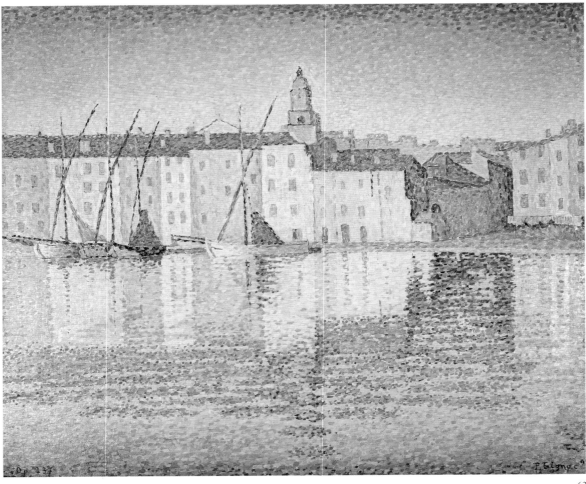

62

sinuous forms and arabesques. From Signac's vantage point near the naval shipyard, the church tower becomes the composition's median axis and accentuates its orthogonal character. Simplification of lines and composition meant giving a stronger role to color, which here gains intensity. According to Jules Christophe, the picture "dazzled"[1] at the Salon des Indépendants, while Antoine de La Rochefoucauld noted the effect of "full sunlight."[2]

Signac, who wanted to push colors to the maximum and disliked the slightly gray effect produced by too subtle a color division, was evidently satisfied with this painting. The same subject is to be found on a fan in 1894, together with plant motifs and a pine grove. Two lithographs from 1894 (KW 5, 6 [fig. 27]) show the shipyard in the foreground. The broader brushstrokes, the absence of curved lines, and the strict geometry of this frontal view will reappear in other Saint-Tropez seascapes from 1895: *The Red Buoy, The Storm,* and *The Lighthouse* (cat. nos. 89, 91, 94).

This painting once belonged to Denys Cochin, a Parisian politician whose large art collection, assembled at the turn of the twentieth century, included works by Manet, many Cézannes (twenty-one paintings, according to Rewald), and a Van Gogh. Ambroise Vollard, Cézanne's dealer, complained of Cochin's indecisiveness and habit of returning his purchases. MFB

NOTES
1 Christophe 1893, p. 133.
2 La Rochefoucauld 1893a, pp. 6–7.

63. WOMEN AT THE WELL, OPUS 238, 1892

(YOUNG PROVENÇAL WOMAN AT THE WELL—DECORATION FOR A PANEL IN HALF-LIGHT)
Oil on canvas, 76¾ x 51⅝ in. (195 x 131 cm)
Signed and dated, lower left: P. Signac 92;
inscribed, lower right: Op 238
Musée d'Orsay, Paris (RF 1979-5)
FC 234 (*Femmes au puits [jeunes Provençales au puits—décoration pour un panneau dans le pénombre*)

Exhibitions: Paris 1893, Salon des Indépendants, no. 1214, *Jeunes Provençales au puits. Opus 238 (décoration pour un panneau dans le pénombre)*; Brussels 1894, Salon de la Libre Esthétique, no. 396, under the same title

"An unfortunate effort"—so Charles Saunier described this work at the 1893 Salon des Indépendants.[1] And among the chorus of negative critics, his voice was not the most severe. Even critics most favorable to the artist almost all expressed reservations about the strangeness of this work. Jules Bois, however, found it "infinitely subtle and vibrant," and Antoine de La Rochefoucauld wrote with his usual lyricism that "on entering the room, the visitor is fascinated by the symphony of radiant hues that sing their hymn to the sun in this canvas."[2] Otherwise there were no defenders of this work. The artist's friends remained reticent or silent. Angrand remarked that Signac should have sacrificed the landscape to the figures, or vice versa, since this composition belonged to neither genre.[3] Fénéon held his tongue. Gauguin, a self-proclaimed opponent of the Neo-Impressionists, left a withering evaluation: "On the seashore, a well: several Parisian figures in colorful striped dresses, parched by their pretensions, seek in this dried-out well the water that will quench their thirst. Nothing but confetti."[4]

More recently, art historians have likewise expressed reservations. Claire Frèches, writing on the occasion of the work's entry into the French national collections, asked, "How far did Signac go when he went too far in 1892?" and spoke of "theoretical extremism."[5] Strangeness, stiffness, and excessive theorizing are the terms most often used to describe this work, which shows with disturbing clarity the uncertainty in which Seurat's sudden death left Signac.

The elaboration of this, the artist's first major outdoor piece, is discussed at length elsewhere.[6] In brief, its genesis can be traced in a series of preparatory studies. A preliminary drawing (cat. no. 64) reveals a more ambitious, multifigured project, which resulted in *In the Time of Harmony* (cat. no. 75). A series of oil sketches at the Musée d'Orsay shows the composition coming together fairly quickly, with the number of figures ultimately reduced to three: a woman on either side of the well and a third walking away on the road to the citadel. In a final sketch the landscape was synthesized into an imaginary view in the purest classical tradition, with the citadel-topped hill and harbor jetty arbitrarily combined. The influence

of Puvis de Chavannes has been well analyzed by Marie-Thérèse Lemoyne de Forges.[7] Signac acknowledged it himself, and his admiration for "the great Puvis" was shared by an entire generation of artists. Fénéon had even called Seurat a "modernizing Puvis."[8]

With Seurat gone, Signac took the fate of Neo-Impressionism into his own hands. He continued to make converts and to struggle for a cause which many considered already lost. Decorative painting was a major element of the late-nineteenth-century obsession with "total art," and Signac realized that with Seurat's death the movement had lost its only artist capable of executing large-scale murals. He therefore undertook a work more ambitious than anything he had ever done. Signac believed that decorative painting had a precise function: to bring light into dark interiors. The painting's subtitle, "decoration for a panel in half-light," indicates that the picture was supposed to act like a window in a dim interior. Several years later Signac complained of the way Puvis's compositions were hung at the Musée des Beaux-Arts in Amiens: "they are invisible because of the blinding light from the windows that frame them." He went on to recommend a divisionist approach: "in these circumstances a *divided* decoration would have created colored hues on these panels which would have emerged victorious over the excessive brightness of the adjacent windows."[9] Thus this work's strident colors were intended to lighten the shadows.

Georges Seurat's works were already illuminating "the sad bourgeois apartment on the Boulevard Magenta," where Seurat's mother lived after his death.[10] The present painting was modeled, no doubt unconsciously, on *The Circus* (fig. 42), Seurat's

artistic testament. The primitive simplicity of Mediterranean life is far from the sophisticated spectacle of a Parisian circus, but the difference in subject matter does not conceal the memories that haunt Signac's picture. Seurat had introduced perspective distortions in his abstract and decorative conception.[11] Signac modified his subject matter in a similar way (the scene is faithfully depicted in Luce's *Coast of the Citadel at Saint-Tropez* [fig. 97]). He created an ideal, imaginary landscape, a synthesis of Saint-Tropez motifs underlaid by Seurat's composition: a static area at upper left in opposition to the dynamic lines of the rest of the picture, both areas being separated by a sinuous, ascending diagonal. Other elements have their source, and even meaning, in relation to Seurat's *Circus*: the path leading up the hill recalls the strange whip held by the clown, the movement of the pines corresponds to that of the musicians in the balcony, and the foreground shadow can only be understood as the phantom of Seurat's clown.

A host of elements in Signac's work speak of his admiration for his lost friend. This painting also expresses the full ambiguity of Signac's situation at a crucial moment in his development as an artist. Conscious of becoming the leader of the Neo-Impressionists, he was surely less aware of his disguised yet direct quotations from Seurat's last painting. He acquired the captivating work in 1900 and made sure it entered the French national collections. Signac was confident of his ability as a painter of landscapes and seascapes, and the success of his exhibitions had confirmed his assurance. His figurative compositions, however, had found little favor. He knew that Seurat would be hard to equal in large-scale decorative painting, but he took it upon himself to demonstrate Neo-Impressionism in this field. This stilted decoration intended for the "half-light" was, however, overshadowed by its prototype and was too timid in its intention to be understood. Seen in this new light, it appears as a fascinating and colorful slip, speaking of an unexpected loss of self-confidence in the otherwise fervent Signac. MFB

Fig. 97. Maximilien Luce, *The Coast of the Citadel at Saint-Tropez*, 1892, oil on canvas, 20⅞ x 25¼ in. (53 x 64 cm). L'Annonciade, Musée de Saint-Tropez

NOTES

1 Saunier 1893, p. 17.
2 Bois 1893, p. 3; La Rochefoucauld 1893a, p. 6.
3 Letter from Charles Angrand to Signac, undated [1893], Signac Archives.
4 Gauguin 1923, p. 448.
5 Frèches-Thory 1983, p. 36.
6 Ibid.; Ferretti-Bocquillon in Saint-Tropez–Reims 1992, pp. 32–39.

7 Lemoyne de Forges 1958, p. 44.

8 See Halperin 1988, p. 230.

9 Signac 1899, reprinted in Cachin 1978, p. 125; translated in Ratliff 1992, pp. 264–65.

10 Signac journal entry, January 3, 1898, in Rewald 1952, pp. 273, 301.

11 Distel in Paris–New York 1991–92, p. 363.

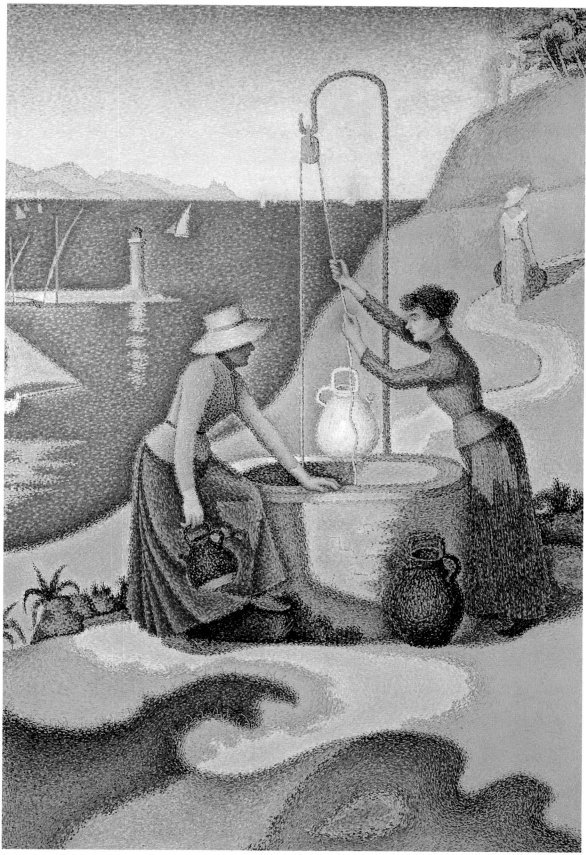

63

64. STUDY FOR "WOMEN AT THE WELL," 1892

Graphite and black ink, heightened with watercolor, 7¾ x 11¼ in. (19.6 x 28.7 cm)
Signac atelier stamp, lower right
Musée du Louvre, Département des Arts Graphiques, Fonds du Musée d'Orsay, Paris, Gift of Ginette Signac, 1979 (RF 37 071)

Exhibited in Paris only

65. STUDY FOR "WOMEN AT THE WELL," 1892

Graphite and black ink, heightened with watercolor, 11¼ x 7¾ in. (28.7 x 19.6 cm); image, 10 x 5½ in. (25.3 x 14 cm)
Signac atelier stamp, lower right
Musée du Louvre, Département des Arts Graphiques, Fonds du Musée d'Orsay, Paris, Gift of Ginette Signac, 1979 (RF 37 070)

Exhibited in Paris only

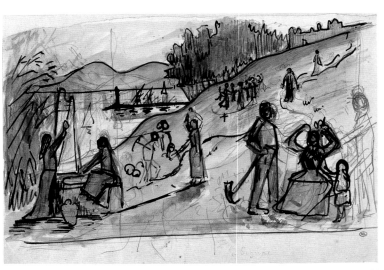

64

65

66. TARTANS WITH FLAGS, OPUS 240, 1893

Oil on canvas, 22 x 18¼ in. (56 x 46.5 cm)
Signed and dated, lower right: P. Signac 93; inscribed, lower left: Op. 240
Von der Heydt–Museum, Wuppertal (G 239)
FC 242 (Tartanes pavoisées. Opus 240)

Exhibitions: Paris 1893–94, rue Laffitte, no. 3, *Bateaux pavoisés*; Brussels 1894, Salon de la Libre Esthétique, no. 398, *Tartanes pavoisées*; Paris 1895, Salon des Indépendants, no. 1407, *Tartanes pavoisées, Saint-Tropez*

Exhibited in Paris only

Here the artist again made the port's sun-drenched facades a backdrop for the typical masts of the fishing boats (tartans). In a previous painting of this site, Signac chose to emphasize the orthogonal character of the lines by adopting a vantage point opposite the quai Jean-Jaurès to have a straight-on view of the facades. But for this work he chose an oblique viewpoint and created a composition based on the triangle, emphasizing the rising diagonal, or "dynamogenic" lines to express a sense of joy. The yellow facades in the center, whose reflection is subtly decomposed in the blue water and sky, endow the picture with an

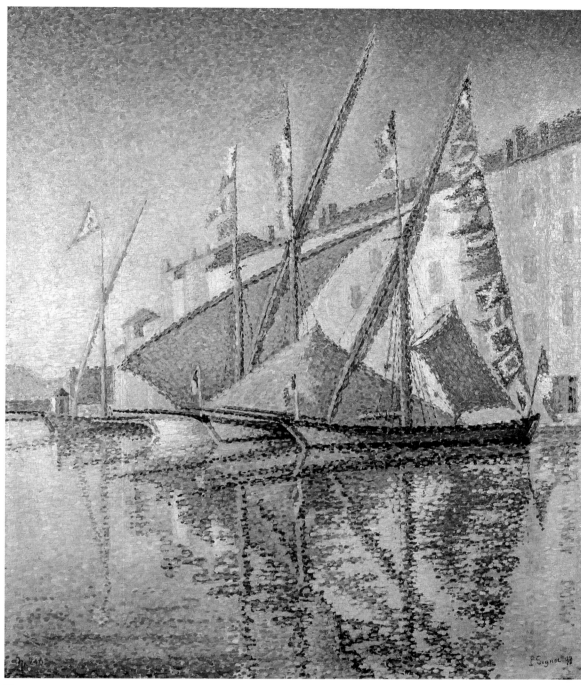

66

intense luminosity, enhanced by the total accents of the red, white, and blue flags. The painting was preceded by three preliminary studies (FC 243–245) which show that the artist had a triangular scheme in mind from the start but hesitated between a horizontal and a vertical format.

The history of this modest but light-filled painting shows that the artist was satisfied with it, for he exhibited it regularly. The work was shown in the same year as its creation at the newly opened "Neo-Impressionist boutique" in the rue Laffitte and again a few months later at the first Salon de la Libre Esthétique in Brussels.

In 1895 it was shown at the Salon des Indépendants and then traded for a bicycle to Rodolphe Darzens, who owned one of Signac's first Neo-Impressionist paintings, *The Junction at Bois-Colombes, Opus 130* (cat. no. 15). Acquired in 1910 by the Von der Heydt–Museum, Wuppertal, *Tartans with Flags* was the first painting by the artist to enter a public collection. Official recognition came first from Germany. Two years later the French State purchased *Evening, Avignon (Château des Papes)* (cat. no. 131). MFB

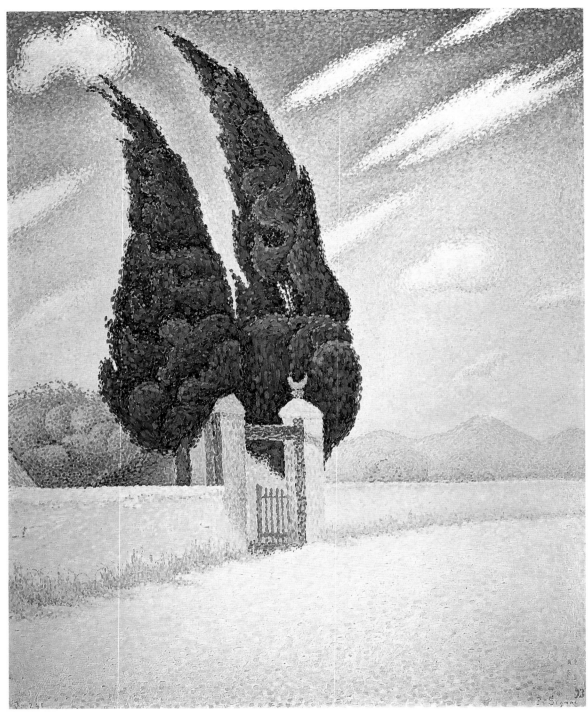

67

67. TWO CYPRESSES, MISTRAL, OPUS 241, 1893

Oil on canvas, 31½ x 25¼ in. (80 x 64 cm)
Signed and dated, lower right: P. Signac 93;
inscribed, lower left: Op 241
Kröller-Müller Museum, Otterlo,
The Netherlands (713-13)
FC 246 (*Les Deux Cyprès. Opus 241 [mistral]*)

Exhibitions: Brussels 1894, Salon de la Libre
Esthétique, no. 399, *Les Cyprès*; Paris 1895, Salon des
Indépendants, no. 1405, *Les Cyprès, Mistral, Saint-Tropez*

During his second summer at Saint-Tropez Signac
painted another view of the harbor (cat. no. 66),
Woman with a Parasol (cat. no. 69), and three pictures
depicting the most typical Mediterranean trees:
The Bonaventure Pine (FC 240), a magnificent parasol
pine done in a very ornamental style; *Two Cypresses*
(the present painting); and *Plane Trees* (cat. no. 68).
He had used pine groves as a main subject the
year before, and trees often appeared in his work.

 The motif of cypress trees evokes Van Gogh,
whom Signac visited during his hospitalization

in Arles in 1889. Yet unlike the trees painted by Van Gogh, these are not dramatic or overwrought. On the contrary, bent slightly backward by the mistral, they have the somewhat comical appearance of stiff guards surprised by the wind. They flank a gate that could be that of the villa La Hune. Only one cypress stands on this site today; the wall was raised and modified for the construction of a garage, but the slight discrepancy in the alignment of the two posts remains. The view of the Maures hills shows the site before houses were constructed and gardens laid out. In 1893 Signac had not yet moved to La Hune but was living at La Ramade, a nearby villa. The well-situated La Hune, which overlooked the surrounding landscape, had, however, already caught his attention.

As indicated by his title, the artist wanted to depict the crisp and transparent light of mistral weather. The sky is clear, with long-drawn-out clouds stretched in the direction of the wind. The pale yellow, almost white path evokes the distinctive atmosphere of days when the mistral blows.

Three oil sketches on the front and back of the same panel (FC 247) rapidly established the linear, colorful, and simple composition. The third study realizes the forms and colors, as well as the diagonal brushstrokes on the upper portion of the panel that render the effects of the wind. At the end of the summer Signac wrote to Cross that he was "a bit happier about the cypresses than the other pictures. From this season, in any case, I will emerge better equipped to tackle the large canvas. Simplification of the elements leads you to more color."[1]

Two Cypresses is one of some ten works by Signac which were acquired by the Kröller-Müller collection in 1913.[2] Most are characterized by a marked simplicity in the handling of form and light, which beyond a certain stiffness gives them a definite antinaturalism and air of modernity. MFB

NOTES
1 Letter from Signac to Henri Edmond Cross, undated [1893], Signac Archives.
2 At the time, Henri van de Velde was involved in the creation of the collection, which was later housed in the museum designed by him.

68. PLANE TREES, PLACE DES LICES, SAINT-TROPEZ, OPUS 242, 1893
Oil on canvas, 25⅝ x 32¼ in. (65.4 x 81.8 cm)
Signed and dated, lower right: 93 P. Signac; inscribed, lower left: Op 242
Carnegie Museum of Art, Pittsburgh, acquired through the generosity of the Sarah Mellon Scaife family, 1966 (66.24.2)
FC 248 (*Les Plantanes. Opus 242 [place des lices, Saint-Tropez]*)

Exhibitions: Brussels 1894, Salon de la Libre Esthétique, no. 400, *Les platanes*; Paris 1895, Salon des Indépendants, no. 1406, *Les Platanes, Saint-Tropez*; Paris 1933–34, Galerie Beaux-Arts, no. 89, ill., *Les Lices à Saint-Tropez*

Exhibited in New York only

Here, Signac depicts the place des Lices at the center of Saint-Tropez, which has retained its rural character to this day. Yet instead of showing the boules players who were already fixtures at the aperitif hour, he painted an old man sitting on a bench under the plane trees, facing the sunset. A sense of serenity pervades this canvas; the conception is at one with the sentiment, powerfully expressed, of the harmony that exists between man and nature.

The picture's modernity is linked with the pronounced *japonisme* of the composition, which has been aptly compared to the Hokusai print *Mount Fuji Seen from the Bamboo Grove*.[1] Indeed, the ornamental effect produced by the repetition of plane trees in supple arabesques is incontestable. The strong stylization of the trunks and leaves forms a curtain of silhouetted trees backlit by the setting sun. The evening sky clearly delineates the contours of the foliage, shining through the leaves and speckling the ground with spots of light. The violet and orange tones render the contrast between light and shadow. The perspectival effect created by the triple row of trees is broken

by the wall in the back, which unifies and contains the space.

The artist often exhibited *Plane Trees*—which was considered one of his masterpieces by George Besson, his friend and biographer[2]—but at the 1895 Salon des Indépendants his *In the Time of Harmony* (cat. no. 75), with its "twelve square meters," monopolized attention. Signac chose *Plane Trees* to illustrate the article he wrote for the *Gazette des Beaux-Arts* in 1933, on the occasion of the exhibition held at the magazine's offices.[3]

After having long remained in the artist's studio, *Plane Trees* was purchased by Marcel

Kapférer, a French aviation pioneer. He and his brother Henri were depicted by Roger de La Fresnaye in *Conquest of the Air* (Musée de l'Art Moderne, Troyes). Marcel Kapférer was a great admirer of the work of Redon, Vuillard, and Bonnard and often purchased at the Galerie Bernheim-Jeune. MFB

NOTES
1 Cachin 1980, p. 236.
2 Besson 1951, pp. 1, 5.
3 Signac 1934, p. 59.

68

69. WOMAN WITH A PARASOL, OPUS 243 (PORTRAIT OF BERTHE SIGNAC), 1893

Oil on canvas, 32¼ x 26⅜ in. (82 x 67 cm)
Signed and dated, lower right: P. Signac 1893;
inscribed, lower left: Op 243
Musée d'Orsay, Paris, Gift, retaining life interest,
of Dr. Charles Cachin (RF 1989-5)
FC 250 (*Femme à l'ombrelle. Opus 243 [portrait de Berthe Signac]*)

Exhibition: Paris 1893–94, rue Laffitte, no. 1,
Portrait

Exhibited in Paris only

With this work of 1893, Signac completed a gallery of portraits of his most intimate friends and relations begun in 1884, when he painted his grandfather seated in the garden (FC 81), and resumed in 1889–92 with a depiction of Gabriel Fabre at the piano (FC 180), the emblematic image of Félix Fénéon (cat. no. 51), an oil sketch of Van Rysselberghe (FC 224 recto), and a portrait of his mother (FC 228).

As was his custom, Signac took a typical subject of the Impressionists, a woman with a parasol—masterfully rendered by Monet—and presented a Neo-Impressionist version of it. His intention was not to capture an ephemeral effect, but to portray with a certain solemnity the woman with whom he had been sharing his life for ten years and whom he had wed just a few months before. Berthe Signac (née Roblès) was a distant cousin of Camille Pissarro's. She met Signac when he was frequenting the Chat Noir, and she appears at his side in a photograph taken about 1882 (fig. 109). Berthe worked as a milliner until 1889. She sat for Signac a number of times, always with her face hidden to avoid being recognized. In 1893 she modeled for *The Red Stocking* (cat. no. 3) and in the following year for *Woman Putting on Her Shoes* (FC 55). Although these two studies were not intended for exhibition, her features

remain more or less concealed. She is recognizable by her full figure and by her hair: she was a broad-shouldered brunet with bangs and a chignon atop her head. She sat—again with averted face—for the woman bending in *The Milliners* (fig. 4), for the woman at the window in *Sunday* (cat. no. 40), and for *Woman Arranging Her Hair* (cat. no. 57), in which her features are barely visible in a reflection in the mirror.

When Signac wrote his mother in 1892 of his intention to marry Berthe Roblès, he described her in the following terms: "Berthe's portrait: very dark-haired, skin olive-brown . . . petite . . . plump . . . the half-Creole, half-Gypsy type; the most beautiful eyes in the world, very gentle and good. A pretty chin . . . disheveled hair. . . . A marked Oriental type . . . nothing of the Parisian mien. She generally appeals to artists. Charpentier made a medallion of her: I have it in bronze in my atelier."[1] This bronze portrait (fig. 98) dates from about 1891, at which time Alexandre Charpentier was sculpting the portraits of many figures associated with André Antoine's Théâtre-Libre. Signac himself also appears in this gallery of contemporary portraits on a medallion in the Musée d'Orsay.

A letter from Charpentier mentions the sittings with Berthe and perhaps also with Signac: "You say that you spend your days at the Indépendants. It would be good if your wife came to the house some morning and you picked her up again at lunch."[2] Berthe is in fact represented not on a medallion but on a rectangular plaque that shows her in left profile and with her usual coiffure. The nose, chin, and shape of the ear are remarkably close to those in Signac's painting and in the photograph which served as a model for it (fig. 99). Although there are stylistic differences due to different media, the similarity is striking.

In the preliminary sketch for this portrait, painted with strong and smooth brushstrokes, Signac demonstrates the advantages of Divisionism

Fig. 98. Alexandre Charpentier, *Berthe in Profile*, ca. 1891, bronze, 8¼ x 5½ in. (21 x 14 cm). Musée des Arts Décoratifs, Paris, on deposit at the Musée de la Monnaie, Paris

Fig. 99. Berthe Signac with a parasol, ca. 1893, photograph. Signac Archives

Fig. 100. Paul Signac, *Study for "Woman with a Parasol,"* 1893, oil on canvas, 21⅝ x 16⅞ in. (55 x 43 cm). Private collection, FC 251

(fig. 100). This dynamic study in color is based on the laws of simultaneous contrast, featuring green and orange, yellow and violet. The parasol's handle veers from orange to green depending on the color of the respective background, and the shadows on the woman's face are green as well. In the definitive version Signac heightened his stylization of the model and gave her a deliberate hieratism. The space has been reduced to the two dimensions of the canvas; there is no illusion of depth. The forms contain little modeling and have been subjected to a strict geometry, like the pieces of a large puzzle. The only sense of movement derives from the vibration of the touches of pigment, which he applied in a great variety of hues to form a richly variegated background. The artist indulged in a virtuoso play of colors, both subtle and varied. Some very fin-de-siècle arabesques—the lines of the sleeves, the parasol, and decorative details like the stylized flower or the braid motif—accentuate the decorative intention of this canvas. Waldemar-George has seen it as an allusion to the woman on the right of Seurat's *A Sunday Afternoon on the Island of La Grande Jatte.*[3]

Signac again used his wife, Berthe, as a model for *In the Time of Harmony* (cat. no. 75) and *Woman in Pink* (FC 289) but never again undertook a straightforward portrait. He seems to have been satisfied with the present picture, writing to Cross in 1893 about his recent paintings: "Compared to my earlier works, they make the simplification—of line and color—more apparent. In terms of color, none stands comparison with Berthe's portrait, and even that of my mother is weak beside it. This is because of the simplicity of these broad, graded hues, in which nothing hinders the intensity of the light and color."[4] MFB

NOTES

1 Letter from Signac to his mother, undated [1892], Signac Archives.
2 Letter from Alexandre Charpentier to Signac, undated, Signac Archives.
3 Waldemar-George 1964, pp. 6–7.
4 Letter from Signac to Henri Edmond Cross, undated [1893], Signac Archives.

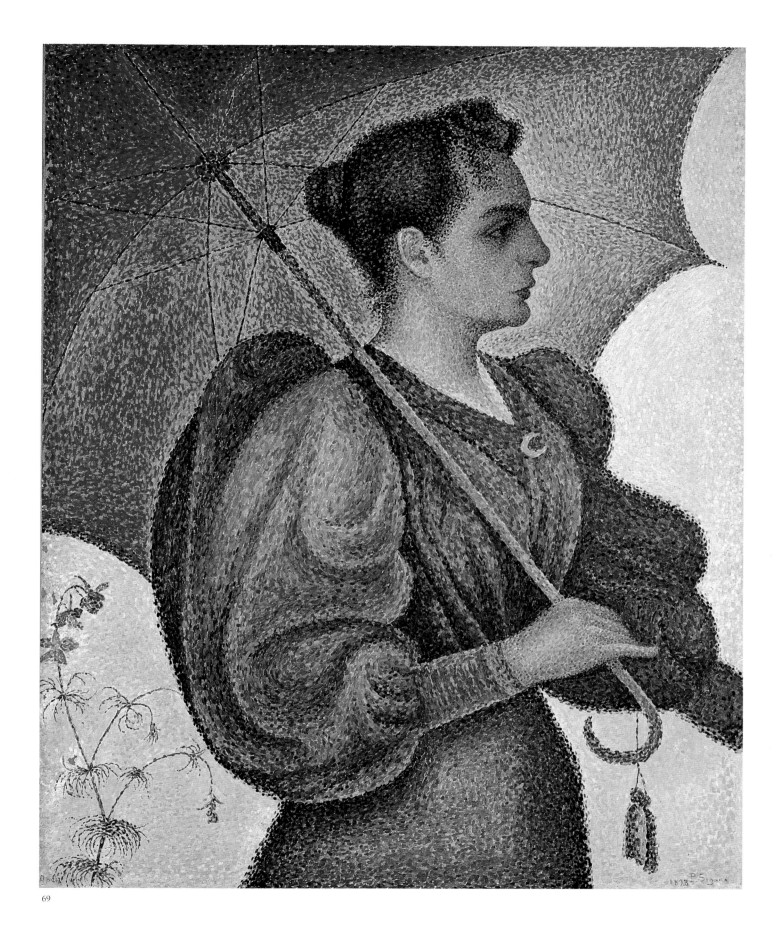

69

70. THE PINK HOUSE,
LA RAMADE, 1892
Watercolor and ink, 7⅞ x 10¼ in. (20 x 26 cm)
Private collection

Exhibited in Paris only

This drawing must date from the artist's early
days in Saint-Tropez, since it depicts the first
house he lived in after his 1892 arrival. The
handling is a bit studious: this was an initial
attempt at a technique recalling the graphic
qualities of Van Gogh, which became character-
istic of his first decade in Saint-Tropez. AD

71. THE MARINERS' CEMETERY,
ca. 1894
Watercolor and graphite, heightened with ink,
5⅛ x 7⅞ in. (13 x 20 cm)
Private collection

Exhibited in Paris only

This dynamically punctuated watercolor
was among the earliest done by Signac in Saint-
Tropez. AD

70

71

72. LA PONCHE,
 SAINT-TROPEZ, 1894
 Watercolor and ink, 8¼ x 10⅜ in. (21 x 26.5 cm)
 Signed, with interlaced initials, and dated, lower
 right: PS 94
 Private collection

This watercolor representing one of the small
beaches at Saint-Tropez used by fishermen is
dated 1894, as is *The Coastal Path* (cat. no. 73). It is
exceptionally finished and may have been exhib-
ited at the Salon des Indépendants, where Signac
had begun showing his "watercolor notations" in
1893, or at the "Neo-Impressionist boutique" at
20 rue Laffitte in November 1894. It belonged to
the descendants of Seurat's mother, whom Signac
visited regularly until her death in 1899. AD

73. THE COASTAL PATH,
 SAINT-TROPEZ, 1894
 Watercolor and ink, 7½ x 11¾ in. (19.2 x 29.7 cm)
 Signed, with interlaced initials, and dated, lower
 left: PS 94
 Private collection

This watercolor, unusual because it is dated,
serves as a reference point in the earliest series of
watercolors done at Saint-Tropez. The technique
shows Signac's admiration for Van Gogh. AD

72

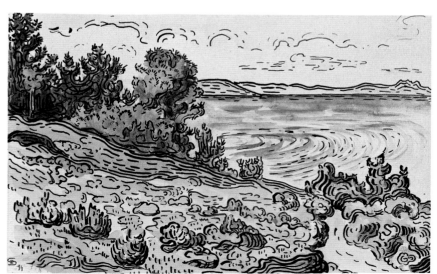

73

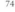

74. THE CHAPEL OF SAINTE-ANNE AT SAINT-TROPEZ, ca. 1895

Watercolor and ink, 8¼ x 11¼ in. (21 x 28.5 cm)
Signed, lower right: P. Signac
Arkansas Arts Center Foundation Collection,
Little Rock, Gift of James T. Dyke, 1999
(99.065.007)

Exhibited in Amsterdam and New York

This watercolor, "heightened with ink,"[1] belongs to a distinctive group of works that Signac made in the mid- to late 1890s, in which he exploits the graphic potential of line to articulate structure, delineate contour, and animate the scene. Critics were quick to note that stylistically these early efforts recall Van Gogh's pen-and-ink drawings,[2] particularly those done in Arles during the spring and summer of 1888. The drawings made a strong impact on Signac when ten were shown in the 1891 Van Gogh retrospective, which he helped to organize, for Les XX in Brussels.[3] The present composition, a view of the Saint-Tropez landscape through the chapel's arches, reinforces the connection between the two artists; its subject evokes Van Gogh's drawings of cloistered hospital gardens in Arles and Saint-Rémy, notably two now in the Van Gogh Museum, Amsterdam: *The Courtyard in the Hospital at Arles* (F 1467) and *The Fountain in the Garden of Saint Paul's Hospital* (F 1531), both exhibited in the 1891 retrospective.

Acquired in 1984 by businessman James T. Dyke, this work proved to be the starting point for an impressive collection, recently donated to the Arkansas Arts Center, of more than 130 watercolors and drawings by Signac. SAS

NOTES
1 Quote is from Signac's description of these works in his notebook, as recorded by Ferretti-Bocquillon in Little Rock 2000, p. 14.
2 As early as 1894 Octave Mirbeau commented: "Why is it also that his [Signac's] 'watercolor notations,' which have grandeur and character, remind me, obscurely enough, of the drawings by Van Gogh?" Mirbeau 1894, p. 1.
3 Cachin (1988, p. 234) records that Signac described them as those "terrible reed-pen drawings" in a letter to Fénéon of February 10, 1891 (Signac Archives); the adjective (in French, *terribles*), as she points out, can mean either ugly or striking.

75. IN THE TIME OF HARMONY,
1893–95

(THE GOLDEN AGE HAS NOT PASSED; IT IS STILL TO COME)

Oil on canvas, 117 x 156 in. (300 x 400 cm)
Signed and dated, lower right: P. Signac 94–95
Mairie de Montreuil (MH 10-11-1980)

FC 253 (Au temps d'Harmonie [l'âge d'or n'est pas dans le passé, il est dans l'avenir])

Exhibitions: Paris 1895, Salon des Indépendants, no. 1401, Au Temps d'Harmonie./L'âge d'or n'est pas dans le passé, il est dans l'avenir; Brussels 1896, Salon de la Libre Esthétique, no. 389, Au Temps d'Harmonie, L'âge d'or n'est pas dans le passé, il est dans l'avenir; Paris 1926, Salon des Indépendants, no. 2367, Au temps d'Harmonie (décoration pour une maison du peuple)

Exhibited in Paris only

In the shaded foreground a man has put his shovel down to pick a fig, a man reads, a woman gives a child a fruit, and two men play boules. In front of them is a frieze of poppies and irises and a rooster and hen. In the sun-filled middle ground a couple embraces, a woman picks flowers, and other women hang laundry; on the right is a man sowing, and on the left a painter with his muse and, farther back, bathers. Tartans are moored at the dock, and a schooner approaches. The canvas presents an idealized synthesis of Signac's favorite subjects from Saint-Tropez: the pine grove, the Bertaud pine, and the jetty, which has been arbitrarily placed in front of the plage des Graniers, where the artist lived. In the distance there are agricultural machines, young people dancing a farandole, and an old man at the foot of the Bertaud pine teaching younger generations.

The whole is replete with aesthetic, political, and social meaning. It stands out in Signac's work not only because of its size but also because of its symbolic scope and personal significance. The man picking a fig is a self-portrait of Signac, and his wife, Berthe, sat for the figure of the woman

in the foreground. Like Courbet in his *Painter's Studio* (Musée d'Orsay, Paris), Signac created a utopian "workshop" for his social ideals: society conceived as a bucolic phalanstery in which all participate. The idea of painting a large composition celebrating the Mediterranean coast and the harmonious life it promised occurred to Signac as soon as he arrived in Saint-Tropez. The initial idea for *Women at the Well*, rapidly done in the summer of 1892 (cat. no. 64), already evoked the family, work, and play and presented such subjects as a worker, a round dance, and a pine grove. These subjects were left out of the finished version of *Women at the Well* (cat. no. 63) but reappeared in *In the Time of Harmony*.

Once again Signac wanted to demonstrate that Divisionism could be used for monumental decorative painting. Here, too, the memory of Seurat—and above all *A Sunday Afternoon on the Island of La Grande Jatte* (fig. 3)—is very much present, despite the radically different subject matter. As in *Women at the Well*, Signac abandoned the depiction of Parisian society at leisure in the 1880s in favor of presenting an ideal rural society. Reportage has given way to a utopian vision.

The tripartite arrangement of *La Grande Jatte* is visible here in the three successive zones of shade, light, and water. Signac's composition, however, proceeds from left to right, adhering more closely to Charles Henry's theories of orienting lines to express happiness. Puvis de Chavannes's *Pleasant Land* (fig. 101) inspired the left part of the canvas, up to and including the representation of the fig tree with its clearly outlined leaves. Signac objected to Puvis's low-key palette, but he continued to regard Puvis as a touchstone. His close study of Puvis's works before undertaking *In the Time of Harmony* is reflected not only in the overall spirit of calm and abundance which pervades this bucolic idyll but also in such details as the group of young people listening

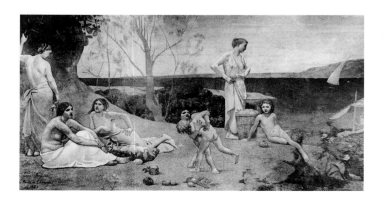

Fig. 101. Pierre Puvis de Chavannes, *Pleasant Land,* 1882, oil on canvas, 90½ x 169¼ in. (230 x 430 cm). Musée Bonnat, Bayonne

attentively to the teachings of the old man sitting in the shade of a mighty pine. Indeed, this group is a direct quotation from Puvis's *Repose* (fig. 102).

In 1892 Signac began a program of adapting the Neo-Impressionist idiom to mural painting and of emulating Puvis de Chavannes and Seurat. He encouraged his friend Henri Edmond Cross to follow suit and to undertake a large-scale composition of his own. The result was Cross's *The Evening Air* (fig. 46). These respective projects led to a substantial correspondence between the two artists. Their letters and the journal that Signac started in 1894 provide a detailed account of his progress on the present canvas. It was not an easy task, and for a self-taught painter like Signac, the transition to working on a monumental scale was more difficult still.

The idea of a large composition took shape during the summer of 1893, in the course of his dialogue with Cross, who wrote: "Your idea of a large canvas is perfect. . . . Until now, the pictures dealing with the theme of anarchy always depicted revolt either directly or indirectly, through scenes of poignant misery. Let us imagine instead the dreamed-of age of happiness and well-being and let us show the actions of men, their play and their work in this era of general harmony."[1] It was in this spirit that Cross painted *The Evening Air.*

Signac executed a first sketch of his own composition that summer. This sketch has been lost, but we can get an idea of it from Cross's comments on the second sketch of December 1893 (cat. no. 76). He congratulated Signac for having replaced a female figure on the left with a male figure and for having modified the gesture, which he considered a "déjà vu," that is, an allusion to Puvis's *Pleasant Land.* He also approved of the new

conception of the landscape but deplored the omission of the boules player: "He extends the foreground arabesque perfectly . . . it was a find that your mimosa will never be able to replace."[2]

Back in Paris after having "spent an afternoon of perfect felicity" contemplating Puvis's works in Lyons, Signac continued thinking about his big canvas. He went to see Puvis's murals at the Sorbonne and read an article by Malato in *La Revue anarchiste* which gave him the subtitle of his work: "L'Âge d'or n'est pas dans le passé, il est dans l'avenir" (The golden age has not passed; it is still to come).[3] While the article was a call to revolution, Signac focused on the idea of a golden age, embodied by an ideal society living in a simple and bucolic way along the lines of his happy life at Saint-Tropez. Instead of representing an image of revolution, he created a utopian image of the sought-after ideal.

During the winter of 1893–94 in Paris, Signac worked on enlarging the sketch to the size of the present painting and told his friend: "I will not receive my large canvas until tomorrow. . . . I will cover it with paper and take my time looking for lines and curves with my charcoal." He was afraid of being disappointed by the enlargement of the small sketch. In another letter he wrote: "I am charcoaling my twelve square meters of paper in developing my composition. Little by little, with great difficulty, everything is clearing up. . . . I put the boules player back in."

But the work did not progress well, and it was not until the next season at Saint-Tropez that he began applying the colors. As his journal indicates, it was then that he painted an impressive series of oil panels. He worked on the torso of the reading figure and had his gardener Bech sit "very quickly" for a small panel. Then, still using Bech as model, he worked on the figure picking a

Fig. 102. Pierre Puvis de Chavannes, *Repose*, 1863, mural (oil and wax on canvas), 141¾ x 214⅝ in. (360 x 545 cm). Musée de Picardie, Amiens

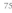

75

fig and noted: "Did a small panel [cat. no. 78] and a study of naked flesh." On August 29 he had Bech pose again for the boules player (cat. no. 81), which he worked up the next day "after the drawing and the panel."[4] During this same summer season at Saint-Tropez he painted the panel of the reclining female figure (cat. no. 80), with his wife, Berthe, as model, and studies for the flowers and landscape (cat. nos. 82–85). At first he made brisk notations of the beach scene (cat. nos. 85a, 85b) and irises (cat. no. 83) in a more realistic style. Finally, in the last panels, such as the one with the poppies (cat. no. 84), he simply noted some color effects in near-abstract, broad square strokes, scaled to the large canvas.

During the winter of 1894–95, in order to judge the effect of his work at a greater distance, he took it to the studio of Eugène Carrière, his neighbor at the Villa des Arts, 15 rue Hégésippe-Moreau. Upset that color division was ineffective on so large a scale, he told Cross that he was

afraid he would be forced to violate the tenets of Divisionism by making the brushstrokes overlap. "How difficult it is to be honest!" he lamented. When he saw the picture exhibited at the 1895 Salon des Indépendants, he decided to rework it completely and noted in his journal: "It is fortunate that I have three good weeks to repaint it almost entirely. . . . To sum up, it pleased me. One could see it from the entrance of the rooms, that is to say, from about 150 meters, and when one came close, one had passed by the point at which the effect is produced. The white frame enclosing an oak frame . . . made a rather good effect."[5]

The work was not warmly received at the Salon des Indépendants of 1895. At the Salon de la Libre Esthétique in 1896, where Signac had arranged to hang it in the same place where *A Sunday Afternoon on the Island of La Grande Jatte* had caused a sensation eight years before, the work inspired little enthusiasm.[6] But Félix Fénéon wrote to Signac: "It is the marvel of the exhibition and

of your entire oeuvre. All my compliments and more."[7] Camille Pissarro, negatively predisposed toward the picture, wrote to his son Lucien: "The Signac is better than anything else he has done so far; his large decoration is not lacking in gaiety."[8] In fact, most of the reviews concluded with qualified praise. Van de Velde considered it "the most essentially pictorial manifestation of this Salon. . . . An evocation of Happiness, unequaled perhaps because it depends only on the arrangement of lines and colors" but criticized the costumes, which he said stemmed from a "puritanical anarchism."[9]

Signac wanted to evoke the milieu of the workers and he may have thought that nudes would have been too academic. He was pleased by the approval of the Belgian sculptor Constantin Meunier: "Père Meunier, when I went to see him, was good enough to say that he grasped the arrangement of my large picture, that he saw what I had tried to do, and that he liked it. He made me very happy by telling me that he had tried the same thing in his admirable bas-relief of 'work.'"[10] Verhaeren, who would dedicate Les Aubes, a book about the establishment of an age of peace and harmony, to Signac, said it was an "attempt at decoration in which the theory of line dear to the author plays perhaps too overt a part, but which one cannot help defending because of the fine artistic conviction that fresco professes."[11] To be sure, most commentators picked up more on the work's anarchist message than on its aesthetics.

Signac had made a genuine attempt to paint an anarchist picture. He stated his position clearly around 1902: "Justice in sociology, harmony in art; the same thing. . . . The anarchist painter is not the one who represents anarchist pictures"; and in 1891: "It would be a mistake, one that well-meaning revolutionaries like Proudhon have too often committed, to systematically demand a specific socialist tendency in works of art."[12] For Signac, a painter was a revolutionary because he was an innovator and not because he illustrated political ideas with politicized images. He agreed with Saint-Simon's statement: "Artists, men of imagination, will open the march; they will proclaim the future of the human species, they will remove the golden age from the past to enrich future generations with it."[13] The presence of such anarchist symbols as the rooster ([l'Aube] evoking dawn) and the sower is fitting.[14] Although the revolutionary "rooster" was generally represented alone, Signac seems to have intended a political subtext, noting in his journal on August 7, 1894: "Drew the rooster. Beginning of the Trial of the Thirty."

The political environment in which the picture was painted strengthened the artist's anarchist beliefs. There had been more and more bombings by anarchists in recent years, and most of his friends—Camille Pissarro, Jean Grave, Émile Verhaeren, Maximilien Luce, and Félix Fénéon— were open about their anarchist sympathies. The last two were implicated in the Trial of the Thirty but were ultimately acquitted.

The social balance seemed to be shaken, which pleased many of Signac's friends who longed for change. Signac himself wanted to contribute to the establishment of a more harmonious society, but nonviolently, by dedicating a significant artwork to the cause. One of the lesser effects of the contentious assessment of the social order was a vogue for "decorative" painting and an aversion to easel painting, thought to be a useless instrument of bourgeois vanity: "commercial articles sold in our day by professionals enslaved by bread and luxury."[15] Art should be monumental and justified by its usefulness, an extreme philosophy that thrived under the totalitarian regimes of the twentieth century and that led Signac to temper his convictions about socially committed painting.

In the Time of Harmony was intended as the first part of a decorative ensemble with obvious political implications. Dedicated to the struggle for a better world, it was to have included further panels representing Boat Haulers, Wreckers, and Builders.[16] The initial vision of an idyllic future was to have been followed by depictions of the phases necessary to establish the new society. The "Boat Haulers," which Signac mentioned in his journal in 1894, was never realized.[17] Meanwhile, Signac had promised to give Jean Grave, publisher of Les Temps nouveaux, a lithograph of his large canvas for the anarchist review: "Working after the large canvas with drawing and watercolor. I would like to make a litho in black and one in color."[18]

There were probably several drawings done by the artist after In the Time of Harmony; two are known. One, executed in Conté crayon, is today in the Kröller-Müller Museum, Otterlo. It repeats the general composition only in part and would probably have been used for the black-and-white lithograph, which was never realized. Another drawing, previously unpublished, is in the present

exhibition (cat. no. 86). This beautiful ink draw-ing is faithful to the large canvas, constituting a real "portrait of a picture" such as Signac drew on several occasions in order to reproduce his works in periodicals. The graphic style, with its short, discontinuous, rhythmic strokes, re-creates the effect produced by the divided touch in paint-ing. As for the color lithograph, few copies were ever printed (cat. no. 87). Signac was dissatisfied with the print and decided to undertake a litho-graph representing a wrecker (cat. no. 88a)—again for *Les Temps nouveaux*—and so to move on to the next phase of his project. By the fall of 1896, this lithograph was for sale in the review's offices.[19] On January 1, 1897, Signac wrote to Cross, announcing that he was undertaking the painting using the image of the lithograph, only reversed. Once more the work took a long time (1897–99), and the painting (cat. no. 88b) was exhibited at the Indépendants only in 1901.

Signac's enthusiasm had cooled in the mean-time because of difficulties with the Maison du Peuple in Brussels. During a visit to Verhaeren in December 1897, Signac offered to give *In the Time of Harmony* to the Maison du Peuple, then being built after Horta's plans from 1895.[20] The architect, however, does not seem to have been happy about this prospect, and early in 1899, shortly before the building's inauguration, Signac had still not received any news and was getting impatient. He wrote to Octave Maus: "Is it the title that bothers them?—we could call it 'In the Time of the Socialist Deputies' to make them happy!"

Discussions were resumed and several months later Signac informed Maus that there should be a space of twelve to fifteen meters in front of the picture, that he would adapt the large canvas to its final home even if this required time, and that lighting would not be a problem because the divi-sionist technique brought light to dark walls.[21] On May 1, 1900, after returning from a trip to Brussels, he noted that he had found "a not-so-good spot on a landing with about ten meters' viewing distance—soft lighting through frosted panes. The panel will be filled by my canvas, sur-rounded by a frame to be designed by Horta, the architect, in order to connect it to the overall decorative scheme of his building." Several days later *L'Art moderne* announced the gift and men-tioned that the canvas would hang on the second floor, next to the dispensary.[22] The project seemed

well under way, but the architect persistently neg-lected to design the frame, and an outraged Signac withdrew his offer on November 11: "The foot-dragger of the Maison du Peuple, Horta, not having seen fit in six months to find the time to install the four boards that were to serve as frame for my decoration, I purely and simply withdraw my offer."[23]

Only after the artist's death in 1935, and at the initiative of his executor George Besson and his friend Marcel Cachin, did the work find an institutional welcome.[24] In 1938 the artist's widow offered it to the newly built town hall of Montreuil, a communist suburb of Paris. The days of anarchy were over; it was the heyday of the Front Populaire, and idealism had given way to ideology. Signac had never been a commu-nist, and Cachin knew of his increasing reserva-tions about the party. As he wrote in a letter to his son Charles: "Between an old Marxist and an old Bakuninist, it is difficult to find a com-mon ground for action. And so we took refuge on the grounds of personal affinity, and there it is perfect."[25] Maximilien Luce, glad to see his friend's work finally exhibited, stated that the placement "corresponds exactly to what Signac had wanted: a public place in the presence of the people."[26]

The work's artistic progeny is of interest. Dur-ing summer 1896 at Saint-Tropez, spurred on by his friend's convictions, Théo van Rysselberghe undertook a large-scale work with intentions and composition similar to those of Signac's picture. *The Blazing Hour* (Kunstsammlungen zu Weimar), a celebration of life on the Mediterranean shores, was finished in 1897 and shown at the Salon de la Libre Esthétique, where it was hung on the same wall that *La Grande Jatte* and later *In the Time of Har-mony* had occupied. In effect, however, it marked Van Rysselberghe's return to a more academic style and the beginning of his break with Neo-Impressionism. Matisse stayed with Signac at Saint-Tropez during the summers of 1904 and 1905, also spending much time with Cross. Under the tutelage of the two Neo-Impressionists he tried his hand at hedonistic subjects such as *Luxe, calme et volupté* (fig. 47). In 1906 he completed his first large-format canvas, *Joy of Life* (fig. 63). In this Mediterranean pastoral, Matisse celebrated love, harvesting, and repose. This was the first appearance of the round of dancers, which was to become one of the central themes of his

work. But by depicting the figures nude, Matisse placed them beyond time. He had freed himself from the constraints of Neo-Impressionist theory, and his colorful arabesques undulate freely through colored space, disregarding Divisionism. Although Signac considered this a betrayal, the great decorative painter that he had longed for had been born—a rebel son of Neo-Impressionism. MFB

NOTES

1 Henri Edmond Cross–Signac correspondence, Signac Archives.

2 Letter from Henri Edmond Cross to Signac, December 14, 1893, Signac Archives.

3 Malato 1893, p. 78.

4 Signac journal entries, June 25, July 8, August 29, 1894, Signac Archives. The drawings in question were probably the "charcoaled" cartoons in the definitive format, now lost.

5 Signac journal entry, April 26, 1895, in Rewald 1949, pp. 118, 172.

6 Letter from Signac to Octave Maus, late 1895, in Chartrain-Hebbelinck 1969, p. 79.

7 Letter from Félix Fénéon to Signac, undated [1895], Signac Archives.

8 Letter from Camille to Lucien Pissarro, April 11, 1895, in Bailly-Herzberg 1980–91, vol. 4, p. 61, no. 1127.

9 Van de Velde 1896, p. 286.

10 Signac journal entry, February 23, 1896, Signac Archives.

11 Verhaeren 1896, p. 2.

12 See Herbert and Herbert 1960, p. 477; Signac 1891, pp. 3–4.

13 Saint-Simon 1825.

14 Salé 2000, pp. 314–43.

15 Cousturier 1892b, pp. 212–18.

16 Signac outlined this program in his journal entry of June 9, 1896, after having executed a reduction of *In the Time of Harmony*: "to prepare myself for the sketches for my next picture: *The Boat Haulers, The Wreckers, The Builders.*" (Signac Archives).

17 Signac journal entry, June 19, 1894, Signac Archives: "Make a sketch of the haulers (sad picture, harmony green and violet)."

18 Letter from Signac to Henri Edmond Cross, January 1896, Signac Archives.

19 Paris 1987–88, no. 61.

20 Thiébault 1991, pp. 72–78; see also Thiébaut 1998, pp. 25–32.

21 Two letters from Signac to Octave Maus in Chartrain-Hebbelinck 1969, pp. 83–84.

22 *L'Art moderne*, May 6, 1900, p. 144.

23 Signac journal entry, May 1, 1900, cited in Thiébault 1991, p. 77.

24 Notebooks of Marcel Cachin, vol. 4 (1935–47), p. 170, June 2, 1936, Centre National de la Recherche Scientifique, Paris: "settle the Montreuil Signac business."

25 Letter from Marcel Cachin to Charles Cachin, Signac Archives.

26 Luce 1938, p. 826; Ferretti-Bocquillon 1998, pp. 15–17.

76–86. STUDIES FOR "IN THE TIME OF HARMONY"

76. STUDY FOR "IN THE TIME OF HARMONY," 1893
Blue and black ink wash, over graphite, 7⅞ x 10⅝ in. (18.5 x 27 cm)
Signac atelier stamp, upper left
Annotations in ink: bois de pins, ronde, machines, femmes étendant du linge, semeur, amoureux, iris, mimosa, femme cueillant des fleurs, fleurs (pine groves, round, machines, women hanging out washing, sower, lovers, iris, mimosa, women picking flowers, flowers)
Musée du Louvre, Département des Arts Graphiques, Fonds du Musée d'Orsay, Paris, Gift of Françoise Cachin in memory of her mother, Ginette Signac, 1997 (RF 50 854)

Exhibited in Paris only

77. SKETCH FOR "IN THE TIME OF HARMONY," 1893
Oil on canvas, 23⅛ x 31⅞ in. (58.6 x 81 cm)
Private collection
FC 254 (*Au temps d'Harmonie. Esquisse*)

Exhibited in Paris only

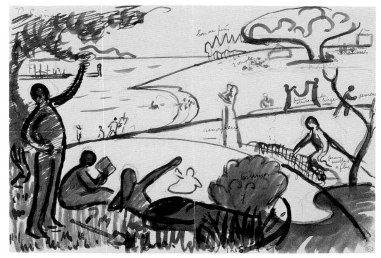

76

77

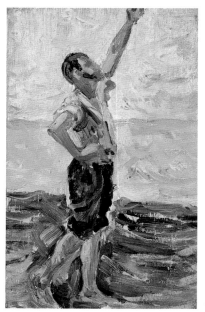

78

78. STUDY FOR "IN THE TIME OF
HARMONY": STANDING MAN,
1894
Oil on wood, 9⅞ x 6⅛ in. (25 x 15.5 cm)
L'Annonciade, Musée de Saint-Tropez (1965.1.1)
FC 255 (*Étude pour "Au temps d'Harmonie"*
[l'homme debout])

Exhibited in Paris only

79

79. STUDY FOR "IN THE TIME OF
HARMONY": MAN READING, 1894
Oil on wood, 6⅛ x 9⅞ in. (15.5 x 25 cm)
Private collection
FC 256 *(Étude pour "Au temps d'Harmonie"*
[l'homme lisant])

Exhibited in Paris only

80

81

80. STUDY FOR "IN THE TIME OF
HARMONY": WOMAN, 1894
Oil on wood, 6⅛ x 9⅞ in. (15.5 x 25 cm)
Private collection
FC 257 *(Étude pour "Au temps d'Harmonie" [la femme])*

Exhibited in Paris only

81. STUDY FOR "IN THE TIME OF
HARMONY": BOULES PLAYER,
1894
Oil on wood, 9⅞ x 6⅛ in. (25 x 15.5 cm)
Private collection
FC 258 *(Étude pour "Au temps d'Harmonie" [le joueur
de boules debout])*

Exhibited in Paris only

82

82. STUDY FOR "IN THE TIME OF
HARMONY": OLEANDERS, 1894
Oil on wood, 7½ x 10⅝ in. (19 x 27 cm)
Private collection
FC 263 *(Étude pour "Au temps d'Harmonie"
[les lauriers-roses])*

Exhibited in Paris only

83

83. STUDY FOR "IN THE TIME OF
HARMONY": IRISES, 1894
Oil on wood, 10¼ x 13¾ in. (26 x 35 cm)
Private collection
FC 264 recto *(Étude pour "Au temps d'Harmonie"
[les iris])*

Exhibited in Paris only

84

84. STUDY FOR "IN THE TIME OF
HARMONY": POPPIES, 1894
Oil on wood, 6⅛ x 9⅞ in. (15.5 x 25 cm)
Private collection
FC 266 *(Étude pour "Au temps d'Harmonie"
[les coquelicots])*

Exhibited in Paris only

85A

85B

85A. STUDY FOR "IN THE TIME OF HARMONY": PLAGE DES GRANIERS, SAINT-TROPEZ, 1894
Oil on wood, 10¾ x 13⅜ in. (26.5 x 34 cm)
Private collection
FC 267 (Saint-Tropez. Plage de Granier [étude pour "Au temps d'Harmonie"])

Exhibited in Paris only

85B. STUDY FOR "IN THE TIME OF HARMONY": PLAGE DES GRANIERS, SAINT-TROPEZ, 1894
Oil on wood, 10¾ x 13¾ in. (26.5 x 35 cm)
Private collection
FC 268 recto (Saint-Tropez. Plage de Granier [étude pour "Au temps d'Harmonie"])

Exhibited in Paris only

86. STUDY FOR "IN THE TIME OF HARMONY,"

1895–96
Black ink and graphite; sheet 19¾ x 24¼ in. (50 x 61.7 cm), image 14¾ x 19¾ in. (37.5 x 50 cm)
Private collection

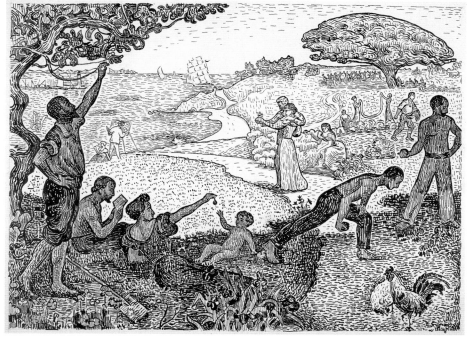

86

87. IN THE TIME OF HARMONY, 1895–96

Color lithograph, 14¾ x 19¾ in. (37.6 x 50.2 cm)
Signed in plate, lower right: P. Signac
Private collection

Exhibited in Amsterdam and New York

This lithograph of the monumental painting with the same title (cat. no. 75) was intended for publication in Jean Grave's anarchist review *Les Temps nouveaux*.[1] The project was never realized and only a small number of copies of this lithograph were printed.[2] AD

NOTES
1 See Signac's letter to Grave published by Herbert and Herbert 1960, p. 520.
2 Kornfeld and Wick 1974, no. 14.

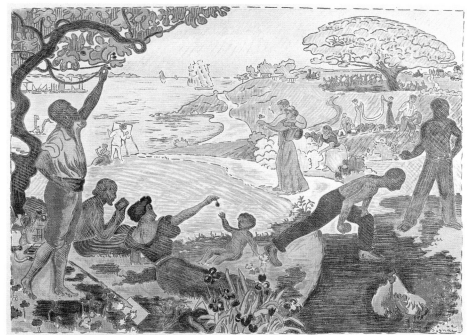

87

88A. THE WRECKERS, 1896

Lithograph, 18½ x 12 in. (47 x 30.5 cm), with
printed title 20⅜ x 14⅛ in. (51.8 x 35.8 cm)
Signed and dated on stone, lower left:
P. Signac 96
Van Gogh Museum, Amsterdam (P 306v/1982)

Exhibited in Amsterdam and New York

88B. THE WRECKER, 1897–99

Oil on canvas, 98⅜ x 59⅞ in. (250 x 152 cm)
Musée des Beaux-Arts, Nancy, on deposit by
the French State
FC 336 (*Le Démolisseur*)

Exhibition: Paris 1901, Salon des Indépendants,
no. 925, *Le démolisseur (panneau pour une Maison du
Peuple)*

Exhibited in Amsterdam only

In a letter to Jean Grave probably dating from
1896, Signac announced his intention to produce
both the present lithograph (cat. no. 88a) and the
large painting which derives from it (cat. no. 88b):
"I am working on a Wrecker, of which I intend to
make a vertical decorative panel. As soon as I am

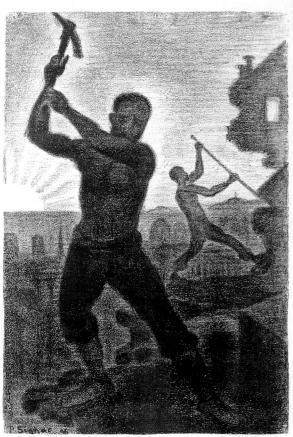

Les Démolisseurs

88A

satisfied with the movement, I will make you a
litho of it. Allowing for the work and the printing,
it will take up to the end of July."[1] The litho-
graph was published in Grave's anarchist review
Les Temps nouveaux in 1896.

The figure of the wrecker is Signac's most
politically charged image. Robert and Eugenia
Herbert have set the lithograph in the context
of other illustrations by Signac and like-minded
artists for radical publications such as *La Révolte*
and *Les Temps nouveaux*, noting that *The Wrecker* is
"undoubtedly to be interpreted as the worker de-
molishing the capitalist state."[2] As John Hutton
has noted, Signac himself had used the metaphor
of the pickax in an essay published in 1891 in *La
Révolte*: the "natural aesthetes, revolutionaries by
temperament" would deal "a forceful blow of a
pickax to the antiquated social structure." Hutton
contrasts Signac's relatively abstract image of the
dismantling of the old order where the workers
seem to "pry open cracks to let in the light" with
more explicit images of working-class solidarity
and empowerment such as Théophile Steinlen's
The Laborer, with its emphasis on "the power and
muscularity of the male working class."[3]

The rich, velvety tones of the lithograph recall
Signac's early drawing style and, of course, the
drawings of Georges Seurat. But in comparison
with other compositions by Signac where the fig-
ures are usually carefully integrated into a two-
dimensional design, the dramatic positioning of
the foreground figure in both the print and the
painting is remarkable. The towering worker
hacks his way toward us, his pickax threatening
to break out into our space. The pose, with its
violent contrapposto echoing a traditional artis-
tic prototype of a warrior raising his sword to
deliver the fatal blow, seems contrived to lend
dignity and heroism to the protagonist. In the
background of the lithograph there is a shadowy
evocation of a city, and in the distance Signac
has depicted the schematic rays of the rising
sun, which by the 1890s was a standard anarchist
symbol for the dawn of a new order.

On January 4, 1897, Signac noted in his journal
that he had begun work on the large painting of
the wrecker now in Nancy (cat. no. 88b).[4] The
picture was projected to be one of an ensemble
of themes of labor, which was also to include
Boat Haulers and Builders. In part these projects
for monumental subjects depicting industry and
work were a counterpart to the rural and modern

idyll that he had developed in his earlier *In the Time of Harmony* (cat. no. 75).[5] But they may also be a response to Émile Verhaeren's volume of poems *Les Villes tentaculaires,* which the Belgian poet had completed in the summer of 1895 while staying in Signac's Paris studio and which he had thought of dedicating to his artist friend. Signac's interest in themes of labor can only have been reinforced by his visit with Maximilien Luce to a mine and steelworks at Couillet in Belgium, where he was fascinated by "the reign of fire, a vision à la Turner, of flames and sparks, of Bengal fires and of suns."[6] The Wrecker was the only one of these heroic themes to see the light of day. Whereas the crepuscular effect of the

lithograph allowed Signac to produce a more generalized image, the painting developed into a more specific depiction of a man at work. The background is clearly industrial, and the central figure has thickened into an impressively robust figure, more obviously derived from a life model. In a squared-up oil sketch (FC 337), the figure is shown in the same pose as in the lithograph. However, as Signac noted in his journal, he decided to reverse the pose: "Angrand, to whom I sent a sketch of my Wreckers, wrote me that the gesture is that of a left-handed person. . . . It wouldn't have mattered at all, and I would not have changed anything, if I hadn't noticed that by turning the fellow around the painting gets much better and the lines fall into order in the right directions."[7] It is typical of Signac that, even in this most charged and dramatic of images, he was still most concerned with the decorative effect of his composition.

In contrast to the fluidity of the lithograph, the surface of the painting suggests that its realization was a tortuous affair. It seems to have been finally completed in 1899 but was not shown until 1901, when it was exhibited at the Indépendants with the subtitle "panneau pour une Maison du Peuple [panel for a Maison du Peuple]." Whatever ambitious plans he may have had for the work came to nothing, and it remained in the artist's studio until his death. This was Signac's last major attempt to produce a painting that would not only carry the weight of his political conviction but would underline his place as an artistic pioneer. The modest reception of this painting and its counterpart, *In the Time of Harmony,* served to deter the artist from grand figure painting, paving the way for his more restricted ambition in his later years. JL

NOTES
1 Letter from Signac to Jean Graves [1896?], cited in Kornfeld and Wick 1974, no. 15.
2 Herbert and Herbert 1960, p. 479.
3 Hutton 1994, pp. 59–63.
4 Signac journal entry, January 4, 1897, Signac Archives.
5 See Ferretti-Bocquillon 1996–97, pp. 59–60.
6 Signac journal entry, Signac Archives; cited in chronology in Cachin 2000, p. 368, under November 15–December 17, 1897.
7 Signac journal entry, March 1, 1897, Signac Archives.

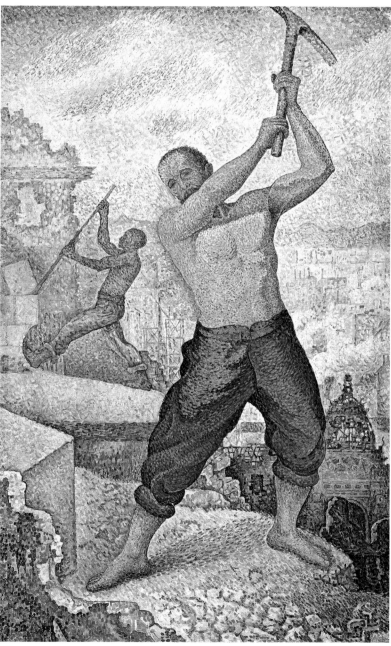

88B

89. THE RED BUOY, SAINT-TROPEZ, 1895

Oil on canvas, 31⅞ x 25⅝ in. (81 x 65 cm)
Signed and dated, lower left: 95 P Signac
Musée d'Orsay, Paris, Gift of Dr. Pierre Hébert
(RF 1957-12)
FC 284 (Saint-Tropez. La Bouée rouge)

Exhibitions: Brussels 1896, Salon de la Libre Esthétique, no. 390, Bouée rouge; Paris 1897, Salon des Indépendants, no. 1091, La Bouée rouge, Saint-Tropez

Exhibited in Paris only

"Began a new canvas; reflections in the harbor; a red buoy," Signac noted in a journal entry dated August 22, 1895. The picture's theme was clear from the start, but the artist sketched on the wharves for a long time in search of his subject. Several drawings and watercolors permit us to follow the genesis of this canvas, which is considered one of his finest seascapes. The background shows the facades on the quai Jean-Jaurès in the late-afternoon sun. Signac, who knew this motif by heart, noted the changing effects of the light on the ocher and rose facades in a prelithographic sketch. He had already devoted several canvases to this characteristic view of the port of Saint-Tropez, and more would follow. Among them are *Houses in the Port, Saint-Tropez* (cat. no. 62), *Tartans with Flags* (cat. no. 66), and *The Storm, Saint-Tropez* (cat. no. 91).

The idea for *The Red Buoy* took shape in a watercolor heightened with ink (cat. no. 90): the foreground is empty, nearly half of the pictorial surface is taken up by water, and the brig on the left (truncated in the definitive version) displays its elegant rigging. The red accent, a significant feature of the final composition, appears in an unpublished drawing in a private collection. A vermilion sail energizes the blue and orange color scheme; the artist was interested in the reflections on the water's surface. Signac observed the effect produced by a buoy in the harbor and integrated it into the composition. The evolution of this motif may be traced in three drawings now in the Musée du Louvre, Paris. In this series the artist made a quick study of the buoy in a horizontal format and then again took up the vertical format centered on the quai Jean-Jaurès, precisely depicting the play of reflections created by the buoy which gave the painting its title. The sail, now orange, harmonizes with the houses. The red accent, moved to the foreground and attached to the buoy and its reflections, becomes the main subject of the painting. The overall composition was rapidly set down in an oil study (FC 285) and found its final form in a sketch that illustrated a letter sent to Cross in late August, in which Signac wrote: "Began some reflections."[1]

One month earlier, on July 5, 1895, the artist was "in search of a freer technique while retaining the advantages of divisionism and contrast," and already had this picture in mind when he mentioned the difficulty of harmonizing two very different colors, like blue and orange.[2] The problem has been completely solved here. The artist respected the rules of the color wheel and added yellow, red, and some dabs of green. The white of the brig lightens up the color scheme. The effect is that of a late summer afternoon: the sky has turned pale; the light modulates the warm colors and orange of the houses on the quay; the fishing boats have returned to port, where the brig casts a blue shadow; the sun scatters yellow flashes on the water's surface; and the reflections bring rhythm to the composition. The Neo-Impressionist technique lent itself perfectly to the study of a visual reality in constant flux, in which shimmering dabs of color unified by the sea created a splendid mosaic.

Exhibited in 1896 at the Salon de la Libre Esthétique in Brussels and at the Salon des Indépendants in the following year, the picture won over the critics, who regarded it as a positive

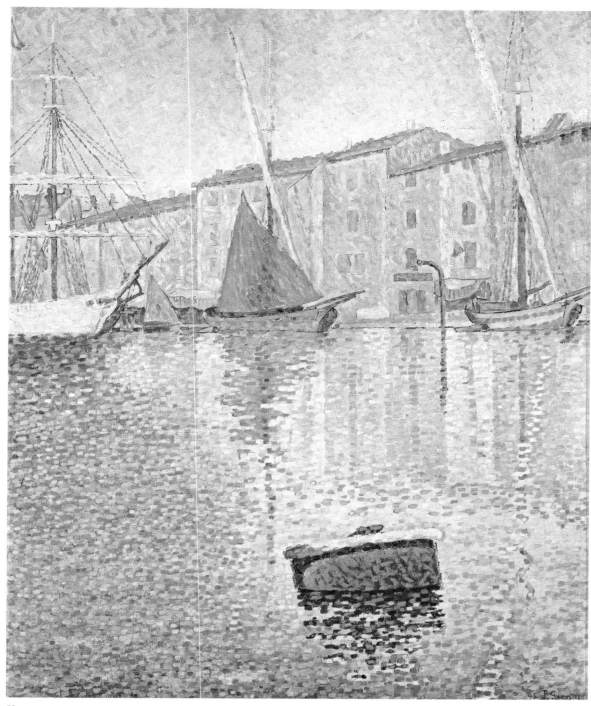

89

development in Signac's painting. The Belgian poet Émile Verhaeren wrote: "It is the freshest and most marvelous seascape at the Salon. The brushwork has broadened, spontaneity has broken the strict formulas; the brilliance, the gaiety, and the near-motion of the colors create the impression of a clear and precise reality, in which the painter has expressed the vibrant song of light and the sweetness of life under the Mediterranean sun."[3] Thadée Natanson, who praised *The Red Buoy* for its "admirable handling of paint," was sensitive to a masterly work that "breathes serenity."[4] MFB

NOTES
1 Letter from Signac to Henri Edmond Cross, undated [late August 1895], Signac Archives.
2 Signac journal entry, July 5, 1895, in Rewald 1949, p. 172.
3 Verhaeren 1896, p. 2.
4 Natanson 1897, p. 558.

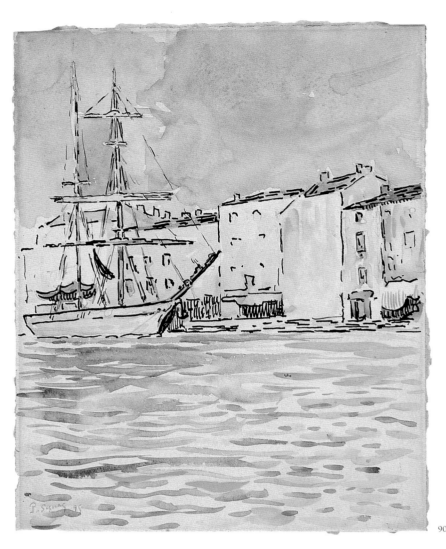

90. THE BRIG, 1895
Watercolor, black ink, and graphite, 10¾ x 8⅜ in. (27.3 x 21.2 cm)
Signed and dated, lower left: P. Signac 95
Musée de la Marine, Paris, Gift of Ginette Signac, August 1974 (90A/145)

Exhibited in Paris only

91. THE STORM, SAINT-TROPEZ, 1895
Oil on canvas, 18¼ x 21⅝ in. (46.5 x 55 cm)
Signed and dated, lower left: P. Signac 95
L'Annonciade, Musée de Saint-Tropez (1993.2.1)
FC 286 (Saint-Tropez. L'Orage)

Exhibitions: Paris 1895–96, L'Art Nouveau, no. 180, L'Orage. Saint-Tropez; Vienna 1900, The Vienna Secession, no. 217, Das Gewitter; Dresden 1904, Arnold gallery, no. 31, Gewitter

Exhibited in Paris and New York

On June 10, 1895, Signac wrote in his journal that he was beginning work on a painting: "The houses of the harbor standing out in full white light against the dark violet of a stormy sky. . . . A small white sail also catches the light and gives a feeling of terror."[1] To complete the series of views of the port of Saint-Tropez that he had undertaken on his arrival in May, Signac depicted his favorite subject twice under stormy skies. The first was *After the Storm, Saint-Tropez* (FC 275), and the second was the present picture. The slate blue sky has violet accents, and the indigo sea greenish reflections. In the midst of these dark surroundings, a cold light pales the sail of a fishing boat returning to port and the facades on the quay. In the sky the clouds form arabesques with tentacular undulations enhancing the sense of menace. Two watercolors (cat. nos. 92, 93) demonstrate the artist's interest in this effect. Even more abstract than the canvas because of the absence of the boat and the blank facades of the houses, they focus on the threatening movement of the sky and can be considered studies of color effects. One (cat. no. 92) presents the same violet-blue dominance and greenish reflections as the present picture. The other (cat. no. 93), with its gray sky, produces a very different color sensation.

The handling of this work is characteristic of the artist's technique in 1895. After *In the Time of Harmony* Signac introduced a stricter simplification into his pictures. The small dot à la Seurat disappeared in favor of bold, square brushstrokes that created a mosaic-like effect. The color, applied

in broad zones with nuanced modulations of the same hue, has gained in power. Here the sea and sky are intensely blue, the surface of the water being heightened only by some touches of yellow. The blue-yellow contrast thus achieves a peak of intensity. Its geometric simplicity gives this composition an impact and a modernity that are far removed from the tonal subtleties and turn-of-the-century arabesques that had characterized the works of the previous years.

This picture was shown in 1895 at Siegfried Bing's gallery, in 1900 at the Vienna Secession, and in 1904 at the Arnold gallery in Dresden. Its history is closely linked with the artistic avant-garde of the turn of the twentieth century and illustrates the spread of interest in Neo-Impressionism to the Germanic world. The work was purchased at the beginning of the twentieth century by the German painter Ivo Hauptmann. He was the son of the writer Gerhart Hauptmann and a friend of Count Harry Kessler's and of Henry van de Velde's, both of whom contributed greatly to the dissemination of French art in Germany. In 1910 Hauptmann finally met Signac after having admired his work and having practiced Divisionism for several years. The two men got along well. Ivo Hauptmann sojourned in Saint-Tropez in 1911 and exhibited at the Salon des Indépendants. MFB

NOTE
1 Signac journal entry, June 10, 1895, Signac Archives.

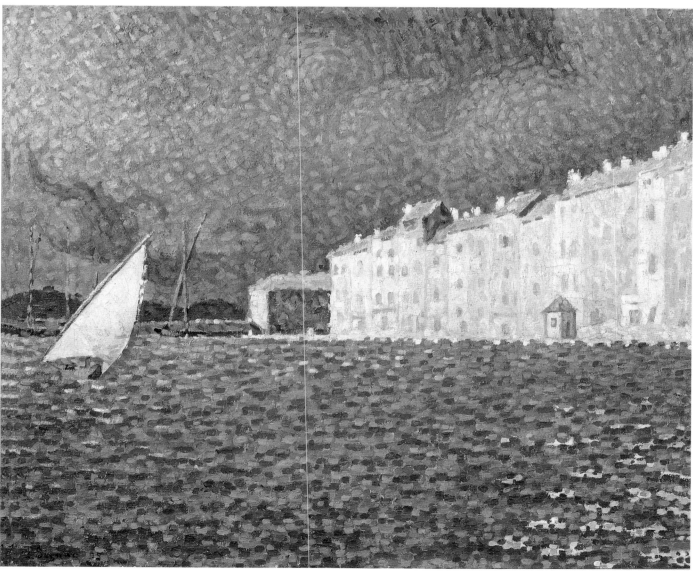

91

92. THE STORM, 1895
Watercolor and ink, 6¼ x 8½ in. (16 x 21.6 cm)
Musée du Louvre, Département des Arts
Graphiques, Fonds du Musée d'Orsay, Paris,
Gift of Ginette Signac, 1979 (RF 37 067)

Exhibited in Paris only

93. THE PORT OF SAINT-TROPEZ,
1895
Watercolor heightened with ink, 8¼ x 10⅝ in.
(21 x 27 cm)
Signed and dated, lower left: Paul Signac 1895
Private collection

This dated and highly finished watercolor serves
as a reference point in the long series of views of
the port and has stylistic affinities with *The Storm*
(cat. no. 92). AD

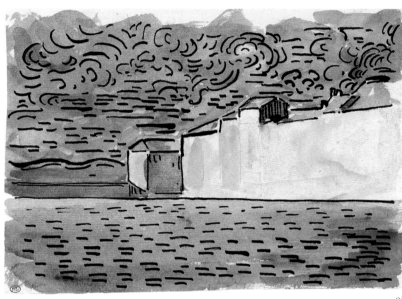

92

93

94. THE LIGHTHOUSE, SAINT-TROPEZ, 1895

Oil on canvas, 18⅛ x 21⅝ in. (46 x 55 cm)
Inscribed on back: *L'entrée du port*
P. Signac
Private collection
FC 287 *(Saint-Tropez. Le Phare)*

Exhibition: Hamburg 1903, Cassirer gallery, no. 74, *St Tropez*

Related to *The Storm, Saint-Tropez* (cat. no. 91), this small canvas was likewise begun on June 10. It has the same format and completes the view of the harbor by extending the jetty to the lighthouse. The brushwork is also broad and square, quite unlike the dots from the heyday of Divisionism. The composition has again been reduced to the bare essentials: the frontality of the jetty, the verticality of the lighthouse, the horizontality of the Maures hills. A fishing boat is shown returning slowly to port at day's end in calm weather and different light. It is sundown and there is only a light breeze: the boat is under full sail and its reflection in the water is scarcely disturbed. The more varied and diffuse coloring creates the impression of hot and calm weather, unlike that of *The Storm, Saint-Tropez*. Signac evidently enjoyed the expressive potential of his synthesized seascapes.

As with *The Storm, Saint-Tropez*, the modernity of this work caught the attention of a German artist who practiced divisionist technique. When it was exhibited in Hamburg in 1903, it belonged to the painter and collector Curt Herrmann, a friend of Henry van de Velde's. Hermann adopted Neo-Impressionism at the turn of the twentieth century and contributed to its dissemination in Germany. He met Signac in Paris in 1902. His wife, Sophie Herrmann, translated Signac's treatise *D'Eugène Delacroix au néo-impressionnisme*, which was published in German in 1903 in Krefeld. Curt Herrmann participated in the Salon des Indépendants from 1905 to 1907. MFB

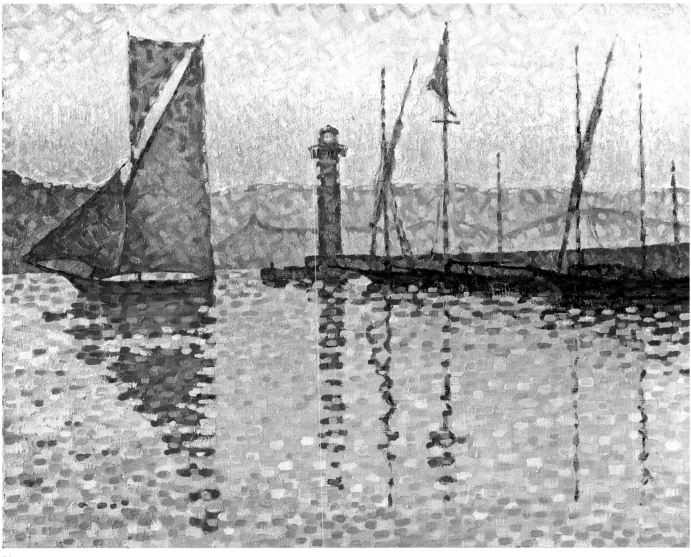

94

95. SAILS AND PINES, 1896
Oil on canvas, 31⅞ x 20½ in. (81 x 52 cm)
Private collection
FC 303 *(Voiles et Pins)*

Exhibition: Paris 1934, Petit-Palais, no. 15, *Saint-Tropez. Le bois de pins* (à M. Paul Signac)

"I am beginning a new canvas: a silhouette of pines where the trunks span the entire picture and the greenery spreads from the top through the pines in shadow. A sunny background reflecting sunset colors and a golden hillside in front of which pass small fishing boats with orange sails. I composed the entire picture, taking a tree trunk here, a pine branch there; . . . pointe Saint-Pierre . . . is topped by the nice tower that I sketched at Port Man. And I want to be just as free in composing my colors, which I would like to obtain by making all the necessary sacrifices, a maximum of coloring and light, in order to oppose this gay meridional, almost Oriental picture with the sad gray northern skies of Holland."[1] Indeed, this is one of the artist's most vivid compositions. The handling of color is extremely free, and the sky, with its pink, yellow, and green tints, announces the bold colors of Fauvism. The composition is dominated by a play of contrasts—red and green, blue and yellow—and heightened by pink and purple accents. Signac displays an increasing freedom in representing his natural environment: the ground is red, the tree trunks blue and red.

In using the word "Oriental," the artist was probably alluding to such meridional splendors as those of Byzantium, whose radiance is captured in this painting. But he probably also had in mind Japanese art, which he admired because of its fresh colors and compositional inventiveness. Here the pines create a formal device dear to the masters of the Japanese print: a curtain of trees that brings out the light of the landscape by an effect of contrast. This same compositional device was used by Henri Edmond Cross in *Seascape with Cypresses* (C 56), where the sea is also shown through a screen of trees but under nocturnal light.

Sails and Pines has been exhibited and reproduced often since the artist's death, but strangely enough Signac exhibited it only once, and at a late date: the 1934 retrospective at the Petit-Palais. He kept it in his studio, unsigned, and did not try to sell or exhibit it. In fact, this work marked the culmination of his efforts of the previous years more than it heralded his later development. About 1897 Signac definitively abandoned *japonisme* and plantlike arabesques, which had become clichés of modernism. Instead he went against the current and developed his chromatic scales in a more composed and classical framework, seeking his inspiration in Poussin, Claude, and above all Turner. MFB

NOTE
1 Signac journal entry, October 16, 1896, Signac Archives.

96. THE TERRACE, SAINT-TROPEZ, 1898
Oil on canvas, 28½ x 36 in. (72.5 x 91.5 cm)
Signed and dated, lower right: P. Signac 98
The National Gallery of Ireland, Dublin, acquired thanks to the Shaw Fund (4361)
FC 320 *(Saint-Tropez. La Terrasse)*

Exhibitions: Paris 1899, Galerie Durand-Ruel, no. 124, *La Terrasse, Provence*; Mâcon 1903, no. 356, *St Tropez. La Terrasse*; Karlsruhe 1906, no. 3; Munich, Frankfurt, Dresden, etc., 1906–7, no. 113, *Die Terrasse*

Exhibited in Paris only

On August 16, 1898, Signac noted in his journal, "began the Terrace." In the weeks that followed

he wrote to Cross describing the picture: "'The Terrace.' A calm and even a bit sickly green-yellow-lilac harmony. A lone figure, a somewhat too young tuberculosis victim, but she disappears into the landscape, she should have less importance than the cloud. I grayed her with a dress with small pink and green dots. I will come to see you when the canvas is completely covered—in about ten days."[1] The person who posed for the "somewhat too young tuberculosis victim" on the terrace of La Hune was the robust Berthe Signac.

In order to improve his view of Saint-Tropez and its bay, Signac had recently built an Italianate terrace. The landscape here has something of Tuscany about it, and the artist evidently chose to represent the end of the day in order to experiment

95

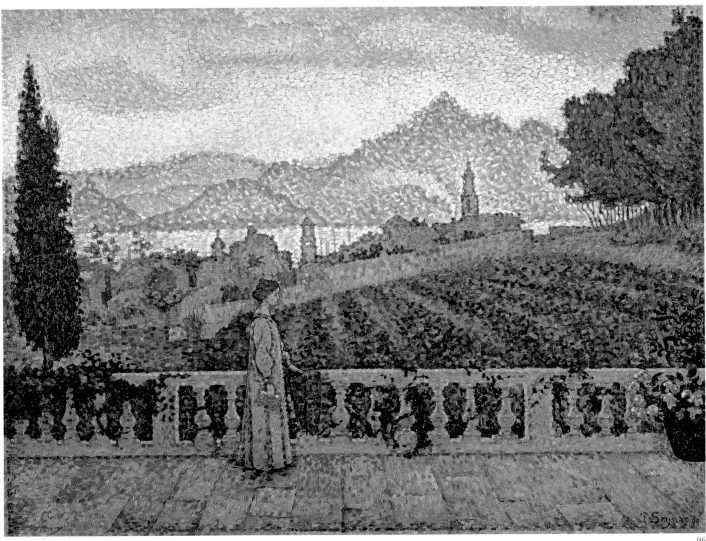

96

with a more matte color scheme that recalled fresco painting. The startling background colors, the agate of the sea and the mauve, orange, and green of the sky, show that color remained at the heart of his artistic preoccupations. To reinforce balance and harmony, Signac altered the scene to emphasize the composition's symmetry. The cypress on the left counterbalances the pine grove; the vineyards adopt a more classical perspective; the Maures hills stand out in relief; and the Saint-Tropez bell tower echoes the silhouette of the female figure.

If this canvas painted in the summer of 1898 contains Tuscan accents, there is a good reason for it: after having finished writing *D'Eugène Delacroix au néo-impressionnisme*, Signac went to London to admire the Turners, as well as the "frescoes of Ghirlandaio, Perugino, Pinturicchio, Signorelli and the pure and fresh colors of the cartoons of Mantegna and Raphael."[2] Shortly thereafter he

visited Denys Cochin's residence to see Maurice Denis's painted decoration, which was full of references to the art of the quattrocento. MFB

NOTES
1 Letter from Signac to Henri Edmond Cross, un-dated [August–September 1898], Signac Archives.
2 Letter from Signac to Charles Angrand [April 1898], Signac Archives; see also Signac journal entry, April 1898, in Rewald 1952, p. 302.

97. SAINT-TROPEZ, 1901–2

Oil on canvas, 51⅝ x 63⅝ in. (131 x 161.5 cm)
Signed, lower right: P. Signac
The National Museum of Western Art, Tokyo
(p187-3)
FC 359 *(Saint-Tropez)*

Exhibitions: Paris 1902, Salon des Indépendants,
no. 1633, *Saint Tropez*; Brussels 1904, Salon de la
Libre Esthétique, no. 153, *Le Port de Saint-Tropez*;
Paris 1907, Galerie Bernheim-Jeune, no. 17,
Saint-Tropez. Le port

Exhibited in Paris and Amsterdam

This painting, recorded in Signac's notebooks under
1901, was in fact finished in January, February,
and March of the following year. In a letter to
Félix Fénéon dated February 13, 1902, he wrote
that the picture was almost completed, the overall
composition well established, and most of the
secondary elements integrated: "Began a rather
large canvas, Port of Saint-Tropez. Blue arabesques
(wharf, barrels, fishermen, nets, fishing boats)
against an orange-colored background (house,
bell tower, tartans, cargo boat, torpedo boat,
brig, sloops)."[1] What he did not mention, how-
ever, was that he was working simultaneously on
three pictures of Saint-Tropez, a veritable trip-
tych painted in honor of his home port. The
present painting was the largest of the three and
was flanked by two smaller canvases: *Entrance to the
Port of Saint-Tropez* (fig. 103) and *Leaving the Port of
Saint-Tropez* (fig. 104).

In the center is the bell tower with its green-
ceramic facing. At the upper right are the citadel
and, directly beneath it, the monument to the
Bailli de Suffren. Sleek tartans on the wharves
await their shipments of barrels. That Signac

invested this work with exceptional importance
is clear from its decorative richness and its scale;
indeed this is the first time that he chose to paint
a seascape on a canvas of this size. The work,
moreover, aptly documents Signac's approach at
the turn of the twentieth century. Long before
the tendency toward classicism became widely
evident, he sought to combine Neo-Impressionist
color principles and an extremely balanced and
well-thought-out composition in the purest
French painting tradition. In the letter to Fénéon
cited above, he also wrote about his thoughts
concerning Poussin's drawings and ideally con-
structed landscapes.

This large-scale seascape clearly points to
Claude Lorrain in the delicate lyricism of its
golden light and balanced composition which is
subtly animated by tiny figures of fishermen, who
replace the mythological and biblical figures in
Claudian landscapes. But this view is not an imag-
inary or visionary construction, and the topo-
graphical accuracy of the site, together with the
contemporary figures, recalls the works of
Joseph Vernet, especially his series of French
ports. Hence by the turn of the century Signac
had already intended to follow the tradition of
great seascape painters of the past, including
Turner, by undertaking a series of harbor views
on a more ambitious scale than usual. In a similar
large format he was to paint Venice (cat. no. 113),
Marseilles (FC 543), and La Rochelle (FC 549).
Ultimately, however, it was as a watercolorist that
he would memorialize the ports of France.

When the present work was shown at the 1902
Salon des Indépendants, the subtlety and mas-
tery of its composition caught the attention of
Henri Bidou, who wrote a perceptive analysis of

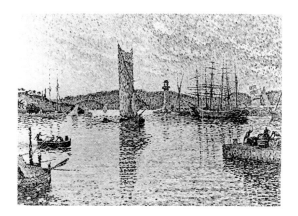

Fig. 103. Paul Signac, *Entrance to the Port of Saint-Tropez*, 1901–2,
oil on canvas, 35 x 45⅝ in. (89 x 116 cm). Location
unknown, FC 361

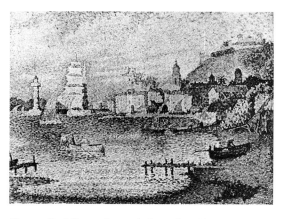

Fig. 104. Paul Signac, *Leaving the Port of Saint-Tropez*, 1901–2,
oil on canvas, 35 x 45⅝ in. (89 x 116 cm). Private collection,
FC 363

97

it.[2] As in *The Terrace, Saint-Tropez* (cat. no. 96), the colors here have achieved a nearly Fauve intensity as well as a surprising unreality. The dominant harmony of orange and violet sets off the paler colors of the pink, green, and yellow sky whose reflections create a broad luminous halo. The curve that begins in the foreground inscribes the composition in a large oval, to which each element—boat, buildings, fishermen—is subordinated. This ellipse, which is closed by the blue line of the Maures hills, encompasses the water and its reflections in the center. The bold color scheme is tempered by deliberate placement and regularized brushwork.

After debuting at the 1902 Salon des Indépendants, this painting was shown at the Salon de la Libre Esthétique in 1904 and at the one-man show held at the Galerie Bernheim-Jeune in 1907, where

it was probably purchased by the German collector Karl Ernst Osthaus, a friend and client of Van de Velde's. Osthaus founded the Museum Folkwang in Hagen, which housed his collection of Impressionists, Neo-Impressionists, and early German Expressionists, assembled between 1905 and 1908. Thanks to his initiative, Hagen became for some years a center for the intellectual and artistic avant-garde. An old photograph shows the present picture hanging next to *Lise*, an important painting by Renoir. In 1920 the collections of the Folkwang Museum were transferred to the museum in Essen, which sold this painting in the 1980s. MFB

NOTES
1 Letter from Signac to Félix Fénéon, February 13, 1902, Signac Archives.
2 Bidou 1902, pp. 253–54.

98. THE PORT OF SAINT-TROPEZ, 1901

Watercolor and graphite, heightened with ink, 9¼ x 11¾ in. (23.4 x 30 cm)
Signed, inscribed, and dated, lower right:
P. Signac St Tropez 01
Musée des Beaux-Arts, Lyons, acquired in 1922 (B I 270a)

Exhibited in Paris only

This view of the port of Saint-Tropez featuring the bell tower gives an impression of the activity on the wharves while it documents the development of Signac's drawing style at the turn of the twentieth century. AD

99. ENTRANCE TO THE PORT OF SAINT-TROPEZ, ca. 1905

Watercolor and graphite, 9⅞ x 16 in. (25 x 40.6 cm)
Inscribed, lower right: *St Tropez;* numerous color notations
Private collection

Exhibited in Paris only

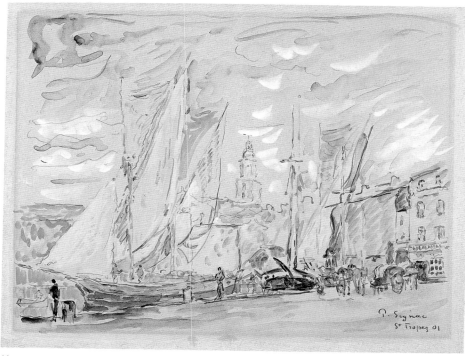

98

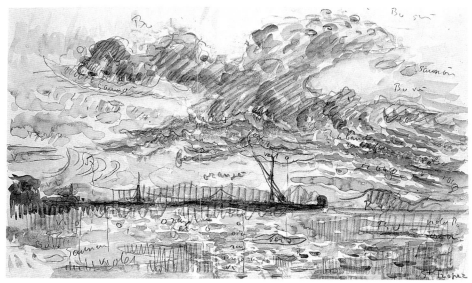

99

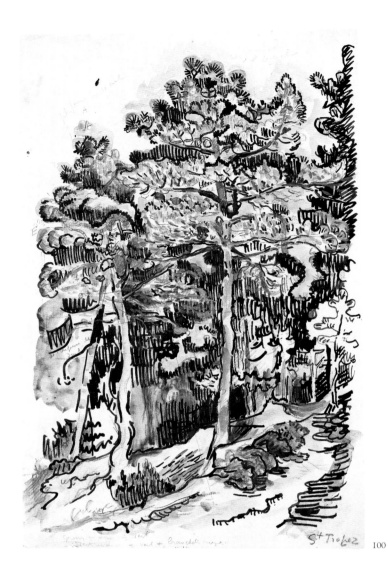

100. THE PINES, SAINT-TROPEZ,
also called **THE CUSTOMS PATH,**
ca. 1905
Watercolor and ink, 17⅛ x 11 in. (43.5 x 28 cm)
Inscribed, lower right: St Tropez
Private collection

101. THE ROCKY INLET,
SAINT-TROPEZ (unfinished), ca. 1906
Watercolor and graphite, heightened with ink,
11 x 17¼ in. (27.8 x 43.8 cm)
Signac atelier stamp, lower left
Private collection

Exhibited in Paris only

This study is one of the last watercolors done in this particular technique, first used in the early 1890s at Saint-Tropez (see cat. nos. 70–74), and is the basis for a painting of the same title (FC 443; Musées Royaux des Beaux-Arts, Brussels). Its unfinished state allows us to see Signac's working methods. AD

100

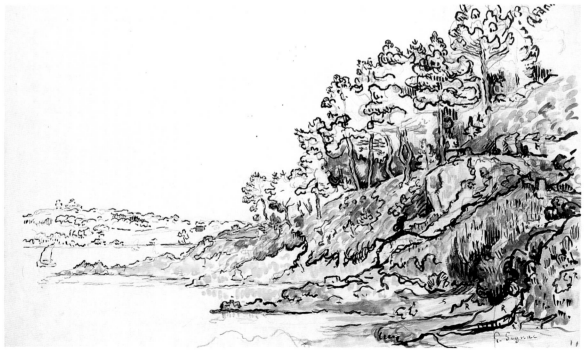

101

102. THE GARDEN OF THE ARTIST'S HOUSE, SAINT-TROPEZ, ca. 1900

Watercolor and india ink, 12 x 15¾ in. (30.6 x 40 cm)

Signed and inscribed, lower right: P. Signac St. Tropez

Arkansas Arts Center Foundation Collection, Little Rock, Promised gift of James T. Dyke, 1999 (EL 99.001.002)

Exhibited in Amsterdam and New York

One of many depictions of the artist's garden in Saint-Tropez, its path lined with eucalyptus trees and bathed in sunlight, this watercolor captures the luminous atmosphere of the Midi. It also demonstrates Signac's use of the paper's white ground to intensify each color and to harmonize adjacent colors. As Signac later described this technique, the surface of the paper consists of a "scatter of juxtaposed strokes, not superimposed ones. Like strewn flowers."[1] KCG

NOTE

1 Signac 1927, p. 110; cited by Ferretti-Bocquillon in Little Rock 2000, p. 26.

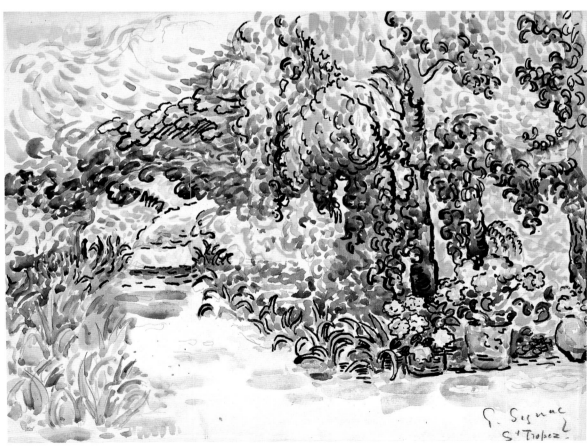

102

103. HAMMOCK IN THE GARDEN OF THE ARTIST'S HOUSE, SAINT-TROPEZ, ca. 1900
India ink, 12⅝ x 17⅞ in. (32 x 45.5 cm)
Private collection

Exhibited in Paris only

104. THE GARDEN OF THE ARTIST'S HOUSE, SAINT-TROPEZ, ca. 1900
Watercolor and india ink, 12¾ x 16⅞ in. (32.4 x 43 cm)
Private collection

Exhibited in Paris only

The painter purchased the villa La Hune (Crow's Nest) in 1897. The garden surrounding his studio and house inspired many works. Here he evokes the delights of cool shade with strong pen strokes and commalike accents. AD

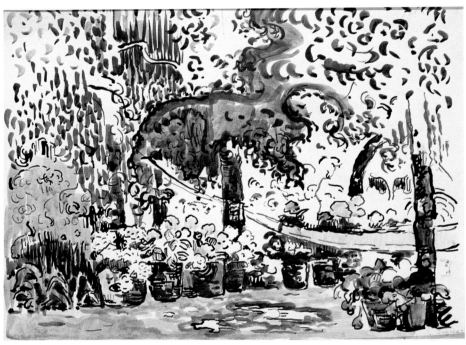

103

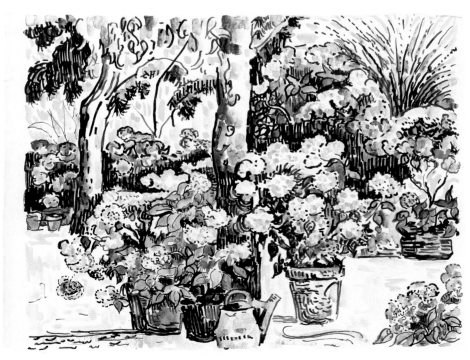

104

PORTS AND TRAVELS: PAUL SIGNAC IN THE TWENTIETH CENTURY

PORTS AND TRAVELS: PAUL SIGNAC IN THE TWENTIETH CENTURY

B Y THE TURN OF THE TWENTIETH century Signac had become a leading figure in the French and European art worlds. He achieved international fame on a scale worthy of note even today. The exhibition held at Galerie Durand-Ruel in 1899 marked the beginning of success for most of the Neo-Impressionists. Signac soon had his first one-man shows: at the Bing gallery in 1902, at Druet in 1904, and at Bernheim-Jeune in 1907. From then on he had a contract with and regularly exhibited at Bernheim-Jeune, which had recently hired Félix Fénéon to run its contemporary art section.

Signac was represented at most avant-garde shows outside France and had long since gained recognition in Belgium. Starting in 1887, the Neo-Impressionists participated in exhibitions of Les XX in Brussels, where they made many converts. They appeared regularly at the exhibitions of the Libre Esthétique, as well as those of the Association pour l'Art in Antwerp. Signac was represented at the Vienna Secession in 1900, and his works and those of the Neo-Impressionists as a whole generated great interest in Germany. They debuted in Berlin in 1898 at the Keller and Reiner gallery; to coincide with the exhibition, the art magazine *Pan* printed an abridged translation

of *D'Eugène Delacroix au néo-impressionnisme* that was distributed free.[1] In 1900 Henry van de Velde's establishment in Berlin helped popularize his Neo-Impressionist friends in Germany. In 1902 and 1903 there were shows at the Arnold gallery in Dresden, at the Paul Cassirer galleries in Berlin and Hamburg, and at the former Grossherzogliches Museum, Weimar, where the Neo-Impressionists enjoyed the support of the patron Count Harry Kessler. Signac's *D'Eugène Delacroix au néo-impressionnisme*, translated into German by Sophie Herrmann, was published in its entirety in 1903 by Baron von Bodenhausen. The treatise was reprinted in Germany in 1910. On the occasion of a French reprint the following year Guillaume Apollinaire remarked: "M. Signac's little book marks an important date in the history of contemporary art."[2] Signac continued to exhibit regularly in Germany until the outbreak of World War I, and he participated in most of the major international shows, such as the Sonderbund in Cologne in 1912 and the New York Armory show in 1913.

Signac was also active in the organization of exhibitions, especially those of the Société des Artistes Indépendants, of which he was named president in 1908. Although an anarchist, Signac was made a chevalier of the Legion of Honor

in 1911, an award that marked the highest official recognition of his career as painter, theoretician, and organizer of exhibitions. The regular presence of Neo-Impressionist works in the galleries and annual salons caught the attention of young painters, as did Signac's treatise, which had a great influence at that time. Many artists who later went in other directions passed through a brief Neo-Impressionist period. As Françoise Cachin wrote: "Between 1900 and 1914 there were few who, at one time or another did not try their hand at this austere technique. None of them stayed with it, but it often helped in resolving intentions in flux, clarifying certain palettes, and encouraging anti-academic tendencies."[3]

Paradoxically, the strict Neo-Impressionist method was a liberating catalyst for artists as different as Robert Delaunay, Picabia, and Kandinsky—who observed that Neo-Impressionist theory already verges upon abstraction[4]—and for the Fauve and Italian Futurist movements. Matisse, for example, read Signac's treatise in 1898 and spent the summer of 1904 at Saint-Tropez, where he tried Divisionism just before adopting Fauvism. For many reasons, not the least of which were his worship of color and his penchant for rational analysis, Signac heralded the art of the twentieth century.

Signac traveled extensively, visiting the great ports of Europe: Venice in 1904 and 1908, Rotterdam in 1906, and Constantinople in 1907. He returned to London in April 1909 to see the Turners. During these journeys he made an increasing number of watercolors, which he later used to compose paintings in his studio. He also recorded his impressions in his journal, which reveals his particular sensitivity to the beauty of frescoes and mosaics: "I could spend hours in front of these frescoes, in these cloisters, these *cenacoli*—while in the museums, I can't wait to leave after half an hour. . . . The art there is dead; it lives only on the walls for which it was conceived and executed."[5]

At the turn of the twentieth century Signac's paintings tended toward a decorative classicism, manifested by broad, well-considered, and balanced compositions. His project for a series of views of famous ports, inspired by a similar series by Joseph Vernet, was realized in unusually large-scale pictures. In this series Signac pays homage to chosen sites; the first work was devoted to Saint-Tropez (cat. no. 97), followed

by Venice (cat. no. 113), then by Rotterdam, Marseilles, and La Rochelle. Conscious of working within a historic tradition, Signac no longer proclaimed a modernity justified by science but alluded to his predecessors, great marine painters like Turner and Claude Lorrain who celebrated light. He became increasingly independent of his subjects, which prompted Maurice Denis to write of his "decorative fantasies on Venice" and to note, aptly, that "his inventions rest more and more on compositional ideas."[6] Denis went on to remark in 1907: "M. Signac . . . is in full maturity and each year attempts a recapitulation in a major picture. He does not enlarge a sketch but composes a work of the imagination from his studies, compensating for the strictness of his theories with his rich romanticism."[7]

Signac's sparkling colors were achieved through a consummate mastery. His vast orchestrations of color and line were generated by his quest for an immense decorative scope. The brushwork is free and varied, close to that of Impressionism. Indeed this great admirer of Delacroix and Turner occasionally achieved an unusual lyricism in the rendering of light and sky with bold color schemes and an inspired line.

During the same period Signac began using large-scale wash drawings, in india ink, to elaborate his compositions. The imposing format of his seascapes drew him to this eminently classical technique, which allowed him to create balanced compositions, in which curves and arabesques led the spectator's eye to scan the entire pictorial surface. The first drawing of this kind (fig. 105) was for the 1905 *Basin of San Marco, Venice* (cat. no. 113). These large drawings in black or brown ink became a usual part of his preparation. He began exhibiting them in 1911, to the delight of Apollinaire, who praised them as "very beautiful drawings, broadly executed and well composed."[8]

Drawing and watercolor were gaining the upper hand in Signac's work. A decisive shift came in 1910. Signac, nearing fifty, painted only two pictures in 1910–11 but devoted his first large watercolor series to the bridges of Paris. At the same time he also stopped listing his works in his cahier d'opus. Henri Edmond Cross's illness and death surely played a part in this drastic decrease in his production of oil paintings. When he was in the south of France, Signac would spend two days a week at Saint-Clair, sitting at Cross's bedside. To Signac's infinite grief, Cross died on

May 16, 1910. Signac was left as the last Neo-Impressionist painter of his generation. Seurat had died in 1891. Van de Velde and Finch abandoned painting for the decorative arts. Angrand devoted himself to drawing, while Luce and Van Rysselberghe no longer practiced Divisionism.

For his part Signac had amply fulfilled the mission that he had undertaken at Seurat's death. He had organized exhibitions for the Neo-Impressionists and the Indépendants, taken care of posthumous shows of his friend's work, formulated the theoretical underpinnings of Divisionism, and wielded his pen or voice when necessary with an inexhaustible combativeness. He also witnessed the birth of Fauvism and was conscious of the part played by his technique in this definitive liberation of color.[9] During the first years of the twentieth century new artistic revolutions came and went, as Cubism gave way to Abstraction. Neo-Impressionism had long ceased to be part of the avant-garde—it had become a precursor, a part of history.

Another immense change in Signac's life, this time of a personal nature, was imminent. Since about 1909 he had had a close relationship with one of his students, Jeanne Selmersheim-Desgrange (1877–1958). In 1913 he gave his beloved villa in Saint-Tropez to Berthe, his wife, and took up lodgings with the then-pregnant Jeanne at Antibes.

During World War I the pacifist and humanitarian Signac witnessed the collapse of everything that he had believed in. Deeply depressed, he painted little and withdrew into a study of Stendhal. He corresponded with painters attached to the camouflage units and refused to open the doors of the Indépendants until the combatants returned. One of the few paintings from this period was *The Pink Cloud, Antibes* (cat. no. 135), which betrays fantastic elements unusual for an artist who prized logic and clarity. In a strangely dense sky, clouds stretch out like a dancer, a Loie

Fuller gracefully slipping away at the top of the composition, while a "black squadron" of torpedo boats dominates the horizon.

After the war Signac assumed the reins of the Indépendants again, in spite of renewed opposition on the part of the younger generation of painters, led by Picabia, who regularly contested the decisions of the exhibitions committee. Each year the faithful Signac painted a small number of divisionist pictures and showed them at the Salon. The critics were predictably appreciative toward a revered elder. Nevertheless, Signac's fine series of studies of Antibes (cat. nos. 136–43) displays a young man's strength and optimism.

Leaving Antibes in 1920, the artist enthusiastically took up his brushes and explorations again. He changed domiciles often. His search for subject matter led him to rediscover the life of a true port at La Rochelle. The next summers were spent successively at Saint-Paul, Lézardrieux, and finally Barfleur, where he bought a house in 1931. But none of these holiday spots was able to hold him. He was a nomad, perpetually displaced, traveling throughout France, contemplating its varied landscapes and recording his impressions in watercolor. Signac became more and more interested in boats and the details of their rigging, especially the *terre-neuvas* (see cat. no. 173), which he painted a number of times. He again turned to subjects like the banks of the Seine at Les Andelys, and several fine oil paintings like *Flood at the Pont Royal, Paris* (cat. no. 158) show that his passion for color had not died. Yet he devoted himself above all to watercolor: it was his greatest joy, and he practiced daily. An impassioned observer, he captured a world in transformation, ultimately executing his series of French ports in watercolor. Having finished this ambitious project, he went on to discover Corsica, a part of the Mediterranean he had not yet seen, and painted his last wonderful watercolors with an astonishing youthful passion. MFB

NOTES

1 This text was printed in summary form in Münster–Grenoble–Weimar 1996–97.
2 Apollinaire 1911c, in Apollinaire 1972, p. 177.
3 Cachin 2000, preface, p. 22.
4 Kandinsky 1954, p. 32.
5 Signac's journal entry of 1908 is cited in Cachin 1994, p. 610.
6 Denis 1905.
7 Denis 1907, p. 197.
8 Apollinaire 1911a; translated in Apollinaire 1972, p. 133.
9 See the exhibition catalogue, Münster–Grenoble–Weimar 1996–97.

105. CAPO DI NOLI, 1898

Oil on canvas, 36 x 28¾ in. (91.5 x 73 cm)
Signed and dated, lower left: P. Signac 98
Fondation Corboud, on permanent loan to the
Wallraf-Richartz-Museum, Cologne (Dep. 682)
FC 319

Exhibitions: Paris 1899, Galerie Durand-Ruel,
no. 123, *Capo di Noli*; Dresden 1901, Arnold gallery

Exhibited in Paris only

Capo di Noli is on the Italian Riviera, near Albenga.
Signac walked there in November 1896 from
Saint-Tropez, via Ventimiglia, Bordighera, San
Remo, and Finale Ligure. The Ligurian coast, a
natural extension of the Côte d'Azur, was not
very far from Saint-Tropez, which was then a
two-day cruise from Genoa. Starting in 1896,
Signac traveled more and more often but with a
predilection for Mediterranean places: Marseilles,
Venice, Constantinople. Here he chose to depict
the Mediterranean as the gateway to the Orient.
Capo di Noli features a surprising balance between

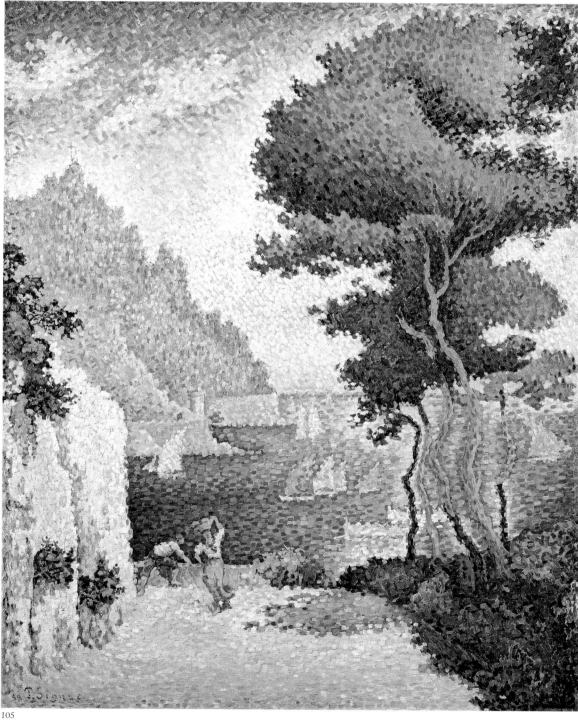

105

the classicism of a composition by Claude Lorrain and the lavish colors of a Byzantine feast. The harmonious composition presents a framework of pines and rocks flanking a seascape enlivened with sailboats, while a timeless offering bearer and fisherman give a sense of scale. But instead of the golden light of Claude, the colors are shimmering and extremely varied, like a Byzantine mosaic or stones from an Ottoman treasury.

When he undertook this picture in the summer of 1898, Signac noted in his journal: "I began the Capo di Noli, in which I would like to achieve an extreme polychromy. To train myself, I am using my samples of dyed silk, which are so intense and brilliant. I will transpose them to my canvas one after the other. I do not want to leave a single centimeter of flat color and [I want] to vary each part of the painting to the extreme. If it is a bit loud, there will always be time to calm it down."[1] The lilac horizon, pink and white rocks, and blue shadows show his desire to heighten color to its maximum intensity. Unlike that of previous works, the highly varied color scheme is no longer dominated by the subtle modulation of two contrasting colors. Here the blue, pink, green, yellow, and violet have been arranged with great freedom and with a staggering mastery. The brushwork is at once impassioned and responsive to natural forms: the motionless mass of the sea is treated in regular tessellated patterns, like the rocks, but the brush follows the dynamic surge of the pine trees and flux of the sky. The result creates a very Oriental, shimmering impression. This work represents a climax in Signac's celebration of color.

This picture was shown at the major exhibition held by the Galerie Durand-Ruel in 1899 to demonstrate the new tendencies in painting. Signac was generously represented and this event ensured recognition of the Neo-Impressionists. Julien Leclercq observed on this occasion: "Paul Signac holds an important place. . . . His painting vibrates warmly, envelops itself, his palette has become richer, his observation better, and nature breathes."[2] Gustave Coquiot wrote in *La Vogue:* "Signac superbly details and balances his forms beneath the halo of the sun. He has a natural sense of grandeur."[3] MFB

NOTES
1 Signac journal entry, June 1891, Signac Archives.
2 Leclercq 1899, p. 94.
3 Coquiot 1899b, pp. 57–58.

106. VIEW OF SEINE, SAMOIS,

1899–1900
Watercolor and graphite, 5 x 9¾ in.
(12.7 x 24.7 cm)
Signed in graphite, lower right: P. Signac
The Metropolitan Museum of Art, New York, Robert Lehman Collection, 1975 (1975.1.707)

Exhibited in Amsterdam and New York

From late 1899 to early 1900 Signac devoted some two hundred watercolors, as well as thirteen oil studies and six paintings, to views of Samois, a small town on the Seine near the forest of Fontainebleau. Many works from this series, including numerous watercolors done *sur le motif,* were included in Signac's first solo exhibition at Bing's gallery L'Art Nouveau in June 1902. In his review

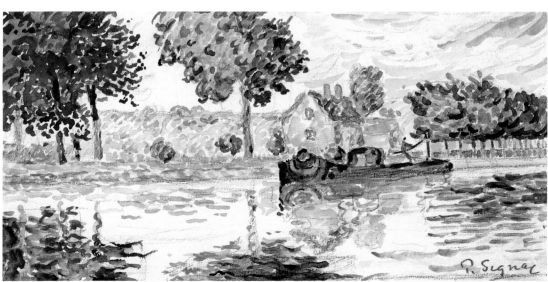

106

of the exhibition Maurice Denis admired Signac's "impulsive" watercolors, which he described as "barely inscribed, and as if created unexpectedly."[1] The present watercolor depicts a barge on the Seine with a man at the tiller—a motif that recurs in his Samois works. Despite the apparent spontaneity of his technique Signac first penciled in the barge, as well as the house on the shore and the large reflections in the water, before applying color. KCG

NOTE

1 Denis 1902, p. 53.

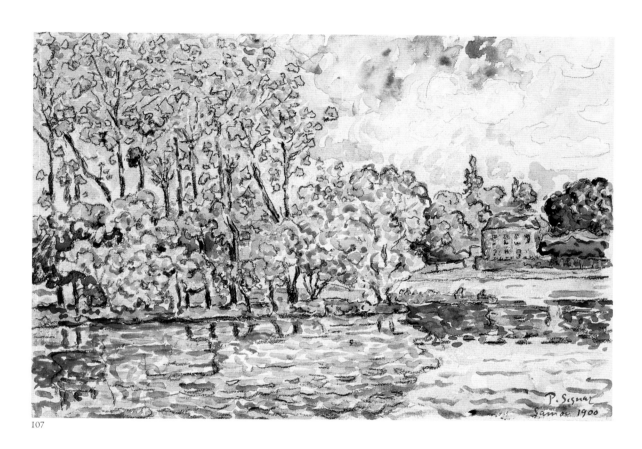

107

107. SAMOIS, 1900

Watercolor and graphite, 6⅞ x 9⅞ in. (17.6 x 25.2 cm)
Signed, inscribed, and dated, lower right: P. Signac Samois 1900
Arkansas Arts Center Foundation Collection, Little Rock, Gift of James T. Dyke, 1999 (99.065.018)

Exhibited in Amsterdam and New York

Samois and its environs offered Signac a wide range of imagery, from views of its wooded riverbanks to the activity of sailors and boats along its quays and canal. In this composition the artist revels in the play of sunlight on the leaves of the trees and on the water's surface. His ability to capture momentary effects was admired by Edmond Cousturier, whose review of Signac's 1902 exhibition singled out those watercolors "where the artist out for a walk, with a gesture following an exclamation, quickly takes out his pocket materials and juggling simultaneously with the paints, the water, and the white of the paper, makes haste before the transience of the sky, before the farewells of the sun setting on the roofs, before the effect created on the water by a gust of wind."[1] KCG

NOTE

1 Cousturier 1902, p. 213.

108. CASTELLANE, 1902–3

Oil on canvas, 35 x 45⅝ in. (89 x 116 cm)
Signed and dated, lower left: P. Signac 1902
Private collection

FC 377

Exhibitions: Paris 1903, Salon des Indépendants, no. 2241, *Castellane*; Weimar 1903, no. 67, *Castellane*; Berlin 1906, no. 4; Munich–Frankfurt–Dresden, etc., 1906–7, no. 114, *Kastellane*; Paris 1923, Galerie Bernheim-Jeune, no. 27, *Castellane. Le roc 1898*; Berlin 1927, Goldschmidt gallery, no. 17, *Castillane* [*sic*]; Paris 1934, Petit-Palais, no. 19, *Castellane 1902*

In November 1902 Signac wrote to Cross to inform him that he had just come back from a bicycle tour in Haute-Provence armed with "some twenty watercolors: that's six a day! I was bushed in the evening. For Castellane the forms will be a rock, a bridge, the Verdon. . . . For Sisteron [cat. no. 109] two rocks, a bridge, the Durance."[1] In addition to the watercolors he mentioned, we also know of an oil study for *Castellane* (FC 378).

Although the color scheme here is calmer than in previous paintings, it is still extremely variegated, and the composition has a solid architectonic base. The rocky mass on the left, a veritable polychrome wall with every color of the rainbow, is counterbalanced by the mountain on the right; the bend in the Verdon River reinforces the breadth and unity of the whole. The laundresses in the foreground give a sense of scale and accentuate the impression of grandeur. The warmth of the colors, the radiance of the autumnal light, and the movement of the sky express a feeling for nature similar to that in the works of Claude Lorrain and Joseph Vernet.

After being shown at the Salon des Indépendants, this painting contributed to establishing Signac's reputation in Germany, where it was widely exhibited between 1903 and 1927. MFB

NOTE
1 Letter from Signac to Henri Edmond Cross, November 8, 1902, Signac Archives.

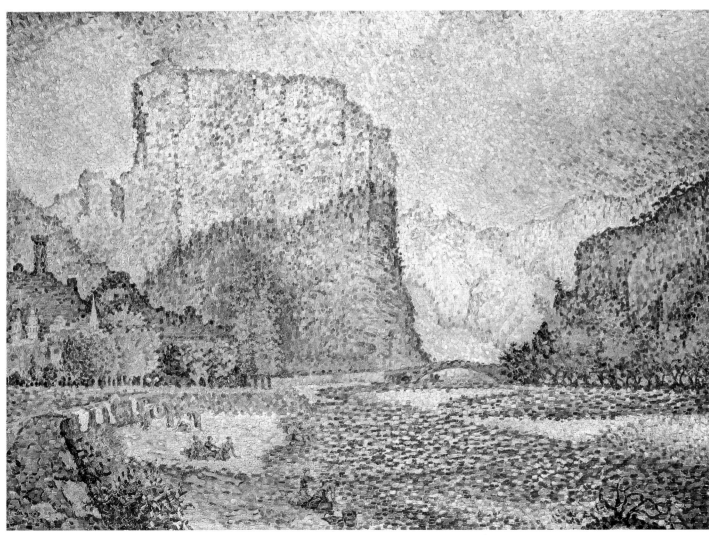

108

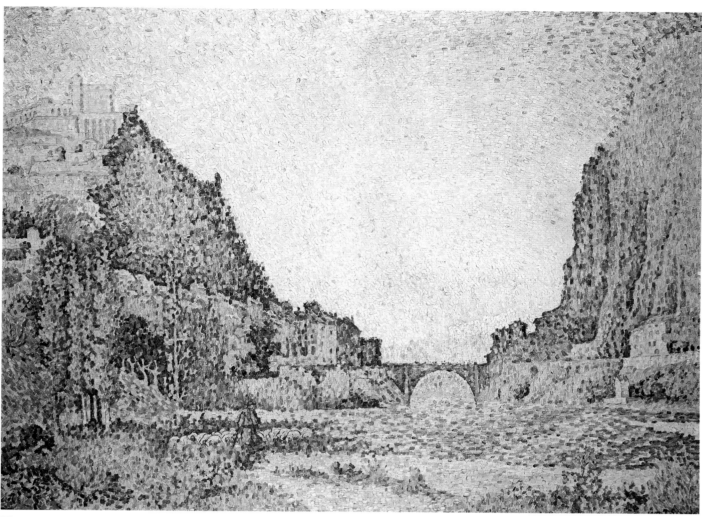

109

109. SISTERON, 1902

Oil on canvas, 35 x 46 in. (89 x 117 cm)
Signed and dated, lower right: P. Signac 1902
The Collection of Simone and Alan Hartman
FC 379

Exhibitions: Paris 1903, Salon des Indépendants,
no. 2240, *Sisteron;* Weimar 1903, Grossherzog-
liches Museum, no. 68, *Ansicht von Sisteron;*
Krefeld 1904, Kaiser-Wilhelm Museum, no. 26,
Ansicht von Sisteron; Paris 1904, Galerie Druet,
no. 20, *Sisteron;* Cologne 1912, Städtische
Ausstellungshalle, no. 195, *Sisteron* (bez. Dr. Alfred
Wolff); Paris 1930, Galerie Bernheim-Jeune,
no. 21, *Sisteron*

Exhibited in Amsterdam and New York

This painting depicting the small town of Sis-
teron, the "Gate to Provence" situated in a narrow
gorge of the Durance River, is the companion
piece to *Castellane* (cat. no. 108). Signac succinctly
summarized the site in a letter as "two rocks, a
bridge, the Durance." Here too the rocky land-
scape is bathed in autumnal light, while in the
foreground a shepherd with his sheep lends the
scene a bucolic character and gives a sense of
scale. In this calculated composition the light tri-
angle of the sky is framed by two rock forma-
tions, which are themselves connected by the arch
of the bridge. The balanced play of light, the har-
monious architecture, and a magnificent natural
spectacle that integrates the barely visible figures
of the shepherd and sheep inevitably recall the
works of Claude Lorrain. But this classicism is
masked by the pure colors and unifying brush-
work. In spite of the subtle gradation of colors,
which Signac took pleasure in modulating, the
divisionist technique creates a strong unity, which
is achieved through the masterly orchestration of
the line and color. The dominant violet tonality

produced by large areas of shadow contrasts with the golden hues of areas illuminated by the late-afternoon sun. In the center the sky fades almost to white, adding light to the composition as a whole.

Shown with its pendant, *Castellane*, in the 1903 Salon des Indépendants, this painting also became known in Germany. It was exhibited in Weimar in 1903 and in Krefeld in the following year, and it was included in the famous exhibition of the Cologne Sonderbund in 1912, which definitively consecrated Signac's reputation as one of the founding fathers of modern twentieth-century painting. By then, it belonged to Alfred Wolff, a German banker, art collector, and friend of Henry van de Velde, who designed Wolff's Berlin apartment in 1903. Wolff was among the leading German collectors of Neo-Impressionist painting, and his daughter, Sophie, a sculptor, made a portrait bust of Signac about 1930. MFB

110

110. LES DIABLERETS, SWITZERLAND, 1903

Watercolor and graphite, 8⅝ x 15⅜ in. (22 x 39 cm)
Signed, inscribed, and dated, lower left:
P. Signac Les Diablerets 03
Private collection

Exhibited in Paris only

During the summer of 1903 Signac stayed at Les Diablerets and painted a series of watercolors that he used for his work that winter. He finished only two oil canvases (FC 396, 397), one of which, *Glacier, Les Diablerets,* would be purchased by his friend Félix Fénéon when it was exhibited at the Salon des Indépendants in 1904. AD

III. THE GREEN SAIL, VENICE, 1904
Oil on canvas, 25⅝ x 31⅞ in. (65 x 81 cm)
Signed and dated, lower left: P. Signac 1904
Musée d'Orsay, Paris, Gift of Ginette Signac,
1979 (RF 1976-77)
FC 414 (*La Voile verte [Venise]*)

Exhibition: Brussels 1908, Salon de la Libre
Esthétique, no. 185, *La Voile verte; Venise*

Exhibited in Paris only

Signac apparently wanted to go to Venice in the
summer of 1903 but gave up the idea because Cross
and his wife were already there, and he wanted to
avoid exhibiting works that were too similar. Upon
his return Cross gently chided him: "I do not think
that in all the years that we exhibited side by side,
you ever had the slightest problem with the fact
that our inspiration came from the same *object.*"[1]
Their mutual fascination with Venice had been
stimulated by John Ruskin's writings. Cross, whose
mother was English, had recently undertaken a

translation of Ruskin's *Elements of Drawing*, which
held great interest for Signac. The author of
The Stones of Venice was very much in vogue at the
turn of the century, and to some extent the two
friends shared his social ideas and moral aesthet-
ics. Signac and Cross, then involved in a debate
with Van Rysselberghe on the soundness of the
Neo-Impressionist method, both subscribed to
Ruskin's opposition to "art of imitation."

Signac finally arrived in Venice on March 27,
1904, and planned to stay a month. He lodged at
the Casa Petrarca, on the Riva degli Schiavoni, and
Cross approved his choice: "You are superbly well
placed to enjoy the endlessly changing skies and
waters which, for the imagination of a colorist like
you, will inspire precious harmonies." Indeed, the
City of the Doges had everything to offer the avid
museum-goer Signac had become in his search for
new subject matter. He visited an impressive num-
ber of churches and museums, always delighted
when he found in the masterpieces of the past

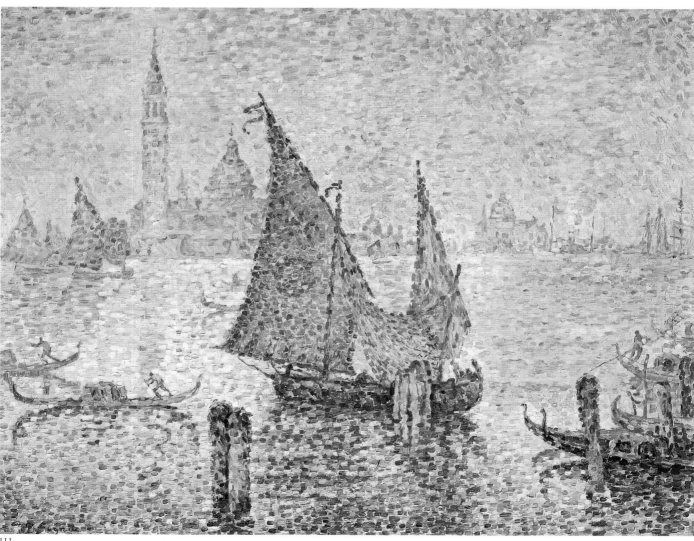

III

traces of an instinctive use of the principles of color division and contrast. Between museum visits he enjoyed the spectacle of the city and executed a large number of watercolors. Upon his return he announced that he had brought back "more than two hundred informal watercolor sketches,"[2] which he then used to paint his first Venetian series. A second series followed his 1908 visit.

Signac was enchanted by the play of light, water, and sky, and the color of the monuments. Clear architectural forms dissolved in the atmosphere in his compositions, which were often centered on boats, gondolas, or *bragozzi* with colorful sails. Here we see the contours of the church of San Giorgio fading into the mist and the green sail that gives the painting its title. In another painting (FC 413; Musée des Beaux-Arts, Besançon), a yellow sail with colorful designs creates a brighter harmony.

The Venice series contributed to the success of the 1904 exhibition at the Galerie Druet and won Signac a new collector. In a letter to Fénéon he wrote: "And now, on the 30th . . . Druet wrote me to say that he had sold the *Green Sail* that you wanted. You will have fewer regrets when you hear that it was acquired by a collector of renown, M. Fayet, who also took the yellow sail and my large Venice from the Indépendants [cat. no. 113]."[3] Gustave Fayet was the future curator of the Musée des Beaux-Arts, Béziers, and a major collector of Neo-Impressionist painting. MFB

NOTES
1 Letter from Henri Edmond Cross to Signac, August 14, 1903, Signac Archives.
2 Letter from Signac to Henri Edmond Cross, [1904], Signac Archives.
3 Letter from Signac to Félix Fénéon, June 5, 1905, Signac Archives.

112

112. SANTA MARIA DELLA SALUTE, VENICE, 1904
Watercolor and graphite, 7⅝ x 12⅛ in. (19.3 x 30.7 cm)
Signed, lower left: P. Signac; inscribed, lower right: 123
Musée du Louvre, Département des Arts Graphiques, Fonds du Musée d'Orsay, Paris, acquired in 1957 (RF 40 191)

Exhibited in Paris only

This lively sketch (which came to the Louvre directly from the artist's studio) records one of the city's most famous monuments and was among the "two hundred informal watercolor sketches" which Signac said he brought back from Venice in 1904. He numbered them and used them for subsequent studio works (see cat. nos. 111, 113, 114). AD

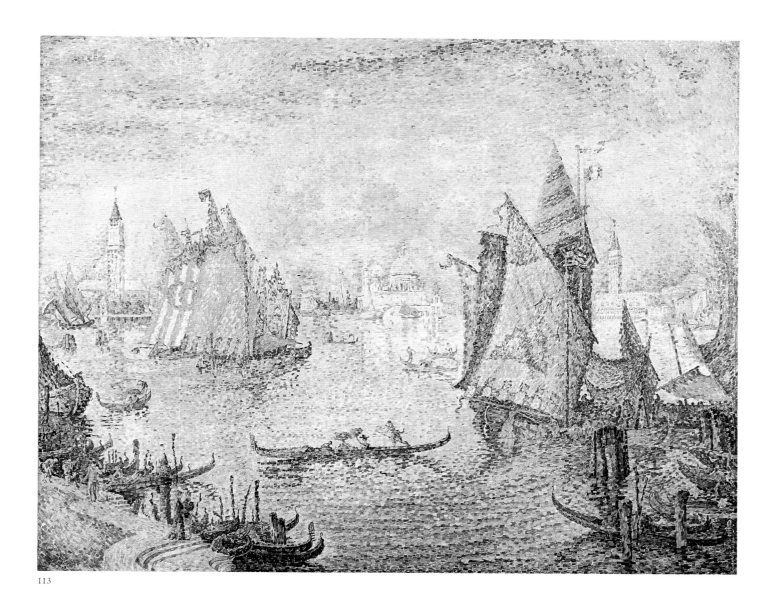

113

113. BASIN OF SAN MARCO, VENICE,
1905
Oil on canvas, 51 x 64 in. (129 x 162.7 cm)
Signed and dated, lower left: P. Signac 1905
Chrysler Museum of Art, Norfolk, Virginia,
Gift of Walter P. Chrysler, Jr. (77.344)
FC 415 (*Venise. Bassin de Saint-Marc*)

Exhibitions: Paris 1905, Salon des Indépendants,
no. 3770, *Venezia*; Paris 1907, Galerie Bernheim-
Jeune, no. 8, *Venise. Le bassin de Saint-Marc*; Paris
1911, Galerie Druet, no. 15, *Bassin de Saint-Marc
(Venise)*; Cologne 1912, Städtische Ausstellungs-
halle, no. 196, *Bassin de Saint-Marc*; Paris 1914,
Salon des Indépendants, no. 6; Paris 1925,
Galerie Druet, no. 151; Paris 1926, Salon des
Indépendants, no. 2369, *Venezia - IND. 1905*
(coll. A. Roudinesco); Paris 1930, Galerie
Bernheim-Jeune, no. 25, *Le Bassin de Saint-Marc.
Venise*; Paris 1933–34, Galerie Beaux-Arts, no. 91,
Venise. Bassin de Saint-Marc (coll. A. Roudinesco);
Paris 1934, Petit-Palais, no. 23, *Le Bassin de Saint-
Marc* (à la M. le Docteur Roudinesco)

Along with *Saint-Tropez* (cat. no. 97), this is one of
Signac's largest port views. In these works, which
were composed in his studio, he showed that he
had not yet given up on the decorative value of
Divisionism. The Neo-Impressionist color
scheme and brushwork have been integrated into
a composition of classical inspiration, in which
Signac quite conspicuously places himself in the
tradition of Claude Lorrain, Turner, and such
great French seascape painters as Joseph Vernet,
Louis Garneray, and Nicolas Ozanne.

In the center of the painting stands Santa
Maria della Salute and the point of the Dogana;
on the right, the Palace of the Doges and the
Campanile; on the left, San Giorgio Maggiore.
To obtain this panoramic view of the most famous
Venetian monuments, Signac positioned himself
on the Riva San Biagio, near the Naval Museum
and the Riva degli Schiavoni, where he lodged.
Most likely he synthesized different vantage

Fig. 105. Paul Signac, *Basin of San Marco, Venice*, preparatory drawing, 1904–5, graphite and brown ink wash, with high-lights in gouache and watercolor, 51 x 62 in. (129.5 x 157.5 cm). The Chrysler Museum of Art, Norfolk

points on the quay into a unique composite view. In the foreground a flotilla of *bragozzi* deploys its colorfully patterned sails, whose robust forms oppose the elongated arabesques of the gondolas. The scene is enlivened by tiny gondoliers, a strolling couple, and two fashionably dressed women about to embark. The light brings the forms together in a broad ellipse underscored by the movement of the clouds and the waves.

Nothing has been left to chance in this formal and chromatic orchestration. This is clear from the squared preliminary drawing (fig. 105), formerly owned by Henry van de Velde, which is the same scale as the canvas. As usual Signac organized the composition with a series of clear axes, angles, and curves. By means of three curves still visible in the drawing, he isolated the three monuments in the manner of an apsidal decoration. In addition to the precise and marked geometry of the major axes, the drawing is exceptional because of its use of color. Contrary to his habit at the turn of the century of preparing his canvases

with cartoons drawn in India ink or sepia, Signac mixed white, blue, yellow, and green tints on ocher paper. The resulting effect is not as austere as that of his usual cartoons. The artist chose to create a festive atmosphere, a carnival of forms and colors dissolving in light. Unique in Signac's graphic production, the color scheme for the painting seems to have been planned exactly, as we can see by the many numbers inscribed on the drawing. The artist often completed his water-colors with color indications abbreviated as let-ters; here, numbers on the drawing correspond to the shades of color in the final work.

At the 1905 Salon des Indépendants, André Fontainas mentioned the "prestigious Signacs evoking a dazzling Venice."[1] Louis Vauxcelles, who continued to prefer the artist's watercolors to his Neo-Impressionist paintings, nevertheless admitted that "nothing is more vibrant, more atmospheric, than the shimmering Venice of M. Signac."[2] The artist evidently seems to have been satisfied with this painting, for it was fea-tured at all his major exhibitions. It was exhib-ited at the one-man show held by the Galerie Bernheim-Jeune in 1907, then at the one-man show at the Galerie Druet in 1911, on which occa-sion André Salmon called it a "first-class" pic-ture.[3] Signac also selected the painting for the 1912 Sonderbund in Cologne, a major exhibition devoted to modern art in which he and Cross participated alongside other founders of mod-ernism, such as Cézanne, Van Gogh, Gauguin, Munch, and Picasso. MFB

NOTES
1 Fontainas 1905, p. 117.
2 Vauxcelles 1905, p. 1.
3 Salmon 1911, p. 4.

114. GRAND CANAL, VENICE, 1905

Oil on canvas, 28⅞ x 36¼ in. (73.5 x 92.1 cm)
Signed and dated, lower right: P. Signac 1905
The Toledo Museum of Art, Purchased with
funds from the Libbey Endowment, Gift of
Edward Drummond Libbey (1952.78)
FC 424

Exhibitions: Paris 1907, Galerie Bernheim-Jeune,
no. 12, *Entrée du Grand Canal*; Paris 1930, Galerie
Bernheim-Jeune, no. 27, *Entrée du Grand Canal.
Venise*; Amsterdam 1930, Stedelijk Museum;
Paris 1934, Petit-Palais, no. 21, *Venise: Entrée du
Grand Canal* (à M. X.)

In this painting, which is as direct as the previous
one is elaborate, Signac depicted the well-known
silhouette of Santa Maria della Salute with gon-
dolas moored in the basin of San Marco. It drew
the attention of Louis Vauxcelles at the 1907
Signac exhibition at the Galerie Bernheim-Jeune:

"Other [canvases] have a marked precision, a
coloring of matchless power (for example, no. 12,
the Entrance to the Grand Canal)." This critic,
finally won over by art that he long considered
too theoretical, noted: "Whether Signac paints a
stormy sea with bobbing Dutch vessels or tran-
quil waters reflecting ancient Venetian palaces, it
is always this sparkling miracle, this rushing pal-
pitation. Signac is one of the greatest painters of
water I know. Opal, emerald, amethyst, pink,
creamy or milky white, all of these vivid tones
are at play in his paintings."[1]

During his second stay in Venice in March–
April 1908, Signac took up the same subject in a
watercolor that once belonged to Claude Monet
and is now in the Musée Marmottan, Paris (fig. 55).
During the spring of 1908 Signac probably met
Alfred William Finch, a founding member of
Les XX, who was in Venice that April, as well as
Henry van de Velde, who was traveling through

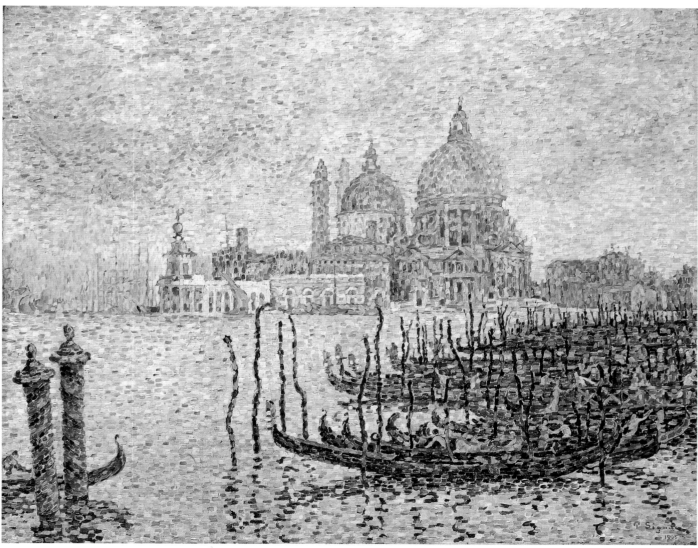

Italy. However, he did not see Monet, who went to Venice for the first time only in October of that year. Mathilde Crémieux's French translation of Ruskin's *Stones of Venice* had revived artists' interest in the water-bound city and Turner's admirers flocked there.

This picture formerly belonged to Christian Cherfils, another great admirer of Turner and collector of Signac's works. He met Signac in December 1904 at the artist's exhibition at the Galerie Druet, where Cherfils acquired two other views of Venice. Cherfils, a major collector like his father, Alphonse (1836–1892), owned some "Turners, Monets and Co.," as Signac proudly

announced to Fénéon.[2] This exceptional man had racehorse stables in Biarritz, wrote poetry, and published *Le Canon de Turner* (1906) and *L'Esthétique positiviste. Exposé d'ensemble d'après les textes* (1909). He converted to Islam at the same time as did his friend the Orientalist painter Étienne Dinet. Cherfils was also an amateur artist. In February 1906 Signac visited him in Biarritz and spent a rainy day in his house drawing several nudes from life (see cat. no. 117). MFB

NOTES
1 Vauxcelles 1907a, p. 2.
2 Letter from Signac to Félix Fénéon, Signac Archives.

115. THE VIADUCT, ASNIÈRES, ca. 1905
Watercolor and graphite, 6¼ x 8½ in.
(16 x 21.5 cm)
Inscribed in graphite, lower right: Asnières
Musée du Louvre, Département des Arts
Graphiques, Fonds du Musée d'Orsay, Paris,
acquired in 1957 (RF 40 187)

Exhibited in Paris only

The energetic and subtle handling of the watercolor medium in this small drawing demonstrates the artist's virtuosity as well as the spontaneity—almost naïveté—of his eye, which remained intact in his maturity. It is interesting to see Signac returning to the haunts of his youth and still finding sources of inspiration. AD

115

116

116. THE LIGHTHOUSE, BIARRITZ,
1906
Watercolor and graphite, 6⅜ x 8½ in.
(16.3 x 21.5 cm)
Signed, lower left: P. Signac; inscribed and
dated in graphite, lower right: Biarritz 06
Musée du Louvre, Département des Arts
Graphiques, Fonds du Musée d'Orsay, Paris,
acquired in 1957 (RF 40 188)

Exhibited in Paris only

Like *Santa Maria della Salute* (cat. no. 112), this
drawing came to the Louvre directly from the
artist's studio. It preserves the memory of a visit
to his friend and collector Christian Cherfils in
February 1906 in Biarritz (see cat. no. 117).
Annoyed by the constant rain, he claimed he was
able to do only "rough sketches." AD

117. SEATED NUDE WOMAN, 1906
Brush, ink, and graphite, 17 x 10 in.
(43.2 x 25.4 cm)
Signed and dated, center right: P. Signac 1906
The Metropolitan Museum of Art, New York,
Bequest of Scofield Thayer, 1982 (1984.433.322)

Exhibited in Amsterdam and New York

The female nude rarely figures in Signac's oeuvre.
One painting is known, a study of a standing
nude woman done about 1910 (FC 489; private
collection); a watercolor, *Nude under a Pine*, is
thought to have been made in summer 1904.[1]
The present work, dated 1906, is closely related
to another drawing representing a seated nude

in two different poses, with the model's con-
tours, as here, emphatically delineated in ink.[2]
The figure, distinguished by her upswept hair,
seems to be identical. It is likely that Signac exe-
cuted both drawings at the same session, in Feb-
ruary 1906 when he was a guest at the home of
the collector Christian Cherfils in Biarritz; Signac
notes in a letter that "Cherfils has [a] 'model'
from time to time, and I have been able to make
some rough sketches."[3] Stylistically the pose and
contoured outline of Signac's figure evoke
Matisse's nudes, particularly those in his *Joy of Life*
of 1905–6 (fig. 63), although Signac initially cen-
sured this work. In a letter to the artist Charles
Angrand of January 14, 1906, Signac exclaimed:

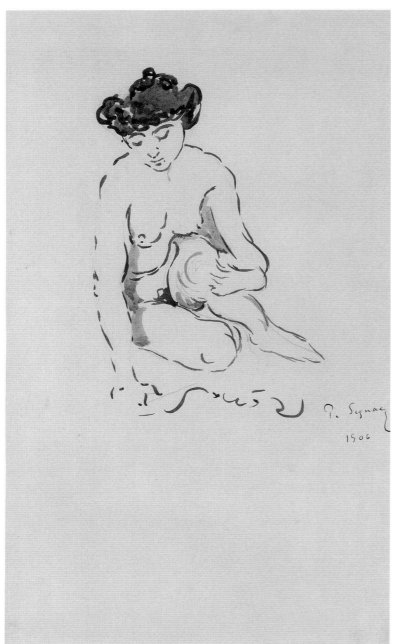

117

"Matisse, whose work I have liked until now, seems to have gone to the dogs. Upon a canvas of two and a half meters he has surrounded some strange characters with a line as thick as your thumb."[4] It is also interesting to note that the following year, Signac purchased a painting of a seated female nude, Kees van Dongen's *The Garter* of 1906, which Van Dongen had executed in response to Matisse's work, outlining the figure with a thick blue line.[5]

Sometime after World War I Signac's nude entered the collection of Scofield Thayer, who in the 1920s was editor and co-owner of the influential modernist journal *The Dial*. Between 1919 and 1924 he acquired more than five hundred twentieth-century paintings, sculptures, drawings, and prints, including works by Matisse, Bonnard, Cézanne, and Picasso, which he bequeathed to the Metropolitan Museum in 1982. KCG

NOTES

1 See Paris 1963–64, no. 108.
2 This work is documented in a photograph in the archives of the Musée d'Orsay, Paris, which Susan Stein kindly brought to my attention.
3 Letter from Signac, private collection; cited in Cachin 2000, p. 377, under February 1906.
4 Letter from Signac to Charles Angrand, January 14, 1906, in Bock 1981, p. 124, n. 64.
5 See Rotterdam–Lyon–Paris 1996–97, no. 116.

118. NOTRE-DAME-DE-LA-GARDE (LA BONNE-MÈRE), MARSEILLES, 1906

Oil on canvas, 35 x 45¾ in. (88.9 x 116.2 cm)
Signed and dated, lower right: P. Signac 1905
The Metropolitan Museum of Art, New York,
Gift of Robert Lehman, 1955 (55.220.1)
FC 433 (*Marseille. La Bonne Mère*)

Exhibitions: Paris 1906, Salon des Indépendants,
no. 4626, *La Bonne Dame. Marseille* (Appartient à
M. Druet); Brussels 1908, Salon de la Libre
Esthétique, no. 182, *La Bonne Mère: Marseille*;
Brussels 1910, Salon de la Libre Esthétique, *La
Bonne Dame: Marseille*; Paris 1911, Galerie Druet,
no. 17, *La Bonne Dame (Marseille)*; Paris 1912,
Ateliers du Quai Rive Gauche, unnumbered,
Port de Marseille; Paris 1930, Galerie Bernheim-
Jeune, no. 28, *La Bonne Mère. Marseille*, 1906

After Venice, Signac rediscovered the south of
France through Marseilles, the largest French
port and gateway to the Orient. He had earlier

visited this city with Cross in October 1898,
attracted, as he noted in his journal, as much by
the murals of Puvis de Chavannes as by Mar-
seilles itself. Using watercolors done on site, he
painted a series of canvases presenting various
views of the port.

Signac apparently went to Marseilles in "late
1905," according to the date he assigned to a
group of oil studies ("Marseilles panels") in his
notebooks. After this trip, he painted two canvases
in his studio: *Saint-Jean Tower, Marseilles* (FC 432;
Gakushikaikan, Tokyo) and the present work,
which bears a date of 1905 but was probably exe-
cuted in the first months of 1906. They offer
entirely different views: the first shows the entrance
to the port and the tower of Saint-Jean; this one
was taken from the docks of the old port, facing
the limestone hill surmounted by Notre-Dame-
de-la-Garde, or the Good Mother, as the church
was called by seafarers. As in two canvases of
Marseilles included in Joseph Vernet's series of

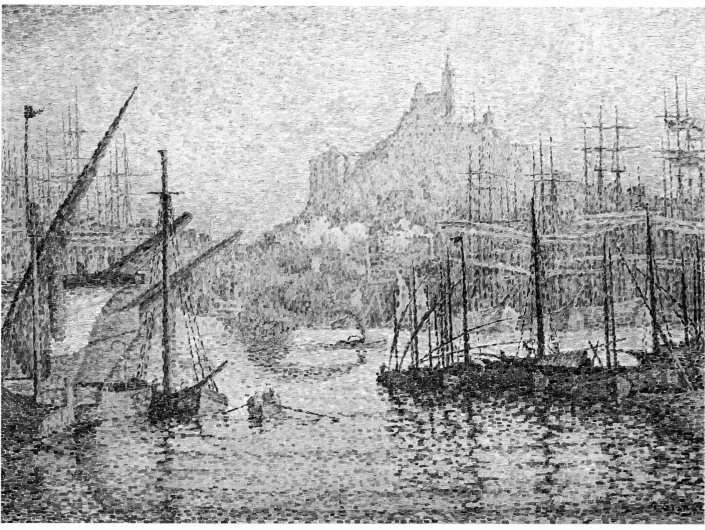

French ports, Signac depicted the port in two stages: seen from the sea and then seen from the docks, like a sailor who catches a glimpse of the entrance to the port before debarking.

Both paintings are recorded under the year 1906 in Signac's "cahier manuscrit" and "pre-catalogue." In their ambition and decorative character they stand apart from the two paintings (FC 441, private collection; FC 442, State Hermitage, Saint Petersburg) Signac made after his visit in July 1906, when Marseilles was hosting the first French colonial fair and he met the painter Charles Camoin, a native of the city.[1] Camoin had painted two views fairly similar to those of Signac in 1904 (Musée du Havre; private collection, Zurich); they serve as a gauge for the liberties Signac took with the site, which include choosing a much closer vantage point and subjecting his motifs to a stricter geometry. The hill has a steeper slope and appears more like a mountain: an impressive triangle against which the delicate filigree of the rigging of the three-masters stands out. He repeated the motif several times, notably in the following year in a smaller, less solemn work (FC 462; Mr. and Mrs. William Mazer collection, New York). The largest picture he devoted to Marseilles was painted in 1918–20, most likely from earlier studies (FC 543; Musée Cantini, Marseilles). In this picture Signac again omitted the bridge and depicted the entrance to the port in a highly organized composition, with Fort Saint-Jean on the left and Fort Saint-Nicolas on the right.

The present painting belonged to two collectors who both played a major part in the dissemination of the artist's work: Gaston Lévy and Robert Lehman. Lévy (1893–1977) was a businessman and supporter of the arts who took an interest in Signac in the 1920s and 1930s. He assembled a large collection of his works, while also collecting those of Jongkind, Monet, Pissarro, and Vuillard. A true patron, he commissioned Signac to paint a series of one hundred watercolors representing the ports of France. Lévy also laid the groundwork for a catalogue raisonné of the artist's work.

Lehman, a banker and collector, was a munificent donor to The Metropolitan Museum of Art. His collection included the superb seascapes *Town Beach, Collioure* (cat. no. 27) and *Evening Calm, Concarneau* (cat. no. 55), a charming oil sketch (cat. no. 32), the present painting, and a large number of watercolors, seventeen of which were purchased at the sale of Gaston Lévy's daughter, Mme Andrée Samama, held at the Hôtel Drouot on May 9, 1952. MFB

NOTE

1 Munck 1999, p. 434.

119. STEAMBOATS, ROTTERDAM, 1906

Oil on canvas, 28¾ x 36¼ in. (73 x 92 cm)
Signed and dated, lower right: P. Signac 1906
Shimane Art Museum, Shimane, Japan
(OF 20010)

FC 436 (*Rotterdam. Les Fumées*)

Exhibitions: Paris 1907, Galerie Bernheim-Jeune, no. 3, *Rotterdam. Les fumées*; Brussels 1910, Salon de la Libre Esthétique, *Les fumées. Rotterdam*; Paris 1911, Galerie Druet, no. 13, *Les fumées (Rotterdam)*; Cologne 1912, Städtische Ausstellungshalle, no. 197, *Rotterdam 1906*; Saint Petersburg 1912, Institut Français, no. 599, *Rotterdam*; Geneva 1926, Musée d'Art et d'Histoire, no. 180

In 1896 Signac, accompanied by Théo van Rysselberghe, made his first trip to the Netherlands. Upon his return he painted six canvases after his numerous watercolor sketches. During his second visit in April–May 1906, he went to Rotterdam, Maassluis, and Amsterdam. From Rotterdam he wrote with delight to the collector Christian Cherfils: "I am struggling against the Maas [River]. It is a perpetual ballet of boats and smoke. And the effects change at every moment. It isn't painting, it's an indictment."[1] Afterward he executed eight pictures, including a large-scale canvas in 1907 (fig. 53), which takes up the same subject as the painting seen here in an amplified form.

The present picture is one of the most refined works of the second Dutch series. After having painted a sparkling and timeless Venice, Signac chose northern light and a major modern industrial port with its steel bridge, dense ship traffic, and smoke. The varied brushwork, which follows the movement of the clouds, water, and steam, and the less formal organization give this picture a more dynamic, improvised character than his strictly classical views of Mediterranean ports. Often compared with the paintings of the Thames

that Monet exhibited at the Galerie Durand-Ruel in 1904, Signac's views of Dutch ports, which are quite Impressionist in character, have sustained unanimous admiration.

In August 1906 Cross wrote to Van Rysselberghe, saying he had just been at La Hune with Signac and found his Dutch series remarkable. "Two pieces in particular impressed me. Soft mauve and green harmonies motivated by boats and smoke mixing with the clouds, with the Rotterdam bridge in the background, have been delightfully realized. It is full of movement, and in my opinion quite new."[2] Georges Lecomte was another admirer: "The port of Volendam and the port of Rotterdam, with their fine grays and their subtle intermingling of grays and smoke, prove that M. Paul Signac knows how to depict with equal success the cold light of the North and the joyful splendors of the Midi."[3] As for

Louis Vauxcelles, he thought that the French state should purchase Signac's *Rotterdam:* "It is the sea, the lapping of the waves, the gauze of mauve and white smoke. It would be interesting to compare this work with one of Claude Monet's famous views of the Thames, to study the techniques and temperaments of these two fine artists. The effects of open sea and sky were achieved with an amazing assurance and great freedom by the pointillist master."[4] MFB

NOTES
1 Letter from Signac to Christian Cherfils, private collection, Paris.
2 Letter from Henri Edmond Cross to Théo van Rysselberghe, Bibliothèque Centrale des Musées Nationaux, Paris, MS 416.
3 Lecomte 1911, p. 74.
4 Vauxcelles 1907b, p. 2.

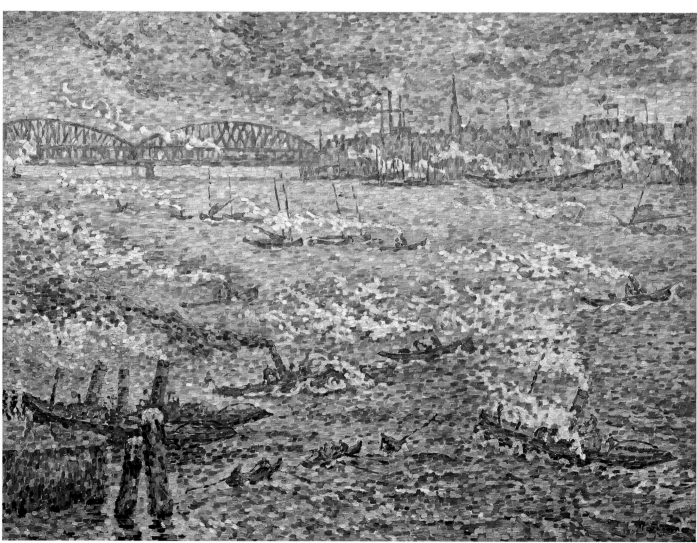

120. ROTTERDAM, 1906
 Watercolor and graphite, 10 x 16 in.
 (25.4 x 40.6 cm)
 Signed, inscribed, and dated, lower right:
 P. Signac Rotterdam 1906
 The Metropolitan Museum of Art, New York,
 Alfred Stieglitz Collection, 1949 (49.70.19)

 Exhibited in Amsterdam and New York

In 1906, a decade after his first visit to Rotterdam, Signac returned to capture the fleeting atmospheric effects of the Maas River. When he included twelve watercolors and four paintings of this port in his one-man show at the Galerie Bernheim-Jeune in 1907, more than one critic mentioned Monet's series of Thames views.[1] The muted palette of rose and blue and the absence of strongly outlined forms in this work evoke Monet's impressions of the Thames as viewed through fog and haze. Signac's watercolor conveys the vitality of the busy commercial port, as sailing vessels—from rowboats to steamships—ply the harbor. The outlines of the bridge and smokestacks of Rotterdam are barely visible through the background haze of smoke and fog. The composition closely resembles that of Signac's 1906 painting *Steamboats, Rotterdam* (cat. no. 119).

This work entered The Metropolitan Museum of Art in 1949 as a bequest of the American photographer Alfred Stieglitz, who had amassed a collection of early-twentieth-century European and American art. KCG

NOTE
1 See Susan Alyson Stein's essay, pp. 70–71, nn. 21, 22, in this volume.

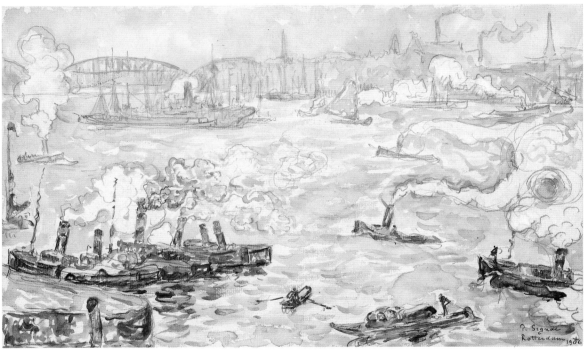

120

121. TUGBOATS, ROTTERDAM, 1906
Watercolor and graphite, 8⅞ x 13¾ in.
(22.5 x 35 cm)
Signed, lower left: P. Signac; inscribed and
dated, lower right: Rotterdam 1906
Private collection

Exhibited in Paris only

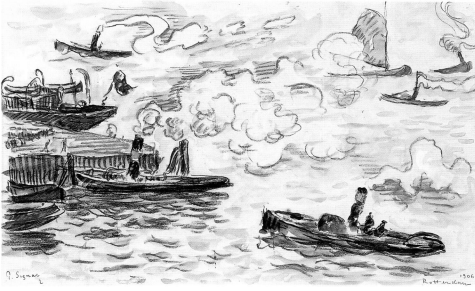

121

122. OVERSCHIE, 1906
Watercolor and graphite, 6¾ x 9⅝ in.
(17 x 24.6 cm)
Signed in graphite, lower left: P. Signac;
inscribed and dated, lower right: Overschie 06
Musée des Beaux-Arts et d'Archéologie,
Besançon, Gift of George and Adèle Besson,
1965 (AM 2921 D 22)

Exhibited in Paris only

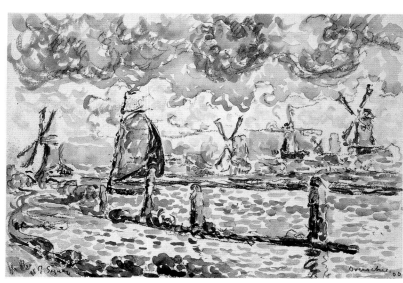

122

Signac brought this watercolor back from his trip
to the Netherlands in the spring of 1906 (see also
the Rotterdam works, cat. nos. 119–21). During
the same period that he was working on wind-
mills and views of the Maas, he was also painting
those from Venice and the Midi. This scene
reappears in modified form in a painting titled
Windmills, Overschie (FC 437; Museum of Fine Arts,
Springfield, Massachusetts).

The present drawing was once part of the
collection of George and Adèle Besson, close
friends of the artist who owned some twenty-five
watercolors, the sketchbooks for the illustrations
of Stendhal's *Mémoires d'un touriste*, many sketches,
and illustrated letters, which they donated to the
museums of Besançon, Bagnols-sur-Cèze, and
Saint-Denis. AD

123–128. VIGNETTES FROM "PAUL SIGNAC," A 1907 BERNHEIM-JEUNE CATALOGUE

123. ROTTERDAM

Ink and graphite, 7¼ x 11 in. (18.3 x 28.1 cm);
image, 3⅝ x 4⅞ in. (9.2 x 12.5 cm)
Musée du Louvre, Département des Arts
Graphiques, Fonds du Musée d'Orsay, Paris,
Gift of Françoise Cachin in memory of her
mother, Ginette Signac, 1996 (RF 50 826)

Exhibited in Paris only

124. THE WINDMILL, ROTTERDAM

Ink, 3¾ x 4 in. (9.4 x 10 cm); image, 2½ x 3 in.
(6.5 x 7.5 cm)
Signed lower right: P. Signac
Musée du Louvre, Département des Arts
Graphiques, Fonds du Musée d'Orsay, Paris,
Gift of Françoise Cachin in memory of her
mother, Ginette Signac, 1996 (RF 50 827)

Exhibited in Paris only

See Paris 1907, no. 3.

125. ENTRANCE TO THE GRAND CANAL, VENICE

Ink, 6⅛ x 7¾ in. (15.5 x 19.8 cm);
image, 3⅞ x 4½ in. (9.7 x 11.5 cm)
Musée du Louvre, Département des Arts
Graphiques, Fonds du Musée d'Orsay, Paris,
Gift of Françoise Cachin in memory of her
mother, Ginette Signac, 1996 (RF 50 832)

Exhibited in Paris only

See Paris 1907, no. 12.

126. THE CYPRESSES OF SAINT ANNE, SAINT-TROPEZ

Ink, 6⅛ x 7⅝ in. (15.7 x 19.5 cm);
image, 3¾ x 4¾ in. (9.5 x 12 cm)
Musée du Louvre, Département des Arts
Graphiques, Fonds du Musée d'Orsay, Paris,
Gift of Françoise Cachin in memory of her
mother, Ginette Signac, 1996 (RF 50 841)

Exhibited in Paris only

See Paris 1907, no. 25.

127. LEAVING THE PORT, SAINT-TROPEZ

Ink, 6⅞ x 8½ in. (17.3 x 21.5 cm);
image, 4¾ x 5⅞ in. (12 x 15 cm)
Musée du Louvre, Département des Arts
Graphiques, Fonds du Musée d'Orsay, Paris,
Gift of Françoise Cachin in memory of her
mother, Ginette Signac, 1996 (RF 50 837)

Exhibited in Paris only

See Paris 1907, no. 19.

128. LES DIABLERETS, SWITZERLAND

Ink, 6¼ x 6¾ in. (16 x 17 cm);
image, 3¼ x 4⅛ in. (8.2 x 10.5 cm)
Musée du Louvre, Département des Arts
Graphiques, Fonds du Musée d'Orsay, Paris,
Gift of Françoise Cachin in memory of her
mother, Ginette Signac, 1996 (RF 50 845)

Exhibited in Paris only

See Paris 1907, no. 29.

Signac was concerned with the reproduction of
his works, suggesting his own solutions suited for
current printing methods. After having tried
stippled drawings (see cat. nos. 18, 19, 25), in
1903–4 he began making sketches in pen and ink.
One of the first known examples of this type is
the detailed reproduction of a painting titled
Sisteron, exhibited at the 1903 Salon des Indépen-
dants (cat. no. 109), which was printed in Henry
Cochin's pamphlet *Quelques Réflexions sur les Salons*
(Paris, 1903). Soon after, he used a sketch in
facsimile of a Venetian composition to illustrate
the cover of the catalogue to his exhibition at
the Galerie Druet in December 1904. Then, for
the catalogue of his 1907 exhibition at Bernheim-
Jeune (January 21–February 2) these reproduc-
tions, printed in green, served to illustrate all
thirty-four pictures in the show—an elegant,
original, and less costly strategy. Twenty-three
original drawings for the vignettes of this cata-
logue are now part of the collections of the
Musée d'Orsay (corresponding to cat. nos. 3–5,
9, 11, 12, 14–16, 18–20, 22, 23, 25–30, 32–34). The
original sketches were reduced to half their size
in the reproduction. Several were used again for
the first monograph devoted to Signac's work by

his friend Lucie Cousturier, which was published in 1922. The sketch titled *Rotterdam* (cat. no. 123) was not included in the Bernheim-Jeune catalogue and does not correspond to any known composition by Signac, but was published in the monograph. Similar sketches were used in George Besson's 1950 monograph. The latter, a friend of Signac, donated some original sketches to the Musée d'Art et d'Histoire in Saint-Denis. Like Cross and Van Gogh, Signac sometimes included sketches of this kind in his letters. He even began a series of ink drawings heightened with watercolor for a catalogue raisonné of his work. AD

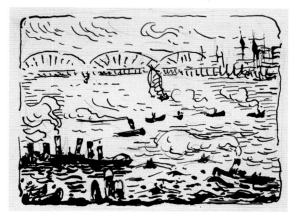

123

124

125

126

127

128

129. THE MOSQUE OF SÜLEYMANIYE, CONSTANTINOPLE, 1907

Watercolor, 5½ x 7⅞ in. (13.9 x 19.9 cm)
Annotated, top: Suleimanie
Musée du Louvre, Département des Arts
Graphiques, Fonds du Musée d'Orsay, Paris,
acquired in 1957 (RF 40 189)

Exhibited in Paris only

Like *Boats on the Golden Horn* (cat. no. 130), this "watercolor notation" dates from Signac's trip to Constantinople in the spring of 1907, which subsequently gave rise to a series of paintings. AD

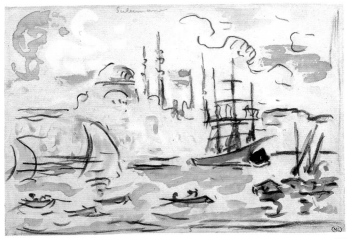

129

130. BOATS ON THE GOLDEN HORN, 1907

Watercolor, 4¾ x 7 in. (12.1 x 17.8 cm)
Inscribed, on image: or, vert foncé
Musée du Louvre, Département des Arts
Graphiques, Fonds du Musée d'Orsay, Paris,
acquired in 1957 (RF 40 190)

Exhibited in Paris only

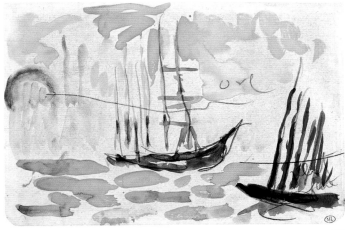

130

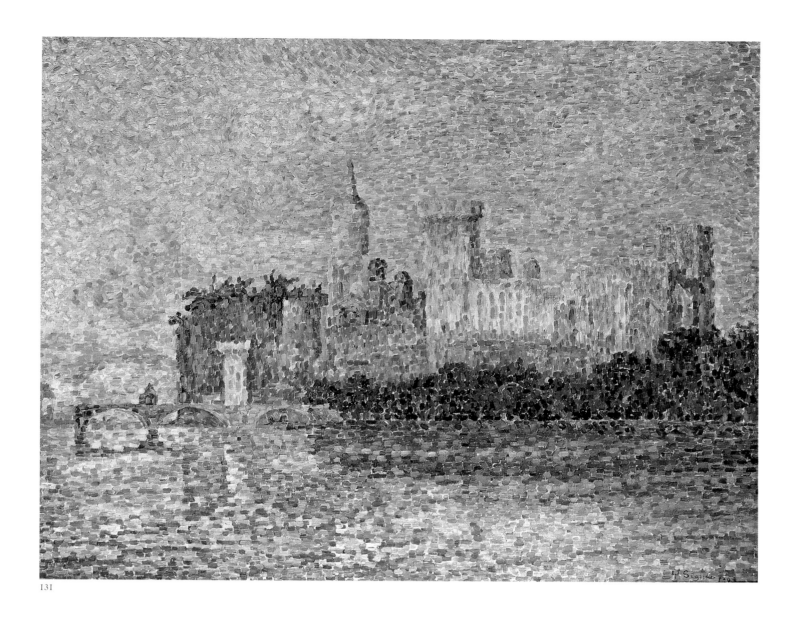

131

131. EVENING, AVIGNON (CHÂTEAU
DES PAPES), 1909
Oil on canvas, 28¾ x 36¼ in. (73 x 92 cm)
Signed and dated, lower right: P. Signac 1909
Musée d'Orsay, Paris (RF 1977-323)
FC 481 (Avignon. Soir [le château des Papes])

Exhibitions: Paris 1912, Salon des Indépendants,
no. 2999, Le Château des Papes (property of MM.
Bernheim-Jeune et Cie); Paris 1912, Musée de
Luxembourg, Exhibition of State Acquisitions
and Commissions, no. 132; Ghent 1913,
Exposition universelle et internationale, no. 366,
Palais des Papes, Avignon; Paris 1934, Petit-Palais,
no. 27, Le Château des Papes à Avignon, 1910 (Musée
du Luxembourg)

Exhibited in Paris only

In 1909 Signac painted a number of architectural
monuments associated with bodies of water, seas,
or rivers: the Laterna in Genoa (FC 476; private
collection, London), the Giudecca in Venice
(FC 482; private collection), two views of Con-
stantinople showing the minarets of Hagia Sofia
rising from the Bosphorus (FC 483, location un-
known; 484, location unknown), as well as two
versions of the Palace of the Popes. The two
versions have similar compositions, but very dif-
ferent color schemes. The first (FC 480; private
collection) depicts the palace by morning light
and the second, shown here, at sunset. Exhibited
at the 1912 Salon des Indépendants, the evening
view was often remarked upon, but most of the
reviews smacked of the mandatory homage due
a president of the Artistes Indépendants or
repeated the hackneyed jokes about "confetti."
Gustave Kahn's admiration was more sincere and
supportive: "This handsome tawny block of stone
has often tempted artists. But I do not recall that
any ever gave its massive yet thrusting silhouette

such a lightness and density at the same time. The towers of the palace and the vegetation on the rock of Notre-Dame-des-Doms burst beneath an admirable azure and purple sky."[1] Théodore Duret's opinion was cooler: "He is the most perseverant of the so-called pointillists. This year we have a work which can be called one of his best: the *Château des Papes in Avignon.* It shows the advantages to be had by a certain method but also the confines within which it traps those who use it."[2]

Having earlier sold the painting to the Galerie Bernheim-Jeune, Signac bought it back in 1912,

whereupon the canvas was immediately acquired by the French state for the Musée du Luxembourg. Signac had been painting for thirty years, and this was the first of his paintings to enter the French national collections, which until then owned only three watercolors from his hand. MFB

NOTES
1 Kahn 1912, p. 634.
2 Duret 1912, p. 36.

132. LA ROCHELLE, 1911
Watercolor and graphite, 9⅛ x 11¼ in. (23.2 x 28.5 cm)
Signed, lower left: P. Signac; inscribed and dated, lower right: La Rochelle 1911; inscribed, on back, in artist's hand: no. 17 La cloche du passeur La Rochelle 1911 P. Signac
Musée du Petit-Palais, Paris, bequeathed by Dr. Girardin, 1953 (PP 3213)

Exhibited in Paris only

This unusually precise watercolor study dates from Signac's first visit to La Rochelle, where he witnessed the departure of the tuna fishing fleet in June. He returned regularly to La Rochelle to work (see cat. nos. 133, 155). AD

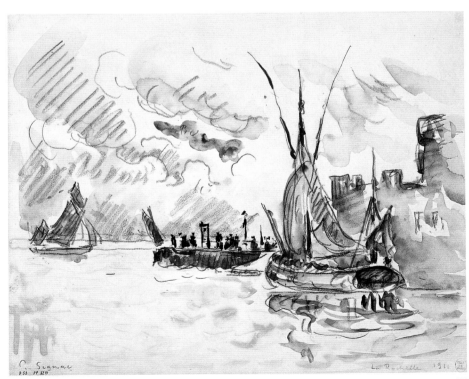

132

133

133. LA ROCHELLE, 1912
China ink, 27½ x 39⅜ in. (70 x 100 cm)
Signed and dated, lower right: Paul Signac 1912
The Metropolitan Museum of Art, New York,
Robert Lehman Collection, 1975 (1975.1.720)

Exhibited in New York only

Signac, who first traveled to La Rochelle in 1911,
would execute eleven paintings of this Atlantic
seaport between 1912 and 1928. This work, done
in black and brown ink wash, served as a full-
scale study for the earliest oil, *Leaving Port, La Rochelle*
(FC 491; Johannesburg Art Gallery) of 1912, de-
picting a group of tuna boats leaving the Vieux
Port. In fact, while visiting La Rochelle, Signac
had noted such an event in a postcard of June 28,
1911, to his wife: "Today the great departure of
the tuna boats; I will leave tomorrow evening."[1]
The departing boats are framed by two of the
port's distinctive towers, the round Tour de la
Chaîne, built in 1375, and the crenellated Tour
Saint-Nicolas of 1384. Signac later executed a
reduced-scale variant of his wash drawing, which

preserves the spontaneity and freedom of execu-
tion of the original, for publication in Lucie
Cousturier's 1922 monograph.[2]

Signac's adoption of La Rochelle as a subject
places him within an artistic tradition descend-
ing from Claude's imaginary seaports through
Joseph Vernet's Ports of France series in the
eighteenth century to Camille Corot, whose 1851
Port, La Rochelle led Renoir to lament in 1918: "The
towers of la Rochelle, ah, what trouble they've
given me! It was his fault, Corot's, that I wanted
to emulate him."[3] KCG

NOTES
1 Letter from Signac to Berthe Signac, June 28, 1911,
 Signac Archives.
2 Cousturier 1922, pl. 38.
3 As cited in Paris–Ottawa–New York 1996–97,
 p. 278.

134. THE BAY, ANTIBES, ca. 1910
India ink, 11¾ x 9¼ in. (29.8 x 23.5 cm)
Arkansas Arts Center Foundation Collection,
Little Rock, Gift of James T. Dyke, 1999
(99.065.036)

Exhibited in Amsterdam and New York

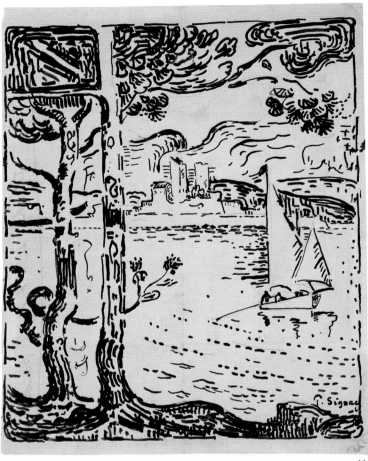

134

In this drawing and related paintings of Antibes, the sinuous pine trees (*pins d'Alep*)—which had earlier captivated Monet at the same locale—frame the view across the bay.[1] The ramparts of the old town and the twin towers of Château Grimaldi are nestled against the backdrop of the Italian Alps, while a *pointu*, a Provençal fishing boat, trolls on the bay. The rhythmic play of broken lines and arabesques is compelling. Delicate yet bold, the emphatic patterning of the black-and-white design is reminiscent of a wood-block print. This effect is surprising since Signac appears to have never made woodcuts; his activity as a printmaker was limited to etchings and to lithographs. SAS

NOTE
1 The composition is closest to that of an oil dated 1916, *La Salis, Antibes* (Rosenthal Group, New York; FC 511), but the trees figure prominently in other views of Antibes (FC 395, 479, 514–16) and elsewhere along the Mediterranean coast (see cat. no. 95).

135. THE PINK CLOUD, ANTIBES, 1916
Oil on canvas, 28 x 35 in. (71 x 89 cm)
Signed and dated, lower left: P. Signac 1916
Scott M. Black Collection, courtesy Portland
Museum of Art, Maine
FC 509 (*Le Nuage rose [Antibes]*)

Exhibitions: Paris 1923, Galerie Bernheim-Jeune, no. 25, *Antibes. Le Nuage;* Berlin 1927, Goldschmidt gallery, no. 18, *Le Nuage rose* (private collection)

During World War I Signac lived in Antibes but was too depressed to paint much. There are only sixteen canvases dated between 1914 and 1917. One of the most remarkable, both because of its originality and strangeness, is the present atypical work. It stands out among the otherwise subdued paintings of the war years, combining dreamlike aspects tinged with humor—such as the interpretation of the cloud's form—with the unsettling vision of warships, the "black squadron" in his words, parading on the horizon.

The elaboration of this painting was long and laborious. It was based on a quick sketch of a sunset (Dyke Collection, Arkansas Arts Center, Little Rock). The color composition, which was already largely established, was further developed in the definitive composition, which presents more intense colors: purple horizon, green and pink sea, and a pink and golden cloud. On December 5, 1914, Signac wrote Fénéon that he had just begun a large cloud on too small a canvas and that he was going to transfer it to a no. 30 format that would allow him to "model this cauliflower."[1] Indeed, a first sketch for the present picture, smaller in scale but with all of the compositional elements in place, has survived (FC 508).

Signac undertook the second version enthusiastically, mentioning it to Fénéon again on December 19 and including a humorous annotated sketch of it in his letter (fig. 106). In the round and compact forms of the "cauliflower"-cloud, Signac discerned "some Michelangelesque figures," the figure of Loie Fuller in the dancing arabesque of the clouds rising on the left, and a strange procession of warships on the horizon. He acknowledged, however, that the picture was not easy to paint, and on January 14, 1915, he confessed: "As for the portrait of the cloud

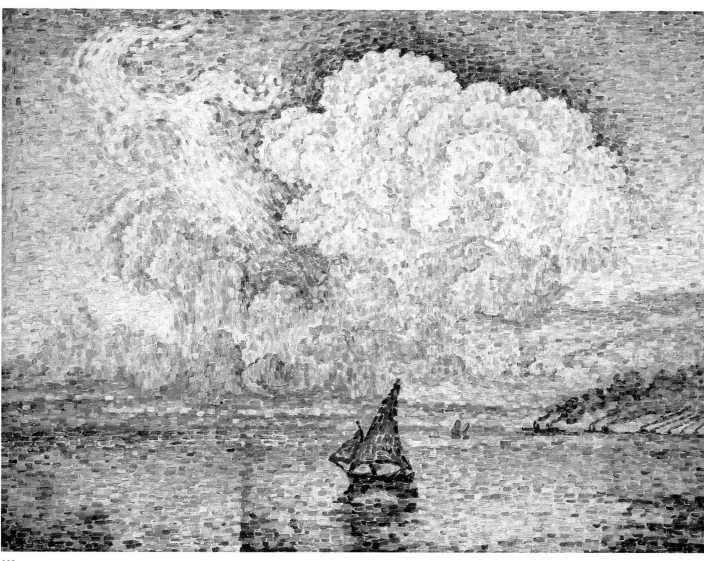

135

(no. 30 canvas), there is an intermission, it is very difficult, but we will go back to it."[2] It was probably in the process of working out the composition that the artist made two quick color studies of sunset effects on both sides of a wood panel (FC 510, recto and verso; private collection). Signac did not date the painting until 1916 and sold it in 1917 to the Galerie Bernheim-Jeune. He had taken more than a year to complete this dazzling work with its biting colors and implications. MFB

NOTES
1 Letter from Signac to Félix Fénéon, December 5, 1914, Signac Archives.
2 Letters from Signac to Félix Fénéon, December 19, 1914, and January 14, 1915, Signac Archives.

Fig. 106. Letter from Paul Signac to Félix Fénéon, December 19, 1914. Signac Archives

136–143. STUDIES FOR "ANTIBES"

136. MORNING, ANTIBES, 1918–19
Oil on wood, 7¼ x 9¼ in. (18.5 x 23.5 cm)
Private collection
FC 523 *(Antibes. Matin)*

137. RED SUNSET, ANTIBES, 1918–19
Oil on wood, 7¼ x 9½ in. (18.5 x 24 cm)
Private collection
FC 524 *(Antibes. Couchant rouge)*

138. YELLOW SUNSET, ANTIBES, 1918–19
Oil on wood, 7¼ x 9½ in. (18.5 x 24 cm)
Private collection
FC 525 *(Antibes. Couchant jaune)*

139. THE STORM, ANTIBES, 1918–19
Oil on wood, 7¼ x 9½ in. (18.5 x 24 cm)
Private collection
FC 526 *(Antibes. Orage)*

140. EAST WIND, ANTIBES, 1918–19
Oil on wood, 7¼ x 9½ in. (18.5 x 24 cm)
Private collection
FC 527 *(Antibes. Vent d'est)*

141. MORNING MIST, ANTIBES, 1918–19
Oil on wood, 7¼ x 9½ in. (18.5 x 24 cm)
Private collection
FC 528 *(Antibes. Brume du matin)*

142. GRAY WEATHER, ANTIBES, 1918–19
Oil on canvas board, 7¼ x 9½ in. (18.5 x 24 cm)
Private collection
FC 529 *(Antibes. Temps gris)*

143. ANTIBES (STUDY), 1918–19
Oil on wood, 7⅜ x 9½ in. (18.7 x 24.2 cm)
Private collection
FC 531 *(Antibes [étude])*

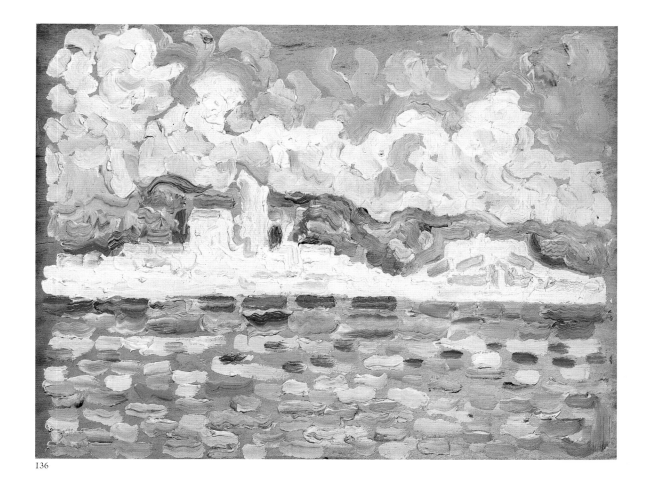

136

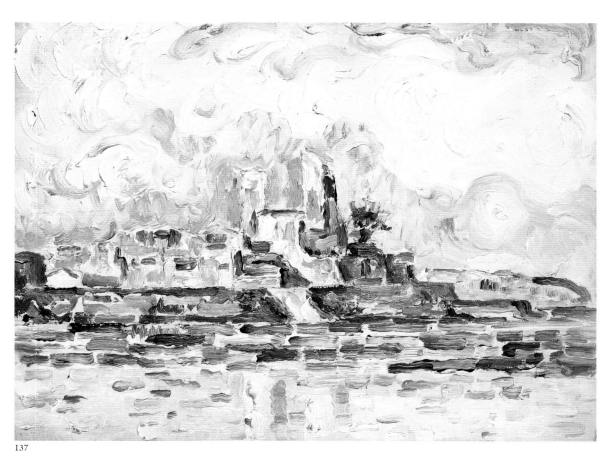

137

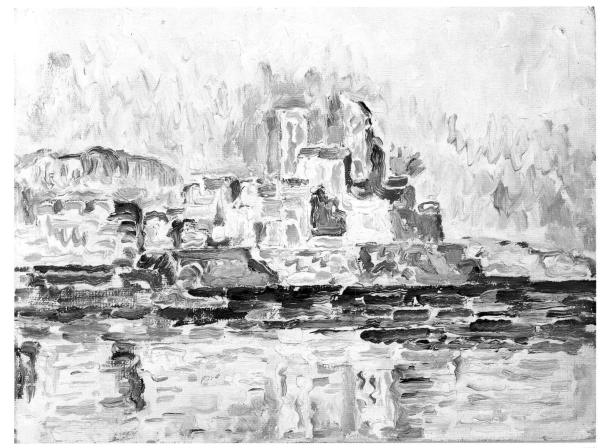

138

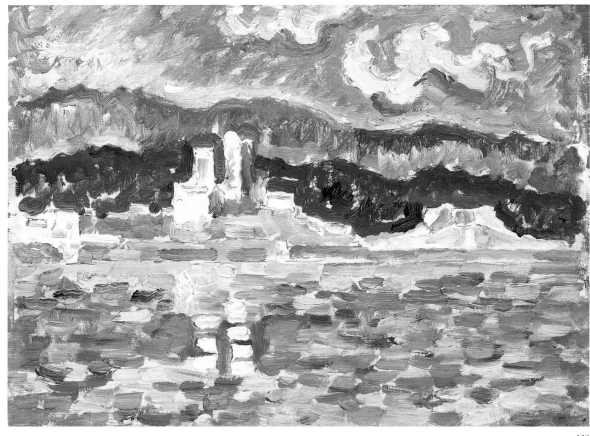

139

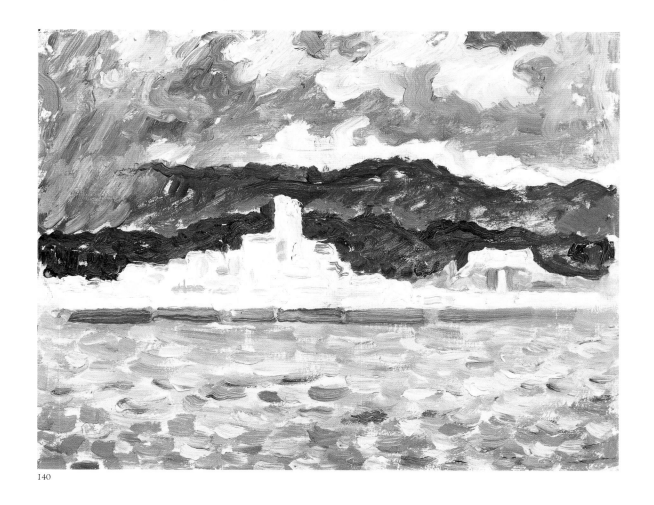

140

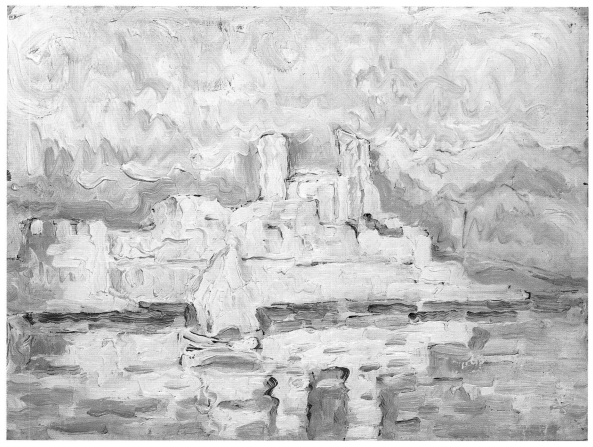

141

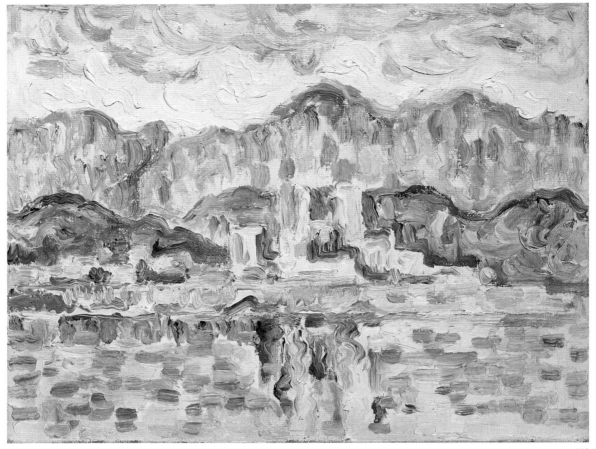

142

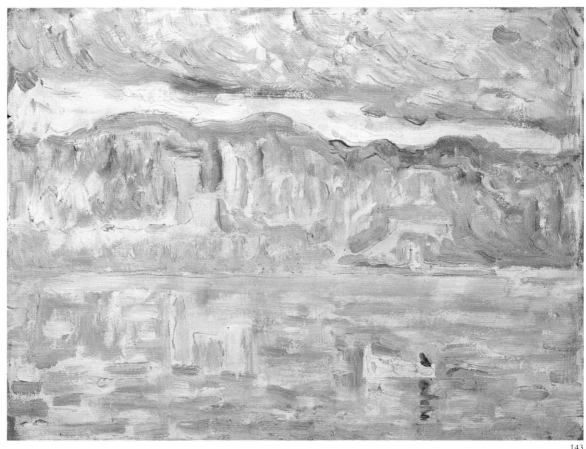

143

Signac's first oil studies from 1882–83 record his enthusiastic discovery of Impressionism as a young man. A small number of oil studies from 1887–88 betray the direct influence of Seurat and display new concerns, as well as greater concentration and meditation. This brief temptation, however, did not suit Signac's temperament, whose "oil notations" were intended above all to serve as an effective means of study, a quick and practical tool. The works linked to *Sunday* (cat. nos. 40–48) show the uneven handling in Signac's oil sketches: the small study of the woman at a window (cat. no. 44) is a masterpiece in its own right, while the first preliminary sketch for the overall composition (cat. no. 45) was considered a simple "document" without great aesthetic ambition.

During the long preparatory work for *In the Time of Harmony* new qualities appear. The artist undertook a very difficult and demanding task. He had problems elaborating the composition, and he struggled to adapt Neo-Impressionist technique to a large format. His studies evolved accordingly: from simple documents, like the brisk panel with oleanders or the overall sketch (cat. nos. 82, 77), to the last preparatory studies, superb panels at once lively and synthetic. But his studies of poppies and the Plage des Graniers (cat. nos. 84, 85a, 85b)—almost abstract, clear, direct, and painted in large square brushstrokes—express something entirely different. Signac's pleasure in painting color studies from nature was obvious. He again worked like an Impressionist, sensitive to color and contrasts and freed from a too strict Divisionism.

The series presented here is perhaps one of the finest demonstrations of the artist's joy in nature. Signac had lived in Antibes since 1913 and knew the site well. His familiarity enabled him to paint without being overly concerned with description, and he was left with the pleasure of observing the effects of the changing weather conditions on a dazzling spectacle: the sea, the mighty forms of Fort d'Antibes, and the snowy peaks of the Alps. This series of studies led to four works painted in the studio: *Storm, Antibes; Morning, Antibes; Sunset, Antibes;* and *Gray Weather, Antibes,* all from the period January–March 1919 (FC 533–536). Signac thus probably painted these panels from life in January and February. He consciously gave himself over to the delights of Impressionism and outdoor painting, likely having in mind the memorable series painted by Monet at this same site in early 1888 (fig. 107). MFB

Fig. 107. Claude Monet, *Old Fort at Antibes II,* 1888, oil on canvas, 25¾ x 31⅞ in. (65.4 x 81 cm). Museum of Fine Arts, Boston, Anonymous Gift, 1978.634

144. STILL LIFE WITH PITCHER, 1919
Watercolor and graphite, 11⅞ x 17⅝ in.
(30.2 x 44.8 cm)
Signed and dated, lower right: P. Signac 191[9]¹
The Metropolitan Museum of Art, New York,
Robert Lehman Collection, 1975 (1975.1.722)

Exhibited in Amsterdam and New York

145. STILL LIFE WITH JUG, ca. 1919–20
Watercolor and graphite, 12 x 17½ in.
(30.5 x 44.5 cm)
Signed, lower left: P. Signac
Private collection

Exhibited in Paris only

Signac's rare foray into the genre of still life, as evidenced by a series of watercolors dating from the fall of 1918, coincided with his preoccupation with Cézanne. Writing to Fénéon in September 1918, Signac requested a photograph of a watercolor by Cézanne, as well as an oil painting of fruit; the following month Signac cited Cézanne's still lifes in a letter to Fénéon that analyzed Cézanne's method as a watercolorist.[2]

Elements of *Still Life with Pitcher,* done in 1919, especially recall Cézanne's approach. Signac's application of color in vertical and horizontal patches suggests Cézanne's constructive brushstroke, and the vantage point from above the objects on the table is reminiscent of Cézanne's experiments with perspective. The broken hatch marks that appear in the background and on the tablecloth visually unify the two surfaces, recalling similarly blurred boundaries in Cézanne's still lifes. Yet Signac's choice of irregularly shaped vegetables and fruit, along with his use of a more high-key palette, distinguishes his works from Cézanne's.

Signac first encountered Cézanne's watercolors in 1908 at an exhibition at the Galerie Druet, which he recorded in a journal entry of December 21, 1908: "Glorious watercolors by Cézanne, so pure, so strong, in which the paper plays its part in the great old painter's customary polychromy. It's a new sensation for me, because I didn't know Cézanne's watercolors."[3] KCG

NOTES
1 The last digit, as recorded in a documentary photograph, was written on the original mount, which was subsequently removed.
2 Letters from Signac to Félix Fénéon, September 20 and 30, 1918, and October 9, 1918, Signac Archives.
3 Signac journal entry, December 21, 1908, in Signac 1947, no. 11, p. 80.

144

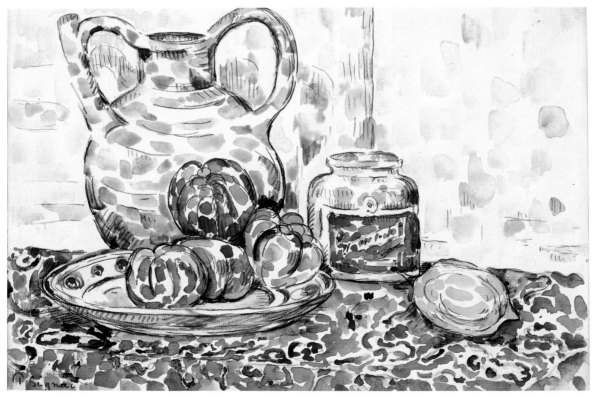

145

146. STILL LIFE WITH PEPPERS,
ca. 1918–20 (or 1926?)
Watercolor and graphite, 12⅝ x 19⅝ in.
(32.2 x 49.7 cm)
Signed, lower left: P. Signac
Arkansas Arts Center Foundation Collection,
Little Rock, Gift of James T. Dyke, 1999
(99.065.063)

Exhibited in Amsterdam and New York

Signac's watercolor still lifes evoke the importance
of Cézanne in his art as well as in his writings.
In his 1927 study on Jongkind, Signac repeatedly
refers to Cézanne as one of the "true masters of
watercolor" (along with Turner and Jongkind)
throughout his chapter on watercolors, which is
effectively a treatise on the subject. He classifies
Cézanne as an "analyst" for whom "the water-
color is a laboratory experiment, in which he
breaks down the connections and transitions of
the elements in order to reconstitute the pictorial
modulation of his volumes."[1] The present com-
position reveals a similar impulse toward struc-
ture and volume: the checked tablecloth, acting
as a grid, provides an underlying structure, while
the pronounced contours of the forms under-
score their volume.[2] KCG

NOTES
1 Signac 1927, p. 116.
2 Ferretti-Bocquillon in Little Rock 2000, p. 24 and
 no. 70, p. 81, dated 1926. On the dating of this work,
 see cat. no. 147, n. 3.

**147. STILL LIFE WITH FRUIT AND
VEGETABLES,** 1926 (or ca. 1918–20)
Watercolor and graphite, 12 x 16⅝ in.
(30.4 x 42.2 cm)
Signed and dated, lower left: 14 Juillet 1926
P. Signac
Arkansas Arts Center Foundation Collection,
Little Rock, Gift of James T. Dyke, 1999
(99.065.060)

Exhibited in Amsterdam and New York

Signac's interest in still life was apparently rein-
forced by a Cézanne retrospective he attended in
Paris.[1] Held at the Galerie Bernheim-Jeune in
June 1926, the exhibition included nearly one
hundred watercolors.[2] Upon his arrival in Bourg-
Saint-Andéol later that month, Signac returned
to his own watercolors; the present work is dated
July 14, 1926.[3] The pitcher might well be an hom-
age to Cézanne, as it recalls the white flowered
pitcher that appears in so many of his late still
lifes. Especially striking is Signac's application of
color in broad patches that bleed into one
another, notably in the body of the pitcher,
which suggests the influence of Cézanne's water-
color technique. Yet the vibrant palette reflects
Signac's own stylistic preference. KCG

NOTES
1 Ferretti-Bocquillon in Little Rock 2000, p. 24.
2 Dorival 1948, p. 183.
3 The inscription on this work originally led Marina
 Ferretti-Bocquillon to identify a second still-life
 campaign undertaken in Bourg-Saint-Andéol in
 1926, which also included cat. no. 146. However, in
 the absence of supporting documentation, she is
 inclined to date all of Signac's still lifes to about
 1918–20, suggesting that the inscription may indicate
 the date the work was presented as a gift or sold,
 rather than its date of execution.

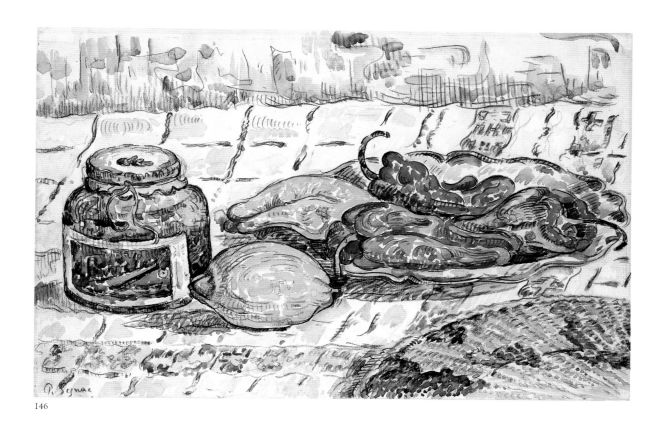

146

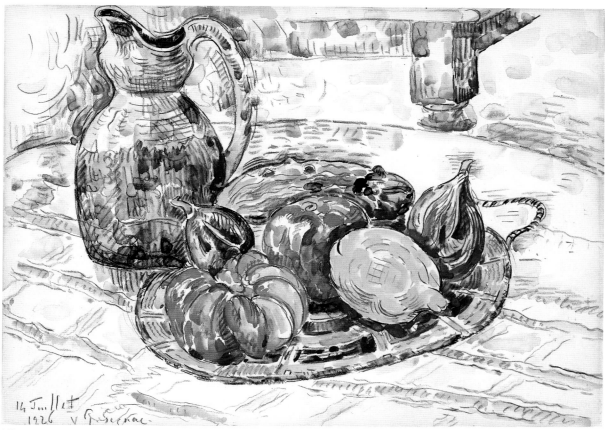

147

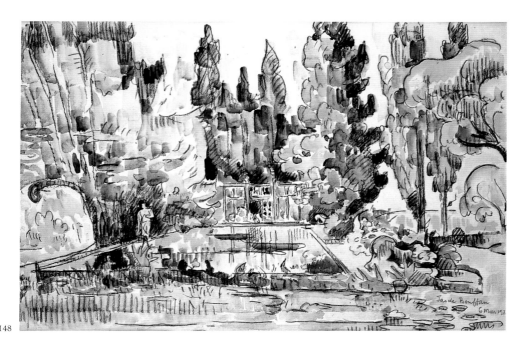

148

148. THE POND AT JAS DE BOUFFAN,
1920
Watercolor and graphite, 11¾ x 17¾ in.
(30 x 45 cm)
Inscribed and dated, lower right: Jas de Bouffan
6 mai 1920
L'Annonciade, Musée de Saint-Tropez, Gift of
Ginette Signac, March 10, 1977 (1977.1.1)

Exhibited in Paris only

Like Stendhal, Signac cultivated the sites associated with the creative minds he admired. This large and highly finished watercolor commemorates his visit to Jas de Bouffan, the Cézanne family home. The circumstances of this pilgrimage are unknown. Although it was no longer the property of the Cézanne family, the estate was more or less intact and still preserved the motifs of the master of Aix-en-Provence. In a moving tribute to his revered precursor, Signac, then nearing sixty, seems to have even worked in a style closely related to that of Cézanne's watercolors. In a similar spirit he rendered homage to Van Gogh at the end of his life (cat. nos. 180, 181). AD

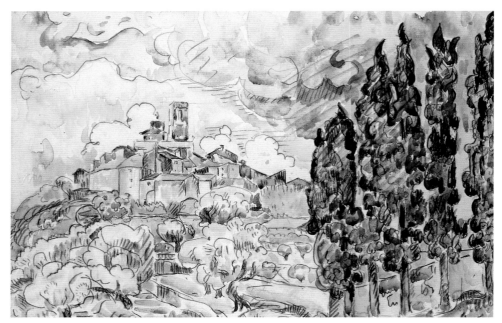

149

149. SAINT-PAUL-DE-VENCE, 1921
Watercolor and graphite, 11⅝ x 17⅜ in.
(29.5 x 44 cm)
L'Annonciade, Musée de Saint-Tropez,
Grammont Bequest, 1956 (AM 2 135d; 1955-1-2)

Exhibited in Paris only

Stylistically related to the watercolor done at Jas de Bouffan (cat. no. 148), this large, carefully composed drawing probably dates from Signac's first visit to this famous village between Cannes and Nice. Although he liked Saint-Paul, he did not stay there long, and we know of only one painting, dated 1923, with the village as a subject (FC 561). AD

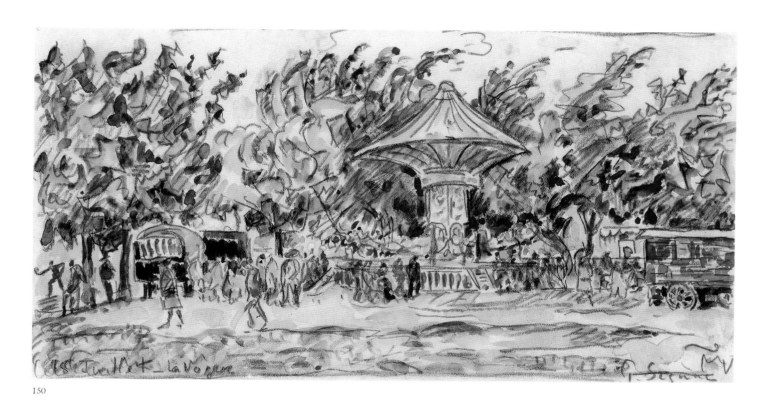

150

150. VILLAGE FESTIVAL (LA VOGUE),
ca. 1920
Watercolor and black crayon, 6 x 11¼ in.
(15.3 x 28.7 cm)
Signed, lower right: P. Signac; inscribed and dated, lower left: 18 Juillet – La Vogue
The Metropolitan Museum of Art, New York,
Maria DeWitt Jesup Fund, 1951; acquired from
The Museum of Modern Art, New York,
Anonymous gift (55.21.6)

Exhibited in Amsterdam and New York

Signac's use of a looser, seemingly more sponta-neous technique serves as a fitting complement to the flurry of activity recorded in this lively view

of a village festival. He inscribed "18 Juillet – La Vogue" in the lower left, indicating that the festival commemorates a saint's day, which, in some departments of the Midi, was known as a *vogue*.[1] Thus, Signac's inscription locates the scene in the south of France. The foliage, which serves as a backdrop to the fair's attractions, is densely rendered in opaque touches of dark green and blue, in contrast to the figures, which are summarily sketched in the foreground. KCG

NOTE
1 Pierre Larousse, *Grand dictionnaire universel du XIXe siècle* (Paris, 1866–90[?]), vol. 15, p. 1145.

151. BLESSING OF THE TUNA BOATS, GROIX, 1923
Oil on canvas, 28¼ x 35½ in. (73 x 90.3 cm)
Signed, lower left: P. Signac
Minneapolis Institute of Arts, The William Hood Dunwoody Fund, the John R. Derlip Fund and Gift of Bernice (Mrs. John S.) Dalrymple (62.36)
FC 562 (*La Bénédiction des thoniers. Groix*)

Exhibitions: Paris 1924, Salon des Indépendants, no. 2810, *Thoniers à Groix*; Paris 1925, Galerie Druet, no. 153, *Grand Pavois*; Paris 1930, Galerie Bernheim-Jeune, no. 39, *La Bénédiction des thoniers à Groix*; Paris 1934, Petit-Palais, *La Thoniers à Groix*, 1924 (à H. Exteens)

"It was marvelous at Groix, the preparation and departure of the tuna boats. I was like a crazy kid, on the lookout at the tip of the jetty from morning to night. But with the evenings came the backlash; I no longer had the strength to open my mouth. It was a rough hunt; but I have many trophies."[1] The inhabitants of the small island of Groix, off the coast at Lorient, still make their living from fishing. The neighboring town, Port-Tudy, was long one of the major tuna-fishing ports of Brittany. Signac was fascinated by the colorful sails and long, flexible fishing poles of the tuna boats and never tired of painting them at Concarneau, La Rochelle, or Groix. In working from the motif, he relied on pencil and watercolor to record his observations of the boats dear to him, as we can see, for example, in a watercolor that once belonged to Monet and that bears an inscription in Signac's hand: "Departure 3rd day June 28" (Musée Marmottan, Paris, no. 5032).

Here the boats are decorated for a celebration at sea. Their bright colors and windblown banners imbue the scene with a considerable liveliness. Although this view of Groix lacks the grandeur of the great ports Signac painted in the manner of Claude Lorrain, the originality of its composition is seductive: the boats, moored side by side, are seen head-on, an unusual point of view.

This compact and colorful work drew the attention of Claude Roger-Marx at the Salon des Indépendants in 1924: "One has to search a long time to find one of the best pictures in the Salon, [and] one of the most recent, *Blessing of Tuna Boats, Groix*, by Signac. Like insects with raised antennae, the boats with their long poles seem to be pumping the azure sky. The sun and wind dance in the banners. What a serene will must have presided over the composition of such a painting! Are there many others here that were painted with such joy?"[2] MFB

NOTES
1 Letter from Signac to Félix Fénéon, July 13, 1923, Signac Archives.
2 Roger-Marx 1924, p. 3.

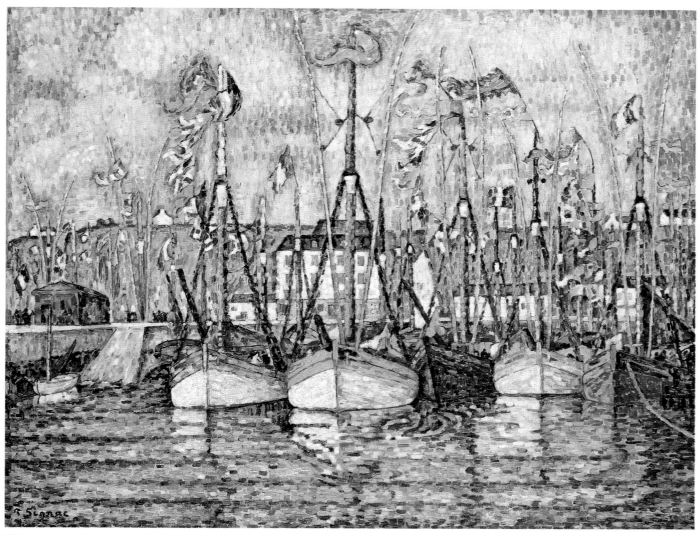

151

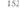

152. THE LIGHTHOUSE, GROIX, 1925
Oil on canvas, 29⅛ x 36⅜ in. (74 x 92.4 cm)
Signed and dated, lower left: P. Signac 1925
The Metropolitan Museum of Art, New York,
Partial and Promised Gift of Mr. and Mrs.
Douglas Dillon, 1998 (1998.412.3)
FC 568 (*Le Phare. Groix*)

Exhibition: Paris 1930, Galerie Bernheim-Jeune,
no. 41, *Le Phare. Groix*

Exhibited in Amsterdam and New York

Here, Signac's subject is the lighthouse of the
small port of Groix, framed by tuna boats with
gracefully curved fishing poles that form a per-
fect arch. The sea and sky are pink and blue; the
colored sails are drying; and the flags indicate
that preparations for a celebration are under way.
It is evening, and a tuna boat returns to port
under full sail.

The preparatory drawing for this canvas shows
that this tuna boat was originally depicted in pro-
file and offshore (cat. no. 153). For this definitive
version Signac found a more dynamic and har-
monious solution. The diagonals of the masts
and poles contribute a welcome movement to a
composition otherwise dominated by horizontals
and verticals, while uniting the larger masses in
a natural way. MFB

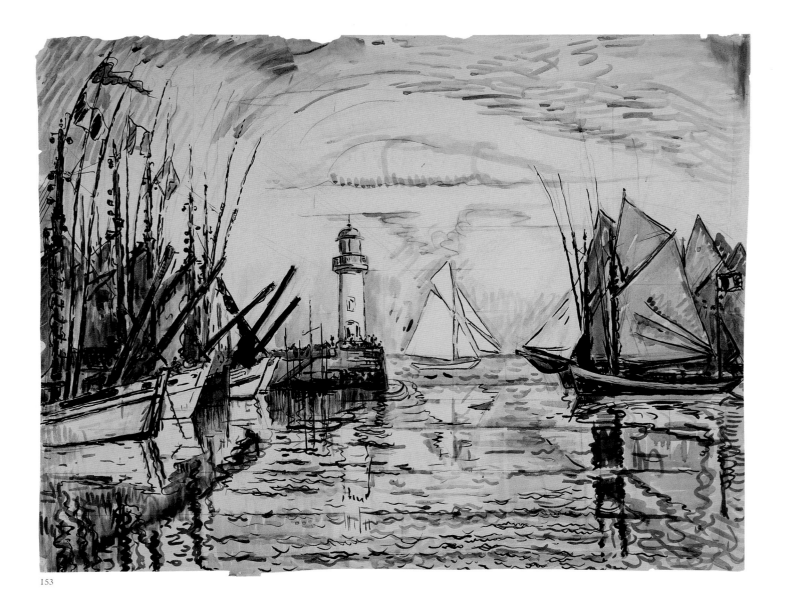

153

153. THE LIGHTHOUSE, GROIX, 1925
India ink wash, 28¼ x 35½ in. (71.6 x 89.8 cm)
Arkansas Arts Center Foundation Collection,
Little Rock, Gift of James T. Dyke, 1999
(99.065.059)

Exhibited in Amsterdam and New York

This large wash drawing of tuna boats and the lighthouse at the entrance of the harbor of Port-Tudy at Groix served as a full-scale study for the painting of 1925 (cat. no. 152); traces of penciled grid lines, used to transfer the study to canvas, are visible. In the painting, however, Signac altered the position of the boat to the right of the lighthouse; no longer parallel to the horizon, the vessel approaches the harbor, its poles dramatically lowered. KCG

154. CONCARNEAU, ca. 1925
Watercolor and black chalk, 11 x 15¾ in.
(27.8 x 40.1 cm)
Signed and inscribed: P. Signac Concarneau
The Metropolitan Museum of Art, New York,
Bequest of Miss Adelaide Milton de Groot
(1876–1967), 1967 (67.187.36)

Exhibited in Amsterdam and New York

Signac discovered the Breton port of Concarneau
in 1891; that same year he executed a series of five
paintings of the harbor, its placid water rhythmi-
cally punctuated by fishing boats (cat. nos. 54–56).
Concarneau, renowned for its sardine and tuna
fishing, established itself as an artists' colony in
the later nineteenth century, and the tradition
persisted well into the twentieth century. The
1926 Blue Guide notes of Concarneau: "a curious
old walled town and sardine-fishing port, pic-
turesquely situated on the Baie de la Forêt, attracts
many artists."[1] Signac, who returned to the port

several times in the 1920s, appears, however, to
have been attracted more by its maritime aspect
than by its community of artists, writing from
Concarneau in 1924: "We have stopped off here to
see the tuna fishing boats. It is as wonderful as ever,
all the more so since all the painters have gone."[2]

This view of fishing boats along the quay,
whose style suggests a date of about 1925, appears
to have been rapidly executed with color applied
in thin, almost transparent washes, thereby leaving
much of the paper reserve exposed. Signac's tech-
nique led a contemporary critic to characterize
his watercolors as "above all drawings."[3] KCG

NOTES
1 *The Blue Guides: North-western France,* Findlay Muirhead
 and Marcel Monmarché, eds. (London, 1926), p. 198.
2 Letter from Signac to Gabriel Fournier, Septem-
 ber 23, 1924, in London 1986, p. 48.
3 Deshairs 1921, p. 14.

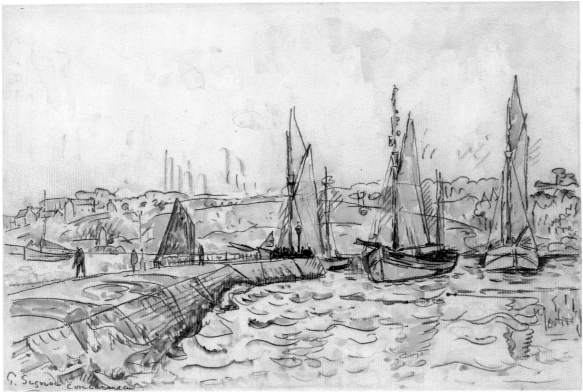

154

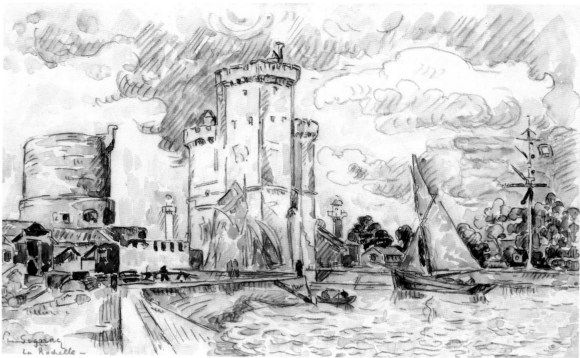

155

155. LA ROCHELLE, ca. 1920–28
Watercolor and graphite, 10⅛ x 15⅞ in.
(25.7 x 40.2 cm)
Signed and inscribed, lower left: P. Signac
La Rochelle
The Metropolitan Museum of Art, New York,
Robert Lehman Collection, 1975 (1975.1.721)

Exhibited in Amsterdam and New York

Following his discovery of La Rochelle in 1911, Signac returned on numerous occasions; his last group of paintings of this site date from 1928. Asked in 1922 why he painted La Rochelle so often, Signac is said to have replied: "I go there for the boats: for the color of the hulls and the sails. A magnificent sight! They come from all over to sell fish, it's like a library of boats."[1] Here the boats' sails, rendered in vivid orange and yellow stains, stand out against the cool gray blue of the sky and ocean. Signac's views of La Rochelle were admired by his contemporaries. One commentator remarked: "La Rochelle where sails of every color and every country glide and intersect . . . one hears the lapping of the shimmering water; light streams everywhere."[2] Although undated, this watercolor is stylistically similar to scenes of La Rochelle from the mid-1920s. It was once owned by Gaston Lévy.[3] KCG

NOTES
1 Paillard 1922, p. 1.
2 Deshairs 1921, p. 11.
3 Sold at auction by Lévy's heir and purchased by Robert Lehman; see Paris 1952, no. 22.

156. THE BRIDGE, LÉZARDRIEUX, 1925

India ink wash, 28⅞ x 36¼ in. (73.4 x 92 cm)
Arkansas Arts Center Foundation Collection,
Little Rock, Gift of James T. Dyke, 1999
(99.065.058)

Exhibited in Amsterdam and New York

For several months a year during the mid- to late
1920s, Signac rented a house in the village of
Lézardrieux, located along the Trieux River in
northern Brittany. Signac was doubtless attracted
by the "magnificent scenery" along the river.[1]
This view of the viaduct spanning the Trieux at
Lézardrieux is the final, full-scale study for a
painting of 1925, *Bridge, Lézardrieux* (FC 567; private
collection). Done in india ink using a Japanese
brush, the study is marked by the boldness of
its design and the freedom of its execution.
When Signac exhibited a group of his pre-
paratory cartoons for the first time in 1911,
the critic Guillaume Apollinaire praised them
as "very beautiful drawings, broadly executed
and well composed."[2] KCG

NOTES
1 *Guides-Joanne, Bretagne* 1914, p. 235.
2 Apollinaire 1911a, translated in Apollinaire 1972, p. 133.

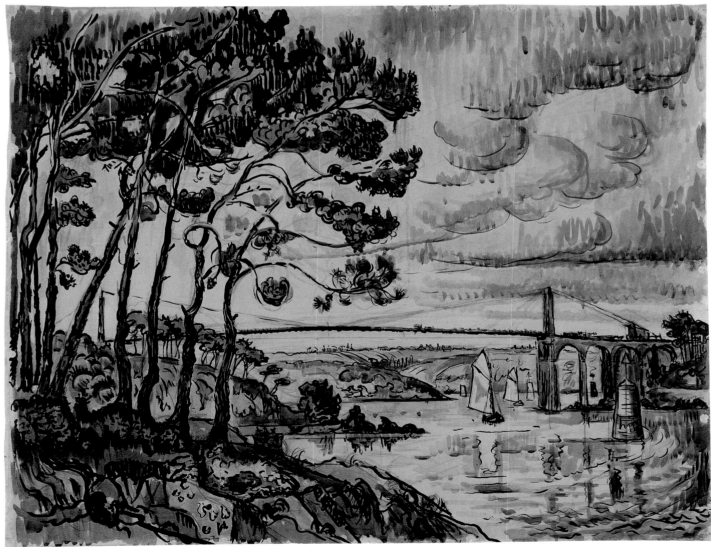

156

157. LÉZARDRIEUX, ca. 1927
Watercolor and graphite, 10⅛ x 16⅛ in.
(25.7 x 41 cm)
Signed, lower right: P. Signac
Private collection

Exhibited in Paris only

157

**158. FLOOD AT THE PONT ROYAL,
PARIS,** 1926
Oil on canvas, 35 x 45⅝ in. (89 x 116 cm)
Signed and dated, lower right: P. Signac 1926
Private collection
FC 572 (*Le Pont Royal. Inondations [Paris]*)

Exhibitions: Paris 1926, Salon des Indépendants,
no. 3325, *Inondations Pont Royal;* Paris 1933–34,
Galerie Beaux-Arts, no. 94, *Le Pont Royal pendant
les inondations*

Over the years bridges became one of Signac's
favorite subjects. He liked to frame his views of
ports and rivers with solid architectural elements,
opposing the motion of sea, sky, and reflections
with the stable forms of a wharf, lighthouse, or
tower. The artist first depicted a bridge in the
early years of Neo-Impressionism (FC 141 and cat.

no. 28). His choice was the bridge at Asnières,
which reappeared in a 1900 sketch for his proposed
decoration of the town hall of Asnières (FC 357).
At the turn of the century bridges and viaducts
can be seen more frequently: *Bellevue; Viaduct,
Auteuil; Bridge, Auxerre; Footbridge, Debilly;* and the
Pont Mirabeau (FC 326, 352, 380, 386, 389). Steel
bridges are a leitmotif in the series of views of
Rotterdam from 1906 and 1907 (see cat. no. 119).

The flood of 1910 gave Signac the opportunity
to paint a series of watercolors devoted to the
bridges of Paris, which was exhibited in the next
year at the Galerie Bernheim-Jeune.[1] From then
on, Signac regularly painted the bridges of Paris,
choosing both older and more up-to-date con-
structions. He was partial to the steel framework
of the Pont des Arts and the venerable stone
arches of the Pont Neuf, which he painted twice

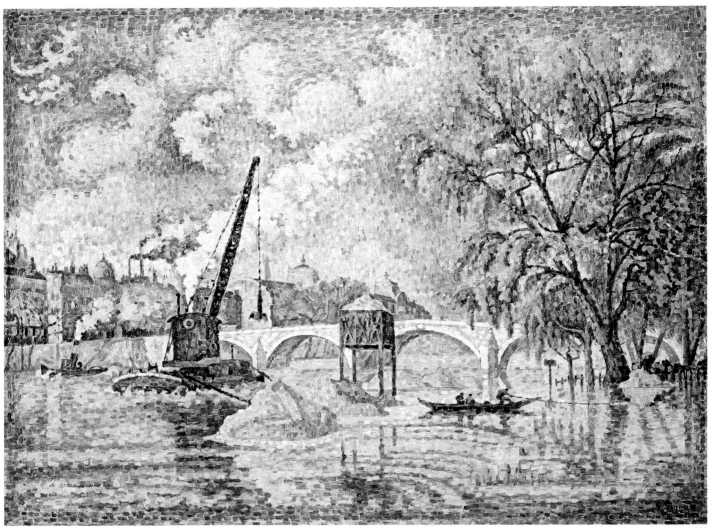

in 1928 in an exceptional elongated horizontal format (FC 582, 583). He painted the bridges of Lézardrieux, Bourg-Saint-Andéol, and Viviers in the 1920s, but his last works were devoted to Parisian bridges: the footbridge over the Canal Saint-Martin celebrated in Marcel Carné's film *Hôtel du Nord*, the Pont Marie, the Pont Saint-Michel (Île de la Cité), and lastly the Pont Neuf.

The present version of the Pont Royal shows the riverbanks flooded in autumn. (As he often did after World War I, Signac took this subject up again in 1929–30 in *Autumn, Pont Royal* [FC 591]). Here the Seine has overflowed its banks and is separated from the sky only by the bridge and facades on the quay, which are seen through the steam of a tugboat. At the left can be seen the silhouette of the Gare d'Orsay, the former train station that today, as the Musée d'Orsay, houses one of the most important collections of Signac's works. The composition is dominated by the broad, fluid masses of clouds, smoke, and reflections. Like the riverbanks, the pillars of the bridge have all but vanished underwater, and the arches spring lightly over the water surface. The partially submerged trunk of a chestnut tree creates a similar effect of lightness and movement. The piles of sand in the foreground seem about to dissolve in the rush of the current, while the clouds in the sky blend with the smoke from the factories. This scene has an almost Impressionist animation, and the sparkle of the bright colors creates an overall effect of vibrancy. Color plays a unifying role and gives the picture its density.

When this canvas was shown at the 1926 Salon des Indépendants, Neo-Impressionism was more than forty years old, and even if some wits still made cracks about colored "confetti,"[2] the movement had long been accepted and had become

part of history. Georges Turpin expressed the general sentiment when he noted, with a sincere if uninspired compliment: "Some fine Signacs, now accepted by everyone."[3] The art critic René-Jean was more sensitive to the brilliance of the work: "Do not think that his *Flood at the Pont Royal* is gloomy or sad. It is sparkling and magnificent. The smoke and mist have been turned into fireworks by M. Signac's passion."[4] MFB

NOTES
1 "Les Ponts de Paris," Galerie Bernheim-Jeune, Paris, January 23–February 1, 1911; sixty-six watercolors of the bridges of Paris, eight oil sketches, and five paintings.
2 Pawlowski 1926, p. 4.
3 Turpin 1926, pp. 1–2.
4 René-Jean 1926, pp. 1–2.

159. TUGBOAT AT THE PONT NEUF, PARIS, 1923

Watercolor and graphite, 10⅛ x 16 in. (25.7 x 40.6 cm)
Signed, inscribed, and dated, lower right: P. Signac Paris 1923
The Metropolitan Museum of Art, New York, Robert Lehman Collection, 1975 (1975.1.717)

Exhibited in Amsterdam and New York

Signac's studio on the rue de l'Abbaye was within walking distance of the Pont Neuf, one of the painter's favorite Parisian motifs. The oldest bridge in Paris, built in two sections between 1578 and 1604, the Pont Neuf connects both banks of the Seine to the Île de la Cité. Signac's view from the Right Bank concentrates on the buildings along the quai des Orfèvres and includes part of the eighteenth-century bathhouse Le Vert-Galant (no longer extant), which extended into the Seine. In 1911 he exhibited a group of paintings and watercolors entitled "Ponts de Paris" (Bridges of Paris), leading the poet and art critic Guillaume Apollinaire to exclaim, "After all, are the Seine and its bridges not the most beautiful things in Paris?"[1]

This work was formerly owned by Signac's friend and patron Gaston Lévy and was purchased from the collection of Lévy's daughter, Mme Andrée Samama, by Robert Lehman in 1952.[2] KCG

NOTES
1 Apollinaire 1911a, in Apollinaire 1972, p. 133.
2 Paris 1952, no. 32.

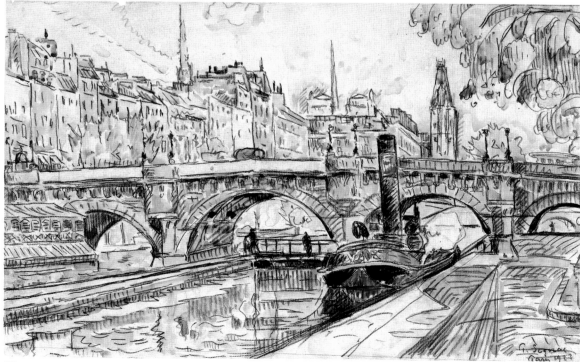

159

160. THE CHEVET OF NOTRE-DAME-
DE-PARIS, ca. 1925
Watercolor and graphite, 9⅝ x 7⅛ in.
(24.4 x 18.2 cm)
Signed in graphite, lower left: Paul Signac
Musée des Beaux-Arts et d'Archéologie,
Besançon, Gift of George and Adèle Besson,
1965 (AM 2921 D 23)

Exhibited in Paris only

This little watercolor is difficult to date with pre-
cision because Signac so often returned to his
favorite spots in Paris after 1900. The now-familiar
subject, endlessly depicted by artists since the
nineteenth century, is nonetheless noteworthy
because of the spontaneous handling and the won-
derful balance between movement and fixity. AD

160

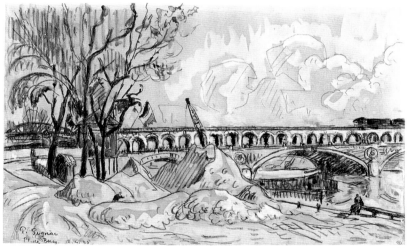

161

161. THE VIADUCT AT THE
PONT DE BERCY, 1925
Watercolor and graphite, 11 x 17½ in.
(28 x 44.3 cm)
Signed, inscribed, and dated, lower left:
P. Signac Pt de Bercy 12.4.25
Musée du Louvre, Département des Arts
Graphiques, Fonds du Musée d'Orsay, Paris,
Gift of André Berthellemy, 1943 (RF 40 183)

Exhibited in Paris only

The bridges of Paris were among Signac's
favorite motifs—so much so that a thematic exhi-
bition was held at the Galerie Bernheim-Jeune as
early as 1911. All types of bridges, both old and
new, were depicted in a variety of mediums
(drawing, watercolor, oils). Here Signac seems to
have returned to one of his earlier subjects from
Asnières and Clichy, namely, the impact of mod-
ern industry on the urban landscape. Although
the densely spaced arches of this bridge can be
seen in other drawings, Signac never depicted
them in a painting. AD

162. THE PONT NEUF, PARIS, 1928

Watercolor and graphite, 11 x 17 in. (27.8 x 43.2 cm)
Signed and dated, lower left: P. Signac 1928
The Metropolitan Museum of Art, New York, Robert Lehman Collection, 1975 (1975.1.713)

Exhibited in Amsterdam and New York

Here the Pont Neuf's *petit bras* (short arm) joins the Left Bank of the Seine to the Île de la Cité, with its imposing buildings and the equestrian statue of Henri IV. This work echoes an image evoked in Zola's *L'Oeuvre*, a novel that Signac originally read on its publication in *Gil Blas* in 1886: "What occupied the center of this vast picture, rising from the river-level and towering high into the sky, was the Cité, the prow of the ancient ship, for ever gilded by the setting sun. Below, the poplars on the terrace raised a powerful mass of greenery, completely hiding the statue on the bridge."[1] In contrast to Zola's "ancient ship," the tugboat in Signac's watercolor offers an element of modernity, underscoring the fusion of past and present characteristic of his Seine imagery.

This motif preoccupied Signac in 1928, the year in which he painted both the Pont Neuf and the Pont des Arts (FC 582, 583). This work was formerly owned by Gaston Lévy.[2] KCG

NOTES
1 Zola 1968, p. 215.
2 Sold at auction by Lévy's heir and purchased by Robert Lehman; see Paris 1952, no. 28.

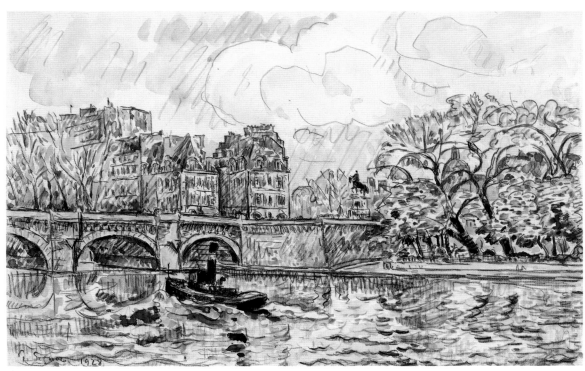

162

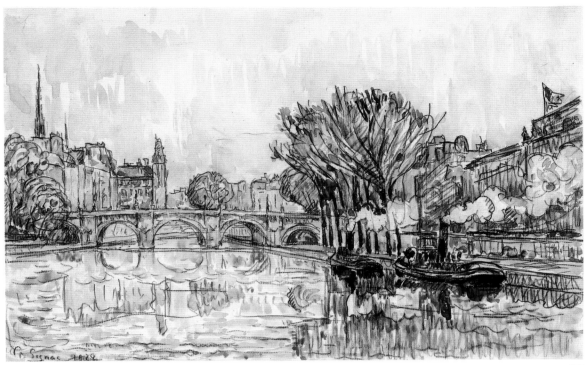

163

163. THE PONT NEUF, PARIS, 1928
Watercolor and graphite, 10⅞ x 17 in.
(27.3 x 43.3 cm)
Signed and dated, lower left: P. Signac 1928
The Metropolitan Museum of Art, New York,
Robert Lehman Collection, 1975 (1975.1.716)

Exhibited in Amsterdam and New York

In a 1921 article on Signac's watercolors, Léon
Deshairs aptly observed Signac's lifelong attrac-
tion to the Seine as a motif: "In Paris it is the
Seine that calls him and holds him, and he finds
the most delicate shades on his palette to express
the mobility of its wakes, the airiness of the
bridges dissolved in the mist, the softness of the
sky in which the towers and spires of the Cité
rise."[1] In particular, the Pont Neuf recurs in

Signac's oeuvre; his first paintings of the bridge
date from 1913. This watercolor, executed in 1928,
possibly served as a study for *Garden, Le Vert-Galant*
(FC 583; private collection), a view of the two sec-
tions of the bridge bisecting the Île de la Cité.
In both works Signac assumes a vantage point
from the Pont des Arts, looking upstream. How-
ever, in the watercolor, whose view is limited to
the short arm of the bridge, the island does not
play a central role, while the Hôtel des Monnaies
along the Left Bank figures more prominently in
the composition. This work was formerly in the
collection of Gaston Lévy.[2] KCG

NOTES
1 Deshairs 1921, p. 12.
2 Sold at auction by Lévy's heir and purchased by
 Robert Lehman; see Paris 1952, no. 44.

**164. THE PONT ROYAL WITH THE
GARE D'ORSAY, PARIS**, ca. 1929–30
Watercolor and graphite, 11⅜ x 17 in.
(28.9 x 43.2 cm)
Signed, lower left: P. Signac
The Metropolitan Museum of Art, New York,
Robert Lehman Collection, 1975 (1975.1.714)

Exhibited in Amsterdam and New York

Signac's images of the Seine record the pictur-
esque beauty of its bridges and quays as well as
signs of modern industry. This view of the Pont
Royal, a Parisian landmark since its completion in
1689, encompasses the Gare d'Orsay (built in 1900),
its mansard roof seen in the distance on the Left
Bank, and a steaming tugboat passing beneath an
arch of the bridge. The brightly colored fall
foliage of the trees on the Right Bank—Signac's
vantage point—is reflected in the pool of water

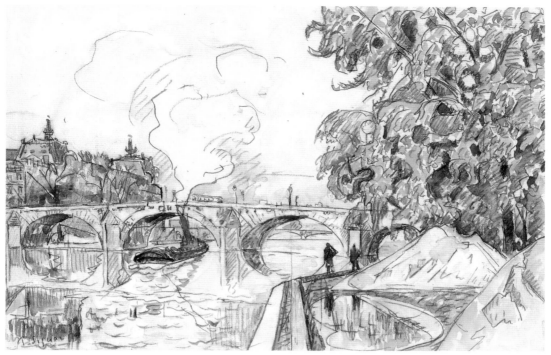

164

formed between two heaps of gravel in the foreground. This work served as a preparatory study for the painting *Autumn, Pont Royal* of 1929–30

(FC 591); in the lower left corner of the composition, traces of color notations, which correspond to the colors of the painting, are visible. KCG

165. FLOOD AT THE PONT DES ARTS, PARIS, 1931

Watercolor and graphite, 10⅞ x 17⅛ in.
(27.5 x 43.5 cm)
Signed and dated, lower left: Paul Signac
13 mars 1931
Musée du Louvre, Département des Arts
Graphiques, Fonds du Musée d'Orsay, Paris,
Gift of the artist, 1933 (RF 40 181)

Exhibited in Paris only

The spectacular flood of the Seine in the spring of 1931 inspired a series of works showing the flooded embankments and bridges. This view of the old footbridge (the arches have since been modified) highlights the impressive mass of the department store La Samaritaine. AD

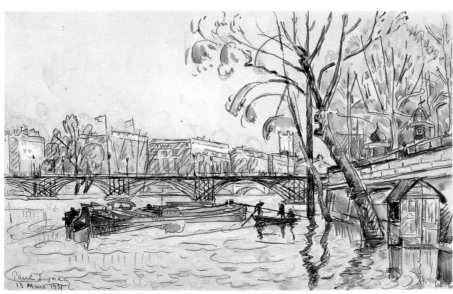

165

166. BOURG-SAINT-ANDÉOL, 1926
Watercolor and graphite, 10⅛ x 15¾ in.
(25.8 x 40 cm)
Inscribed, dated, and signed, lower right:
Bourg St. Andéol 1926 P. Signac
Arkansas Arts Center Foundation Collection,
Little Rock, Gift of James T. Dyke, 1999
(99.065.064)

Exhibited in Amsterdam and New York

Signac spent the spring and summer of 1926 at
Bourg-Saint-Andéol, a picturesque town in the
Rhone Valley. This is possibly a view of the rue
du Rhône, which leads to the Romanesque church
of Saint-Andéol.[1] The work retains the immedi-
acy and spontaneity of a plein air sketch, rapidly
outlined in graphite overlaid with thin washes of
color. Signac's interest in the Rhone Valley might
well have been stimulated by his passion for the
works of Stendhal, who describes his travels in
this region in *Mémoires d'un touriste* (1838). In a letter
to Fénéon of April 15, 1926, Signac wrote, "I am
making sketches along the Rhone for an illustra-
tion in the pages of *Mémoires d'un touriste* devoted
to this region."[2] The following year, three of his
lithographs appeared as illustrations for a reprint
of the second volume of Stendhal's work, pub-
lished by Éditions Crès.[3]

 The present work was once part of the Lévy
collection. KCG

NOTES
1 Ferretti-Bocquillon in Little Rock 2000, p. 83.
2 Letter from Signac to Félix Fénéon, April 15, 1926,
 Signac Archives.
3 See KW 25–27.

167. THE MARKET, TRÉGUIER, 1927
Watercolor and graphite, 10⅞ x 15½ in.
(27.5 x 39.5 cm)
Signed, lower right: P. Signac; inscribed and
dated, lower right: Tréguier 3 Aout 27
Arkansas Arts Center Foundation Collection,
Little Rock, Gift of James T. Dyke, 1999
(99.065.074)

Exhibited in Amsterdam and New York

In the summer of 1927 Signac executed several
watercolor views of Tréguier, a cathedral town in
northern Brittany. This view of the crowded mar-
ket on the place du Martray on a gray, rainy day
is animated by the brightly colored awnings of
the market stalls at the base of the Gothic cathe-
dral of Saint-Tugdual, whose imposing facade
anchors the composition. Juxtaposing past with
present, Signac depicts the gas pump and the
blue-and-gold Citroën sign denoting the garage
beside the cathedral's entrance.[1] The present work
was once part of the Lévy collection. KCG

NOTE
1 Ferretti-Bocquillon in Little Rock 2000, no. 81, p. 89.

166

167

168

168. THE TOWER, VIVIERS, 1928
Watercolor and graphite, 11⅝ x 15¾ in.
(29.5 x 40 cm)
Signed, lower right: P. Signac; inscribed and
dated, lower left: Viviers 31 Juillet 28
Arkansas Arts Center Foundation Collection,
Little Rock, Gift of James T. Dyke, 1999
(99.065.087)

Exhibited in Amsterdam and New York

Signac spent the summers of 1928 and 1930 in
Viviers, a medieval town in the Rhone Valley,
which he described as "very picturesque—a more
ornate and less somber Saint-Paul [-de-Vence]."[1]
This view focuses on the crenellated clock tower,
one of a group of towers along the lower town's
ramparts; seen from a closer vantage point, it
appears in a later watercolor that Signac made
on his return to Viviers in 1930.[2] This work
once belonged to André Lévy, Gaston Lévy's
brother. KCG

NOTES
1 Letter from Signac to Gabriel Fournier, August 21,
 1928, in London 1986, p. 68. They had been neigh-
 bors in Saint-Paul-de-Vence.
2 See London 1986, no. 68: *Viviers*, 1930.

169

169. FISHING BOATS, LE POULIGUEN, 1928

Watercolor and graphite, 10⅞ x 17 in.
(27.5 x 43.3 cm)
Signed, inscribed, and dated, lower left:
P. Signac Le Pouliguen 5 Aout 28
The Metropolitan Museum of Art, New York,
Robert Lehman Collection, 1975 (1975.1.718)

Exhibited in Amsterdam and New York

An old fishing port that became a popular seaside resort in the mid-nineteenth century, Le Pouliguen adjoins the resort of La Baule, where Signac was a guest of Gaston Lévy, the original owner of this work, in August 1928.[1] Signac visited Le Pouliguen several times that August, as the existence of several dated watercolors attests. In this view, dated August 5, boats moored in the yachting harbor create a sweeping sense of movement across the composition; only the steeple of the Gothic chapel breaks the horizontal alignment of boats and buildings along the shore. Signac executed another watercolor from the same vantage point less than a week later, which he presented to his hostess, Mme Lévy.[2] Le Pouliguen subsequently figured in Signac's Ports of France series of watercolors dating from 1929 to 1931. KCG

NOTES
1 Sold at auction by Lévy's heir and purchased by Robert Lehman; see Paris 1952, no. 26.
2 See Ferretti-Bocquillon in Little Rock 2000, no. 92.

170. LE CROISIC, 1928
Watercolor and graphite, 9⅞ x 16 in.
(25 x 40.8 cm)
Signed, inscribed, and dated in graphite, lower
right: P. Signac 2 Aout 28 Le Croisic
The Metropolitan Museum of Art, New York,
Robert Lehman Collection, 1975 (1975.1.708)

Exhibited in Amsterdam and New York

In August 1928 Signac sojourned in La Baule,
a seaside resort in Brittany, staying with Gaston
Lévy, the first owner of this work.[1] From there
he traveled to Le Croisic on the tip of the
Guérande Peninsula, "a small maritime town,
picturesque, white, and clean, with old build-
ings."[2] The harbor, protected by an artificial
promontory, owes its distinctive, compartmen-
talized appearance to quays made of old deposits
of ballast. In this view Signac's treatment of the
sky, rendered with a minimum of color, illus-
trates his belief, as advocated in his book on
Jongkind, that "an overloaded watercolor is
a mistake."[3] KCG

NOTES
1 Sold at auction by Lévy's heir and purchased by
 Robert Lehman; see Paris 1952, no. 37.
2 *Guides-Joanne, Bretagne* 1914, p. 390.
3 Signac 1927, p. 115.

171. LE CROISIC, 1928
Watercolor and graphite, 10⅝ x 17 in.
(27.1 x 43.3 cm)
Signed, inscribed, and dated, lower left:
P. Signac Le Croisic 14 Aout 28.
The Metropolitan Museum of Art, New York,
Robert Lehman Collection, 1975 (1975.1.709)

Exhibited in Amsterdam and New York

Here Signac takes a vantage point on the oppo-
site side of the quay depicted in his watercolor
of August 2 (cat. no. 170). Signac juxtaposes the
multicolored reflections of the sails and build-
ings along the quay against the patches of blue
and green that denote the water's surface, and
following the tenets of Neo-Impressionism, he
rarely allows the colors to bleed into one another.
He would return to Le Croisic again in July 1929
while working on the Ports of France, a series
of watercolors commissioned by Gaston Lévy,
who also owned this work.[1] KCG

NOTE
1 Sold at auction by Lévy's heir and purchased by
 Robert Lehman; see Paris 1952, no. 23.

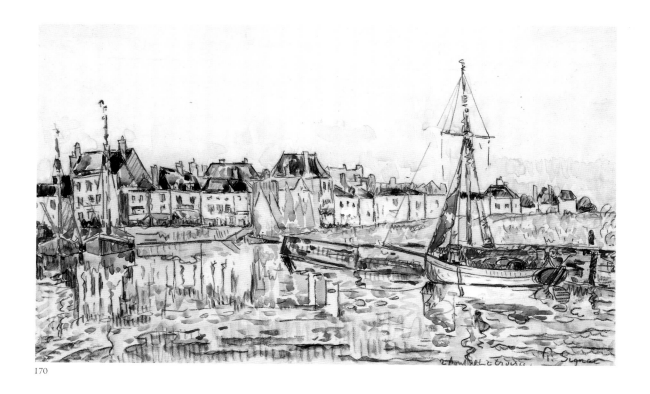

170

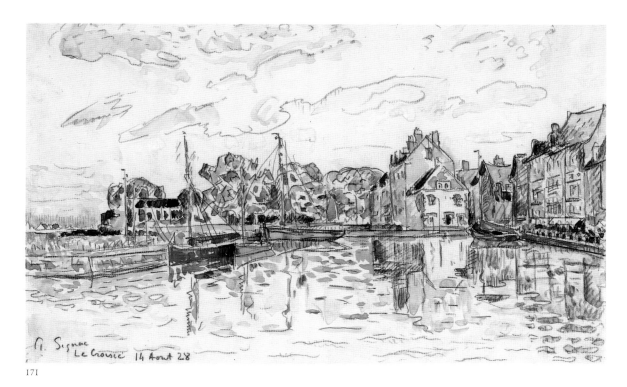

171

172. QUILLEBOEUF, ca. 1928

Watercolor and graphite, 9⅞ x 15¼ in.
(25.2 x 38.6 cm)
Signed and inscribed, lower left: P. Signac
Quilleboeuf
The Metropolitan Museum of Art, New York,
Robert Lehman Collection, 1975 (1975.1.719)

Exhibited in Amsterdam and New York

Quilleboeuf is a small fishing port located near the estuary of the Seine, a few miles east of Honfleur. The placid appearance of the fishing boats moored at the quay belies the navigational difficulties created by powerful currents and shifting sandbanks that make the Seine especially treacherous around Quilleboeuf. In Signac's composition the arrangement of the fishing boats, which recede following the diagonal of the shoreline, recalls the rhythmic placement of the fishing boats in his Concarneau series of 1891 (see cat. no. 56). Beyond, the enfilade of steamboats that balances the diagonal thrust of the foreground reveals Signac's enduring interest in compositional structure.[1] A view of Quilleboeuf done in 1930 also figures in Signac's series Ports of France, commissioned by Gaston Lévy, who owned the present work.[2] KCG

NOTES
1 Marina Ferretti-Bocquillon dates the work to approximately 1928.
2 Sold at auction by Lévy's heir and purchased by Robert Lehman; see Paris 1952, no. 33.

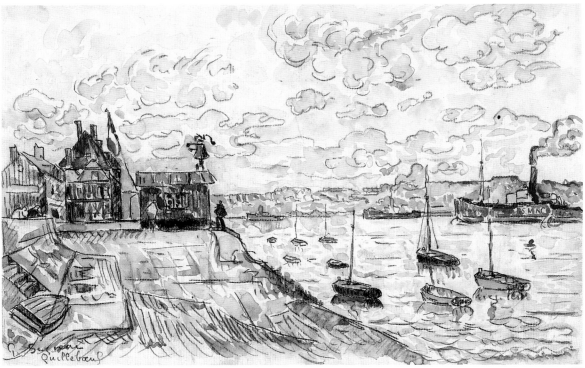

172

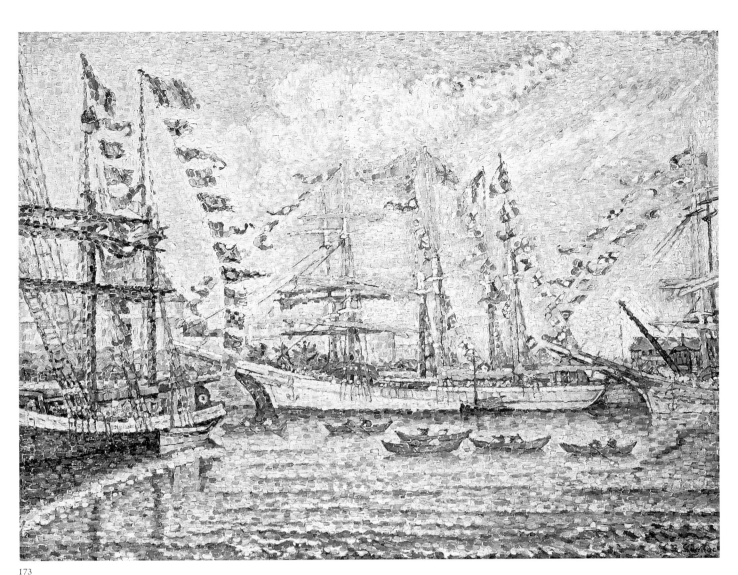

173

173. PARDON OF THE NEWFOUNDLANDERS, SAINT-MALO, 1928

Oil on canvas, 22⅞ x 28 in. (58 x 71 cm)
Signed and dated, lower right: P. Signac 1928
Musée d'histoire, Saint-Malo, Bequest of Guy
La Chambre, 1975 (75.4.2)
FC 587 *(Le Pardon des terre-neuvas [Saint-Malo])*

Exhibitions: Paris 1930, Galerie Bernheim-Jeune,
no. 53, *Le Pardon des Terre-Neuvas*; Paris 1934,
Petit-Palais, no. 39, *Le départ des Terre-neuvas*

Signac spent the early part of 1928 at Saint-Malo painting watercolors. Since 1925 he had regularly visited this seaport, in which life followed the rhythm of the Newfoundlanders (*terre-neuvas*), the three-masted schooners that sailed to Newfoundland (*Terre-Neuve*) to fish for cod. (The perilous ocean crossings and the danger of storms and icebergs provided the subject for Pierre

Loti's popular 1886 novel *Pêcheur d'Islande.*) Signac became more and more interested in the ships and their rigging, drew them incessantly, and noted their names: *Marie-Pauline, Lamotte Picquet, Minerve, Martin Pêcheur.*

The departure for Newfoundland took place in March and was preceded by a solemn ceremony of pardon (remission of sins). The return at the beginning of October was a much-awaited event, and winters were used to make the necessary repairs of broken masts, hulls damaged by icebergs, and flaking paint. Signac wrote from Saint-Malo on February 18, 1928, to his patron Gaston Lévy to tell him that he was painting like one possessed: "The ships are beautiful; with their sails and pennants, they will be magnificent."[1] On March 6 he attended the first day of the departure of the Newfoundlanders.[2]

The artist then finished two pictures begun in December and based on earlier studies: a boat

basin at Saint-Malo (FC 579) and *Return of the Newfoundlanders* (FC 580). In the summer, at his rented house in Viviers, Signac began work on *Departure of the Newfoundlanders* (FC 581) and the present work, as he informed Lévy, whom he hoped would visit him: "I am going to start two Saint-Malo pictures. I have taken up drawings done there and am looking for a composition." The canvases were in progress on July 19: "It is very difficult. I want one of them to be only light, nothing but color, almost no forms. They have bored us enough with their 'volume.' Let's leave that to Derain." On October 7 the pictures were not yet ready, and he told Lévy that he would finish them in Paris.[3]

He was back in Saint-Malo in 1930—"it was impossible to pass by Saint-Malo without dropping anchor. And then, I had to see the old friends back from the 'Grand Banks.' They are much more beautiful than when they left, corroded by the sea and salt; the hulls are veritable opals."[4] MFB

NOTES

1 Letter from Signac to Gaston Lévy, February 18, 1928, private collection.
2 Sketchbook, Musée de la Marine, Paris (R15d/42228); Signac was in Saint-Malo from February 2 until March 13, 1928; letter from Signac to Gaston Lévy, March 6, 1928, private collection.
3 Letters from Signac to Gaston Lévy, June 14, July 19, and October 7, 1928, private collection.
4 Letter from Signac to Gaston Lévy, 1930, private collection.

174. ÎLE-AUX-MOINES, 1929

Watercolor and graphite, 11 x 17 in.
(28 x 43.3 cm)
Arkansas Arts Center Foundation Collection, Little Rock, Gift of James T. Dyke, 1999
(99.065.090)

Exhibited in Amsterdam and New York

This work belongs to a series of watercolors representing the ports of France, commissioned in 1929 by the businessman and art collector Gaston Lévy. For the next three years Signac traveled to seaports along the French coast, his journey commemorated by a series of approximately one hundred watercolors. In May 1929 Signac executed this view of fishing boats in the harbor of Île-aux-Moines, the largest island in the Gulf of Morbihan. The alignment of the brightly colored boats recalls the composition of Van Gogh's *Fishing Boats on the Beach* (F 413; Van Gogh Museum, Amsterdam). Perhaps the relationship is not coincidental, as Van Gogh's painting had recently been shown in Paris in 1925 and again in 1927. The translucent washes of color on the boats' hulls reveal Signac's penciled color notations. This work, along with the other watercolors in Signac's Ports of France series of harbor views, remained unpublished until recently.[1] KCG

NOTE

1 On Signac's series, see Ferretti-Bocquillon in Little Rock 2000, pp. 26–29.

175. THE TUNA BOATS, GROIX, 1929

Watercolor and graphite, 10¼ x 17 in.
(26 x 43.2 cm)
Signed and inscribed, lower left: P. Signac Groix
Arkansas Arts Center Foundation Collection, Little Rock, Gift of James T. Dyke, 1999
(99.065.095)

Exhibited in Amsterdam and New York

Tuna boats were a distinctive feature of the port of Groix: "Disembarkation is on the coast facing the mainland, in a small harbor sheltered by two jetties, with a lighthouse on each. Notable are the multi-colored tuna boats, with their tall spars like antennae, which are used for the fishing lines."[1] This description from a 1914 guidebook was echoed in 1923 by the critic Roger-Marx, who compared the tuna boats in a painting by Signac to "insects with raised antennae."[2] The present watercolor belongs to the series Ports of France, which recalls Joseph Vernet's eighteenth-century serial depictions of French harbors; however, its bold composition, in which the horizontal alignment of the bows of the boats is countered by the rhythmic interplay of their riggings, reflects Signac's modern approach to his subject. KCG

NOTES

1 *Guides-Joanne, Bretagne* 1914, p. 499.
2 Roger-Marx 1924, p. 3.

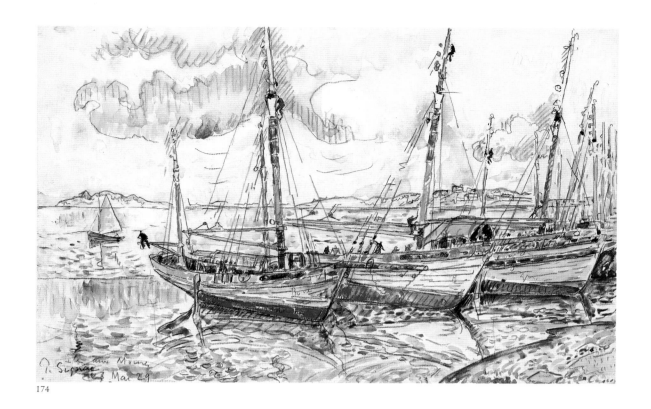

174

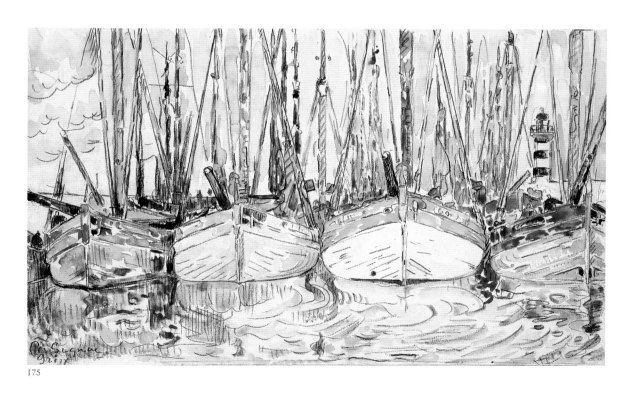

175

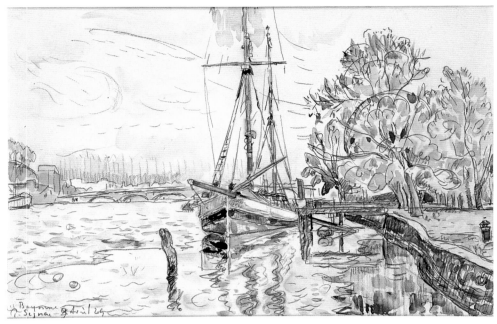

176. BAYONNE, 1929
Watercolor and graphite, 10⅜ x 17⅛ in.
(26.4 x 43.5 cm)
Inscribed, signed, and dated, lower left: Bayonne
P. Signac 9 avril 29
On back, small sketch and ink stamp of the art
dealer Jacques Rodriguès Henriquès, 20, Rue
Bonaparte, Paris 6ème with the penciled
notations: 1912 and 56-41
Musée du Louvre, Département des Arts
Graphiques, Paris, Gift of Norbert Ducrot-
Granderye in memory of his parents, Pierre and
Arlette Ducrot-Granderye, 1994 (RF 43 410)

Exhibited in Paris only

This view of the port of Bayonne was one of the
first watercolors done for the series of French
ports that Signac undertook in the spring of
1929 under the sponsorship of his collector
Gaston Lévy. Other examples from this series in
this exhibition are *Île-aux-Moines* (cat. no. 174)
and *The Tuna Boats, Groix* (cat. no. 175). AD

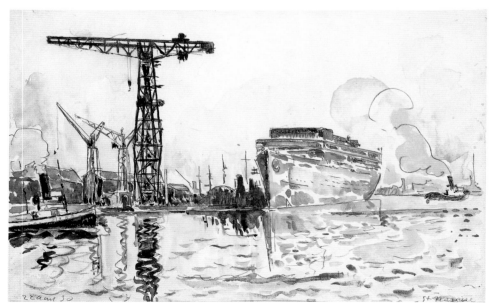

177. SAINT-NAZAIRE, 1930
Watercolor and graphite, 10⅞ x 17⅛ in.
(27.5 x 43.5 cm)
Dated, lower left: 22 août 1930; inscribed,
lower right: St Nazaire
Private collection

Exhibited in Paris only

Signac seems to have been concerned less with
depicting the topography of the site than
with indicating the unusual bulk of the cargo ship
that evokes the shipyards of Saint-Nazaire. AD

178

178. VIVIERS, 1930
Brown ink and brown wash, 11¾ x 17⅝ in.
(30 x 44.8 cm)
Signed, lower left: P. Signac; lower right: P. S.
Arkansas Arts Center Foundation Collection,
Little Rock, Gift of James T. Dyke, 1999
(99.065.101)

Exhibited in Amsterdam and New York

Traveling through the Rhone Valley in the summer
of 1930, Signac returned to Viviers, where he had
stayed in 1928. Signac's view of the skyline of the

old town, dominated by the cathedral of Saint-
Vincent, is closely related to another composi-
tion that is virtually identical in size and subject.[1]
The delicacy and lightness of touch of the pres-
ent work contrast with the other, more labored
drawing of this subject, as does the restrained use
of ink wash. This work was formerly in the col-
lection of Signac's son-in-law, Dr. Charles
Cachin. KCG

NOTE
1 See London 1986, no. 66.

179. THE PORT OF MARSEILLES, 1931
India ink wash and graphite, 29¼ x 35⅞ in.
(74.3 x 91.1 cm)
Arkansas Arts Center Foundation Collection,
Little Rock, Gift of James T. Dyke, 1999
(99.065.105)

Exhibited in Amsterdam and New York

This work is the final study for a painting of the
Mediterranean port of Marseilles (FC 594, *Canal
Junction, Marseilles*, 1931; location unknown), a site
that Signac had first painted in 1898. In this view
the canal leading to the Vieux Port of Marseilles
frames the basilica of Notre-Dame-de-la-Garde,

dramatically situated on a steep limestone peak
overlooking the harbor. Chronicling his visit of
1838, Stendhal wrote admiringly of a similar view
of the old city: "There are some attractive vistas,
looking either toward Notre-Dame-de-la-Garde
or to the sea."[1] Beneath the wash a network of
penciled lines reveals Signac's continued practice
of transposing such wash drawings to canvas,
which he had first adopted at the turn of
the century. KCG

NOTE
1 Stendhal 1932, vol. 3, p. 196.

179

180

181

180. VAN GOGH'S HOUSE, ARLES, 1933
Watercolor and graphite, 10⅞ x 15¾ in.
(27.5 x 40 cm)
Dated and inscribed, lower right: La Maison de
Van Gogh mai 1889–mai 1933–Arles
Private collection

Exhibited in Amsterdam and New York

181. VAN GOGH'S HOUSE, ARLES, 1935
Watercolor and graphite, 11 x 17⅜ in.
(28 x 44 cm)
Date and inscribed, lower right: Van Gogh–
9 août 35
Private collection

Exhibited in Paris only

These two watercolors done toward the very end
of the artist's life commemorate a memory
which evidently meant a great deal to Signac as
an artist and as a man: his visit to Van Gogh in
Arles in March 1889. The watercolor dated 1935
was probably done during his last trip to the
Midi and Corsica. Signac did not indulge in rem-
iniscing but recorded the modern appearance of
this mythical place, not without a certain nostal-
gia and with his usual dynamic accents. AD

182. AJACCIO, 1935

Watercolor and crayon, 11 x 16⅞ in. (28 x 43 cm)
Signed, dated, and inscribed, lower right:
P. Signac, Ajaccio, mai 35
Musée du Louvre, Département des Arts
Graphiques, Fonds du Musée d'Orsay, Paris,
Gift of Ginette Signac, 1964 (RF 31 432)

Exhibited in Paris only

In early 1935 Signac decided to sail for Corsica, which he had never seen: "From Saint-Tropez I had always planned to go there, but always put it off . . . it was too easy then. It would renew my repertoire of pictures, and I could use it."[1] He was in Ajaccio at the end of February and returned there in May–June after a brief stay in Paris. This was to be his last trip before his death, which came two months later. This strong and refined watercolor shows the artist's power and mastery even at the very end. AD

NOTE
1 Letter from Signac to Berthe Signac, Signac Archives.

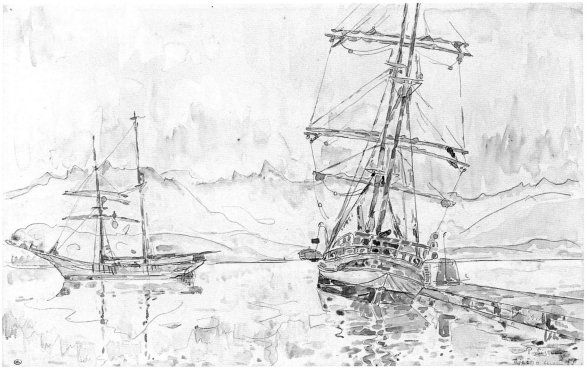

182

CHRONOLOGY

UNITED KINGDOM

London

NETHERLANDS
Volendam
Amsterdam
The Hague
Overschie • Rotterdam

Herblay
Seine River
Asnières • Clichy
Courbevoie
Paris

Maas River

Flushing

Calais • Dunkirk
Antwerp
Lille • Brussels
BELGIUM

English Channel

Dieppe
Barfleur
Le Havre
Port-en-Bessin Quilleboeuf
Honfleur • Rouen
Bayeux Les Andelys
Tréguier Lézardrieux
Paimpol
St-Quay-Portrieux St-Malo
St-Cast
Brest St-Briac
Paris
Samois
Marne River

GERMANY

Concarneau
Lorient
Île-de-Groix Île-aux-Moines
Le Croisic St-Nazaire
Le Pouliguen Nantes
La Baule
Loire River
Seine River

SWITZERLAND

Les Sables-d'Olonne
La Rochelle
FRANCE
Geneva • Les Diablerets
Annecy
Lyons

ATLANTIC OCEAN

ITALY

Bordeaux
Comblat-le-Château
Garonne River
St-Julien-en-Beauchêne
Genoa
Viviers Capo di Noli
Bourg-St-Andéol
Sisteron
Castellane Nice Menton
Avignon St-Paul-de-Vence Monaco
Arles Antibes
Toulouse
Aix-en-Provence
Biarritz Bayonne Sète
St-Jean-de-Luz Marseilles Cassis St-Tropez

St-Florent
Île-Rousse

CORSICA

SPAIN MEDITERRANEAN SEA
Collioure
Ajaccio
Propriano

Rhone River

0 miles 120

Fig. 108. Principal sites in the works of Paul Signac

CHRONOLOGY

Adapted by Kathryn Calley Galitz from the chronology
by Marina Ferretti-Bocquillon in Cachin 2000

Edited and translated by M. E. D. Laing.

1863

NOVEMBER 11

Paul-Victor-Jules Signac is born to Jules-
Jean-Baptiste Signac (1839–1880), saddler
and harness maker, and his wife, Héloïse-
Anaïs-Eugénie, née Deudon (1842–1911),
in Paris, at 33 rue Vivienne (2nd arron-
dissement). Their apartment is above the
saddlery run by Jules Signac, who is in
business with his father. Jules Signac *père*
(1811–1889) and his wife live above the
second of the firm's two commercial
premises, 28 Grande Galerie, passage des
Panoramas (a shopping arcade adjacent to
the rue Vivienne with an entrance on the
boulevard Montmartre).

NOVEMBER 15

Paul Signac is baptized at Notre-Dame-des-
Victoires. His godparents are his paternal
grandfather and his maternal grandmother.

> Register of baptisms, Notre-Dame-des-
> Victoires, Archives de Paris, 1863/3419

1870–71

Franco-Prussian War and Siege of Paris.
Described by his father as a delicate child,
high-strung and impressionable, Paul

Signac is sent to Guise (Aisne), near Saint-
Quentin in northern France, to stay with
the Varlets, his maternal grandmother and
her second husband, until June 1871, when
his mother brings him back to Paris.

> Letter from the Signacs to M. Varlet;
> account of the war and siege by the artist's
> father, November 27, 1870; safe-conduct
> issued to Mme Signac, June 9, 1871,
> Signac Archives

1875

The family, with Jules Signac *père*, now a
widower, moves its living quarters to 12
avenue Frochot (9th arrondissement), a pri-
vate road at the corner of the boulevard de
Clichy and the place Pigalle in Montmartre,
a *quartier* with numerous artist's studios.

> Calepins du Cadastre, Archives de Paris,
> D1P4/472

1877–80

Signac is a pupil—listed as a boarder in his
second and third years—at the new Collège
Rollin in Montmartre, now the Lycée
Jacques Decour. There he meets the broth-
ers Charles and Eugène Torquet, future
writers.

> Archives of the Lycée Jacques Decour

1879

APRIL 10–MAY 11

Fourth Impressionist exhibition. Signac
is able to admire works by Caillebotte,
Cassatt, Degas, Forain, Monet, and
Pissarro, but nothing by Cézanne, Sisley,
or Renoir is included.

> For Signac's run-in with Gauguin, see note
> under April 1880.

1880

MARCH 17

Jules Signac, the artist's father, dies of
tuberculosis in Menton.

> Death certificate, Menton, Archives
> Municipales

In the coming months, the Signac busi-
ness at both its premises is sold, and
Mme Signac, with her son and father-
in-law, moves to a house in Asnières, a
residential suburb along the Seine north-
west of Paris, less than ten minutes by
train from the Saint-Lazare station. Its
popularity surged during the Second
Empire, attracting Parisians in search of
leisure activities, notably boating and
swimming.

APRIL 1–30

Fifth Impressionist exhibition. Works by Caillebotte, Degas, Gauguin, Guillaumin, Pissarro, and Raffaelli are shown, but Monet does not exhibit. Signac does sketches after a Degas and is shown the door by Gauguin, who tells him: "One does not copy here, sir."

> Besson 1935, p. 6; Rewald 1961, p. 440. This incident has been traditionally dated to 1879 on the basis of Besson, who states that it occurred "in 1879, rue des Pyramides." However, the 1879 Impressionist exhibition was held on the avenue de l'Opéra, and Gauguin, a last-minute addition, exhibited *hors catalogue*. The 1880 exhibition, which included eight works by Gauguin, took place at the rue des Pyramides. Rewald, disputing Besson's dating, assigns the encounter between Signac and Gauguin to 1880, a date that seems more likely given Gauguin's more prominent presence in 1880, the exhibition's venue, and the existence of other erroneous dates in Besson's monograph.

In the window of a hardware store selling artist's supplies at the corner of the rue Fontaine in Montmartre, Signac admires "a wonderful view of the Bas-Meudon" by Sisley, "for which they were asking 150 francs. I was sixteen at the time, and the little money I had was spent buying beers for the young ladies of the Brasserie Fontaine. Some of them used to pose for Manet and Degas." He advises his family, but in vain, to buy Impressionist paintings "in the name of glory and gold."

> Letter from Signac to Fénéon, September 9, 1933, Signac Archives; Cousturier 1922, p. 8

APRIL 8–30

Exhibition of new works by Manet in the offices of the journal *La Vie moderne*, 7 boulevard des Italiens.

JUNE

Exhibition of eighteen works by Monet in the offices of *La Vie moderne*. Signac is often to mention the significance of this one-man show in his choice of career, recalling also the effect of seeing reproductions of the paintings published in *La Vie moderne*.

> Guilbeaux 1911; Guenne 1925; Kunstler 1935, p. 4; see also letters from Signac to Monet, May 31, 1912, and to Bonnard, [June] 1933, quoted in the essay by Susan Stein in the present catalogue, at nn. 23, 77

SEPTEMBER 4

Settlement of the estate of Jules Signac, after liquidation of the business and realization of his share of the assets. His son,

Paul, under the legal guardianship of Héloïse Signac, 42bis rue de Paris, Asnières, is the sole heir.

> Registration of estates, Archives de Paris, DQ7/12412, no. 1078

OCTOBER 1

Signac, almost seventeen, enters—as a day boarder this time—the class of elementary mathematics at the Collège Rollin prior to taking his baccalaureate but leaves school after the first term. "My family wanted me to be an architect, but I preferred to draw on the banks of the Seine rather than in a studio at the École des Beaux-Arts."

> Kunstler 1935, p. 4

Signac begins painting and boating on the Seine. His first craft—of the thirty-two that he is to own over the years—is a *périssoire*, a single-seat canoe, that bears the name *Manet–Zola–Wagner* on the prow; on the stern he paints a palette.

> Kunstler 1935, p. 4

1881

APRIL 2–MAY 1

Sixth Impressionist exhibition. Works by Degas, Guillaumin, Pissarro, and Raffaëlli are shown, but Monet, Renoir, and Caillebotte do not exhibit.

AUTUMN

Signac and his friends Henri Rivière, Charles and Eugène Torquet, Georges Porel, Maurice Sallinger, and the Bonnet brothers form a convivial literary society, Les Harengs Saurs Épileptiques Baudelairiens et Anti-Philistins (The epileptic, Baudelairean, antiphilistine smoked herrings).

> Henri Rivière, "Les Détours du chemin," unpublished memoir, private collection

NOVEMBER

Opening of the cabaret Le Chat Noir in Montmartre, 84 boulevard Rochechouart, by Rodolphe Salis and Émile Goudeau, the latter a close friend of Signac's.

DECEMBER

Signac's first extant work: *Landscape with a Boat* (FC 1).

1882

Meets Berthe Roblès (1862–1942), a milliner (until 1889), who is a distant cousin of Camille Pissarro. The following year she

Fig. 109. Paul Signac and friends at the Chat Noir cabaret, ca. 1882, photograph (detail). Front row, left to right: Charles Torquet in Turkish costume, Berthe Roblès, and Signac; standing behind Signac, Henri Rivière, and behind Berthe, Émile Goudeau; back row, Rodolphe Salis, director of the Chat Noir. Signac Archives

appears for the first time in one of Signac's paintings: *The Red Stocking* (cat. no. 3). She becomes Signac's companion and in 1892 his wife.

Takes a studio in the rue de Steinkerque (18th arrondissement), off the boulevard Rochechouart, which he shares with Henri Rivière.

> Cahier d'opus, Signac Archives

FEBRUARY 11

In the new journal *Le Chat Noir* he publishes a pastiche of Zola entitled "Une Trouvaille" (A find), followed in the issue of March 25 by a parody of the naturalists, "Une Crevaison" (A death).

MARCH 1–31

Seventh Impressionist exhibition, under the title "7me Exposition des Artistes Indépendants." Included are Caillebotte, Monet, Pissarro, Renoir, and Sisley.

APRIL–MAY

Paints studies at Asnières.

MAY

Stays with his maternal grandmother at Guise and probably returns there in the course of the summer. Paints *The Haystack* (FC 3), which he annotates in the "pre-catalogue" as the "1st picture painted by Signac."

> Signac Archives

JULY–AUGUST

Paints at Port-en-Bessin, on the Normandy coast.

It is Signac's practice from now on to leave Paris during the summer months in order to paint in the countryside or by the sea.

1883

He studies with the academic artist Émile Bin (1825–1897) at Bin's studio in Montmartre, also frequented by Henri Rivière. There Signac meets "Père" Julien Tanguy, who comes by to sell paints to the students.

> Besson 1935, p. 6

JANUARY–MARCH

Takes a new studio in the rue Berthe (see cat. no. 1), then moves to another at 10 rue d'Orchampt, both in Montmartre in the 18th arrondissement.

> Cahier d'opus, Signac Archives

MARCH 1–27

Monet exhibition is held at the Galerie Durand-Ruel, boulevard de la Madeleine. More than fifty works are shown, with an emphasis on those executed at Varengeville and Pourville, which are to influence Signac's paintings this summer.

SUMMER

At Port-en-Bessin. Signac does a series of paintings markedly more Impressionist in style than those of the year before.

AUTUMN AND WINTER

Paints in Paris, Asnières, and Courbevoie.

1884–86

Signac encounters the literary Symbolists and becomes a member of their circle, attending soirées at the Brasserie Gambrinus, 5 avenue de Médicis, near the Odéon theater on the Left Bank. Some of the writers he meets in this group will become his first critics and his most loyal friends: Félix Fénéon (1861–1944), Gustave Kahn (1859–1936), Paul Adam (1862–1920), and Jean Ajalbert (1863–1947).

1884

According to the artist's daughter, "at the age of twenty," Signac inherits money set aside by his maternal grandmother to purchase his release from military service—no longer needed for that purpose—and

immediately spends it at Père Tanguy's on "several" Cézannes. The sallies this provokes from "the ladies coming to his mother's teas" are such that he keeps only one, *The Oise Valley* (fig. 36).

> Ginette Signac, unpublished memoirs, p. 21bis, Signac Archives (cited more fully in Cachin 2000, p. 349); see also entry for June 2, 1894, below. Variations on this story have been published; among the most recent, see Rewald 1996, p. 290, no. 434, and Paris–London–Philadelphia 1995–96, pp. 29, 212, no. 67 (albeit providing conflicting information).

His first collectors. Édouard Berend, who engraves a portrait of Signac and inscribes a proof to him, buys two paintings done the previous year: *Seine, Courbevoie* (FC 50) and *Quay, Asnières* (lost). The painter Ernest Eugène Cuvillier acquires *Rue Caulaincourt, 1884* (cat. no. 5), which is inscribed to him. Alexandre Lemonier, who had been a close friend of the artist's father, buys paintings from the young man, who calls him his "good uncle."

JANUARY 6–28

Manet retrospective at the École des Beaux-Arts, followed on February 2–3 by his posthumous sale at the Hôtel Drouot.

MAY 14

Replying to Signac, who has written to ask him for an interview and to seek his advice, Claude Monet (1840–1926), proposes a meeting at the Hôtel de Londres et de New York, place du Havre, where he will be staying in Paris. Looking back on their meeting in the last year of his life, Signac recalls: "Our friendship dates from that day. It lasted until his death."

> Letter from Signac to Monet, n.d., in Geffroy 1922, pp. 248–49, and Rewald 1961, p. 503; letter from Monet to Signac, May 14, 1884, Signac Archives; Kunstler 1935, p. 4 (Signac names a different hotel in this interview, but its location—"opposite Saint-Lazare"—is the same)

MAY 15

Opening in the courtyard of the Tuileries is the "Salon des Artistes Indépendants," an exhibition of work by artists rejected by the official Salon. "At the *vernissage*, my painting *Quai d'Austerlitz* [fig. 58] had not been hung. I bribed one of the waiters and got it placed above the steaming coffee pots." Signac meets Georges Seurat (1856–1891), who is exhibiting *Bathers at Asnières* (fig. 2); Charles Angrand (1854–1926); Henri Edmond Cross (1856–1910); and

Fig. 110. Félix Nadar, Michel-Eugène Chevreul, 1886, photograph. From Paris–New York 1994–95, p. 102

Albert Dubois-Pillet (1846–1890). Together they form the Société des Artistes Indépendants, officially founded on June 11, 1884. Signac becomes one of the few friends of Seurat, who is embarking on *La Grande Jatte* (fig. 3). The two men see each other regularly in Paris and correspond when Signac is away during the summer.

> Letter from Signac to Coquiot, n.d., in Coquiot 1921, p. 9, and Coquiot 1924, p. 139; letters from Seurat to Signac, Signac Archives

He meets Armand Guillaumin (1841–1927): "the painter I admired most when I was twenty was Guillaumin. . . . One day I was painting on the quays of the Île Saint-Louis. A man who was looking at my canvas over my shoulder suddenly said to me: 'That's not bad! . . . I do some painting myself . . . my name is Guillaumin.'"

> Signac 1934, p. 52; Kunstler 1935, p. 4

SUMMER

In Port-en-Bessin, where he paints more than a dozen pictures (FC 63–76).

DECEMBER 10–JANUARY 17, 1885

First exhibition of the Société des Artistes Indépendants, Pavillon de la Ville de Paris, Champs-Élysées; held as a benefit for the victims of cholera. From now until almost the end of his life Signac, a founding member of the society, is to devote a great deal of time and energy to organizing its exhibitions.

With Angrand he pays a visit to the nearly one-hundred-year-old chemist and color theoretician Michel-Eugène Chevreul

(1786–1889), an event that he is to recall as "our introduction to the science of color."

D'Eugène Delacroix . . . , p. 114; Roque 1997, pp. 321–22; Ratliff 1992, p. 237

1885

MARCH 6–APRIL 15

Delacroix exhibition at the École des Beaux-Arts.

Signac meets Camille Pissarro (1830–1903) in Guillaumin's studio and soon after introduces Pissarro to Seurat.

Rewald 1956, p. 50; Rewald 1980, p. 63

From the end of December through January 1887 Signac corresponds with Pissarro's son Lucien (1863–1944); they discuss the publication of Lucien's wood-cuts and his use of Signac's studio.

Bailly-Herzberg 1980–91, vol. 2, letters 309, 317, 318, 334, 375, 378, 381

SUMMER

Signac paints in Saint-Briac on the coast of Brittany (FC 92–108).

AUGUST

The polymath Charles Henry (1859–1926), who, like Chevreul, was a scientific mentor of the Neo-Impressionists, publishes "Introduction à une esthétique scienti-fique" in the *Revue contemporaine*.

See Henry 1885

1886

Moves to a new studio at 130 boulevard de Clichy. In June Seurat takes a studio next door, at 128bis boulevard de Clichy.

JANUARY–FEBRUARY

Pissarro adopts Seurat's pointillist brush-stroke.

Letter from Seurat to Fénéon, June 20, 1890, Paris; Bibliothèque nationale de France, gift of César de Hauke, cited in Paris–New York 1991–92, p. 383

Paul Adam publishes a novel, *Soi*. Signac is the inspiration for a minor character, a contemporary painter called Vibrac, whose technique and studio are evidently modeled on his.

Adam 1886a, pp. 420, 422

FEBRUARY 8 AND 10

Signac writes to Émile Zola (1840–1902), whose *L'Oeuvre* is appearing in installments in *Gil Blas*, to correct a statement made by one of the characters—Gagnière, a painter supposedly imbued with Chevreul's theories of complementary colors—and is duly thanked by the novelist for his observation.

Letter from Signac to Zola, February 8, 1886, collection of Dr. F. Émile-Zola, published in a note by H. Mitterand in Zola 1967, p. 1452; Zola's visiting card, Signac Archives

MARCH 31

Seurat and Signac attend the funeral in the church of Saint-Vincent-de-Paul of their friend the novelist Robert Caze (1853–1886), mortally wounded in a duel on February 15.

Trublot 1886, p. 3; Ajalbert 1938, p. 132; Halperin 1988, pp. 73–74

MARCH–APRIL

Signac paints his first divisionist pictures: *The Junction at Bois-Colombes* (cat. no. 15), *The Gas Tanks at Clichy* (cat. no. 16), and *Passage de Puits-Bertin, Clichy* (fig. 74).

He stays with the Pissarros at Éragny-sur-Epte in Normandy.

Letter from Signac to Lucien Pissarro, Ashmolean Museum, Oxford

APRIL 10

Opening of the exhibition "Works in Oil and Pastel by the Impressionists of Paris" organized by Durand-Ruel at the galleries of the American Art Association, New York. The exhibition reopens, with additional loans, on May 25 at the National Academy of Design, New York. Signac is represented by six paintings. On Pissarro's advice, the dealer had visited Signac in his studio in January and had asked him to exhibit.

None of Signac's paintings, though Impressionist in style, find buyers, and his association with Durand-Ruel does not resume until 1899.

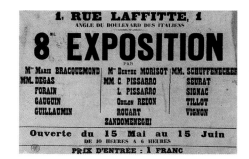

Fig. 111. Poster for the Eighth Exhibition (1886), the last held by the Impressionists. From Washington–San Francisco 1986, p. 19

Letter from Camille Pissarro to his son Lucien, January 1886, Bailly-Herzberg 1980–91, vol. 2, letter 306; Rewald 1980, p. 66

MAY 15–JUNE 15

"8me Exposition de Peinture," the eighth and last Impressionist exhibition, 1 rue Laffitte. Berthe Morisot had earlier visited the studios of Signac and Seurat to ask them to take part in the exhibition; but a week before it opens, her husband, Eugène Manet, has a "violent run-in" with Pissarro over their inclusion. Reporting to his son Lucien, Camille Pissarro notes: "Monsieur Manet would also have liked to prevent Signac from showing his figure painting." Subsequently he writes that he, Lucien, Seurat, and Signac will be showing in the same room.

Sale of the Pissarro Archives, Paris, November 21, 1975, no. 163, and letter from Pissarro to Schuffenecker, early May 1886, Bailly-Herzberg 1980–91, vol. 2, letter 333; letters to Lucien from Camille Pissarro, May 8, 1886, ibid., letters 334–35; Rewald 1980, pp. 73–74 (In his translation of Pissarro's letters, Rewald incorrectly transcribes Seurat's name in place of Signac's on p. 74 in the context of the quote cited above; Colin Harrison of the Ashmolean Museum, Oxford, has kindly consulted the original letter to confirm that Signac's name appears.)

JUNE

Signac departs for Les Andelys in Normandy, twin towns (Le Grand Andely, Le Petit Andely) on the Seine twenty miles southeast of Rouen, where Lucien Pissarro later joins him.

Letter from Camille to Lucien Pissarro, Bailly-Herzberg 1980–91, vol. 2, letter 339; and two letters from Signac to Camille Pissarro: n.d., sale of the Pissarro Archives, Paris, November 21, 1975, no. 164; and Ashmolean Museum, Oxford

Signac has arranged for Camille Pissarro and Gauguin (1848–1903) to use his studio in Paris in his absence. Seurat, unaware of this arrangement, apparently has Gauguin barred from Signac's studio—an incident that would permanently sever their relationship with Gauguin.

Letters from Seurat to Signac, June 19, 1886, and from Gauguin to Signac, Signac Archives; letter from Signac to Pissarro [ca. June 20, 1886], in Merlhès 1984, no. XXIX; letter from Gauguin to Signac [ca. July 1–15, 1886], in Merlhès 1984, no. 103; Rewald 1956, p. 41

AUGUST 21–SEPTEMBER 21

Second exhibition of the Indépendants, Building B near the Pavillon de Flore, rue

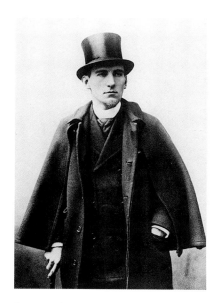

Fig. 112. Félix Fénéon, 1886, photograph. Paulhan Archives, Paris

des Tuileries. Signac, who is on the hanging committee, exhibits ten paintings, including *The Milliners* (fig. 4), *The Gas Tanks at Clichy* (cat. no. 16), *Passage de Puits-Bertin, Clichy* (fig. 74), *The Junction at Bois-Columbes* (cat. no. 15), and landscapes painted at Les Andelys.

SEPTEMBER 19

The term "néo-impressionniste" appears for the first time, in a review of the Indépendants exhibition by Fénéon: "The truth is that the Neo-Impressionist method calls for an exceptionally fine eye." In October, a compilation of Fénéon's reviews, "Les Impressionnistes en 1886," is published as a brochure by *La Vogue.*

> Fénéon 1886b, pp. 300–302

OCTOBER 10

Opening of an exhibition in Nantes of the work of living artists—"Ouvrages de peinture, sculpture, architecture, gravure et lithographie des artistes vivants"—organized by John Floury, a pupil of Pissarro, with Signac and other Neo-Impressionists present.

> See Paris 1975, nos. 165–67; Thorold 1993, pp. 69–70

OCTOBER

Stays at Fécamp on the Normandy coast. On his return, Signac sees Charles Henry, "who is due to explain to us next Friday the Theory of Contrast, Rhythm, and Measure."

> Paris 1975, no. 167, letter from Signac to Camille Pissarro, n.d.

DECEMBER–JANUARY 1887

The Galerie Martinet, 26 boulevard des Italiens, exhibits works by Signac, Pissarro, and Seurat.

> Paris 1988, p. 30; Bailly-Herzberg 1980–91, vol. 2, letter 374

1887

Signac meets Vincent van Gogh (1853–1890) at Tanguy's shop, and in April and May the two men paint together in and around Asnières.

> Letter from Signac to Gustave Coquiot [1923], cited in Coquiot 1923, p. 140; translated in Stein 1986, p. 89

JANUARY

In Paris. He often sees Pissarro, who meets him at Asnières.

> Letters from Pissarro to his son Lucien, January 12, 14, and 21, 1887, published in Bailly-Herzberg 1980–91, vol. 2, letters 378, 381, and 385, and Rewald 1980, pp. 92–93

Publication of Jean Ajalbert's *Sur les talus* (On the Banks) with an illustration by Signac, *The Bench* (cat. no. 20).

FEBRUARY 2

In Brussels with Seurat, who has been invited to exhibit *La Grande Jatte* (fig. 3) at the Salon des XX. Meets the painter Théo van Rysselberghe (1862–1926) and the writer Émile Verhaeren (1855–1916).

> Letter from Signac to Pissarro on the opening of the Salon des XX, February 2, 1887, Paris 1975, no. 171

FEBRUARY

Seurat is ill-humored on his return from Brussels. "He doesn't want to see me any more," writes Signac to Pissarro. Seurat's touchiness over the anteriority of his works causes comment among his friends; Pissarro observes: "Don't fail to put Seurat forward when it is a question of who gave the impetus to the scientific movement."

> Paris 1975, no. 172; letters from Pissarro to his son Lucien, February 23 and 25, Bailly-Herzberg 1980–91, vol. 2, letters 397–98, and Rewald 1980, pp. 99–100; letter from Pissarro to Signac [April? 1887], Bailly-Herzberg 1980–91, vol. 2, letter 415

MARCH

A small exhibition at Asnières shows pointillist studies by Émile Bernard (1868–1941). Signac sees the show and introduces himself to the artist. Bernard in turn visits Signac's studio, later recalling that the experience led him to abandon the technique: "instantly I adopted an opposite theory."

> Bernard 1994, p. 318; Toronto–Amsterdam 1981, p. 263; Rewald 1956, pp. 50–51

MARCH 26–MAY 3

Third exhibition of the Indépendants, Pavillon de la Ville de Paris, Champs-Élysées; Signac, Seurat, and Pissarro are on the hanging committee. Signac exhibits nine paintings, including *The Dining Room* (cat. no. 24), four paintings done at Les Andelys (FC 124, 125 [cat. no. 22] 127, 128 [cat. no. 21]), one from Fécamp (FC 132), one at Asnières (FC 129), and two from Paris, *Snow, Boulevard de Clichy, Paris* (cat. no. 13), and *Snow, Montmartre* (FC 135), as well as the drawing for *The Gas Tanks at Clichy* (see cat. no. 17). He buys Maximilien Luce's *Toilette* (B 562), the first picture that Luce has shown at the Indépendants.

> Luce 1938, p. 8

JUNE

Abandoning his intention to spend the summer in Antwerp, Signac is in the Auvergne, at Comblat-le-Château. Verhaeren visits Signac's Paris studio in his absence—"I have just climbed your five flights and [been] shown in by the concierge, who has some amazing ideas about your painting"—and writes to express admiration for his works, especially *The Dining Room* (cat. no. 24). Taking up an earlier offer by Signac, Verhaeren mentions his interest in three paintings and leaves the

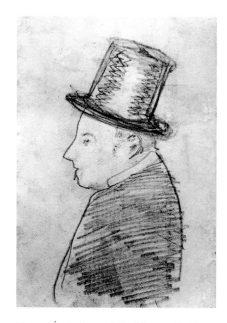

Fig. 113. Émile Bernard, *Paul Signac in Profile,* ca. 1887, pencil, 3½ x 2⅜ in. (9 x 6 cm). Private collection. Signac Archives

choice to Signac, who decides to give him *Pontoon of la "Félicité," Asnières,* 1886 (FC 129).

> Letters from Signac to Pissarro, early June and June 30, 1887, Paris 1975, nos. 174, 175; letter from Verhaeren to Signac, n.d., Courtrai, Bibliothèque de Poortere

JULY–OCTOBER

At Collioure in the south of France near the Spanish border, where he paints four particularly fine scenes of the harbor (see cat. no. 27).

NOVEMBER

Van Gogh, who has earlier advised Émile Bernard to be more tolerant of Signac and the Neo-Impressionists, organizes an exhibition in which Bernard refuses to participate if Signac is included. This is the exhibition of the "Petit Boulevard" at the Grand Bouillon–Restaurant du Chalet, 43 avenue du Clichy, which includes works by Anquetin, Bernard, Van Gogh, and Toulouse-Lautrec.

> Letter from Van Gogh to Bernard, Van Gogh 1958, vol. 3, pp. 474, 476, letter B1 [summer 1887]; Paris 1988, pp. 33–34

END OF NOVEMBER–BEGINNING OF JANUARY 1888

Signac, with Seurat and Van Gogh, takes part in the exhibition organized in the rehearsal room of the Théâtre-Libre (founded in 1887 by André Antoine [1858–1943]) at 96 rue Blanche.

1888

Guy de Maupassant publishes *Sur l'eau,* a collection of short stories evoking the charms of traveling in the Côte d'Azur, including Saint-Tropez and the Massif des Maures. The name "Côte d'Azur," covering the Mediterranean coast from Cassis to Menton, is a new one, whose first recorded use is in Stephen Liégeard's *Côte d'Azur,* published in 1887.

JANUARY

Exhibition in the offices of the journal *La Revue indépendante,* 11 rue de la Chaussée d'Antin. Works by Manet, Pissarro, and Seurat among others are on view; Signac shows *The Gas Tanks at Clichy* (cat. no. 16).

> Fénéon 1888a, pp. 171–74

La Revue indépendante publishes Signac's lithograph of a woman at the window (cat. no. 41).

JANUARY 30

Leaves for Brussels, where he is exhibiting at the Salon des XX for the first time. He stays in an apartment shared by Verhaeren and Van Rysselberghe, who is away, and there initiates Willy Finch (1854–1930) in the Neo-Impressionist technique: "the talk is of nothing but complementaries and contrasts," reports Verhaeren. After the preview of Les XX on February 5, Signac goes to Antwerp for about a month.

> Bailly-Herzberg 1980–91, vol. 2, letter 470, and Paris 1975, no. 178; letter from Verhaeren to Van Rysselberghe, in Van de Kerkhove 1997, p. 64; letter from Signac to Pissarro sent to Octave Maus, February 9, 1888, Brussels, A.A.C.

FEBRUARY 9

He publishes a review of the Salon des XX signed "Néo" in *Le Cri du peuple.* Favorable to Dubois-Pillet and himself, this review pays homage to Pissarro but says nothing about Seurat (who had not exhibited) and is critical of the Impressionist generation.

> Signac 1888a, p. 3

MARCH 22–MAY 3

Fourth exhibition of the Indépendants, Pavillon de la Ville de Paris, Champs-Elysées. Signac exhibits ten paintings, representing views of Clichy, Comblat-le-Château, and Collioure. Writing under the pseudonym "Néo," Signac publishes a review of the exhibition in *Le Cri du peuple.*

> Signac 1888b, p. 3

JULY–SEPTEMBER

Spends the summer in Brittany, at Portrieux with Berthe Roblès and Jean Ajalbert.

> Postcard from Seurat to Signac at Portrieux, July 7, 1888, Paris, Fondation Custodia, 1977, A1730; Ajalbert 1934, p. 4, and Ajalbert 1938, p. 37; letter from Signac at Portrieux to Pissarro, September 7, 1888, Paris 1975, no. 180

AUGUST 13

Publication of an article by Arsène Alexandre (1859–1937), in which he refers to Seurat's paternity of Neo-Impressionism as contested "by critics who are not very well informed or friends who are not very scrupulous."

> Alexandre 1888, p. 1

SEPTEMBER 22

A letter written by Signac appears in *La Cravache.*

> Paul Signac, "Lettre," *La Cravache,* September 22, 1888, p. 2

OCTOBER

Signac illustrates the application of Charles Henry's *Cercle chromatique,* first as a watercolor design for a poster and then as a color lithograph bearing the letters "T-L" on the recto of the Théâtre-Libre's program for the 1888–89 season (cat. no. 33).

> Fénéon 1888b, p. 137

1889

JANUARY

Signac leases an apartment, which includes an artist's studio, at 20 avenue de Clichy.

> Calepin du Cadastre, Archives de Paris, DIP4/279

MARCH 23, 24

En route to Cassis on the Côte-d'Azur, he visits Van Gogh, hospitalized in Arles, and accompanies him to his yellow house "to see his pictures, many of which are very good, and all of which are very curious," as he reports in a letter to Van Gogh's brother Theo on March 24. Signac, who had to force entry into the house, which had been closed up by the police, received a souvenir of his visit from Van Gogh—a still life that had "annoyed" the local gendarmes "because it represented two [smoked herrings] [fig. 37], and, as you know they, the gendarmes, are called that." He also writes to thank Signac for his visit, which he credits with raising his morale. From Cassis, Signac later invites Van Gogh to join him, but Van Gogh lacks the means to do so.

> Van Gogh 1958, vol. 3, letters 581, 581a, 583b (fig. 60), 584, 584a; London 1962, pp. 90–93

APRIL–JUNE

In Cassis, where he paints a remarkable series of views of the harbor (FC 183, cat. nos. 34–36).

JUNE 25

Jules Signac *père,* the artist's grandfather, dies at home in Asnières. In October his mother leaves Asnières for an apartment in Paris at 17 boulevard Péreire (17th arrondissement).

Death certificate, Asnières-sur-Seine, Archives Municipales; Calepin du Cadastre, Archives de Paris, DIP4/863

AUGUST–SEPTEMBER

Signac paints at Herblay (Val-d'Oise), a small town northwest of Paris on the right bank of the Seine, where he spends several weeks with Maximilien Luce (1858–1941).

Bouin-Luce and Bazetoux 1986, p. 25

SEPTEMBER 3–OCTOBER 4

Fifth exhibition of the Indépendants, Salle de la Société d'Horticulture, 84 rue de Grenelle. Signac exhibits two paintings done at Portrieux (see cat. no. 31) and one at Cassis (cat. no. 35). In spite of the success of the exhibition, Pissarro is distancing himself from the Neo-Impressionists: "Certainly at first sight the Neo-Impressionists seem meager, lusterless and white—particularly Seurat and Signac."

Letter from Camille Pissarro to his son Lucien, September 9, 1889, Bailly-Herzberg 1980–91, vol. 2, letter 540; Rewald 1980, p. 136

OCTOBER 8

By his own account Signac has already spent six hundred hours of his time preparing illustrations for a publishing project in collaboration with Charles Henry.

Letter from Signac to Fénéon, October 8, 1889, Dijon 1989, no. 198

1890

Charles Henry publishes *Applications de nouveaux instruments de précision (cercle chromatique, rapporteur et triple-décimètre esthétique) à l'archéologie* and *Éducation du sens des formes*, with plates and graphics by Paul Signac.

JANUARY 17

Signac is in Brussels for the opening of the Salon des XX. With Toulouse-Lautrec he takes a stand against the painter Henry De Groux (1867–1930), who has made some offensive remarks about Van Gogh and refuses to exhibit with him. The affair nearly ends in a duel, and De Groux is forced to resign from Les XX by the other members of the group.

Brussels, A.A.C., De Groux, nos. 5307, 5338

FEBRUARY 1

Under the initials "S.P." Signac publishes a review of the Salon des XX.

Signac 1890, pp. 76–78

MARCH 20–APRIL 27

Sixth exhibition of the Indépendants, Pavillon de la Ville de Paris, Champs-Elysées. Signac exhibits *Sunday* (cat. no. 40) and works from his Cassis (see cat. nos. 34, 36) and Portrieux (see cat. no. 29) series. On the opening day the president of the Republic, Sadi Carnot, visits the exhibition and is introduced to the leading painters, probably Signac and Seurat.

MARCH–APRIL

Signac travels in Italy with his mother.

Letters to Berthe Roblès, Signac Archives

APRIL 25–MAY 22

Exhibition of Japanese prints at the École des Beaux-Arts, which Signac visits with Arsène Alexandre, who subsequently recalls: "We spent a long time looking at the landscapes by Hiroshige."

Alexandre 1892, p. 2

END OF APRIL–LATE JULY

In Brittany at Saint-Briac (April 29); at Saint-Cast with his friend Eugène Torquet (May 15); and again at Saint-Briac (July 21).

Letters to Fénéon, Signac Archives

MAY–JUNE

Fénéon publishes a biography of Signac in the journal *Les Hommes d'aujourd'hui* (no. 373), which features Seurat's drawing of the artist on the cover (see figs. 30, 91). On June 18 Signac writes to Fénéon to thank him, adding: "I have it in mind this winter to do a painted, life-size biography of Félix Fénéon. What do you think?" Fénéon replies on June 25: "I am only too willing to be your accomplice."

Paris, Bibliothèque Central des Musées Nationaux, Ms 408; letter from Fénéon to Signac, June 25, 1890, Signac Archives; Halperin 1988, p. 14

Despite the fact that he has already been the subject of an issue of *Les Hommes d'aujourd'hui* (no. 368), Seurat complains to Fénéon that his "prior paternity" of the new technique has once again been ignored.

Letter from Seurat to Fénéon, June 20, 1890, Bibliothèque nationale de France, gift of César de Hauke, cited in Paris–New York 1991–92, p. 383

JULY 29

Death of Vincent van Gogh, at Auvers-sur-Oise.

AUGUST 17

Death of Albert Dubois-Pillet, at Le Puy.

NOVEMBER 10

Paul Adam publishes an article in which he suggests that readers should buy Neo-Impressionist paintings, "an excellent speculation."

Adam 1890, p. 261

NOVEMBER 21

Signac invites Fénéon to come to his studio "in the light yellow overcoat" in order to begin his portrait (cat. no. 51).

Paris, Bibliothèque Central des Musées Nationaux, Ms 408

1891

FEBRUARY 2

Signac speaks at a dinner given by the Symbolists in honor of the poet Jean Moréas (1856–1910) on the publication of *Le Pèlerin passionné*, Moréas's third collection of lyrics. Among the more than one hundred guests are Seurat, Gauguin, Redon, and Arsène Alexandre.

Le Figaro, February, 1891, p. 1; Chiron 1986, p. 119

FEBRUARY 7

Brussels, opening of the Salon des XX. Signac, a member of Les XX, exhibits eight paintings. He returns to Paris at the beginning of March.

Letter from Signac to Fénéon, February 10, 1891, Signac Archives

MARCH 20–APRIL 27

Seventh exhibition of the Indépendants, Pavillon de la Ville de Paris, Champs-Élysées. Signac exhibits his portrait of Fénéon (cat. no. 51), four Herblay landscapes (cat. nos. 38, 39), and four coastal scenes (cat. nos. 49, 50). The exhibition also includes a large-scale Dubois-Pillet retrospective, organized by Signac and Fénéon, as well as a ten-work posthumous tribute to Van Gogh.

Bailly-Herzberg 1980–91, vol. 3, letter 651

MARCH 23

Dinner in honor of Gauguin's departure for the Pacific; Seurat and Signac are present.

Zimmermann 1991, p. 317

MARCH 29

Sudden death of Seurat, aged thirty-one, in Paris. On March 31 Signac attends his

friend's burial in the Père Lachaise cemetery. Pissarro, also present, writes to his son Lucien the next day: "I saw Signac who was deeply moved by this great misfortune. I believe you are right, pointillism is finished."

> Letter from Pissarro to Lucien, April 1, 1891, Bailly-Herzberg 1980–91, vol. 3, letter 649; Rewald 1980, p. 158

APRIL

Signac moves to the Villa des Arts, 15 rue Hégésippe-Moreau (18th arrondissement), where he occupies an apartment with a large artist's studio until 1898. Among the building's tenants during this period are Marie Bashkirtseff, Eugène Carrière, Benjamin Constant, and Renoir.

> Calepin du Cadastre, Archives de Paris, DIP4/542

MAY

The inventory of Seurat's works—to be divided between his mistress and his family—is undertaken at the family's request by Fénéon, Luce, and Signac, and initialed by them. By June 22–25 this settlement leads to a bitter quarrel with Gustave Kahn.

> Archives César de Hauke, cited in Paris–New York 1991–92, pp. 411–12; Paris, Bibliothèque Central des Musées Nationaux, Ms 416; Bailly-Herzberg 1980–91, vol. 3, letters 674–76; Rewald 1980, pp. 181–82

For much of May Signac is at Roscoff in Brittany, where his yacht *Olympia*—a 36-foot cutter—is being built.

> *Le Yacht*, March 21, 1891, pp. 92–93; ibid., September 24, 1891, pp. 112–13

JUNE 13

Signac publishes an anonymous article, "Impressionnistes et révolutionnaires," in the literary supplement of *La Révolte*.

> Signac 1891, pp. 3–4

AUGUST–SEPTEMBER

In Brittany, where he is joined by Fénéon and successfully takes part in several regattas (Lorient, Douarnenez, Concarneau, Île Tudy). He is still in Concarneau on September 11, with Georges Lecomte and Berthe Roblès.

> Letters from Signac and Lecomte to Fénéon, Dijon 1989, nos. 202, 203

DECEMBER–FEBRUARY 1892

Participates in an exhibition of Impressionists and Symbolists at the Galerie Le Barc de Boutteville, 47 rue Le Peletier. Pissarro writes to Lucien: "Signac has sent two canvases but he will not leave them for long." The catalogue lists three paintings: *The Balancelles, Collioure* (FC 155) and two titled *The Seine, Herblay*.

> Letter from Pissarro to Lucien, December 16, 1891, Bailly-Herzberg 1980–91, vol. 3, letter 730

1892

FEBRUARY

Stays with Van Rysselberghe in Brussels, where Les XX hold an exhibition honoring Seurat that they have organized.

> Letter from Signac to Cross, February 7, 1892, Signac Archives

MARCH 19–APRIL 27

Participates in the eighth exhibition of the Indépendants, Pavillon de la Ville de Paris, Champs-Élysées. Exhibits seven paintings, including five views of Concarneau (cat. nos. 54–56).

MARCH 24

Signac, accompanied by Berthe Roblès and a fellow sailor, sets sail in *Olympia* from Bénodet in Brittany south to Bordeaux, where Van Rysselberghe joins them. Navigating the Garonne as far as Toulouse and there venturing into the Canal du Midi, they reach the Mediterranean near Sète on April 14. Signac subsequently publishes an account of the trip for the benefit of other yachtsmen.

> Signac 1892, pp. 343–44, 351–52

Fig. 114. Paul Signac on board the *Olympia*, Saint-Tropez, ca. 1892, photograph. From Cachin 1971, p. 56

MAY 6–10

Arrival at Saint-Tropez, where he rents "a pretty little furnished cottage" (La Ramade) in the old part of the town, overlooking the sea, with a beach and a good anchorage for *Olympia*: "There is enough material to work on for the rest of my days. Happiness—that is what I have just discovered." Announcing his liaison with Berthe Roblès, he invites his mother to join them at Saint-Tropez and subsequently assures her that they are to be married.

> Letter from Signac to his mother, n.d. [mid-May 1892], Signac Archives; Cachin 1992, p. 15

MAY 29

Opening of the first salon of the Association pour l'Art in Antwerp, at which Signac exhibits.

MAY–AUGUST

Second exhibition of Impressionists and Symbolists at Le Barc de Boutteville. Signac shows *Evening Calm, Concarneau* (cat. no. 55).

NOVEMBER 7

Paul Signac, four days before his thirtieth birthday, and Berthe Roblès, aged thirty-one, are married in Paris at the *mairie* of the 18th arrondissement. The witnesses are Georges Lecomte, Alexandre Lemonier, Maximilien Luce, and Camille Pissarro.

DECEMBER 2–JANUARY 8, 1893

First Neo-Impressionist exhibition, organized by Signac and held in the Hôtel Brébant, 32 boulevard Poissonnière. Signac exhibits *Portrait of My Mother* (FC 228), two landscapes from Saint-Tropez and two from Concarneau, as well as *The Dining Room* (cat. no. 24) and *Woman Arranging Her Hair* (cat. no. 57).

1893

All the paintings done this year are begun in Saint-Tropez, including the portrait of Berthe Signac (*Woman with a Parasol*, cat. no. 69).

FEBRUARY–JUNE

Signac takes part in several exhibitions: February, the tenth Salon des XX, Brussels; March 18–April 27, the ninth exhibition of the Indépendants, Pavillon de la Ville de Paris, Champs-Élysées; April–May, the fourth exhibition of Impressionists and Symbolists at Le Barc de Boutteville, Paris;

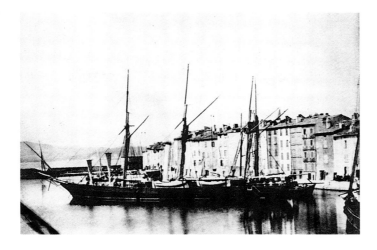

Fig. 115. The harbor of Saint-Tropez, ca. 1893, photograph. From Cachin 1971, p. 58

May, the second exhibition of the Association pour l'Art, Antwerp; June, exhibition of portraits of the writers and journalists of the century (1793–1893) at the Galerie Georges Petit, Paris, in which he shows his portrait of Fénéon (cat. no. 51).

END OF DECEMBER

Opening of the "Neo-Impressionist boutique," 20 rue Lafitte, financed by Count Antoine de La Rochefoucauld. Signac exhibits *Woman with a Parasol* (cat. no. 69), *The Bonaventure Pine* (FC 240), *Tartans with Flags* (cat. no. 66), two prints, and some watercolors. The invitation to the first show notes that the works on view will be changed monthly and that these exhibitions will be followed by one-man shows of works by artists in the association. However, the opening exhibition results in a financial setback.

> Compin 1964, p. 34

1894

Most of Signac's time as a painter this year is spent on his large canvas *In the Time of Harmony* (cat. no. 75). He makes frequent visits to galleries and museums. He also tries his hand at lithography (KW 5, 6, fig. 27).

JANUARY 23

Hostile article by Mirbeau in *L'Écho de Paris*, which attacks the paintings of Signac, "an overcompliant and overliteral devotee" of Neo-Impressionism, whose "continual dryness" he finds shocking. Signac asks Pissarro to intervene with Mirbeau but without success.

> Mirbeau 1894, p. 1; letter from Pissarro to Signac, January 23, 1894, Bailly-Herzberg 1980–91, vol. 3, letter 980; letters from Pissarro to his son Lucien, January 25 and January 27, 1894, ibid., vol. 3, letters 981–82; Rewald 1980, pp. 228–32

FEBRUARY 17–MARCH 15

Signac participates in the first Salon de la Libre Esthétique in Brussels, staying four days with Van Rysselberghe and his wife, Maria.

> Letter from Van Rysselberghe to Signac, n.d., Signac Archives

APRIL 7–MAY 27

Shows five works in the tenth exhibition of the Indépendants, Palais des Arts Libéraux, Champ-de-Mars.

JUNE 2

Sale of the Julien Tanguy collection in Paris. Signac's *Gray Weather, Quai de la Tournelle* of 1885 (FC 87), no. 58 in the sale, had probably been acquired by the color merchant in exchange for a work by Cézanne.

> Cachin 2000, p. 165, no. 87, posits in this context Cézanne's *The Oise Valley* (fig. 36) but now believes that Signac received a more modest work in the transaction.

JUNE 14

In Saint-Tropez, Signac, who is reading Delacroix's *Journal*, published the previous year, begins his own journal. He stops giving his pictures "opus" numbers and writes to Fénéon that he is no longer doing plein-air painting.

> Rewald 1949, p. 101

JUNE 24

Assassination of Sadi Carnot, president of the Republic, by a young Italian anarchist, Santo Caserio. This is followed by a wave of arrests in anarchist circles: Pissarro takes refuge in Belgium; Fénéon and Luce are arrested and imprisoned but are subsequently cleared.

DECEMBER

Exhibition of works by Luce (twenty oils) and Signac (forty watercolors) at the "Neo-Impressionist boutique." Despite favorable reviews it is the last exhibition held at this short-lived gallery, which is forced to close at the end of the year.

1895

Publication of Charles Henry's *Quelques aperçus sur l'esthétique des formes,* with drawings by Paul Signac, Éditions de la Revue Blanche, Paris, Librairie Nouy et Cie.

JANUARY 16

Signac attends a dinner in honor of the seventieth birthday of Puvis de Chavannes (1824–1898).

> Rewald 1949, p. 115

FEBRUARY 23–APRIL 1

Salon of La Libre Esthétique, Brussels. Signac exhibits watercolors.

APRIL

Publication of the first issue of the German periodical *Pan,* listing Signac as a collaborator.

APRIL 9–MAY 26

Eleventh exhibition of the Indépendants, Palais des Arts Libéraux, Champ-de-Mars. Signac's submission of ten works, which is like an ode to Saint-Tropez, is a significant one. It includes *The Bonaventure Pine* (FC 240), *Tartans with Flags* (cat. no. 66), *Two Cypresses* (cat. no. 67), *Plane Trees, Place des Lices, Saint-Tropez* (cat. no. 68), and three watercolors of Saint-Tropez.

MID-APRIL–MAY

Leaving Paris for the south in mid-April, Signac is in Saint-Tropez by April 26.

> Signac Archives; Rewald 1949, p. 117

Having occupied La Ramade, situated above the Plage des Graniers, since 1892, Signac rents a larger villa overlooking the same beach. He buys this house at the end of 1897 and names it La Hune (the crow's nest).

DECEMBER 28

Siegfried Bing (1838–1905) opens his gallery, L'Art Nouveau, 22 rue de Provence. His first exhibition features works by Cross, Van Rysselberghe, and Signac in the setting of a *cabinet d'amateur* designed by the Belgian architect Henry van de Velde

(1863–1957). Signac helps hang the exhibition and is taking pains to harmonize the frames with the colors of Van de Velde's interior.

> Letter from Signac to Cross, end of December 1895 or beginning of January 1896, Signac Archives

1896

FEBRUARY 18

Leaves for Brussels with Van Rysselberghe to attend the opening of the salon of La Libre Esthétique (February 22–March 30) and the banquet in honor of Verhaeren; etching lessons with Van Rysselberghe. At the end of the month Signac and Van Rysselberghe leave for Holland, visiting Antwerp, Flushing, Veere, Dordrecht, Rotterdam, The Hague, Amsterdam, and Volendam.

> Letters from Signac to Cross, n.d., Signac Archives

APRIL 1–MAY 31

Twelfth exhibition of the Indépendants, Palais des Arts Libéraux, Champ-de-Mars. Signac shows three paintings and three watercolors. Pissarro reports to his son Lucien that he finds the Signacs "really abominable."

> Letter from Pissarro to Lucien, April 25, 1896, Bailly-Herzberg 1980–91, vol. 4, letter 1238; Rewald 1980, pp. 287–88

APRIL

Signac begins writing his book *D'Eugène Delacroix au néo-impressionnisme*.

SUMMER

At Saint-Tropez. Van Rysselberghe and his family spend about two months with the Signacs.

> Letter of thanks from Van Rysselberghe to Berthe Signac, November 10, 1896, Signac Archives; letter from Van Rysselberghe to Viele-Griffin, Brussels, A.M.L.; Ferretti-Bocquillon 1998, pp. 11–18

OCTOBER 1

The anarchist review *Les Temps nouveaux* publishes a black-and-white lithograph by Signac, *The Wreckers* (cat. no. 88a), as one of a number of artists' lithographs issued by the journal.

NOVEMBER

Walking tour along the Italian Riviera, taking in Ventimiglia, the Nervia Valley, Bordighera, San Remo, Alassio, Albenga, Pietra Ligure, Finale Ligure, Noli, Savona, and Genoa. Signac is back in Paris by the end of the month.

> Notebook of the trip, Signac Archives; letter from Van Rysselberghe to Berthe Signac, November 10, 1896, Signac Archives

DECEMBER 2

He writes to Angrand, who has left Paris to settle in Normandy at Saint-Laurent-en-Caux, about his visit to the Manet exhibition at Durand-Ruel.

> Letter from Signac to Angrand, December 2, private collection; Lespinasse 1988, p. 77, n. 2

DECEMBER

He makes etchings at the studio of noted etcher Auguste Delâtre (1822–1907).

> Signac journal entry, Signac Archives; KW 16–18

1897

JANUARY 18

Makes lithographs at the Imprimerie Auguste Clot.

> Signac journal entry, Signac Archives; on Signac's lithographs printed by Clot, see Kornfeld and Wick 1974, nos. 8–13, 19, 20, and Gilmour 1990, pp. 272–75

FEBRUARY 1–2

Sale of the Henri Vever collection at Galerie Georges Petit, Paris. Signac has made eight sketches of a selection of paintings by Albert-Charles Lebourg and Alfred Sisley to illustrate an article by Thadée Natanson in *La Revue blanche*.

> *La Revue blanche* 12 (1897), pp. 192–95

FEBRUARY 11

Leaves for Mont-Saint-Michel. He has previously written to Angrand: "I should like to spend a couple of weeks roaming around this silhouette to see what one can get out of it."

> Letters from Signac to Angrand, February 6, 1897; and to Cross, February 10, 1898, Signac Archives; Lespinasse 1988, p. 79

APRIL 3–MAY 31

Thirteenth exhibition of the Indépendants, Palais des Arts Libéraux, Champ-de-Mars. Signac shows four Saint-Tropez paintings, including *The Red Buoy, Saint-Tropez* (cat. no. 89), five watercolors, and a lithograph.

APRIL 22

Visits the Salon des Champs-Élysées with Cross. "I had not seen a Salon for close to ten years and I am stupefied at the platitude and imbecility of these painters."

> Rewald 1952, pp. 267, 299

MAY 12

Leaves for Saint-Tropez, arriving on May 20, via Mâcon, Lyons, and Marseilles.

> Signac journal entry, Signac Archives

Fig. 118. Wrought-iron gate of the Castel Béranger by Hector Guimard, 1898. From Cachin 1971, p. 69

MAY 24

At Saint-Tropez he paints the Mont-Saint-Michel series (FC 306–12) and works on *D'Eugène Delacroix au néo-impressionnisme*.

> Rewald 1952, p. 269

BEGINNING OF NOVEMBER

In Paris, where the Signacs move into an apartment on the sixth floor of the recently built Castel Béranger (see fig. 118), designed by the architect Hector Guimard (1867–1942), at 14 rue La Fontaine (16th arrondissement). Signac subsequently tells Angrand how delighted he is to have a "finer studio" in a house near Cross that is "ultramodern, light, gay, practical." He later publishes an article on the building in *La Revue blanche*.

> Signac journal entry, cited in Thiébaut 1991, p. 74; letter from Signac to Angrand, December 18, private collection; Signac 1899b, pp. 317–19

NOVEMBER 15–DECEMBER 17

Stays with the Van Rysselberghes in Brussels in order to discuss the project for the decoration of the Maison du Peuple with the socialist deputy Émile Vandervelde. Van Rysselberghe gives Signac the portrait he painted of him at Saint-Tropez the year before (fig. 31).

> Signac journal entry, Signac Archives

DECEMBER 27

Buys La Hune in Saint-Tropez (see fig. 119), the deed to be signed in a few days' time.

> Letter from Signac to Cross, Signac Archives

DECEMBER 28

The Models by Seurat is for sale at Vollard's. Signac regrets not being able to buy the picture, which is too large for him to house.

> Rewald 1952, pp. 270–71, 300

DECEMBER 29

The celebrated German collector Count Harry Kessler (1868–1937) visits Signac's studio. He asks Signac to do a lithograph for the German review *Pan* (KW 20, published in 1898) and buys several of his works. On Signac's advice, he subsequently acquires Seurat's *The Models*.

> Rewald 1952, pp. 271–72, 300

1898

Verhaeren publishes *Les Aubes* (Brussels: Deman), dedicated to Paul Signac, and moves to Paris in November.

JANUARY 15

Signac signs a collective statement in support of Émile Zola, congratulating him on his "noble, militant position . . . in this murky Dreyfus affair, which covers up if not a grave injustice, illegalities at the very least."

> Statement of support for Émile Zola, Lagny-sur-Marne, Musée Gatien-Bonnet; Rewald 1952, pp. 275, 301

MARCH 27–APRIL 18

In London: "It's forever Turner, this smoky town." On April 1 he visits Lucien Pissarro, who has been living in London since 1890. Signac goes to the National Gallery and the British Museum and on his return writes enthusiastically to Angrand about all that he has seen, including "the unknown magic of Turner."

> Signac journal entry, Signac Archives; see also the travel notebook, Louvre, Fonds du Musée d'Orsay, RF 50 856; letter from Signac to Angrand, April 18, 1898, copy in Signac Archives and cited in Rewald 1953, pp. 32, 73

APRIL 19

Visits the Symbolist exhibition at Vollard's.

> Rewald 1952, pp. 280, 302

APRIL 19–JUNE 12

Fourteenth exhibition of the Indépendants, Palais de Glace, Champs-Élysées. Signac exhibits three paintings and two watercolors.

APRIL 25

Visits Denys Cochin's town house to see the decorations painted by Maurice Denis (1870–1943). Subscribes to the fund for the purchase of *Balzac* by Rodin, rejected by the Société des Gens de Lettres.

> Rewald 1952, pp. 280, 303; Lecomte, *L'Illustration*, July 1, 1939, pp. 335–36

MAY 26

Leaves for Saint-Tropez.

> Signac journal entry, Signac Archives

JULY

Beginning of a major disagreement about style with Van Rysselberghe, who, feeling the need to return to an art closer to nature, begins distancing himself from what he perceives as the constraints of Neo-Impressionism. Van Rysselberghe moves from Brussels to Paris.

> Ferretti-Bocquillon 1998, pp. 11–18

AUGUST 16

Inaugurates the vast studio in Saint-Tropez that has been built in the course of construction work on La Hune.

> Rewald 1952, pp. 281, 303

Fig. 119. La Hune, view of the garden, ca. 1960, photograph. From Cachin 1971, p. 88

SEPTEMBER 12

Death of Mallarmé (1842–1898). "I dearly loved that man and poet. . . . He was the 'Vater,' the father-poet, patriarchal and tender."

> Rewald 1952, pp. 282, 303

BEGINNING OF OCTOBER

To Marseilles with Cross. He is back at Saint-Tropez on October 16: "I begin three canvases at once, while I still have a fresh memory of the effects seen in Marseilles."

> Rewald 1952, pp. 283, 304; Marseilles notebook, 1898, Signac Archives

OCTOBER 22–DECEMBER 20

Exhibition of the Neo-Impressionist group at the Keller and Reiner gallery, Berlin, the first appearance of the Neo-Impressionists in Germany. Distributed free is an offprint of *D'Eugène Delacroix au néo-impressionnisme*, abridged and translated into German, as issued by the journal *Pan* before its publication in French.

OCTOBER 28

Death of Puvis de Chavannes. "Now the great Puvis is gone. Who, then, will henceforth decorate the walls?"

> Rewald 1952, pp. 283, 304

DECEMBER

In Paris. On December 15, with Édouard Vuillard (1868–1940), Signac visits Odilon Redon (1840–1916) to discuss the organization of an exhibition at the Galerie Durand-Ruel (which is offering its space for free); the exhibition is to bring together the various trends that are succeeding Impressionism, outside official art circles. On December 16, with Van Rysselberghe and Vuillard, he visits the private houses that Vuillard has decorated, notably that of the Natansons. On December 23 Signac refuses to sell Vollard the largest of his Cézannes (*The Oise Valley*, fig. 36) but agrees to exchange "the small still life" (possibly *Three Pears*, R 345) for a "pretty little Renoir" (the head of a woman), two watercolors by Jongkind, and an early Seurat from "the beginning of [Divisionism]" (perhaps *Village Road*, H 53).

> Rewald 1953, pp. 34, 35, 37, 74; Signac journal entry, Signac Archives

1899

JANUARY–MAY

Mainly in Paris. He sees a number of exhibitions: Boudin, at the École des Beaux-Arts (January 12); the Salon du Champ-de-Mars ("a dismal return to black and glazing," May 1); and two at Durand-Ruel, a selection of Impressionists ("the apotheosis of Impressionism," April 22) and Jongkind ("this lesson of art and life," May 16). On January 6 he visits Maurice Denis at Saint-Germain-en-Laye, and on February 21, he and Luce visit Pissarro in the apartment where he is painting the Tuileries Gardens; he also admires the early Sisleys of 1877 at Bernheim-Jeune. On May 5 he goes to the Louvre to look at Ingres's *Odalisque* (fig. 50) and Delacroix's *Women of Algiers* (fig. 51).

> Rewald 1953, pp. 38, 40, 43, 52, 54, 55, 75, 76, 79, 80

MARCH 10–31

"Exposition d'oeuvres de MM. P. Bonnard, M. Denis, H.-G. Ibels . . . ," Galerie Durand-Ruel. Signac exhibits eleven paintings in this show, which includes works by other Neo-Impressionists, as well as the Nabis and Redon. His journal entry of March 15 provides a detailed account of the Neo-Impressionist room. Despite Signac's initial anxieties, the Neo-Impressionists garnered critical acclaim, and Signac was credited with "triumphantly justifying the divisionist technique."

> Rewald 1953, pp. 45–51, 76–78; see also Ferretti-Bocquillon 1996–97, p. 69

APRIL 10–MID-APRIL

A trip to Normandy: Isigny, Port-en-Bessin, Honfleur, and Rouen, where he sees Angrand.

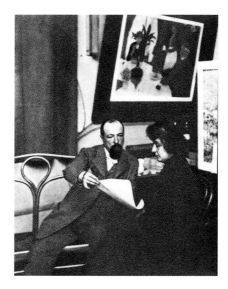

Fig. 120. Paul and Berthe Signac at Castel Béranger, ca. 1900, photograph. From Cachin 1971, p. 83

> Rewald 1953, p. 52; letter from Signac to Angrand, April 14, 1899, private collection

JUNE

Publication of *D'Eugène Delacroix au néo-impressionnisme* (Paris: Éditions de la Revue Blanche). Appearance of the book has been preceded in 1898 by the publication of extracts in *La Revue blanche* (May–July) and *Revue populaire des arts* (October), as well as by the abridged German version in *Pan* (July).

AUGUST

Sailing in the south of France.

> Letter from Signac to Van Rysselberghe, September 3, 1899, Signac Archives

OCTOBER 21–NOVEMBER 26

Exhibits one painting, a view of Marseilles (FC 324), in the fifteenth exhibition of the Indépendants, Garde-Meuble du Colisée, 5 rue du Colisée, Champs-Élysées.

DECEMBER

Signac is in Saint-Tropez. His correspondence with Angrand gives evidence of his preoccupation with finding a form closely tied to color. Angrand writes: "this is a familiar worry of yours, one of long standing."

> Letter from Angrand to Signac, Lespinasse 1988, pp. 116, 117

1900

JANUARY 2–MARCH 8

Still in Saint-Tropez.

> Letter from Signac to Octave Maus, January 2, 1900, Chartrain-Hebbelinck 1969, p. 83; watercolor dated March 8, 1900, private collection

JANUARY 25

Signac passes a driving test and receives his first driver's license. He writes to Angrand: "I have in fact acquired at a good price a small car, a mini Bollée. . . . We launched my diploma, doing with Cross 30 kilometers an hour on our department roads."

> Letter from Signac to Angrand, January 25, 1900, Lespinasse 1988, p. 120, n. 4

MARCH 1–31

Seventh exhibition of La Libre Esthétique, Brussels. Signac shows fourteen watercolors and an oil of Saint-Tropez. Other pictures of his listed in the catalogue seem not to have arrived.

> Desfagnes, *L'Art décoratif*, May 1900, p. 51; letters from Signac to Maus, Chartrain-Hebbelinck 1969, nos. 28–31

Seurat exhibition in the offices of *La Revue blanche*, organized by Fénéon. Signac, who returns from the south of France in time to see the exhibition, buys *The Circus* (fig. 42) for 500 francs. Fénéon buys *Bathers at Asnières* (fig. 2) and Casimir Brû *La Grande Jatte* (fig. 3). Brû's daughter Lucie, the future wife of the critic Edmond Cousturier, is a painter and a pupil of Signac, who in 1922 will publish the first monograph on him.

> Signac journal entry, Signac Archives, quoted in part in Halperin 1998, p. 317

OCTOBER

Signac is in Samois (Seine-et-Marne), a small town near Fontainebleau, southeast of Paris on the left bank of the Seine.

> Letter from Angrand to Signac, October 1900, Lespinasse 1988, p. 129

DECEMBER 5—25

Sixteenth exhibition of the Indépendants, Garde-Meuble du Colisée, 5 rue du Colisée. Signac exhibits a painting of Saint-Tropez (FC 314).

DECEMBER 10

Before leaving for Saint-Tropez, Signac submits his sketches in the contest for the decoration of the Salle des Fêtes in the town hall at Asnières "without any hope" of winning. On December 15 he writes in his journal: "I am not among the painters whose sketches are being considered . . . not even the three others who received an honorable mention."

> Signac 1947, pp. 98–101

1901

MARCH

In Saint-Tropez, undertakes a project to enlarge La Hune, including the building of a new studio. Van Rysselberghe designs the fireplaces.

> Lespinasse 1988, p. 138; Signac journal entry, March 1, 1901, quoted in Thiébaut 1991, p. 78, n. 47

Second Neo-Impressionist exhibition organized by the Keller and Reiner gallery in Berlin. The paintings are subsequently shown—without much success—by the dealer Gutbier in Dresden.

> Letter from Gutbier to Signac, April 1, 1901, Signac Archives

Fig. 121. Signac's studio at La Hune in 1903, photograph. From Cachin 1971, p. 88

APRIL 20—MAY 21

Seventeenth exhibition of the Indépendants, Grande Serre de l'Alma, Cours-la-Reine. Signac exhibits *The Wrecker* (cat. no. 88b), his rejected four-panel project for the town hall at Asnières (FC 355–358), three Midi landscapes, and two watercolor sketches.

MAY—JUNE

He takes part in the international exhibition in The Hague.

> *New York Herald*, April 27 and May 3, 1901

DECEMBER

Spends three weeks with Van Rysselberghe in Paris. He sees the decoration of the church in Le Vésinet painted by Maurice Denis, with whom he exchanges two small panels.

> Signac 1947, p. 102

1902

MARCH 29—MAY 5

Eighteenth exhibition of the Indépendants, Grande Serre de l'Alma, Cours-la-Reine. Signac shows two paintings from Saint-Tropez and two from Samois, as well as two oil sketches and two watercolors.

MAY 15

Signac's review of an exhibition of Provençal painters in Marseilles appears in *La Revue blanche*.

> Signac 1902

JUNE 2

Opening of "Exposition d'oeuvres de Paul Signac" at Siegfried Bing's gallery, L'Art Nouveau, 22 rue de Provence. At the age of thirty-eight the artist has his first one-man show; it comprises nine paintings, twelve oil sketches, two pastels, and one hundred watercolors.

> Weisberg 1986, p. 235

1903

Publication in Krefeld of the German edition of *D'Eugène Delacroix au néo-impressionnisme*, in a translation by Sophie Hermann, by Baron von Bodenhausen. The book is reissued in 1910.

JANUARY 3

Opening of the "Neo-impressionisten" exhibition in Hamburg, in a branch of the Cassirer gallery. In March the works are shown at the Cassirer gallery in Berlin.

FEBRUARY

Les Éditions de La France étrangère publishes a collection of antiwar postcards, after drawings by artists, notably Signac.

> *L'Aurore*, February 8, 1903

MARCH 20—APRIL 25

Participates in the nineteenth exhibition of the Indépendants, Grande Serre de l'Alma, Cours-la-Reine.

MAY 31

In Saint-Tropez.

AUGUST

At Les Diablerets, a resort in the Swiss Alps.

> Letter to Signac from Angrand, Lespinasse 1988, p. 149

NOVEMBER 13

Death of Camille Pissarro, in Paris. Asked by Jean Grave to write an article for *Les Temps nouveaux*, Signac replies: "My dear Grave, I am really too upset by the death of poor 'Père Pissarro' to be able to write collectedly about this good man and great painter in the week of his burial."

> Letter from Signac to Grave, n.d.; Herbert and Herbert 1960, p. 519

Opening of the Galerie Druet in the faubourg Saint-Honoré, "a sumptuous store" in which works by the Neo-Impressionists and the Nabis are exhibited, as well as ceramics, sculptures, and photographs.

L'Occident, December 1903

"Der Französische Impressionismus," an exhibition organized by Count Harry Kessler, is held in Weimar, moving to Krefeld in February 1904. Signac shows fourteen works: two paintings, six watercolors, four oil sketches, and two lithographs.

1904

FEBRUARY 21–MARCH 24

Twentieth exhibition of the Indépendants, Grande Serre de l'Alma, Cours-la-Reine. Signac exhibits five paintings. Henri Matisse (1869–1954), associate secretary of the committee, meets Signac, vice-president, and is invited to Saint-Tropez.

FEBRUARY 25–MARCH 29

Exhibition of Impressionist painters, La Libre Esthétique, Brussels. Signac exhibits five paintings.

MARCH

A false report of Signac's death appears in the newspapers, which have confused him with a painter named Paul Seignac (1826–1904).

APRIL–MAY

In Venice. Leaving about April 15, the Signacs reach Venice via Porto Maurizio, Genoa, Milan, and Verona. On April 27 Signac reports that he will be bringing back "more than 200 informal watercolor sketches" but no paintings. On May 10 he writes to Angrand, enthusiastic about Tintoretto and Veronese but finding Tiepolo "sickening."

Letter from Signac to Fénéon, April 1, 1904, and two letters to Cross, n.d. and April 27, 1904, Signac Archives; letter to Angrand, May 10, 1904, private collection, copy in Signac Archives

JULY 12–OCTOBER 15

The Matisses are in Saint-Tropez, where Signac has arranged for them to have La Ramade. Matisse spends the summer in Signac's company and undertakes the

sketch for *Luxe, calme et volupté* (fig. 47), a painting he executes that winter.

Paris 1993, pp. 63–64; Munck 1999, p. 424

OCTOBER

On October 4 Henri Manguin (1874–1949) arrives in Saint-Tropez and meets Signac. Signac's letter on the separation of the fine arts in France is published in *Les Arts de la vie*.

Archives Manguin, cited in Munck 1999, p. 424; Signac 1904, pp. 251–52

DECEMBER 13–31

Signac exhibition at the Galerie Druet. A critical and commercial success, it consists of twenty paintings, ten oil sketches, and twenty watercolor sketches of Venice. Raoul Dufy (1877–1953) and Matisse visit the exhibition; Matisse is struck by the luminosity of Signac's works.

Letter from Signac to Angrand, Lespinasse 1988, pp. 167–68; Lyon–Barcelona 1999, p. 227, cited in Munck 1999, p. 425

1905

MARCH 24–APRIL 30

Twenty-first exhibition of the Indépendants, Grande Serre de l'Alma, Cours-la-Reine. It includes Van Gogh and Seurat retrospectives, the latter with sixteen works lent by Signac. Matisse shows *Luxe, calme et volupté* (fig. 47), which Signac acquires later in the year for "500 francs in gold and 500 francs in painting," that is, he offers Matisse five hundred francs and one of his own paintings; Matisse will select *The Green House, Venice* (FC 417).

Letter from Signac to Matisse, cited in Paris 1993, p. 420

After the opening of the Indépendants, Signac goes to Saint-Tropez for a protracted stay. The young painters who are soon to band together under the aegis of Matisse are there too: Manguin, Charles Camoin (1879–1965), and Albert Marquet (1875–1947). On May 20 Marquet writes of having danced the farandole as part of the *bravade*, a Saint-Tropez festival, with Manguin and the Signacs. About August 10 the Marquets and the Signacs go on a bicycling trip together as far as Menton.

Vauxcelles, *Gil Blas*, October 17, 1905, pp. 1–2; Giraudy 1997, p. 54; Munck 1999, p. 429

By the autumn the alterations to La Hune are finished, and Signac hangs his friends'

pictures in the dining room: *Women at the Seashore* by Valtat (fig. 45), *The Evening Air* by Cross (fig. 46), and Matisse's *Luxe, calme et volupté* (fig. 47). He has had them framed in veined plane wood, as he tells Manguin, and they are "very effective. What sumptuous meals now. . . ."

Letters from Signac to Van Rysselberghe, n.d., The Getty Research Institute (no. 870355, folder 6); and to Manguin, Archives Jean-Pierre Manguin

1906

EARLY JANUARY

Maurice Denis goes to Saint-Tropez with Ker-Xavier Roussel (1867–1944), who has a house near La Hune. Denis comments on Signac's comfortable house, with its gardens (they try his oranges), terraces, and immense studio.

Denis 1957–59, vol. 2, p. 3

FEBRUARY

Signac stays in Biarritz with the collector Christian Cherfils. From there he makes a short trip to Spain with Dario de Regoyos (1857–1913).

Letter from Signac, private collection

MARCH 20–APRIL 30

Twenty-second exhibition of the Indépendants, Grande Serre de l'Alma, Cours-la-Reine. Signac exhibits seven landscapes, painted in Marseilles, Venice, Provence, and the Île de France.

MID-APRIL–BEGINNING OF MAY

In Holland, where he visits Rotterdam, Maasluis, Overschie (now a suburb of Rotterdam), and Amsterdam and paints a series of watercolors.

Letter from Signac to Cherfils, Paris, private collection

SUMMER

Eleventh exhibition of the Berlin Secession, Berlin; a room is set aside for the Neo-Impressionists. Signac shows one painting, four studies, and two watercolors.

SUMMER–AUTUMN

At the beginning of July Signac is in Marseilles with Camoin. In August Cross spends a day and a half with him in Saint-Tropez and is impressed by the watercolors done in Holland. Around September 20 Signac returns from a Mediterranean

cruise with the painters Henri Person (1876–1926) and André Roberty (1877–1963) aboard Person's boat, the *Henriette*.

Munck 1999, p. 434; letters from Cross to Van Rysselberghe, Paris, Bibliothèque Central des Musées Nationaux, Ms 416; and from Roberty to his mother, September 20, 1906, Roberty Archives

SEPTEMBER 28

Le Courier européen publishes an antimilitaristic drawing by Signac done for the anarchist weekly *Les Temps nouveaux*.

Le Courier européen, September 28, 1906

OCTOBER 23

Death of Cézanne, in Aix-en-Provence.

BEGINNING OF NOVEMBER

Fénéon is hired by the Galerie Bernheim-Jeune, with responsibility for the contemporary art section.

Halperin 1988, pp. 358–59

1907

JANUARY 21–FEBRUARY 7

Signac exhibition at the Galerie Bernheim-Jeune, the first show organized by Fénéon in his new capacity. It numbers thirty-four paintings (Holland, Venice, the Midi, and the Île-de-France), six oil sketches, and forty watercolors. Each canvas is illustrated in the catalogue with a sketch by the artist; the preface is by Paul Adam. Derain writes to Matisse: "Signac triumphs at Bernheim's."

Archives Matisse, quoted in Munck 1999, p. 435

MARCH 20–APRIL 30

Twenty-third exhibition of the Indépendants, Grandes Serres de l'Alma et des Invalides, Cours-la-Reine. Signac exhibits four paintings and a watercolor.

MARCH 28–MAY 15

In Constantinople with Henri Person. Berthe, whose mother is seriously ill, remains in France.

Letter from Signac to Van de Velde, Brussels, A.M.L. XI 726

1908

MID-FEBRUARY–EARLY MAY

The Signacs are in Italy, traveling to Portofino, Florence, Siena, Rome, and Perugia before arriving in Venice toward the end of March. Leaving Venice in early

May, they visit Verona on the way back to Saint-Tropez. On his return Signac is reported by Cross to be "full of infectious enthusiasm for the frescoes of Perugino, Pinturicchio, etc."

Postcards from Signac to Person, Archives Roberty; letters from Signac to his mother and Fénéon, Signac Archives; notebook of the Italian trip, Cachin 1994, pp. 607–15; letter from Cross to Angrand, May 28, 1908, quoted in Compin 1964, p. 60

MARCH 20–MAY 2

Twenty-fourth exhibition of the Indépendants, Grandes Serres de l'Alma et des Invalides, Cours-la-Reine. Signac, who has been named president of the society, exhibits *Morning, Golden Horn* (FC 457) and thirteen watercolors.

MAY 16

Sale of the Kessler collection at the Hôtel Drouot, Paris, including five oils and five watercolors by Signac, as well as works by Cézanne, Courbet, Degas, Gauguin, Van Gogh, Maillol, Matisse, and Seurat. Signac is among those present at the sale, as are Fénéon and André Gide. Signac buys back one of his Marseilles watercolors. Bernheim buys two of Signac's paintings of Venice.

Gide 1951, pp. 266–67; annotated sale catalogue, Signac Archives

SUMMER

Arriving in June with two friends, André Dunoyer de Segonzac (1884–1974) calls on Signac at La Hune and is lent the artist's "former little villa," probably La Ramade, for the summer.

Dunoyer de Segonzac, *Art et style*, no. 53 (1959), n.p.

BEGINNING–MID-NOVEMBER

Signac and Person, aboard the latter's boat *Henriette II*, sail along the coast (Antibes, Villefranche, Nice) "in order to do some watercolors before the return to Paris."

Letter from Signac to Van Rysselberghe, private collection

1909

EARLY JANUARY

Francis Picabia (1879–1953) is in Saint-Tropez, where he paints several Neo-Impressionist works, including *Saint-Tropez Viewed from the Citadelle*, dated 1909 (L'Annonciade, Musée de Saint-Tropez).

FEBRUARY 1–20

Pierre Bonnard (1867–1947) exhibition at Bernheim-Jeune. Signac, who notes in his journal on February 6 that he is spending every evening there, buys a small painting: *Hounds in Greenery* (D 256).

Signac 1947, pp. 80–82

MARCH 3

In letters Signac mentions his purchase "this month" of the Bonnard as well as of a Pissarro of 1881, *Peasants in the Woods* (V 531), and Roussel's *Three Couples*.

Letters from Signac to Van Rysselberghe, March 3, 1909, private collection; and to Lucien Pissarro, Ashmolean Museum, Oxford

MARCH 25–MAY 2

Twenty-fifth exhibition of the Indépendants, Grande Serre de l'Orangerie, Jardin des Tuileries. Signac exhibits two paintings.

APRIL 4–9

Brief trip to London with Fénéon. At the National Gallery Signac makes colored sketches after Turner's watercolors. Visits the British Museum with Fénéon (Greek and Assyrian sculptures and drawings by Claude Lorrain). Sees Lucien Pissarro and Walter Sickert.

Letters from Signac to Angrand, n.d., Lespinasse 1988, p. 197; to Berthe Signac, Signac Archives; and to Lucien Pissarro, Ashmolean Museum, Oxford

MAY 3–15

Exhibition of Signac's watercolors and pastels, Galerie Bernheim-Jeune.

END OF DECEMBER

Opening of the International Exhibition, also called the first Odessa Salon, which subsequently travels to Kiev, Saint Petersburg, and Riga. Signac exhibits three works: *Traghetto Lantern* (FC 416), a *Diablerets*, and a *Port Decorated with Flags, Saint-Tropez*.

1910

Signac stops recording his works in his handwritten journal. His output slows down abruptly: only one oil painting is done in 1910, *The Channel, Marseilles* (FC 488), dated 1910–11, compared to eleven paintings in 1908 and twelve in 1909. He spends more and more of his time on watercolors. His role in the organization of the Brussels international exhibition and the illness and death of his friend Cross undoubtedly

contribute to this development. Another likely factor is the beginning of his relationship, in 1909–10, with Jeanne Selmersheim-Desgrange (1877–1958), a Neo-Impressionist painter married to the architect Pierre Selmersheim (1869–1941), with whom she had three children.

JANUARY

The Seine floods. Signac's watercolors of the scene will be included in an exhibition devoted to the bridges of Paris at Bernheim-Jeune in winter 1911 (see below).

MARCH 12–APRIL 17

"L'Évolution du paysage" (The evolution of landscape), La Libre Esthétique, Brussels. Signac exhibits three works.

MARCH 18–MAY 1

Twenty-sixth exhibition of the Indépendants, Baraquement du Quai d'Orsay, Pont de l'Alma. Signac shows four paintings.

APRIL 18–30

"D'après les maîtres" (After the Old Masters), Galerie Bernheim-Jeune. Signac exhibits twelve drawings, including a group of watercolors after the Turners seen in London the previous year.

MAY 14–NOVEMBER 15

Exposition Universelle et Internationale, Brussels. Signac, who has organized the French section, exhibits one painting.

MAY 16

Death of Henri Edmond Cross at his home in Saint-Clair, a hamlet near Saint-Tropez. Signac has been going there twice a week from La Hune during his friend's illness. Jean Grave asks him to pay tribute to Cross in an article for *Les Temps nouveaux*, but Signac responds: "I have tried in vain to do a piece on our poor friend—I really have neither the head for it nor the heart."

> Compin 1964, p. 74; letter from Signac to Maus, Chartrain-Hebbelinck 1969; Herbert and Herbert 1960, p. 520

JULY 10–AUGUST 31

"Exhibition of the Work of Modern French Artists," Public Art Galleries, Brighton. Signac exhibits two paintings.

AUGUST 6

Signac publishes an antimilitaristic drawing, *For the Vultures*, in a special protest number

of *Les Temps nouveaux* entitled "Biribi" (a slang term for the military police in Algeria). He is one of nine artists, including Angrand and Luce, who contribute drawings to this issue.

> *Les Temps nouveaux*, August 6, 1910; the original drawing is in the James Dyke collection, see Little Rock 2000, no. 133

NOVEMBER 8–JANUARY 15, 1911

"Manet and the Post-Impressionists," Grafton Galleries, London. The exhibition is organized by Roger Fry, who coins the term "Post-Impressionist." Signac exhibits three paintings (FC 276, 326, 440), a pastel, and a drawing.

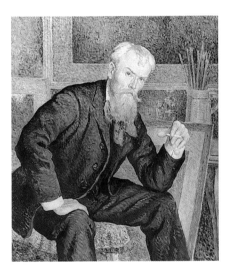

Fig. 122. Maximilien Luce, *Henri Edmond Cross*, 1898, oil on canvas, 39⅜ x 31⅞ in. (100 x 81 cm). Paris, Musée d'Orsay

1911

Signac paints only one picture, *Towers, Antibes* (FC 490).

JANUARY 23–FEBRUARY 1

"Les Ponts de Paris" (The bridges of Paris), Galerie Bernheim-Jeune, showing watercolors by Signac and tapestries by Maillol. In addition to sixty-six watercolors, Signac exhibits eight cartoons and five paintings.

APRIL 21–JUNE 13

Twenty-seventh exhibition of the Indépendants, quai d'Orsay. Signac exhibits three paintings, one cartoon, and two watercolors. Despite his wish to hold a

Cross retrospective at the Indépendants this year, Signac is able to show only six of his friend's paintings because of an exhibition of Cross's work organized by Octave Maus at La Libre Esthétique in Brussels, which opened earlier.

> Compin 1964, p.74; Herbert and Herbert 1960, p. 520; letters from Signac to Maus, Chartrain-Hebbelinck 1969

JUNE 7

Sale of the Henry Bernstein collection at the Hôtel Drouot, Paris. It includes six watercolors of Antibes by Signac.

> Album of press clippings, Signac Archives

JUNE 19–JULY 3

Exhibition of works by Cross and Signac at the Galerie Druet. Signac shows seventeen paintings and a selection of watercolors.

JUNE 26–JULY 18

"L'Eau" (Water), Galerie Bernheim-Jeune. Signac, who is an exhibitor, buys a painting by Bonnard, *Boats in the Harbor, Cherbourg* (D 633).

AUGUST 7

In response to the reissue of *D'Eugène Delacroix au néo-impressionnisme* (Paris: Librairie Floury), with a cover designed by Van Rysselberghe, Apollinaire notes that the original edition is now rare: "M. Signac's little book marks an important date in the history of contemporary art."

> Apollinaire 1911, in Apollinaire 1972, p. 177

OCTOBER 25

Signac is made a chevalier of the Legion of Honor. The presentation of the insignia, by Pierre-Auguste Renoir (1841–1919) in Cagnes, is delayed because Signac's mother is ill.

> Paris, Archives Nationales, Paris, 21/4038

NOVEMBER 16

Death of the artist's mother, Héloïse Signac, aged sixty-eight, while on a visit to Saint-Tropez.

> Death certificate, Archives Municipales, Saint-Tropez

1912

Signac paints four pictures.

MARCH 20–MAY 16

Twenty-eighth exhibition of the Indépendants, Baraquement du Quai d'Orsay, Pont de l'Alma. The state buys

Evening, Avignon (Château des Papes) (cat. no. 131) for the Musée du Luxembourg.

MAY 25–SEPTEMBER 30

"Sonderbund Internationale Kunstaustellung," Cologne. An ambitious panorama of modernism, this international exhibition of almost one hundred artists pays homage to Signac, Cézanne, Cross, Gauguin, Van Gogh, Munch, and Picasso, whose work is given monographic treatment in separate rooms. Signac exhibits fifteen paintings and three watercolors.

MAY 28–JUNE 9

Exhibition of Monet's paintings of Venice at the Galerie Bernheim-Jeune. On May 31 Signac writes to Monet expressing his admiration of these paintings, and on June 5 Monet replies: "The opinion of some, of whom you are one, is precious to me."

> Wildenstein 1985, vol. 4, p. 385, no. 2014; for Signac's letter to Monet of May 31, 1912, see the essay by Susan Stein, at n. 23, and Geffroy 1922, pp. 248–49

MAY–OCTOBER

From May to July Signac travels in France, mainly in the southwest, and complains of his asthma; his wide-ranging itinerary takes in Limoges, Cahors, Montauban, Albi, Gordes, Lyons, Le Puy, Bordeaux, and Les Sables-d'Olonne. On August 22 he writes from the station in Caen. By October 10 he is in Paris. From mid- to late October he is back at Les Sables-d'Olonne (Vendée), on the Atlantic coast, where his boat *Sindbad*, a forty-six-foot yacht, is being built.

> Letters from Signac to Berthe Signac, Signac Archives; and to M. Rosenthal, Paris, Fondation Jacques Doucet; unidentified article in album of press clippings, Signac Archives

1913

Signac paints five pictures.

MID–LATE JANUARY

In Les Sables-d'Olonne for the construction of the *Sindbad*.

> Letters to Berthe Signac, January 13, 19, 23, and 31, Signac Archives

FEBRUARY

Contributes the preface to the catalogue of the Henri Person show at the Galerie Bernheim-Jeune.

FEBRUARY 17–MARCH 15

"International Exhibition of Modern Art," Armory of the Sixty-Ninth Regiment, New York. The exhibition travels to Chicago (March 24–April 16) and Boston (April 28–May 19). Signac is represented by fifteen watercolors and one painting of Marseilles (the two paintings listed in the catalogue are possibly the same work under different titles).

> Brown 1963, p. 290

MARCH 9–APRIL 13

"Interprétations du Midi (Interpretations of the South of France)," La Libre Esthétique, Brussels. Signac exhibits five paintings and thirteen watercolors.

MARCH 19–MAY 18

Twenty-ninth exhibition of the Indépendants, Baraquement du Quai d'Orsay, Pont de l'Alma. Signac exhibits *Rainbow, Port, La Rochelle* (FC 494), with its preparatory cartoon and a watercolor study. In April he buys a drawing by Angrand shown in the exhibition.

> Lespinasse 1988, p. 249

MAY–JUNE

Signac sails the *Sindbad* from Les Sables-d'Olonne via Bordeaux and the Canal du Midi to the Mediterranean. Delayed in Toulouse by the flooding of the Garonne, he reaches Marseilles on June 19 before arriving in Saint-Tropez.

> Unidentified article, Signac Archives; letter from Signac to Angrand, private collection

Van Rysselberghe exhibition, Galerie Druet. It includes few of his Neo-Impressionist paintings. Defections and deaths have made Signac the only remaining representative of the first generation of Neo-Impressionists.

MID-MAY

"Exposition universelle et internationale, Groupe II. Oeuvres modernes," Ghent. Signac shows one painting.

> *Démocratie sociale*, May 18, 1913; *L'Indépendance belge*, August 1913

END OF MAY

Second Salon de Mai in Marseilles. Signac exhibits a painting and some watercolors.

> *Soleil du Midi*, June 1, 1913; *Gil Blas*, June 4, 1913

Creation of Cercle et Carré (Circle and square), a left-wing intellectual body organized in response to attacks on individual liberty. Signac is among the founding members, as are Émile-Antoine Bourdelle, Paul Clemenceau, Anatole France, and Émile Verhaeren.

> Album of press clippings, Signac Archives

SEPTEMBER 23

Le Petit Niçois reports that Signac has just rented a villa at Cap d'Antibes for the winter. He moves in with his companion, Jeanne Selmersheim-Desgrange, who is expecting their child, and makes his home with them from now on, living more modestly than before. He leaves La Hune and the apartment in Paris, rue La Fontaine, with all their contents to his wife, Berthe. The Signacs do not divorce, and he continues to see Berthe regularly, to assist her financially, and to assure her of his affection.

> *Le Petit Niçois*, September 23, 1913

OCTOBER 2

Birth in Antibes of Ginette-Laure-Anaïs (d. 1980), daughter of Signac and Jeanne Selmersheim-Desgrange. Signac names her after Gina del Dongo, duchess Sanseverina, the heroine of Stendhal's *La Chartreuse de Parme.*

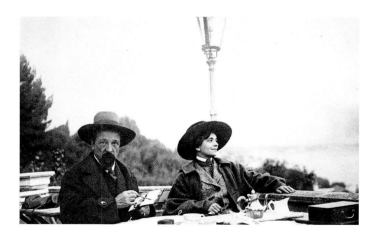

Fig. 123. Signac and Jeanne Selmersheim-Desgrange at Antibes, 1913, photograph. From Cachin 1971, p. 114

NOVEMBER 24–DECEMBER 6

Signac exhibition, Galerie Bernheim-Jeune, shown previously in Düsseldorf at the Alfred Flechtheim gallery. It comprises twenty paintings, five ink drawings, and twenty-five watercolors.

DECEMBER–JANUARY 1914

Signac finances the private publication of his "aide-mémoire Stendhal-Beyle," encapsulating in four pages all that is known about the writer; fifty-nine copies are published. This is a prelude to a much larger literary work that is to occupy Signac during the coming war years, "Beyle par Stendhal" or "Stendhal par lui-même" (Beyle by Stendhal or Stendhal by himself), which has never been published.

Bulletin, no. 1, January 1914, reprinted in *Stendhal Club* 11 (1963–64), p. 71; B. Cendrars, *La Rose rouge*, June 5, 1919, p. 92

1914

Éditions Bernheim-Jeune publishes a tribute to Cézanne, illustrated with lithographs after his paintings and watercolors. Signac contributes a lithograph of *Standing Bather* (fig. 56), a painting from his own collection.

JANUARY 18

Signac is in Saint-Tropez, where he sees Bonnard.

Letter from Signac to Angrand, January 18, 1914, private collection

MARCH–JUNE

Participates in a succession of exhibitions. March 1–April 30: thirtieth exhibition of the Indépendants, Paris, Champ-de-Mars; May 15–June 30: exhibition of French nineteenth-century art, Statens Museum for Kunst, Copenhagen; May–June: exhibition of the Mánes Union of Artists (S.V.U. Mánes), Prague; June 8–16: "Le Paysage du Midi," Galerie Bernheim-Jeune, Paris.

JUNE

While painting outdoors in the Hautes-Alpes, Signac meets Amédée Ozenfant (1886–1966) and invites him to Antibes.

Letter from Ozenfant to Signac, August 21, 1914, Signac Archives; Ozenfant 1968, pp. 78, 83–84

MID-JULY–OCTOBER 1

Apart from a brief stay in Saint-Tropez in September followed by a quick business trip to Paris, Signac spends the summer and early autumn with Jeanne and their daughter at the Hôtel des Alpins, Saint-Julien-en-Beauchêne (Hautes-Alpes), driving to the mountains on July 9 and departing on October 1.

List of addresses, Signac Archives

World War I breaks out during this time, following the assassination by Serbs of Archduke Franz Ferdinand of Austria and his wife on June 28 and successive declarations of war among the European powers beginning a month later. On July 31 Germany issues an ultimatum to France; on August 1 France orders a general mobilization; on August 3 Germany declares war on France and invades Belgium. In a letter to Berthe, Signac expresses his horror at the ensuing events, including the destruction of Rheims Cathedral: "It's not the Germans that are to be cursed, it's the war. . . . I really think that I shall never be able to recover from the appalling distress in which I am sinking, despite my efforts."

Letter from Signac to Berthe Signac, n.d., Signac Archives. Rheims Cathedral was shelled by the Germans on September 4, 17, 18, and 19, resulting in a catastrophic fire. The letter is likely to have been written just after that event, although shelling of the cathedral continued between September 24 and December 1914, and sporadically into 1918.

OCTOBER

Arrives in Antibes on October 3. Thereafter Signac divides his time between Antibes and Saint-Tropez.

Letters from Signac to Fénéon, Signac Archives

Signac writes to the young artists who have been drafted, keeps abreast of their news, and tries to cheer them up. He corresponds regularly with Dunoyer de Segonzac, who is assigned to the camouflage section.

Letters from Dunoyer de Segonzac to Signac, Signac Archives

1915

Signac, depressed by events, paints little.

JANUARY 31

From Saint-Tropez, with Berthe and the Bonnards, he writes to Angrand: "I am trying to paint, but one thinks about other things." Despite a shortage of paints, "I have begun the portrait of a cloud—of a very large cloud [cat. no. 135]."

Letter from Signac to Angrand, January 31, 1915, private collection

APRIL 17

Signac is officially named painter to the department of the navy, which will allow him to be sent on missions to work in ports without being accused of espionage.

WINTER

Verhaeren spends almost a month with Signac in Saint-Tropez.

Letter from Signac to Angrand, December 3, 1916, copy supplied by Pierre Angrand, Signac Archives

1916

END OF JULY–MID-AUGUST

In Le Puy, not to paint but for Ginette's health. The altitude is too much for Signac, forcing him to return to Saint-Tropez.

Letters from Signac to Fénéon, July 27, 1916, Signac Archives, and from Jeanne Selmersheim-Desgrange to Fénéon, August 18, 1916, Signac Archives

SEPTEMBER 28

Signac reports that the *Sindbad* has been requisitioned by the naval authorities in Saint-Tropez.

Letter from Signac to Fénéon, September 28, 1916, Signac Archives

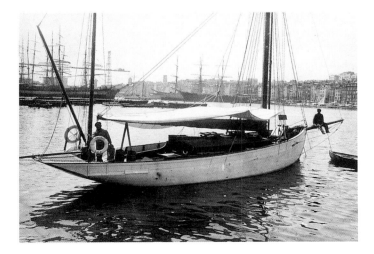

Fig. 124. *Sindbad* in the port of Marseilles, photograph. From Cachin 2000, p. 382

NOVEMBER 27

Death of Émile Verhaeren, run down by a train in the Rouen station. Profoundly upset, Signac writes to Angrand from Antibes: "Of all the men of letters he was virtually the only one to have great character as a man. His universal fame had not spoiled him, and I remember with emotion the happy hours spent with him in his little apartment in St Cloud. . . . I was his friend since 1886, when I was his guest in Brussels; and he was always loyal to me."

> Letter from Signac to Angrand, December 3, 1916, copy supplied by Pierre Angrand, Signac Archives

DECEMBER

From Antibes Signac visits Renoir in Cagnes.

> Letter from Signac to Fénéon, January 12, 1917, Signac Archives

1917

Signac divides his time between Antibes and Saint-Tropez.

JANUARY 23

He turns down the suggestion that the annual exhibitions of the Sociéte des Artistes Indépendants, suspended because of the war, should be resumed at a time when some of its members, on active duty for the last two-and-a-half years and unable to paint or exhibit, "are fighting, suffering, perhaps dying."

> Letter from Signac to an unknown artist, January 23, 1917, Paris, Fondation Custodia

APRIL 18

In Antibes, where he regrets the departure of the Bonnards.

> Letter from Signac to Fénéon, April 18, 1917, Signac Archives

MAY

"I have sent seven paintings to Bernheim. Three years' work!"

> Letter from Signac to Angrand, private collection

AUGUST 1

Because of his asthma and restricted diet, Signac has turned down an official Department of Fine Arts mission to Salamis and Milos, enabling him to work in ports without being accused of espionage. His hopes for a posting to a French or Italian port are not realized.

> Letters from Signac to Berthe Signac and Fénéon, August 1, 1917, Signac Archives

AUGUST 16

He finishes his *Stendhal critique d'art* (Stendhal, art critic)—a fifteen-hundred-page manuscript—and is about to send it to Louis Vauxcelles.

> Letters from Signac to Vauxcelles, August 16, 1917, Paris, Fondation Custodia; and to Fénéon, September 10, 1917, Signac Archives

AUGUST 30

He is sailing the *Sindbad* back to Saint-Tropez the next day.

> Letter from Signac to Fénéon, August 30, 1917, Signac Archives

NOVEMBER

The so-called October Revolution in Russia (November 6–7), leading eventually to the establishment under Lenin in 1922 of the Union of Soviet Socialist Republics (USSR). From Antibes Signac writes on the eighteenth that it would be painful to go to Paris while "we are undergoing these horrors." He puts off plans for an exhibition.

> Letter from Signac to Fénéon, November 18, 1917, Signac Archives

1918

JANUARY 25

From Antibes Signac reports that he has seen George Besson (1882–1971), the art historian, and Matisse in Nice. The dealer Léon Marseille has sold an 1886 painting of Les Andelys and one of Fécamp. Signac is renegotiating his contract with Bernheim.

> Letter from Signac to Fénéon, January 25, 1918, Signac Archives

FEBRUARY

He contributes a preface to the catalogue of the Juliette Cambier exhibition at the gallery L'Artistique, Nice.

APRIL 2

In Antibes. He has seen Matisse and Marquet. He has in hand a size-thirty canvas, *Les Allées, Cannes* (FC 521), which he sells to Léon Marseille later in the month.

> Letters from Signac to Fénéon, April 2 and 29, 1918, Signac Archives

APRIL 22

From Saint-Tropez he writes that he has begun a large view of the port of Marseilles (FC 543).

> Letter from Signac to Fénéon, April 22, 1918, Signac Archives

Fig. 125. Henri Matisse, posing beside his *Self-Portrait*, late 1917 or early 1918 in Nice, photographed by George Besson. From Paris 1993, p. 125

SEPTEMBER

On September 20 Signac reports that he has done a series of watercolors, still lifes of flowers and fruit. On September 30 he asks Fénéon for photographs of two works by Cézanne: a watercolor, to tack on his wall, and an oil painting of fruit.

> Letters from Signac to Fénéon, September 20 and 30, 1918, Signac Archives

NOVEMBER 11

Declaration of the Armistice between Germany and the Allies.

NOVEMBER 15

The Bonnards arrive in Antibes. Signac asks Fénéon to push the sale of his (Signac's) paintings.

> Letter from Signac to Fénéon, November 15, 1918, Signac Archives

1919

JANUARY 15

Signac, in Antibes, has no wish to go to Paris if "the victory junketing continues." He sees the Bonnards and occasionally Matisse.

> Letter from Signac to Fénéon, January 15, 1919, Signac Archives

MARCH 7

From Saint-Tropez Signac writes that he is selling the *Sindbad*—the sale is concluded by April 15—in order to buy back his own paintings. He has undertaken the purchases partly to maintain their market value but principally because he has decided to form a collection that will assure the financial future of his daughter; as an illegitimate

child, Ginette has no legal claim on his estate.

> Letters from Signac to Fénéon, March 7 and April 15, 1919, Signac Archives

JUNE

Signac is in Paris for at least part of the month, at his apartment on the rue La Fontaine.

> Letter from Signac to Lucien Pissarro, June 8, 1919, Ashmolean Museum, Oxford

EARLY JULY–SEPTEMBER

In the Haute-Savoie, with a brief trip to Switzerland. In Annecy with Jeanne on July 6; then in Thonon-les-Bains. He writes from Sallanches on August 6, mentioning the anticipated move of his household from Antibes to Paris, and again on September 13 ("My room in the inn was Ruskin's, perhaps Turner's too"). In Geneva on August 15, Signac meets the Neo-Impressionist painter Édouard Fer (1887–1959), who has organized an exhibition of French painting at the Galerie du Rhône. With his traveling companion, the poet Charles Vildrac (b. 1882), he attends a "conference on international thought" held in Geneva and stays with the Nobel-prize-winning author Romain Rolland (1866–1944), a committed pacifist. By September 22 Signac is in Saint-Tropez, having returned from Sallanches via Grenoble, where he had a good day "with Stendhal and Jongkind."

> Letters from Signac to Fénéon, July 6, August 6, September 13 and 22, 1919, Signac Archives; and watercolor dated August 15 and dedicated to Fer, James Dyke collection, in Little Rock 2000, no. 51

DECEMBER 1

With Jeanne and Ginette, Signac takes up residence in Paris, in an apartment at 14 rue de l'Abbaye (6th arrondissement), beside the church of Saint-Germain-des-Prés. Signac holds an open house in his studio every Sunday. Besson, Signac's future biographer, recalls: "Those Sundays of friendship, over the course of a dozen years, were Sundays of loyalty, Sundays of anger and of joy; on the agenda were painting, politics, literature, the future of the USSR, Brittany and the sea, music with sea shanties or songs from the Opéra de Quat'sous. And Stendhal? It was really something of a Stendhal Club that Signac's studio turned into."

> Besson 1968, p. 31

DECEMBER 6

Bernheim-Jeune, Léon Marseille, Charles Vildrac, and Signac enter into a contract whereby the artist places his entire output in the hands of the three dealers. The dealers undertake to acquire a maximum of twenty-one oil paintings a year, on terms stipulated in the agreement, without Signac being obliged to produce that number. Nothing is stipulated, apart from the prices, about the watercolors. Valid for a year, the contract is tacitly renewed thereafter until 1928, when it is renegotiated.

> Contract, Signac Archives

DECEMBER 18–JANUARY 20, 1920

Signac participates in the exhibition, "Indépendants," Galerie d'Art des Éditions G. Crès et Cie.

1920

JANUARY

Signac writes the preface to the catalogue of a Seurat exhibition at the Galeries Bernheim-Jeune. He organizes the first postwar Salon des Artistes Indépendants.

> "Exposition Georges Seurat (1859–1891)," Galeries Bernheim-Jeune, January 15–31, 1920

JANUARY 28–FEBRUARY 28

Thirty-first exhibition of the Indépendants, Grand Palais. A sculpture by Constantin Brancusi (1876–1957), *Princess X*, is withdrawn by order of the prefect of police. A protest is published on February 25, signed by numerous artists and art critics, but not by Signac, who is very ill with a high fever.

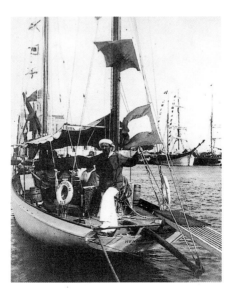

Fig. 126. Signac on board the *Henriette II*, ca. 1920, photograph. From Cachin 2000, p. 386

(His recovery is slow, for as late as April 18 he complains of still feeling weak.)

> "Pour l'indépendance de l'art," *Journal du peuple*, February 25, 1920, p. 3; letters from Jeanne Selmersheim-Desgrange to Fénéon, February 20 and 23, 1920, Signac Archives; letter from Signac to Fénéon, April 18, 1920, Signac Archives

FEBRUARY 28

Purchase by the state for the Musée du Luxembourg of *Port of Marseilles* (FC 543), now in Marseilles (Musée Cantini, RF 1977–324).

APRIL 15–OCTOBER 31

Venice Biennale. Signac, who is the commissioner for the French pavilion, mounts a Cézanne exhibition (twenty-eight paintings); he also shows his own works (seventeen oils and watercolors, of which sixteen are sold during the first two days) and works by Angrand, Bonnard, Cross, Guérin, Luce, Marquet, Matisse, Redon, Roussel, Seurat, and Valtat.

> Letter from Signac to Fénéon, Signac Archives

MAY 25

"I am invited to lunch at Monet's." By now he has sold all of his pictures shown in the Venice Biennale.

> Letter from Signac to Angrand, May 25, 1920, private collection

EARLY JULY–MID-OCTOBER

On the Atlantic coast, mainly in La Rochelle (Charente-Maritime) with Jeanne and Ginette. He spends two weeks in September with Berthe in Croix-de-Vie (Vendée), a small resort farther up the coast.

> Letters from Signac to Fénéon, July 4 and September 20, Signac Archives

OCTOBER 15–DECEMBER

In Paris from October 15 to the end of the month, before leaving for the Midi. He writes from Nice on December 21 to say that he is doing a little work and occasionally sees Matisse.

> Letters from Signac to Thiébault-Sisson, October 3, 1920, Paris, Fondation Custodia; and Fénéon, December 21, 1920, Signac Archives

1921

Publication of the third edition of *D'Eugène Delacroix au néo-impressionnisme* (Paris: Éditions Floury).

JANUARY 6

Detained for two weeks in Saint-Tropez because of poor health, he is unable to organize the Indépendants exhibition.

> Letter from Signac to Lucien Pissarro, Ashmolean Museum, Oxford; see also his letter to Fénéon, January 4, 1921, Signac Archives

JANUARY 23–FEBRUARY 28

Participates in the thirty-second exhibition of the Indépendants, Grand Palais.

FEBRUARY 2

From Nice Signac writes that he has just discovered Saint-Paul-de-Vence (a walled village about a mile and a half inland from Nice), where he has encountered Dufy, Jean Marchand, Charles Hall Thorndike (an American landscape painter born in Paris), and Othon Friesz. The painter and illustrator Gabriel Fournier (1893–1963) finds him a house, the old archbishops' residence, on which he takes a three-year lease. Fournier later recalls Signac as "the pleasantest of neighbors . . . the most attentive friend, a very often exuberant comrade."

> Letter from Signac to Fénéon, February 2, 1921, Signac Archives; Fournier 1957, pp. 190–91

APRIL 8

From Saint-Paul-de-Vence Signac writes that because Ginette has measles he will be coming to Paris on his own this year "for the meeting of the Indépendants." Afterwards he will return to pick up the others and drive along the Rhone, where he will be doing watercolors for his project *Stendhal touriste* (Stendhal, tourist). Signac, still a passionate Stendhalian, is also preparing a compilation of the writer's views on such topics as painting, religion, love, and war: "Les Manies de M. de Stendhal" (The notions of M. de Stendhal).

> Letter from Signac to Fénéon, April 8, 1921; Cousturier 1922, pp. 46–47

The German dealer Marcel Goldschmidt buys several of Signac's early studies painted at Port-en-Bessin, and in 1922 makes further purchases, mainly of his youthful, pre–Neo-Impressionist works.

JULY 15–OCTOBER 15

In Les Andelys. On September 16 he reports that he has had an encouraging visit from Monet (Giverny is not far), who wanted to have some of his watercolors (now Musée Marmottan, Paris, bequest of

Michel Monet, inv. nos. 5032, 5046, 5058, 5074 [fig. 56]).

> Letter from Signac to Fénéon, September 16, 1921, Signac Archives

NOVEMBER

Exhibition of Signac's watercolors, Paris.

> Letter from Signac to Thiébault-Sisson, November 23, 1921, Paris, Fondation Custodia, thanking him for his kind words on the exhibition

DECEMBER

In Brittany, where he paints watercolors in Concarneau, Groix, and Lorient among other places.

> Letter from Signac to Fénéon, December 22, 1921, Signac Archives

1922

Publication of the first monograph devoted to the artist: *Paul Signac* by Lucie Cousturier (1876–1925), in the series Cahiers d'Aujourd'hui (Paris: Éditions G. Crès).

JANUARY 28–FEBRUARY 28

Thirty-third exhibition of the Indépendants, Grand Palais. As president of the society, Signac writes to Francis Picabia on January 17, informing him that the committee has rejected two Dadaist canvases that he submitted because they do not fall "within the categories of works admitted to the exhibition." Picabia immediately retaliates by publishing an open letter to Signac in the popular press on January 23 and reproducing Signac's rejection letter on one side of scathing handbill distributed at the entrance to the exhibition.

> Letter from Signac to Picabia, January 17, 1922, Paris, Bibliothèque Littéraire Jacques Doucet; letter and handbill reproduced in Poupard-Lieussou and Sanouillet 1974, pp. 76–77

FEBRUARY 15

Signac comments on the distinction between easel painting and decorative painting in a survey of artists published in the *Bulletin de la vie artistique*.

> Signac 1922, p. 77

SPRING

In Saint-Paul-de-Vence. On March 24 he writes to Fénéon mentioning an attack of asthma. In Vence he has seen Dufy, Marchand, Thorndike, Élie Faure, and Derain. He has refused to sell the state his *La Rochelle* (FC 549) from the Indépendants

exhibition, despite the offer of ten thousand francs and the promise that it will be placed in the Musée de Luxembourg: "The Luxembourg! They have hung my *Marseilles* [FC 543] so well there that I avoid going into the museum when I take Ginette to the [Luxembourg] Garden." On May 5 he thanks Fénéon for having returned his letters to his friend Cross.

> Letters from Signac to Fénéon, March 24 and May 5, 1922, Signac Archives

SUMMER–EARLY AUTUMN

In Brittany, at Port-Louis (Morbihan), a small town near Lorient. On June 17 he reports that he is delighted with the five or six ports or anchorages within reach of his pencil, not including Lorient, one of the country's chief naval bases which the department of the navy has put at his disposal. On July 6 he writes about a proposal from Henri-Pierre Roché (1879–1959) to buy Seurat's *The Circus* (Roché is acting on behalf of the American collector John Quinn [1870–1924]). In August and September Signac complains of being immoblized by sciatica and asthma.

> Letters from Signac to Fénéon, June 17, July 6, August 29, and September 14, 1922, Signac Archives

OCTOBER

In Les Andelys by October 7: in spite of his sciatica Signac and his wife have driven their Peugeot from Port-Louis, via Paimpol (Côtes-d'Amor), and Granville (Manche) on the English Channel. In Paris by October 14.

> Letters from Signac to Fénéon, October 7 and 14, 1922, Signac Archives

CHRISTMAS

In Saint-Paul-de-Vence. En route Signac painted watercolors in Cahors, Albi, Montauban, and Marseilles, where he met Marquet; he visited the Musée Toulouse-Lautrec in Albi and the Musée Ingres in Montauban.

> Letter from Signac to Fénéon, December [25], 1922, Signac Archives

1923

Signac's first meeting with Marcel Cachin (1869–1958), imprisoned at the time in the Santé in Paris on a charge of high treason for having protested against the occupation of the Ruhr. Ultimately the case against Cachin is dismissed. One of the founding members of the French communist party

and director of the official party newspaper *L'Humanité* from 1918 until his death, he became the first communist senator in 1935 and was elected deputy of the Seine in 1946.

> Interview with Charles Cachin (son of Marcel Cachin and Signac's future son-in-law) by M. Ferretti-Bocquillon, January 8, 1998

JANUARY 31

In Paris, staying with Berthe in the apartment on the rue La Fontaine, Signac concludes the Seurat transaction with Roché: *The Circus* (fig. 42) is sold to Quinn on condition that it is bequeathed to the Louvre. Quinn, who is in remission from cancer, has limited time to enjoy the painting; he dies in July 1924.

> Letter from Signac to Fénéon, January 30, 1923, Signac Archives

FEBRUARY 10–MARCH 11

Thirty-fourth exhibition of the Indépendants, Grand Palais. Signac shows an oil of Venice and two watercolors.

FEBRUARY 27–MARCH 14

"On propose," an exhibition organized by Fénéon, Galerie Bernheim-Jeune. Signac shows three oil paintings.

> Halperin 1988, p. 329

MARCH–APRIL 18

In Saint-Paul-de-Vence, where he paints and works on a translation begun by Cross of Ruskin's *Elements of Drawing* (1857) mentioning in a letter to Cherfils the "Turnerian advice" that it offers. On April 18, he informs Fénéon that, having finished the translation, he is leaving the next day and will be in Paris by May 1, traveling by way of Rodez, the Lot, the Aveyron, the Tarn, and the Dordogne.

> Letters from Signac to Fénéon, March 3 and April 18, 1923, Signac Archives; and to Cherfils, March 4, 1923, private collection

The translation of *The Elements of Drawing*, a joint project that Signac and Cross had undertaken at the beginning of the century, was interrupted by Cross's illness and death in 1910. Despite Signac's claim to have finished it, he is still working on it early next year (see January 1924). The translation is never published.

MAY 6–31

One-man show of Signac's paintings, oil sketches, drawings, and watercolors: "P. Signac. Peintures—cartons de tableaux—dessins—aquarelles," Galerie Bernheim-Jeune.

JUNE

In Brittany, at Groix (on the Île de Groix) and Lorient.

> Notebook 15 XII, Signac Archives

JULY 11–OCTOBER 11

Mainly in Le Petit-Andely; drives around "on board my nice little 6HP Renault" in the first half of September. Returning to Paris on October 12, Signac brings back two oils of Les Andelys and some sixty watercolors (of Groix, Lorient, Les Andelys, Quilleboeuf, Honfleur, and other sites).

> Letters from Signac to Fénéon, July 12, August 13, and September 18, 1923

OCTOBER

"Cousturier et Signac," Galerie Giroux, Brussels.

NOVEMBER

In Paris. Signac is ill for part of the month.

> Letters from Signac to Berthe Signac, November 13, 19, and 20, 1923, Signac Archives

1924

Publication of *Seurat* by Gustave Coquiot (1865–1926), dedicated "To the painters Charles Angrand, Aman-Jean, and Paul Signac, who were the faithful friends of Georges Seurat."

JANUARY

In Paris. On January 4 Signac asks Fénéon to thank Mme Cross for the Ruskin papers. On January 26 he writes to Lucien Pissarro that he has visited his exhibition, which opened at the Galerie Marcel Bernheim five days earlier. At present he is barely able to leave the Grand Palais (where the Indépendants are due to open next month). He is still working on the Ruskin translation.

> Letters from Signac to Fénéon, January 4, 1924, Signac Archives; and to Lucien Pissarro, January 26, 1924, Ashmolean Museum, Oxford

FEBRUARY 9–MARCH 12

Thirty-fifth exhibition of the Indépendants, Grand Palais. Its organization is once again controversial. A faction of young artists systematically contests the committee's selection. Last year's hanging, in alphabetical order by artist—which seemed to Signac the fairest arrangement and one that avoided grouping participants by schools—had been severely criticized. This time the pictures are hung along national lines, a solution that also comes under fire. Accused of nationalism, Signac resigns as president, as do Luce, his vice president, and two members of the staff. The society's general assembly, meeting shortly thereafter as a result of these resignations, endorses Signac, who resumes his duties.

FEBRUARY 22

Angrand agrees to sell Signac a pastel, *The Port*.

> Letter from Angrand to Signac, February 22, 1924, Signac Archives

SUMMER–OCTOBER 10

In Brittany, staying in Lézardrieux (Côtes-d'Amor), a commune west of Paimpol on the Trieux estuary. There he rents the same house, Le Grand Cardinal, every summer until 1930.

1925

FEBRUARY 26

From Paris Signac writes to a friend: "I have just had my dining room painted chrome yellow no. 2 and hung five flamboyant Crosses there!" He subsequently invites Fénéon to come and admire the effect.

> Letters from Signac to a friend, February 26, 1925, collection P. Lévy, in Lévy 1982, p. 112; and to Fénéon, March 4, 1925, Signac Archives

MARCH

He reports on March 7 that he has agreed to be the Paris representative of the Berlin Secession and on March 21 that Mánes, the Czech group of artists, has just named him a "corresponding member" in France.

> Letters from Signac to Fénéon, March 7 and 21, 1925, Signac Archives

MARCH 20

Jacques Guenne's interview with Signac is published in *L'Art vivant*.

> Guenne 1925, pp. 1–4

MARCH 21–MAY 3

Signac participates in the thirty-sixth exhibition of the Indépendants, Palais de Bois, Avenue de la Grande-Armée.

MAY 9

"Every day, for lack of works, I have to turn down invitations to participate from exhibition organizers—I have eleven requests in hand!"

> Letter from Signac to Fénéon, May 9, 1925, Signac Archives

MAY 25

"At the Hôtel [Drouot] I have acquired an attractive Cross of his nephew on the steps [*Child in the Garden,* 1901], and a forceful Valtat; I also have a fine Angrand, an oil of a Georgian woman, and one of a Japanese man, 'the sailor.'"

> Letter from Signac to Fénéon, May 25, 1925, Signac Archives

MAY 26/27−MID-OCTOBER

In Brittany, reaching Lézardrieux by June 25 by way of Vannes and the Île aux Moines, with a week at Concarneau for the annual departure of the tuna boats. From Lézardrieux Signac paints watercolors at Île à Bois, Tréguier, and Portrieux. On August 16, complaining of the stifling air in Lézardrieux, he notes: "I am permanently barred from all promotions in the Legion of Honor for having signed the protest against the war in Morocco. I was well aware of the harm I was doing myself by signing." On September 28, anticipating his return to Paris about October 15, Signac again mentions his difficulties breathing.

> Letters from Signac to Fénéon, May 25, June 10, 13, 25, July 6, August 3, 9, 12, 16, September 9, 28, 1925, Signac Archives

The summer of 1925 marks the beginning of the friendship between Signac and his family and the Marcel Cachins (see above, 1923, for the two men's first meeting). From then on, the Cachins are habitués of the Sunday gatherings in the Signac apartment on the rue de l'Abbaye.

> Interview with Charles Cachin by M. Ferretti-Bocquillon, January 8, 1998

OCTOBER 31

Signac writes to Florent Fels (b. 1893), who has just published a monograph on Monet, correcting his account of Monet's "studio": "The room in which you were received—I visit it frequently—contains not the scraps that you report but the finest Monets of every period, kept for himself by the old master. I always have the urge to make off with some of them!"

> Letter from Signac to Fels, October 31, 1925, copy kindly supplied by the descendants, Signac Archives

1926

FEBRUARY 20−MARCH 21

"Trente Ans d'art indépendant, 1884−1914" (Thirty years of independent art, 1884−1914), the thirty-seventh exhibition of the Indépendants, Grand Palais. Organized by Signac, this is an eloquent demonstration of the part that the Société des Artistes Indépendants has played in the development of contemporary art. All those who have ever exhibited with the Indépendants have been invited, and each presents a brief retrospective of his work.

MARCH 2

In Paris: "Yesterday bought some beautiful flowers by Valtat [1905]."

> Letter from Signac to Fénéon, March 2, 1926, Signac Archives

APRIL 1

Death of Charles Angrand, in Rouen.

BEGINNING OF APRIL−OCTOBER

Mainly in the Ardèche, staying first in Bourg-Saint-Andéol, where Signac learns of Angrand's death, and then in Viviers, where he rents a house, Les Maraniousques; both towns are on the right bank of the Rhone, south of Montélimar. In April Signac makes sketches along the Rhone for an illustrated edition of Stendhal's *Mémoires d'un touriste* (1838). In the first part of June he spends two weeks in Paris, attending the meeting of the Indépendants on June 16, and returns to Bourg-Saint-Andéol before the move to Viviers. He writes from Viviers at the end of October that he has suffered a lot over his book *Jongkind* and that he has no enthusiasm left for exhibitions—there are so many of them; nor does he care much for galleries.

> Librairie Charavay, catalogue no. 716, November 1964; letters from Signac to Fénéon, April 15, May 26, June 16, August 19, October 20, 1926, Signac Archives

DECEMBER 5

Death of Claude Monet in Giverny. On January 1 Signac is among the artists and writers who contribute to a tribute in the journal *L'Art vivant,* lamenting "the loss of the Master and Friend, whose entire life and work were for me encouraging examples . . . Claude Monet has liberated French painting. There is not a painter who is not indebted to him for something."

> Signac 1927b, p. 23, which reprints, verbatim, the letter from Signac to an unknown correspondent, *Catalogue d'autographes, dessins, portraits,* sale cat., Librairie Jean-Claude Vrain, Paris, 1998, no. 188, ill.

1927

Publication of Signac's *Jongkind* in the series *Cahiers d'Aujourd'hui* (Paris: G. Crès). The last—and longest—chapter is effectively a treatise on watercolor painting and has been called "one of the most brilliant essays on the subject."

> Cachin 1971, p. 120

Signac contributes three lithographs to the illustrated edition of Stendhal's *Mémoires d'un touriste,* published by Crès.

JANUARY

Signac publishes an article on the founding of the Indépendants in *Partisans.*

> Signac 1927a, pp. 3–7

JANUARY 21−FEBRUARY 27

Signac participates in the thirty-eighth exhibition of the Indépendants, Grand Palais.

FEBRUARY−MARCH

Exhibition of Signac's works at the Goldschmidt gallery in Berlin, and then in Frankfurt from March to May.

MARCH 13

Staying in Audierne (Finistère), on the Atlantic, where he expects to be for another ten days: "I am working like a young man." In watercolors "I struggle with the wind, the tide, the current, and the sails—the oil painter is deprived of these jousts."

> Letter from Signac to Fénéon, March 13, 1927, Signac Archives

APRIL 6

Decision of the Civil Court of First Instance of the Seine: Ginette is officially adopted by Signac (named as the father in her birth certificate).

MAY 7−JUNE 12

Signac publishes an essay on the artistic contribution of the Neo-Impressionists as the foreword to the catalogue for the Salon du Sud-Est in Lyons.

> Paul Signac, "L'apport des néo-impressionnistes," in the catalogue for the Salon du Sud-Est, Lyons, May 7–June 12, 1927

SUMMER–MID-SEPTEMBER

In Brittany at Lézardrieux, returning to
Viviers in mid-September. Signac writes
from Lézardrieux on July 27, mentioning his
itinerary via Carantec, Camaret, Roscoff,
Morlaix, and Portrieux. He and Jeanne are
seeing no one but the "nice Thorndike."
Matisse, staying with the Thorndikes, visits
Signac and Jeanne in August.

> Letters from Signac to an unidentified
> friend, July 27, 1927, Charavay catalogue, no.
> 712; and to Fénéon, August 28, 1927, Signac
> Archives

1928

The businessman Gaston Lévy (1893–1977),
cofounder of the Monoprix department
store chain, begins to buy works by Signac
and subsequently embarks on compiling
the "pre-catalogue" of his paintings.

JANUARY 20–FEBRUARY 29

Participates in the thirty-ninth exhibition
of the Indépendants, Grand Palais.

FEBRUARY 26–MARCH 13

In Saint-Malo (Ille-et-Vilaine). Signac
witnesses the departure of the fishing fleet
for the Grand Banks on March 6.

> Notebook, Paris, Musée de la Marine,
> R15d/42228

APRIL 1

Signac enters into a new contract with the
three dealers Bernheim-Jeune, Léon
Marseille, and Charles Vildrac, whereby he
puts three-quarters of his output of oil
paintings at their disposal, reserving one-
quarter for himself. In addition, the dealers
undertake to purchase a total of at least
seventy-five-thousand francs' worth of his
watercolors per year, allowing Signac to
keep one-quarter of his output to dispose
of as he pleases.

> Contract, Signac Archives

SUMMER

Mainly in Viviers. In August he spends
time at the Villa Orphée, Gaston Lévy's
property in Brittany at La Baule (Loire-
Atlantique), and paints in the area. On
August 28 he dedicates a watercolor to
Lévy's wife, Liliane, "in memory of
a happy cruise on board the 'Orphée.'"

> Letter from Signac to Fénéon, June 7, 1928;
> watercolor of Le Pouliguen dated August 11,
> 1928, inscribed to Mme G. Lévy on August
> 28, Little Rock, Arkansas, collection James
> Dyke, in Little Rock 2000, no. 92

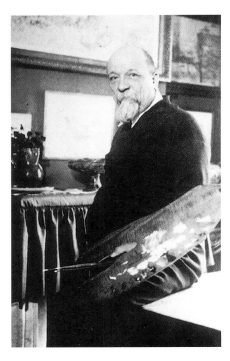

Fig. 127. Signac in his apartment on the rue
de l'Abbaye, Paris, 1928, photograph. From
Distel 2001, p. 121

DECEMBER

Signac asks Lévy to consider commission-
ing him to do a series of watercolors of
the ports of France, a proposal that Lévy
accepts.

> Correspondence between Signac and Lévy,
> private collection

1929

JANUARY 18–FEBRUARY 28

Participates in the fortieth exhibition of
the Indépendants, Grand Palais.

END OF MARCH–LATE APRIL

Signac embarks on his Ports of France
series of watercolors, beginning at Sète on
the Mediterranean on March 25 and work-
ing on them as he travels south and west to
Port-Vendres on the Spanish border. He
then crosses to the Atlantic coast and
paints at a number of harbors from the
area around Saint-Jean-de-Luz northward
to Les Sables-d'Olonne (April 20).

> Notebook 1929 1, Signac Archives; and dated
> watercolors, private collection

MAY–JUNE

He pursues the Ports of France series in
northern Brittany from Vannes to Morlaix,
covering some twenty sites.

> Dated watercolors, private collection

JULY–MID-OCTOBER

Again in Brittany for the Ports of France
series, starting on the Atlantic coast around
La Baule, where he stays between July 13 and
30. Most of August is spent at Lézardrieux.
From Nantes on August 24 he returns to
northern Brittany and continues his watercol-
ors, traveling from Brest to Granville, finding
himself in Saint-Malo on October 16.

> Notebook 1929 5, Signac Archives; and dated
> watercolors, private collection

1930

JANUARY–FEBRUARY

Signac contributes an article to a special
issue of Les Cahiers de l'étoile devoted to
Charles Henry.

> Signac 1930a, n.p.

JANUARY 14

In Paris. He sends Durand-Ruel six thou-
sand francs in payment of the outstanding
balance on a watercolor by Jongkind,
Honfleur 1 Oct. 1863.

> Archives Durand-Ruel, Paris; Hefing 1975,
> no. 273

JANUARY 17–MARCH 2

Participates in the forty-first exhibition of
the Indépendants, Grand Palais.

EARLY–MID-FEBRUARY

He resumes his watercolors of French
ports, this time on the channel coast, trav-
eling northward from Honfleur to Saint-
Valery-sur-Somme.

> Notebook 1930 1, Signac Archives; and dated
> watercolors, private collection

MARCH 11–20

In Saint-Malo, where he is present at the depar-
ture of the fishing fleet for the Grand Banks.

> Postcard and letter from Signac to Vauxcelles,
> Paris, Fondation Custodia; letter from Signac
> to M. Joyant, Paris, Bibliothèque Central des
> Musées Nationaux, Ms 310; and notebook,
> Paris, Musée de la Marine R15d/42228

MAY 19–30

Signac exhibition at the Galerie Bernheim-
Jeune.

JUNE

Returning to the channel coast for the Ports
of France series, Signac works as he travels
south from Dunkirk, near the Belgian border,
to Cherbourg.

> Notebook "De Tréport à Barfleur," 1930 3,
> Signac Archives; and dated watercolors,
> private collection

JULY–SEPTEMBER

In Brittany: at Lézardrieux in July; traveling in August. He is with the Lévys at the Villa Orphée in La Baule near the end of September, and in Saint-Malo on September 30.

> Notebooks 1930 3–6, Signac Archives; list of addresses, Signac Archives

OCTOBER 27

In a letter to Lévy, Signac mentions the prospect of renting a house in Barfleur, in Normandy, citing among the advantages of the place its active port, "magnificent countryside," and mild climate. "And then it's not far from Paris."

> Letter from Signac to Lévy, October 27, 1930, private collection

NOVEMBER

Leaving Paris early in the month for about three weeks, Signac visits La Rochelle, La Pallice, Rochefort, and Bordeaux for the Ports of France series. By November 30 he arrives in northern Brittany at Landerneau.

> Letter from Signac to Fénéon, November 5, 1930, Signac Archives; notebook "Océan Martigues," 1930 7, Signac Archives; and dated watercolors, private collection

1931

JANUARY 24–MARCH 1

Participates in the forty-second exhibition of the Indépendants, Grand Palais.

APRIL

In the closing phase of his Ports of France project Signac returns to the Mediterranean, this time to the east of Sète (where he began the series two years ago), painting harbors from Marseilles and Toulon to Menton on the Italian border. He works "like a madman" for the first two weeks and falls ill thereafter: "I so overdid it on the coast—here to finish my series of ports—that I am half-dead. The treacherous climate got to me. I escaped the snows of Dunkirk and the ocean squalls, but Menton got to me. If it hasn't killed me—as it killed my father in two days—it has laid me low."

> Letter from Signac to Fénéon, April 30, 1931, Signac Archives; see also Fournier 1957, p. 189

JUNE–OCTOBER

In Barfleur, where he buys a small house opposite the church, looking out on the

harbor to the east and the Gatteville lighthouse, on the Pointe de Barfleur, to the west.

> Notebook, summer 1931, Paris, Musée de la Marine, R15d/42228

DECEMBER

In Paris he meets Mahatma Gandhi, who is on a European tour following the failure of the London Round Table Conference on Indian constitutional reform. Signac has declined an invitation to preside at the meeting (too bourgeois) organized in Gandhi's honor. In a letter to Berthe he describes Gandhi as "an old fox. But he was very clear on the question of peace and the refusal to bear arms against his enemies. . . . Everything is becoming very serious. . . . We must resist this wave of nationalism that will lead us into war."

> Letter from Signac to Berthe, 1931, Signac Archives

1932

Signac is preoccupied by the political climate and fears a new war. Affected by the Depression, he finds it more and more difficult to support his two households, but refuses to sell off the pictures in his collection. He even offers to take a very fine Monet, *Apple Trees in Bloom beside the Water* (fig. 38), in settlement of the thirty-two thousand francs he is owed by his dealer Marseille, who has been ruined in the crash—a proposal that is accepted.

The irony of the situation in which he and others find themselves does not escape Signac, however. He visits the Bobino, a music hall in Montparnasse, to hear a popular singer on a Saturday afternoon, when the stalls are half-price: "There I met, inspired by the same motives of economy, a great collector of paintings, M. Bernard, ruined banker; behind him was Werth, ruined art critic and writer; and farther off P. Signac, ruined painter with his old overcoat."

> Letters from Signac to Berthe, 1932, Signac Archives

JANUARY 22–FEBRUARY 28

Participates in the forty-third exhibition of the Indépendants, Grand Palais.

FEBRUARY 25–MARCH 17

Signac exhibits in "Le Néo-Impressionnisme," Galerie Braun et Cie, Paris.

JULY 12–OCTOBER 13

In Barfleur, returning to Paris via Dinan and Pont-l'Abbé by November 11.

> Notebooks 1932 4–6, Signac Archives; and dated watercolors, private collection

DECEMBER 24

Signac is featured on the front page of *L'Humanité*, the communist daily, beside its director, Marcel Cachin, to support the second session of the Bureau of the World Committee against War.

Clearsighted in his attitude toward the communist party, Signac maintains his distance and expresses his reservations. As an impassioned pacifist, however, he will always support antiwar demonstrations and take part in meetings of the Vigilance Committee of Anti-Fascist Intellectuals, together with avowed party members or sympathizers at the time such as Eugène Dabit, André Gide, Paul Nizan, and the editor in chief of *L'Humanité*, the politician Paul Vaillant-Couturier.

> Letters from Signac to Fénéon, August 25, September 2, 1932, Signac Archives

1933

Signac donates a watercolor of 1931, *Flood at the Pont des Arts, Paris* (cat. no. 165), to the Musée du Luxembourg.

JANUARY

Trial of Henri Guilbeaux, Germanist writer and pacifist accused of high treason and condemned to death in absentia in 1919, who has returned from Russia of his own accord. Signac testifies on his behalf; Guilbeaux is acquitted of the charge.

> A. Reuze, *Excelsior*, January 27, 1933, pp. 1–2

JANUARY 20–FEBRUARY 26

Participates in the forty-fourth exhibition of the Indépendants, Grand Palais.

JANUARY 28

"I made four thousand francs in 1932."

> Letter from Signac to Fénéon, January 28, 1933, Signac Archives

FEBRUARY 24

Aware of important rearrangements under way at the Louvre and the Musée du Luxembourg, Signac writes to Henri Verne, director of the Musées Nationaux, to express concern about the fate of Seurat's *The Circus*, bequeathed to the Louvre by John Quinn: "It was at my request that this generous donor stipulated

Fig. 128. Signac, right, and fishermen at the port of Barfleur, ca. 1932, photograph. Signac Archives

that this painting be returned to France and he destined it for the Louvre."

> Letter from Signac to Verne, February 24, 1933, Paris, Archives des Musées Nationaux, P8/1927, Quinn Bequest

MARCH 27

Shortly before leaving Paris for Vaison-la-Romaine in Provence, he comments on his depleted finances and queries Fénéon about an asking price for Seurat's sketch for *Le Chahut* (H 198), should he decide to part with it.

> Letter from Signac to Fénéon, March 27, 1933, Signac Archives

APRIL 7–MAY 4

"Vingt-trois Artistes soviétiques" (Twenty-three Soviet artists), Galerie Billet, Paris. Signac contributes a preface to the catalogue.

MAY

Asked to comment on decorative painting by the journal *Art et Décoration*, Signac expresses his admiration for Delacroix.

> Paul Signac, in "Premières réponses à nôtre enquête: évolution ou mort de l'ornement?" *Art et décoration*, May 1933, p. II

JUNE

Bonnard exhibition at the Galerie Bernheim-Jeune. Signac writes to Bonnard warmly congratulating him. After leaving Paris for the summer toward the end of the month, he describes the joy given him by this exhibition, which makes him want to paint: "Everything seems easy. Painting for painting's sake, nothing else."

> Signac journal entry, June 29, 1933, Signac Archives

END OF JUNE–LATE OCTOBER

In Barfleur from June 28 to September. In Brittany October 14–21, where he paints watercolors at Cancale, Loctudy, and Pont-l'Abbé.

> Notebooks 1933 5 and 6, Signac Archives; letters from Signac to Fénéon, Signac Archives; and dated watercolors, private collection

DECEMBER–JANUARY 1934

"Les Étapes de l'art contemporain I, Seurat et ses amis, La Suite de l'impressionnisme" (The stages of contemporary art. I. Seurat and his friends: The sequel to Impressionism), Galerie Beaux-Arts. Signac, who shows fourteen works, also actively participates in the organization of the exhibition and publishes "Le Néo-Impressionnisme, documents" in the preface to the catalogue. He sells Seurat's sketch for *Le Chahut* (H 198) included in the exhibition, to the Wildenstein gallery.

> Signac 1934, pp. 49–59

DECEMBER 30

Signac is promoted to commander of the Legion of Honor.

1934

JANUARY

In spite of suffering attacks of enteritis, Signac is actively engaged in preparing the fiftieth-anniversary exhibition of the Indépendants. He has no money and the galleries are deserted: "I make less than I did thirty years ago."

> Letters from Signac to Berthe Signac, Signac Archives

FEBRUARY 2–MARCH 11

"Exposition du Cinquantenaire," forty-fifth exhibition of the Indépendants, celebrating the society's fiftieth anniversary, Grand Palais. Signac contributes the preface to the catalogue (an extract appears in *Beaux-Arts*).

> Signac 1934, pp. 3–5

FEBRUARY 10

Signac publishes a virulent article on the École des Beaux-Arts in *Monde.*

> Paul Signac, "Malheur à l'homme qui invente et qui ose," *Monde,* February 10, 1934, pp. 6–7

FEBRUARY–MARCH

"Exposition Paul Signac," Petit-Palais. The exhibition is comprised of forty-nine paintings and nineteen works on paper.

SPRING

In Paris Ginette Signac, aged twenty, marries Dr. Charles Cachin (b. 1907), aged twenty-six, son of Marcel Cachin.

JUNE–SEPTEMBER

In Barfleur between June 21 and September 20; in Marseilles by September 26.

> Notebooks 1934 4–6, Signac Archives

NOVEMBER 7

Signac resigns as president of the Société des Artistes Indépendants. On November 15 Maximilien Luce, persuaded by Signac to accept the post, is elected president in his place.

> Letter of resignation, in *Bulletin de la Société des artistes indépendants,* December 1937, pp. 15–21; see also articles in *Comoedia,* November 14–15, 1934

1935

George Besson publishes his monograph *Signac* (Paris: Rombaldi).

Signac writes an article for the *Encyclopédie française,* which is being issued in installments, on "The subject in painting" and "The meaning of the picture" under the title "Les Besoins individuels et la peinture" (Individual needs and painting). The section in which it appears is published posthumously in November.

> Signac 1935, vol. 16, pt. 2, sect. B, chap. 2:3, pp. 16.84:7–10; see also the editor's comments on Signac in ibid., p. 16.14:9; reprinted in Cachin 1964, pp. 143–65

JANUARY 1

Signac publishes an antiwar piece in *La Revue mondiale.*

> Signac 1935a, pp. 11–12

JANUARY–FEBRUARY

The long-postponed project of a visit to Corsica appeals to Signac, who has earlier written to Berthe: "I should like to go and see this island and to work there before I die. . . . It would renew my repertoire of pictures, and I could use it." Leaving Paris for the south early in January, Signac makes a reconnaissance trip to Corsica between February 9 and 28, visiting the coastal towns of Calvi, Ajaccio, Propriano, Bonifacio, and Bastia.

JANUARY 18–MARCH 3

Participates in the forty-sixth exhibition of the Indépendants, Grand Palais.

MARCH

Signac receives an invitation from the USSR to visit the country, all expenses paid beyond the Russian frontier, but he does not feel up to the journey or the emotional strain it would entail.

> Letter from Signac to Berthe Signac, March, 1935, Signac Archives

MARCH 14

Signac takes part in an antifascist meeting at the Mutualité and calls for a boycott of German products in order to hold Hitler to his promises to the German workers. Marcel Cachin is opposed to this tactic.

> *L'Humanité*, March 14, 1935, pp. 1–2

APRIL 4

Signac's interview with Charles Kunstler appears in *Le Petit Parisien*.

> Kunstler 1935, p. 4

APRIL–LATE JUNE

Signac travels for the last time, setting out from Paris in early April. With a stay in Saint-Tropez on the way, he is at Saint-Florent in Corsica by May 1. From there his watercolors take him south along the coast to L'Île Rousse, Ajaccio, and Propriano (June 14–24).

> Notebooks 1935 2–5, Département des Arts Graphiques Fonds du Musée d'Orsay, Paris (notebooks 4 and 5 reflect Corsica but without specific dates). For notebook 2, see Cachin 1990

MAY

Signac is named honorary president of the Société des Artistes Indépendants.

BEGINNING OF JULY

Upon his return from a trip to the USSR, the painter André Marchand (b. 1907) visits Signac at his apartment. The year before Signac had shown him a Soviet magazine, exclaiming in horror over the reproductions of Soviet paintings: "It's for this that we had the revolution . . . we've been betrayed . . . the revolution is done for." Marchand confirms Signac's appraisal.

> Interview with Marchand by F. Cachin and M. Ferretti-Bocquillon, October 20, 1988, Musée d'Orsay, Paris

ABOUT JULY 10

Signac takes to his bed, suffering from uremia, soon complicated by a pulmonary congestion. During what proves to be a fatal illness, Fénéon, contacted by Signac's doctor, the artist's son-in-law, comes up from the country to visit him.

> Letter from Fénéon to Émile Compard, August 23, 1935, private collection

AUGUST 15

Signac dies in Paris, aged seventy-one. The cause of death is septicemia, following a renal infection brought on by a prostate tumor.

> Interview with Charles Cachin by M. Ferretti-Bocquillon, January 8, 1998

AUGUST 18

Signac is cremated at the columbarium of the Père Lachaise cemetery. The cortège is led by his daughter, Ginette, followed by Berthe Signac and Jeanne Selmersheim-Desgrange. Although he was never a member of the communist party, Signac's funeral is made the occasion for a massive demonstration of party solidarity, with large numbers of workers in the Paris region turning out in response to a summons issued by Paul Vaillant-Couturier.

AUGUST 21

Gustave Kahn writes a fine article in *Le Quotidien* on the friend of his youth, concluding: "There is more poetry than he thought . . . in his painter's art, the art of a great painter, a great landscapist, illuminated with pure purple, rose, and golden light."

> Kahn 1935a, p. 2

AUGUST 23

Fénéon, describing himself as "no connoisseur of funerals," stays away from Signac's. Commenting on the event, he writes: "The painters . . . were many, but not enough to have been able to make up the bulk of the cortège. The militants of the revolution were there in force." As for himself, this bereavement "was singularly cruel: so many memories, some going back a very long way, bound me to the dead man."

> Letter from Fénéon to Compard, August 23, 1935, private collection

BIBLIOGRAPHY

KEY TO ABBREVIATIONS

B Bouin-Luce and Bazetoux 1986
 [Luce]
C Compin 1964 [Cross]
D Dauberville and Dauberville
 1966–74 [Bonnard]
F Faille 1970 [Van Gogh]
FC Cachin 2000 [Signac]
H Hauke 1961 [Seurat]
KW Kornfield and Wick 1974 [Signac]
L Lemoisne 1947–48 [Degas]
R Rewald 1996 [Cézanne]
S Schmit 1973 [Boudin]
V Venturi 1939 [Pissarro]
W Wildenstein 1996 [Monet]

KEY TO SELECTED
SIGNAC EXHIBITIONS

Paris 1884. "Salon des Artistes Indépen-
 dants." Courtyard of the Tuileries,
 Paris, May 15–June 30, 1884.
Paris 1884–85. "1ᵉ Salon de la Société des
 Artistes Indépendants." Pavillon de la
 Ville de Paris, Champs-Élysées,
 December 10, 1884–January 17, 1885.
Nantes 1886. "Ouvrages de peinture, sculp-
 ture, architecture, gravure et lithographie
des artists vivants." Palais du Cours
 Saint-André, Nantes, October 10–
 November 30, 1886. Organized by John
 Floury.
Paris 1886. "8ᵉ Exposition de peinture."
 1 rue Laffitte, Paris, May 15–June 15, 1886.
Paris 1886. "2ᵉ Salon des Indépendants."
 Building B, near the Pavillon de Flore,
 rue des Tuileries, Paris, August 21–
 September 21, 1886.
Paris 1887. "3ᵉ Salon des Indépendants."
 Pavillon de la Ville de Paris, Champs-
 Élysées, Paris, March 26–May 3, 1887.
Paris 1887–88. Exhibition, rehearsal room,
 Théâtre-Libre, 96 rue Blanche, Paris,
 late November 1887–early January 1888.
Brussels 1888. "Vᵉ Exposition des XX."
 Exhibition, Brussels, February 5– , 1888.
Paris 1888. "4ᵉ Salon des Indépendants."
 Pavillon de la Ville de Paris, Champs-
 Élysées, Paris, March 22–May 3, 1888.
Paris 1889. "5ᵉ Salon des Indépendants."
 Salle de la Société d'Horticulture, 84
 rue de Grenelle, Paris, September 3–
 October 4, 1889.
Brussels 1890. "VIIᵉ Exposition des XX."
 Exhibition, Brussels, January 17– , 1890.
Paris 1890. "6ᵉ Salon des Indépendants."
 Pavillon de la Ville de Paris, Champs-
 Élysées, March 20–April 27, 1890.
Brussels 1891. "VIIIᵉ Exposition des XX."
 Exhibition, Brussels, February 7– ,
 1891.
Paris 1891. "7ᵐᵉ Salon des Indépendants."
 Pavillon de la Ville de Paris, Champs-
 Élysées, March 20–April 27, 1891.
Antwerp 1892. "Iᵉ Exposition de l'Associa-
 tion pour l'Art." Exhibition, Antwerp,
 May 29–June, 1892.
Brussels 1892. "IXᵉ Exposition des XX."
 Exhibition, Brussels, February 1892.
Paris 1892. "8ᵉ Salon des Indépendants."
 Pavillon de la Ville de Paris, Champs-
 Élysées, March 19–April 27, 1892.
Paris 1892. "Deuxième Exposition des
 peintres impressionnistes et sym-
 bolistes." Le Barc de Boutteville, Paris,
 May–August 1892.
Paris 1892–93. "Exposition des peintres
 néo-impressionnistes." Salons de l'Hô-
 tel Brébant, Paris, December 2, 1892–
 January 8, 1893.
Antwerp 1893. "IIᵉ Exposition de l'Associ-
 ation pour l'Art." Exhibition, Antwerp,
 May 1893.
Brussels 1893. "Xᵉ Exposition des XX."
 Exhibition, Brussels, February 1893.
Paris 1893. "9ᵉ Salon des Indépendants."
 Pavillon de la Ville de Paris, Champs-
 Élysées, March 18–April 27, 1893.

Paris 1893. "Exposition des portraits des écrivains et journalistes du siècle (1793–1893)." Galerie Georges Petit, Paris, June 1893.

Paris 1893–94. "Groupe des peintres néo-impressionnistes." 20 rue Laffitte, Paris, December 1893–January 1894.

Brussels 1894. "Iᵉ Salon de La Libre Esthétique." Exhibition, Brussels, February 17–March 15, 1894.

Paris 1895. "11ᵉ Salon des Indépendants." Palais des Arts Libéraux, Champ-de-Mars, Paris, April 9–May 26, 1895.

Paris 1895–96. Exhibition, L'Art Nouveau Bing, Paris, December 28, 1895–January 1896.

Brussels 1896. "IIIᵉ Salon de La Libre Esthétique." Exhibition, Brussels, February 22–March 30, 1896.

Paris 1897. "13ᵉ Salon des Indépendants." Palais des Arts Libéraux, Champ-de-Mars, Paris, April 3–May 31, 1897.

Paris 1899. "Exposition d'oeuvres de Mm. P. Bonnard, M. Denis, H.-G. Ibels. . . ." Galerie Durand-Ruel, Paris, March 10–31, 1899.

Vienna 1900. "VII Kunstausstellung der vereinigung bildender Künstler Österreichs Secession." Exhibition, Vienna, 1900.

Dresden 1901. Exhibition, Galerie Ernst Arnold, Dresden, 1901.

Paris 1901. "17ᵉ Salon des Indépendants." Grande Serre de l'Alma, Cours-la-Reine, Paris, April 20–May 21, 1901.

Paris 1902. "18ᵉ Salon des Indépendants." Grande Serre de l'Alma, Cours-la-Reine, Paris, March 29–May 5, 1902.

Hamburg 1903. "Neo-impressionisten." Cassirer gallery, Hamburg, January 3– , 1903.

Mâcon 1903. "Exposition des Beaux-Arts." Mâcon, July 5–August 24, 1903.

Paris 1903. "19ᵉ Salon des Indépendants." Grande Serre de l'Alma, Cours-la-Reine, Paris, March 20–April 25, 1903.

Weimar 1903. "Deutsche und französische Impressionisten und Neo-impressionisten." Grossherzogliches Museum, August 1903. Organized by Harry Kessler.

Brussels 1904. "Exposition des peintres impressionnistes." La Libre Esthétique, Brussels, February 25–March 29, 1904.

Dresden 1904. Exhibition, Galerie Ernst Arnold, 1904.

Krefeld 1904. "Der französische Impressionismus." Kaiser-Wilhelm Museum, Krefeld, February 16–28, 1904.

Paris 1904. "Exposition Paul Signac." Galerie Druet, Paris, December 13–31, 1904.

Paris 1905. "21ᵉ Salon des Indépendants." Grande Serre de l'Alma, Cours-la-Reine, March 24–April 30, 1905.

Paris 1906. "22ᵉ Salon des Indépendants." Grande Serre de l'Alma, Cours-la-Reine, March 20–April 30, 1906.

Munich and other cities 1906–7. "Französischer Künstler." Kunstverein, Munich, September 1906; Kunstverein, Frankfurt, October 1906; Galerie Ernst Arnold, Dresden, November 1906; Kunstverein, Karlsruhe, December 1906; Kunstverein, Stuttgart, January 1907. Exhibition organized by Rudolf Adelbert Meyer, Paris.

Paris 1907. "Paul Signac." Galerie Bernheim-Jeune, Paris, January 21–February 7, 1907.

Brussels 1908. "Salon de La Libre Esthétique." Salon Jubilaire, Brussels, March 1–April 5, 1908.

Brussels 1910. "L'Évolution du paysage." Salon de La Libre Esthétique, Brussels, March 12–April 17, 1910.

Paris 1911. "Exposition de peintures et d'aquarelles de Henri Edmond Cross et Paul Signac." Galerie Druet, Paris, June 19–July 3, 1911.

Cologne 1912. "Internationale Kunstausstellung des Sonderbundes Westdeutscher Kunstfreude und Künstler zu Cöln." Städtische Ausstellungshalle, Cologne, May 25–September 30, 1912.

Paris 1912. "28ᵉ Salon des Indépendants." Baraquement du Quai d'Orsay, Pont de l'Alma, Paris, March 20–May 16, 1912.

Paris 1912. "Salon de mai." Ateliers du Quai Rive Gauche, Paris, May 1–15, 1912.

Paris 1912. "Exposition des acquisitions et des commands de l'État livrées en 1912." Musée de Luxembourg?, Paris, 1912.

Saint Petersburg 1912. "L'Art français à Saint-Pétersbourg: Exposition centennale sous les auspices de S.A.I. le grand-duc Nicolas Mikhaïlovitch." Le Palais Youssoupoff, Saint Petersburg, January 15–28, 1912. Organized by the Institut Français.

Brussels 1922. "Les Maîtres de l'impressionisme et leur temps." Palais des Beaux-Arts, Brussels, July 25–August 1922.

Brussels 1923. "Cousturier et Signac." Galerie Georges Giroux, Brussels, October 1922.

Paris 1923. "On propose." Galerie Bernheim-Jeune, Paris, February 27–March 14, 1923.

Paris 1924. "35ᵉ Salon des Indépendants." Grand Palais, Paris, February 9–March 12, 1924.

Paris 1925. "Exposition de 25 peintres contemporains." Galerie Druet, Paris, June 2–September 30, 1925.

Geneva 1926. "Art contemporaine français." Musée d'Art et d'Histoire, Geneva, 1926.

Paris 1926. "37ᵉ Salon des Indépendants: Trente Ans d'art indépendant, 1884–1914." Grand Palais, Paris, February 20–March 21, 1926.

Berlin 1927. Exhibition, Goldschmidt gallery, Berlin, February–March, 1927.

Düsseldorf 1928. Exhibition, Städtische Kunsthalle Düsseldorf, 1928.

Amsterdam 1930. "Vincent Van Gogh en zijn tijgenoten." Stedelijk Museum, Amsterdam, September 6–November 2, 1930.

Paris 1930. "Paul Signac." Galerie Bernheim-Jeune, Paris, May 19–30, 1930.

Paris 1932. "Le Néo-Impressionnisme." Galerie Braun et Cie, Paris, February 25–March 17, 1932.

Paris 1933–34. "Les Étapes de l'art contemporain, 1: Seurat et ses amis, la suite de l'impressionnisme." Galerie Beaux-Arts, Paris, December 1933–January 1934.

Paris 1934. "Exposition Paul Signac." Petit-Palais, Paris, February–March 1934.

WORKS CITED

Adam 1886. Paul Adam. "Peintres impressionnistes." *La Revue contemporaine* 4 (April 4, 1886), pp. 541–51.

Adam 1886a. Paul Adam. *Soi.* Paris, 1886.

Adam 1887. Paul Adam. "Les Artistes indépendants." *La Revue rose*, May 1887, pp. 139–45.

Adam 1890. Paul Adam. "Le Culte de la douleur." *La Grande Revue de Paris et Saint-Pétersbourg*, November 20, 1890, p. 261.

Ajalbert 1886a. Jean Ajalbert. "Le Salon des impressionnistes." *La Revue moderne* (Marseilles) 30 (June 20, 1886), pp. 385–93.

Ajalbert 1886b. Jean Ajalbert. In *Lutèce*, August 22, 1886, p. 3.

Ajalbert 1886c. Jean Ajalbert. *Sur le vif: Vers impressionnistes.* Paris, 1886.

Ajalbert 1934. Jean Ajalbert. "Un Demi-siècle d'art indépendant." *Les Nouvelles littéraires*, February 10, 1934, p. 4.

Ajalbert 1938. Jean Ajalbert. *Mémoires en vrac: Au temps du symbolisme, 1880–1890*. Paris, 1938.

Alexandre 1888. Arsène Alexandre. "Le Mouvement artistique." *Paris*, August 13, 1888.

Alexandre 1892. Arsène Alexandre. "Chronique d'aujourd'hui." *Paris*, March 19, 1892, p. 2.

Amsterdam–Pittsburgh 2000–2001. *Light! Revolution in Art, Science, and Technology, 1750–1900*. Exhibition, Van Gogh Museum, Amsterdam, October 20, 2000–February 11, 2001; Carnegie Museum of Art, Pittsburgh, April 7–July 29, 2001. Catalogue by Andreas Blühm and Louise Lippincott. Amsterdam, 2000.

Antoine 1891. Jules Antoine. "Exposition des artistes indépendants." *La Plume*, May 1, 1891, pp. 156–57.

Antoine 1921. André Antoine. *Mes souvenirs sur le Théâtre-Libre*. Paris, 1921.

Apollinaire 1911a. Guillaume Apollinaire. [Watercolors by Signac–Tapestries by Maillol.] *L'Intransigeant*, January 28, 1911. Translated in Apollinaire 1972, p. 133.

Apollinaire 1911b. Guillaume Apollinaire. [The Salon des Indépendants.] *L'Intransigeant*, April 20, 1911. Translated in Apollinaire 1972, pp. 149–50.

Apollinaire 1911c. Guillaume Apollinaire. [From Eugène Delacroix to Neo-Impressionism.] *L'Intransigeant*, August 7, 1911. Reprinted in Apollinaire 1972, pp. 176–77.

Apollinaire 1972. Guillaume Apollinaire. *Apollinaire on Art: Essays and Reviews, 1902–1918*. Edited by Leroy C. Breunig; translated by Susan Suleiman. New York, 1972.

Association des Écrivains et Artistes Révolutionnaires 1933. L'Association des Écrivains et Artistes Révolutionnaires. *Ceux qui on choisi. . . : Contre le fascisme en Allemagne, contre l'imperialisme français*. Preface by Vaillant-Couturier. Paris, 1933.

Bailly-Herzberg 1980–91. Janine Bailly-Herzberg. *Correspondance de Camille Pissarro*. 5 vols. Paris, 1980–91.

Barr 1974. Alfred H. Barr Jr. *Matisse: His Art and His Public*. New York, 1974. Originally published New York, 1951.

Bazalgette 1976. Lily Bazalgette. *Albert Dubois-Pillet, sa vie, son oeuvre*. Paris, 1976.

Bernard 1911. Émile Bernard, ed. *Lettres de Vincent van Gogh à Émile Bernard*. Paris, 1911.

Bernard 1994. Émile Bernard. *Propos sur l'art*. Edited by Anne Rivière. Paris, 1994.

Berson 1996. Ruth Berson. *The New Painting: Impressionism, 1874–1886. Documentation, Volume I: Reviews*. San Francisco, 1996.

Besson 1935. George Besson. *Paul Signac*. Paris, 1935.

Besson 1951. George Besson. "Une des Grandes Aventures de la peinture: L'Oeuvre de Paul Signac." *Arts*, October 26, 1951, pp. 1, 5.

Besson 1965. George Besson. "Pour la couleur: Paul Signac et Zavaro." *Les Lettres françaises*, June 24, 1965.

Besson 1968. George Besson. "Marcel Cachin devant les peintres." *Les Lettres françaises*, February 21, 1968.

Bidou 1902. Henri Bidou. "Le Salon des indépendants." *L'Occident*, June 1902, pp. 253–64.

Bihr 1992. Jean-Pierre Bihr, with the assistance of Henri Fermin. *Regards d'émeraude*. Saint-Jacut de la Mer, 1992.

Bock 1981. Catherine C. Bock. *Henri Matisse and Neoimpressionism, 1898–1908*. Ann Arbor, 1981. Revision of the author's Ph.D. dissertation, UCLA, 1977.

Bois 1893. Jules Bois. "Chez les indépendants." *Gil Blas*, March 21, 1893.

Bonnard 1938. Pierre Bonnard. In "Hommage à Paul Signac." *L'Humanité*, March 5, 1938.

Bordeaux 1995. *Louis Valtat (1869–1952)*. Exhibition, Galerie des Beaux-Arts, Bordeaux, May 19–August 27, 1995. Catalogue by Françoise Garcia. Bordeaux, 1995.

Borgmeyer 1914. Charles Louis Borgmeyer. "Armand Guillaumin." *Fine Arts Journal* 30 (January 1914), pp. 51–75.

Bouin-Luce and Bazetoux 1986. Jean Bouin-Luce and Denise Bazetoux. *Maximilien Luce: Catalogue raisonné de l'oeuvre peint*. 2 vols. Catalogue raisonné by Denise Bazetoux. Paris, 1986.

Boyer 1991. Patricia Eckert Boyer. "*L'Estampe original* and the Revival of Decorative Art and Craft in Late Nineteenth-Century France." In *L'Estampe Original: Artistic Printmaking in France, 1893–1895*, by Patricia Eckert Boyer and Philip Dennis, pp. 26–45. Zwolle, 1991.

Brown 1963. Milton W. Brown. *The Story of the Armory Show*. New York, 1963.

Cachin 1964. Françoise Cachin, ed. *D'Eugène Delacroix au néo-impressionnisme*, by Paul Signac. Paris, 1964.

Cachin 1966. Françoise Cachin, ed. *Au-delà de l'impressionnisme*, by Félix Fénéon. Paris, 1966.

Cachin 1969. Françoise Cachin. "Le Portrait de Fénéon par Signac: Une Source inédite." *La Revue de l'art*, no. 6 (1969), pp. 90–91.

Cachin 1971. Françoise Cachin. *Paul Signac*. Translated by Michael Bullock. Greenwich, Conn., 1971.

Cachin 1978. Françoise Cachin, ed. *D'Eugène Delacroix au néo-impressionnisme*, by Paul Signac. Paris, 1978.

Cachin 1980. Françoise Cachin. "Les Néo-impressionnistes et le japonisme, 1885–1893." In *Japonisme in Art: An International Symposium*, pp. 225–37. Tokyo, 1980.

Cachin 1988. Françoise Cachin. "Van Gogh and the Neo-Impressionist Milieu." In *Vincent van Gogh International Symposium, Tokyo, October 17–19, 1985*. Tokyo, 1988.

Cachin 1990. Charles Cachin. *Paul Signac: Dernier carnet de voyage*. Edited by M.-J. Jacomet. Saint-Baldolph, 1990.

Cachin 1992. Françoise Cachin. "L'Arrivée de Signac à Saint-Tropez." In Saint-Tropez–Reims 1992, pp. 11–15.

Cachin 1994. Françoise Cachin. "Paul Signac, notes et voyages en Italie, février–mars 1908." In *Hommage à Michel Laclotte*, pp. 607–15. Paris, 1994.

Cachin 2000. Françoise Cachin with the collaboration of Marina Ferretti-Bocquillon. *Signac: Catalogue raisonné de l'oeuvre peint*. Paris, 2000.

Camfield 1979. William A. Camfield. *Francis Picabia: His Art, Life, and Times*. Princeton, 1979.

Chartrain-Hebbelinck 1969. Marie-Jeanne Chartrain-Hebbelinck. "Les Lettres de Paul Signac à Octave Maus." *Bulletin de la Société des Musées Royaux des Beaux-Arts de Belgique* 18, nos. 1–2 (1969), pp. 52–102.

Chastel 1963. André Chastel. "Le Centenaire de Paul Signac." *Le Monde*, December 13, 1963.

Chiron 1986. Yves Chiron. *Maurice Barrès: Le Prince de la jeunesse*. Paris, 1986.

Christophe 1886. Jules Christophe. "Chronique: Rue Laffitte, N° 1." *Journal des artistes*, June 13, 1886, pp. 193–94.

Christophe 1887. Jules Christophe. "Les Évolutionnistes du Pavillon de la Ville de Paris." *Journal des artistes*, April 4, 1887, pp. 122–23.

Christophe 1889. Jules Christophe. "L'Exposition des artistes indépendants." *Journal des artistes*, September 29, 1889, pp. 305–6.

Christophe 1890. Jules Christophe. "Causerie: L'Impressionnisme à l'exposition des artistes indépendants." *Journal des artistes*, April 6, 1890, pp. 101–2.

Christophe 1890a. Jules Christophe. "Dubois-Pillet." *Les Hommes d'aujourd'hui* 8, no. 370 (1890).

Christophe 1892. Jules Christophe. "Salon des artistes indépendants." *La Plume*, no. 71 (April 1, 1892), pp. 156–58.

Christophe 1893. Jules Christophe. "Impressionnistes au Salon des indépendants." *Journal des artistes*, April 2, 1893, p. 133.

Cochin 1903. Henry Cochin. *Quelques réflexions sur les salons.* Paris, 1903. Also published in *Gazette des Beaux-Arts*, ser. 3, 29 (June 1, 1903), pp. 441–64.

Compin 1964. Isabelle Compin. *H. E. Cross.* Paris, 1964.

Cooper 1983. Douglas Cooper. *Paul Gauguin: 45 Lettres à Vincent, Théo et Jo van Gogh. Collection Rijksmuseum Vincent van Gogh, Amsterdam.* The Hague, 1983.

Coquiot 1899a. Gustave Coquiot. "La Vie artistique: Une Exposition." *Gil Blas*, March 18, 1899.

Coquiot 1899b. Gustave Coquiot. "La Vie artistique, II: Signac, Luce, et Cross." *La Vogue*, no. 4 (April 1899), pp. 56–60.

Coquiot 1914. Gustave Coquiot. "Paul Signac." In his *Cubistes, futuristes, passéistes.* Rev. ed. Paris, 1914.

Coquiot 1923. Gustave Coquiot. *Vincent van Gogh.* Paris, 1923.

Coquiot 1924. Gustave Coquiot. *Georges Seurat.* Paris, 1924.

Coquiot n.d. Gustave Coquiot. *Les Indépendants, 1884–1920.* Paris, n.d.

Coret 1999. Noël Coret. *Autour des impressionnistes: Le Groupe de Lagny.* Paris, 1999.

Cousturier 1892a. Edmond Cousturier. "Société des artistes indépendants." *L'En-dehors*, March 27, 1892.

Cousturier 1892b. Edmond Cousturier. "L'Art dans la société future." *La Plume*, 1892, pp. 212–18.

Cousturier 1902. Edmond Cousturier. "Gazette d'art: Exposition d'oeuvres de Paul Signac." *La Revue blanche* 28 (June 1902), pp. 213–14.

Cousturier 1922. Lucie Cousturier. *Paul Signac.* Cahiers d'aujourd'hui. Paris, 1922.

Cros and Henry 1884. Henry Cros and Charles Henry. *L'Encaustique et les autres procédés de peinture chez les anciens: Histoire et technique.* Paris, 1884. Reprinted, 1988.

Dagen 1986. Philippe Dagen, ed. *La Peinture en 1905: "L'Enquête sur les tendances actuelles des arts plastiques" de Charles Morice.* Paris, 1986.

Dauberville and Dauberville 1966–74. Jean Dauberville and Henry Dauberville. *Bonnard, Catalogue raisonné de l'oeuvre peint.* 4 vols. Paris, 1966–74.

Denis 1902. M[aurice] D[enis]. "Aquarelles de Paul Signac." *L'Occident* 2 (July 1902), pp. 52–53.

Denis 1905. Maurice Denis. "La Réaction nationaliste." *L'Ermitage*, May 15, 1905. Reprinted in Denis 1920, pp. 187–98.

Denis 1907. [Maurice Denis.] "Les Indépendants." *L'Occident*, April 1907, pp. 195–200.

Denis 1920. Maurice Denis. *Théories, 1890–1910: Du symbolisme et de Gauguin vers un nouvel ordre classique.* 4th ed. Paris, 1920.

Denis 1957–59. Maurice Denis. *Journal.* 3 vols. Paris, 1957–59.

Deshairs 1921. Léon Deshairs. "Les Aquarelles de Signac." *Art et decoration* 39 (January 1921), pp. 11–16.

Devaldès 1896. Manuel Devaldès. "Art nouveau." *La Revue rouge*, no. 2 (February 1896), pp. 21–22.

Dijon 1989. *Ventes d'autographes.* Sale cat. Hôtel des Ventes, Dijon, September 30, 1989. Dijon, 1989.

Distel 1991. Anne Distel. *Seurat.* Profils de l'art. Paris, 1991.

Distel 2001. Anne Distel. *Signac: Au temps d'harmonie.* Paris, 2001.

Dorival 1948. Bernard Dorival. *Cézanne.* Paris, 1948.

Dorra and Askin 1969. Henri Dorra and Sheila C. Askin. "Seurat's Japonisme." *Gazette des Beaux-Arts*, ser. 6, 73 (February 1969), pp. 81–94.

Durand-Tahier 1892. H. Durand-Tahier. "Exposition des néo-impressionnistes." *La Plume*, December 15, 1892, p. 531.

Duret 1912. Théodore Duret. "Le Salon de la Société des artistes indépendants." *La Grande Revue*, May 10, 1912, pp. 36–49.

Ernst 1891. Alfred Ernst. "Exposition des artistes indépendants." *La Paix*, March 27, 1891, p. 2.

Faille 1970. J.-B. (Jacob-Baart) de la Faille. *The Works of Vincent van Gogh: His Paintings and Drawings.* Revised edition. London, 1970.

Fénéon 1886a. Félix Fénéon. "Les Impressionnistes en 1886: VIIIe Exposition impressionniste." *La Vogue*, June 13–20, 1886, pp. 261–75. Reprinted in Cachin 1966, pp. 57–73, and Halperin 1970, pp. 29–38.

Fénéon 1886b. Félix Fénéon. "Correspondance particulière de l'art moderne: L'Impressionnisme aux Tuileries." *L'Art moderne de Bruxelles*, September 19, 1886, pp. 300–302. Reprinted in Cachin 1966, pp. 73–80, and Halperin 1970, pp. 53–58.

Fénéon 1887. Félix Fénéon. "L'Impressionnisme." *L'Emancipation sociale* (Narbonne), April 3, 1887. Reprinted in Cachin 1966, pp. 81–86, and Halperin 1970, pp. 64–68.

Fénéon 1888a. Félix Fénéon. "Exposition de *La Revue indépendante.*" *La Revue indépendante*, no. 15 (January 6, 1888), pp. 171–74. Reprinted in Halperin 1970, pp. 91–93.

Fénéon 1888b. Félix Fénéon. "L'Affiche de M. Paul Signac." *La Revue indépendante*, no. 24 (October 1888), pp. 137–38. Reprinted in Halperin 1970, pp. 117–18.

Fénéon 1889a. Félix Fénéon. "Autre groupe impressionniste." *La Cravache*, July 6, 1889. Reprinted in Halperin 1970, pp. 157–59.

Fénéon 1889b. Félix Fénéon. "5ème Exposition de la Société des artistes indépendants." *La Vogue*, no. 3 (September 1889), pp. 252–62. Reprinted in Halperin 1970, pp. 162–70.

Fénéon 1890. Félix Fénéon. "La Peinture optique: Paul Signac." *Les Hommes d'aujourd'hui* 8, no. 373 (May 1890). Reprinted in Cachin 1966, pp. 114–20, and Halperin 1970, pp. 174–79.

Fénéon 1891. Félix Fénéon. "Paul Signac." *La Plume*, September 1, 1891. Reprinted in Halperin 1970, pp. 197–99.

Fénéon 1892. Félix Fénéon. "Au Pavillon de la Ville de Paris: Société des artistes indépendants." *Le Chat Noir*, April 2, 1892. Reprinted in Halperin 1970, pp. 212–13.

Fenton 1998. James Fenton. "Seurat and the Sewers." In his *Leonardo's Nephew: Essays on Art and Artists*, pp. 150–59. New York, 1998.

Ferretti-Bocquillon 1996–97. Marina Ferretti-Bocquillon. "Paul Signac au temps d'harmonie, 1892–1913." In Münster–Grenoble–Weimar 1996–97, pp. 51–73.

Ferretti-Bocquillon 1998. Marina Ferretti-Bocquillon. "Signac and Van Rysselberghe: The Story of a Friendship, 1887–1907." *Apollo* 147 (June 1998), pp. 11–18.

Ferretti-Bocquillon 2000. Marina Ferretti-Bocquillon. "The James Dyke Collection: Paul Signac's Graphic Work." In Little Rock 2000, pp. 10–29.

Fèvre 1886. Henry Fèvre. "L'Exposition des impressionnistes." *La Revue de demain*, no. 3–4 (May–June 1886), pp. 148–56. Reprinted in Berson 1996, pp. 445–47.

Flam 1978. Jack Flam, ed. *Matisse on Art.* New York, 1978.

Flam 1988. Jack Flam, ed. *Matisse: A Retrospective.* New York, 1988.

Fontainas 1905. André Fontainas. "L'Art à Paris: Les Artistes indépendants." *L'Art moderne*, April 9, 1905, p. 117.

Fontainas and Fontainas 1997. Adrienne Fontainas and Luc Fontainas. *Théo Van Rysselberghe, l'ornement du livre: Catalogue raisonné.* Cahier, no. 3. Antwerp, 1997.

Fournier 1957. Gabriel Fournier. *Cors de Chasse, 1912–1954.* Geneva, 1957.

Frèches-Thory 1983. Claire Frèches-Thory. "Paul Signac: Acquisitions récentes." *La Revue du Louvre* 33, no. 1 (1983), pp. 35–46.

Gachet 1956. Paul Gachet. *Le Docteur Gachet et Murer: Deux amis des impressionnistes.* Paris, 1956.

Gage 1999. John Gage. *Color and Meaning: Art, Science, and Symbolism.* Berkeley and Los Angeles, 1999.

Gauguin 1923. Paul Gauguin. *Avant et après; avec les vingt-sept dessins du manuscrit original.* Paris, 1923.

Geffroy 1881. Gustave Geffroy. "L'Exposition des artistes indépendants." *La Justice*, April 19, 1881.

Geffroy 1892. Gustave Geffroy. "Les Indépendants." *Le Matin*, March 21, 1892.

Geffroy 1922. Gustave Geffroy. *Claude Monet: Sa vie, son temps, son oeuvre.* 2 vols. Paris, 1922.

Geffroy 1980. Gustave Geffroy. *Claude Monet: Sa vie, son temps, son oeuvre.* Critical ed. annotated by Claudie Judrin. 2 vols. Paris, 1980.

Gide 1951. André Gide. *Journal, 1889–1939.* Bibliothèque de la Pléiade, 54. Paris, 1951.

Gilmour 1990. Pat Gilmour. "New Light on Paul Signac's Colour Lithographs." *Burlington Magazine* 132 (1990), pp. 271–75.

Giraudy 1997. Daniele Giraudy. "Camoin et Matisse: Une Amitié." In *Charles Camoin: Rétrospective, 1879–1965*, pp. 53–61. Exh. cat. Lausanne, 1997.

Van Gogh 1958. *The Complete Letters of Vincent van Gogh, with Reproductions of All the Drawings in the Correspondence.* 3 vols. Greenwich, Conn., and London, 1958. French ed., Paris, 1960.

Grisebach 1996. Lucius Grisebach. *Ernst Ludwig Kirchner, 1880–1938.* Translated from German by Michael Hulse. Cologne and New York, 1996.

Guenne 1925. Jacques Guenne. "Entretiens avec Paul Signac, président du Salon des indépendants." *L'Art vivant*, March 20, 1925, pp. 1–4.

Guides-Joanne; Bretagne 1914. *Collection des Guides-Joanne: Bretagne.* Edited by Paul Gruyer. Paris, 1914.

Guilbeaux 1911. Henri Guilbeaux. "Paul Signac et les Indépendants." *Les Hommes du jour*, April 22, 1911, unpaged.

Halperin 1970. Joan U. Halperin. *Félix Fénéon: Oeuvres plus que complètes.* 2 vols. Geneva, 1970.

Halperin 1988. Joan U. Halperin. *Félix Fénéon: Aesthete and Anarchist in Fin-de-Siècle Paris.* New Haven, 1988.

Halperin 1991. Joan U. Halperin. *Félix Fénéon: Art et anarchie dans le Paris fin-de-siècle.* Translated into French by Dominique Aury and Nada Rougier. Paris, 1991.

Hauke 1961. César M. de Hauke. *Seurat et son oeuvre.* 2 vols. Paris, 1961.

Hefting 1975. Victorine Hefting. *Jongkind: Sa vie, son oeuvre, son époque.* Paris, 1975.

Hennequin 1886. Émile Hennequin. "L'Exposition des Artistes indépendants." *La Vie moderne*, September 11, 1886, pp. 581–82.

Henry 1885. Charles Henry. "Introduction à une esthétique scientifique." *La Revue contemporaine* 2 (August 1885), pp. 441–69.

Henry 1890a. Charles Henry. *Application de nouveaux instruments de précision (cercle chromatique, rapporteur et triple décimètre esthétique) à l'archéologie.* Paris, 1890.

Henry 1890b. Charles Henry. *Éducation du sens des formes.* Paris, 1890.

Henry 1895. Charles Henry. *Quelques aperçus sur l'esthétique des formes.* Paris, 1895.

Herbert 1991. *See* Paris–New York 1991–92.

Herbert 2000. Robert L. Herbert. *Nature's Workshop: Renoir's Writings on the Decorative Arts.* New Haven and London, 2000.

Herbert and Herbert 1960. Robert L. Herbert and Eugenia W. Herbert. "Artists and Anarchism: Unpublished Letters of Pissarro, Signac, and Others." *Burlington Magazine* 102 (November–December 1960), pp. 472–82, 517–21.

French ed.: "Les Artistes et l'anarchisme." *Le Mouvement social* 36 (July–September 1961), pp. 2–19.

Hermel 1886. Maurice Hermel. "L'Exposition de peinture de la rue Laffitte, II." *La France libre*, May 28, 1886, pp. 1–2.

Hoschedé 1961. Jean-Pierre Hoschedé. *Blanche Hoschedé-Monet: Peintre impressionniste.* Rouen, 1961.

Hutton 1994. John G. Hutton. *Neo-Impressionism and the Search for Solid Ground: Art, Science, and Anarchism in Fin-de-Siècle France.* Baton Rouge, 1994.

Huysmans 1883. Joris-Karl Huysmans. *L'Art moderne.* Paris, 1883.

Huysmans 1887. Joris-Karl Huysmans. "Les Indépendants." *La Revue indépendante*, no. 6 (April 1887), pp. 51–57.

Huysmans 1889. Joris-Karl Huysmans. *Certains. . . .* Paris, 1889.

Jamot 1907. Paul Jamot. "Exposition Paul Signac (Galerie Bernheim)." *La Chronique des arts et de la curiosité*, January 26, 1907, p. 28.

Javel 1886. Firmin Javel. "Les Impressionnistes." *L'Événement*, May 16, 1886, p. 1.

Jourdain 1953. Francis Jourdain. *Sans remords ni rancune: Souvenirs épars d'un viel homme "né en '76."* Paris, 1953.

Kahn 1887. Gustave Kahn. "À l'exposition des artistes indépendants." *La Vie moderne*, no. 15 (April 9, 1887), pp. 229–31.

Kahn 1888. Gustave Kahn. "Exposition des indépendants." *La Revue indépendante*, no. 18 (April 1888), pp. 160–64.

Kahn 1912. Gustave Kahn. "L'Art." *Mercure de France*, April 1, 1912, pp. 634–43.

Kahn 1935. Gustave Kahn. "Deux morts: Paul Signac, Frantz Jourdain." *Mercure de France*, October 1, 1935, pp. 168–73.

Kahn 1935a. Gustave Kahn. "Images et souvenirs: Paul Signac." *Le Quotidien*, August 21, 1935, p. 2.

Kandinsky 1954. Wassily Kandinsky. *Du spirituel dans l'art et dans la peinture en particulier.* Translated by M. and Mme. de Man. Collection Le Cavalier d'épée, 2. Paris, 1954.

Van de Kerkhove 1997. Fabrice van de Kerkhove. "Au coeur de la correspondance." In *Émile Verhaeren: Un Musée imaginaire*, edited by Marc Quaghebeur, pp. 57–75. Exh. cat. Paris and Brussels, 1997.

Klingsor 1921. Tristan Klingsor. *L'Art français depuis vingt ans: La Peinture.* Paris, 1921.

Kornfeld 1997. Eberhard W. Kornfeld. "Quelques remarques sur les lithographies en couleurs de Signac." In

Münster–Grenoble–Weimar 1996–97, pp. 83–118.

Kornfeld and Wick 1974. Eberhard W. Kornfeld and Peter A. Wick. *Catalogue raisonné de l'oeuvre gravé et lithographié de Paul Signac.* Bern, 1974.

Kunstler 1935. Charles Kunstler. "Chez Paul Signac; ou, L'Apothéose du pointillisme." *Le Petit Parisien,* April 4, 1935, p. 4.

Lagny-sur-Marne–Geneva–Quebec 1999–2001. *Autour des néo-impressionnistes: Le Groupe de Lagny.* Exhibition, Musée Gatien-Bonnet, Lagny-sur-Marne, November 25, 1999–January 30, 2000; Petit Palais, Musée d'Art Moderne de Genève, March 1–May 14, 2000; Musée des Beaux-Arts de Sherbrooke, Quebec, September 30, 2000–January 15, 2001. Catalogue by Noël Coret. Geneva, Paris, and Lagny-sur-Marne, 1999.

La Rochefoucauld 1893a. Tiphereth. [Antoine de La Rochefoucauld.] "L'Art: Les Indépendants." *Le Coeur,* no. 1 (April 1893), pp. 6–7.

La Rochefoucauld 1893b. Tiphereth. [Antoine de La Rochefoucauld.] "Paul Signac." *Le Coeur,* no. 2 (May 1893), pp. 1–5.

Leblond-Zola 1939. Denise Leblond-Zola. "Paul Alexis, ami des peintres, bohème et critique d'art." *Mercure de France,* March 1, 1939.

Leclercq 1899. Julien Leclercq. "Galerie Durand-Ruel." *La Chronique des arts et de la curiosité,* March 18, 1899, p. 94.

Lecomte 1890a. Georges Lecomte. "Beaux-Arts: L'Exposition des néo-impressionnistes, Pavillon de la Ville de Paris, Champs-Elysees." *Art et critique,* March 29, 1890, pp. 203–5.

Lecomte 1890b. G[eorges] L[ecomte]. "Notes et notules." *Les Entretiens politiques et littéraires,* October 1, 1890, pp. 239–40.

Lecomte 1911. Georges Lecomte. "La Vie artistique: Le Néo-impressionnisme, Henri-Edmond Cross et Paul Signac." *Le Matin,* June 25, 1911, p. 7.

Lemoisne 1947–48. Paul-André Lemoisne. *Degas et son oeuvre.* 4 vols. Paris, 1947–48.

Lemoyne de Forges 1963. Marie-Thérèse Lemoyne de Forges. "L'Exposition Paul Signac au Musée du Louvre." *La Revue du Louvre* 13, no. 6 (1963), pp. 245–54.

Lespinasse 1988. François Lespinasse, ed. *Charles Angrand: Correspondances, 1883–1926.* Preface by Joan U. Halperin. Lagny-sur-Marne, 1988.

Lévy 1982. Pierre Lévy. *L'Art ou l'argent.* Paris, 1982.

Little Rock 2000. *Paul Signac: A Collection of Watercolors and Drawings.* Exhibition, Arkansas Arts Center, Little Rock, February 19–April 9, 2000. Catalogue by Marina Ferretti-Bocquillon and Charles Cachin. Little Rock, Ark., and New York, 2000.

London 1962. *Van Gogh's Life in His Drawings: Van Gogh's Relationship with Signac.* Exhibition, Marlborough Fine Art Ltd., May–June 1962. Catalogue by Abraham Marie Hammacher. London, 1962.

London 1986. *Paul Signac (1863–1935), Watercolours and Drawings.* Exhibition, Marlborough Fine Art Ltd., London, November–December 1986. Catalogue by Suzanne Bosman. London, 1986.

Luce 1938. Maximilien Luce. In "Hommage à Paul Signac." *L'Humanité,* March 5, 1938.

Lyon–Barcelona 1999. *Raoul Dufy.* Exhibition, Musée des Beaux-Arts, Musée de l'Imprimerie, Lyon, January 28–April 18, 1999; Museu Picasso, Museu Tèxtil i d'Indumentària, Barcelona, April 29–July 11, 1999. Catalogue by Christian Briend and Jacqueline Munck. Published in French and Spanish. Lyon and Barcelona, 1999.

Malato 1893. Malato. "Le Rêve d'Humanus." *La Revue anarchiste,* November 1, 1893.

Mantes-la-Jolie 2000. *Maximilien Luce: Peindre la condition humaine.* Exhibition, Musée de l'Hôtel-Dieu, Mantes-la-Jolie, June 17–October 31, 2000. Mantes-la-Jolie, 2000.

Martigny 2000. *Van Gogh.* Exhibition, Fondation Pierre Gianadda, Martigny, Switzerland, June 21–November 26, 2000. Catalogue by Ronald Pickvance. Martigny, 2000.

Maus 1891. Octave Maus. "Courrier de Belgique." *La Revue des deux mondes,* March 21, 1891, p. 216.

Maus 1926. Madeleine Octave Maus. *Trente années de lutte pour l'art, 1884–1914.* Brussels, 1926.

Merlhès 1984. Victor Merlhès, ed. *Correspondance de Paul Gauguin: Documents, témoignages.* Vol. 1, *1873–1888.* Paris, 1984.

Mirbeau 1886. Octave Mirbeau. "Exposition de peinture (1, rue Laffitte)." *La France,* May 21, 1886. Reprinted in Mirbeau 1993a, pp. 275–79.

Mirbeau 1891. Octave Mirbeau. "Vincent van Gogh." *L'Écho de Paris,* March 31, 1891. Reprinted in Mirbeau 1993a, pp. 440–45.

Mirbeau 1894. Octave Mirbeau. "Neo-impressionnistes." *L'Echo de Paris,* no. 3529 (January 23, 1894), p. 1. Reprinted in Mirbeau 1993b, pp. 50–53.

Mirbeau 1993a. Octave Mirbeau. *Combats esthétiques 1, 1877–92.* Edited by Pierre Michel and Jean-François Nivet. Paris, 1993.

Mirbeau 1993b. Octave Mirbeau. *Combats esthétiques 2, 1893–1914.* Edited by Pierre Michel and Jean-François Nivet. Paris, 1993.

Monod 1914. François Monod. "Nouvelles diverses." *Art et décoration,* April 1914.

Munck 1999. Jacqueline Munck. Chronology. In Paris 1999–2000, pp. 418–47.

Münster–Grenoble–Weimar 1996–97. *Signac et la libération de la couleur: De Matisse à Mondrian.* Exhibition, Westfälisches Landesmuseum für Kunst und Kulturgeschichte, Münster, December 1, 1996–February 16, 1997; Musée de Grenoble, March 9–May 25, 1997; Kunstsammlungen zu Weimar, June 15–August 31, 1997. Catalogue edited by Erich Franz, with contributions by Cor Blok et al. Paris, 1997. Also published in German.

Natanson 1897. Thadée Natanson. "Petite Gazette d'art: Les Salons." *La Revue blanche,* no. 1 (May 1, 1897), pp. 554–60.

Natanson 1899. Thadée Natanson. "Une Date dans l'histoire de la peinture française. Mars 1899." *La Revue blanche,* April 1, 1899, pp. 504–12.

Natanson 1948. Thadée Natanson. *Peints à leur tour.* Paris, 1948.

New Brunswick–Amsterdam 1991–92. *L'Estampe originale: Artistic Printmaking in France, 1893–1895.* Exhibition, Jane Voorhees Zimmerli Art Museum, New Brunswick, N.J., September 15–November 19, 1991; Van Gogh Museum, Amsterdam, December 13, 1991–January 26, 1992. Catalogue by Patricia Eckert Boyer and Phillip Dennis Cate. Zwolle and Amsterdam, 1991.

New York 1886. *Works in Oil and Pastel by the Impressionists of Paris.* Organized by Durand-Ruel. Exhibition, American Art Association, New York, April 10– ; National Academy of Design, New York, May 25– . New York, 1886.

New York 1968. *Neo-Impressionism.* Exhibition, Solomon R. Guggenheim

Museum, New York, February–April 1968. Catalogue by Robert L. Herbert. New York, 1968.

New York 1997–98. *The Private Collection of Edgar Degas.* The Metropolitan Museum of Art, New York, October 1, 1997–January 11, 1998. Catalogue by Ann Dumas et al. 2 vols. New York, 1997.

Olin 1892. Pierre M. Olin. "Les XX." *Mercure de France,* April 1892, pp. 342–43.

Ozenfant 1968. Amédée Ozenfant. *Mémoires, 1886–1962.* Paris, 1968.

Paillard 1922. Louis Paillard. "Aux Indépendants avec Paul Signac leur président." *Le Petit journal,* January 27, 1922, p. 1.

Paris 1907. *Paul Signac.* Exhibition, Galerie Bernheim-Jeune, Paris, January 21–February 2, 1907. Catalogue by Octave Maus, with preface by Paul Adam. Paris, 1907.

Paris 1907a. *Exposition H. E. Cross.* Exhibition, Galerie Bernheim-Jeune et Cie, Paris, April 22–May 8, 1907. Catalogue by Maurice Denis. Paris, 1907.

Paris 1908. *Exposition Van Dongen.* Exhibition, Galerie Bernheim-Jeune et Cie, Paris, November 25–December 8, 1908.

Paris 1913. *Exposition Henri Person.* Galerie Bernheim-Jeune, Paris, February 10–22, 1913. Catalogue preface by Paul Signac. Paris, 1913.

Paris 1932. *Le Néo-Impressionnisme.* Exhibition, Galerie d'Art Braun et Cie, Paris, February 25–March 17, 1932. Catalogue preface by Paul Signac. Paris, 1932.

Paris 1933–34. *Les Étapes de l'art contemporain, I: Seurat et ses amis, la suite de l'impressionnisme.* Exhibition, Galerie Beaux-Arts, Paris, December 1933–January 1934. Catalogue preface by Paul Signac. Paris, 1933.

Paris 1934. *Exposition Paul Signac.* Exhibition, Petit-Palais, Paris, February–March 1934. Paris, 1934.

Paris 1952. *Collection de Madame S[amama].* Sale cat., Galerie Charpentier, Paris, May 9, 1952. Paris, 1952.

Paris 1961. *Paris vu par les maîtres de Corot à Utrillo.* Exhibition, Musée Carnavalet, Paris, March–May 1961. Catalogue by Jacques Wilhelm. Paris, 1961.

Paris 1963–64. *Signac.* Exhibition, Musée du Louvre, Paris, December 1963–February 1964. Catalogue by Marie-Thérèse Lemoyne de Forges. Paris, 1964.

Paris 1975. *Archives of Camille Pissarro.* Sale cat. Hôtel Drouot, Paris, November 21, 1975. Paris, 1975.

Paris 1987–88. *"Les Temps nouveaux," 1895–1914: Un Hebdomadaire anarchiste et la propagande par l'image.* Exhibition, Musée d'Orsay, Paris, November 30, 1987–February 28, 1988. Catalogue by Aline Dardel. Les Dossiers du Musée d'Orsay 17. Paris, 1987.

Paris 1988. *Van Gogh à Paris.* Exhibition, Musée d'Orsay, Paris, February 2–May 15, 1988. Catalogue by Bogomila Welsh-Ovcharov et al. Paris, 1988.

Paris 1993. *Henri Matisse, 1904–1917.* Exhibition, Centre Georges Pompidou, Paris, February 25–June 21, 1993. Paris, 1993.

Paris 1999–2000. *Le Fauvisme, ou, "l'épreuve du feu": Éruption de la modernité en Europe.* Exhibition, Musée d'Art Moderne de la Ville de Paris, October 29, 1999–February 27, 2000. Catalogue by Suzanne Pagé et al.; chronology by Jacqueline Munck. Paris, 1999.

Paris 2000. *1900.* Exhibition, Galeries Nationales du Grand Palais, Paris, March 14–June 26, 2000. Catalogue by Philippe Thiébaut et al. Paris, 2000.

Paris–Chicago 1994–95. *Gustave Caillebotte, 1848–1894.* Exhibition, Galeries Nationales du Grand Palais, Paris, September 12, 1994–January 9, 1995; Art Institute of Chicago, February 15–May 28, 1995. Catalogue by Anne Distel et al. Published in French and English. Paris, 1994.

Paris–London–Philadelphia 1995–96. *Cézanne.* Exhibition, Galeries Nationales du Grand Palais, Paris, September 25, 1995–January 7, 1996; Tate Gallery, London, February 8–April 28, 1996; Philadelphia Museum of Art, May 30–August 18, 1996. Catalogue by Françoise Cachin et al. Published in French and English. Paris, 1995; London and Philadelphia, 1996.

Paris–New York 1991–92. *Seurat.* Exhibition, Galeries Nationales du Grand Palais, Paris, April 9–August 12, 1991; The Metropolitan Museum of Art, New York, September 9, 1991–January 12, 1992. Catalogue by Françoise Cachin, Robert L. Herbert, Anne Distel, Susan Alyson Stein, and Gary Tinterow. Published in English and French. Paris and New York, 1991.

Paris–New York 1994–95. *Nadar.* Exhibition, Musée d'Orsay, Paris, June 7–September 11, 1994; The Metropolitan Museum of Art, New York, April 14–July 9, 1995. Catalogue

by Maria Morris Hambourg et al. New York, 1995.

Paris–Ottawa–New York 1996–97. *Corot 1796–1875.* Exhibition, Galeries Nationales du Grand Palais, Paris, February 28–May 27; Musée des Beaux-Arts du Canada, Ottawa, June 21–September 22; The Metropolitan Museum of Art, New York, October 22, 1996–January 19, 1997. Published in French and English. Paris and New York, 1996.

Pawlowski 1926. G. de Pawlowski. "37ème Salon des indépendants." *Le Journal,* March 20, 1926.

Peraté 1907. André Peraté. "Les Salons de 1907." *Gazette des Beaux-Arts,* ser. 3, 37 (May 1907), pp. 353–78.

Picabia 1922. Francis Picabia. "La Bonne Peinture." *L'Ère nouvelle,* August 20, 1922.

Pissarro 1993. Joachim Pissarro. *Camille Pissarro.* Paris and New York, 1993.

Pogu 1963. Guy Pogu. *Théo van Rysselberghe: Sa vie.* Paris, 1963.

Poupard-Lieussou 1974. Yves Poupard-Lieussou, comp. *Documents Dada.* Paris, 1974.

Ratliff 1992. Floyd Ratliff. *Paul Signac and Color in Neo-Impressionism.* Includes the first English translation of *D'Eugène Delacroix au néo-impressionnisme* by Paul Signac; translated from the 3d French ed. (Paris, 1921) by Willa Silverman. New York, 1992.

Renart 1912. Ernest Renart. *Supplement au Répertoire des collectionneurs. . . .* Paris, 1912.

René-Jean 1926. René-Jean. "Le Salon des artistes indépendants." *Comoedia,* March 19, 1926.

Retté 1891. Adolphe Retté. "Septième exposition des artistes indépendants." *L'Ermitage* 2 (May 1891), p. 295.

Retté 1894. Adolphe Retté. "Notes de voyage." *La Plume,* no. 129 (September 1, 1894), pp. 351–53.

Rewald 1949. John Rewald, ed. and trans. "Extraits du journal inédit de Paul Signac / Excerpts from the Unpublished Diary of Paul Signac, I, 1894–95." *Gazette des Beaux-Arts,* ser. 6, 36 (July–September 1949), pp. 97–128, 166–74.

Rewald 1952. John Rewald, ed. and trans. "Extraits du journal inédit de Paul Signac / Excerpts from the Unpublished Diary of Paul Signac, II, 1897–98." *Gazette des Beaux-Arts,* ser. 6, vol. 41 (April 1952), pp. 265–84, 298–304.

Rewald 1952a. John Rewald. "Des Signac inconnus à Düsseldorf." *Arts, beaux-arts, littérature, spectacles*, no. 382 (October 1952), p. 7.

Rewald 1953. John Rewald, ed. and trans. "Extraits du journal inédit de Paul Signac / Excerpts from the Unpublished Diary of Paul Signac, III, 1898–99." *Gazette des Beaux-Arts*, ser. 6, vol. 42 (July–August 1953), pp. 27–57, 72–80.

Rewald 1956. John Rewald. *Post-Impressionism: From Van Gogh to Gauguin.* New York, 1956.

Rewald 1961. John Rewald. *The History of Impressionism.* 3d ed. New York, 1961.

Rewald 1978. John Rewald. *Post-Impressionism: From Van Gogh to Gauguin.* 3d ed. New York, 1978.

Rewald 1980. John Rewald, ed., with the assistance of Lucien Pissarro. *Camille Pissarro, Letters to His Son Lucien.* 4th ed. London, 1980.

Rewald 1996. John Rewald, with the assistance of Walter Feilchenfeldt and Jayne Warman. *The Paintings of Paul Cézanne: A Catalogue Raisonné.* 2 vols. New York, 1996.

Roger-Marx 1924. Claude Roger-Marx. "Vernissage." *Les Nouvelles littéraires*, February 9, 1924.

Rood 1879. Ogden Rood. *Modern Chromatics.* New York, 1879. French ed., 1881.

Roque 1997. Georges Roque. *Art et science de la couleur: Chevreul et les peintres, de Delacroix à l'abstraction.* Nîmes, 1997.

Rotterdam–Lyon–Paris 1996–97. *The Van Dongen Nobody Knows: Early and Fauvist Drawings, 1895–1912.* Exhibition, Boymans Van Beuningen Museum, Rotterdam, November 2, 1996–January 5, 1997; Musée des Beaux-Arts, Lyon, January 23–April 6, 1997; Institut Néerlandais, Paris, April 17–June 8, 1997. Catalogue by Anita Hopmans. Rotterdam, 1996.

Rouanet 1886. Rouanet. In *Le Passant*, June 5, 1886.

Saint-Simon 1825. Henri Saint-Simon. *Opinions littéraires, philosophiques et industrielles.* Paris, 1825.

Saint-Tropez–Reims 1992. *Signac et Saint-Tropez, 1892–1913.* Exhibition, Musée de l'Annonciade, Saint-Tropez, June 20–October 6, 1992; Reims, Musée des Beaux-Arts, November 6–December 13, 1992. Catalogue by Marina Ferretti-Bocquillon. Paris, 1992.

Salé 2000. Marie-Pierre Salé. "Le Mythe de l'âge d'or et le retour à la nature." In Paris 2000, pp. 314–43.

Salmon 1911. A[ndré] S[almon]. "Henri Edmond Cross et Paul Signac." *Paris-journal*, June 20, 1911, p. 4.

Saunier 1892. Charles Saunier. "L'Art nouveau, II: Les Indépendants." *La Revue indépendante*, April 1892, pp. 40–48.

Saunier 1893. Charles Saunier. "Salon des indépendants." *La Plume*, April 15, 1893, pp. 171–73.

Schmidt 1912. Paul Ferd. Schmidt. "Die Internationale Austellung des Sonderbundes in Cöln." *Zeitschrift für bildende Kunst* 23 (1912), pp. 229–38.

Schmit 1973. Robert Schmit. *Eugène Boudin, 1824–1898.* 3 vols. Paris, 1973.

Sertat 1895. Raoul Sertat. "La Vie artistique." *La Revue encyclopédique*, June 15, 1895, p. 229.

Signac 1882a. Paul Signac. "Une Trouvaille, Mounard, dit La Trique." *Le Chat Noir*, February 11, 1882.

Signac 1882b. Paul Signac. "Une Crevaison." *Le Chat Noir*, March 25, 1882.

Signac 1888a. Néo [Paul Signac]. "À Minuit: Les XX." *Le Cri du peuple*, February 9, 1888, p. 3.

Signac 1888b. Néo [Paul Signac]. "À Minuit: 4ᵉ exposition des artistes indépendants." *Le Cri du peuple*, March 29, 1888, p. 3.

Signac 1890. S. P. [Paul Signac]. "Catalogue de l'exposition des XX à Bruxelles." *Art et critique* 2, no. 36 (February 1, 1890), pp. 76–78.

Signac 1891. Anonymous [Paul Signac]. "Impressionnistes et révolutionnaires." *La Révolte* (literary supplement), June 13–19, 1891, pp. 3–4. English translation in Hutton 1994.

Signac 1892. Paul Signac. "D'Océan en Méditerranée par les canaux," parts 1, 2. *Le Yacht*, September 17, 1892, pp. 343–44, September 24, pp. 351–52.

Signac 1899. Paul Signac. *D'Eugène Delacroix au néo-impressionnisme.* Paris, 1899. Excerpts published in *La Revue blanche*, May–July 1898; published in German in *Pan*, July 1898; reprinted in Cachin 1964 and Cachin 1978; English translation in Ratliff 1992.

Signac 1899b. Paul Signac. "Hector Guimard: L'Art dans l'habitation moderne, le Castel Béranger." *La Revue blanche*, February 15, 1899, pp. 317–19.

Signac 1902. Paul Signac. "Exposition des peintres provençaux à Marseille." *La Revue blanche*, May 15, 1902.

Signac 1904. Paul Signac. "Enquête sur la séparation des Beaux-Arts en France." *Les Arts de la vie*, October 1904, pp. 251–52.

Signac 1905. Paul Signac. In *Mercure de France*, September 1, 1905.

Signac 1922. Paul Signac. "Tableaux de chevalet ou peinture décorative." *Bulletin de la vie artistique*, February 15, 1922, p. 77.

Signac 1927. Paul Signac. *Jongkind.* Paris, 1927.

Signac 1927a. Paul Signac. "Fondation de la Société des artistes indépendants." *Partisans*, January 1927, pp. 3–7.

Signac 1927b. Paul Signac. In "Opinions." *L'Art vivant*, special no. 49 (January 1, 1927), p. 23.

Signac 1930. Paul Signac. "Charles Henry." *Les Cahiers de l'étoile*, no. 13 (January–February 1930), unpaged.

Signac 1934. Paul Signac. "Le Néo-impressionnisme: Documents." *Gazette des Beaux-Arts* ser. 6, 11 (January 1934), pp. 49–59.

Signac 1934a. Paul Signac. "Peinture 1880." *Beaux-Arts*, no. 57 (February 2, 1934), pp. 3–5.

Signac 1934b. Paul Signac. "Malheur à l'homme qui invente et qui ose." *Monde*, February 10, 1934, pp. 6–7.

Signac 1935. Paul Signac. "Les Besoins individuels et la peinture." In *Encyclopédie française*, vol. 16, *Arts et littératures*, part 2, sect. B, chap. 2:3, pp. 16.84:7–10. Edited by Pierre Abraham. Paris, 1935. Reprinted in Cachin 1964, pp. 143–65.

Signac 1935a. Paul Signac. "Pourra-t-on éviter la Révolution? Enquête dirigée par Paul Gsell." *La Revue mondiale*, January 1, 1935, pp. 11–12.

Signac 1947. Paul Signac. "Fragments du journal de Paul Signac." [Edited by George Besson.] *Arts de France*, no. 11 (1947), pp. 97–102; nos. 17-18 (1947), pp. 75–82.

Stein 1986. Susan A. Stein, ed. *Van Gogh: A Retrospective.* New York, 1986.

Stendhal 1932. Stendhal [Marie-Henri Beyle]. *Mémoires d'un touriste.* 3 vols. Edited by Louis Royer. Oeuvres complètes de Stendhal. Paris, 1932.

Sutter 1986. Jean Sutter. *Maximilien Luce, 1858–1941: Peintre anarchiste.* Paris, 1986.

Tabarant 1929. Adolphe Tabarant. *Peinture sous vers.* Paris, 1929.

Tériade 1929. E. Tériade. "Visite à Henri Matisse," parts 1, 2. *L'Intransigeant*, January 14, 22, 1929.

Tériade 1951. E. Tériade. "Matisse Speaks." *Art News Annual* 21 (November 1951), pp. 40–77.

Terrasse 1988. Antoine Terrasse. *Bonnard*. Paris, 1988.

Thiébaut 1991. Philippe Thiébaut. "Art nouveau et néo-impressionnisme: Les Ateliers de Signac." *La Revue de l'art*, no. 92 (1991), pp. 72–78.

Thomson 1985. Richard Thomson. *Seurat*. Oxford, 1985.

Thorold 1993. Anne Thorold, ed. *The Letters of Lucien to Camille Pissarro, 1883–1903*. Cambridge, 1993.

Toronto–Amsterdam 1981. *Vincent van Gogh and the Birth of Cloisonism*. Exhibition, Art Gallery of Ontario, Toronto, January 24–March 22, 1981; Van Gogh Museum, Amsterdam, April 9–June 14, 1981. Catalogue by Bogomila Welsh-Ovcharov. Toronto, 1981.

Trublot 1886. Trublot [Paul Alexis]. In *Le Cri du peuple*, April 1, 1886, p. 3.

Trublot 1887. Trublot [Paul Alexis]. "Chez les artistes indépendants." *Le Cri du peuple*, May 13, 1887.

Turpin 1926. Georges Turpin. "Le Salon des artistes indépendants." *L'Âme gauloise*, April 11, 1926, pp. 1–2.

Vauxcelles 1904. Louis Vauxcelles [Louis Mayer]. "Le Salon d'automne." *Gil Blas*, October 14, 1904.

Vauxcelles 1905. Louis Vauxcelles [Louis Mayer]. "Le Salon des indépendants." *Gil Blas*, March 23, 1905.

Vauxcelles 1906. Louis Vauxcelles [Louis Mayer]. "Le Salon des indépendants." *Gil Blas*, March 20, 1906.

Vauxcelles 1907a. Louis Vauxcelles [Louis Mayer]. "La Vie artistique: Exposition Paul Signac." *Gil Blas*, January 26, 1907, p. 2.

Vauxcelles 1907b. Louis Vauxcelles [Louis Mayer]. "Le Salon des indépendants." *Gil Blas*, March 20, 1907, pp. 1–2.

Van de Velde 1896. Henry van de Velde. "Les Expositions d'art I: À Bruxelles." *La Revue blanche* 10, no. 1 (1896), pp. 284–87.

Venturi 1939. Lionello Venturi. *Camille Pissarro: Son art, son oeuvre*. 2 vols. Paris, 1939. Reprinted San Francisco, 1989.

Verhaeren 1891. Émile Verhaeren. "Le Salon des indépendants." *L'Art moderne*, April 5, 1891, pp. 110–12.

Verhaeren 1896. Émile Verhaeren. "Le Salon de la Libre Esthétique," part 2. *L'Art moderne*, March 8, 1896, p. 2.

Vidal 1886. Jules Vidal. "Les Impressionnistes." *Lutèce*, May 29, 1886, p. 1.

Waern 1892. Cecilia Waern. "Some Notes on French Impressionism." *Atlantic Monthly* 69 (April 1892), p. 541.

Waldemar-George 1964. Waldemar-George. "Triomphe de Signac," *Le Peintre*, January 1, 1964, pp. 6–7.

Ward 1996. Martha Ward. *Pissarro, Neo-Impressionism, and the Spaces of the Avant-Garde*. Chicago, 1996.

Washington–San Francisco 1986. *The New Painting: Impressionism, 1874–1886*. Exhibition, National Gallery of Art, Washington, D.C., January 19–April 6, 1986; M. H. de Young Memorial Museum, San Francisco, April 19–July 6, 1986. Catalogue by Charles S. Moffett et al. Geneva, 1986.

Wauters 1888. A. J. Wauters. "Aux XX." *La Gazette*, February 18, 1888.

Weisberg 1985. Gabriel P. Weisberg. "Siegfried Bing, Louis Bonnier et la maison de l'Art Nouveau en 1895." *Bulletin de la Société de l'histoire de l'art français*, 1983 (1985), pp. 241–49.

Weisberg 1986. Gabriel P. Weisberg. *Art Nouveau Bing: Paris Style 1900*. Exhibition organized by the Smithsonian Institution Traveling Exhibition Service and shown from September 1986–September 1987. New York, 1986.

White 1984. Barbara E. White. *Renoir: His Life, Art, and Letters*. New York, 1984.

Wick 1962. Peter A. Wick. "Some Drawings Related to Signac Prints." In *Prints: Thirteen Illustrated Essays on the Art of the Print*, edited by Carl Zigrosser, pp. 83–96. New York, 1962.

Wildenstein 1985. Daniel Wildenstein. *Claude Monet: Biographie et catalogue raisonné*. Vol. 4, *1899–1926*. Lausanne, 1985.

Wildenstein 1996. Daniel Wildenstein. *Monet*. 4 vols. Cologne, 1996. Rev. ed. (in English, French, and German) of *Claude Monet: Biographie et catalogue raisonné*, Lausanne, 1974–91.

Zimmermann 1991. Michael F. Zimmermann. *Les Mondes de Seurat*. Antwerp and Paris, 1991.

Zola 1967. Émile Zola. *Les Rougon-Macquart: Histoire naturelle et sociale d'une famille sous le Second Empire*. 20 vols. Paris, 1967. A series of 20 novels first published under this collective title, 1871–98.

Zola 1968. Émile Zola. *The Masterpiece*. Translated by Thomas Walton. Ann Arbor, Mich., 1968. Originally published as *L'Oeuvre* (Paris, 1886).

INDEX

Page references to illustrations
are in *italics*.

PHOTOGRAPH CREDITS

AMIENS Musée de Picardie: fig. 102

AMSTERDAM Van Gogh Museum: cat. nos. 14, 88a; fig. 69

ASNIÈRES Archives Municipales: figs. 75, 76, 84, 85

BALTIMORE The Baltimore Museum of Art: cat. no. 26

BAYONNE Musée Bonnat: fig. 101

BERLIN Staatliche Museen zu Berlin, National-galerie, photo Jörg P. Anders: cat. no. 8

BESANÇON Musée des Beaux-Arts et d'Archéologie, photo Charles Choffet: cat. nos. 122, 160

BOSTON Museum of Fine Arts: cat. no. 49; fig. 107

BRUSSELS Centre International pour l'Étude du XIXe Siècle: fig. 61

CHICAGO The Art Institute: cat. no. 22; fig. 3

DUBLIN The National Gallery of Ireland (Dublin, Adagp, Paris, and DACS, London 2001): cat. no. 96

GLASGOW Glasgow Museums: Art Gallery and Museum, Kelvingrove: cat. no. 38

HARTFORD Wadsworth Atheneum, The Ella Gallup Sumner and Mary Catlin Sumner Collection Fund: fig. 40

THE HAGUE Gemeentemuseum Den Haag, photo Strengers: cat. no. 34

LEEDS Leeds Museums and Galleries (City Art Gallery) © The Bridgeman Art Library: cat. no. 15

LITTLE ROCK Arkansas Arts Center Foundation Collection: cat. nos. 74, 102, 107, 134, 146, 147, 153, 156, 166–68, 174, 175, 178, 179

LONDON Courtauld Institute Galleries: fig. 92
National Gallery: fig. 2

LYON Musée des Beaux-Arts, photo Studio Basset: cat. no. 98

MELBOURNE National Gallery of Victoria: cat. no. 16; fig. 10

MEMPHIS The Dixon Gallery and Gardens: cat. no. 10

MERION The Barnes Foundation, photo © 2000: fig. 63

MINNEAPOLIS Minneapolis Institute of Arts: cat. nos. 13, 151

MIYAZAKI Miyazaki Prefectural Art Museum: cat. no. 58

MONTREUIL Mairie de Montreuil, photo Antoine Darnaud: cat. no. 75; fig. 14

NANCY Musée des Beaux-Arts: cat. no. 88b; fig. 15

NEW YORK The Metropolitan Museum of Art: cat. nos. 18, 25, 27, 32, 33, 35, 41, 55, 106, 117, 118, 120, 133, 144, 150, 152, 154, 155, 159, 162, 163, 164, 169, 170–72; figs. 7, 20, 22, 27–29, 77, 79
The Museum of Modern Art: cat. nos. 51 (photo Malcolm Varon), 56; figs. 6, 9, 48, 83, 96
The Solomon R. Guggenheim Museum: fig. 19

NORFOLK Chrysler Museum of Art: cat. no. 113; fig. 105

OTTERLO Kröller-Müller Museum: cat. nos. 7, 24, 67; figs. 5, 11, 67

PARIS Bibliothèque Nationale de France: cat. no. 41
Musée Carnavalet: cat. no. 5
Musée de la Marine: cat. no. 90
Musée des Arts Décoratifs: fig. 98
Musée du Petit-Palais, Photothèque des musées de la ville de Paris: cat. no. 132
Musée Marmottan, Bequest of Michel Monet, © Giraudon: fig. 55
Réunion des Musées Nationaux, photos by R. G. Ojeda, H. Lewandowski, G. Blot, C. Jean, B. Hatala, M. Bellot, J.-G. Berizzi, Jean Schor-mans: cat. nos. 4, 11, 12, 19, 21, 23, 39, 63–65, 69, 76, 89, 92, 111, 112, 115, 116, 123–31, 161, 165, 176, 182; figs. 13, 42, 46, 47, 50, 51, 57, 71, 93, 122
Signac Archives: figs. 26, 33–35, 62, 64, 99, 109, 113, 116, 117, 128

PITTSBURGH Carnegie Museum of Art, photo Peter Harholdt: cat. no. 68

ROTTERDAM Museum Boijmans Van Beunin-gen: fig. 53

SAINT-MALO Musée d'Histoire: cat. no. 173

SAINT-TROPEZ L'Annonciade, Musée de Saint-Tropez: cat. nos. 78, 91, 148, 149; figs. 94, 97

SAN FRANCISCO Fine Arts Museums: fig. 54

SHIMANE Shimane Art Museum: cat. no. 119

STUTTGART Staatsgalerie Stuttgart: cat. no. 31

TOKYO The National Museum of Western Art: cat. no. 97; fig. 17

TOLEDO The Toledo Museum of Art: cat. no. 114

WASHINGTON, D.C. The National Gallery of Art: fig. 52

WUPPERTAL Von der Heydt-Museum: cat. no. 66

ZURICH Kunsthaus Zurich: fig. 32

PRIVATE COLLECTIONS Scott M. Black Collection, photo Portland Museum of Art, Maine: cat. no. 135
Foundation E. G. Bührle Collection: figs. 4, 82
Fondation Corboud, on permanent loan to the Wallraf-Richartz-Museum, Cologne: cat. no. 105
Ray and Dagmar Dolby, San Francisco: cat. no. 9
Collection of Simone and Alan Hartman: cat. no. 109
Collection Kakinuma: fig. 58
Ambassador John L. Loeb, Jr.: cat. no. 62
Mr. and Mrs. Donald B. Marron, cat. no. 50
The Phillips Family Collection: cat. no. 30
Lord and Lady Ridley-Tree: cat. no. 37
Tai Cheung Holdings, Ltd.: cat. no. 6

ANONYMOUS Cat. nos. 1–3, 17, 20, 28, 29, 36, 40, 42–48, 52–54, 57, 59–61, 70–73, 77, 79–87, 93–95, 99–101, 103, 104, 108, 110, 121, 136–45, 157, 158, 177, 180, 181; figs. 1, 12, 16, 18, 21, 23, 24, 30, 31, 36–39, 41, 43–45, 49, 56, 60, 65, 66, 68, 70, 72, 73, 78, 81, 87–90, 95, 100, 104